G000129412

V. ON THE HISTORY OF HANDBILLS

VI. THE FUTURE OF FLYERS

VII. FLYERS OF THE WORLD | FLYER DER WELT

GERMANY | DEUTSCHLAND

EUROPE | EUROPA

WORLD | WELT

VIII. APENDIX | ANHANG

PREFACE MARC WOHLRABE

In the late 1980s, thanks to the democratisation of the means of production via computers and programs which were affordable to all, a new development took place in the pop sector, namely the rise of the electronic music movement and its events. Its main characteristics were its unconventionalism, the changing venues, improvised and ecstatic celebrations without ridiculous dress-codes. The illegality of the extraordinary venues created the necessity to publicise these ceremonies in an appropriate manner - and without giving too much away. The usual listing magazines were therefore out of the question. Flyers became the best source of information and even in the early '90s there was much competition regarding their originality and creativity. Whoever got a flyer, knew all s/he needed to know, and whoever collected a lot of them, could see directly in front of his eyes how rapidly the locations and the styles came and went. Berlin, with its uncounted number of clubs over the last fifteen years demonstrates this in a particularly impressive way.

My own lifestory is undividedly connected with flyers. Between 1989 and 1994 I collected every scrap of paper I found on walls, tables and on the floor, and I set myself the goal to visit all those places in Berlin which presented themselves as being a club. At the end of 1994 I was ready: not only to keep all the infos that I carried around, bundled up on all those handbills, to myself, but to pass this information on. The FLYER was born, the journal for the coat pocket, which existed to give the new clubs and the (electronic) music culture a platform, as a partner, without exposing them (and getting them closed down). The name was chosen consequently – here, in FLYER, the reader should find the details from the collected flyers along with editorial recommendations. For almost ten years the FLYER accompanied party people in many towns and cities.

Meanwhile, the FLYER doesn't exist anymore, but at the same time the flyers still fulfill their purpose - getting noticed, helping remember the event beforehand and afterwards - who has never visited a flat where the best ones are displayed on the kitchen wall?! – and transporting taste and atmosphere. While it is true that text messaging and e-mail have become an important competitor to paper flyers, flyers remain the clearest expression of stance, of expectations. Therefore I am sure that in the future we will find, within the masses of paper, cute examples which provide what they promise.

I am very pleased that an institution such as FLYER SOZIOTOPE was founded many years ago and that Mike Riemel and his many colleagues managed to find time within the tribulations of everyday life to create the flyer archive, and now, this book. The archive has also become the home for my collection of thousands of flyers from around the world, and in particular from Berlin, which I collected over fifteen years. I wish it much success for the future. Through flyers we can follow pop history.

Marc Wohlrabe
Former publisher, FLYER
Mexico City, February 2005
Translation: Matthew Heaney

Ende der 80'er Jahre des 20.Jahrhunderts fiel mit der Demokratisierung der Produktionsmittel durch erstmals erschwingliche Computer und Programme für jedermensch eine neue Entwicklung im Popbereich zusammen: Der Aufschwung der elektronischen Musikbewegung und deren Partys. Unkonventionalität, wechselnde Orte, improvisiertes, ekstatisches Feiern ohne lächerliche Dresscodes waren die charakteristischen Erscheinungsmerkmale. Die Illegalität der aussergewöhnlichen Orte schuf die Notwendigkeit, diese Zeremonien entsprechend zu bewerben ohne sie vollends zu verraten. Herkömmliche Stadtmagazine und Veranstaltungskalender fielen also aus. Der Flyer wurde zum optimalen Informationsmittel, um auf sich hinzuweisen und schnell setzte schon in den frühen 90'ern ein Wettlauf um Originalität und Ausgefallenheit ein. Wer einen Flyer hatte, wusste bescheid und wer viele sammelte, der hatte bunt vor Augen, wie rasend schnell die Orte und Stile kamen und verschwanden. Berlin mit seinen ungezählten Clubs der letzten 15 Jahre demonstriert das besonders eindrucksvoll.

Meine eigene Geschichte ist untrennbar mit Flyern verbunden. In den Jahren 1989-94 sammelte ich jeden Schnipsel von Wänden, Tischen und Fussböden auf und hatte es mir zum Ziel gesetzt, alle Orte in Berlin zu erleben, die sich als Club präsentierten. Ende 1994 war es dann soweit, all die Infos, die ich gebündelt in Form der vielen Handzettel herumtrug, nicht mehr nur für mich zu behalten. Der FLYER war geboren, das Magazin für die Jackentasche, der den neuen Clubs und der (elektronischen) Musikkultur eine Plattform bieten sollte; als Partner, ohne sie auffliegen zu lassen. Der Name war konsequent gewählt: Hier sollten sich die Infos der gesammelten Flyer individuell bewertet und mit redaktionellen Empfehlungen wiederfinden. Fast 10 Jahre hat der FLYER in vielen Städten feiernde Menschen begleitet.

Nun, den FLYER gibt es nicht mehr, doch die Flyer erfüllen weiterhin ihren Zweck: Aufmerksamkeit erregen, an das Event davor und danach erinnern (wer hat nicht schon bei vielen zu Hause die Besten an der Küchenwand wiedergesehen), Geschmack und Atmosphäre transportieren. Zwar ist den Papierflyern ein gewichtiger Infokonkurrent durch E-Mail und Sms Verteiler erwachsen, doch ist ein Flyer immer noch der klarste Ausdruck für eine Haltung, ein Versprechen. So bin ich mir sicher, dass wir weiterhin in der papiernen Infoflut schnuckelige Stücke finden werden, die ihr Versprechen einhalten.

Ich freue mich sehr, dass eine Institution wie FLYER-SOZIOTOPE sich schon vor vielen Jahren gebildet hat und Mike Riemel und seine vielen Mitstreiter unter den Mühen des Alltags das Flyer-Archiv und jetzt dieses Buch geschaffen haben. So ist das Archiv auch Heimat für meine Sammlung tausender Flyer geworden, die ich in 15 Jahren in der ganzen Welt und insbesonders in Berlin zusammengetragen habe. Ich wünsche viel Erfolg für die Zukunft. An Flyern lässt sich Popgeschichte verfolgen.

Marc Wohlrabe,
Ex-FLYER Herausgeber,
Mexiko-City, Februar 2005

PREFACE MARC WOHLRABE

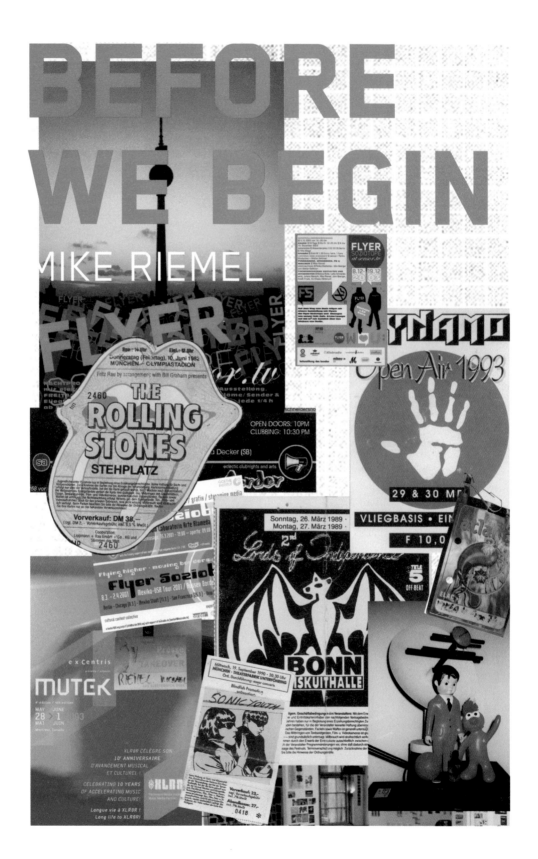

BEFORE
WE BEGIN

MIKE RIEMEL

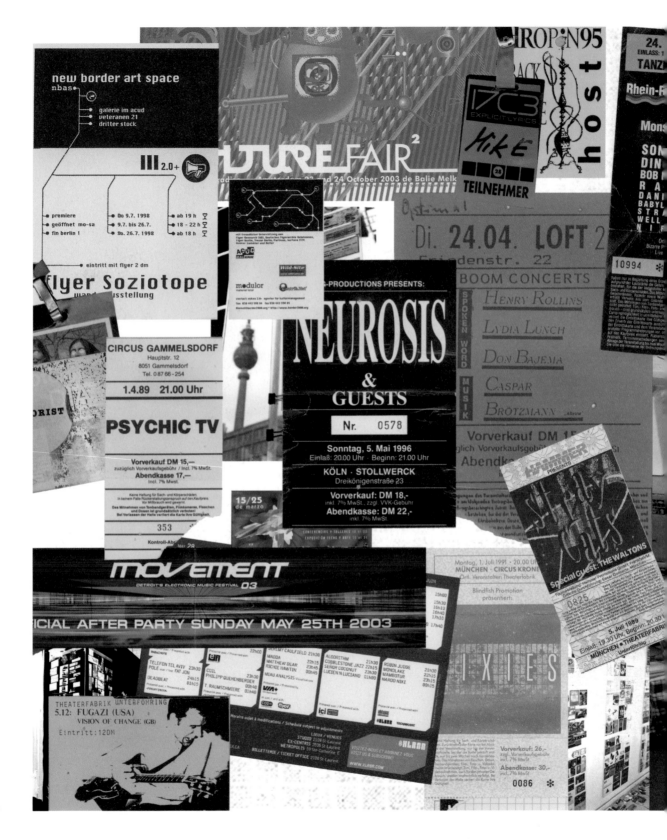

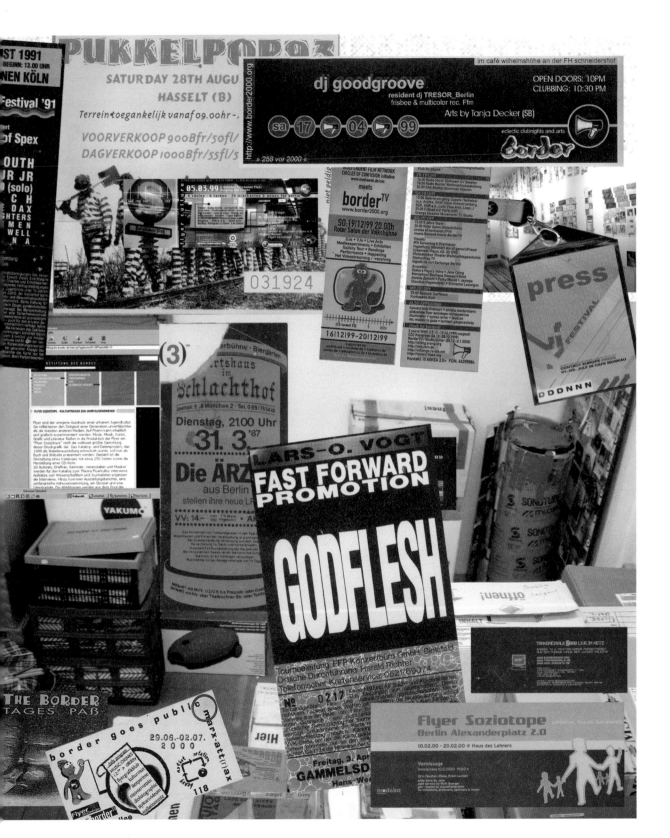

How did the Flyer Soziotope project come about? How do people become collectors? And why? As someone born in 1967, I experienced plenty of input, and the amount on offer was still manageable. In the beginning was ABBA and the Disco Fever compilation. Before that, there was classical music, brass band music, radio of course, even jazz. And Ilja Richter's Disco. Seeing DAF on Bios Bahnhof at age 12 was amazing. The first video I saw was probably Once in a Lifetime by Talking Heads on MTV. My first LP was Sheik Yerbouti by Frank Zappa, followed by Ian Dury, the B52's, rockabilly and psychobilly, Pink Floyd, AC/DC, disco and funk records. My first rock concert was the Stones in '82, not having been allowed to go to Munich to see Status Quo the year before. In 1983, aged 15, I spent a year in the USA; the musical highlights were a Rocky Horror Picture Show night in San Jose and the Mexican b-boys at the high school. After this, I began going to clubs across Lower Bavaria, from 1984 to 1990 at places like 38B in Straubing, Bauhaus in Landshut, Libella in Kirchweihdach, Babalu + Tanzcafe Größenwahn in Munich (with DJ 'Hell'mut Geier), Scala + Factory in Regensburg; and finally the fantastic Circus Gammelsdorf near Freising; all of these made a lasting impression on me. At the Lords of Independence festival in Bonn in '89, there was no doubt in my mind: I was a die-hard music fan. From then on, I was a regular at the Popkomm in August; a subscriber to music magazines like Spex, Howl and Trust; always listening to radio Zündfunk; collecting records; using mail order for obscure material; addicted to moshing, rocking and pogo dancing whenever the chance arose. As a fan in the Bavarian countryside, you have to travel long distances. And back then, there were next to no flyers. I would have collected them. There were tickets. Nice enough. I began DJing - at the afterhours location of the Circus, that had to shut at 1am. Hype in Pfeffenhausen was my first Saturday residency with music from Elvis to the Butthole Surfers. Finally, my student days took me from Regensburg to Trier. From there, I made regular trips to Cologne (Rose Club, IZ, Underground) and Frankfurt (Negativ, Batschkapp, Box). The festivals in Holland (Dynamo) and Belgium (Pukkelpop) were nearby. And I kept making my own music as Mad Hatter. In 1996, I lived in Cologne and was a regular guest at Liquid Sky. Hearing jungle grow into drum'n'bass. 15-times visitor to Popkomm. Writing a diploma dissertation in sociology entitled "Upheavals in the music market - a socio-economic analysis with special reference to progressive styles and their marketing" - with a book of flyers as an appendix.

After seeing around 2000 bands (I stopped keeping a list in 1995) and visiting well over 1000 clubs, it was high time for: The Border: 1000 Days to 2000. In April '97, I came to Berlin, and immediately started organizing a series of festivals with the main theme of promoting progressive cultural work in networked systems around the millennium. The aim was to have an event every hundred days, building a platform for cooperation between people and venues from all areas of cultural activity. These events, that were networked on a nationwide basis, led to an exchange that gave all those involved access to a larger audience. The Border worked online at http://www.border2000.org and through project modules like galleries (New Border Art Space 1998, Invalid 2001, Foto-Shop 2002), Internet radio (Radio AussenBorder, Klubradio, Radio Internationale Stadt), Internet TV (Border TV, Offenes Video Archiv, Re:publik TV), clubs (Borderlinerlounge, Eclectic Clubnights, MediaBeat Sessions) and a mobile exhibition (Flyer Soziotope). The latter went on an extended tour, always supported by many enthusiasts and helpers, and accompanied by our mascot Elvis. Radio and TV activities were taken to a professional level, and the time had come for an extensive catalog: loving the artifacts and their creators; looking after them and STIMULATING REPRODUCTION; keeping on keeping on, seeking inspiration, gaining knowledge - these are the mission statements of this undertaking. And they still apply.

DEFINITION OF "SOCIOTOPE"

Flyer sociotopes: social symbioses of music-centered community life in urban spaces revolving around the medium of flyers. See also club culture, club art, street art, propaganda, fashion theory, cultural studies, pop culture, design culture, guerilla marketing, media culture.

Latin "socio" relating to community, Greek "topos" place. Concrete living contexts for groups. Sociotopes involve strong ties between a lively place (apartment, house, neighborhood, club) and the corresponding community (scene, posse, gang, tribe). What goes on is closely related to the physical environment (location, decoration), the people present, and group experience of the moment (party). It can be described as a constellation of us/here/ now. In modern societies, sociotopes (like biotopes) need to be designed as open "reserves of the concrete" and protected against damaging influences by institutional means.

ALBROW, M.: AUF REISEN JENSEITS DER HEIMAT. SOZIALE LANDSCHAFTEN IN EINER GLOBALEN STADT. IN: BECK, U. (ED.): KINDER DER FREIHEIT. FRANK-FURT, 1997. PP. 288-314.

In whatever realm, this requires diversity of types and symbioses. In the realm of nature, we refer to these types as "biotopes", in the human realm as "homotopes", and in the realms of society and the world at large, as "sociotopes".

HTTP://WWW.PHYTOBUNKER.DE/VERSION%2002/HTML/DEUTSCH/TREE/SOCIO-1.HTM

TOPOGRAPHY OF A MEDIA PHENOMENON

One could say: surface analysis (geography) meets biology (Darwin). Flyer sociotopes are also not unrelated to isotopes: small entities that radiate their information - media-active, not radioactive, resulting not from fission but from fusion.

One key question answered by flyers is "where?". For the user, it is also important to know "who?". For collectors, "where from?". Of course, we are also interested in "when?" and "what?". But this last question brings us into highly subjective territory, as it is extremely diverse and hard to judge. Sure, we may know the residents and the stars – but not everyone does, and not always. Excitement and anticipation, curiosity, an element of the unknown, the experience in store - a good flyer tries to press all these buttons. You don't want to miss this!

Keep it unreal ...

CO-WORKER, FRIEND & ICON KIDNAPPED!

IN EARLY MORNING HOURS OF 7 MAY, WE NOTICED
THE DISAPPEARANCE OF

 ELVIS

(ORANGE SKIN, RED HAIR, APPROX 25CM TALL,
FRIENDLY STARING EYES & FUNNY TAIL)
AT VEEJAY GROOVE OSNABRÜCK

ELVIS IS AN ESSENTIAL PART OF ALL BORDER2000 EVENTS!

THIS TIME, HE WAS WELCOMING GUESTS TO
THE "FLYER SOZIOTOPE" EXHIBITION THAT WAS SET UP
IN A CONTAINER OUTSIDE THE MAIN ENTRANCE.
NAIVE AND DRUG-FREE, HE OBVIOUSLY LET HIMSELF BE KIDNAPPED!
HIS FAILURE TO TURN UP AT THE TOUR BUS ON TIME DEFINITELY
CANNOT BE BLAMED ON ANY KIND OF FLIRTATIOUS ENCOUNTER!

WE WANT OUR ELVIS BACK!
REWARD GUARANTEED!
WATCH OUT & RESPECT!

FLYER SOZIOTOPE - WWW.BORDER2000.ORG

www.carhartt-europe.com - work in progress - exclusive distributor for europe © 2005 carhartt inc. USA ® **carhartt** and **carhartt** logo ⚒ are registered trademarks of carhartt inc., Dearborn, MI 48121

EINE ART VORWORT

Wie entstand das Flyer-Soziotope-Projekt? Wie wird man ein Sammler? Und warum? Als 67er durfte ich eine Menge Input mitnehmen, und die Dinge waren noch übersichtlich. Am Anfang war da ABBA und die 'Disco Fever'-Compilation. Davor gab es Klassik, Blasmusik, Radio natürlich, sogar Jazz war dabei. Und Ilja Richters Disco. Mit zwölf bei Bio`s Bahnhof DAF sehen war Wahnsinn. Das erste Video war wohl 'Once in a lifetime' von den Talking Heads auf MTV. Meine erste Doppel-LP war 'Sheik Yerbouti' von Frank Zappa, gefolgt von Ian Dury, den B52's, diversen Rockabilly- und Psychobilly-Machwerken, Pink Floyd, AC/DC, Disco- und Funkscheiben. Die ersten Rockkonzerte meines Lebens waren die Stones 82. Das Jahr vorher nach München zu Status Quo durfte ich noch nicht. Als 15jähriges Kid folgte 1983 ein USA-Jahr mit dem musikalischen Highlight einer Rocky Horror Picture Show-Nacht in San Jose und den mexikanischen B-Boys an der Highschool. Danach begannen meine Clubreisen in Niederbayern, zwischen 1984 und 1990 an Orte 38B/Straubing, Bauhaus/Landshut, Libella/Kirchweihdach, Babalu + Tanzcafe Größenwahn/München (schon mit DJ 'Hell'mut Geier), Scala + Factory/Regensburg; schließlich der fantastische Circus Gammelsdorf in der Nähe von Freising; sie haben mich nachhaltig geprägt. Beim 'Lords of Independence'-Festival 89 in Bonn war alles klar: ich war ein 'die hard'-Musikfan. Ab dann stand die Popkomm regelmäßig im August auf dem Fahrplan. Fleißig Spex, Howl und Trust lesen. Zündfunk hören. Platten sammeln. Mailorder nutzen für Obskures. Moshen, Rocken, Pogen, abtanzen als Sucht in allen Lagen. Als Fan auf dem niederbayerischen Land musste man lange Wege bewältigen. Und es gab quasi keine Flyer damals. Ich hätte sie gesammelt. Eintrittskarten waren schon da. Auch hübsch. Damals begann ich mit DJing. In der After Hour Location des Circus', der um 1 Uhr schliessen musste. Das Hype in Pfeffenhausen war meine erste Samstags-Residency mit Musik zwischen Elvis und Butthole Surfers. Mein Studium brachte mich schließlich über Regensburg nach Trier. Von dort begannen die Ausflüge nach Köln (Rose Club, IZ, Underground) und Frankfurt (Negativ, Batschkapp, Box). Die Festivals in Holland (Dynamo) und Belgien (Pukkelpop) waren naheliegend. Dazu weiter Musik machen als Mad Hatter. 1996 in Köln wohnen und regulärer Liquid Sky Guest sein. Den Jungle zu Drum'n'Bass-Growen hören. 15 Mal auf der Popkomm sein. Eine Diplomarbeit am Lehrstuhl für Soziologie schreiben, die da hieß: Der Musikmarkt im Umbruch - eine sozioökonomische Analyse am Beispiel progressiver Stile und ihrer Vermarktung mit einem Flyerbuch als Anhang.

Nach ca. 2000 gesehenen Bands (die Liste habe ich 1995 aufgehört) und wohl mehr als 1000 besuchten Clubs war die Zeit reif für: The Border: 1000 Tage vor 2000. Im April 97 ging's nach Berlin, und zugleich begann eine Festivalreihe, die die Förderung progressiver kultureller Arbeit in vernetzten Systemen rund um die Jahr-

tausendwende als Hauptthema hatte. Ziel war, alle hundert Tage Veranstaltungen zu organisieren und so eine Plattform für kooperierende Aktive und Orte aus allen Bereichen des Kulturschaffens aufzubauen. Diese überregional vernetzten Ereignisse führten zu einem Erfahrungsaustausch, der alle beteiligten Kulturschaffenden einer größeren Öffentlichkeit zugänglich machte. The Border arbeitete im Internet unter der Adresse http://www.border2000.org. und mit den Projektmodulen Galerie (New Border Art Space 1998, Invalid 2001, Foto-Shop 2002), Netz Radio (Radio AussenBorder, Klubradio, Radio Internationale Stadt), Netz TV (Border TV, Offenes Video Archiv, Re:publik TV), Club (Borderlinerlounge, Eclectic Clubnights, MediaBeat Sessions) und Wanderausstellung (Flyer Soziotope). Letztere begab sich auf eine längere Tour, immer getragen von vielen Liebhabern und Helfern und begleitet von unserem Maskottchen Elvis. Die Radio- und TV-Aktivitäten wurden professionalisiert und es wurde Zeit für einen umfassenden Katalog. Die Artefakte und Macher lieb haben, sie bewahren und REPRODUKTION STIMULIEREN. Weitermachen, anstecken lassen, Wissen erhalten, sind Mission Statements des Unterfangens. Immer noch.

DEFINITION SOZIOTOPE

Flyer Soziotope: Gesellschaftliche Symbiosen musikzentrierter Gesellung in urbanen Räumen rund um das Medium Flyer. Siehe auch Clubkultur, Clubart, Streetart, Propaganda, Szenetheorie, Cultural Studies, Popkultur, Designkultur, Guerilla Marketing, Medienkultur.

Lat. sozio die Gemeinschaft betreffend, griech. topos Ort. Konkrete Lebensräume von Gruppen. In Soziotopen besteht ein enger Zusammenhang zwischen der belebten Örtlichkeit (Wohnung, Haus, Nachbarschaft, Kiez, Club) und der sie belebenden Gemeinschaft (Szene, Posse, Gang, Tribe). Das Geschehen ist stark an die gegenständliche Umgebung (Location, Dekoration), die anwesenden Personen und das gegenwartsnahe gemeinschaftliche Erleben (Party) gebunden. Man kann es als eine wir/hier/jetzt-Konstellation bezeichnen. In modernen Gesellschaften müssen diese in gewisser Analogie zu Biotopen als offene »Reservate des Konkreten« gestaltet und institutionell gegen schädigende Einflüsse abgesichert werden.

ALBROW, M.: AUF REISEN JENSEITS DER HEIMAT. SOZIALE LANDSCHAFTEN IN EINER GLOBALEN STADT. IN: BECK, U. (HRSG.): KINDER DER FREIHEIT. FRANKFURT/M. 1997, 288-314.

In allen Räumen erfordert dies eine Vielfalt von Typen und Symbiosen. Im Raum der Natur wollen wir diese Typen als Biotope, im Menschlichen Raum als "Homotope" und in den Räumen Gesellschaft und Welt als "Soziotope" bezeichnen.

HTTP://WWW.PHYTOBUNKER.DE/VERSION%2002/HTML/DEUTSCH/TREE/SOCIO-1.HTM

BEFORE WE BEGIN... MIKE RIEMEL

TOPOGRAPHIE EINER MEDIENGATTUNG

Im Prinzip könnte man sagen: Oberflächenanalyse (Erdkunde) trifft Biologie (Darwin). Auch Isotope sind den Flugzettel-Soziotopen nicht unverwandt: Kleine Körper, die nicht leicht radioaktiv, aber doch medial ihre Informationen ausstrahlen und Produkte nicht von Spaltungen, sondern von Fusionen sind.

Eine Hauptinformation von Flyern ist das 'Wo?'. Für den User mit entscheidend: das 'Von wem?'. Für den Sammler auch das 'Woher?'. Das 'Wann?' und das 'Was?' sind natürlich in unserer Erlebnisgesellschaft auch nicht ganz uninteressant. Aber spätestens beim 'Was?' wird die Sache sehr subjektiv, da hochgradig divers und schwer einzuschätzen. Klar: die Residents und Stars kennt man noch… Aber eben nicht jeder und auch nicht immer. Diese Spannung und Erwartung, die Neugier, dieser Faktor unbekannt, dieses Erlebnispotential versucht ein guter Flyer zu stimulieren. Man könnte ja was verpassen!

Keep it unreal

MITARBEITER, FREUND UND IKONE ENTFÜHRT!
IN DEN MORGENSTUNDEN DES 7. MAI 2004 VERSCHWAND UNSER

ELVIS
(ORANGER TEINT, ROTE HAARE, CA. 25CM GROSS, FREUNDLICH ERREGTE GLUPSCHAUGEN & LUSTIGES SCHWÄNZCHEN) AUF DER VEEJAY GROOVE OSNABRÜCK

ELVIS IST ESSENTIELLER BESTANDTEIL DER BORDER2000-AKTIONEN!
DIESMAL BEGRÜSSTE ER DIE GÄSTE DER FLYER-SOZIOTOPE-AUSSTELLUNG, WELCHE VOR DEM HAUPTEINGANG IN EINEM CONTAINER INSTALLIERT WAR. NAIV UND DROGENFREI LIESS ER SICH OFFENSICHTLICH EINFACH ENTFÜHREN!
EIN NICHT RECHTZEITIGES ERSCHEINEN AM TOURBUS AUFGRUND EINER LIEBELEI KANN AUSGESCHLOSSEN WERDEN!

WIR WOLLEN UNSEREN ELVIS WIEDERHABEN!
KOPFGELD ODER BELOHNUNG GARANTIERT!
WATCH OUT AND RESPECT!
FLYER SOZIOTOPE - WWW.BORDER2000.ORG

EASTPAK® U.S.A.

BUILT TO RESIST
www.eastpak.com

VF Germany Textil-Handels GmbH · Vogelsangerstrasse 195a · 50825 Köln

TOUR DATES 1998– 2004

1998

ACUD-GALERIE & TRESOR – BERLIN

Flyer Soziotope was launched on the 10th anniversary of the Love Parade. New Border Art Space presented the first version of the flyer show in the gallery of the ACUD artists collective. It was visited by a fun bunch of flyer-fanatics, DJs who saw themselves mentioned, and club owners chatting with graphic designers about forthcoming information and visual campaigns. At the same time, there was also a show at the world-famous TRESOR club that confronted party people with our concept directly. The first screening of the slide show took place at Neue Berliner Initiative (NBI). Two weeks with numerous visitors, intensive media coverage and the beginnings of a project team vindicated our idea of provoking communication.

WWW.TRESORBERLIN.DE | WWW.ACUD.DE

NATURE ONE – PYDNA / KASTELLAUN PART 1

The first stop for our traveling exhibition was at Nature One, one of the biggest music festivals devoted to electronic music: 40,000 visitors saw a 300-square-meter bunker at the former American missile base covered with flyers, slides, books, and a TV area. Our visitors book filled up with comments.

WWW.NATURE-ONE.DE

ENERGY VS. LETHARGY – ROTE FABRIK – ZURICH

We fitted the VIP area at Energy with our flyer banners, and on the drum'n'bass floor of the Rote Fabrik we witnessed and helped design a highly imaginative and progressive event for the Zurich Street Parade. DJs like Krust, Goldie and Grooverider, the friendly atmosphere throughout the city, and some new contacts made our debut in Zurich most enjoyable.

WWW.ENERGY.CH | WWW.SHEDHALLE.CH

START!

ZURICH

PUKOMM 10 – KÖLN

TRIER & LUXEMBURG

Berlin

Nature One – Pydna
Kastellaun Part 1

TRIER & LUXEMBURG

The Soziotope slide show gave visitors to local pubs and bars a brief outline of our story.

WWW.HUNDERTTAUSEND.DE

POPKOMM 10 - COLOGNE

Flyer Soziotope showed one particular section of flyer culture - the early days, in collaboration with PopDom and Marc Wohlraabe (co-founder of Flyer magazine). We also presented unusual object flyers in glass display cases. Our flyer banners hung in the legendary Warehouse techno club Warehouse, and we rode piggyback on another event: a label showcase by Kitty-Yo Int. / Ninja Tune / Domino & Infracom in Building 9 at the KHD Halls. We ended our trip to Cologne with a chilled projection session at LiquidSky.

WWW.POPKOMM.DE | WWW.WAREHOUSE.DE | WWW.LIQUID-SKY-COLOGNE.DE

BETA CONGRESS & JUGENDFESTSPIELE - BERLIN

In August, we checked out the foyer of the Kongresshalle on Alexanderplatz, fittingly featuring the interface between the organizers and visitors of the Beta Congress - with our documentation of collaborations between media, DJs, projection specialists, and advertising/marketing. WWW.BERLINBETA.DE

BIG WARP - SAARBRÜCKEN

While the Beta Congress was running, we exported our slide show to this big circus of sounds where it appeared as a special high-content form of optical support. WWW.BIGWARP.DE

KROKODIL - BERLIN / KÖPENICK

For eight weeks, John Boerger's flyer collection hung in a pub in Köpenick that was also acting as the festival café for the 1st Köpenick Youth Culture Festival.

MARIA AM OSTBAHNHOF - BERLIN

In October, the newly opened club with panoramic views of the East Side Gallery provided a forum for parts of the exhibition. We experimented with UV light and presented our slide show. WWW.CLUBMARIA.DE

OBZONE - BERLIN

On the Day of German Unity, we took up residence under a railway arch across from the Reichstag and joined with very few visitors in celebrating our weird angle on Germany today: the OBZONE art network project was an interesting partner.

BERLIN

KÖLN

LE BIT - LEIPZIG

At the end of 1998, our first joint exhibition with Flyer Research from Heidelberg at the Le Bit Internet café in Leipzig. WWW.LE-BIT.DE

1999

1000 PLATEAUS – VOLKSBÜHNE – BERLIN

To a puzzle composed of lectures, installations, speeches, conferences, concerts and workshops we add a fraction of our exhibition and thus promote our own visions into the subsisting cultural chaos.
WWW.MILLEPLATEAUX.DE

WHAT'S UP BAR – PARIS

Then, in February '99, our Paris-action takes place. The What's Up Bar's strong party- and exhibition-concept as well as the cooperation with X-Fly Paris are being honored with extensive ingestion of beverages typical for the Bar and with excessive celebrations. Djs Eva Cazal and Otaku from Berlin enjoy visual support from an exhilarating slide-projection. WWW.WUB.FR

TRESOR 8Y ANNIVERSARY/S-BAHNHOF POTSDAMER PLATZ/C-BASE/ESCHSCHLORAQUE-BERLIN

March provides us with some great heppenings. We create birthday-greetings for 8 year old club Tresor and showcase our cultural pillars in public space at S-Bhf. Potsdamer Platz within a presentation-forum for more than 20 institutions of Berlin's cultural scene as well as supra-regional guests - flyer research. We party at C-Base and eschloraque featuring excerpts from our exhibition. WWW.C-BASE.ORG | WWW.TRESORBERLIN.DE

ATLANTIS '99 – GALERIE ELAC – LAUSANNE

Consequently we attend the festival of electronic music, Atlantis '99, where we find enough room for a fantastic mixture of party and exhibition in the Lausanne art gallery for contemporary arts ELAC. Flyer Research among other artists serve a well matured package loaded with visuals, culture and fun. WWW.ATLANTIS.CH

GASWERK – WEIMAR

In july more than 600 visitors enjoy our exhibition at the former gas-plant, they pose questions and hand out invitations. We rock.
WWW.SCHWANSEE92.DE | WWW.WORLDHAUSTV.DE

LAUSANNE

STUTTGART

WEIMAR

PARIS

BERLIN

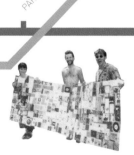

ZWIELICHT – WIEN

Without us being present, a part of our slideshow travels to ZwieLICHT, a festival of crossing borders for mainly super 8 performances, Vienna, on its own. WWW.ARTHOC.AT/ZWIELICHT

EVANGELISCHER KIRCHENTAG – STUTTGART

The 28th german protestant gathering is being provided with a comprehensive bundle from Flyer Soziotope Berlin and Flyer Research Heidelberg. A diverse discussion about Rhythm, Dance & Ecstasy is being held. WWW.DEKT.DE

MERZ AKADEMIE – STUTTGART

Initialized by Diedrich Diederichsen a delicate blend of lectures, exhibition-analysis and some rather experimental planes is organised at Merz Academy. 20 design-students plunge into the depths of flyer-culture. New established contacts extend the horizon of visions, design and culture. WWW.MERZ-AKADEMIE.DE

NATURE ONE – PYDNA / KASTELLAUN PART 2

Round Two at Nature One is really successful: People either know us and appreciate our altered appearance (new formats, flyers, books, slides, videos...), or they get confronted with us for the first time and applaud, discuss or just relax to the tunes of Sven Väth, Andrea Parker, Hell, Tanith... WWW.NATURE-ONE.DE

INTERSTANDING 3 – TALLIN / ESTLAND

The congress receives some enhancement from Mike with a lecture about 'sub-culture-media-biz: rumours about open community ghettos'. Communication between many different visionaries creates a pool of interested parties that help spread our concept. WWW.INTERSTANDING3.ET

SPACE - ERKNER

We install our exhibition on several floors as well as at the club entrance and we meet an interested juvenile audience.

BORDER X – VOLKSBÜHNE – BERLIN

Our flyers are one component amidst a mélange of shortfilms, lectures, DJ-sets, web-surf orgies and VJ-crossculture at Border X.
The same weekend C-Base is haunted by us once again.

WWW.VOLKSBUEHNE.DE

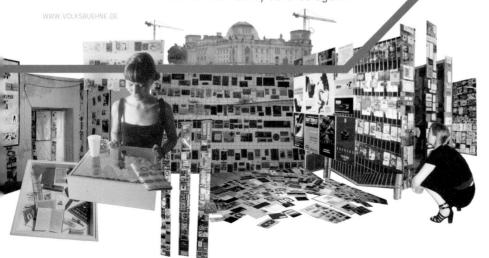

2000

INTERKÖRMET AHNUNGSLOS – ALTE MÖBELFABRIK – BERLIN / KÖPENICK

In order to accommodate to InterKÖrmet's b/w-theme Flyer Soziotope offers a sweet selection of monochromatic flyers. During the vernissage on January 29th 2000 these flyers are presented as a slideshow. WWW.INTERKOERMET.DE

HAUS DES LEHRERS – BERLIN / ALEXANDERPLATZ

Parallel to Transmediale, festival for media art, we squat the 'Haus des Lehrers'-building's foyer and 9th floor for our second stay at Alexanderplatz. We celebrate the vernissage on consecutive days by running the bar and DJ-ing. A crowd of intrigued citizens as well as non-berliners gratefully consumes this facet of media culture. WWW.TRANSMEDIALE.DE

MS STUBNITZ – ROSTOCK

This one serves as an appetizer to the bigger InterKÖrmet-production due on April 15th. On culture-space-ship MS Stubnitz in Rostock Flyer Soziotope Berlin exhibits ten strips of fibre-glass and a smaller slide show. WWW.MSSTUBNITZ.COM

1ST FESTIVAL 'NEUE BEITRÄGE ZUR DEUTSCHEN POPKULTUR' – WERK II – LEIPZIG

Using curtains, light boxes, projections and strips of flyers the exhibition transforms the festival's concert hall into a symphony for people's visual senses, celebrating pop-culture while propagating flyer-culture. WWW.DEUTSCHE-POPKULTUR.DE

SONAR – MOOG CLUB – BARCELONA

Our trip to Barcelona pays off: The festival's main theme is 'Berlin: represent'. Several of our friends' graphical objects are being exhibited. The slide-projectors we brought along aid DJ Hell and Acid Maria at Moog Club for one of the sweatiest appearances experienced ever. WWW.SONAR.ES | WWW.MOOGCLUB.ES

ROSTOCK

VEEJAY GROOVE – EUROPEAN MEDIA ART FESTIVAL (EMAF) – OSNABRÜCK

Next to the main entrance we present a new version of our exhibition in a brand new cargo container. Steel and aluminium team up with light and colors. The display cases and strips are complemented by slides and a desk garnished with books. Sounds from the computer accompany this delightful cast. Alec Empire, Spooky, Koze and Erobique along with their VJs brawl and blind the unwary from the back. WWW.EMAF.DE | WWW.VEEJAYGROOVE.DE

MARX ATTRAX - BORDER GOES PUBLIC - KARL-MARX-ALLEE 118 – BERLIN

Slides alongside flyers and tour-impressions are a vital component of the Border-Shop at Marx Attrax – a concept for reviving the surroundings of Karl-Marx-Avenue with culture. Many visitors stop by at the Border-shop where a diverse mix of about 30 artists' output is being shown. Several new contacts are established and our Flyer-Soziotope-project is readily perceived and explored with great interest.

2 JAHRE FLYER SOZIOTOPE & LOOKING FOR ELVIS / FRANKFURTER ALLEE 12 BERLIN

After analysing different locations that had already been used in the course of Marx Attrax we decide to use the old fashion-shop 'Männermode' some more time. In record time we arrange a documentation about the Flyer-Soziotope-tour based on photos and texts in less than five hours (roughly the time that was left between affirmation of the shop and the first visitors arriving). DJ Otaku and other guest DJs combined with slide shows and bizarre installations including the SUCT textile presentation are components for this special display of work. A wall with large scale pictures serves as homage to Elvis, our lost buddy who disappeared at EMAF. A whole week of creative actions taking place in a (almost) public space.

FUCK PARADE – BERLIN

Fuck Parade is a forum for alternative culture apart from Loveparade - the Trabant aka Bordermobil is our contribution - receives much recognition and can be best described as the ultimate art-car! We tied a bed onto the car's roof, draped shitloads of quaint odds and ends across it and brought along a whole arsenal of flyers. In this fashion we moved the carriage from Bunker to Mauerpark. Our Bordermobil invites various reactions and contacts. It's a communication thing - respect to Fuck Parade! WWW.FUCKPARADE.DE

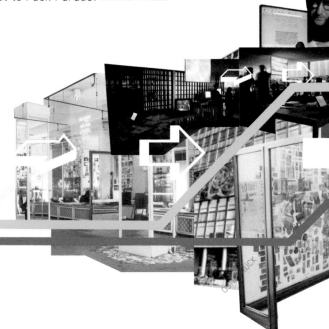

MOJO CLUB – HAMBURG

For 2 weeks we gratefully accept the honor to decorate the four huge light boxes at Reeperbahn with objects of musical desire. A wonderful vernissage announces our act in Hamburg: Aussenborder, kritt_g, Honzadaz Nadelterror, Christopher Flush the Rythm, Otaku and Pfadfinderei's speedy images as well as the slower ones by Flyer Soziotope immerse this club classic in a pleasant flavor.

WWW.MOJOCLUB.DE

NET.CONGESTION – AMSTERDAM

Due to a special event dealing with streaming media we present our project Border2000 in all its complexity. The flyer-exhibition points out the relation between analogue and digital media, particularly in regard to progressive music.

WWW.NET.CONGESTION.ORG

E-CULTURE FAIR – AMSTERDAM

Amsterdam's calling again after only a month: e-Culture Fair, parallel to 'Doors of Perception' introduces visitors to practical samples from fields like interaction, playing, staging and learning. Our booth on the 'Future of Staging'-platform pleases our guests with videos, books, slide shows and a documentary about our project. Klubradio is being presented two booths away from ours.

WWW.DOORSOFPERCEPTION.NL | WWW.VIRTUEELPLATTFORM.NL

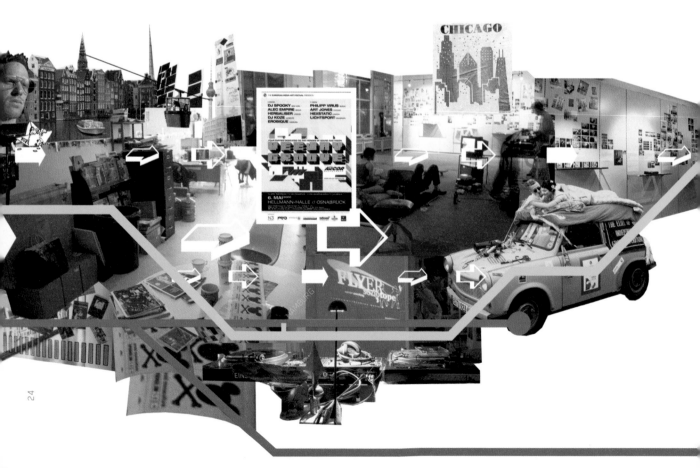

2001

SUPERSPHERE – CHICAGO

On our way to Mexico we enjoy generous hospitality from our friends of Supersphere, who join us for a wonderful show in the studio. Finally there is a professional overview about our whole project and we move on to explore Chicago.

WWW.SUPERSPHERE.COM | WWW.LUMPEN.COM

TECHNOGEIST II – MEXICO CITY

A fantastic festival organized by the Goethe Institut and with a dozen german and about the same amount of mexican DJs participating. The exhibition we put up with Cologne-based artist Kalaman takes place at Museo Laboratorio del Arte Alameda and tantalizes crowds of intrigued visitors. Panels and discussions aid in keeping a constant flow of audience. A fantastic journey and a beautiful exhibition, supplemented by four monitors, slide-projectors, computer-presentations and 9 display cabinets that we provided.

WWW.TECNOGEIST.FOLAMSA.COM

BETALOUNGE – SAN FRANCISCO

On our way home from Mexico we can't resist the temptation to grace San Francisco with a short visit. It is way cool to help designing one of the legendary Betalounge Parties. 7 residents and a series of fresh tour-flyers, Pan's little horns and our slides make this evening a party to be remembered and give the room an elaborate finish.

WWW.BETALOUNGE.COM | WWW.HOUSEOFHORNS.COM

BERLIN BETA / BETA LOUNGE – HAUS SCHWARZENBERG – BERLIN

Back home the fourth version of the Media and Filmfestival is taking place. Together with Kurvenstar we create a small lounge at Haus Schwarzenberg at Hackescher Markt. We present parts of our exhibition collected in Chicago, Mexico and San Francisco as well as several series from Berlin-based clubs like Sternradio, Icon, Ostgut, WMF, Maria, Tresor, nbi, Klangkrieg, Pfadfinderei and many others. For one week visitors can gaze at the colourful time-witnesses and watch borderTV's documentary '14 days of clubculture'. WWW.BERLINBETA.DE

SAN FRANCISCO

MEXICO CITY

2002

INVALID – BERLIN

The old stationery shop is reopened as a gallery for stamps, shadows and miniatures. Its former purpose of vending forms or producing stamps is being replaced by a new one: The swapping of flyers and information as well as the exhibition of invalid objects of exchange from the fields of literature, photography, economy, art, music, design and performance. After 6 months the collecting of outdated or converted currencies ends according to schedule. The Deutsche Mark was led into invalidity and the flyers' and stamps' grade of obscurity in our collection has increased a lot.

HAUS DES REISENS – BERLIN

The project moves to a new location, the former archive of the GDR's travel bureau, located in the 15th floor at Alexanderplatz. Sound artist Penko Stoitschev sublets the rooms to us that we occupy with four computers for scanning and where we sort our flyers into a gigantic system of shelves to do our research.

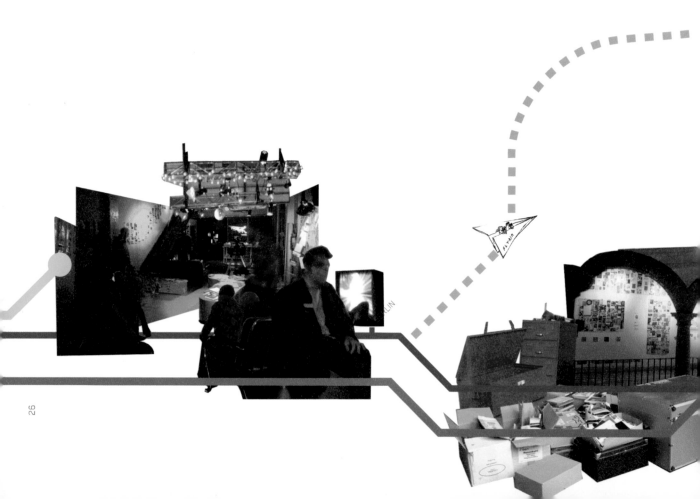

2003

FOTO-SHOP – BERLIN

The small gallery for photography hosts the second photographic retrospective since 2000. Foto Shop serves as a decentralized picture editorial office and reception desk for flyers. Apart from the pictures there are early logo- and layout-drafts in the exhibition and project documentation for the public to see. ModeSelektor blast out their sounds and stir the tiny gallery's air with their laptops. WWW.FOTO-SHOP-BERLIN.DE

ELECTRONIC MUSIC FESTIVAL - DETROIT

Together with Vladislav Delay I take off to the U.S. bringing along a new edition of flyers that serve as invitationcards to join the Flyer Lovers' and as infosheets. Together we head towards the cradle of techno music. Wether it'd be Jeff Mills, Theo Parrish, Derek May or Richie Hawtin:
They are all invited and informed - three days with these big musical innovators leave us deeply impressed. A couple of historic flyers find their way onto our desks. The last evening our own flyers are presented on a laptop on the festival's alternative floor that had been set up by Detroitunderground right beside DJ Kero at the shore of the river that runs between Canada/Windsor and Detroit/USA. WWW.DEMF.COM

MUTEK FESTIVAL – MONTREAL

We travel to Montreal to attend an intensive gathering about the bleeding edge of electronic music for five days. Several locations spiced with the future of music. During breakfast and the after hour our laptop is put to use again. Most of the 500 guests stop by to see our project. Flyers, stories, materials and contacts make for some very nice souvenirs. To see that people are with us and how excited they are by our project is a great motivation. WWW.MUTEK.ca

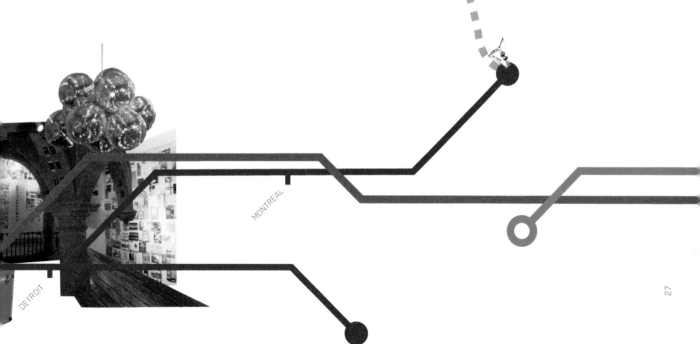

MONTREAL

DETROIT

SONAR FESTIVAL – BARCELONA

We attend for the fourth time. Anett and I fly to Barcelona to hold a couple of interviews, to hand out invitations and to promote our project. With great success. We meet Tite Barbuzza who created the 'Barcelona Club Flyers' book. We swap lots of tips and experiences. We come across same-minded people from all over the world. Also we make good use of our right to celebrate.

WWW.SONAR.ES

FUSION FESTIVAL

We leave town and travel to the countryside, near river Mueritz in order to present our pictures on the festival-cinema's screen. The event develops such strong dynamics on its own that we sort of get carried away. Even though we are right in the middle of where flyer culture acclaims its very peak. The protagonists are being invited. Spread the word!

WWW.FUSION-FESTIVAL.DE

POPKOMM – KÖLN

During the fair a small info-wall appears around our project at several places in Cologne. It is the last Popkomm taking place in this city and appears to be a little unmotivated but still serves the purpose to communicate our mission there very well. What might the relocation to Berlin influence this fair? That's to be found out soon.

WWW.POPKOMM.DE

SONNE MOND UND STERNE FESTIVAL – BLEILOCHTALSPERRE

We have been invited to present our flyers in the form of videos on several beamers on one of the floors, so we go there to find a very professional festival in Thuringia. On location technical difficulties prevent our images from being released to the audience. Thus there is plenty of time for us to communicate and exchange information. Hopefully next year we get another chance.

WWW.SMS.DE

CAMP TIPSY – NEAR BERLIN

A beautiful lake, a bizarre pioneer-colony revived in a very freaky way and Foto-Shop's outdoor exhibition produces some extraordinary beautiful moments. 'Jesus loves you'-flyer meet dozens of amused peoples' eyes while projectors amidst trees enhance the atmosphere. Laughter and dance. A festivity for flyer-culture.

WWW.CAMP-TIPSY.DE

GARAGE B FESTIVAL – STRALSUND

Summer tends to lure berliners to the baltic sea, especially when there is reason to look forward to participating at one of the world's most likeable media-festivals. Vjing seems to be a very good possibilty to present our collection.

WWW.GARAGEB.DE

BACKUP FESTIVAL – WEIMAR

A second journey to the lovely town of Weimar. This time as a VJ like at Camp Tipsy and at Garage festival. Three projectors and I accompany Ilja Gabler through a housey night. Visitors' competent remarks are a pleasure and I get hold of a delicate collection of Drum'n Bass flyers. www.backup-festival.de

SHRINKING CITIES / BAUHAUS – DESSAU

For another project with government aid from Kulturstiftung des Bundes I among other experts get invited to develop a strategy for dealing with the shrinkage of cities in a creative way taking into account the youth, music and clubs. Aside from the well studied regions of Leipzig and Halle we encounter Detroit once again.

WWW.SHRINKINGCITIES.COM

SENSOR TV / HAUS DES REISENS – BERLIN

Radio Riff abroad

2004

CLUB TRANSMEDIALE - MARIA AM OSTBAHNHOF - BERLIN

For nine days our terminal resides at the foyer of the club Maria am Ufer, where the media-festival's exciting club-program takes place, as a teaser for our book and providing people with an extensive slide show consisting of photos and flyers. International guests from east to west have come and gaze at the torrent of pictures. Anticipation towards our book is growing. When we run into technical problems Richard Devine, armed with a laptop, aids us in rebooting the terminal. That's the spirit!

WWW.CLUBMARIA.DE

REBELART FESTIVAL - REDESIGN DEUTSCHLAND - BERLIN

We are invited to comment on the topic 'Design the revolution or just revolutionary design' in a critical way concerning the border areas of sell-out and commercialism. A commited discussion helps to narrow down the scope from a wide range of possible as well as impossible instances of cultural funding's different purposes. In the evening we showcase our selection of Rebel-flyers in the huge vaults of ZMF (zur Moebelfabrik). A great festival for a well done magazine. WWW.REBELART.NET/F001.HTML

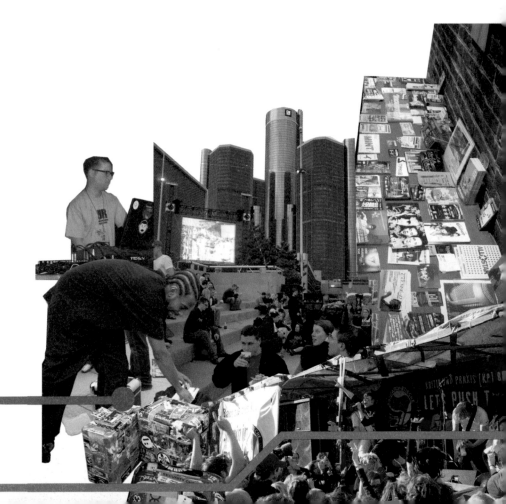

1. BERLINER KUNSTSALON

Foto-Shop is being invited to the 1st Berliner Kunstsalon that takes place simultaneously to Art Forum and Berliner Liste. 30 berlin based galleries install their works for Kunstherbst. In the foyer in front of the Glashaus a replica of the gallery inspired by the Stammhaus is built with all possibilities to accompany the art with music. Thousands of visitors regard the project with favor and we receive some of our oldest pieces there: GDR flyers from the 70ies. The history of pop-culture starts to tumble. WWW.BERLINERKUNSTSALON.DE

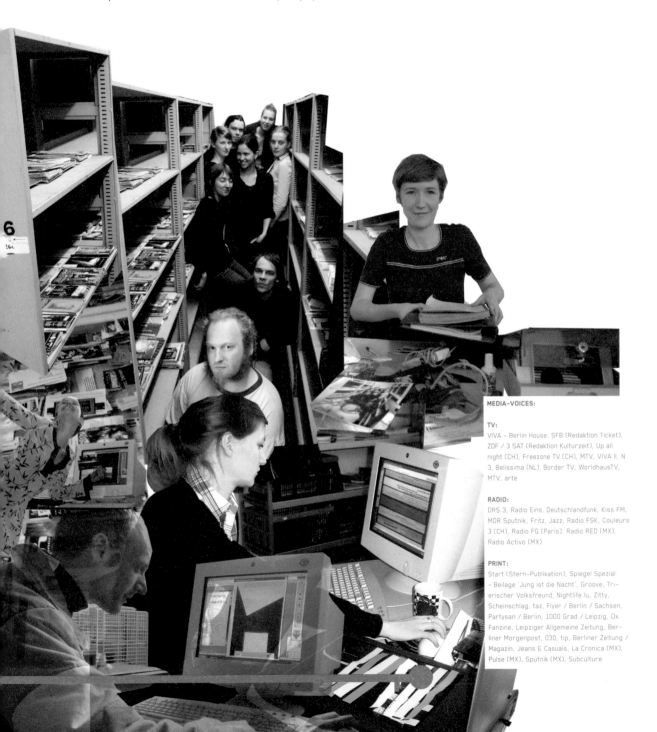

MEDIA-VOICES:

TV:
VIVA - Berlin House, SFB (Redaktion Ticket), ZDF / 3 SAT (Redaktion Kulturzeit), Up all night (CH), Freezone TV (CH), MTV, VIVA II, N 3, Belissima (NL), Border TV, WorldhausTV, MTV, arte

RADIO:
DRS 3, Radio Eins, Deutschlandfunk, Kiss FM, MDR Sputnik, Fritz, Jazz, Radio FSK, Couleurs 3 (CH), Radio FG (Paris), Radio RED (MX), Radio Activo (MX)

PRINT:
Start (Stern-Publikation), Spiegel Spezial - Beilage 'Jung ist die Nacht', Groove, Trierischer Volksfreund, Nightlife.lu, Zitty, Scheinschlag, taz, Flyer / Berlin / Sachsen, Partysan / Berlin, 1000 Grad / Leipzig, Ox Fanzine, Leipziger Allgemeine Zeitung, Berliner Morgenpost, 030, tip, Berliner Zeitung / Magazin, Jeans & Casuals, La Cronica (MX), Pulse (MX), Sputnik (MX), Subculture

DIE GESCHICHTE DER FLYER SOZIOTOPE
TOURSTOPS 1998 - 2004

1998
ACUD-GALERIE & TRESOR – BERLIN

Flyer Soziotope ist pünktlich zum 10-jährigen Bestehen der Loveparade am Start. In der Galerie des Kunstvereins ACUD zeigt das Ausstellungskonzept New Border Art Space die erste Version der Flyerausstellung. Dabei trifft sich eine lustige Schar emsiger Fanatiker, Menschen, die von den kleinen Werbeträgern begeistert sind, DJs, die sich auf den Flyern wieder entdecken, Clubbesitzer, die mit Layoutern über neue Informations- und Optikattacken plauschen. Parallel dazu stellen wir im international renommierten Club TRESOR aus und konfrontieren Partypeople direkt mit unserem Konzept. Die Diashowpremiere findet in den Räumen der Neuen Berliner Initiative (NBI) statt. Gute 2 Wochen mit zahlreichen Besuchern, einer intensiven Medienresonanz und einem sich formierenden Team bestätigen die Idee Kommunikation zu provozieren. WWW.TRESORBERLIN.DE | WWW.ACUD.DE

NATURE ONE – PYDNA / KASTELLAUN PART 1

Wir begeben uns auf den ersten Trip unserer Wanderausstellung und machen Station auf der Nature One, einem der größten Musikfestivals, mit Fokus auf elektronische Musik. 40.000 Besucher sehen einen 300 Quadratmeter großen Hochbunker auf der alten US-amerikanischen Raketenabschussbasis versiegelt mit Flyern, Dias, Büchern und TV-Area. Unser Gästebuch füllt sich mit Reaktionen. WWW.NATURE-ONE.DE

ENERGY VS. LETHARGY – ROTE FABRIK – ZÜRICH

Wir versorgen den VIP-Bereich der Energy mit unseren Flyerbahnen und sind im Drum`n`Bass-Floor der Roten Fabrik Zeugen und Mitgestalter einer ausgesprochen fantasievollen und progressiven Veranstaltung anlässlich der Zürich Street Parade. DJs wie Krust, Goldie oder Grooverider, die freundliche Stimmung der ganzen Stadt und neue Kontakte machen unser Debüt in Zürich sehr angenehm. WWW.ENERGY.CH | WWW.SHEDHALLE.CH

TRIER & LUXEMBURG

Die Soziotope-Diashow gibt den Besuchern der Kneipen und Bars vor Ort eine kurze Skizze unserer Story. WWW.HUNDERTTAUSEND.DE

POPKOMM 10 – KÖLN

Flyer Soziotope zeigt einen speziellen Teil Flyerkultur: die Anfänge der Szenepost werden von uns in Zusammenarbeit mit dem PopDom und Marc Wohlraabe (Mitbegründer des Magazins Flyer) ausgestellt. Außerdem präsentieren wir skurrile Objektflyer in Glasvitrinen. Zusätzlich hängen Flyerstreifen im legendären Techno-Club Warehouse, und wir steigen einer weiteren Veranstaltung auf`s Dach: Ein Label-Showcase von Kitty-Yo Int. / Ninja Tune / Domino & Infracom im Gebäude 9 der KHD Hallen. Wir beenden unsere Köln-Visite mit einem chilligen Projektionsmodul im LiquidSky. WWW.POPKOMM.DE | WWW.WAREHOUSE.DE | WWW.LIQUID-SKY-COLOGNE.DE

BETA KONGRESS & JUGENDFESTSPIELE – BERLIN

Im August gestalteten wir das Foyer der Kongresshalle am Alexanderplatz und zeigten thematisch passend die Schnittstelle zwischen den Machern und Besuchern der Beta - die Dokumentation der Zusammenarbeit von Medien, DJs, Optik-Projektionsspezialisten und der Werbe- und Marketingebene. WWW.BERLINBETA.DE

BIG WARP – SAARBRÜCKEN

Parallel zur Beta exportierten wir unsere Dia-Show zum grossen Zirkus der Klänge, um dort einen speziellen und gehaltvollen Optik-Support zu inszenieren. WWW.BIGWARP.DE

KROKODIL – BERLIN / KÖPENICK

Die Sammlung von John Boerger hängt für acht Wochen in einer Kneipe in Köpenick - welche zu dieser Zeit auch als Festivalcafé des 1. Köpenicker Jugend-Kulturfestivals fungiert.

MARIA AM OSTBAHNHOF – BERLIN

Der frisch eröffnete Club mit Blick auf die East Side Gallery bietet im Oktober ein Forum für Teile der Ausstellung. Wir experimentieren mit Schwarzlicht und zeigen unsere Slide-Show. WWW.CLUBMARIA.DE

OBZONE – BERLIN

Zum Tag der Deutschen Einheit beziehen wir Quartier in einem S-Bahn-Bogen vis-à-vis des Reichstages und feiern mit einigen wenigen Besuchern unsere skurrile Form der Wahrnehmung von Deutschland heute. Das Kunst-Netzwerkprojekt OBZONE ist dabei ein interessanter Nachbar.

LE BIT – LEIPZIG

Zum Ende des Jahres `98 die erste gemeinsame Ausstellung mit Flyer Research Heidelberg im Internet-Café Le Bit in Leipzig. WWW.LE-BIT.DE

1999
1000 PLATEAUS – VOLKSBÜHNE – BERLIN

Wir fügen dem Puzzle aus Lesungen, Installationen, Vorträgen, Gesprächsrunden, Konzerten und Werkstätten noch einen minimalen Teil unserer Ausstellung hinzu und promoten unsere Visionen im existenten Kulturchaos. WWW.MILLEPLATEAUX.DE

WHAT`S UP BAR – PARIS

Im Februar `99 dann die Paris-Aktion: Die What`s Up Bar über-

zeugt durch Party- und Ausstellungskonzept, und die Zusammenarbeit mit X-Fly Paris wird mit bar-typischen Getränken ausgelassen gefeiert. Die DJs Eva Cazal und Otaku aus Berlin werden durch eine spannende Diashow unterstützt. WWW.WUB.FR

8 JAHRE TRESOR / S-BAHNHOF POTSDAMER PLATZ / C-BASE / ESCHSCHLORAQUE – BERLIN

Im März stehen schöne Happenings ins Haus. Wir gestalten einen Geburtstagsgruß für den 8jährigen Tresor, zeigen uns im öffentlichen Raum im S-Bhf. Potsdamer Platz mit dem Präsentationsforum für über 20 Institutionen der Kulturszene Berlin und überregionalen Gästen und feiern mit Auszügen der Ausstellung in der C-Base und im eschschloraque. WWW.C-BASE.ORG | WWW.TRESORBERLIN.DE

ATLANTIS `99 – GALERIE ELAC – LAUSANNE

Anschließend besuchen wir das Electronic Music Festival Atlantis `99, wo die Galerie ELAC Platz für eine gute Mixtur von Party und Ausstellung bietet. Flyer Research und weitere Künstler sind Garant für eine exzellente Packung, gefüllt mit Optik, Kultur und Spaß! WWW.ATLANTIS.CH

GASWERK – WEIMAR

Die Kulturhauptstadt Weimar wird von Flyer Soziotope Mitte Juni bereichert, wo im Gaswerk mehr als 600 Besucher die Ausstellung bewundern, Fragen stellen und Einladungen aussprechen. WWW.SCHWANSEE92.DE | WWW.WORLDHAUSTV.DE

ZWIELICHT – WIEN

Ohne personelle Betreuung unsererseits geht ein Teil unserer Diashow zum Festival der Grenz- überschreitungen ZwieLICHT nach Wien. WWW.ARTHOC.AT/ZWIELICHT

EVANGELISCHER KIRCHENTAG – STUTTGART

Der 28. Deutsche Evangelische Kirchentag wird mit einem Paket aus Flyer Soziotope Berlin und Flyer Research Heidelberg versorgt. Rhythm, Dance&Ecstasy wird als Thematik kontrovers behandelt und diskutiert. WWW.DEKT.DE

MERZ AKADEMIE – STUTTGART

Eine gelungene Mischung aus Vortrag, Ausstellungsanalyse und experimentellen Ebenen wird in der Merz Akademie auf Einladung von Diedrich Diederichsen organisiert. 20 Designstudenten tauchen in die Tiefen der Flyerkultur ein, und neue Kontakte erweitern den Horizont der Welt aus Visionen, Design und Kultur. www.MERZ-AKADEMIE.DE

NATURE ONE – PYDNA / KASTELLAUN PART 2

Die zweite Runde auf der Nature One ist sehr erfolgreich: Entweder man kennt uns und freut sich über die veränderte Ausstellungsform (neue Formate, Flyer, Bücher, Dias, Videos...), oder man trifft das erste Mal auf uns und lobt, streitet, philosophiert und relaxt von oder vor den Beats von Sven Väth, Andrea Parker, Hell, Tanith... WWW.NATURE-ONE.DE

INTERSTANDING 3 – TALLIN / ESTLAND

Dieser Kongress wird von Mike durch einen Vortrag zum Thema `sub-culture-media-biz´ bereichert. Die Kommunikation mit vielen Visionären schafft einen Pool von neuen Interessenten, die unser Konzept in die Welt tragen. WWW.INTERSTANDING3.ET

SPACE – ERKNER

Wir installieren für eine Nacht die Ausstellung auf mehreren Floors und im Eingangsbereich des Clubs und treffen auf ein interessiertes junges Publikum.

BORDER X – VOLKSBÜHNE – BERLIN

Ein Punkt in einer Melange aus Kurzfilm, Lesungen, DJ-Sets, Internet-Surforgien und VJ-Crosskultur zum Happening Border X sind die von uns ausgestellten Flyer. An diesem Wochenende wird auch die C-Base erneut von uns heimgesucht. WWW.VOLKSBUEHNE.DE

2000

INTERKÖRMET AHNUNGSLOS – ALTE MÖBELFABRIK – BERLIN / KÖPENICK

Zum Motto Schwarz-Weiß liefert Flyer Soziotope InterKÖrmet, dem Verein für Kulturaufruhr aus Berlin-Köpenick, eine schöne Auswahl von sw-Flyern. Zur Vernissage am 29.1.2000 gibt es eine Auswahl von sw-Flyern als Diashow. WWW.INTERKOERMET.DE

HAUS DES LEHRERS – BERLIN / ALEXANDERPLATZ

Parallel zum Medienkunstfestival Transmediale organisieren wir im Foyer und in der neunten Etage den zweiten Aufenthalt am Alex. Vernissage und die folgenden Tage werden mit Barbetrieb und DJ-Performances zelebriert. Eine interessierte Schar aus Berlinern und Nicht-Berlinern nimmt die Facette von Medienkultur dankbar auf. WWW.TRANSMEDIALE.DE

MS STUBNITZ – ROSTOCK

Einen Vorgeschmack auf die große Flyeraustellung gibt der kleine Appetizer zur InterKÖrmet-Produktion am 15.April. Flyer Soziotope Berlin zeigt auf dem Kultur-Raum-Schiff MS Stubnitz in Rostock zehn Plexiglasstreifen und eine kleine Diashow. WWW.MS-STUBNITZ.COM

1. FESTIVAL NEUE BEITRÄGE ZUR DEUTSCHEN POPKULTUR – WERK II – LEIPZIG

Die Ausstellung verwandelt die Konzerthalle des Festivals mit Vorhängen, Lichtkästen, Projektionen und Flyerstreifen in ein facettenreiches Seherlebnis, das Popkultur feiert und Flyerkultur propagiert. WWW.DEUTSCHE-POPKULTUR.DE

VEEJAY GROOVE – EUROPEAN MEDIA ART FESTIVAL (EMAF) – OSNABRÜCK

In einem nagelneuen Überseecontainer neben dem Haupteingang präsentieren wir eine neue Version der Ausstellung. Stahl und Alu verbinden sich mit Licht und Farbe. Die Objektflyervitrinen und Streifen werden durch Dias und einem Büchertisch ergänzt.

Der Sound aus dem Rechner untermalt den Aufenthalt. Alec Empire, Spooky, Koze und Erobique und ihre VJs lärmen und blenden derweilen im Hintergrund. WWW.EMAF.DE | WWW.VEEJAYGROOVE.DE

SONAR – MOOG CLUB – BARCELONA

Die Reise nach Barcelona lohnt sich: Der Hauptaspekt der Ausstellung lautet 'Berlin: represent', und vor Ort wurden eine Vielzahl grafischer Kulturen unserer Freunde ausgestellt. Die mitgebrachten Diaprojektoren kommen im Moog Club DJ Hell und Acid Maria zu Ehren. WWW.SONAR.ES | WWW.MOOGCLUB.ES

MARX ATTRAX – BORDER GOES PUBLIC – KARL-MARX-ALLEE 118 – BERLIN

Dias mit Flyern und Tourimpressionen sind wichtiger Bestandteil vom Border-Laden im Rahmen von Marx Attrax – ein Konzept zur kulturvollen Belebung des Stadtraumes Karl-Marx-Allee. Viele Gäste besuchen den vier Tage geöffneten Bordershop, der ein vielseitiges "Output-Gewirr" von ca. 30 Künstlern aufzeigt. Es ergeben sich zahlreiche neue Kontakte, und unser Flyer-Soziotope-Projekt wird interessiert wahrgenommen.

2 JAHRE FLYER SOZIOTOPE & LOOKING FOR ELVIS / FRANKFURTER ALLEE 12 – BERLIN

Nach Besichtigung verschiedener schon zu Marx Attrax genutzter Locations einigen wir uns auf den alten Männermode-Laden. Wir arrangieren in Rekordzeit – von der Bestätigung des Ladens bis zum Eintreffen der ersten Vernissagengäste vergehen keine 5 Stunden – die hauptsächlich auf Photos und Texten basierende Dokumentation der Flyer-Soziotope-Tour. DJ Otaku u.a., Diaprojektionen und skurrile Installationen einschließlich der SUCT-Textilpräsentation sind Bausteine für eine Werkschau der etwas anderen Art. Die Wand mit großformatigen Photos als Hommage an Elvis, unseren auf der EMAF verschollenen treuen Kumpanen, findet vielfache Beachtung. Insgesamt eine Woche vielseitigste Aktionen im nahezu öffentlichen Raum.

FUCK PARADE – BERLIN

Die Fuck Parade als Forum für Kultur abseits der Loveparade. Der Trabant aka Bordermobil als unsere Aktion zu diesem Anlass – viel beachtet und wohl der ultimative Wagen am Start! Ein Bett auf das Dach geschnallt, allerhand kuriosen Kleinkram drapiert und ein Arsenal an Flyern dabei – so bewegen wir das Mobil vom Bunker bis zum Mauerpark. Unser Beitrag beschert uns Reaktionen und Kontakte verschiedener Couleur. It`s a communication thing – respect to Fuck Parade! WWW.FUCKPARADE.DE

MOJO CLUB – HAMBURG

Zwei Wochen wurde uns die Ehre zuteil, die vier großen Lichtkästen auf der Reeperbahn zu füllen mit den Objekten der musikalischen Begierden. Eine wunderbare Vernissage (die unverständlicherweise schon vor 2 Uhr beendet werden mußte) läutete unseren Hamburg-Auftritt gebührend ein: Außenborder, kritt_g, Honzadaz Nadelterror, Christopher Flush the Rhythm, Otaku und die schnellen Bilder der Pfadfinderei sowie die langsamen der

Flyer Soziotope tauchten den Clubklassiker in einen sehr angenehmen Flavour. WWW.MOJOCLUB.DE

NET.CONGESTION – AMSTERDAM

Anläßlich der Spezialveranstaltung rund um das Thema Streaming präsentieren wir das Projekt Border2000 in seiner Gesamtheit. Die Flyerausstellung illustriert hier die Nähe der analogen Medien zu den digitalen, insbesondere im Falle progressiver Musik. WWW.NET.CONGESTION.ORG

E-CULTURE FAIR – AMSTERDAM

Schon einen Monat später ruft Amsterdam ein weiteres Mal: Die e-Culture Fair vermittelt parallel zur 'Doors of Perception' den Gästen praktische Beispiele aus den Bereichen Interacting, Playing, Staging und Learning. Unser Stand auf der Bühne des 'Staging' erfreut die Gäste mit unseren Videos, Büchern, Slideshows und einer Dokumentation unseres Projekts. Klubradio präsentiert sich zwei Stände weiter. WWW.DOORSOFPERCEPTION.NL | WWW.VIRTUEELPLATTFORM.NL

2001
SUPERSPHERE – CHICAGO

Auf dem Weg nach Mexiko geniessen wir die Gastfreundschaft unser Freunde von Supersphere, die mit uns eine wunderschöne Sendung im Studio präsentieren. Ein Überblick über das gesamte Projekt in professioneller Qualität existiert endlich, und wir entdecken Chicago. WWW.SUPERSPHERE.COM | WWW.LUMPEN.COM

TECHNOGEIST II – MEXIKO CITY

Ein fantastisches Festival, vom Goethe Institut organisiert, mit der Beteiligung von einem Dutzend deutscher DJs und etwa dem gleichen Anteil von mexikanischen Experten. Unsere Ausstellung im Museo Laboratorio del Arte Alameda zusammen mit dem Kölner Künstler Kalaman erfreut sich eines regen Zuspruchs. Panels und Diskussionen sorgen für täglichen Publikumsverkehr. Eine fantastische Reise und eine schöne Ausstellung, die wir ergänzen mit vier Monitoren, Diaprojektoren, Rechnerpräsentationen und 9 Vitrinen. WWW.TECHNOGEIST.FOLAMSA.COM

BETALOUNGE – SAN FRANCISCO

Auf dem Rückweg von Mexiko können wir es nicht lassen und müssen San Francisco mit einem Kurzbesuch beehren. Einen Abend der legendären Betalounge Parties mitgestalten zu dürfen macht extrem Spaß. 7 Residents und eine Serie frischer Tourflyer, die kleinen Hörner von Pan sowie unsere Dias machen aus dem Abend ein bleibendes Erlebnis und runden den Raum hervorragend ab. WWW.BETALOUNGE.COM | WWW.HOUSEOFHORNS.COM

BERLIN BETA / BETA LOUNGE – HAUS SCHWARZENBERG – BERLIN

Wieder zurück schließt sich der Kreis. Anläßlich der vierten Version des Medien- und Filmfestivals kreieren wir zusammen mit Kurvenstar eine kleine Lounge im Haus Schwarzenberg am Hackeschen Markt. Gezeigt werden Stücke aus unser Sammlung

von Boston, Mexiko und San Francisco sowie diverse aktuelle Serien Berliner Clubs wie Sternradio, Icon, Ostgut, WMF, Maria, Tresor, NBI, Klangkrieg, Pfadfinderei und anderen. Eine Woche betrachten Gäste die bunten Zeitzeugen und die Dokumentationen von borderTV. WWW.BERLINBETA.DE

2002
INVALID – BERLIN
Der ehemalige Miniatur Schreibwarenladen wird als Galerie für Stempel, Schatten und Miniaturen eröffnet. Dem einstigen Zweck des Formularkaufs oder der Stempelanfertigung wird ein neuer entgegengesetzt: Flyer und Informationstausch sowie die Ausstellung ungültiger Tauschobjekte der Bereiche Literatur, Fotografie, Wirtschaft, Kunst, Musik, Alltagsdesign und Performances. Die Sammlung alter und umfunktionierter Währungen endet nach 6 Monaten planmäßig. Die DM wurde in ihre Ungültigkeit begleitet, und der Grad an außergewöhnlichen Flyern und Stempeln hat zugenommen.

KULTURSTIFTUNG DES BUNDES – FÖRDERUNG
Nach einem Tip vom Senat wenden wir uns mit einem umfassenden Antrag an die neu gegründete Kulturstiftung in Halle und – siehe da – wir werden als eins der ersten 28 Projekte angenommen, und unser Baby wird gefördert. Genug Geld, um das kommende Jahr ein großes Buch zu entwickeln und Räume und Maschinen zu besorgen, an denen man mit dem Monstrum der digitalisierten Datenbank beginnen kann. We really get started. WWW.KULTURSTIFTUNG-DES-BUNDES.DE

HAUS DES REISENS – BERLIN
Das Projekt schlägt ein neues Lager auf. Diesmal das ehemalige Archiv des Reisebüros der DDR in der 15. Etage am Alexanderplatz als Untermieter des Klangkünstlers Penko Stoitschev. Es wird auf vier Rechnern gescannt und in ein riesiges Regalsystem einsortiert und recherchiert, während im Headquarter in der 2. Etage eine Redaktion das Buchprojekt vorbereitet und Sponsoren akquiriert. Mehr als 25 Praktikanten und Volontäre arbeiten in diesem Jahr hier und machen sich um die Flyerkultur verdient.

2003
FOTO-SHOP – BERLIN
Die kleine Ladengalerie für Fotografie, die dem Projekt auch in seiner Anfangsphase als dezentrale Bildredaktion und als Flyerannahmestelle dient, ist Gastgeber für die zweite größere fotografische Retrospektive seit 2000. In der Ausstellung von Mike und John Boergers Projektdokumentation werden neben Bildern auch erste Logo- und Layoutstudien der Grafiker der Öffentlichkeit vorgestellt. Musikalisch rockt das Haus mit Mode Selektor, die – durch ihre großen Auftritte stark beeindruckt von der Kleinheit der Galerie – mit ihren zwei Laptops frischen Wind verbreiten. WWW.FOTO-SHOP-BERLIN.DE

ELECTRONIC MUSIC FESTIVAL – DETROIT
Mit einer frischen Druckauflage von Flyern, die als 'Invitationcard to join the Flyer Lovers' und Infosheet dienen, starte ich nach USA. Zusammen mit Vladislav Delay auf in die Wiege des Techno. Ob Jeff Mills oder Theo Parrish, ob Derek May (;)) oder Richie Hawtin: sie alle werden eingeladen und informiert- 3 Tage mit den großen musikalischen Innovatoren beeindrucken nachhaltig. Einige historische Flyer landen im Anschluss auf unseren Tischen. Am letzten Abend laufen unsere Flyer als Laptoppräsentation auf dem von Detroitunderground ausgerichteten alternativen Floor des Festivals neben DJ Kero am Ufer des Grenzflusses zwischen Canada/Windsor und Detroit/USA. WWW.DEMF.COM

MUTEK FESTIVAL – MONTREAL
Weiter geht`s nach Montreal zum intensiven fünftägigen Gathering rund um modernste elektronische Musik. Mehrere Veranstaltungsorte, angereichert mit der Zukunft der Musik. Beim Breakfast und der After Hour kommt wieder unser Laptop zum Einsatz. Wohl kaum einer der 500 Gäste kommt an unserem Projekt vorbei. Flyer, Stories und Materialien sowie weiterführende Kontakte sind tolle Mitbringsel. Das Gefühl, das die Leute die Daumen drücken und begeistert sind von unserem Projekt, motiviert ungemein. WWW.MUTEK.CA

SONAR FESTIVAL – BARCELONA
Das vierte Mal nehmen wir teil. Anett und ich fliegen nach Barcelona, um Interviews zu führen, Einladungen zu verteilen und das Projekt bekannter zu machen. Voller Erfolg. Wir treffen auf Tite Barbuzza, die das 'Barcelona Flyer Buch' zusammenstellte. Viele Tips und Erfahrungen werden ausgetauscht. Gleichgesinnte aller Länder kreuzen unseren Weg. Es darf auch gefeiert werden. WWW.SONAR.ES

JUNIRADIO
Eine Flyer Soziotope Radio Show? Was passiert da? Eine Stunde live am Nachmittag mit Anekdoten rund um unsere Tournee, mit Kommentaren unserer mittlerweile 15 Praktikanten und Helfer sowie Musik aller Genres, die uns begleitet hat. Während die Crew im Hintergrund Ping Pong spielt, moet sich Mike durch die Show. WWW.JUNIRADIO.NET

FUSION FESTIVAL
Mit dem Ziel, im Festial-Kino Bilder zu zeigen, fahren wir los aufs Land an die Müritz. Das Treffen hat eine dermaßen große Eigendynamik, dass dieses Vorhaben zwar nicht klappt. Trotzdem sind wir da, wo die Flyerkultur ihre Höhepunkte feiert. Die Protagonisten werden eingeladen. Spread the word!. WWW.FUSION-FESTIVAL.DE

POPKOMM – KÖLN
An diversen Orten in Köln erscheint während der Messe eine kleine Infowand rund um unser Projekt. Die etwas lustlose letzte Messe ihrer Art am alten Ort ist trotzdem nach wie vor ein guter Kommunikationsort für unser Anliegen. Was der Umzug nach Berlin bringen wird? Bald wird man es wissen. WWW.POPKOMM.DE

SONNE MOND UND STERNE FESTIVAL – BLEILOCHTALSPERRE

Eingeladen, unsere Flyer als Videos auf diversen Beamern in einem der Floors zu zeigen, reisen wir zum sehr professionellen und großen Festival in Thüringen. Vor Ort verhindern technische Probleme die Realisierung. Trotzdem bleibt viel Zeit für Kommunikation und Informationsaustausch. WWW.SONNEMONDSTERNE.DE

CAMP TIPSY – BEI BERLIN

Ein traumhafter See, eine aufs Wundersamste wiederbelebte alte Pionier-Feriensiedlung und der Rahmen der Ausstellung des Foto-Shop im Grünen erlauben einige traumhafte Momente. 'Jesus loves you'-Flyer treffen dutzende belustigter Augen bei Beamerprojektionen unter Bäumen. Lachen und Tanzen. Ein Fest für die Flyerkultur. WWW.CAMP-TIPSY.DE

GARAGE B FESTIVAL – STRALSUND

Der Sommer zieht einen Berliner an die Ostsee. Insbesondere wenn klare Signale zu vernehmen sind, dass er bei einem der nettesten Medienfestivals der Welt teilnehmen darf. WWW.GARAGEB.DE

BACKUP FESTIVAL – WEIMAR

Ein zweiter Weg ins schöne Weimar. Diesmal als VJ nach dem Vorbild der Camp-Tipsy und Garage-Festivals. Mit drei Beamern und Laptop begleite ich Ilja Gabler durch seine housige Nacht. Kompetente Kommentare der Besucher machen Spass und eine sehr delikate Sammlung von Drum'n'Bass-Flyern wird mir zugespielt. WWW.BACKUP-FESTIVAL.DE

SHRINKING CITIES / BAUHAUS – DESSAU

Ein weiteres von der Kulturstiftung des Bundes gefördertes Projekt lädt mich ein Thema Jugend, Musik und Clubs Strategien für einen kreativen Umgang mit schrumpfenden Städte mit anderen Experten (unter anderem auch unser Verleger Klaus Farin) zu entwickeln. Dabei begegnet uns neben den gut studierten Regionen Leipzig und Halle auch Detroit wieder. WWW.SHRINKINGCITIES.COM

SENSOR TV / HAUS DES REISENS – BERLIN

Als Abschied aus dem Haus des Reisens produzieren wir eine kleine, aber feine Abschiedsausstellung. In der 15. Etage entsteht nach einem Umbau eine neue Ausstellungsfläche, in der wir klassische Berliner Serien sowie Reisemitbringsel aus USA, Kanada, Spanien und Frankreich. Eine tolle Vitrine zeigt einige unserer interessantesten 3D-Materialien. Wir beenden das Jahr und unseren Aufenthalt im Reisebüro der DDR mit einer langen Finissage, die live bei Radio Riff auf Reisen ausgestrahlt wird.

2004
CLUB TRANSMEDIALE – MARIA AM OSTBAHNHOF – BERLIN

9 Tage steht unser Terminal mit einer umfassenden Slideshow aus Fotos und Flyern als Teaser für unser Buch im Foyer des Maria am Ufer, wo das spannende Clubbegleitprogramm zum Medienfestival statt findet. Internationale Gäste aus Ost und West staunen über die Bilderflut, und die Vorfreude auf das Buch wächst. Als unser Terminal technische Probleme hat, hilft der mit Laptop bewaffnete Richard Devine uns beim Rebooten. That's the spirit! WWW.CLUBMARIA.DE | WWW.CLUBTRANSMEDIALE.DE

REBELART FESTIVAL – REDESIGN DEUTSCHLAND – BERLIN

Wir sind eingeladen, uns zum Thema 'Design the revolution or just revolutionary design' und dabei auch kritisch zu den Randbereichen des Sell-outs und der Verkommerzialisierung zu äußern. Eine engagierte und kritische Diskussion steckt den Rahmen um ein weites Feld von möglichen und unmöglichen Fallbeispielen der Funktionen unabhängiger Kulturarbeit. Abends zeigen wir unsere Auswahl von Rebelflyern in den großen Gewölben des ZMF (zur Möbelfabrik). Ein gelungenes Festival rund um ein gelungenes Magazin. WWW.REBELART.NET/F001.HTML

KONRAD-ADENAUER-STIFTUNG – BERLIN

Das Projekt wird präsentiert vor einer Runde engagierter Gäste der Young Creative Industries und Dr. Hassemer. Das Projekt Zukunft Berlin - Capitale Potenziale oder nur Projekt B bekommt eine der ersten öffentlichen Darstellungen eines zukünftigen Flyermuseums präsentiert. Nach der Vorstellung wird bei leckeren Kleinigkeiten geklönt und diverse Ideen werden beigetragen. WWW.KAS.DE

1.BERLINER KUNSTSALON – BERLIN

Foto-Shop wird geladen auf den ersten Berliner Kunstsalon, parallel zu Art Forum und Liste. In der Arena installieren 30 Berliner Galerien anlässlich des Kunstherbstes ihre Arbeiten. Im Foyer vor dem Glashaus entsteht ein dem Stammhaus nachempfundener Nachbau der Galerie inklusive aller Möglichkeiten, die Kunst auch musikalisch zu untermalen. Mehrere tausend Besucher registrieren die Aktion wohlwollend, und einige der ältesten Objekte werden unserer Sammlung übergeben: Flyer aus der DDR der 70er Jahre. Die Geschichte der Popkultur gerät ins Wanken. WWW.BERLINERKUNSTSALON.DE

MEDIENREAKTIONEN
TV:

VIVA - Berlin House, SFB (Redaktion Ticket), ZDF / 3 SAT (Redaktion Kulturzeit), Up all night (CH), Freezone TV (CH), MTV, VIVA II,N3, Belissima (NL), Border TV, Worldhaus TV, MTV, Arte

RADIO:

DRS 3, Radio Eins, Deutschlandfunk, Kiss FM, MDR Sputnik, Fritz, Jazz, Radio FSK, Couleurs 3 (CH), Radio FG (Paris), Radio RED (MX), Radio Activo (MX)

PRINT:

Start (Stern Publikation), Spiegel Spezial - Beilage Jung ist die Nacht, Groove, Trierischer Volksfreund, Nightlife.lu, Zitty, Scheinschlag, TAZ, Flyer / Berlin / Sachsen, Partysan / Berlin, 1000 Grad / Leipzig, Ox Fanzine, Leipziger Allgemeine Zeitung, Berliner Morgenpost, 030, Tip, Berliner Zeitung / Magazin, Jeans & Casuals, La Cronica (MX), Pulse (MX), Sputnik (MX), Subculture

FLYER RE- SEARCH

THE PARTY FLYER AS A COMMUNICATIONS MEDIUM

Jannis Androutsopoulos | Keiko Schmitt | Ronni The

The Flyer Research Project

WHAT IS A FLYER?

Englisch: ein jedes Flugblatt, ein Handzettel schlechthin.

flyer [flʌɪɐ] m.

... 5. a small handbill

(Oxford Concise English Dictionary)

Neudeutsch: Handzettel für eine spezielle Veranstaltungsart; Party-Flyer.

Flyer ['flaɪɐ] engl. s.

... 9. am. Flugblatt n, Handzettel m

für Tanzveranstaltungen mit Schallplattenunterhaltern

(Flyermania)

Duden-Deutsch: etwas ganz Anderes.

Fly|er ['flaɪɐ], der; -s, -

[1: engl. flyer, zu: to fly = fliegen; eilen] (Technik):

1. besondere Spinnmaschine. 2. Arbeiter an einem Flyer (1)

(Duden Universal Wörterbuch)

[01] TRADITION WITHIN A TRADITION

Flyers have stories to tell. Any comprehensive collection of flyers will reflect the development of youth culture during the 1990s: the transition within club culture from uniformity to diversity, from the the early days of rave to the European rave boom. Styles and formats came and went, from breakbeats to jungle to drum & bass. Dance events became larger and more specialized. The good old mega-rave paved the way for the 12-floor event .

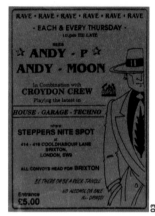

During the rave boom of the 1990s, the form and layout of flyers underwent dramatic changes. But over the years, certain patterns and symbols also remained constant. In a short time, the technical possibilities for producing flyers exploded. Today, complicated shaped flyers are affordable for many clubs. But this does not automatically make them any better. Prototypical flyers – straightforward and rectangular – are still around, and most importantly, anyone can make them with a personal computer.

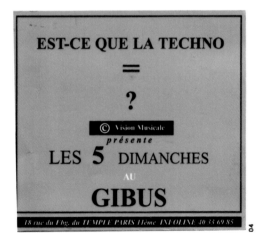

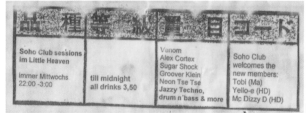

Since the beginnings of rave culture, flyers have been a field for experimentation with new ideas in communication design – "perfect examples of the kind of thing people dream up to give events an unmistakable face" (**FLYERMANIA**). Innovative ideas emerged very early: iconic flyers, bootlegs and object flyers have been around since 1993. Designs are repeated, successful ideas are copied or continued – clear signs of the development of a tradition in flyer design.

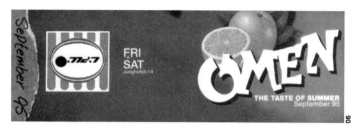

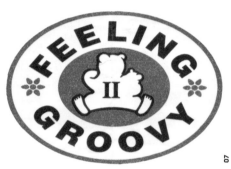

05 SOHO CLUB, 1997, LITTLE HAVEN, HEIDELBERG, D
06 THE TASTE OF SUMMER, 1995, OMEN, FRANKFURT AM MAIN, D

03 ANDY-P & ANDY-MOON, 1989, STEPPERS NITE SPOT, LONDON, UK
04 EST-CE QUE LA TECHNO, 1996, GIBUS, PARIS, F

01 SOUNDS OF LIFE, 1997, MS CONNEXION, MANNHEIM, D
02 TECHNOMANIA, 1994, ALTER FLUGHAFEN, MÜNCHEN, D

In historical terms, party flyers are a very recent, highly specialized variation on a centuries-old theme, forming part of the tradition of handbills that have been used ever since the invention of printing for a wide variety of purposes: commercial and cultural, revolutionary and religious. Within this specific category, new traditions have swiftly emerged that distinguish party flyers from other types of handbill. This can be seen in people's spontaneous reactions to flyers that do not match expectations, reactions along the lines of: What! No DJs!? What could this mean? Sloppy work or deliberate irritation? Both are conceivable. In either case, the reaction shows that information about the featured DJs is part of the collective notion of a typical flyer.

Although such collective notions in themselves are hard to describe, one can examine their concrete impact and their reflections in reality: the words and designs used. If flyers are analyzed using the tools of text and communication analysis, the result is an abstract text pattern that forms the accepted minimum standard for all the handbills we see around us – a prototypical or ur-flyer, so to speak, that is recreated again and again around the world in countless variations every week.

[02] FLYER FUNCTIONS

In the communications chain, the party flyer is a medium (mediator) between event organizers (senders) and clubbers (receivers). The message it carries consists of information about a party. The purpose of this communication is an appeal to the receiver to come to this party. In this chain, the function of the graphic designer is similar to that of a translator – in the words of Klaus Mai, a "visual translator of da bass and da beat". **[KM7]**

From the producer's point of view, the flyer is the "face" of an event. It can make the party a success and help establish or maintain the image of a team or club. From the point of view of the recipient, flyers are a source of information about the club and party scene. They often supply information that isn't available in magazines. And in some cases, they offer concrete advantages: reduced price or entry with flyer only. It's no coincidence that in England, flyers are also known as "invites".

As a text or "semiotic unit", a flyer contains a more or less standardized set of information that is communicated visually and in words. It also offers a semiotic playground for the encoding of messages specific to youth subcultures.

A BASIC FLYER TYPOLOGY: As a promotional text, the flyer's job is to draw attention to a dance event. But what kind? From weekly village discos to one-off mega-events, from secret parties in a forest or bunker to clubs in major cities, there are different types of party for very different kinds of people. Considering both the type of event and the way the flyer is made, flyers can be broken down into three categories: standard, mega and calendar flyers.

THE STANDARD FLYER: Not restricted to any specific type of event, this is the most common flyer, the flyer prototype. Basic form: rectangular, between A5 and A6 format, printed on one side. Message: usually announcing a one-off event, private or public, sometimes for a special occasion such as a birthday party or a release party. Or a weekly club night: in this case, there are also series of flyers that stretch over a month or a whole season. Private and/or alternative parties (including illegal events) are often announced via homemade flyers made with a PC. Many such flyers follow in the layout tradition of punk collage.

THE MEGA FLYER: As the raves grew, the flyers followed suit. The right way to advertise a mega-rave is with a mega-flyer: at least one large-format folded sheet printed both sides, sometimes growing into a booklet with several pages. It contains vital and less vital additional information on the many DJs and live acts, listed by floor/area, each of which might, for example, take up one page of a booklet. Plus details of any other attractions, often with a map, and always with sponsor logos and other advertisements.

THE CALENDAR FLYER: In addition to these first two types, regular clubs also use calendar flyers to give an overview of the events of the month. These flyers often have an elongated format, usually organized as a table that can be read from top to bottom or from left to right.

14 YELLOW KITCHEN, 1997, MANNHEIM, D
15 MANIAC LOVE, 1996, TOKYO, JP
16 MANIAC LOVE, 1996, TOKYO, JP

11 SPOON, 1993, DORIAN GRAY, FRANKFURT AM MAIN, D
12 SOUNDS OF LIFE, 1997, MS CONNEXION, MANNHEIM, D
13 EUPHORIA 4, 1995, DORIAN GRAY, FRANKFURT AM MAIN, D

08 OSMOSIS, 1997, THE END, LONDON, UK
09 LOCALIZER 1.0 RELEASE-PARTY, 1995, E-WERK, BERLIN, D
10 RADICAL REHOUSING, 1997, HERENGRACHT 114, AMSTERDAM, NL

[03] FLYER COMPONENTS

Every flyer contains certain types of information that can be described as a set of building bricks. Taken together, the following components add up to the "flyer" as a semiotic unit:

TEAM: the organizers
HEADLINE: name of the event and/or motto
ACTS: what's on offer – DJs, live acts, VJs, dancers, etc.
VISUAL: image/graphic on flyer, or the shape of the flyer itself
DATA: the actual information: where – when – how long – how much
SPONSOR: sponsor logos, other advertisements, maybe also artist logos.

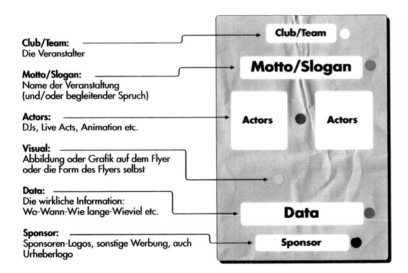

Club/Team:
Die Veranstalter

Motto/Slogan:
Name der Veranstaltung
(und/oder begleitender Spruch)

Actors:
DJs, Live Acts, Animation etc.

Visual:
Abbildung oder Grafik auf dem Flyer
oder die Form des Flyers selbst

Data:
Die wirkliche Information:
Wo-Wann-Wie lange-Wieviel etc.

Sponsor:
Sponsoren-Logos, sonstige Werbung, auch
Urheberlogo

The components "team" and "headline" are the variables in the equation "X presents Y". The featured acts are almost always accompanied by the name of their label or home club; in mega-flyers there may even be a short text. The amount of data provided fluctuates with the scale of the party. Sponsors can range from a local record shop to multinationals, depending on how commercial the event is.

Many visuals communicate messages central to rave culture as a whole or to one of its many branches. Styles like trance or jungle have their own visual trademarks. Many visual motifs have quite specific meanings for the rave community, often understood only within this group. The motto and the visual share two important properties: they appeal to emotions and they stick in the recipient's mind. This is why flyer makers create special club and event logos for use alongside or in place of a visual. The Metalheadz and Mayday logos are familiar examples, the Masquerade logo is less well-known.

Not all these components must be present on every flyer: underground parties do not usually have a sponsor; a route plan often features on mega-flyers (addressed to people from different regions) or on flyers for parties in the woods, but not usually for clubs in cities, with the exception of megacities such as Tokyo (**NARCOTIQUE**). The size and quality of the components vary depending on the function of the flyer: the more commercial the party and the more luxurious the flyer, the more acts, data and sponsors there will be, while the club and motto may remain the same.

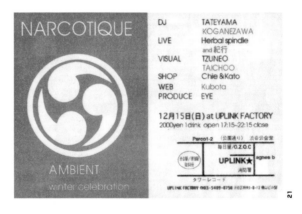

LAYING OUT THE COMPONENTS

Where and how are the various components positioned within the graphic layout? This depends on whether the flyer in question is printed on one or both sides. One-sided flyers can be described using two dimensions that are important in the composition of visual texts as a whole. The vertical axis connects the opposites of "ideal" and "reality". The ideal represents the dream vision of the event or product being promoted and is typically con-

Die Dimensionen des visuellen Raums

tained in the headline text, contrasting with the basic facts usually positioned at the bottom of the flyer. The horizontal dimension follows the basic direction of visual semiosis in western culture, with familiar material usually on the left, new material more commonly on the right. The highest information content is found at the intersection of these two axes, at the centre of the layout **(KRESS & VAN LEEUWEN 1996)**.

OSMOSIS is structured along the vertical axis: at the top and slightly offset towards the centre, the "ideal vision" of the event, consisting of the motto and a visual. What is on offer (acts) is positioned slightly below the centre, and the reality (data) is right at the bottom.

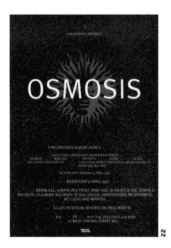

For other one-sided flyers, this model is less appropriate. **GIFT** is minimalist: there is no visual, the flyer is dominated by the black and white background, the only prominent component is the club name, everything else is pushed into the corner. **MOOT** and **DUSTED**, on the other hand, have a typographic focus: no visual, with text covering the entire surface.

Flyers printed on both sides offer far greater potential. There is always a front and a back: the front is where the identity of the event is expressed, its face, with the visual, the motto and the club logo. The back is where the recipient finds expected information such as data and sponsors.

29 JUNI SPECIALS, 1994, TRESOR, BERLIN, D
30 ELECRONIC, 1998, XHUI, NEW YORK CITY, USA
31 ELECRONIC, 1998, XHUI, NEW YORK CITY, USA

› **CAB CONNECTION** reserves the front of its flyers for the motto and the visual, a taxi stripe on a yellow background. The data, acts (listed as "drivers"), and sponsors are on the back.

26 CAB CONNECTION, 1993, ALTE HALLE, DILSBERG, D
27 CAB CONNECTION, 1993, ALTE HALLE, DILSBERG, D
28 JUNI SPECIALS, 1994, TRESOR, BERLIN, D

› The front of the **TRESOR JUNE CALENDAR** features the motto, the club, and a visual matching the club name. On the back there are details of the various events: data – slogan – acts.

22 OSMOSIS, 1997, THE END, LONDON, UK
23 GIFT, 1996, FRANKFURT AM MAIN, D
24 MOOT, 1995, CHUMEL, LONDON, UK
25 DUSTED, 1995, BLUE NOTE, LONDON, UK

› **ELECRONIC** has the motto and the visual on the front. On the back, the organizers are at the top (club logos), the acts in the middle (one column per event), and the data and sponsors at the bottom.

Unlike the early days of flyer production, the late 1990s were characterized by a combination of minimalist front side (motto/club logo only) with text dominating the reverse (acts, data). **REVOLT** is an example of this.

 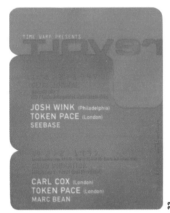

LANGUAGE

Language holds the flyer as a whole together. The flyer's message – what, when, where, who – cannot do without language. But in most cases, the actual text function –Be there! – is not coded in language. Such direct appeals, even funny ones like on the **GROOVE KITCHEN** flyer "let the music consume you" are rare.

Besides straight information, the verbal text of flyers also has an emotional and social function. It contains references to rave culture's specific system of knowledge, emotions and values: love, technology, community, future, peace, energy, visions, friends, and other "loaded" terms appear on flyers as mottos or club names. They are also linked to visual motifs, often to the visual used on the flyer in question.

Linguistic signs also have an aesthetic function - they too are forms that can be designed. They provide an additional field for experimentation, possibly also referring to the musical style of the event – as in the case of the Hindi-style lettering for **ANOKHA** or the Kanji-inspired styling of **FUTURE**, both representing letters of the Latin alphabet.

Around the world, the language most commonly used on flyers is English. The language of the country in question appears, if at all, only in certain components (e.g. motto in English, directions to the venue in German) or as part of an imitation or parody as in the case of bootleg and object flyers (see sections below). In these cases, the mother tongue allows the flyer to refer to stereotypes of local culture. Which is why flyers like **LOVE SHAG** and **KINGS & QUEENS** only work in German, in spite of their English motto. Or how would you say **SAUWER DIE WORSCHT GEPELLT!** (i.e. 'to peel the sausage', but written in an approximation of local German dialect) in English?

[04] **FLYER IMAGES**

The "visual code" of flyers follows the general rules of visual design and crystallized as an integral part of the evolution of rave culture. It does not always function independently, interacting with the verbal code in a variety of ways. The flyer is a "bi-medial" text – its meaning is generated by the combination of the two systems.

For example, there is often a match between the motto and the visual. The motto **PARADISE** is accompanied by a picture of Adam and Eve, the motto **LOVE SPIRIT** by a heart, where love is known to reside. In these cases, the visual illustrates the motto, or the motto acts as a caption to the image. In either case, the verbal and visual codes match: two expressions for a single concept.

The choice of a visual is often a creative act, but it also follows international traditions. Style communities and flyer makers return to the same visuals again and again, either because they stand for deeper convictions of a particular cultural current, or because that's just the way things are done. How are **PSYCHOACTIVE PLANTS** established as a theme? Not only in the motto (**MUSHROOM ISLAND**), but also via the layout (**PSYCHLOTRON**), pictures of mushrooms (**OTHER WORLD**), or a flyer in the shape of a mushroom (**SUNRISE ZONE**).

Certain motifs are so closely linked to specific styles that they function as **VISUAL STYLE NAMES**. You can recognize the style of the party just by looking at the visual. But beware – these are visual stereotypes and they only exist to be transgressed.

41 PARADISE, 1996, UTOPIA, BASEL, CH
42 LOVE SPIRIT, 1995, HACKESCHER MARKT, BERLIN, D
43 MUSHROOM ISLAND, 1998, NOTHSEA VENUE, ZAANDAM, NL
44 OTHER WORLD, 1997, BERLIN, D

45 SUNRISE ZONE, 1997, ALSOS ATHEN, GR
46 3RD PSYCLOTRON PSYCHADELIC VISUAL HAPPEN'N, 1992, HALLE DES
47 ABSTRACT PHAZE, 1995, ON AIR WEST, TOKYO, JP

48 HOUSE BOX, 1996, THE BOX, FRANKFURT AM MAIN, D
49 REVOLT, 1997, NORMAL, HEIDELBERG, D
50 JUNGLE MADNESS, 1997, VIBRATION, FORST, D

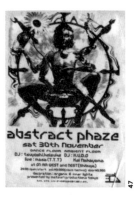

› **GOA TRANCE** = Hinduism, Celtic patterns, and fractals

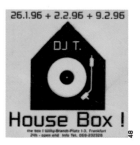

› **HOUSE** = glamorous models or everyday household items

› **TECHNO** = computer graphics and database look

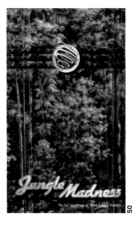

› **JUNGLE** = jungle pictures and graffiti style

Flyers pick up all kinds of visual motifs from human culture and reclassify them according to their status within rave culture. So what does the range of images cover? The main categories are: objects, animals, people, humanoids, outer space, religion, nature, logos and symbols.

Many recurring images on flyers represent core elements of the party itself: sound equipment, mostly turntables (**GROOVE**), and partygoers, mostly female (**HOUSEHOLD**). Then there are the symbols or "trademarks" of rave culture, such as alien faces (**THE FAR SIDE**) and human-machine hybrids representing techno evolution; household devices stand the roots of electronic music (i.e. house); mushrooms signify the psychedelic element of rave culture; add to the above all kinds of fragments from media culture, from comic heroes (**MASTERS OF EUROPEAN NOISE CONTROL**) to product packaging.

However, not all flyers have visuals in the usual sense. There are many ways of avoiding concrete or recognizable references: decorative shapes and fill-ins, fractals, abstract patterns without beginning or end. Or a minimal graphic background, or a balance between typography and empty space.

[05] FORMS OF FLYER

In order to stand out among the flood of images and to do distinguish themselves from standard motifs, flyer designers (or at least those who can afford it) experiment with shapes and materials. This begins with choosing a type and grade of paper: there is bleached, unbleached, coated, gummed or glossy paper – a diversity that is sadly all-too-often ignored.

In rare but all the more eye-catching cases, flyers are made from other materials: plastic sheet or tracing paper, blotting paper or textiles. Even marvelous combinations of various materials sometimes occur (**E-NERGIE**). Cases in point are the flyers for **STOFFWECHSEL**, a club based in Mannheim, Germany, which experiment with every conceivable material (**KRANKHEIT UND REVOLUTION**).

55

56

Besides providing a resource for innovation, the material used for flyers also indicates the social context of an event. While most **HOMEMADE** flyers are printed on normal 80gm copier paper, flyers on glossy 170gm paper underline the commercial nature of an event.

Flyers are not always rectangular. They come in large and small, narrow and wide, round and square. Sometimes they take on the form of animals (**SOMMERNACHTS-TRAUM**), fruit (**STRAWBERRY ISLAND**), body parts, or objects. One special category is **ICONIC** flyers: their shape corresponds to the content of one of the components (club

51 GROOVE, NO YEAR, NO LOCATION, SAN FRANCISCO, USA
52 HOUSEHOLD, 1996, G-POINT, ATHENS, GR
53 THE FAR SIDE, 1994, THE ROBEY, LONDON, UK
54 MASTERS OF EUROPEAN NOISE CONTROL, 1993, XS, FRANKFURT A.M., D
55 DIE E-NERGIE, 1997, PARKHUAS TREPTOW, BERLIN, D
56 KRANKHEIT UND REVOLUTION, 1997, STOFFWECHSEL, MANNHEIM, D

name, party motto) or the occasion of the event. A flyer with the motto **PLANET HOUSE** looks like a house, and what could be more appropriate for the opening party at a film festival than a film strip flyer (**MULTIMEDIA ART IN PROGRESS**).

[06] **BOOTLEG FLYERS**

Another option for unusual flyers is **BOOTLEGGING**, i.e. the faking of a company or brand logo. The basic recipe is simple: take a logo and replace its text content with one or more flyer components, e.g. club, motto or acts. The relationship between the original and rip-off version is known as "intertextuality" (**NEVER MIND THE BOLLOCKS...**).

The concept of faking company and brand logos is nothing new. It can be seen in Dada collages from the 1920s and in the Pop Art

of the 1960s. But only the spread of digital technology since the 1980s has made this technique widely accessible. Rave culture was the first to take up this new game. In Germany, this style was pioneered by the clubzine **FLYER** (issued monthly since 1992 in Berlin), that based the cover for each issue on a different logo, and the dance music magazine **GROOVE** that embellished its parodies of **BILD**, Germany's leading yellow press newspaper, with fake company logos.

The most common victims are foodstuffs such as ice cream, candy, milk and muesli. Other examples are familiar cultural products like record covers and movie posters. Some take their inspiration from more official domains: a bank note (**BANK OF SOUNDS**) and a "soldier died in action" notice (**ELECTROFUNKSOULREC.**) are repurposed as messengers of the night.

57 SOMMERNACHTSTRAUM, 1993, SOUND FACTORY, FRANKFURT AM MAIN, D
58 STRAWBERRY ISLAND, 1994, WALZMOEHLE, LUDWIGSHAFEN AM RHEIN, D
59 PLANET HOUSE, 1997, KITZINGEN, D
60 MULTIMEDIA ART IN VERY PROGRESS, 1997, KARLSTORBAHNHOF, HEIDELBERG, D

61 NEVER MIND THE BOLLOCKS HERE'S THE PEACH, 1996, THE LEISURE LOUNGE
62 FLYER FRANKFURT, NR. 6 1996
63 FLYER FRANKFURT, NR. 13 1997

64 GRROVE AUG–SEP 1994
65 GRROVE AUG–SEP 1994
66 BANK OF SOUND – FIVERS, 1994 ROLLER EXPRESS ARENA, LONDON, UK
67 ELCTROFUNKSOULREC., 1997, LITTLE HEAEN, HEIDELBERG, D

Good bootlegs achieve their new meaning by minimal alterations to the text and/or layout of the original. If there is a slogan, for example, then it may be enough to replace a single word: the candies now have "Various **HOUSE** Flavors". Points are also scored if several flyer components are integrated into the bootleg: if the original is a foodstuff, for example, the DJs become the ingredients (**QUALITY BREED**) or the filling (**MORE HOUSE**).

In the Monopoly bootleg by **OKTAN,** each square promotes a single event, with the date at the top and the motto and/or acts at the bottom. The **TRESOR** bootleg from two and a half years earlier keeps the original squares but features a cool chance card.

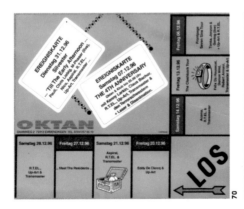

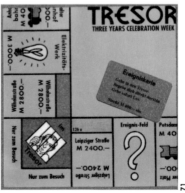

The **XS-MARKT** series uses the style of supermarket advertising: DJ Carl Cox, for example, appears as a washing machine called "Masters Waschautomat Cox", the date of his show forms the serial number "MI 25.5" (Wednesday May 25), the entrance fee becomes "Pay in easy installments – 12x1".

68 MORE HOUSE, 1993, COOKY'S, FRANKFURT AM MAIN, D
69 QUALITY BREED, 1994, KUEHLHAUS, SAARBRUECKEN, D
70 OKTAN, 1996, EMMENDINGEN, D

71 TRESOR THREE YEARS CELEBRATION WEEK, 1994, TRESOR, BERLIN, D
72 XS MARKT, 1994, XS, FRANKFURT AM MAIN, D

73 XS MARKT, 1994, XS, FRANKFURT AM MAIN, D
74 LA BELLE XS MENUE, 1994, XS, FRANKFURT AM MAIN, D

[07] TEXT PATTERNS AND OBJECT FLYERS

Other flyers with an intertextual dimension are designed to be reminiscent of some everyday text or object. What distinguishes them from the bootlegs? In this case, instead of faking any specific logo, an abstract but identifiable text pattern is imitated. Read an excerpt from the "January menu" at XS, a club based in Frankfurt, Germany: **"MASTERS OF EUROPEAN NOISE CONTROL WITH TOMATOES AND FRESH HERBES-DE-VINYLE ON HOUSE-BAKED BAGUETTE"**. Has someone been quoting from mum's cookbook? Not quite, just evoking the pattern of a recipe (**LA BELLE XS MENUE**).

There are flyers with text patterns from every imaginable walk of life: tickets (**HOUSE TRAM**); packaging merchandise (**DAS GUTE FREUDEN HOUSE**); charts (**FINANCIAL PROTECTION**); announcements (**WEDDING PARTY**); warnings (**DO NOT DISTURB**).

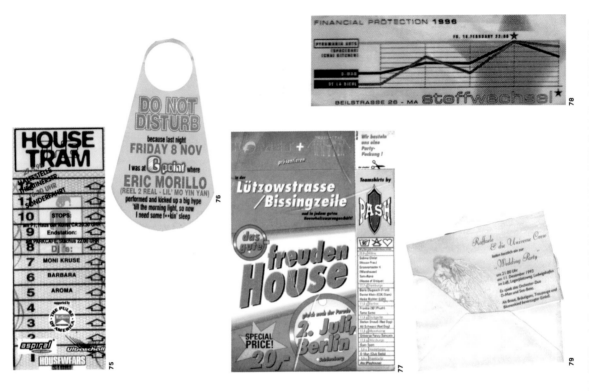

The logical progression in this direction is the 3D flyer that transmits its message via an actual object or is built to resemble one. Examples suggest that there are no limits to the imaginative powers of flyer makers. But even here, there are imitations (**ANGELS OF LOVE**, issued in July 94) that come nowhere near the originals (**BERLINNIGHT AXIOM**, issued June 94).

Intertextual fun and games can be more or less refined. Some flyers only use the original as a background image (**FRESH HOUSE**), while others completely adapt the original: the flyer components are semiotically "dressed up", placed in a new context with new roles. If the text pattern is a plane ticket, for example, then the opening hours appear as flight times (**THE PSYCHEDELIC HIGH NOON PARTY**). At the **WEDDING PARTY**, the location is the "Bürgerhaus" (i.e. town hall), and the DJs are the "orchestra".

Of course, objects can be tailored to the motto or occasion of an event just as fittingly as visuals. A case in point is **SYLVESTER WEEKEND**, a flyer in the shape of a sparkler box, to promote a New Year's Eve party. In the words of its designer, Klaus Mai: "With the ever-increasing number of parties, attention-grabbing and easily identifiable visuals take on a vital role. The problem is solved by keeping the main focus simple and direct. On the flyer for the Dorian Gray three-day **SYLVESTER-RAVE**, the flame stands for the fireworks and other new year festivities." (**KM7**).

[08] AROUND THE WORLD IN 80 FLYERS

Today, flyers exist the world over – or to be more precise, wherever there is a youth and club culture. Examining flyers from various countries, there will be similarities and differences.

Series of flyers created by a single graphic designer, sharing at least one motif, and continuing over a period of weeks or months can be found in several countries. They provide evidence of different flyer design strategies in action. Different countries and locations, different graphic designers, similar strategies.

› The series **MASTERS OF EUROPEAN NOISE CONTROL** by the German club XS scans its way in calling card format through the world of comics. The layout remains the same, the flyer components are added. Even tiny details are adjusted, such as wordplay in the speech bubbles: "Where's the **VINYL** sauce?" Throughout the series, the reverse features the XS logo.

› The **HOUSEHOLD** series from Athens, Greece, plays on the equation "house" [music] = "house" [household] and uses the corresponding images: household items and sexy housewives. Note that the vacuum cleaner on the **GROOVER** flyer features a faked logo.

› The **GIFT** series from Frankfurt, Germany, goes for a low-key minimalist style: same layout, differences in the size and position of individual elements, DJ names in different positions.

› The **TWIRL** series from Berlin is one-sided, all with advertising on the reverse. The front always names the club, the motto, the acts and the details in various sizes and positions. The visuals are abstract, in intense colors.

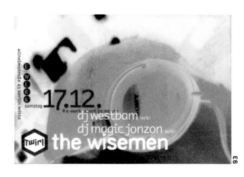
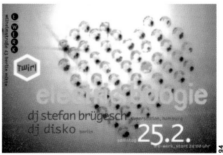

The **LAB** series from Athens, Greece, is the least uniform: different formats, as well as different compositions. One flyer in this series features a bootleg, another includes a wordplay with similar-sounding English words (i.e. **LAMB, LAMP, LAB**), one of which is the name of the club.

Flyers from different countries differ, for example, in their level of technical perfection: the more developed a country and its party culture, the greater the technical scope, e.g. for shaped flyers. Common graphical (and musical) styles also differ from country to country, as do languages. But what is far more striking is the amount of similarities. Everywhere, and independently of each another, flyer makers use the same range of design solutions. People who live in the same historical period, grow up with the same culture, and share similar lifestyles are bound to do things that point in the same direction (**MILCH-LECHE-MILK**).

Anyone looking for a new world language will find part of it on flyers. Their mottos, visuals and symbols are used and similarly understood everywhere (**HEDONISM**).

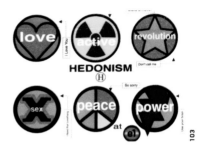

THE FLYER RESEARCH PROJECT

This text was developed for the exhibition Flyer Research that has been presented in the time form october 1998 and june 1999 in Heidelberg, Leipzig, Berlin and Weimar. (HTTP://FLYER.ARCHETYPE.DE).

THE FLYER RESEARCH Project was brought into life by the communication designer Kei-ko Schmitt, the graphic designer Ronald The and the Linguist Jannis Androutsopoulos and meant as a bridge between research and exhibition. Our goal was to present the topic of flyers different than Flyermania and other Flyer Collections that simply let us adore a bunch of colourfull pieces. That is beautifull but not the whole story. What about the flyer as a textform, as a carrier of meaning and information ? Flyer are supposed to be a 'visual code', whose knowledge seems to be presumed. We are trying to describe this special code rudimentary.

FLYER RESEARCH works with a small collection derived from private archives from the time of 1992 - 1999. Approximately 1000 flyers from 8 countries: Germany, France, Greece, Great Britain, Netherlands, Japan, Switzerland and the USA. The selection of the roundabout 200 exhibitied objects follows a main criteria: how representative is a specific aspect of a flyer for the 'chapter' it is appearing in the exhibition ? Age, Origin and Rarity of the flyers were additional criteria so that older and more original piec-es were favoured. Of course we took care that in each chapter flyers from different countries were presented. Criteria like Taste, personal memory, publicity of the club or event didn't play a role at all. **FLYER RESEARCH** shows 'beautifull' and 'ugly', 'profes-sional' and 'amateur', 'commercial' and 'underground', 'progressive' and 'ordinary' fly-ers - just like in real life.

102 MILCH-LECHE-MILK-LATTE-MELK-LAIT, 1993, MILK, MANNHEIM, D
103 HEDONISM, 1995, QUEEN MARY & WESTFIELD COLLEGE, LONDON, UK

100 LAB - THE AFTERHOURS BREAKFAST CLUB 1996, ALSOS, ATHENS, GR
101 LAB - THE AFTERHOURS BREAKFAST CLUB.1996, ALSOS, ATHENS, GR

97 LAB - THE AFTERHOURS BREAKFAST CLUB 1996, ALSOS, ATHEN, GR
98 LAB - THE AFTERHOURS BREAKFAST CLUB 1996, ALSOS, ATHEN, GR
89 LAB - THE AFTERHOURS BREAKFAST CLUB.1996, ALSOS, ATHEN, GR

REFERENCES

FLYERMANIA = Die Gestalten (Eds.) (1998).
Flyermania. Berlin: Ullstein.

KM7 = Klanten, Robert (Ed.) (1997).
Design Agent KM7: Licence to Design. Berlin:
Die Gestalten Verlag.

ANDROUTSOPOULOS, JANNIS (2000).
"DIE TEXTSORTE FLYER".
In: Adamzik, Kirsten (Ed.), Textsorten. Reflex-
ionen und Analysen, 175-213.
Tübingen: Stauffenburg.

ANDROUTSOPOULOS, JANNIS (2000).
"VERBAL KONSTITUIERTE UND VISUELL STRUKTU-
RIERTE TEXTSORTEN: DAS BEISPIEL FLYER".
In: Ulla Fix & Hans Wellmann (Eds.), Bild im Text –
Text und Bild, 343-366. Heidelberg: Winter.

KRESS, GUNTHER/THEO VAN LEEUWEN (1996).
READING IMAGES:
The Grammar of Visual Design. London: Rout-
ledge.

FLYER
RESEARCH

DER PARTY-FLYER ALS KOMMUNIKATIONSMEDIUM

[01] DIE ENTSTEHUNG EINER TRADITION

An einer gut sortierten Flyer-Sammlung lassen sich die Entwicklungen der Jugendkultur in den 1990er Jahren ablesen: die Wandlung der Clubkultur von der Einheitlichkeit zur Ausdifferenzierung, von den ersten Rave-Tagen (**ANDY-P & ANDY-MOON**, Abb. 03) zum europäischen Rave Boom. Musik und Gruppenstile lösten einander ab, aus Breakbeats wurde Jungle wurde Drum & Bass. Die Tanzveranstaltungen wurden größer und gleichzeitig spezialisierter. Der gute alte Megarave (**TECHNOMANIA, 1994**, Abb. 02) räumte den Weg für die 12-Floors-Veranstaltung (**SOUNDS OF LIFE, 1997**, Abb. 01).

Im Rave-Boom der 1990er Jahre haben sich die Form und das Layout von Flyern dramatisch verändert. Gleichzeitig sind bestimmte Muster und Symbole über die Jahre hinweg konstant geblieben. Die technischen Möglichkeiten der Flyer-Gestaltung haben sich in kurzer Zeit enorm erweitert, kompliziert gestanzte Flyer sind heute für viele Clubs erschwinglich. Das bedeutet aber nicht automatisch, dass sie "schöner" sind. Der prototypische Flyer, viereckig und schnörkellos, ist immer noch da, und vor allem: jede/r kann ihn am persönlichen Rechner selber machen (**EST-CE QUE LA TECHNO**, Abb.04, **SOHO CLUB**, Abb.05).

Seit dem Anfang der Ravekultur waren Flyer eine Experimentierfläche für die Umsetzung neuer Ideen im Kommunikationsdesign – "Musterbeispiele dafür, was man sich einfallen lassen kann, um einer Veranstaltung ein unverkennbares Gesicht zu verpassen" (**FLYERMANIA**). Die innovativen Ideen waren schon sehr früh da: Ikonische Flyer, Bootleg-Flyer und Objekt-Flyer gab es schon 1993 (**FEELING GROOVY**, Abb.07, **THE TASTE OF SUMMER**, Abb.06). Die Designs wiederholen sich, gelungene Ideen werden abgekupfert oder fortgesetzt – unverkennbare Zeichen für die Entwicklung einer Tradition in der Flyergestaltung.

Geschichtlich betrachtet ist der Party-Flyer eine sehr junge, auf einen bestimmten Markt spezialisierte Variante eines alten Textmusters. Hinter dem Flyer steht die Tradition des Flugblatts, das seit den ersten Tagen des Buchdrucks zu den verschiedensten Zwecken eingesetzt worden ist: Kommerz und Kultur, Revolution und Religion. In der Nische der Partykultur sind aber sehr schnell neue Traditionen entstanden, die den Party-Flyer von anderen Flugblatt-Varianten unterscheiden. Das erkennt man zum Beispiel an spontanen Reaktionen auf Flyer, die dem Prototyp nicht entsprechen. Beispielsweise so: Wie! Da stehen keine DJs drauf!? Was könnte das bedeuten? Schlechte Arbeit oder Verfremdungsabsicht? – Beides mag sein. In jedem Fall zeigt die Reaktion, dass Information über die auftretenden DJs ein fester Teil der kollektiven Vorstellung vom typischen Flyer ist.

Eine kollektive Vorstellung an sich kann man nicht beschreiben, dafür ihr Ergebnis und Spiegelbild, den Text und seine Gestaltungsmittel. Der Flyer als Text lässt sich mit dem Werkzeug der Text- und Kommunikationsanalyse untersuchen. Was dabei herauskommt ist ein abstraktes Textmuster als gemeinsamer Nenner der ganzen Handzettel, die wir um uns herum sehen. Ein prototypischer Flyer, der jede Woche auf der ganzen Welt in zahllosen Variationen immer wieder neu entsteht.

[02] FLYER-FUNKTIONEN

Der Party-Flyer ist ein Medium in der Kommunikationskette zwischen Veranstaltern und Clubgängern. Seine Mitteilung ist die Information über eine Party. Sein eigentlicher Zweck ist der Appell an den Empfänger, diese Party zu besuchen. In dieser Kette hat der Grafiker eine ähnliche Stellung wie der Übersetzer. Nach Klaus Mai ist er ein "visual translator of da bass and da beat". (**KM7**)

Aus der Sicht des Auftraggebers bildet der Flyer das "Gesicht" einer Veranstaltung. Er kann die Party zum Erfolg machen und helfen, ein gutes Image für das Team und den Club aufzubauen oder aufrechtzuerhalten. Aus der Sicht des Empfängers stellt der Flyer eine Informationsquelle für das Club- und Partygeschehen dar. Er liefert oft Infos, die in keinem Magazin zu finden sind. Manchmal hat er auch ganz konkrete Vorteile, wie eine Ermäßigung am Eingang oder gar einen exklusiven Eintritt. Nicht von ungefähr nennt man Flyer in England auch "invites", Einladungen. Als Text betrachtet, enthält der Flyer eine mehr oder weniger standardisierte Menge an Information, die verbal und visuell übertragen wird. Darüber hinaus bietet er ein Codierungsfeld oder eine "semiotische Spielwiese" für die speziellen Botschaften jugendlicher Subkulturen.

Als Werbetext dient der Flyer also dazu, auf eine Tanzveranstaltung aufmerksam zu machen. Aber was für eine? Von der allwöchentlichen Dorfdisco über das einmalige Mega-Event und die geheime Waldparty bis hin zum Großstadtclub gibt es ganz verschiedene Partys für ganz verschiedene Leute. Zieht man die Art der Veranstaltung und die Bauweise des Flyers zusammen in Betracht, lassen sich drei Flyer-Typen unterscheiden: Standard-, Mega- und Kalender-Flyer.

A BASIC FLYER TYPOLOGY

As a promotional text, the flyer's job is to draw attention to a dance event. But what kind? From weekly village discos to one-off mega-events, from secret parties in a forest or bunker to clubs in major cities, there are different types of party for very different kinds of people. Considering both the type of event and the way the flyer is made, flyers can be broken down into three categories: standard, mega and calendar flyers.

› **DER STANDARD-FLYER:** nicht auf eine spezielle Art von Veranstaltung eingeschränkt, sondern im Gegenteil der üblichste Flyer, der Flyer-Prototyp. Seine Grundform: viereckig, Größe zwischen A5 und A6, einseitig bedruckt (**OSMOSIS**, Abb.08). Seine Mitteilung: in der Regel eine einmalige Veranstaltung, privat oder öffentlich, manchmal aus besonderem Anlass, z.B. eine Release-Party oder eine Geburtstagsfeier (**SPOON**, Abb.11, **LOCALIZER RELEASE PARTY**, Abb.09). Oder eine wöchentliche Clubnacht, in welchem Fall es auch Flyer-Reihen gibt, die sich über einen Monat oder eine ganze Saison erstrecken. Kleine, private oder auch illegale Partys werben oft mit einem am eigenen PC erstellten Home Made-Flye, der oft in der Layout-Tradition der Punk-Collage steht (**RADICAL REHOUSING**, Abb.10).

› **DER MEGA-FLYER:** Zusammen mit der Party- wächst auch die Flyer-Größe. Die angemessene Werbung für den Megarave ist eben ein Mega-Flyer: mindestens ein größeres beidseitiges Faltblatt, das bis zum mehrseitigen Booklet wachsen kann. Er enthält nötige und weniger nötige Zusatzinfos zu den vielen DJs und Live Acts, gegliedert nach Floor oder Area, wovon jede z.B. eine Booklet-Seite einnehmen kann. Außerdem die übrigen Attractions des Abends, häufig ein Wegplan und immer auch Sponsoren-Logos und sonstige Werbung (**EUPHORIA**, **SOUNDS OF LIFE**, Abb.12-13).

› **DER KALENDER-FLYER:** Reguläre Clubs benutzen auch Kalender-Flyer, die einen Überblick über die "events of the month" bieten. Typisch hierfür ist das längliche Formatund die tabellarische Anordnung,so dass sich von oben nach unten oder von links nach rechts durchlesen lässt (**MANIAC LOVE**, Abb.15-16, **YELLOW KITCHEN**, Abb.14).

[03] FLYER-BAUSTEINE

Jeder Flyer enthält bestimmte Informationstypen, die sich nach dem Baukasten-Prinzip beschreiben lassen. Die nachfolgend genannten Bausteine machen zusammengenommen den typischen Flyer aus:

TEAM: die Veranstalter.
MOTTO: Name der Veranstaltung und/oder begleitender Spruch.
AKTEURE: das Angebot: Disc Jockeys, Live Acts, Animation etc.
VISUAL: Abbildung oder Grafik auf dem Flyer oder die Form des Flyers selbst.
DATEN: die eigentliche Information: Wo - Wann - Wie lange - Wie viel.
Sponsor: Sponsoren-Logos, sonstige Werbung, auch Urheber-Logos.

Die Bausteine TEAM und MOTTO sind die Glieder der Formel "X presents Y". Die AKTEURE begleitet fast immer der Name ihres Labels oder Stammclubs, bei Mega-Flyern sogar ein Kurztext. Die DATEN wachsen oder schrumpfen mit dem Umfang der Party. Die SPONSOREN reichen vom lokalen Plattendealer bis zum Multi, je nach Kommerzialität der Veranstaltung. Viele VISUALS vermitteln Inhalte der gesamten Ravekultur oder einer bestimmten Stilrichtung.

Motto und Visual teilen zwei wichtige Eigenschaften: Sie sprechen das Gefühl an und bleiben im Gedächtnis hängen. Flyermacher kreieren deshalb spezielle Club- oder Event-Logos, die zusammen mit oder anstelle des Visuals eintreten. **METALHEADZ** (Abb. 18) und **MAYDAY** (Abb. 19) sind bekannte Logos, **MASQUERADE** (Abb. 20) ein weniger bekanntes.

Nicht alle Bausteine müssen auf jedem Flyer vorhanden sein. Underground-Parties haben in der Regel keinen Sponsor. Eine Weganleitung sieht man z.B. auf Mega-Flyern (die sich an Leute aus verschiedenen Regionen wenden) oder Waldparty-Flyern, aber normalerweise nicht auf Stadtclub-Flyern, es sei denn man befindet sich in einer Megacity wie Tokyo (**NARCOTIQUE**, Abb.21). Größe und Qualität der Bausteine richten sich nach der Funktion des Flyers: je kommerzieller die Party und fetter der Flyer, desto umfangreicher die AKTEURE, DATEN und SPONSOREN bei identischem CLUB und MOTTO.

DIE BAUSTEINE IM GRAFISCHEN RAUM

Wo und wie werden die Bausteine auf die grafische Fläche platziert? Das hängt davon ab, ob der Flyer ein- oder beidseitig bedruckt ist. Der einseitig bedruckte Flyer lässt sich entlang von zwei Dimensionen beschreiben, die für die Komposition visueller Texte überhaupt von Bedeutung sind (**KRESS & VAN LEEUWEN 1996**). Die vertikale Achse verbindet die Gegenpole des "Ideals" und der "Realität". Das Ideal repräsentiert die Idealvorstellung vom beworbenen Event oder Produkt und steht typischerweise am Textkopf. Ihm gegenüber werden im Fußbereich des Textes die nackten Fakten dargestellt. Die horizontale Dimension folgt der Grundrichtung der visuellen Semiose in der westlichen Kultur: Bekanntes wird eher links, Neues eher rechts platziert. Den höchsten Informationswert hat die Kreuzung der zwei Achsen, das Zentrum der Komposition.

OSMOSIS (Abb. 22) zum Beispiel ist an der vertikalen Achse strukturiert: Oben und leicht gegen Mitte gerückt sieht man das "Idealbild" der Veranstaltung, bestehend aus Motto und Visual. Leicht unter der Mitte steht das Angebot (Akteure), ganz unten die Realität (Daten).

Für andere einseitige Flyer ist dieses Schema weniger geeignet. **GIFT** (Abb. 23) zum Beispiel ist minimalistisch: Es gibt kein Visual, der monochrome Hintergrund dominiert, der einzige sichtbare Baustein ist der Clubname, alles andere in die Ecke gedrängt. **MOOT** (Abb. 24) und **DUSTED** (Abb. 25) sind typografisch

orientiert: kein Visual, der Text bedeckt die gesamte Fläche.

Der beidseitig bedruckte Flyer bietet mehr Möglichkeiten. Trotzdem gibt es immer noch eine Vorder- und Hinterseite. "Vorne" kommt die Identität, das Gesicht des Events zum Ausdruck, und zwar durch das Visual, das Motto und das Club-Logo. "Hinten" stehen erwartbare Information wie die Daten und Sponsoren.

› Bei **CAB CONNECTION** (Abb. 26, 27) hat die Vorderseite nur Motto und als Visual den Taxi-Streifen auf gelbem Hintergrund. Hinten gibt es Daten, Akteure – sprachlich schön an das Motto angepaßt ("drivers") – und Sponsoren.
› Beim **TRESOR JUNI-KALENDER** (Abb. 28, 29)sieht man vorne das Motto, das Club-Logo und ein zum Club-Namen passendes Visual. Hinten gibt es Infos zu den einzelnen Events im Format Daten – Slogan – Akteure.
› Bei **ELECRONIC** (Abb. 30, 31) sieht man vorne das Motto und das Visual. Auf der Hinterseite stehen
oben die Veranstalter (Club-Logos), in der Mitte die Akteure (eine Spalte pro Event) und unten Daten und Sponsoren.

Im Vergleich zu den ersten Flyer-Tagen ist für die späteren 1990er Jahre eine Kombination typisch: die minimalistische Vorderseite (nur Motto/Club-Logo) mit Text-dominierter Hinterseite (Akteure, Daten). **REVOLT** (Abb. 32, 33) ist ein Beispiel hierfür.

SPRACHGESTALTUNG

Die Sprache hält das Gesamtzeichen Flyer zusammen. Ohne sie kommt die Flyer-Mitteilung – "Was passiert wann mit wem und wo?" – nicht aus. Aber meistens wird die eigentliche Textfunktion – "Sei dabei!" – nicht sprachlich kodiert. Aufrufe an den Empfänger, selbst poetisch-witzige wie bei **GROOVE KITCHEN** (Abb. 34) – "let the music consume you" – sind selten.

Neben trockener Information hat der sprachliche Flyer-Text emotionale und soziale Funktion. Er vermittelt Hinweise auf das spezielle Wissen, Gefühls- und Wertesystem der Ravekultur: Liebe, Technologie, Gemeinsamkeit, Zukunft, Frieden, Energie, Visionen, Freude und andere "geladene" Begriffe erscheinen auf Flyern als Mottos oder Club-Namen. Sie haben wiederum Verbindungen zu visuellen Motiven, oft auch zum Bild desselben Flyers.

Außerdem haben Sprachzeichen eine ästhetische Funktion. Auch sie sind Formen, die gestaltet werden (**SUGAR ATTACK**, Abb.35). Ihre Fläche ist Träger von Experimenten, die wiederum auf den Musikstil der Veranstaltung verweisen können: Beispielsweise die hinduistische Schrift für **ANOKHA** ("The future soundz of India") oder die japanische Schrift für **FUTURE** (Abb. 37) – beides für lateinische Zeichen.
Die üblichste Sprache auf Flyern in der ganzen Welt ist Englisch. Die Landessprache erscheint, wenn überhaupt, nur in bestimmten Bausteinen – z.B. das Motto auf Englisch, die Weg-

beschreibung auf Deutsch – oder aber im Rahmen einer Imitation oder Parodie wie bei den Bootleg- und Objekt-Flyern. Die Muttersprache bietet dabei die Möglichkeit, auf eingeprägtes Wissen und Stereotype der Stammeskultur zu verweisen. Das ist der Grund, weshalb Flyer wie **LOVE SHAK** (Abb. 40) oder **KINGS & QUEENS** (Abb. 38) nur auf Deutsch – trotz englischen Mottos – funktionieren.
Oder wie sagt man **SAUWER DIE WORSCHT GEPELLT!** (Abb.39) auf Englisch?

[04] FLYER-BILDER

Der visuelle Code der Flyerkultur beruht auf den allgemeinen Regeln des visuellen Designs und entwickelt sich zusammen mit der Evolution der Ravekultur. Er unterhält verschiedenartige Beziehungen zum sprachlichen Code. Der Flyer ist eben ein "bimodaler" Text; seine Gesamtbedeutung entsteht erst aus der Verbindung von Text und Bild.

Es kommt häufig vor, dass Motto und Visual einander entsprechen. Ein Bild von Adam und Eva begleitet das Motto **PARADISE** (Abb. 41) und das Visual "Herz" entspricht dem Motto **LOVE SPIRIT** (Abb. 42), da im Herzen bekanntlich die Liebe ist. Das Visual veranschaulicht hier das Motto oder dieses ist die Legende zum Visual, wie man's nimmt. In beiden Fällen stimmen verbaler und visueller Code miteinander überein. Zwei Ausdrücke für einen Begriff.

Die Auswahl der Visuals ist häufig ein kreativer Akt, folgt aber auch internationalen Traditionen. Flyermacher greifen immer wieder auf dieselben Visuals zurück, entweder weil sie für tiefere Glaubensinhalte einer Strömung stehen oder weil's einfach so üblich ist. Wie macht man beispielsweise psychoaktive Pflanzen zum Thema? Nicht nur durch das Motto (**MUSHROOM ISLAND**), sondern auch durch das Layout (**PSYCHLOTRON**), die Abbildung von Pilzen (**OTHER WORLD**) oder einen Flyer in Pilzform (**SUNRISE ZONE**).

Bestimmte Motive sind mit ganz bestimmten Stilen derart eng verbunden, dass sie als visuelle Stilnamen funktionieren. Du kannst den Stil der Party schon an der Abbildung erkennen. Doch Vorsicht: Es handelt sich um visuelle Stereotype und diese nur da, um überschritten zu werden.

Certain motifs are so closely linked to specific styles that they function as **VISUAL STYLE NAMES**. You can recognize the style of the party just by looking at the visual. But beware – these are visual stereotypes and they only exist to be transgressed.

› **GOA-TRANCE** = Hinduismus, keltische Muster und Fraktale [**ABSTRACT PHAZE**, Abb.47]
› **HOUSE** = glamouröse Models, Haushaltsartikel oder Häuschen [**HOUSE BOX**, Abb.48]
› **TECHNO** = Computer-Grafics und abstrakte Formen [**REVOLT**, Abb.49]

› **JUNGLE** = Dschungelbilder und Graffiti-Style [**JUNGLE MADNESS**, Abb.50)

VISUELLE MOTIVE

Der Flyer greift auf alle möglichen visuellen Motive der menschlichen Kultur zurück und ordnet sie neu je nach ihrem Stellenwert in der Ravekultur.

Typische Flyer sind Kernkomponenten des Party-Abends: Tonerzeuger, meistens Plattenspieler (**GROOVE**), und Party-gäste, meistens weiblichen Geschlechts (**HOUSEHOLD**, Abb.52). Außerdem Symbole der Ravekultur wie Alien-Gesichter (**THE FAR SIDE**, Abb.53) und Mensch-Maschinen für die Techno-Evolution; Haushaltsgeräte für die Wurzeln der elektronischen Tanzmusik (**HOUSE**); Pilze für das psychedelische Rave-Element; und allerlei Fetzen aus der Medienkultur, von bekannten Comicfiguren (**MASTERS OF EUROPEAN NOISE CONTROL**, Abb.54) bis zu Produktverpackungen.

Nicht alle Flyer haben ein Bild im herkömmlichen Sinn. Es gibt viele Möglichkeiten, das Konkrete und Erkennbare zu vermeiden: dekorative Formen und Flächen, Fraktale, abstrakte grafische Muster ohne Anfang und Ende; oder auch der minimalistische grafische Hintergrund, oder das Spiel zwischen Typografie und Leerfläche.

[05] FORMS-FORMEN

Um in der Bilderflut aufzufallen und sich von gängigen Motiven abzusetzen, experimentieren Flyermacher (wenn sie sich's leisten können) mit der Form und dem Material des Flugblatts. Es fängt schon bei der Auswahl der Papiersorte und -qualität an: Da gibt es gebleichtes, ungebleichtes, gestrichenes, gummiertes, geglättetes Papier - Vielfältigkeit, die leider kaum beachtet wird.

Selten, dafür umso auffallender, sind Flyer aus anderen Materialien: Kunststoff-Folie und Transparentpapier, Löschpapier oder Stoff. Sogar Kombinationen aus mehreren Materialien sind zu bewundern [**E-NERGIE**, Abb.55). Die Flyer des Mannheimer **STOFFWECHSEL**-Clubs experimentieren mit allen möglichen Materialien.

Das Flyer-Material liefert auch Auskunft über den sozialen Kontext einer Veranstaltung: Während die meisten Home Made-Flyer auf normalem 80g/m^2-Kopierpapier gedruckt sind, markieren Flyer aus 170g/m^2-Glanzpapier die Kommerzialität einer Veranstaltung.

Der Flyer ist nicht nur viereckig. Seine Form wird größer oder kleiner, enger oder breiter, rund oder eckig. Manchmal nimmt sie die Gestalt von Tieren, Körperteilen und Gegenständen an. Eine Besonderheit sind die ikonischen Flyer: Ihre Form entspricht dem Inhalt eines Bausteins (Club-Namen, Party-Motto) oder dem speziellen Anlass der Veranstaltung. Ein Flyer mit dem Motto **PLANET HOUSE** (Abb. 59) sieht selber wie ein Häuschen aus, und was passt besser zur Eröffnungs-Party eines Filmfestivals als ein Filmstreifen-Flyer...

[06] BOOTLEG-FLYERS

Ein anderer Weg zum ungewöhnlichen Flyer ist das Bootlegging, die Verfälschung eines Firmen- oder Markenlogos. Das Grundrezept: Man nehme ein Logo und ersetze seinen Text durch einen oder mehrere Flyer-Bausteine, z.B. Club, Motto, Akteure. Die Beziehung zwischen der verfälschten Vorlage und dem Flyer nennt man Intertextualität.

Die Verfälschung von Firmen- und Markenlogos ist vom Konzept her nicht neu. Man findet sie in Dada-Collagen aus den 1920ern und in der Pop-Art der 1960er. Aber erst die digitale Technologie hat sie seit den 1980ern breit zugänglich gemacht, und die Ravekultur hat das neue Spiel als erste aufgegriffen. Stilbildend wirkten dabei seit 1992 das Clubzine **FLYER**, das seine Titelseite jeden Monat nach einem anderen Logo gestaltete (Abb.62, 63), und die Zeitschrift **GROOVE** (Abb. 64, 65), die eine Bildzeitung-Parodie namens **GRIND** mit Falschlogos schmückte.

Die üblichsten Vorlagen sind Nahrungsmittel: Eis und Süßigkeiten, Milch und Müsli. Andere sind breit bekannte Kulturprodukte wie Plattencover und Filmplakate. Manche suchen ihre Vorlagen in offizielleren Domänen: Eine Banknote (**BANK OF SOUNDS**, Abb.66) und eine militärische Todesmeldung (**ELECTROFUNKSOULREC.**, Abb.67) verbreiten nun die Botschaften der Nacht.

Gelungene Bootlegs erreichen ihren neuen Sinn durch minimale Änderungen im Text und/oder Layout der Vorlage. Hat diese z.B. einen Slogan, so genügt ein einziges ersetztes Wort: Die Bonbons haben jetzt "Various House Flavours". Gelungen auch, wenn mehrere Flyer-Bausteine auf einmal an die Vorlage angepasst werden. Ist diese z.B. ein Nahrungsmittel, so sind die DJs nun die Zutaten (**QUALITY BREED**, Abb.69) oder die Füllung (**MORE HOUSE**, Abb.68).

Im Monopoly-Bootleg von **OKTAN** (Abb. 70) wirbt jedes Spielfeld um einen Event: Oben steht das Datum, unten das Motto und/oder die Akteure. Das zweieinhalb Jahre ältere Bootleg von **TRESOR** (Abb. 71) hat da noch die Originalfelder, dafür eine coolere Ereigniskarte. Die Reihe **XS-MARKT** (Abb. 72, 73) behält den Stil der Supermarkt-Werbung. DJ Carl Cox z.B. erscheint als Waschmaschine "Masters Waschautomat Cox", sein Auftrittsdatum als Geräte-Code "MI 25.5," der Eintritt als "Finanzkaufpreis – bequem zahlen – 12x1,-". Je komplexer die Verschmelzung der zwei Welten, desto witziger das Ergebnis.

[07] TEXTMUSTER UND OBJEKTE

Andere intertextuell geprägte Flyer erinnern an einen alltäglichen Text oder Gegenstand. Was ist ihr Unterschied zu

den Bootlegs? Hier wird kein konkretes Logo verfälscht, sondern ein abstraktes, aber erkennbares Textmuster nachgeahmt. Hier eine Kostprobe aus dem **JANUAR-MENÜ** von **XS**: "Masters of european noise control auf Tomaten mit frischem Vinyl-icum und housegebackenem Baguette". Hat da wer aus Mamis Kochbuch zitiert? Eben nicht, sondern das Muster eines Kochrezeptes abgerufen (**LA BELLE XS MENUE**, Abb.74).

Vertreten sind Textmuster aus allen denkbaren Lebensbereichen: Texte, die zu einer Dienstleistung berechtigen (**HOUSE TRAM**, Abb.75); eine Ware umhüllen (**DAS GUTE FREU-DEN HOUSE**, Abb.77); Informationen grafisch darstellen (**FINAN-CIAL PROTECTION**, Abb.78); eine besondere Feier ankündigen (**WEDDING PARTY**, Abb.79); vor etwas warnen (**DO NOT DIS-TURB**, Abb.76).

Der logische Fortschritt in diese Richtung ist der 3D-Flyer, der einen Gegenstand als Träger benutzt oder wie ein solcher gebaut ist. Auch hier gibt es Nachahmungen, die an ihre Vorbilder nicht herankommen.

Das intertextuelle Spiel ist mehr oder weniger fein. Manche Flyer benutzen die Vorlage nur als grafischen Hintergrund (**FRESH HOUSE**, Abb.83), andere sind auf die Vorlage komplett abgestimmt. Hier werden die Bausteine des Flyers semiotisch "verkleidet". Sie stehen in einem neuen Konzept, das neue Rollen enthält. Ist z.B. das Textmuster ein Flugticket, so erscheinen die Öffnungszeiten als Flugzeiten (**THE PSYCHEDELIC HIGH NOON PARTY**, Abb.84). In der **WEDDING PARTY** (Abb. 79) ist die Location das Bürgerhaus, die DJs sind das Orchester.

Natürlich lässt sich ein Textmuster auf das Motto oder den Anlass der Veranstaltung gezielt abstimmen, als wäre es ein Visual. Für den Grafiker Klaus Mai ist es so: "Bei der ständig steigenden Zahl von Partys kommt Aufmerksamkeit heischenden und leicht wiedererkennbaren Visuals wesentliche Bedeutung zu. Das Problem wird gelöst, indem der Hauptfokus einfach und direkt gehalten wird. Auf der Einladung für den 3tägigen Sylvester-Rave von Dorian Gray steht die Flamme für die Feuerwerke und die sonstigen Feierlichkeiten am Jahreswechsel." (**KM7**, S. 120).

[08] AUF 80 FLYERN UM DIE WELT

Flyer gibt es mittlerweile auf der ganzen Welt, genauer gesagt überall dort, wo es Jugend- und Clubkultur gibt. Zwischen Flyern aus unterschiedlichen Ländern wird man Gemeinsamkeiten und Unterschiede entdecken.

In mehreren Ländern findet man Flyer-Reihen, die von einem Grafiker gestaltet sind, mindestens ein gemeinsames Motiv haben und sich über mehrere Wochen oder Monate fortsetzen. Bei ihnen kann man verschiedene Strategien der Flyer-Gestaltung in Aktion sehen. Andere Länder und Locations, andere Grafiker, ähnliche Strategien.

› Die **XS**-Reihe **MASTERS OF EUROPEAN NOISE CONTROL** (Abb. 85-88) scannt sich im Visitenkartenformat durch die Comiclandschaft. Das Bild-Layout bleibt unverändert, die Flyer-Bausteine kommen hinzu. Auch Mikro-Komponenten wie die Wortspiele in den Sprechblasen sind angepasst: "Where's the vinylsauce?" Die Rückseiten der kompletten Reihe bilden das XS-Logo.
› Die Die **HOUSEHOLD**-Reihe (Abb. 89-90) spielt mit der Gleichung "House" [Musik] = "Haus" [Haushalt] und nutzt die entsprechende Bilder: Haushaltsartikel und sexy Hausfrauen. Der "Groover" enthält außer-dem ein Falschlogo auf dem Staubsauger.
› Die **GIFT**-Reihe (Abb. 91-92) setzt auf dezent-minimalistischen Stil: gleiche Raumverteilung, Unterschiede in der Größe und Position einzelner Elemente, neuer Platz für die Akteure.
› Die **TWIRL**-Reihe (Abb. 93-96) ist einseitig mit Party-Infos bedruckt, auf den Rückseiten steht eingeschaltete Werbung. Auf der Vorderseite stehen immer Club, Motto, Akteure und Daten in wechselnder Größe und Position. Die Visuals sind vom abstrakten, dafür farbintensiven Typ.
› Die **LAB**-Reihe (Abb. 97-101) ist uneinheitlich: unterschiedliche Formate, Unterschiede in der Komposition. Sie umfasst ein Bootleg und ein Wort- und Formspiel mit ähnlich klingenden englischen Begriffen, wovon einer der Clubname ist.

Flyer aus mehreren Ländern unterscheiden sich z.B. im Grad der technischen Perfektion: je entwickelter ein Land und seine Partykultur, desto größer die technischen Spielräume, etwa für gestanzte Flyer. Weitere Unterschiede gibt es in den landesüblichen Grafik- (und Musik-)Stilen, manchmal auch in der Sprache. Noch auffälliger sind aber die Gemeinsamkeiten. Überall und unabhängig voneinander greifen Flyermacher auf denselben Bestand von Gestaltungsmitteln zurück. Leute, die im demselben Zeitalter leben, mit derselben Kultur aufwachsen und ähnliche Lebensstile haben, machen folgerichtig Dinge, die in die gleiche Richtung zeigen (**MILCH-LECHE-MILK**, Abb.102).

Wer die neue Weltsprache sucht, wird auf den Flyern einen Teil davon finden. Ihre Mottos, Visuals und Symbole werden überall verwendet und ähnlich verstanden (**HEDONISM**, Abb.103).

DAS FLYER RESEARCH-PROJEKT

Dieser Text entstand im Zusammenhang mit der Ausstellung **FLYER RESEARCH**, die zwischen Oktober 1998 und Juni 1999 in Heidelberg, Leipzig, Berlin und Weimar vorgestellt worden ist (HTTP://FLYER.ARCHETYPE.DE).

Das **FLYER RESEARCH**-Projekt wurde von der Kommunikationsdesignerin Keiko Schmitt, dem Grafikdesigner Ronald The und dem Sprachwissenschaftler Jannis Androutsopoulos ins Leben gerufen und als eine Art Brückenschlag zwischen Forschung und Ausstellung betrieben. Unser Ziel war es, das Thema Flyer einmal anders darzustellen als Flyermania und andere Flyer-Sammlungen, die uns einfach eine Menge bunt gemisch-

ter Flugblätter bewundern lassen. Das ist schön, aber nicht die ganze Geschichte. Denn wo bleibt dabei der Flyer als Text, als Träger von Sinn und Information? Flyer gelten als "visueller Code", dessen Kenntnis irgendwie vorausgesetzt wird. Uns ging es darum, diesen speziellen Code ansatzweise zu beschreiben.

FLYER RESEARCH arbeitete mit einer kleinen, aus Privatarchiven stammenden Flyersammlung aus dem Zeitraum 1992-1999. Ca. 1000 Flyer verteilen sich dabei auf acht Länder: Deutschland, Frankreich, Griechenland, Großbritannien, Holland, Japan, die Schweiz und die USA. Die Auswahl der rund 200 ausgestellten Objekte folgte einem Hauptkriterium: Wie repräsentativ ist ein spezifischer Aspekt eines Flyers für das "Kapitel" der Ausstellung, in dem er erscheint? Alter, Herkunft und Seltenheit der Flyer waren zusätzliche Kriterien, so dass ältere und/oder "ausgefallene" Teile oft bevorzugt wurden. Natürlich wurde auch darauf geachtet, dass in jedem Kapitel Flyer aus mehreren Ländern vertreten sind. Kriterien wie Geschmack, persönliche Erinnerungen, die Bekanntheit eines Clubs oder Events spielten hingegen keine Rolle. Bei **FLYER RESEARCH** gibt es "schöne" und "hässliche", "professionelle" und "amateurhafte", "kommerzielle" und "untergrundige", "progressive" und "ordinäre" Flyer zu sehen – genauso wie im wirklichen Leben.

LITERATUR

FLYERMANIA = Die Gestalten (Hg.)
(1998). Flyermania. Berlin: Ullstein.

KM7 = Klanten, Robert (Hg.)
(1997). Design Agent KM7: Licence to Design. Berlin: Die Gestalten Verlag.

ANDROUTSOPOULOS, JANNIS (2000).
"DIE TEXTSORTE FLYER". In: Adamzik,
Kirsten (Hg.), Textsorten. Reflexionen und
Analysen, 175-213. Tübingen: Stauffenburg.

ANDROUTSOPOULOS, JANNIS (2000).
"VERBAL KONSTITUIERTE UND VISUELL STRUKTURIERTE TEXTSORTEN: DAS BEISPIEL FLYER". In: Ulla Fix & Hans Wellmann
(Hg.), Bild im Text - Text und Bild, 343-366. Heidelberg: Winter.

**KRESS, GUNTHER/THEO VAN LEEUWEN (1996). READING
IMAGES:** The Grammar of Visual Design. London: Routledge.

FLYER LIFE CYCLES

THEY'RE ALIVE, AREN'T THEY?

Flyers touch the lives of a whole lot of people. Making them involves club owners, musicians, VJs, media partners, sponsors, distributors and of course graphic designers. But that isn't all. Once the event has taken place, the flyers are picked up as either trash or collectors items and put in either a landfill or an archive. And then someone decides to make a book about them with a full-scale production team. All along the value creation chain, then, life can be seen to thrive around flyers. Within the club scene, too, historical periods and popularity cycles can be observed in the development of club culture, often defined by local situations and mostly by the constant emergence of new styles and technical innovations. As a business studies graduate, I can report that longer product life cycles, regardless of the product in question, are the key to survival in markets with high competitive pressure. Once the product exists, its profile must be raised, its position established and defended against imitations and new trends.

Living flyers? Sure! If it didn't exist before, this phenomenon has been around since the organizer of St. Kilda Trips Drill toured the clubs as a "walking billboard". On the evening before this sporadic club was due to open its doors for a party, he would wear a single flyer in the transparent window on his ski jacket originally designed to hold route maps: the club host as his own flyer.

Rumor has it that there was once even a "club pig" that hung around with event details written in permanent ink on its hide. A spectacular method, and extremely tough on the animal, especially if it was a tattoo. But then again, ravers love their flyers, and piglets like to be stroked from time to time. What follows is a tour of the natural habitats and social contexts of our beloved reminders of the sweat and the noise.

FLYER LIFE CYCLES

ARE THE FLYERS READY?

Flyers were the communications medium for the party culture of the 90s and they are still a commonly used form of advertising. Promoting parties and events relies heavily on the right media and distribution strategies. For each group of party people, access to "the place to be" depends on getting hold of the right information. Although electronic mailing lists and SMS text messages are gradually taking over from the tactile experience of paper flyers, they have yet to match these cult art objects in terms of aesthetics and design.

FLYERS = DISTRIBUTION Once the flyers are at the printers, it's time to start thinking about how they will be spread. If the print run is small, you can make the effort to take them round yourself, dropping them off at selected places or handing them to potential guests in person. You can also make things easier by commissioning professional distributors who drop flyers off at targeted locations like clothes and record stores, hairdressers, clubs, cafes and bars.

From 1993 to 2003, **TEC 9** (aka Alexander Wolf) acted as the link between producers and users, working out different flyer routes for different clients, and visiting up to 280 drop-off points in Berlin several times a month. Motivated by a desire to get to know art in the form of flyers and people, Tec 9 also supports projects like Haus Schwarzenberg, an alternative art space in the middle of Berlin Mitte that has no shortage of cultural content on offer but which lacks funds to get its message out.

On the other hand, professional distribution of printed matter like flyers and brochures has established itself as a lucrative business. Everyone knows the colorful, overflowing display stands and racks, usually to be found in shabby, badly lit corners just outside the toilets to the left of the cigarette machine.

THE LATER THE HOUR, THE MORE INTERESTING THE FLYERS The flyer factor (the amount of flyers left in a club by guests) indicates how popular a club is with other event organizers. Non-commercial, individually distributed flyers enter the club with the people who made them. Hours after the doors open, new flyers suddenly appear that were not around before. This is a good sign, as party organizers are the most likely to know what is "the place to be". They often come along in person to pass on information to their preferred clientele or to check out a live set by an interesting act.

The promotional effect of flyers has been researched less than that of posters, so there is no clear TCP (thousand contact price) to define their advertising value.

The best moment? At five in the morning, either in person or laid out as bait, around four days before the event. This is when the real party people gather. This is when they make their plans for the week ahead. Here, the message gains direct access to their subconscious. In England, promoters have contingents for cheap entry and

sometimes also 'free drinks' - once a certain number of guests turn up with the corresponding flyers, the promoter in question receives a small commission or (pragmatically) free drinks for the distributor.

In this context, it is interesting that venues like Sven Väth's new super-club 'Cocoonclub' in Frankfurt have banned the distribution of flyers. According to an article in Intro magazine (issue 12/04), guests who do not take this to heart will be banned from the club. This trend highlights the importance and relevance of the place where flyers change hands.

There are countless clubs and venues for dance events. Any attempt to base a comprehensive statement about flyer culture on this huge diversity would take forever. We have selected a handful of organizers, labels and distributors to give us insights into how they position flyer brands and how they rate the efficiency of flyers as eye-catching information carriers in mid-2003. One key question in this context is which parties are interesting for sponsors, as this often determines the quality and print-run of the flyers.

SIMONE HOFFMANN manages service and organization for various events, primarily in the public domain on the streets of Berlin. Festivities with an international profile like the "Fête de la Musique" are familiar to almost everyone. For this mega-event, flyers are an incredibly important guide to the abundance of individual events on offer. Comparable challenges are posed by major events like "Clubs United - The Night of the Clubs" or the "Carnival of Cultures".

How do you design the "Fête de la Musique" with this unbelievable information density on a single flyer?
The idea was to design a folded A2 poster for the "Fête de la Musique" with the international logo on one side and the details of party dates and locations on the back. We used the original French logo, deliberately not converting it into a German brand. It is hard to appeal with this bright, squeaky logo to the broad target group for the "fête" aged between 17 and 48. Of course, there are also standard A6 format flyers, but they are not large enough to fit on all the details.

How is a project like this funded? The only sponsors I see on the Fête flyers are media partners.
There is no sponsor. I came up with the idea of so-called "stage partnerships". This means that the "Fête" logo is also present at the various stages themselves, some of which print their own flyers that also use the brand.

Another mega-event, Berlin's best-known street festival, is the Love Parade. The organizers of this event spent years dealing with sponsors and media partnerships.

RALF REGITZ is a founding father of the Berlin techno scene. When the new music came to the city in the mid-80s, he was involved from the start in getting these club sounds heard, organizing parties at venues like Fischlabor, an underground gallery. The first regular club was UFO, that later became Walfisch, now known as the location of the Sage Club.

After the Planet parties and the E-Werk period, the Love Parade became his profession in 1990. We chatted to him about the first techno parties and the flyer culture of the early 90s in Berlin.

In your view, who brought the new electronic music to Berlin after 1987?
It came from several different sources at the same time of course. One of the first was Westbam, who was resident DJ at the Metropol club. In 1986, he played in Berlin at "Die Macht der Nacht". Dr Motte also embarked on some electronic research, later he founded his own club, Turbine Rosenheim (later Kit Kat Club, now XS) where he organized the first acid house parties on a small scale. I would also include Peter Rubin. The first big techno party featuring electronic music only took place at Tempodrom with 2000 people. When the wall came down, Wolle XDP appeared on the scene.

À propos conversion: in 1987, the Berlin Wall was still standing .
With our electronic music, we were always the pariahs, "normal" clubs like Metropol or Ex und Pop were not interested, actually disliked us. So we built up our own club structures beyond the borders of the existing club culture. We used art spaces of one kind or another, rented Haus Bethanien. We had a basement location under the Fischlabor club, the first UFO only lasted six months because it was illegal.

Were there flyers for these parties and how were they produced?
There were flyers. They were really cool, black and white with computer-generated graphics. There was a photocopying place on Yorkstrasse with an Atari where you could make your own graphics. At the time, it

was the only place in Berlin where you could do that. It wasn't cheap, but we were willing to pay the price. We did everything ourselves, calling it "UFO-Techno-Danceclub". Flyers with fractals and no address.

What was going on as the wall came down?
With the second UFO, that had legal status, things took off. Monika Dietl at SFB2 played our music on the radio (she was the only one) and the day the wall fell Wolle XDP was standing there in front of me saying he liked what we were doing and he wanted to do something similar. He then organized the first techno party in East Berlin, at Pavillon am Weinbergsweg. Later, he started hosting "Technozid" at the "Haus der Jungen Talente", today's Podewil. The parties were good. It was totally dark and there were just a few green East German lasers with a stroboscope and a few slides that projected virtual spaces into the club. Bones from Detroit played there. Dimitri Hegemann (Tresor) made sure the music came to Berlin.

From 1990, legendary parties also took place at Planet. This location in the middle of town right on the river, which is now totally overgrown, still exists. How did you judge a good party?
Hiller and Andreas were not allowed to have techno parties at 90 Grad: instead, they shut up shop at six, threw everyone out, hired a smoke machine, and had secret parties for themselves. Before long, they got thrown out themselves by Bob Young. After that, they dropped by at Fischlabor and we decided to organize Planet. The dancefloor still needed to be reinvented, the big difference between parties in the 90s and the 80s. Instead of a stereo dancefloor, it was about using the PA to build a surround sound and putting the DJ in the spotlight right next to the dancefloor. We always spent a lot of money on getting a great sound. It knocked you out right away, whether or not you had taken anything. There was also the visual environment, a combination of light and decoration. Planet was the first club to use projections in a big way.

What were the flyers for these events like?
Planet had the first credit card size color photocopies with the "cheese planet" logo, carefully scanned, copied and cut out by hand.

How did you organize distribution? After all, Planet was an illegal club at the time.
We worked on the principle of only giving people flyers personally, and only people we knew. This got us a very elitist reputation. Planet was still the club with a seven foot bouncer wearing hugely expensive clothes and standing in the dirt in front of the door, one colored guy and a hundred-yard line. He would sometimes say things like: "I don't like your shoes." He was strict on style, but also someone who could make a fool of himself in front of people, with travesty shows where he would go totally over the top in some kind of little dresses, a real legend.

After three years of Planet and the parallel projects with Wolle (XDP - xtasy dance project), Radio T and Technozid, the E-Werk opened its doors in 1993. How many flyers did you distribute when E-Werk was at its peak?
Tec 9 distributed the flyers. He dropped off five to ten thousand flyers every month at official locations. I designed the first flyers myself, until the Moniteurs came up with the Twirl series.

You were also among the organizers of the Love Parade. When would you say big brands began to discover music as a sponsoring vehicle? You were already the contacts for Berlin.
In 1991, the Frankfurt influence came to the Love Parade with Jürgen Laarmann from the magazine Frontpage, which he had maneuvered towards techno. That was the formative period when the Parade became a platform for the Raving Society. The sponsors in 1991 included Phillip Morris. The first Mayday was the same year, 1991, a hall in Weissensee.

FLYER LIFE CYCLES

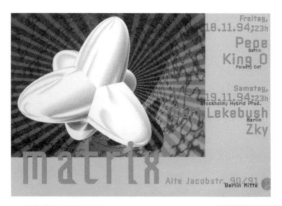

Freitag,
18.11.94;23h
Pepe
Berlin
King O
Poison; Def

Samstag,
19.11.94;23h
Stockholm; Hybrid Prod.
Lekebush
Berlin
Zky

matrix
Alte Jacobstr. 90/91
Berlin Mitte

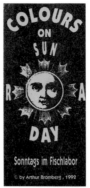

COLOURS
ON
SUN
R A
DAY
Sonntags im Fischlabor
© by Arthur Bromberg, 1992

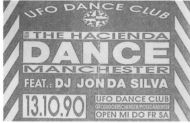

UFO DANCE CLUB
THE HACIENDA
DANCE
MANCHESTER
FEAT.: DJ JON DA SILVA
13.10.90
UFO DANCE CLUB
GROSSGOERSCHENSTR/POTSDAMERSTR
OPEN MI DO FR SA

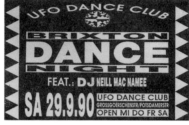

UFO DANCE CLUB
BRIXTON
DANCE
NIGHT
FEAT.: DJ NEILL MAC NAMEE
SA 29.9.90
UFO DANCE CLUB
GROSSGOERSCHENSTR/POTSDAMERSTR
OPEN MI DO FR SA

westbam
dick
marusha
FR 27.11.92

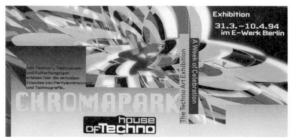

Exhibition
31.3. – 10.4.94
im E-Werk Berlin

A Week of Celebration

The Techno Art Exhibition

Alle Techno-, Technologie-
und Kulturhungrigen
erleben hier die aktuellen
Impulse von Partyenvironment
und Technografik.

CHROMAPARK
house of Techno

E-Werk im Mai '95

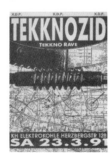

X.D.P. X.D.P. X.D.P.
TEKKNOZID
TEKKNO RAVE
KH ELEKTROKOHLE HERZBERGSTR 128
SA 23.3.91

TEKKNOZID
TEKKNO PART 3
LX EMPIRE
PEACE LIGHT
PSYCHICK WARRIORS ov Gaia
DJ TANITH
DJ ROLAND 120 BPM
KID PAUL
THE MAGIC BASS-LINE

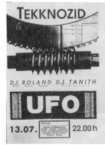

TEKKNOZID
D.J. ROLAND D.J. TANITH
UFO
13.07. 22.00 h

X.D.P.
TEKKNOZID
TEKKNO RAVE

X.D.P.
TEKKNOZID
DANCE PARTY
Metropolis
TEKKNO RAVE
D.J. TANITH
CYBERSPACE
D.J. ROLAND
XTASY DANCE PROJECT

MAYDAY
A NEW CHAPTER OF HOUSE AND TECHNO '92
30.4.92 KÖLN
EIS- UND SCHWIMMSTADION

MAYDAY
FORWARD EVER · BACKWARD NEVER
SA 12.12.92
BERLIN · DIE HALLE · WEISSENSEE

CYBERSPACE
TECHNOCENTER
D.J: TANITH
EVERY WEDNESDAY
START: 11PM
UFO DANCE CLUB
GROSSGOERSCHENSTR./POTSDAMERSTR.

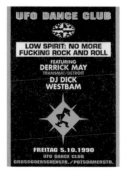

UFO DANCE CLUB
LOW SPIRIT: NO MORE
FUCKING ROCK AND ROLL
FEATURING
DERRICK MAY
TRANSMAT/DETROIT
DJ DICK
WESTBAM
FREITAG 5.10.1990
UFO DANCE CLUB
GROSSGOERSCHENSTR./POTSDAMERSTR.

77

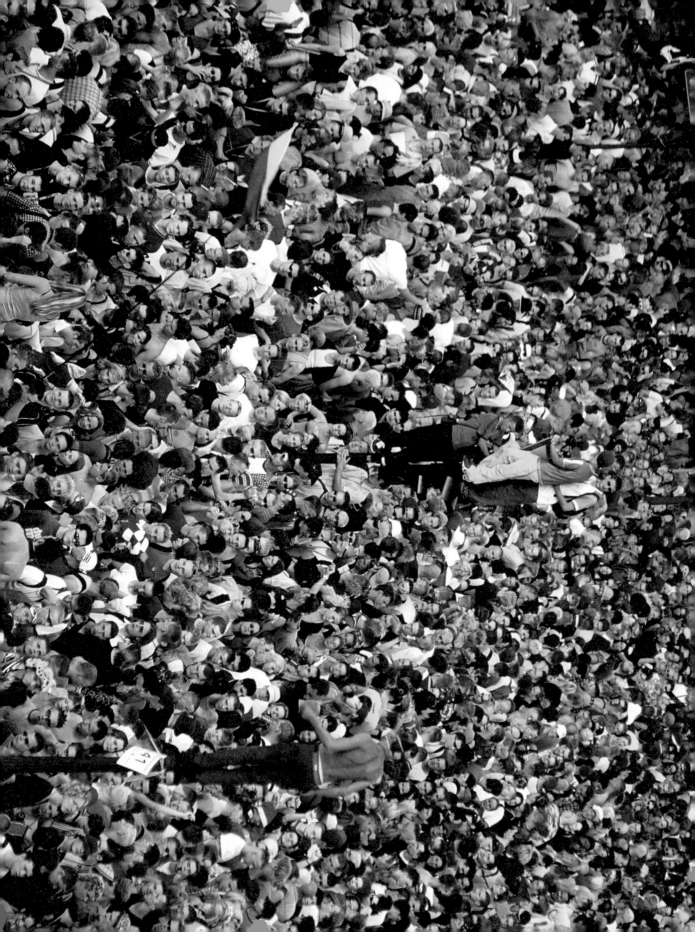

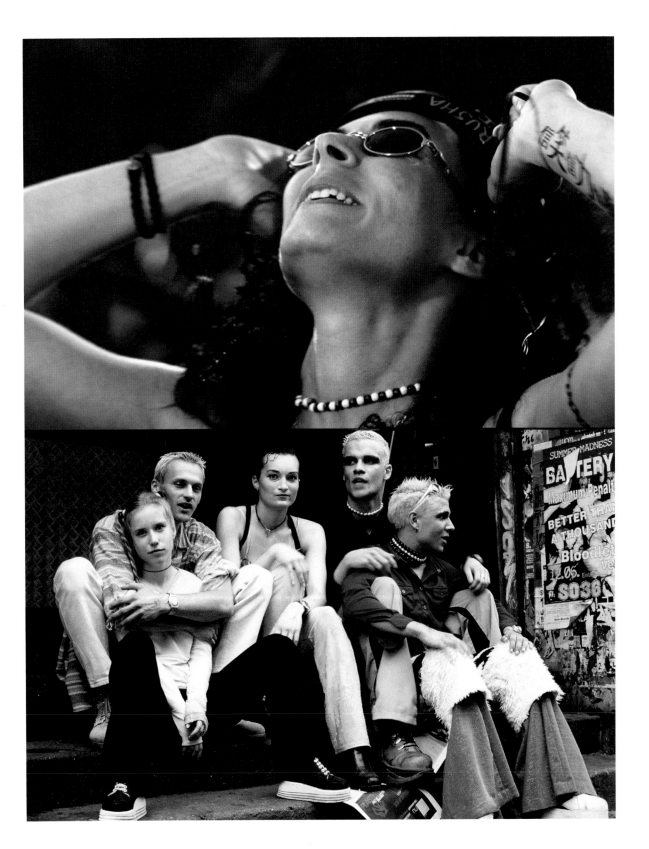

WMF has a rich flyer history. Thanks to his experience as former front man of the band Fleischmann, as a party organizer and as a member of the WMF team, **GERRIET SCHULZ** has endless stories to tell about working in the dance culture. The WMF club has been around for 13 years, and has now moved into its seventh location. Each venue, starting with the one on Mauerstrasse, has had its own representative flyer phase. With each move, the club logo changed to match the interior of the new location. Illustrated by a handful of anecdotes, Gerriet takes us on a trip through the world of WMF club flyer design:

From the very start, we communicated our club concept through our flyers. The materials we found at our first location, the WMF House, were repurposed for the interior design. In the basement, we found a load of WMF files, receipt blocks and advertising material from the 20s and 30s, and we used them to make rubberstamped flyers. That was basically our only advertising because we were illegal and not able to appear in program magazines, which we didn't want anyway, we liked that. The third location on Burgstrasse was where we finally started to appear legally in Flyer magazine. From then on, we also worked conceptually with flyers.

The WMF is now among Berlin's most established clubs. How did you design your corporate identity - what were your priorities when creating the graphical image for WMF?
At first we had a problem with our WMF brand, as it is the logo of the Württembergische Metallwaren Fabrik, in whose former head office we had our first club. We looked for a solution for the mid-term and renamed ourselves MFL. Then Daniel Pflumm had the brilliant idea of converting the three letters into the deaf and dumb alphabet - we printed the resulting logo on flyers, with the effect that those who didn't know couldn't decipher it, which also covered our traces as far as the authorities were concerned. Daniel then developed the WMF logo based on the CNN logo. Using this elongated oval, we then worked with Fred Rubin and Die Gestalten to develop the first flyers with punched logos. For the next generation of flyers at Johanneshof, the design was based on the various types of melamine wood veneer in the interior. When the American military bases pulled out to southern Germany in the early 90s, we bought a whole load of furniture and equipment. We used the "item tags" from the labels as flyers. Then Till Helmbold designed two-sided flyers for the WMF at Johanneshof with Stadtbezugsfeld and rounded corners. Daniel Pflumm designed the flyers for the Ziegelstrasse venue and when WMF Records was founded he also did the cover designs as well as the website and the logo for WMF FM, the Klubradio live stream. The series of monthly flyers had the reduced format of a CD with absurd objects on the front, all with Pflumm's usual clear color schemes, and using a minute font size that no one could read. For some time now, our design has been looked after by Rikus Hillmann, who does the layout for De:Bug. The design is influenced by the Moscow theme - rougher paper, two-color printing, no glossy finish, working with the retro feel of the building, its socialist past, and adopting elements of propaganda style.

How do you rate the effectiveness of flyers?
With our flyers, we aim to give an overview of the program for the month so people know what's going on here. Instead of being focused strongly through flyers as it used to be, the image of the club and the label is now represented more by the website and PR. We still have a monthly print-run of 8000 flyers. But there are too many flyers now, things are getting too random. There is certainly a case for questioning the usefulness of flyers. Maybe we should consider advertising exclusively via newsletters, e-mails or flash flyers. I personally find flash flyers very interesting, but I think SMS flyers are awful. Spam is the biggest drawback both on the Internet and on mobile phones. But apart from the purely economical aspect, flyers will always have a role to play for WMF as a form of artistic expression, as they offer an opportunity to communicate style and commitments in concentrated form.

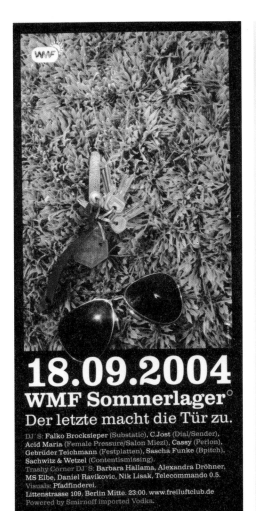

18.09.2004
WMF Sommerlager°
Der letzte macht die Tür zu.

DJ´S: **Falko Brocksieper** (Substatic), **C.Jost** (Dial/Sender),
Acid Maria (Female Pressure/Salon Miezi), **Cassy** (Perlon),
Gebrüder Teichmann (Festplatten), **Sascha Funke** (Bpitch),
Sachwitz & Wetzel (Contentismissing).
Trashy Corner DJ´S: **Barbara Hallama, Alexandra Dröhner,
MS Elbe, Daniel Ravikovic, Nik Lisak, Telecommando 0.5.**
Visuals: Pfadfinderei.
Littenstrasse 109, Berlin Mitte. 23:00. www.freiluftclub.de
Powered by Smirnoff imported Vodka.

WMF IM VOLKSPALAST
CLUB INSTALLATION IM ERDGESCHOSS VOM PALAST DER REPUBLIK!

VOLKSPALAST/SCHLOSSPLATZ 1, BERLIN ZENTRUM

WWW.WMFCLUB.DE/WWW.VOLKSPALAST.COM

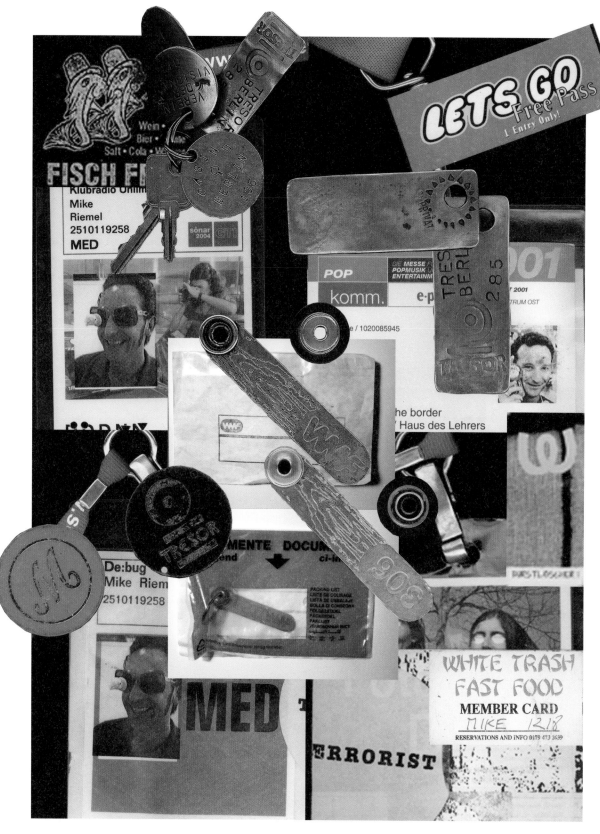

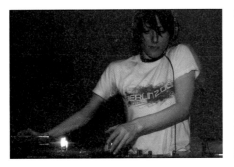

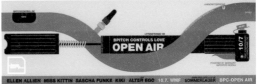

Ellen Allien im Tacheles Sylvester 2000 **FOTO:** Dirk Plamböck

ELLEN ALLIEN is a producer and has been working since 1999 on her own label, BPitch Control, an innovative, Berlin-based outfit with collective structures. As one of the original techno DJs, her reputation extends beyond Germany's borders with successful gigs worldwide. As well as the design principles for the BPitch corporate identity, we are also interested in how far she as an act/DJ is able to influence the design of flyers for parties outside Germany.

Ellen, about your position as a label and as an act/DJ: when BPitch organizes its own parties, who looks after the flyers and what are the design criteria?
Since the label was launched in 1999, the flyer and our logo have always been designed by the guys at Pfadfinderei, in consultation with me, there is a close partnership between Bpitch Control and the Pfadfinderei team. The design of the flyers is always based either on the music or on the artistic aims of the act. A few examples: when Kiki is lovesick, she has a heart with an arrow through on her cover. The Modeselektors love cables, so they had photos taken wound up in cables. Sascha Funke is our tech-house minimalist, so his covers work exclusively with typography.

With its label logo, Bpitch Control has a clearly defined CI not only in Germany but also abroad. How important is it to you to play live or to deejay outside of Germany?
It's fun and it always generates new artistic connections that bring new input. It helps us all realize how big our electronic networks are, and that's important.

When you or other BPitch acts play abroad, how much influence do you have over the way the event is announced on local flyers? Do you have a say in the design in the different countries? Is it important to you or is it enough if the flyers feature the logo and the names of the acts?
We always have a degree of influence, usually we can produce the artwork ourselves, and our names are always named in connection with Bpitch. The organizers often copy our artwork or use the logo.

RAIK HOELZL has been managing the Kitty-Yo label since 1994. He had a revelation when he saw a flyer for Surrogat, who later became the first band to be released on Kitty-Yo. The label's minimalist aesthetic comes through on its flyers mainly via the format - a postcard cut lengthways - and via the consistently reduced typography, making a point of using the label's own "kitty-yo news gothic" font designed by Angela Lorenz Berlin. Different backgrounds may be used to reflect a band's cover artwork or a current release.

Over the years, Kitty-Yo has put out quite a number of flyers. You always keep the information to a simple minimum, the graphics and typography are plain and clear. What phases has the design of Kitty-Yo flyers been through?
Everything began with a photocopy aesthetic, a kind of copy art. Sometimes we would put together the typography for the flyers using rubber stamp kits for the basic information, the where, when and what. Later, we used standard wooden stamp motifs on found materials like old postcards or old flyers. In some cases, we used a recycling principle, just correcting the date and over-stamping the acts. Initially, we did this for financial reasons, but we also used and understood it as a means of aesthetic expression. We were not afraid to sabotage the postcard format and reduce the size of the flyers to small strips, until the printers stopped cooperating. But in general terms, we have settled with postcards that are glossy on one side with different versions on the back.

As a special feature, specific motifs link the label's different promotion platforms, like for the relaunch of the website when a helicopter on the flyer referred to the competition on the homepage, where it reappeared, as well as on t-shirts. Have there been other campaigns where recurring motifs presented a specific message?
Not really. We don't concentrate so much on flyers at the moment. We used to have flyers as stickers, a special product with a small print run, with party dates printed on the back. When motifs are repeated, then mostly as a series, for example as a graffiti stencil or as a continuation of the cover artwork for record release parties.

How does distribution work at Kitty-Yo?
Our focus for promotion is on mailing lists and posters. We also produce small numbers of flyers which we usually distribute ourselves in small amounts around Berlin, according to the psychological principle that a small pile next to a big pile suggests greater demand and awakens interest. Of course, distribution by hand is even more effective.

What does flyer culture mean to you?
To me, flyers really mean inspiration. But I also think that unfortunately, flyer culture is rather weak at the moment because too much emphasis is being placed on pure communication of information and not enough on flyers as a whole as an independent and important form of expression that can even be of high artistic quality. I think that flyers should be far more innovative, appealing, clear, intellectual and demanding, and that they would then have a greater impact.

A few more thoughts on the future of flyers. Can you imagine Kitty-Yo setting up a tool to send an SMS text message to subscribers whenever a label party takes place with a photo of the DJ and details of the event?
I could imagine doing it once the technology has matured enough for it to be aesthetically pleasing, as well as user friendly and affordable. At some point, when the color displays on cellphones have good enough color quality and resolution for flyers to look really good, and if the typography works well, then it would be conceivable. At the moment, what's on offer doesn't match my aesthetic expectations. Added to which, people don't always like to give you their mobile number. The Internet is still the craziest and cheapest promotion medium in existence, both for information about music and for introducing people to the music itself. In spite of all this, I still believe in the sense of touch.

FLYER LIFE CYCLES

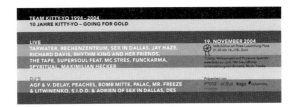

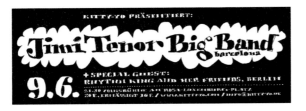

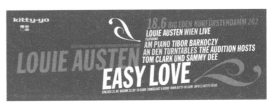

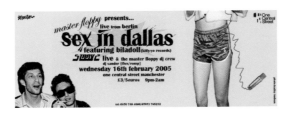

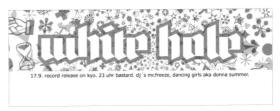

TOMAS KOCH has been editing Groove magazine since 1989. As a party organizer and flyer designer, he has direct insights and access to the interfaces between events, graphic design and effectiveness of flyers as a medium. Looking back, the yearly Groove anniversary parties give a good idea of the willingness of sponsors to cooperate with event organizers and of how much money is made available for such advertising materials. We asked Tomas Koch how he rates cooperation between organizers and sponsors over recent years.

In the late 80s and early 90s, there was still a kind of goldrush mentality among club organizers, and sponsors would give huge amounts of money for medium-sized events even without outstanding locations, DJs or concepts. Thanks to this sponsorship money, clubs could afford to spend six to ten thousands marks on advertising packages with flyers, posters, etc.. Sponsors like Camel spent over a million on their "Move Campaign". T-Mobile and New Yorker were throwing money around, which kept the whole scene alive.

How much influence do sponsors have over club nights or events?
Between 1996 and 1998, club culture reached its peak and demands increased. For years now, Red Bull have abandoned print campaigns simply featuring the logo on flyers in favor of being present at the event themselves with additional presentation tools. All-encompassing presence was the offensive demand. The flyers increasingly featured so-called "head presenters" and the layout was expected to include the brand's CI colors. At the parties, everything was supposed to be plastered with banners with logos stuck everywhere, if possible even in the toilets. Gradually, in consultation with the organizers, the brands also became involved in the events themselves. As a result, an event like "Sonne Mond und Sterne", for example, featured the "Diebels Water Sports Fun Park". Red Bull founded the "Music Academy" and the T-Mobile brand organized a "House Congress" all of its own at Popkomm 2001. The sponsors tried to make an actual contribution to the scene itself, making a point of keeping it discreet. With its tours, Marlboro is unbeaten for maximum image transfer. As far as parties are concerned, after the recession of 1998/99, only major events received sponsoring money, prestigious festivals like "Nature One" and "Sonne, Mond und Sterne". And they took everything.

How did you try to capture the zeitgeist on your flyers?
In the early 90s, when techno was taking off, everything was totally overloaded with typography, colors and 3D graphics, it was all incredibly jumbled, bright and chaotic, until the trend back towards more classical forms emerged - in England this was already the norm by the end of the 80s. From around 1996/97, high levels of reduction and clarity also became established in Germany, with more white surface and no background patterns. In some cases, Groove abandoned graphics entirely and developed solutions based purely on typography.

How do you rate the effectiveness of flyer distribution when you think about reaching target groups or about the future of flyers?
In these times of e-mail and text messaging, we have reduced the print run for our Groove flyers. As the organizer of the Monza Club, I could imagine hanging posters with the dates for the month in key stores and doing without flyers entirely. There is certainly a trend away from printed materials, but without totally getting rid of them.

FLYER LIFE CYCLES

HELGE BIRKELBACH was a manic flyer collector and is a media player with many strings to his bow. Besides co-founding numerous projects, he helped organize the first Love Parades, published the "Very Important" scene guides for Berlin and Hamburg, and initiated the monthly network salon "Private Thursday". As publisher and editor-in-chief, he has worked on magazines including "HYPE Megazine", "FLYER Up-Dates" and now also the classical music title "classix - Musik für immer".

What we wanted to hear from this all-rounder was: How did Flyer magazine happen?

With the "Very Important" project in 1993, I collected all the important addresses and phone numbers of organizers, DJs, clubs, equipment and lighting people, etc. in a telephone book for the scene, in Berlin and later also for Hamburg, which was distributed free of charge. This was such a success that people began asking why there is no detailed event guide that is up-to-date and to-the-point? This demand from within the scene, that arose because TIP and the other local magazines failed to deliver, then led to the founding of Flyer. The idea was to take the medium that is en vogue, that circulates, i.e. flyers, bundle them all together - because even then things were getting out of hand - and stick it all together with some editorial glue. That was the first edition of Flyer that came out in 1994, using the idea of bootlegging, ripping off a different commercial brand every month.

At first there were problems with the cover, because many brands were against being placed in this unaccustomed context, but then they all wanted to be on the cover of Flyer. Businesses always react badly, understandably enough, when an established brand is used ironically like this. But on the other hand, it showed how consumerist, how happily at home in the consumer world the techno movement is, inhabiting this world and playing with its constitutive elements, but not rejecting it. This is a totally different approach to the culture of the late 60s, where such attitudes were of course categorically rejected. Soon enough, the manufacturers of brand products realized that this hijacking of the brand is cool and that it brings new consumers closer to the brand. We turned this round by generating a huge amount of suspense about who was going to be bootlegged on the cover of the next issue.

Why did you found Flyer magazine? What was your motivation?

Primarily to bring together various media platforms and to take advantage of various options. With the Chromapark art exhibition at E-Werk, the idea was to bring together various forms of representation in the techno movement. We wanted Flyer to include the superstructure, the artistic side of the movement. Not just the music, fun, dancing, but also the communication of ideas and goals, visualizing a version of the future.

FLYER LIFE CYCLES

"I have problems with handing out flyers for an event that I can't at least halfway recommend," says **DANIEL METEO**. With his Meteosound label, he is an organizer and promoter. Since 2001, he has hosted his own monthly series of club nights with various dub-based acts at Berlin clubs like Maria and WMF. As an events organizer, he works mainly with the labels Shitkatapult and Scape, and looks after organization of the Ocean Club evenings.

When did you start working with flyers and why? What do think is the advantage of this medium as a form of communication?
I've always worked with flyers, ever since the first event I organized. And I also think that what I'm interested in through my work with Meteosound is creating something that is not purely ephemeral. Something that is created and that exists as an object. It is also a way for me to give the event a face, an idea, a color, a format. All that can be taken literally. And that's the good thing about flyers: they are so clear and unambiguous.

Who takes care of designing the flyers?
At first, we didn't care much who designed the flyers, until I realized that it's much better to let go of this task and hand over the job to a designer and to talk about it: after all, design is an art in its own right. The main Meteosound design and the flyers for the early years were all done by Propella - a friend of mine. She's the most important graphic designer for the label. Nowadays I also work a lot with Bianca Strauch, as I really appreciate her clear style and simple ideas, but I also often work with Sascha Ring or Carsten Aermes from the Berlin label Shitkatapult.

Do you work on distribution alone or with friends and acquaintances? And what is your distribution strategy?
On distribution, I work together with the artists, the booker, the club or the label. Recently I've been doing a lot of the distribution myself, something I couldn't stand for a long while. But I rarely give flyers to people I don't know. As far as strategy is concerned, I'd say less is better, and never force anyone to take them, don't be in people's faces. I drop off flyers in record stores and clubs, coming back a second time later with more. The flood of flyers in Berlin can be annoying. But for beginners it's not so simple: where should I put them, how many, how do I get in, how do I persuade the bouncer, etc.. Some things really annoy me, like all the clubs that don't want anyone else's flyers but go round dropping off tons of their own everywhere else. Then I get angry, that's part of the job, I have high stress levels. At moments like that, I'd love to have a professional distribution service, but they are either cheap and bad or just too expensive. I don't rate distribution companies. My advice is to make 200 flyers by hand and distribute them yourself.

Do you use any other forms of advertising or communication?
I don't think that today any one single advertising medium is the key. The big picture is made up of an ensemble of acceptance within the scene, electronic mailing list, traditional PR, radio and flyers. With the current financial difficulties, flyers are a luxury, but I often insist on them! For a release party, I usually use the cover of the product, then the label is prepared to contribute to the printing costs. Posters are far cooler, but much more expensive. For a club like Maria, they don't make economic sense.

What is the background to the design of "your" flyers?
I organize events with a specific content and that content is coded with a specific musical attitude that extends to the way the flyers are made. You can hear it in the records and identify it in the graphics. The flyer is practically the icing on the cake. I have a weakness for "fake series" - events that are linked together but that are only related to a certain degree, but where their identity as a series often only becomes clear after a certain amount of time. This is quite hard work, but it is fun and it pays off in the long run.

For you, do flyers have a function beyond their pure information and publicity value?
I think their function is purely beyond these aspects. Flyers express a certain care for the event, for the

people involved and the music. If money is spent on a picture for the flyer, it's like a message to myself: make sure it's worth it! We're in Berlin, currently one of the freest and most overpopulated club cultures anywhere. The existence of so much freedom, so many niches and amateurs, is the peculiar charm of the whole business.

What do you think people pay most attention to? How the flyer looks, what acts are on the bill, or the person handing out the flyer?
I think people prefer to read something they've already heard about. First you find the club's schedule for the month, then someone else tells you about it, then you find a flyer and read about the party in a magazine or two. And decisions are usually made on the night itself anyway.

How do you see the future of flyers? Will you carry on using them or are there serious alternatives?
Serious - that's the last thing I want to mention. I would have liked to do more posters. One reason for making flyers is always product placement and sponsor integration. The future is in cross-marketing, campaigns like "Intro intim". The designs will move away from the club event itself towards increasingly abstract on the one hand and increasingly appealing motifs on the other. Flyers usually have to promote several things at once - the releases, the brand of beer, the Internet radio, Spex, Groove, De:Bug, Intro etc.. It's a case of always keeping an eye on breaking even, always having the costs of producing the flyer in mind and doing the math. But totally arty flyers like those by Designers Republic with no data at all are completely out, they don't interest me at all.

FLYER LIFE CYCLES

SASCHA (BLEED) KÖSCH is a manager and music editor at De:Bug magazine, and a DJ. The magazine has relatively little to do with flyers directly: if there is an anniversary party or if De:Bug DJs are playing, the logo is usually there on the flyer. Indirectly, event dates are distributed via a mailing list. In the winter months, the De:Bug dates list announces 250-350 events per month, in summer around 200. Details of some parties are sent directly by the organizers to the editorial office, which then sends selected dates to the mailing list. At www.de-bug.de, you can subscribe or consult the latest information directly. Occasionally, data from new flyers and faxes is added to the homepage. De:Bug never relies on information from printed event guides.

Do you get any feedback on the dates list, and if so, in what form?
There are sometimes discussion on the mailing list. In conversations at clubs I often hear people saying that they regularly check the website when they want to go out, or that they heard about the party from the mailing list. I would say that the dates in the printed De:Bug and on the mailing list are among the five most important tools for deciding where to go out in Berlin, except of course for events that have their own mailing lists.

Have you ever had problems with the police or the music licensing authorities monitoring the De:Bug homepage, like a certain illegal party was know to be only announced via the De:Bug dates list?
Allegedly, but that's mostly hearsay. When we asked for more details, we usually found out there was some other reason. I've restricted online access to the dates list to De:Bug members so that no search engines can access it, and so that we have at least a rough idea of who reads them. And we are usually careful not to repost dates if people don't want us to. Of course, things sometimes go wrong. But I don't think it's ever caused any club to close or have trouble with the police.

MASSIMO D'ELECTRO is an events organizer and DJ with his own label (electrobot). But he sees himself primarily as an artist.

What do flyers mean to you?
I've never looked at flyers as printed paper. For me, they've always been an opportunity for artistic expression. I think of flyers as the calling cards for a party! You can give someone a statement to go with the party. Just as a calling card should faithfully reflect the person in question, the flyer is important for the party. I look forward to developing a new flyer for a new event. I've always enjoyed distributing flyers and observing their impact on people's faces.

What do you think is the advantage of communicating through flyers?
For me it's important to be able to invite people directly to an event or party. I only approach certain people who I want to have at my event. I give them to friends and acquaintances, to people with a certain look, interesting people and people who I get talking to. Flyers act as a reminder in people's pockets, and don't forget, they also have an artwork that you gave them!

How many flyers do you have printed?
At the moment 2000. Early on, I always printed 101 flyers and treated the handover of each one as a performance! Once I made armbands out of laminated card and selected my audience directly in the clubs by placing the flyers round their wrists. The idea was to make flyers into accessories that are worn visibly in clubs. For me, it was always important to add an extra dimension to things.

Do you use any other forms of information or advertising?
At the moment, I also make very minimalist posters with symbols or words sprayed on using stencils.

What is the background to the look of your flyers, how has their design developed?

I used to design and produce small flyers in postage stamp format, but then that became a fashion. There was a series of parties called Disco Inferno, so I laminated my flyers and sealed a match under the surface. At the moment, I'm using a triangular format.

For you, do flyers have a function beyond their pure information and publicity value?

Yes. I see flyers as an additional form of expression and I consider them as my babies. They are part of my art!

You distribute quite a lot yourself. What motivates you to go out again and again? Are their any pleasant side effects?

At present, many collectors are focusing on flyers as a medium. I have always tried to keep one step ahead in developing my style, always pushing the envelope! At the beginning, I wanted to go beyond two-dimensionality so I made 3D flyers. They were so weird and so popular that some Berlin designer stores like "Eisdieler" and "Betty Bund" put them in their shop windows. For me, that was and still is a great honor.

How do you see the future of flyers? Will you carry on using them or are there serious alternatives?

Some respect for this medium, please! Flyers are A-R-T. I could never do without flyers as an artistic form of interpersonal communication in my work as a promoter and designer!

FLYER LIFE CYCLES

Anyone who goes in search of good music in Berlin clubs will eventually bump into **RAN HUBER**. Although this tireless organizer seems shy at first, he has no trouble pressing the flyers for his amSTART series into the hands of music enthusiasts. He seems to know every talented guitar band and electronic act, always booking them before their inevitable breakthrough. He also has a fine instinct in his choice of venues. Since the series started in 1999, he has taken his mobile concert series to every important location in Berlin. The presence of his flyers in a club almost counts as a recommendation. What we wanted to know from this energetic user and promoter of flyer culture:

How many events do you organize?
Around 30 to 50 concerts a year, between 3 and 5 a month. In total probably around 200 so far. There are more details on my website http://www.ag-parka.de/amstart/.

How long have you been making flyers?
Since the first concert. Flyers are great. In the past, I used to print two or three thousand, now I mostly only order 1000.

Do you use any other forms of information or advertising?
Just promo/PR stuff, and of course my electronic mailing list.

Who designs the flyers?
Me. For special events, I get help from specific artists or graphic designers, sometimes from the band themselves.

Your flyers are immediately recognizable: how did this design emerge?
The key recurring feature is the format inspired by strips of passport photos, with portraits of the artists lined up in a row. And then maybe also the font, Arial. Although I collect flyers, I don't base the graphic style on other flyers.

For you, do flyers have a function beyond their pure information and publicity value?
I see them as miniature artworks and collectors items.

Who looks after distribution?
Mostly me or friends of mine, for money or for free. I rarely commission professional distributors.

What motivates you to go out again and again? What annoys you? Are there pleasant side-effects?
I go out a lot, so it's not a problem to distribute flyers myself. It's nice to get a reaction. When I'm dropping off flyers, I get annoyed by the piles of trashy commercial flyers.

What do you think is the best way of using flyers: do you have strategies or is it all chance?
I go totally on gut instinct.

What happens when you hand over a flyer?
The standard question about flyers for concerts is: What is this? One anecdote: after three or four years, I once met someone who actually thought it was always one and the same flyer for all the different concerts.

What do people pay most attention to: How the flyer looks, what acts are on the bill, or the person handing out the flyer?
I think first impressions are very important. Whether the flyer stands out from the others. If flyers are distributed by hand, the person involved definitely matters.

How do you see the future of flyers? Will you carry on using them or are there serious alternatives?
Making flyers is somehow a luxury, decadent, but it is still a means of passing on information. But there are also posters, SMS, word of mouth, e-mail, etc.

FLYER LIFE CYCLES

LEBENSZYKLEN DER FLYER

DIE DINGER LEBEN, NICHT WAHR, ODER?

An der Herstellung eines Flyers sind eine Menge Leute beteiligt. Clubmacher, Musiker, VJs, Medienpartner, Sponsoren, Verteiler und natürlich die Graphiker. Damit nicht genug. Ist die Veranstaltung erst gelaufen kommt die Stadtreinigung oder irgendein Sammler und trägt die Flyer entweder in die Müllverbrennung oder zur Sammelbox, dem Umweg zum nächsten Museum. Oder man bastelt ein Buch mit einer Vielzahl beteiligter Personen. Also entlang der gesamten 'Wertschöpfungskette' lässt dich das Leben zumindest rund um die Flyer beobachten. Auch szenehistorisch lassen sich Popularitätszyklen und Epochen in der Geschichte der Flyerkultur belegen, die oft von lokalen Situationen, aber meist von der Blüte neuer Stile oder technischen Innovationen eingegrenzt werden. Als gestandener BWLer kann ich auch berichten, dass die Verlängerung von Produktlebenszyklen - egal welchen Produktes - der Schlüssel des Überlebens auf von den vom Verdrängungswettbewerb gekennzeichneten Märkten ist. Steht das Produkt muss man es bekannt machen, aufbauen und verteidigen gegen Nachahmer und Trends.

Lebende Flyer? Es gibt sie tatsächlich. Spätestens seit der Macher des St.Kilda Trip Drill als 'wandelnde Litfasssäule' durch die Clubs ging, gab es dieses Phänomen. Er trug immer am Vorabend, wenn das unregelmässig geöffnete Projekt wieder die Tür aufmachte, exakt einen Flyer in einer eigentlich für Tageskarten vorgesehenen Kunststofftasche seiner Skijacke. Der Macher als Flyer also.

Gerüchteweise soll es ein 'Clubschwein' gegeben haben, das die Message mit Edding auf den leckeren Schinken geschrieben im Club zur Schau stellte. Sehr auffallende Methode und - falls es sogar ein Tattoo war - extrem tierunfreundlich. Wobei: Raver lieben ihre Flyer und so ein Schweinchen liebt es sicher auch mal gestreichelt zu werden. Im Folgenden also ein Streifzug durch die Biotope und den sozialen Rahmen unserer geliebten Artefakte des Schwitzens und Rauschens.

SIND DIE FLYER SCHON FERTIG?

Flyer waren das Kommunikationsmedium der Feierkultur der 90er und sind immer noch ein gängiges Werbemittel. Um Parties und Events präsent zu machen, sind die richtigen Distributionsmedien und Verteilerstrukturen unabdingbar. Für das jeweilige Partyvolk gilt: Ohne die nötigen Infos in der Hosentasche kein Zugang für den "place to be". Allerdings laufen Mailinglisten und SMS, dem haptischen Printmedium, langsam den Rang ab, ohne aber bis dato dem kultigen Kunstobjekt an Ästhetik und Design entsprechen zu können.

FLYERN MEINT VERTEILEN

Sind die Flyer im Druck, sollte man sich Gedanken über die Verteilung machen. Das läuft dann entweder in Eigeninitiative bei kleinerer Auflage so, dass man sich die Mühe macht und selbst die Handzettelchen an ausgesuchten Stellen platziert oder sie den potentiell gewünschten Gästen persönlich in die Hand drückt. Man kann sich auch den Aufwand erleichtern und beauftragt professionelle Verteiler, die Party-Flyer an zielgruppengerechten Orten, wie Platten- und Klamottenläden, Frisörstübchen, Clubs, Cafes und Bars auslegen.

Tec 9 aka Alexander Wolf war zwischen 1993 und 2003 das Verbindungsglied zwischen Produzent und User, hat für diverse Kunden unterschiedliche Verteiler-Routen ausgelotet und fährt mehrmals im Monat bis zu 280 Auslegeständer in Berlin an. Motiviert, Kunst in Form von Flyern und Menschen kennen zu lernen, unterstützt Tec 9 aber auch Projekte wie das Haus Schwarzenberg e.V, einem alternativen Kunsthaus mitten in der Mitte Berlins, dem es zwar an Geld für die Verteilung ihres Anliegens, aber nicht an Kulturplattform mangelt.

Auf der anderen Seite hat sich die professionelle Distribution von Print-Produkten wie eben Flyern und Broschürchen als gutes Geschäft fest etabliert. Jeder kennt die bunt befüllten Display-Ständer und Aufhänger, meist zu finden, in schlecht beleuchteten Schrabbel-Ecken kurz vor den Toiletten links neben dem Zigarettenautomaten.

JE SPÄTER DER ABEND DESTO INTERESSANTER DIE FLYER

Der Flyerfaktor (die Menge von Flyern, die Gäste in einem Club auslegen) sagt wie populär der Club bei anderen Veranstaltern ist. Nicht kommerziell vertriebene, einzeln verteilte Flyer, kommen mit den Machern ins Haus. Nach Stunden tauchen plötzlich neue Flyer auf, die bislang noch nicht zu finden waren. Ein gutes Zeichen, denn: Die Macher wissen, wo das beste Programm der Stadt läuft am Besten. Sie erscheinen oft persönlich, um ihre Wunschgäste zu informieren oder den Musiker XY Superkrass bei seinem Gig zu sichten.

Die Werbewirkung ist noch weniger untersucht als bei Plakaten, das heißt, es gibt keinen klaren TKP (Tausenderkontaktpreis), der den Wert der Werbung definiert. Der beste Zeitpunkt? 5 Uhr morgens, persönlich oder als Köder, etwa 4 Tage vor der Veranstaltung. Da sind die wirklich Feierwilligen versammelt. Da entstehen die Planungen für die folgende Woche. Da trifft man direkt ins Unterbewusste mit seinen Nachrichten. In England haben Promoter Kontingente für günstigere Eintritte und gelegentlich auch 'free drinks'. Wenn dann eine gewisse Anzahl von Gästen mit Flyern des jeweiligen Promoters im Club erscheinen, gibt es eine kleine Gage oder - ganz pragmatisch - Freigetränke für den Verteiler.

Interessant ist in diesem Zusammenhang die Tatsache, dass Clubs wie Sven Väths neuer Superclub 'Cocoonclub' in Frankfurt das Verteilen von Flyern verbietet. Gäste, die dies nicht beherzigen, werden laut einem Artikel in Intro (12/04) des Hauses verwiesen. Diese Tendenz verdeutlicht wie wichtig und relevant der Ort der Übergabe ist.

Es gibt unzählige Clubs und Orte für Tanzveranstaltungen. Hier ein umfassendes Statement zur Flyerkultur herauszuhören, wäre nahezu unerschöpflich. Wir haben uns eine Hand voll Veranstalter, Labelbetreiber und Verteiler herausgepickt, uns ein paar Statements zu geben, wie sie selbst Flyerbrands setzen oder wie Mitte 2003 die Effizienz von Flyern als informationsträchtige Eyecatcher einzuschätzen sind. Nicht unerheblich dabei

FARBBILDER: AM START-Flyer
SCHWARZWEISSBILDER: Flyer oder Fotos?

stellt sich die Frage, welche Parties für Sponsoren interessant sind, denn daran angebunden ist auch oft die Ausstaffage und die Auflage der Flyer.

SIMONE HOFFMANN managet den Service und die Organisation von diversen Veranstaltungen vorrangig im öffentlichen Berliner Straßenraum. International bekannte Festivitäten wie die "Fête de la Musique" kennt praktisch jeder. Für dieses Megaevent sind Flyer unglaublich wichtige Guides durch die Fülle von Angeboten, wo sich Veranstaltungen wie "Clubs United - Die Nacht der Klubs" oder der "Karneval der Kulturen" an Ereignisfülle nahtlos mit einreihen.

Wie designt ihr die "Fête de la Musique" mit dieser unglaublichen Dichte an Informationen auf einem Flyer?
"Die Idee war für die "Fête de la Musique" ein faltbares A2 Plakat zu entwerfen, mit dem internationalen Bildmarken-Logo auf der einen Seite und den detaillierten Partydates und Orten auf der Rückseite. Wir haben das Original, das französische Logo übernommen und bewusst nicht in eine deutsche Marke übersetzt. Schwierig dabei ist, mit diesem quitschigen und bunten Logo eine Zielgruppenbreite zu erreichen, die sich für die "Fête" zwischen 17 und 48 Jahren bewegt. Es gibt natürlich auch klassische A6 Flyer, wo man allerdings gar nicht den Raum hat alle Informationen unterzubringen."

Wie finanziert sich ein solches Projekt? Ich sehe nur Medienpartnerschaften auf den "Fête" Flyern?
"Es gibt keinen Sponsor. Ich habe die sogenannten Bühnenpartnerschaften ins Leben gerufen. Dadurch wird das "Fête" Logo auch direkt an den Bühnen repräsentiert, die teilweise auch selbst Flyer drucken und die Marke weiter verwenden."

Ein weiteres Megaevent oder besser das bekannteste Berliner Stadtfest ist wohl die Loveparade. Hier dealte man jahrelang mit Sponsoren und Medienpartnerschaften.

RALF REGITZ ist ein Berliner Techno-Urgestein. Als Mitte der 80er Jahre neue Musik in die Stadt kommt, ist er von Anfang an mit dabei, diesen clubtauglichen Sound hörbar zu machen und veranstaltet Partys, wie in der Undergroundgalerie Fischlabor. Der erste regelmäßige Club war dann das UFO, zwischendurch Walfisch, heute bekannt als Location des Sage Clubs.
Nach feisten Planet-Partys und den E-Werk Zeiten wird die Loveparade 1990 zur Profession. Wir haben ein wenig mit ihm über die ersten Techno-Partys und die Flyerkultur der frühen 90er in Berlin geplaudert.

Wer hat deiner Meinung nach 1987 neue elektronische Musik in die Stadt gebracht?
"Es gab natürlich ein paar Quellen, aus denen das gleichzeitig passierte. Einer der ersten war natürlich Westbam, der damals Resident im Metropol war. Er hat damals 1986 in Berlin auf "Die Macht der Nacht" gespielt. Motte hat auch erste elektronische Forschungen gemacht, später hatte er seinen eigenen Klub, die Turbine Rosenheim (zwischendurch der Kit Kat Club, heute

das XS), wo er die ersten Acid House Partys im ganz kleinen Rahmen veranstaltet hat. Peter Rubin zähle ich auch dazu. Die erste große Techno Party, die sich ausschließlich mit elektronischer Musik beschäftigt hat, fand mit 2000 Leuten im Tempodrom statt. Wolle XDP kam dann zur Maueröffnung ins Spiel."

Stichwort: Konversion. 1987 stand ja noch die Mauer ...
"Aus der elektronischen Musikecke waren wir letztendlich immer die Aussätzigen, weil wir für die "normalen" Klubs, wie das Metropol oder das Ex und Pop uninteressant, ja abstoßend waren. Wir haben uns dann im Abseits der bestehenden Klubkulturen unsere eigenen Klubstrukturen aufgebaut. Wir sind auf irgendwelche Kunsträume ausgewichen, haben das Betanien-Haus gemietet. Unter dem Fischlabor hatten wir einen Partykeller, das erste UFO hatten wir, weil es illegal war, nur für ein halbes Jahr."

Gab es zu den Partys Flyer und wie wurden die produziert?
"Es gab Flyer. Die waren schon sehr cool, in schwarz-weiß mit computergenerierten Graphiken. Damals gab es einen Copy-Shop in der Yorckstrasse, dort stand ein Atari, wo man sich seine Graphiken basteln konnte. Das war damals der einzige Laden in Berlin, wo es das gab. Das war damals nicht billig, aber wir haben uns das geleistet. Wir haben alles selber gemacht, das hieß dann "Ufo-Techno-Danceclub". Flyer mit Fraktalen und ohne Adresse."

Wie ging es in den Wendezeiten weiter?
"Mit dem zweiten UFO, das dann ein offizieller Laden war, gings dann los. Monika Dietl auf SFB2 hat als einzige unsere Musik gespielt und am Tag der Maueröffnung stand Wolle XDP vor mir und sagte, er findet unsere Sachen cool und er will auch so etwas machen. Er hat dann die erste Technoparty im Osten der Stadt organisiert im Pavillon am Weinbergsweg. Später hat er angefangen "Technozid" zu machen im "Haus der Jungen Talente", heute das Podewil. Die Partys waren gut. Es war komplett dunkel und es gab nur einen Fünf-Fraktal-Ostlaser in grün mit einer Stroboskop Installation und ein paar Dias, die die virtuellen Räume in den Klub projiziert haben. Dort hat Bones aus Detroit aufgelegt. Dimitri Hegemann (Tresor) hat sich darum gekümmert, dass die Musik in die Stadt kommt."

Legendäre Partys wurden ja auch ab 1990 im Planet gefeiert. Das mittlerweile wild bewucherte Gelände mitten in der Stadt und direkt an der Spree gibt es ja heute noch. Welchen Anspruch hattet ihr an eine gute Party?
"Hiller und Andreas durften damals im 90 Grad keine Techno-Partys feiern, sprich, die haben um sechs den Laden zugesperrt, alle Leute rausgeschmissen, eine Nebelmaschine gemietet und heimlich für sich selbst Party gefeiert. Es hat nicht lange gedauert, dann hat Bob Young sie rausgeschmissen. Sie kamen daraufhin im Fischlabor vorbei und wir beschlossen zusammen das Planet zu machen. Damals musste man ja noch die Tanzfläche neu erfinden, also das, was die neunziger Jahre Partys von den 80ern unterscheidet. Praktisch keine Stereo-Tanzfläche mehr, sondern mit der PA echte Vierecke bauen und den DJ als Mittelpunkt direkt an die Tanzfläche ran. Wir haben immer

sehr sehr viel Geld für geilen Sound ausgegeben. Der Sound hat dich sofort weggeschossen, ob du was genommen hattest oder nicht. Optisches Environment, sprich Tanzflächendekos, eine Kombination aus Licht und Dekoration kam hinzu. Beim Planet gab es Projektionen das erste Mal im großen Stil."

Wie wurden die Partys beflyert?
"Beim Planet gab's die ersten kreditkarten-großen Farbkopieschnipsel, mit dem "Käseplanet-Logo," die noch in mühsamer Handarbeit gescannt, kopiert und geschnitten wurden."

Wie habt ihr die Verteilung organisiert? Immerhin war das Planet zu der Zeit ein illegaler Club.
"Es war ein Grundsatz, dass wir das nur Leuten in die Hand geben und auch nur Leuten, die wir kennen. Dadurch hatten wir dann auch den super-elitären Ruf. Planet war immer noch der Laden mit zwei-Meter großem Türsteher, der mit Klamotten für 5000 DM im Dreck vor der Tür stand, ein fetter farbiger Kerl und hundert Meter Schlange. Der hat dann auch einfach mal gesagt: "I don`t like your shoes." Ein Styler, der sich aber auch vor den Leuten zum Affen gemacht hat, mit Travestie-Shows, wo er dann so dermaßen abgegangen ist in irgendwelchen Kleidchen, unglaublich legendär."

Nach drei Jahren Planet und den Parallel-Projekten mit Wolle (XDP - xtasy dance project) Radio T und Technozid öffnet 1993 das E-Werk seine Pforten. Wieviele Flyer habt Ihr zu E-Werk Hochzeiten verteilt?
"Die Flyerverteilung hat Tec 9 übernommen. An offiziellen Auslegestellen hat er im Monat fünf- bis zehntausend Flyer verteilt. Die ersten Flyer habe ich noch selbst gestaltet, bis dann später die Moniteurs die Twirl-Reihe aufgelegt haben."

Du hast ja auch die Loveparade mit organisiert. Ab wann würdest du sagen, ging es los, dass viele Marken Musik als Sponsoring-Ding entdeckt haben? Ihr ward ja schon für Berlin die Ansprechpartner.
"Zur Loveparade 1991 kam die Frankfurter Linie rein mit Jürgen Laarmann von der Frontpage. Der hat sein Magazin in Richtung Techno getrimmt. Das war die Urstunde, wo die Parade zur Plattform für die Raving Society wurde. Sponsoren waren 1991 z.B. Phillip Morris. Die erste Mayday war ja auch im gleichen Jahr, 1991, in der Halle Weißensee."

Auf Flyer verzichtet das WMF ganz und gar nicht. **GERRIET SCHULZ** kann wegen seiner Erfahrungen als Ex-Fleischmann-Bandleader, Partyorganisator und WMF-Clubmacher Geschichten zur Tanzkulturarbeit aus der Westentasche zaubern. Das WMF gibt es seit 13 Jahren und ist mittlerweile ins 7. Quartier eingezogen. Jede Station hat, angefangen von der Mauerstraße, seine eigene repräsentative Flyer-Phase. Das Clublogo war und ist mit jedem Umzug immer ans Interieur der jeweiligen Location angebunden. Eine exemplarische Reise zum Clubflyerdesign des WMF gibt Gerriet anhand von kleinen Anekdoten zum Besten:

"Wir haben von Anfang an unser Klubkonzept über die Flyer kommuniziert. Das Material, das wir in unserer ersten Location, dem WMF Haus gefunden haben, wurde adäquat zum Recycling in Sachen Innenausstattung. Eine Menge WMF-Akten, Quittungsblöcke und Werbematerial haben wir aus den 20er/30er Jahren im Keller gefunden und haben daraus gestempelte Flyer gebastelt. Das war praktisch unsere einzige Werbung, weil wir illegal waren und nicht in Stadtmagazinen präsentiert werden durften und auch gar nicht wollten, was auch den Reiz ausgemacht hat. Erst ab unserem dritten Laden in der Burgstraße sind wir langsam legal beispielsweise im Flyermagazin aufgetaucht. Ab da haben wir auch konzeptionell mit Flyern gearbeitet."

Mittlerweile ist das WMF zu einem der etabliertesten Clubs in Berlin geworden. Wie habt ihr eure corporate-identity konzeptioniert, sprich, worauf kam es euch an, als ihr dem WMF ein graphisches Gesicht geben wolltet?
"Zunächst hatten wir das Problem mit unserem WMF Brand, was ja das Logo der Württembergischen Metallwaren Fabrik ist, in dessen ehemaligen WMF Stammhaus wir unsere erste Station hatten. Wir suchten nach einer mittelfristigen Lösung und nannten uns also um in MFL. Daniel Pflumm hatte dann die geniale Idee, die drei Buchstaben ins Taubstummenalphabet umzusetzen. Das Logo haben wir dann auch auf die Flyer gedruckt, mit dem Effekt, dass es Nichteingeweihte auch nicht lesen konnten, dass unsere Spur auch gegenüber dem Gewerbeamt verwischte. Daniel hat dann aus der CNN Typo das WMF Logo entwickelt. Aus diesem langestreckten Oval haben wir dann mit Fred Rubin zusammen die ersten Flyer mit Logo Stanzung in Zusammenarbeit mit den Gestalten entwickelt. Für die nächste Flyergeneration im Johannishof dienten die verschiedenen Resopal-Furnierholz-Typen des Interieurs als Vorlage für das Design. Als die amerikanischen Militärbasen sich in Süddeutschland Anfang der 90er zurückzogen, haben wir zugeschlagen und Möbel und Technik gekauft. Die "item tags" der Etiketten haben wir als Flyer verwendet. Till Helmbold hat dann folgend für das WMF im Johanneshof doppelseitige Flyer mit Stadtbezugsfeld und abgerundeten Ecken entworfen. In der Ziegelstrasse hat Daniel Pflumm das Flyer Design entworfen und auch mit der Labelgründung von WMF Records das Coverdesign gemacht sowie die Website und das Logo für WMF FM, den Klubradio Live Stream. Die Monatsflyer Serie hatte das verkleinerte Format einer CD und hat absurde Objekte auf die Vorderseite gesetzt; das Ganze mit der Pflummschen Reinfarbigkeit und super kleiner Schrift, die kein Mensch lesen konnte. Seit geraumer Zeit macht Rikus Hillmann, der Layouter von der De:Bug unser Design. Das Thema Moskau bestimmt das Design, sprich das gröbere Papier, die Zweifarbigkeit, kein Hochglanz, etwas mit dem Retro-Ambiente des Hauses, mit dieser sozialistischen Vergangenheit zu arbeiten und Propaganda-Elemente stilistisch mit aufzunehmen."

Wie schätzt du die Effizienz von Flyern ein?
"Wir wollen mit unserem Flyer eine Übersicht geben über das Monatsprogramm, dass man weiß, was hier stattfindet. Das Image des Ladens und des Labels wird bei uns nicht mehr so sehr über den Flyer repräsentiert, wie es früher war, sondern mehr über die Website und über Pressearbeit. Wir haben aber

immer noch eine Auflage von 8000 Monatsflyern. Allerdings gibt es zu viele Flyer, alles wird beliebig. Zu hinterfragen ist das Flyern in seiner Sinnhaftigkeit auf jeden Fall. Man sollte sich doch überlegen, ob man Werbung vielleicht nur noch über Newsletter, E-mails oder Flashflyer macht. Flash Flyer finde ich persönlich sehr interessant, SMS Flyer allerdings furchtbar. Spam ist sowohl im Netz, als auch über die Handys der große Nachteil. Wenn man aber mal vom Wirtschaftlichen absieht, dann wird der Flyer als Möglichkeit sich künstlerisch auszudrücken für den Laden immer sehr wichtig sein, weil das eine Möglichkeit ist, den Stil und das Engagement ganz konzentriert mitzuteilen."

ELLEN ALLIEN ist Produzentin und arbeitet seit 1999 als Macherin ihres eigenen Labels BPitch Control, einer Berliner Innovationsschmiede mit Kollektivcharakter. Als Techno-Djane der ersten Stunde ist sie nicht nur in Deutschland gefragt - ihre Gigs sind international erfolgreich. Uns interessiert neben den Gestaltungsansätzen der BPitch CI, inwiefern sie als Act/Djane im Ausland auf das Flyerdesign zur Party einflußnehmen kann

Ellen, es geht um deinen Standpunkt als Labelmacherin und als Act/Djane: Wenn BPitch eigene Partys veranstaltet, wer nimmt dann Einfluß auf die Flyergestaltung und wonach richtet sich das Design?
"Die Flyer und unser Logo haben seit dem Start unseres Labels 1999 in Absprache mit mir immer die Jungs von der Pfadfinderei gestaltet, es besteht eine enge Zusammenarbeit zwischen Bpitch Control und den Pfadfindern. Das Flyerdesign richtet sich jeweils entweder nach der Musik oder dem künstlerisches Anliegen des Musikproduzenten. Vielleicht ein paar Beispiele: Wenn Kiki Liebeskummer hat, dann kommt bspw. ein Herz mit Pfeil auf das Cover. Die Modeselektors lieben Kabel und werden deshalb verschlungen in Kabeln fotografiert. Sascha Funke ist unser Tech-House Minimalist, es wird demnach nur mit Typo gearbeitet."

Bpitch Control hat ja nicht nur in Deutschland mit dem Label-logo eine unverwechselbare CI, sondern auch im Ausland. Wie wichtig sind dir Auslandsaufenthalte bzw. ist es dir, außerhalb von Deutschland zu spielen oder aufzulegen?
"Es macht mir Spaß und es werden immer neue künstlerische Verbindungen geschaffen, die neuen Input bringen. So wird uns und den anderen klar, wie groß unsere elektronischen Netzwerke sind, und das ist wichtig."

Wenn du oder BPitch Acts im Ausland spielen, wie groß ist die Einflußnahme von eurer Seite aus auf die dortige Flyerankündigung? Habt ihr Einfluss auf das Ankündigungsdesign im jeweiligen Land? Ist euch das überhaupt wichtig oder reicht es aus, wenn das Logo und die Acts auf den Flyern stehen?
"Wir haben immer Einflussmöglichkeiten, meist können wir selber das Artwork produzieren oder unsere Namen werden zumindest im Zusammenhang mit Bpitch genannt. Gerne wird auch von den Veranstaltern unser Artwork kopiert oder das Logo benutzt."

RAIK HOELZL ist seit 1994 Macher und Chef des Labels Kitty-Yo. Er erlebte eine Flyer-Initialzündung durch einen Flyer von

Surrogat, der später ersten auf Kitty-Yo veröffentlichten Band. Die minimale Ästhetik des Labels zeigt sich auf den Flyern meist über das Format, einer längs geteilten Postkarte und über die durchgezogen reduzierte Typographie im eigenen Font "kitty-yo news gothic" entworfen von Angela Lorenz Berlin, worauf besonders wert gelegt wird. Verändern können sich künstlerbezogene Hintergründe, die auf das Coverartwork bzw. eine aktuelle Künstlerveröffentlichung hinweisen.

Ihr habt mit dem Label schon einige Flyer graphisch auf dem Buckel. Bei Kitty-Yo Flyern ist die Information auf ein überschaubares Minimum reduziert, die Graphik und Typo ist schnörkellos und klar. Welche Stationen hat das Kitty-Yo Flyerdesign durchlaufen?
"Angefangen hat alles mit Copyshop Ästhetik, also Copyart. Zum Teil haben wir die Typo der Flyer mit Stempeln aus Bastelbuchstaben zusammengesetzt, um die reduzierte Information - wann, wo, wer bzw. was - zu liefern. Später haben wir mit klassischen Holzstempel-Motiven auf vorhandenen Materialien, wie alten Postkarten oder alten Flyer gearbeitet. Zum Teil wurde in Benutzung des Recyclingprinzips auch nur das Datum aufgefrischt und die Acts übitempelt. Dieses Prinzip hatte zunächst finanzielle Gründe, wurde aber auch als ästhetischer Ausdruck benutzt und verstanden. Wir haben uns nicht gescheut, das Postkartenformat zu sabotieren und die Flyergröße auf Ministreifengröße zu minimieren, bis die Druckerei gestreikt hat. Grundsätzlich hat sich allerdings für uns die Postkarte mit einer Seite hochglanz und der Rückseite matt in verschiedenen Versionen bewährt."

Als special Feature vernetzen bestimmte Motive die einzelnen Promotionplattformen des Labels, wie zum Relaunch der Webseite, als ein Hubschrauber auf dem Flyer auf das Gewinnspiel der Homepage hinwies und dort, wie auch auf T-Shirts wieder auftauchte. Gab es noch weitere Aktionen, wo bestimmte Motive omnipräsent ein bestimmtes Anliegen präsentierten?
"Eigentlich nicht. Flyer fristen bei uns mittlerweile ein gewisses Schattendasein. Es gab mal Flyer als Aufkleber, ein Mehrwert in Miniserie also, wo auf der Rückseite das Partydate stand. Wenn Motive öfter auftauchen, dann meist in Serie, zum Beispiel als Schablonengraffiti oder aber als weitergeführtes Coverartwork bei Record Release Partys."

Wie funktioniert für Kitty-Yo die Verteilung?
"Unser Fokus bei der Promotion liegt auf den Mailinglisten und auf Plakatankündigungen. In geringer Stückzahl lassen wir auch Flyer drucken und verteilen diese dann meist auch selbst in kleinen Häufchen in Berlin, gemäß dem psychologischen Prinzip, liegt ein kleiner Stapel neben einem großen Haufen, suggeriert das eine große Nachfrage und weckt Interesse. Handverteilt ist die Effizienz natürlich noch größer."

Was bedeutet dir Flyerkultur?
"Flyer bedeuten für mich eigentlich Inspiration. Ich denke aber auch, dass Flyerkultur zum jetzigen Zeitpunkt leider etwas verwässert ist, weil zu viel auf pure Informationsverbreitung

gesetzt wird und zu wenig auf das Ganze als eine eigenständige, vielleicht sogar künstlerisch hochwertige und wichtige Form der Meinungsäußerung wert gelegt wird. Ich denke, dass Flyer wesentlich innovativer, ästhetischer, klarer, intellektueller und fordernder sein müssten und dann auch eine größere Wirkung haben würden."

Noch ein paar Gedanken zur Zukunft des Flyers. Kannst du dir für euer Label vorstellen, ein Tool einzurichten, um den Subscribers via SMS Bescheid zu klingeln, wenn eine Kitty-Yo Party stattfindet mit Foto vom DJ und kurzer Information zum Abend?
"Ich könnte mir es vorstellen, wenn die technischen Voraussetzungen soweit ausgereift sind, dass es ästhetisch ansprechender wie auch anwendungsfreundlich und bezahlbar wird. Wenn irgendwann die Farbdisplay so farbgut und hochauflösend sind, dass man kleine Flyer auch sehr gut darstellen kann und ich auch meine Typographie sehr gut hineinpacken kann, dann ist es für mich denkbar. Momentan ist die Anwendbarkeit mit meinem ästhetischen Empfinden nicht parallel laufend. Außerdem gibt man ja seine Handynummer auch nicht so gerne heraus. Das Netz ist immer noch das abgefahrenste und billigste Promotionmedium, das es gibt, sowohl was Informationen über, als auch das Hörbarmachen von Musik angeht. Ich glaube trotz allem immer noch an das Haptische."

TOMAS KOCH ist seit 1989 Herausgeber des Groove-Magazins. Als Partyveranstalter und Flyerdesigner hat er direkten Einblick und Zugang zu den Schnittstellen Event, graphische Umsetzung und Effizienz des Flyermediums. An den alljährlichen Groove Jubiläums-Parties kann man rückblickend gut beobachten wie es um die Koalitionsbereitschaft der Sponsoren mit den Veranstaltern steht und wieviele Gelder letztendlich für derart Werbemittel locker gemacht werden. Unser Interesse fokussiert sich darauf, wie Tomas Koch die kooperative Zusammenarbeit zwischen Veranstalter- und Sponsoren-Kooperationen in den letzten Jahren einschätzt?
"Ende der 80er Anfang der 90er herrschte bei vielen Clubveranstaltern noch eine Art Goldgräberstimmung und Sponsoren haben unheimlich viel Geld auch für mittelgroße Veranstaltungen ausgeschüttet, ohne besondere Location, tolle DJ's und abgefahrene Konzepte. Die Clubs konnten es sich aufgrund von Sponsorengeldern leisten für Werbepakete mit Plakaten, Flyern etc. noch sechs bis zehn Tausend DM auszugeben. Sponsoren wie Camel haben für ihre "Move Kampagne" 7-stellige Summen ausgeschüttet. T-Mobile und New Yorker haben so richtig mit Geld rumgeschmissen, wovon die ganze Szene gelebt hat."

Wie einflußreich sind Sponsoren auf Clubabenden oder Events?
"1996-1998 war der Zenit der Clubkultur erreicht und der Anspruch an Leistungspakete stieg an. Red Bull ziehen sich seit Jahren aus den Printkampagnen mit ausschließlichem Abdruck in den Logoleisten auf den Flyern zurück und wollen direkt vor Ort auf den Parties mit zusätzlichen Präsentationstools mitmischen. Allumfassende Präsenz war die offensive Forderung. Auf den Flyern fielen zusehens sogenannte "Head-Präsentatoren" auf und im Layout sollten die markentypischen CI Farben

eingebunden sein. Auf den Parties sollte alles zugebannert und mit Logos beklebt sein, am Besten noch auf dem Klo. Nach und nach wurden die Marken in Absprache mit dem Veranstalter auch inhaltlich eingebunden. Das führt dann dazu, dass es eben zum Beispiel bei "Sonne Mond und Sterne" so etwas wie einen "Diebels Wassersport Fun Park" gibt. Red Bull hat die "Music Academy" gegründet und T-Mobile haben als Marke 2001 zur Popkomm einen "House Kongress" komplett selbst veranstaltet. Man hat also versucht auch inhaltlich was zur Szene beizusteuern und sehr viel Understatement walten lassen. Marlboro ist mit seinen Touren beispiellos für maximalen Image-Transfer. Was die Parties angeht: Spätestens seit der Rezession um 1998/99 herum bekommen nur noch die großen Veranstalter, also Vorzeigefestivals wie "Nature One" und "Sonne, Mond und Sterne" Sponsorengelder. Und die bekommen dann alles ab."

Wie habt ihr den Zeitgeist versucht auf den Flyern umzusetzen?
"Anfang der 90er, als es mit Techno losging, sah man überall die totale Überladenheit von Typos, Farben und 3D Graphiken, es war unglaublich durcheinander, wirr und bunt, bis dann der Trend zurück zum Klassischen entdeckte wurde, was Ende der 80er auch schon in England gängig war. Ab 1996/97 ist in Deutschland dann auch die große Reduktion und Schlichtheit eingekehrt mit mehr weißer Fläche und keinen hinterlegten Rastern. Groove hat teilweise der Graphik entsagt und reine Foto-Typo-Lösungen entwickelt."

Wie effizient erscheint dir die Flyerverteilung wenn du über Erreichbarkeit oder auch die Zukunft von Flyern denkst?
"In Zeiten von E-mail und SMS Verteilung haben wir auch unsere Groove Flyer-Auflage reduziert. Als Betreiber vom Monza Club ist es für mich auch denkbar, Plakate mit dem Monatsprogramm in die wichtigsten Shops zu hängen und ganz auf Flyer zu verzichten. Sicherlich gibt es einen Trend weg vom Print ohne schon ganz darauf zu verzichten."

HELGE BIRKELBACH war frenetischer Flyersammler und ist Medienmacher mit Multivita. Er hat neben etlichen Gründungsaktivitäten die ersten Loveparades mitorganisiert, den Szeneführer "Very Important" für Berlin und Hamburg herausgegeben und initiiert den monatlichen Netzwerk-Salon "Private Thursday". Als Herausgeber und Chefredakteur hat er u.a. das Musikmagazin "HYPE Megazine", die "FLYER Up-Dates" und nun auch das Klassik-Magazin "classix - Musik für immer" gemacht.

Unser Interesse an diesem Allrounder ist natürlich, wie das Flyermagazin entstehen konnte?
"Mit "Very Important" habe ich 1993 für Berlin und später auch für Hamburg alle wichtigen Telefonnummern und Adressen der Veranstalter, DJ's, der Clubs, Techniker und Licht usw. in einem Szenetelefonbuch zusammengetragen und kostenlos vertrieben. Das kam so gut an, dass man sich fragte, warum gibt es eigentlich kein Veranstaltungsmagazin, das aktuell ist und auf den Punkt kommt? Aus diesem Verlangen aus der Szene heraus, weil TIP und Konsorten das eben nicht abgebildet haben, ist dann der "Flyer" entstanden. Die Idee war, wir

nehmen das Medium was en vogue ist, was weitergereicht wird, nämlich die Flyer, bündeln diese, weil es eben auch schon zu der Zeit überhand nahm, und bauen noch einen redaktionellen Mantel herum. Das war dann der erste "Flyer", der 1994 herauskam, mit der Idee des Bootleggings, also dem monatlichen Verfremden einer neuen Marke.

Zunächst gab es ja Probleme mit dem Cover, weil viele Marken den verfremdeten Kontext sträubten, doch dann wollten alle auf das Flyer Cover. Die Industrie reagiert natürlich immer sauer, das kann man auch verstehen, wenn eine eingeführte Marke so ironisiert verwendet wird. Das hat auf der anderen Seite auch gezeigt, wie konsumfreudig oder in der Konsumwelt lebend doch die Techno Bewegung ist, die sich darin aufhält und mit den Elementen der Konsumwelt spielt, aber nicht ablehnend ist. Also eine ganz andere Herangehensweise als noch die Kultur der 68er, die so etwas von vornherein natürlich ablehnen würden. Es wurde dann auch bald den Markenartiklern klar, dass die Verfremdungsidee cool ist und neue Konsumenten noch näher an eine Marke heranrückt. Der Return war dann, dass wir die große Spannung geschaffen haben, wer denn beim nächsten Mal auf dem Flyer Cover gebootlegt wird."

Warum hast du das Flyer Magazin gegründet? Was war die Motivation?
"Zunächst einmal das Zusammenbringen von verschiedenen medialen Plattformen und auch das Befruchten von unterschiedlichen Möglichkeiten. Damals im Chromapark, der Kunstausstellung im E-Werk, hat man versucht die verschiedenen Darstellungsformen der Technobewegung zusammenzubringen. Wir wollten den Überbau, die künstlerische Note in der Bewegung in den "Flyer" mit einbringen. Also nicht nur das rein musikalische, den reinen Fun, das Abtanzen, sondern dass Ideen und Lebensziele vermittelt werden, dass es eine "Zukunftsversion" auch visuell abbildet."

"Ich habe Probleme einen Flyer einer Veranstaltung zu verteilen, die ich nicht halbwegs empfehlen kann", sagt **DANIEL METEO**. Er ist Macher des Labels Meteosound, selbst Veranstalter und Promoter. Seit 2001 organisiert er etwa einmal im Monat seine eigenen Partyreihen mit verschiedenen Künstlern aus dem Dub-Umfeld in Berliner Clubs wie der Maria oder dem WMF. Als Veranstalter arbeitet er vorwiegend mit den Labels Shitkatapult und Scape zusammen und übernimmt in einer gewissen Tradition die Organisation der Oceanclub-Abende.

Seit wann arbeitest du mit Flyern und warum? Was ist für Dich der Vorteil über dieses Medium zu kommunizieren?
"Ich arbeite schon immer, wirklich seit der ersten Veranstaltung, die ich organisiert habe, mit Flyern. Ich glaube auch, über meine Arbeit mit meinem Label Meteosound interessiert es mich, etwas herzustellen, was nicht allein auf der Zeitachse entsteht. Etwas was hergestellt wird und als Objekt existiert. Genauso ist es für mich eine Möglichkeit, dem Abend ein Bild zu geben- eine Idee, eine Farbe, ein Format. Das kann man auch alles wörtlich lesen. Und das ist das Gute am Flyer - er ist so klar und eindeutig."

Wer übernimmt das Flyerdesign?
"Zunächst war es uns nicht so wichtig, wer das Flyerdesign macht, bis ich gemerkt habe, dass es viel besser ist, loszulassen und lieber einem Designer/einer Designerin das Heft zu übergeben und darüber zu reden. Denn die Gestaltung ist ja klar eine Kunst für sich. Das Meteosound Hauptdesign und die ersten Flyerjahre kamen immer von Propella - einer Feundin von mir. Sie ist die wichtigste Graphikerin für das Label. Inzwischen arbeite ich viel mit Bianca Strauch, deren klaren Stil und einfache Ideen ich sehr schätze, aber auch oft mit Sascha Ring oder Carsten Aermes vom Berliner Label Shitkatapult."

Verteilst nur Du als professioneller Verteiler oder auch Freunde und Bekannte? Wie ist dabei deine bzw. eure Verteilstrategie?
"Ich arbeite in der Verteilung sowohl mit den Künstlern, dem Booker, dem Club oder dem Label zusammen. In letzter Zeit verteile ich auch wieder viel mehr selbst, was ich eine zeitlang nicht ausstehen konnte. Allerdings übergebe ich selten Flyer an Leute, die ich nicht kenne. Was die Strategie betrifft: Lieber wenig und keinem die Flyer in die Hand zwingen, sondern unaufdringlich bleiben. Ich verteile in Plattenläden und Clubs und lege sie dort lieber ab, komme dann meistens ein zweites Mal, um aufzufüllen. Die Flyerflut in Berlin kann ja auch sehr nerven. Es ist für Anfänger auch durchaus gar nicht so leicht: Wo lege ich die Flyer hin, wieviele, wie komm ich rein, wie überzeuge ich den Türsteher usw. Mich regen dann auch Sachen auf, z.b. viele Clubs wollen keine Fremdflyer, müllen aber selber alles zu. Dann muss ich mich auch mal aufregen, das gehört eben dazu. Ich bin ein Stresser. In solchen Momenten hätte ich gerne einen Profiverteiler, aber entweder sind sie billig und schlecht oder eben einfach zu teuer. Verteilfirmen schätze ich nicht, da rate ich, mach lieber 200 handkopierte und verteile sie selbst."

Wirbst oder informierst Du noch auf andere Art?
"Ich glaube nicht, dass heutzutage EIN Werbemittel ausschlaggebend ist. Erst das Ensemble aus Szeneakzeptanz, E-mail Verteiler, traditioneller Pressearbeit, Radio und Flyer machen das Bild komplett. Bei den finanziellen Schwierigkeiten derzeit ist der Flyer auch ein Luxus, aber oft box' ich ihn durch! Ich verwende dann ganz gerne das Cover des Produktes bei einer Release Party, dann ist das Label bereit, sich an den Druckkosten zu beteiligen. Poster sind übrigens noch geiler, aber viel viel kostspieliger. Für einen Club wie die Maria lohnt sich das nicht."

Was steckt hinter der Aufmachung "deiner" Flyer?
"Ich veranstalte nur einen bestimmten Content und der ist mit einer bestimmten musikalischen Haltung codiert, die sich auch bis zum Flyermachen erstreckt. Das lässt sich an den Platten hören und an den Graphiken erkennen. Der Flyer ist praktisch das i-dot. Ich habe dabei ein Faible für "falsche Reihen", also Veranstaltungen, die miteinander verkettet sind, die sich allerdings nur bedingt auf einander beziehen, aber über einen Reihencharakter oft erst nach einer Zeit verständlich werden. Das kostet etwas Mühe, macht aber Spaß und sich auch nach einiger Zeit bezahlt."

Haben Deine Flyer für Dich eine Funktion über den rein informativen und Publicity Wert hinaus?
"Meiner Meinung nach geht die Funktion nur darüber hinaus. Die Flyer sprechen ein bisschen von einer Sorge um die Veranstaltung, um deren Akteure und Musik. Wenn dann noch Geld für das Bild dazu ausgegeben wird, ist das auch ein Statement, das ich an mich selbst richte: Lass es dir was wert sein. Wir befinden uns ja in Berlin, sicher einer der freiesten und gleichzeitig hochgezüchtetsten Clubkulturen derzeit. Das gerade hier viele Freiräume herrschen, Lücken und Amateure ist auch wieder der besondere Charme dieses ganzen Gewerbes."

Worauf achten die Leute deiner Meinung nach am meisten? Auf das Aussehen des Flyers, das angekündigte Programm oder auf den Menschen, der verteilt?
"Ich glaube am liebsten lesen die Leute das, was sie schon gehört haben. Erst fängt man irgendwo das Monatsprogramm des Clubs auf, dann erzählt es ein weiterer, dann entdeckt man einen Flyer und liest über die Party noch in ein, zwei Zeitschriften oder City Mags. Und die Entscheidung fällt meist eh erst am Abend."

Wie siehst Du die Zukunft des Flyers? Wirst Du weiter mit Flyern arbeiten oder gibt es seriöse Alternativen?
"Seriös – ist mein letztes Schlagwort. Ich hätte gerne öfter Plakate hergestellt. Die Flyer werden auch gemacht, um Präsentationen und Sponsoren zu platzieren und anzubinden. Die Zukunft liegt im crossmarketing, Aktionen á la Intro intim. Das Design wird weg gehen vom Abend und hin zu immer abstrakteren auf der einen und gefälligeren Motiven auf der anderen Seite. Der Flyer muss dann meist mehr als eine Sache bewerben, wie auch die Releases, die Biermarke, das Internet Radio, Spex, Groove, De:bug, Intro etc.pp. Das ist schon ein hartes Schielen auf den break-even, also immer die Kosten des Flyers und den Aufwand vor Augen haben und zu rechnen. Allerdings so ganz künstlerische Flyer wie bspw. von Designers Republic ohne Infos sind auch total out und für mich nicht interessant."

SASCHA (BLEED) KÖSCH ist Geschäftsführer und Musikredakteur der De:Bug - Zeitschrift für elektronische Lebensaspekte und DJ. Mit Flyern direkt hat das Magazin recht wenig zu tun. Feiert man Geburtstag oder legen De:Bug Dj's auf, dann blinkt natürlich meist das Logo auf den Flyern. Indirekt werden die Partydates über Mailinglisten verteilt. In den Wintermonaten werden über die De:Bug Dates Mailingliste um die 250-350 und im Sommer um die 200 Dates pro Monat verschickt. Die Partyinfos werden von den Veranstaltern teils direkt in die Redaktion geschickt und dann ausgesucht an die Mailingliste versendet. Auf www.de-bug.de kann man sich subscriben oder die aktuellen Infos direkt einsehen. Sporadisch werden Flyer und Faxe in die Liste und Homepage eingepflegt. Auf Stadtzeitungen verlässt sich De:Bug nie.

Gibt es Feedback auf die Dates? Wenn ja, in welcher Form?
"Gelegentlich kommt es zu Diskussionen auf der Mailingliste. In Gesprächen abends auf Partys höre ich oft Leute sagen, dass sie immer auf der Webseite nachsehen, wenn sie ausgehen

wollen, oder dass sie über die Mailingliste von der Party erfahren haben. Ich würde mal sagen, dass die Dates bei De-Bug im Heft und auf der Mailingliste schon eins der 5 wichtigsten Tools in der Stadt fürs Ausgehen sind, abgesehen natürlich von Leuten, die für ihre Veranstaltungen eigene Mailinglisten haben."

Gab es schon mal Probleme in Form von polizeilicher Kontrolle der De:bug Homepage bzw. von der Gema, wenn z.b. klar war, dass über eine illegale Party nur über die De-bug Dates informiert wurde?
"Angeblich, aber das ist mehr Hörensagen. Auf genauere Nachfrage kam dann meist raus, dass es andere Gründe hatte. Ich habe den Webzugang auf die Datesliste auf De-Bug Mitglieder reduziert, so dass nicht auch noch Searchengines darauf zugreifen können und man wenigstens ungefähr weiß, wer drauf ist. Meist achten wir ja auch darauf, wenn Leute ihre Dates nicht weitergeposted haben wollen. Manchmal geht das natürlich schief. Aber ich glaube nicht, dass ein Club deshalb zumachen musste oder von der Polizei Stress bekommen hat."

MASSIMO D'ELECTRO ist Veranstalter, DJ und Labelbetreiber (electrobot). Vor allem aber versteht er sich als Künstler.

Was bedeuten Flyer für dich?
"Flyer waren für mich nie bedrucktes Papier. Sie waren und sind stets die Möglichkeit sich als Künstler auszudrücken. Flyer sind für mich die Visitenkarte zur Party! Du kannst jemandem ein Statement zu einer Party mitgeben. So sensibel wie eine Visitenkarte passend zur Person sein sollte, so wichtig sind die Flyer zur Party. Ich freue mich immer zu einem neuen Event einen neuen Flyer zu entwickeln. Ich habe mich immer wieder gefreut meine Flyer zu verteilen und die Gesichter der Leute dabei zu beobachten."

Was ist für Dich der Vorteil mit Flyern zu kommunizieren?
"Für mich ist es wichtig, die Leute direkt damit zum Event/zur Party einladen zu können. Ich spreche auch nur bestimmte Menschen an, die ich auf meinem Event sehen möchte. Ich verteile an Freunde und Bekannte, an Leute mit einem bestimmten Look, Menschen, die interessant sind und mit denen ich ins Gespräch komme. Mit dem Flyer hat man einen Reminder in der Tasche und nicht zu vergessen, ein Stück Kunst von dir!"

Wieviele Flyer lässt Du drucken?
"Derzeit sind wir auf 2000 Stück. Am Anfang habe ich immer 101 Flyer drucken lassen und die Übergabe war für mich jedes mal eine Performance! Einmal habe ich Armbänder aus laminiertem Karton gefertigt und habe die Leute direkt in den Clubs eingefangen, indem ich ihnen die Flyer um das Handgelenk gelegt habe. Die Idee war, aus Flyern Schmuck zu machen, der sichtbar im Club getragen wird. Für mich war es immer wichtig eine Dimension zum Ganzen hinzuzufügen."

Wirbst oder informierst Du noch auf eine andere Art?
"Derzeit mache ich auch sehr minimalistische Plakate und sprühe mit Schablone Symbole oder Wörter drauf."

Was steckt hinter der Aufmachung deiner Flyer, wie hat sich das Design entwickelt?
"Früher habe ich kleine briefmarkenartige Flyer entworfen und gefertigt, jedoch kam das irgendwie in Mode. Es gab eine Partyreihe, die Discoinferno hieß, dafür laminierte ich meine Flyer, schweiße ein Streichholz mit ein. Derzeit ist mein Flyerformat dreieckig."

Haben Deine Flyer für Dich eine Funktion über den rein informativen und Publicity-Wert hinaus?
"Ja. Flyer sind für mich eine weitere Form des Ausdrucks und ich erachte sie als meine Babies. Sie sind Teil meiner Kunst!"

Du verteilst ziemlich viel selbst. Was ist Dein Antrieb, immer wieder loszuziehen? Gibt es angenehme Nebeneffekte?
"Es gibt derzeit viele Sammler für dieses Medium. Ich habe mich immer bemüht, bei der Entwicklung einen Schritt weiter zu gehen, um jeweils den Rahmen zu sprengen! Am Anfang wollte ich raus aus der Zweidimensionalität und habe dreidimensionale Flyer entwickelt. Die waren so schräg und so beliebt, dass einige Berliner Designerläden z.b. "Eisdealer" und "Betty Bund" sie ins Schaufenster gestellt haben. Für mich war und ist das immer noch eine große Ehre."

Wie siehst Du die Zukunft des Flyers? Wirst Du weiter mit Flyern arbeiten oder gibt es seriöse Alternativen?
"Ich bitte um Respekt vor dem Medium! Flyer sind K-U-N-S-T. Natürlich werde ich die Flyer als kunstkommunikative Form von Mensch zu Mensch nicht aus meiner Arbeit als Promoter und Designer bannen!"

Wer in Berlin auf der Suche nach guter Musik durch die Clubs zieht, muss irgendwann **RAN HUBER** begegnen. Obwohl der unermüdliche Veranstalter zunächst eher schüchtern wirkt, drückt er Musikbeflissenen zielsicher die Flyer seiner amSTART-Abende in die Hand. Er scheint jede begabte Gitarrenband und die interessantesten Electronic-Acts zu kennen und bookt sie schon vor ihrem unvermeidlichen Durchbruch. Dabei beweist Ran ein besonderes Feingefühl bei der Auswahl seiner Locations. Seit den Anfängen 1999 hat er alle stilbildenden Läden in Berlin mit seiner mobilen Konzertreihe bespielt. Die Präsenz seiner Flyer könnte in einem Club fast schon als Empfehlung gelten. Fragen an einen umtriebigen User und Förderer der Flyerkultur.

Wie viele Veranstaltungen machst Du?
"Ich veranstalte ungefähr 30 bis 50 Konzerte im Jahr, dass heißt im Monat ca. 3 bis 5. Insgesamt dürften es nun knapp 200 sein. Genaueres steht auf meiner Webseite http://www.ag-parka.de/amstart/"

Seit wann machst Du Flyer?
"Seit dem ersten Konzert. Flyer sind eine schöne Sache. Früher ließ ich 2000 bis 3000 Stück drucken, jetzt meistens nur noch 1000."

Wirbst oder informierst Du noch auf andere Art?
"Sonst mache ich nur Promo/Pressearbeit und natürlich mein E-mail Verteiler."

Wer gestaltet die Flyer?
"Icke. Bei besonderen Veranstaltungen wende ich mich an besondere Künstler oder Graphiker, manchmal auch an die Band selbst."

Deine Flyer sind immer gleich zu erkennen: Wie hat sich diese Aufmachung entwickelt?
"Zum einen liegt der Wiedererkennungseffekt natürlich an dem, dem Pass-Foto-Streifen nachempfundenen, Format. Das heißt: Die Porträts der Künstler sind nebeneinander abgebildet. Dann liegt es vielleicht an der Schrift: Arial. Obwohl ich Flyer sammle, orientiere ich mich eigentlich graphisch nicht an anderen Flyern."

Haben Deine Flyer für Dich eine Funktion über den rein informativen und Publicity-Wert hinaus?
"Ich fasse sie als kleine Kunstwerke und Sammlerstücke auf."

Wer verteilt?
"Meistens verteilen nur ich und Freunde, jobmässig oder für umsonst. Ich beauftrage nur selten professionelle Verteiler."

Was ist Dein Antrieb, immer wieder loszuziehen? Was nervt? Gibt es angenehme Nebeneffekte?
"Da ich viel ausgehe, ist es kein Problem, selbst zu verteilen. Angenehm ist es, Reaktionen zu bekommen. Es nervt aber, beim Verteilen Dieter-Bohlen-Müller-Milch-Flyer zu finden."

Wie bringt flyern Deiner Ansicht nach am Meisten: Hast Du Strategien entwickelt oder ist alles Zufall?
"Ich gehe da ganz nach Gefühl."

Was geschieht bei der Übergabe?
"Die klassische Frage bei Flyern für Konzerte lautet: Was ist das? Eine Anekdote: Nach drei oder vier Jahren habe ich mal jemand kennen gelernt, der tatsächlich dachte, dass über Jahre hinweg immer ein und derselbe Flyer ausgelegt wurde."

Worauf achten die Leute: Auf das Aussehen des Flyers, das angekündigte Programm, den Menschen, der verteilt?
"Ich denke, dass der erste Eindruck eine große Rolle spielt. Ob sich der Flyer abhebt von den anderen. Wenn die Flyer persönlich übergeben werden, ist, glaube ich, auch der verteilende Mensch wichtig."

Wie siehst Du die Zukunft des Flyers? Wirst Du weiter mit Flyern arbeiten oder gibt es seriöse Alternativen?
"Flyer zu machen ist irgendwie Luxus und dekadent, aber immer noch eine Möglichkeit, Information weiterzugeben. Es gibt ja auch Plakate, SMS, Mund-zu-Mund, E-mail, etc."

LEBENSZYKLEN DER FLYER

Jakob Schillinger
Learning from Disney World

MANAGEMENT MITTE · CULTURE

BETREIBER

PERSONAL & BESUCHER

Flyer sind Werbung. Sie tragen die relevanten Daten der Veranstaltung (Line-up, Datum, Ort). Das Design transportiert in codierter Form nicht weniger wichtige Informationen: es dient als Aushängeschild. Es visualisiert das Image der Veranstaltung. Und das der Sponsoren. Deren Logos sind auch auf dem Flyer. Und nicht nur dort.... Für Marketing-Strategen haben Flyer keine große Bedeutung – die wichtigsten Medien sind Menschen.

Learning from Disney World. Mitte, d.h. die (pop)kulturelle Szene deren Herz sich im gleichnamigen Stadteil Berlins befindet, ist hip, bunt, stylish und macht Spaß. Mitte funktioniert wie ein Themenpark: eine perfekt gestaltete, ästhetisierte Welt, die Fun verspricht und alles andere ausblendet. Themenparks sind aus der Besucherperspektive geschlossene Systeme, kleine Welten mit eigenen Regeln. Der Themenpark kennt keine Bedürfnisse, die er nicht befriedigt – weil er alle Bedürfnisse vorgibt.

Thema: Culture. Der Begriff *Thema* bezeichnet die Rolle, in die der Besucher eines Themenparks schlüpft, indem er dessen Werte und Regeln annimmt und die angebotenen Aktivitäten ausübt. Als Besucher von *Disney World* wird man Abenteurer in einer Märchenwelt; entsprechend kann man seinen Mut in Geister- oder Wildwasserbahnen beweisen. Das Thema in *Mitte* ist Lifestyleproduzent – die Aktivitäten heißen *Culture*, ausgeübt werden sie in

Clubs, Shops, Cafés. Glaubhaft vermitteln sie das Gefühl, Teil einer kulturschaffenden Szene zu sein, verleihen der Gestus des Lifestyleproduzenten und bieten Gelegenheit zur entsprechenden Selbstinszenierung.

Besucher. Der Besucher im Themenpark *Mitte* erlebt sich als Teil einer Elite. Einen Unterschied zwischen Personal und Besuchern gibt es in der Wahrnehmung der Besucher nicht, weil alle Aktivitäten dazu dienen, ihn zu verbergen. Der Unterschied ist ein struktureller. Er existiert lediglich in der Funktion für die Betreiber: Die Besucher speisen den Motor des Parks. Sie sind Neuankömmlinge oder gehören zur riesigen Gruppe derer, die den Themenpark nur medial reproduziert erleben. Sie können gegen hohe Eintrittspreise an den Aktivitäten teilhaben, oder die vorgelebten Attitüden mit Hilfe des aktuellsten Merchandise nachahmen.

Personal. Die *Mitte-Hipster* wohnen im Park. Anders als das Personal in Disney World, das abends das *Mickey Mouse* Kostüm ablegt, um in die Realität jenseits des Parks zurück zu kehren, haben sie sich völlig dem Lebensstil des Lifestyleproduzenten verschrieben, den Spaß professionalisiert. Eine Realität außerhalb des Themenparks gibt es nicht mehr. Die Gegenleistung für ein Dasein als Requisite und Projektionsfläche besteht in freiem Eintritt und kostenlosem Merchandise. (Die Fachbezeichnung

für das Ausstatten »gesellschaftliche[r] Leuchttürme«[1] mit Markenartikeln lautet *Individualsponsoring*.) Die Bewohner des *Magic Kingdom* sind das »Fussvolk des Fun«[2].

Management. Während Personal und Besucher den Lifestyle des Produzenten leben, liefert das Management eigentliche Produzent dieses Lifestyles. In ständiger Rücksprache mit den Betreibern gestaltet das Management den Themenpark: Marketing Agenturen wie *Circle Culture*, *Movement Marketing* oder *Häberlein & Maurer*, sind Mittler zwischen Betreibern auf der einen, Personal und Besuchern auf der anderen Seite. Sie ermöglichen den Betreibern, Thema und Regeln des Parks vorzugeben, ohne als gestaltende Größe wahrgenommen zu werden. Dabei bedienen sie sich des Personals – die *Opinion-Former* sind die wichtigsten Medien für die Vermittlung der Werte.

Regeln. In jedem Themenpark gibt es Regeln für die Teilnahme an den Aktivitäten. Während man in *Disney World* meist nur den Hinweis »Benutzung auf eigene Gefahr« zur Kenntnis nehmen muß, sind die Regeln in Mitte komplizierter: Es gibt Verhaltensregeln und Kleiderordnung für die unterschiedlichen Aktivitäten. Wer Fehler macht oder kein bisschen *Gossip* zur Unterhaltung beitragen kann, darf nicht mehr mitspielen. Noch schwieriger wird's dadurch, dass die Regeln nicht wie in *Disney World* auf

großen Tafeln direkt neben der entsprechenden Attraktion stehen, sondern immer aufs Neue aus diversen Magazinen zusammengetragen werden müssen.

Betreiber. Themenparks werden betrieben, um Gewinn zu erwirtschaften. Das geschieht vor allem durch den Verkauf von Merchandise und Verpflegung. Die Betreiber des Themenparks *Mitte* sind dementsprechend vornehmlich Konzerne aus der Textil- und Getränke-Industrie. Sowohl in *Disney World*, als auch in *Mitte* sind die Logos der Betreiber allgegenwärtig. Ihre Interessen und die beschriebene "Mechanik" bleiben den Besuchern aber hinter den bunten Kulissen des Themenparks, hinter ästhetizistischem Rebellentum und einer Rhetorik der Subkultur verborgen. Ein Blick hinter die Kulissen ist im Themenpark nicht vorgesehen – daher auch nicht verboten. Die Namen aus den Impressen der Szene-Magazine legen die Ansätze eines Netzwerks offen, *Google* informiert über die Rollen derselben Personen in Marketing Agenturen. Deren Sprache – gerichtet an potenzielle Auftraggeber – paßt nicht recht zur Rhetorik des Themenparks: Das »Netzwerk aus Opinionleadern, Artists und kreativen Zellen ist dabei das Tool zur Umsetzung einer erfolgreichen und trendorientierten Markenführung.«[3] Bewegt man sich ersteinmal unter der gestylten Oberfläche, erscheinen Institutionen und Protagonisten des Kulturbetriebs im Kontext ihrer strukturellen Funktion.

learningfromdisneyland.com

reCharge

electronic cash

i LOVE BERLIN
SO LOVE ME TOO.

Bitte wählen Sie:

IDENT...
RES...
INDIVIDUAL...
I'm f...

...PPINESS
UNIQUENESS
EXCITEMENT
ATTENTION

I ♥ BERLIN

Der Sekundärzielgruppe wird ein einfaches Interface zur Mitte-Coulture angeboten: Shopping

Vorangegangene Seite:
Grauel (2002), S.72
Timm / Durka (2004)

zeitschrift für populärkultur und bewegungskunst

LIFE IS ALL ABOUT STYLE YOU NEED lifted knowhow
AND YOU HAVE TO ADJUST YOUR POINT OF VIEW NOW BECAUSE LIFE IS
complex 300+ PRODUCTS **. BUT DON'T WORRY – MAGAZINES WILL**
BE YOUR TRUSTFUL GUIDE TO 200 NEW PRODUCTS **AND BEYOND. GET**
YOUR styeguide **NOW AND BUY THIS USELESS INFORMATION.**

»REDAKTIONELLE BEITRÄGE«

ANZEIGEN

Magazine sind eine wichtige Schnittstelle zwischen der kulturellen Elite und der *Sekundärzielgruppe*. Zeitschriften wie *Lodown*, *Style & the family tunes* oder *Qvest* transportieren Trends in die entlegensten Winkel der Republik, wirken als stilbildende Autoritäten. Ein Magazin nennt sich konsequenterweise gleich *Styleguide*.

In den Magazinen stehen den Konzernen neben herkömmlichen Anzeigen auch »redaktionelle Beiträge« als Projektionsflächen für ihre Marken zur Verfügung. Personal und Inhaber der Marketing Agenturen, die die Produktion und Vermittlung der sogenannten »Advertorials« anbieten, sind meist Teil der Redaktion.

Advertorials sind als verkleidete Werbung. Offiziell sollen die Fotostrecken Trends illustrieren. Sie werden von einer Marke dominiert, finanziert und in Auftrag gegeben, aber im Magazin nicht als Anzeige sondern als »redaktioneller Beitrag« platziert. Das Magazin wirkt wie ein Gütesiegel; es präsentiert die Marke glaubwürdig als Teil der Kultur.

Eine weitere Möglichkeit, eine Marke zum Thema redaktioneller Beiträge zu machen, ist, die Marke mit wichtigen kulturellen Ereignissen, Institutionen oder Protagonisten zu verbinden. Marketing Agenturen beraten bei der Gestaltung von *Flagshipstores*, organisieren die Bespielung mit Ausstellungen und Parties und sorgen für ein großes Echo in den relevanten Magazinen.

Vgl. o.V.: CIRCLEcultureCc:

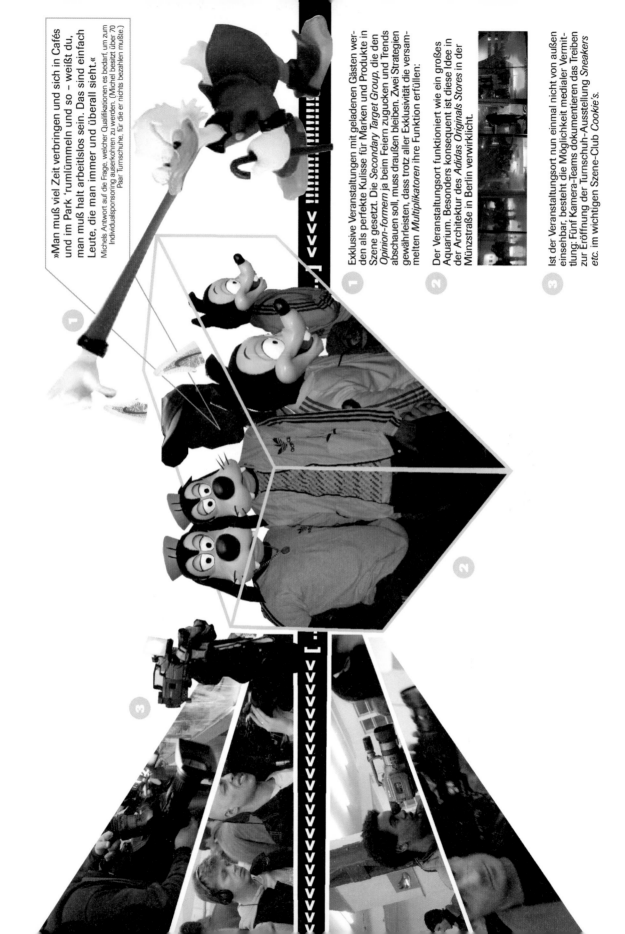

»Man muß viel Zeit verbringen und sich in Cafés und im Park 'rumlümmeln und so – weißt du, man muß halt arbeitslos sein. Das sind einfach Leute, die man immer und überall sieht.«

Michels Antwort auf die Frage, welcher Qualifikationen es bedarf, um zum Individualsponsoring auserkohren zu werden. (Michel besitzt über 70 Paar Turnschuhe, für die er nichts bezahlen mußte.)

1. Exklusive Veranstaltungen mit geladenen Gästen werden als perfekte Kulisse für Marken und Produkte in Szene gesetzt. Die *Secondary Target Group,* die den *Opinion-formern* ja beim Feiern zugucken und Trends abschauen soll, muss draußen bleiben. Zwei Strategien gewährleisten, dass trotz aller Exklusivität die versammelten *Multiplikatoren* ihre Funktion erfüllen:

2. Der Veranstaltungsort funktioniert wie ein großes Aquarium. Besonders konsequent ist diese Idee in der Architektur des *Adidas Originals Stores* in der Münzstraße in Berlin verwirklicht.

3. Ist der Veranstaltungsort nun einmal nicht von außen einsehbar, besteht die Möglichkeit medialer Vermittlung: Fünf Kamera-Teams dokumentieren das Treiben zur Eröffnung der Turnschuh-Ausstellung *Sneakers etc.* im wichtigen Szene-Club *Cookie*'s.

8 o.V.: :: haebmau ::
9 Vgl. Grauel (2002)
10 Vgl. o.V.: CIRCLEcultureCc:

»ICH BIN NE ABSOLUTE TREND-SETTERIN – OPINION-LEADER«

Begriffe wie »Individualsponsoring«8 »Opinion-Former« und »Style-Leader« sind unsexy. Auch die Marketingagenturen sprechen lieber von »Freunde[n]«. So kommt es, dass nun auch Adidas einen grossen Freundeskreis in Mitte hat.9

Auf den wichtigsten Parties muss man auch mit Gästelisten-Platz anstehen, weil sowieso nur geladenen Gäste Einlass finden. Wer hier an den Wartenden vorbei gehen kann, ist richtig wichtig.

Wer etwas auf sich hält, steht auf den Gästelisten aller wichtigen Parties und muss nichts für Getränke bezahlen.

Ein Platz auf der Gästeliste bietet noch ein zusätzliches Vergnügen: man kann demonstrativ an allen, die in der Schlange auf Einlass warten, vorbei gehen. Die Türpolitik garantiert, dass immer eine Schlange von Menschen wartet, selbst wenn der Club fast leer ist.

Limitierte collector's items sind wichtige Statussymbole. Sie symbolisieren Einzigartigkeit und Kenntnis der Szene: es kostet viel Zeit, zu wissen, welche Produkte hot sind und wo man sie bekommt.

Ingas Bewusstsein bezüglich ihrer Funktion im Themenpark zeigt, dass sie wichtige »Protagonist[in] junger Kultur«10 ist. Was sich hinter diesen Formulierungen verbirgt, erklären die folgenden Seiten...

»ICH HAB DIE JACKE BEKOMMEN, ALS DIE GEMÄSSIG DRAUSSEN WAR. DA HAT MIR MEIN FREUND RAUSGEHOLT BEI ... GENAU WUSSTE, DASS DAS MEINE JACKE IST.«

DASS DIE GRÖSSE SEIN KÖNNEN, DASS ICH DIESE JACKE TRAGE, WEIL DA... WAS WIRD DEN WASH AUF JEDEN FALL IN DIE HÖHE SCHNELLEN.«

»OHNE INDIVIDUALITÄT SIND WIR ALLE GLEICH, UND GLEICH SEIN IST MASSE SEIN, UND DAS FIND ICH GEFÄHRLICH.«

»ICH BIN EINE GROSSE GEMEINSCHAFT.«

ICH

»ICH HAB MEIN MUSIKLABEL ROT. ICH BIN JEMAND, DER IMMER AM SYSTEM KRATZT, DER SO BANDS WIE MIA PRODUZIERT...«

Am Eingang eines der wichtigsten Clubs hängt immernoch ein Schild mit der Aufschrift »nur für Freunde«.

Das Netzwerk der Freunde ist das wichtigste Kapital. Je mehr Freunde man kennt und je wichtiger sie sind, desto wichtiger wird man selbst im Netzwerk – und seit Marketingagenturen auch Konzerne ins Netzwerk geholt haben, sind die Freunde bares Geld wert.

Mitte ist identitätsstiftend.

EIN INTERVIEW MIT INGA VOM 1. MAI 2003 BESCHREIBT ALLE WICHTIGEN MOTIVE UND AKTIVITÄTEN IM THEMENPARK MITTE.

Die rebellische Attitüde kann man mit Hilfe einer Vielzahl von Street-Art und Subkultur Attributen stilgerecht ausdrücken.

Ein riesiges Angebot an Skateboards, Graffiti-Ausrüstung und DJ-Equipment stellt sicher, dass sich jeder ein bisschen als Kulturproduzent fühlen darf.

In Mitte heißt der auf Feiern, Mode und Shopping konzentrierte Lebensstil culture.

Am Eingang eines der wichtigsten Clubs hängt immernoch ein Schild mit der Aufschrift »nur für Freunde«.

Das Netzwerk der *Freunde* ist das wichtigste Kapital. Je mehr *Freunde* man kennt und je wichtiger sie sind, desto wichtiger wird man selbst im Netzwerk – und seit Marketingagenturen auch Konzerne ins Netzwerk geholt haben, sind die *Freunde* bares Geld wert.

Begriffe wie »Individualsponsoring«, »Opinion-Former« und »Style-Leader« sind unsexy. Auch die Marketingagenturen sprechen lieber von »Freunde[n]«. So kommt es, dass nun auch *Adidas* einen grossen Freundeskreis in *Mitte* hat.[9]

Auf den wichtigsten Parties muss man auch mit Gästelisten-Platz anstehen, weil sowieso nur geladene Gäste Einlass finden. Wer hier an den Wartenden vorbei gehen kann, ist richtig wichtig.

Wer etwas auf sich hält, steht auf den Gästelisten aller wichtigen Parties und muss nichts für Getränke bezahlen.

Ein Platz auf der Gästeliste bietet noch ein zusätzliches Vergnügen: man kann demonstrativ an allen, die in der Schlange auf Einlass warten, vorbei gehen. Die *Türpolitik* garantiert, dass immer eine Schlange von Menschen wartet, selbst wenn der Club fast leer ist.

Limitierte *collector's items* sind wichtige Statussymbole. Sie symbolisieren Einzigartigkeit und Kenntnis der Szene: es kostet viel Zeit, zu wissen, welche Produkte *hot* sind und wo man sie bekommt.

Was sich hinter Formulierungen wie »Protagonisten junger Kultur[10]« verbirgt, erklären die folgenden Seiten...

o.V.: :: haebmau ::
Vgl. Grauel (2002)
Vgl. o.V.: CIRCLEcultureCc:

»ICH BIN NE ABSOLUTE TRENDSETTERIN – OPINIONLEADER«

»... DASS DIE FROH SEIN KÖNNEN, DASS ICH DIE JACKE TRAGE. WEIL DIE NACHFRAGE NACH WIRD DER AUF JEDEN FALL IN DIE HÖHE SCHNELLEN.«

»ICH HAB DIE JACKE BEKOMMEN, ALS DIE GERADE PROTOTYP MÄSSIG DAS WAR. MEIN FREUND DIE RAUSGEHOLT BEI NIKE, WEIL ER GENAU WUSSTE, DASS DAS NE JACKE IST.«

ICH

» ICH BIN EINE GROSSE GEMEINSCHAFT. «

»OHNE INDIVIDUALITÄT SIND WIR ALLE GLEICH, UND GLEICH SEIN IST MASSE SEIN, UND DAS FIND ICH GEFÄHRLICH.«

»ICH HAB MEIN MUSIKLABEL. ICH BIN JEMAND, DER IMMER AM SYSTEM KRATZT, DER BANDS PRODUZIERT...«

...ance / ma... admits one!

Mitte ist identitätsstiftend.

EIN GESPRÄCH MIT EINER PROTAGONISTIN VERDEUTLICHT ALLE WICHTIGEN MOTIVE UND AKTIVITÄTEN IM THEMENPARK MITTE.

Die rebellische Attitüde kann man mit Hilfe einer Vielzahl von Street-Art und Subkultur Attributen stilgerecht ausdrücken.

Ein riesiges Angebot an Skateboards, Graffiti-Ausrüstung und DJ-Equipment stellt sicher, dass sich jeder ein bisschen als Kulturproduzent fühlen darf.

In *Mitte* heißt der auf Feiern, Mode und Shopping konzentrierte Lebensstil *culture*.

act like a banker

ZIELGRUPPE. STRATEGIE. MEINUNGSFÜHRER. ADDED VALUE. BELOW-THE-LINE. MARKETING.
MARKTSEGMENTE. MULTIPLIKATOREN. WERKZEUG. POSITIONIEREN. MEDIALE TAKTIK. EMOTIONALE BOTSCHAFT. SYSTEMATISCHE AUSRICHTUNG. VERBRAUCHER.

Die externe Rhetorik der *Culture* (in Magazinen, Kunst, Veranstaltungen etc.) steht in krassem Gegensatz zur internen Rhetorik von Marketing Agenturen und Konzernen. Auf ihrer Website rechnet die Agentur Circle Culture vor, wie aus Marketing Kunst wird: »Entwicklung von Kommunikationsansätzen + [...] Austausch mit den Protagonisten junger Kultur [...] + Systematische Ausrichtung, User-Affinität, Emotionale Botschaft, Mediale Taktik, Markenaufbau = Art«[11]

»Circle Culture betreibt Markenkommunikation in einem Netzwerk kultureller Meinungsführer [...] Circle Culture arbeitet mit den Agenten der Verbraucherkommunikation zusammen: Marketingabteilungen, Werbeagenturen, [...] Austausch mit den Protagonisten junger Kultur, User-Affinität, Emotionale Botschaft, Mediale Taktik, Markenaufbau [...] in Zusammenarbeit mit den Protagonisten verschiedener kreativer Disziplinen. Mode, Grafik, Journalismus, Design, Musik, Kunst, Fotografie... Circle Cultures Raum für neue Kultur, Kunst und Design ist die Plattform für unser lokales und internationales Kreativnetzwerk. Ausstellungen, Features, Aktionen [...] Ein Raum für Dialog, Inspiration und Bewusstseinsbildung [...] Creative Workshops: Mit ausgewählten Persönlichkeiten aus unserem Netzwerk werden Ideen und Konzepte entwickelt. Hier wird die Markenwelt untersucht und (sic!) Grundlagen für neue Kommunikationsansätze erarbeitet. [...] Wir integrieren Protagonisten aus der europäischen Kulturszene in die Entwicklung von Kommunikations- und Produktkonzepten. So können wir eine offene und differenzierte Beziehung zwischen Marke und Verbraucher entstehen lassen.«[11]

»Wir arbeiten mit integrierten Kommunikations-Konzepten. Über die klassische Pressearbeit hinaus konzentrieren wir uns auf die Disziplinen Eventmarketing, Sponsoring, Trendmarketing, Brandrelation und strategische Beratung. [Um] eine Balance zu finden zwischen der Ansprache (sic!) eines Millionenpublikums und der gezielten Ansprache (sic!) von Zielgruppensegmenten. In beiden Fällen geht es darum (sic!) das Image von Produkten, Unternehmen und Dienstleistungen genauer zu profilieren und auf den gesellschaftlichen Wandel abzustimmen. Aus diesem Grund benutzen immer mehr unserer Kunden PR als vielfältiges Instrument [...] Wir sind ständig gefordert individuellere Formen der Zielgruppenkommunikation zu entwickeln und umzusetzen. [...] Betreuung | Durchführung | Eventsponsoring | Individualsponsoring | Markenkooperationen | Marktanalysen | Medienkooperationen | Sponsoring-Checklisten | Testimonials | Titelsponsoring | unterstützende Kommunikation (klassische Werbung) | Verhandlungen«[12]

»Movement Marketing ist eine Agentur mit Sitz in Berlin, die sich spezialisiert hat auf Public Relations im Bereich Sport- und Lifestyle-Marketing. Die Firma wurde 1998 gegründet, um das kreative Netzwerk und Knowhow anzubieten, das durch die Produktion des Magazins Lodown über die Jahre aufgebaut worden ist. Das PR-Angebot umfasst alle klassischen Dienstleistungen von Corporate PR und Produkt-PR, über Below the Line-Marketing-Aktivitäten, bis hin zu Messen/Events. Movement Marketing erstellt individuelle Kommunikationsstrategien, die sowohl klassische Werbung als auch innovative Below the Line-Marketing Strategien umfassen. Das globale Netzwerk aus Opinionleadern, Artists und kreativen Zellen ist dabei das Tool zur Umsetzung einer erfolgreichen und trendorientierten Markenführung.«[13]

[11] o.V.: CIRCLEcultureCc: | [12] o.V.: :: haebmau :: | [13] o.V.: ©2002 MOVEMENT MARKETING GMBH

Levis

Vans

Nike

Marok

Movement Marketing

Bianca

Circle Culture

Auftraggeber: Textilindustrie

Vermittler: Marketing-Agenturen

Medien: Protagonisten Institutionen Events Magazine

Smirnoff

Adidas

Johann

Häberlein und Maurer

Style & the Family Tunes

Lodown

Pfadfinderei

Spirit-Room

Diverse Events: Z.B. Jamel Shabbazz Ausstellung »Back in the Days«

Adidas Originals Store

Adidas Lounge

Berlin Industries

77

o.V.: :: haebmau ::

Vgl. o.V.: CIRCLEcultureCc:

o.V.: ©2002 MOVEMENT MARKETING GMBH

o.V.: ©2002 MOVEMENT MARKETING GMBH

o.V.: ©2002 MOVEMENT MARKETING GMBH

o.V.: ©2002 MOVEMENT MARKETING GMBH

Auf dieser Vernissage (und vielen anderen) wird Smirnoff Ice gratis ausgeschenkt. »Um (die) Lücke zwischen Industrie und Trendlocation zu schließen, werden in Berlin, Hamburg, Leipzig und Köln Smirnoff City Manager eingesetzt. Sie kommen selber aus der Zielgruppe und bekommen daher auch glaubwürdig Zutritt in die sonst eher verschlossenen outlets. Sie kennen ihre Stadt und Kunden und können sensibel auf die Bedürfnisse des Gastronomen eingehen.« (o.V.: :: haebmau ::)

seit Ausgabe 26 wechselnde Aufgaben: »contributing editor«, »office coordination«, »foreign affairs«... (Vgl. o.V.: Impressum, Lodown, (2001-2003) 26-31)

"Spiritroom Berlin Die Agentur Circle Culture hat in Zusammenarbeit mit Nike ein neues Showroom Konzept entwickelt" (o.V.: CIRCLEcultureCc:)

"Das Design wird saisonal von jungen Künstlern neu interpretiert. Hier ein Arbeitsbeispiel aus dem Spiritroom 1. Gestaltet von Pfadfinderei.com" (o.V.: CIRCLEcultureCc:)

"Stylisten, Fotografen und Journalisten können sich (im Spiritroom) über die neusten Kollektionen junger deutscher Avantgarde Designer und ausgefallene Kollektionen von Nike informieren." (o.V.: CIRCLEcultureCc:)

"Marok exhibits at nike spiritroom" Vgl. Circle Culture, Einladung zur Vernissage 2004

Die aufwendig gestaltete *Culture*-Kulisse wird bisweilen auch der Öffentlichkeit zugänglich gemacht: Ausstellungen von wichtigen Szene-Künstlern verleihen der Marke *Nike* Authentizität. Vernissage und ähnliche Events sind exklusiv, hier finden nur geladene Gäste – die »Protagonisten der kreativen Disziplinen« (o.V.: CIRCLEcultureCc:)

Vgl. o.V.: M Publication Volume 02 Luxury :: One _Night Exhibition :: Page 2,

"Mode/ Musik/ Kultur Redakteur bei Style & the Family Tunes Magazin" (o.V.: CIRCLEcultureCc:)

Vgl. o.V.: :: haebmau ::

Vgl. o.V.: :: haebmau ::

Diese Karte zeigt nur einen kleinen Ausschnitt des *Mitte*-Netzwerks der »Freunde«. Sie beschränkt sich dabei auf einen kleinen Kreis von Personen und Einrichtungen, um den Kontext ausgewählter Phänomene zu erhellen. Das tatsächliche Netzwerk ist viel größer. Zudem sind hier nur offizielle Verbindungen aufgezeigt, die wichtigsten Verbindungen hingegen sind privater Natur und/oder inoffiziell: Das »Individualsponsoring«[14], das beispielsweise die PR-Agentur Häberlein und Maurer auf ihrer Website anbietet, meint das Ausstatten von »gesellschaftlichen Leuchttürmen«[15] (sog. »Opinionleader« bzw. »Multiplikatoren«) mit Markenprodukten. Dazu bemerkt

ein individualgesponorter Multiplikator: »Das weiß ja kein Schwein. Das ist ja grad das Gute. Tatsächlich ist es so, dass die Sponsoren nicht möchten, dass wir bekannt machen, dass wir gesponsort werden.« Chris Häberlein beschreibt die Partner ihrer Agentur in einem Interview: »ein paar Shops, Veranstalter, Medien, Agenturen und Freunde, mit denen wir in ständigem Austausch sind. [...] Uns interessieren die Style-Leader und Opinion-Former, die Impulsgeber.«[15]

[14] o.V.: :: haebmau ::
[15] Grauel (2002), S.72

Mein Dank gilt
Cornelia Durka, Ralph Ammer, Moritz Gimbel.

Literatur und Quellen:
GRAUEL, Ralf (2002): Moden (er-)finden, in: Brand eins, 4. Jg.(2002), Heft 08
o.V.: :: haebmau :: <URL: http://www.haebmau.com>, online: 18.08.2004
o.V.: CIRCLEcultureCc:, <URL: http://www.circleculture.com>, online: 10.01.2004
o.V.: Editorial, Lodown 0, Heft 36
o.V.: M Publication Volume 02 Luxury :: One _Night Exhibition :: Page 2, <URL: http://www.m-publication.com/container/M&Nike/?pagenumber=2>, online: 18.08.2004
o.V.: ©2002 MOVEMENT MARKETING GMBH, <URL: http://www.movement-berlin.com>, online: 28.04.2003
Mönkemöller, Dirk: Dogtown and Z-Boys, in: Lodown (2002), Nr. 30, S. 19
TIMM, Tobias / DURKA, Cornelia: Das Fußvolk des Fun hat ausgedient, in: Süddeutsche Zeitung, Jg. 60, Nr. 104, 06.05.2004, S. 17

FLYERS ARE FOR ADVERTISING. A FLYER CARRIES THE DETAILS OF THE EVENT (LINE-UP, DATE, VENUE). IN CODED FORM, THE DESIGN COMMUNICATES INFORMATION THAT IS NO LESS IMPORTANT: IT IS A CALLING CARD. THE DESIGN OF THE FLYER VISUALIZES THE IMAGE OF THE EVENT. AND OF THE SPONSORS. THEIR LOGOS ARE ALSO ON THE FLYER. AND NOT ONLY THERE...

FOR MARKETING STRATEGISTS, FLYERS ARE OF NO REAL IMPORTANCE - IN CLUB CULTURE, PEOPLE ARE THE MOST IMPORTANT MEDIUM.

LEARNING FROM DISNEY WORLD

MITTE - THE (POP) CULTURAL SCENE CENTERED ON THE BERLIN DISTRICT OF THE SAME NAME - IS HIP, COLORFUL, STYLISH, AND FUN. MITTE FUNCTIONS LIKE A THEME PARK: A PERFECTLY DESIGNED, AESTHETIC WORLD THAT PROMISES AMUSEMENT AND BLOCKS OUT EVERYTHING ELSE. FROM THE VISITOR'S POINT OF VIEW, THEME PARKS LIKE DISNEY WORLD ARE CLOSED SYSTEMS, SMALL WORLDS WITH THEIR OWN RULES. FOR A THEME PARK, THERE ARE NO NEEDS IT CANNOT SATISFY - BECAUSE IT DEFINES ALL NEEDS.

CULTURE - THE THEME OF THE PARK

The term "theme" describes the role adopted by the visitor to a theme park by accepting its values and rules and by making use of the activities on offer. As a visitor to Disney World, one becomes an adventurer in a fairytale world; correspondingly, one can prove one's courage in ghost trains or log chutes. The theme in Mitte is "lifestyle producer" - the activities are culture, and they take place in clubs, shops, and cafés. They offer a credible feeling of being part of a thriving cultural scene, instill the airs and graces of a lifestyle producer, and provide corresponding opportunities for theatrical self-display.

CLIENTELE

Visitors to the Mitte theme park experience themselves as part of an elite; all activities suggest constant enhancement of social status. From the visitor's perspective, there is no distinction between staff and guests because all activities are designed to conceal this divide. The difference is a structural one. It is only a question of function for the owners: the visitors fuel the motor of the park. They are new in town, or belong to the huge group of people who only experience the theme park in mediated form. In return for high entry prices, they can take part in the activities or imitate the attitudes on display with the help of the latest merchandise.

STAFF

The Mitte hipsters live in the park. Unlike the staff at Disney World, who take off their Mickey Mouse outfits and return to the reality outside the park at the end of the day, they have totally devoted themselves to the habitus of the lifestyle producer – made a profession of having fun. For them, there is no longer a reality outside the theme park. The reward for an existence as a full-time walk-on and embodiment of other people's dreams is free entry and free merchandise. (The technical term for supplying "society beacons"[1] with brand items is "individual sponsoring".) The inhabitants of the Magic Kingdom are the »rank and file of amusement«[2].

MANAGEMENT

While the staff and the visitors live the life of the producer, the real producer of this lifestyle is the management. In constant consultation with the event organizers, the management shapes the theme park: marketing agencies like Circle Culture, Movement Marketing, and Häberlein & Maurer mediate between event organizers on the one hand and the staff and guests on the other. They allow club owners to define the theme and rules of the park without being perceived as a defining influence. In this process, the staff are a tool – opinion-formers are the key media for communicating values.

RULES

In any theme park, there are rules for participation in the activities. Whereas at Disney World, this usually goes not further than "use at your own risk", the rules in Mitte are more complicated: there are codes for dress and behavior for the various activities. Anyone who makes mistakes or has no gossip to contribute is excluded from the game. Things are all the more complicated because, unlike in Disney World, the rules are not written on huge signs next to the various attractions; instead, they have to be gleaned from various magazines as part of an ongoing process.

OWNERS

Theme parks are run to make a profit. This is achieved above all by sales of merchandise and refreshments. The owners of the Mitte theme park are therefore mostly large companies from the textiles and beverages sectors. In Mitte, as in Disney World, the owners' logos are everywhere. Their interests and the "mechanisms" described above, however, remain hidden from the visitors behind the brightly colored facades of the theme park, behind an air of aestheticist rebellion and a rhetoric of subculture. At this theme park, a look behind the scenes is not part of the package - which is why it is also not explicitly forbidden. The names in the imprints of the fashionable magazines give some idea of the network, and a quick Internet search leads to information about the role of these individuals at marketing agencies. Their language - aimed at potential clients - doesn't quite fit with the rhetoric of the theme park: the "network of opinion leaders, artists and creative cells constitutes a tool for implementing successful and trend-oriented brand management."[3] Once one penetrates the stylish surface, the institutions and players of the culture machine appear in the context of their structural function.

1 Grauel (2002), p.72
2 Timm / Durka (2004)
3 Author not named: ©2002 MOVEMENT MARKETING GMBH

IS SPONSORING
FLYER CULTURE?

Especially in the '90s, parties seemed to be totally wallpapered with the logos of various consumer brands. Big names from the New York scene like the jungle producers from Liquid Sky, led by DJ Soulslinger, went on extensive tours of Germany and Europe and the flood of logos in the clubs was devastating. Funds were provided for transatlantic flights, big advertising campaigns, all kinds of merchandise, and local promotion teams who tried everything to get hold of the addresses of the target groups. Some of the more expensive and elaborate flyers were milled, etched, punched and stamped. Whether or not the desired image transfer took place is open to debate. But they were certainly eye-catching. At the end of the millennium, when mega-events like the Love Parade and Nature One appeared as extreme cases of commercial partnerships with budgets and turnover in the millions, there was a break in the long-standing friendship between brands and organizers. The limits of growth had been reached. A formerly avant-garde scene became so mass-compatible that only mass brands were interested. A flood of energy drinks competed for the mainstream; fashion labels and shoe brands were replaced by beer mix drinks and alcopops. Unadulterated consumption and turnover were back. The luxury brands cooperated with special agencies and developed new strategies of "social engineering". The buzzwords were the search for "the man in the middle" and "networking".

NETWORKS CATCH FISH

The trend towards expermission marketing demanded a return to more credibility. Product placements in movies and television, usually associated with stars, and emotional event communication replaced the sum of smaller commitments at events. The focus shifted back towards other fields of culture including fashion and sport. Another important factor was the legislative restrictions imposed on the previously extensive sponsoring activities of tobacco companies and liquor manufacturers. Consumer-driven marketing, i.e. marketing where the images and sounds are supplied by the consumers, is a further development of the idea of viral marketing, the idea of a message being passed on from one user to the next. Guerilla methods of all kinds - from stickers through copy art, from one-to-one sales through VIP guest lists - were deployed in attempts to reach the trendsetters and opinion-leaders. In the marketing of club culture, all this is still going on.

In major urban centers, the ratio between work and leisure has changed. Districts like Berlin Mitte (where over 30% households have a monthly income under 700 Euro) have spawned 4-shift work models: first some freelancing, then a few hours serving drinks in a bar, and later a DJ session at an after hours party. The mornings are left for school, bureaucratic tasks, and other such duties in the life of the city-dweller.

Flyers are the fingerprints of temporary strategic business alliances; manifestations of a cultural event resulting from the parameters of space, content (audio, video, interior, performances), medium and contact. They document economies based on beer and barter, making them the bank statements of the scenes and their partnerships with media and brands.

Global brands like Nike hope that flyers will be able to get their message to "the places where conventional advertising cannot reach". In this case, flyers are tailor-made communications tools - for events targeted at creative, active people, people who make things happen.

The risk of sponsoring remains. Brands like Diesel say no to flyers and pay no money for logo placements. Organizations like Greenpeace withdrew their support for the Love Parade on ecological grounds. But they did act as partners for the "Ecosystem" drum'n'bass festival organized by Liquid Sky in the rain forest near Manaus, Brazil, that lasted several days. This festival was organized to comply with strict ecological guidelines. It raised worldwide awareness for the preservation of the rain forests. Some of the acts who played, including Air Liquide, bought several square kilometers of rain forest to save it from being cut down.

The modalities of give and take are not subject to precise rules. Running a popular club may hugely increase planning security and the likelihood of finding sponsors, but it is no guarantee. Nonetheless, good ideas and special events always have a chance of finding supporters. But the process of acquiring funds for this book, during which several hundred brands were asked to contribute, shows how difficult it can be even for such a straightforward and diverse project. The policies of the brands have become very narrow. Conservative attitudes and caution among even the most progressive decision-makers increase with the value of the brand in question. When it comes down to it, it's a "people business": in other words, your chances are hugely increased by knowing the decision-maker personally.

CAMPAIGNS

Royal Elastics Streetwise / Vans Warped Tour / Pash: The Wrong Festival / Heineken Thirst / Warsteiner Club World / Red Bull DJ Academy / Motorola Live Visual Award / Stabilo Lumina Tour 2004 / Lucky Strike Phat Vibes / Marlboro: The Pulse Network / West Millennium Lounge, nightclub / Camel Airrave and Private Club / Axe Voodoo Nights / Smirnoff Red Nights, Experience / Southern Comfort River Jam / Ritmo de Bacardi / Jägermeister Band Support / Pernod French Club / Finlandia Fresh Styles Approved / Absolut Streaming / Drum + Intro Festivalguide/ T-Mobil Electronic Beats / Mixery Music Camp / Coke DJ Culture / Levi's Engineered Sessions / New Yorker Official Dance Charts / TDK Dance Marathon und Time Warp/ Gauloises Cookin' Blue

Credits: NBI-Fries by Gösta Wellmer

FLYER LIFE CYCLES

WHO IS AFRAID OF A FRIENDLY CAPITALISM ??

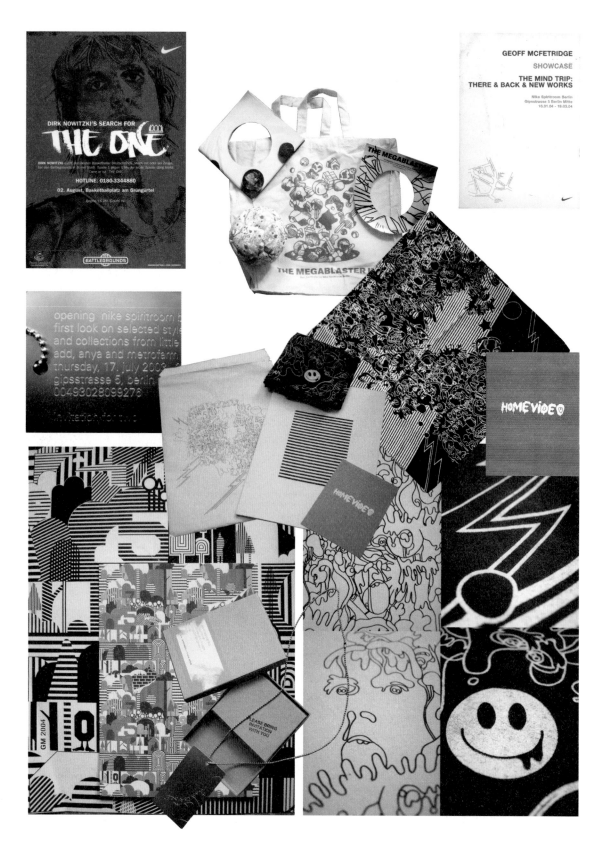

FLYER LIFE CYCLES

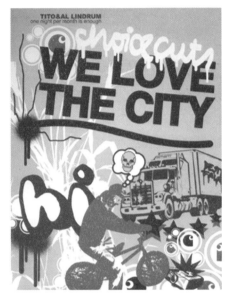

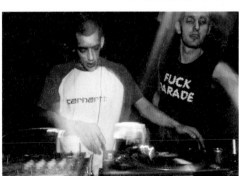

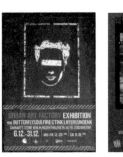

LINKS: Nike Einladungskultur
RECHTS: Carhartt Einladungskultur
Wolle E.I. und Wolle XDP im Tacheles, **FOTO:** Dirk Plambböck

IST SPONSORING FLYERKULTUR?

Gerade in den 90er Jahren schien es, als seien die Parties komplett überzogen von Logos diverser Konsumartikler. New Yorker Szenegrößen wie die Jungle-Produzenten des Liquid Sky, allen voran DJ Soulslinger, gingen auf umfassende Deutschland- und Europa-Tourneen und die Logoflut im Club war verheerend. Finanziert wurden transatlantische Flüge, umfassende Werbekampagnen, Merchandise aller Art und Promotionsteams vor Ort, die alles versuchten, die Adressen der Zielgruppen zu erheischen. Einige der aufwendigsten und teuersten Flyer wurden gefräst, geätzt, gestanzt und geprägt. Ob der gewünschte positive Imagetransfer eintrat, sei dahingestellt. In jedem Fall fiel man auf. Als Ende des Jahrtausends mit Großveranstaltungen wie der Loveparade oder Nature One Extremfälle kommerzieller Partnerschaften mit mehreren Millionen Budget und Umsatz auftraten, erfolgte ein Bruch in der lange praktizierten Marken- und Veranstalterfreundschaft. Die Grenzen des Wachstums waren erreicht. Eine vormals avantgardistische Szene wurde so mehrheitskonform, dass nur noch Publikumsmarken Interesse hatten. Die Flut von Energiegetränken konkurrierte um den Mainstream, Biermischgetränke und Alkopos lösten Modelabels und Schuhmarken ab. Purer Konsum und Umsatz zählten wieder. Die Edelmarken kooperierten mit Spezialagenturen und entwickelten neue Strategien des "social engineering". Die Suche nach dem "Man in the middle" und Networking waren die Schlagworte.

NETZWERKE FANGEN FISCHE

Der Trend hin zum Erlebnismarketing machte wieder eine größere Glaubwürdigkeit des Engagements notwendig. Die Productplacements in Film und Fernsehen, meist im Umfeld von Stars, und die emotionale Event-Kommunikation ersetzten die Summe kleinerer Engagements bei Veranstaltern. Es wurde wieder mehr auf andere Kulturbereiche wie Mode und Sport gesetzt. Nicht zuletzt der Gesetzgeber limitierte die Möglichkeiten vormals stark engagierter Tabakkonzerne und Spirituosenhersteller. Das "Consumer Driven Marketing", sprich Marketing, dessen Images und Sounds von den Konsumenten geliefert werden, erweiterte den Begriff des "Viralen Marketings", das auf die Weitergabe der Message durch die User setzte. Guerila-Methoden aller Art - vom Sticker bis zur Copyart, vom 'One to One' Vertrieb bis zur VIP-Gästeliste - versuchten die Trendsetter und Meinungsführer zu erreichen. So sieht es auch nach wie vor aus in der Vermarktung der Nachtkultur.

In den Metropolen hat sich das Freizeit-/Arbeit-Verhältnis gewandelt. Stadtteile wie Berlin Mitte (mit mehr als 30% Haushalten mit Einkommen unter 700 Euro) haben zu 4-Schichten-Lebensmodellen geführt: Nach dem Freelancen wird an der Bar gearbeitet und noch bei einer After Hour aufgelegt. Die Vormittage bleiben in der Hand der Schulen, Behörden und anderer Pflichten im Leben der Städte.

Flyer sind Fingerprints ökonomisch relevanter strategischer temporärer Allianzen; sozusagen Manifestationen eines Kulturereignisses, das sich durch die Parameter Raum, Beiträge (Audio, Video, Deko, Aktion), Medium und Kontakt ergibt. Sie dokumentieren Bier- und Tauschökonomie und sind damit die Kontoauszüge der Szenen und ihrer Partnerschaften mit Medien und Marken.

Global Brands wie Nike setzen ihre Erwartungen in der Flyerkommunikation auf das "dort, wo klassische Werbung nicht hinkommt". Hier sind Flyer maßgeschneiderte Kommunikationsmittel - für Events, die sich an die Kreativen, Aktiven und Macher richten.

Das Risiko beim Sponsoring bleibt. Marken wie Diesel sagen nein zu Flyern und zahlen kein Geld für Logoplacements. Organisationen wie Greenpeace zogen sich von der Loveparade aus ökologischen Gründen zurück. Trotzdem waren sie Partner bei dem von Liquid Sky organisierten mehrtägigen Drum'n'Bass-Festival 'Ecosystem' im Regenwald bei Manaus, Brasilien. Das Festival wurde streng nach ökologischen Kriterien ausgerichtet. Es wurde weltweite Awareness geschaffen für den Erhalt des Regenwalds. Einige der dort auftretenden Künstler wie Air Liquide haben sich mehrere Quadratkilometer Regenwald gekauft, um diesen vor Rodung zu schützen.

Den Modalitäten des Geben und Nehmens ist kein genauer Rahmen gesetzt. Einen populären Club zu betreiben, steigert die Planbarkeit und Wahrscheinlichkeit Sponsoren zu finden zwar sehr, Garant ist es keiner. Trotzdem haben gute Ideen und spezielle Ereignisse immer ihre Chance Unterstützer zu finden. Die Akquise für dieses Buch, bei der mehrere hundert Marken aufgefordert wurden zu unterstützen, zeigt aber, dass selbst ein so klares und vielfältiges Projekt schwer zu vermitteln ist. Die Policies der Marken sind sehr eng geworden. Die konservativen Haltungen und die Vorsicht selbst progressiver Entscheider steigen mit dem Wert der Marken. Im Einzelfall ist das Ganze ein "people's business": soll heissen - den Entscheider persönlich zu kennen steigert die Chancen ungemein.

KAMPAGNEN Royal Elastics Streetwise / Vans Warped Tour / Pash: The Wrong Festival / Heineken Thirst / Warsteiner Club World / Red Bull DJ Academy / Motorola Live Visual Award / Stabilo Lumina Tour 2004 / Lucky Strike Phat Vibes/ Marlboro: The Pulse Network / West Millenium Lounge, Nachtclub / Camel Airrave und Private Club / Axe Voodoo Nights / Smirnoff Red Nights, Experience / Southern Comfort River Jam / Ritmo de Bacardi / Jägermeister Band Support / Pernod French Club / Finlandia Fresh Styles Approved / Absolut Streaming / Drum + Intro Festivalguide / T-Mobil Electronic Beats / Mixery Music Camp / Coke DJ Culture / Levi's Engineered Sessions / New Yorker Offical Dance Charts / TDK Dance Marathon und Time Warp / Gauloises Cookin' Blue

AGENTUREN Häberlein und Maurer / Schröder und Schömbs / Mainhattan Media / Avantgarde / Megacult / Die Brut / Ideenhaus / Krauts PR / VOK DAMS Gruppe

NBI FRIES

ON THE PSYCHOLOGY OF THE FLYER: WHAT MAKES A SUCCESSFUL FLYER?

by Jana Bendig

"THEY'RE GOING LIKE VULTURES FOR THEIR PIECE OF FLYER (CULTURE)..." For this to happen, a flyer should ideally suggest the fulfilment of all urges and desires. This includes eating, drinking, dancing, music, beautiful subjects of the other or the same sex, naked skin and lots of sex - briefly: everything, that everyone wants in their 'wishful dreams' at night, and all this at one place. At least that would be the deep-psychological interpretation according to Freud.

Certainly we should ask the question if there is much to designing an effective flyer, or not. If we examine them more closely it is clear that a lot more is involved than just the fulfilment of desire.

While researching I was told that "a flyer can only be good if the party's good". You can't argue with that, but isn't the exact opposite also true? Where do the interesting people that you can party with come from, if not through interesting advertising?

And how can you grab other people's attention? To air this secret, we can analyse flyers on various levels: on a language-psychological level; on the level of processing of information; the awareness and use of colour; the use of tricks; and on the level of their effectivity.

TO BE BRIEF IS BEST According to Arnold Langenmayer in his book on the psychology of language, "four dimensions of compre hensibility" are relevant. The first, and according to research the most important dimension for the clarity and the retainment of information, deals with sentence construction and the choice of vocabulary. Both should be kept as simple as possible, e.g. by using short and common terms and phrases. It should also be noted that these terms should not be "thrown together" senselessly.

A logical connection between the words should be noticeable. This can be supported, for example when listing things on a flyer, through brief points, general clarity and the visual signposting of related points.

Because flyers do not offer very much space for elaboration, and as they are not even meant to fulfil this function, the third dimension as described by the author is relevant when it comes to the design.

To provide a quick overview of information, forceful and conspicuous expressions should be used. It is also a good idea to concentrate on only the most necessary details and at the same time to preempt all questions that the consumer could ask through as few answers as possible.

THE "ICING ON THE CAKE" REGARDING LANGUAGE USE The crowning achievement for a flyer is when humour, emotion, and examples taken from everyday (club)life are all used in the wording. Encouraging opinions as well as exciting questions, whose answers are left open, also have a stimu-

lating effect. In this way the reader will maybe not only check to see if something is "hidden" behind the positive message, but at the same time he is encouraged to try his luck.

Advertising works best on the buying-decisions of the consumer when his attention is caught and her feelings are aroused through the content, and when references are made to known themes. Five word sentences, headlines and pictures as well as the avoidance of ambiguities help influence the reader successfully. In wordlists, verbs are less easily remembered than nouns. If the text is meant to be noticed while being connected with something particular, then the characters can be made to be pictorial - e.g. a name of a drink could be written in the form of a bottle. In this way, the item will get noticed and will be unmistakable.

"The amount of information is the extent of uncertainty that can be removed through an event (a statement)"

PROCESSING OF INFORMATION AND GETTING NOTICED We have seen how language gets quickest into the reader's head and how it remains there for the longest time. Some of the previous points and the reasons to take notice of them will become clearer when I show here how the brain processes information. While doing this I wish to concentrate on whether a particular idea or framework supports the process of processing the information, or if a pure listing of points could just as easily be "inputted".

"The more a human being can sort what is observed via a detailed enough information processing system, the more he or she is capable of enjoyment. To this also belongs that he or she is able to differently name the observations."

THE CREATION OF "NETWORKS" IN THE BRAIN THROUGH THE INFLUX OF DATA Firstly, information from the environment is absorbed through the senses. When the consumer holds a flyer in the hand, differing impressions affect him, like when counting through a list. She reads the text, sees the colours and feels the material, i.e. the absorbment is "data-led".

The interpretation of this data happens step-by-step and beginns with the conversion of physical energy into psychological or mental forms - impressions from the senses are turned into nerve impulses that can be understood by the brain. These impulses are then transferred via the synapse which serve as a junction for the nerve cells. These synapse networks are better- or worse-appointed when relating to particular themes, according to the usage or training of the head.

SELECTION OF DATA VIA CONCEPTS AND IDEAS If you think about it, it is clear why connections between the flyer content and everyday (club)life are to be recommended. When the brain notices something that is already known to it, the nerve cells react, in that they pass on the physical energy absorbed outside. If only unknown and new data enters the head, this data cannot be sorted to any of the synapse connections and therefore none of the networks can be extended. In this way the information remains useless.

Apart from this, these knowledge also shows that the brain makes selections and makes consequential decisions, i.e. it is "driven by ideas and concepts". The more ideas

and optical attraction that are put into a flyer, the more connections that can be made inside the head. It is particularly advantageous when a stored memory can be called up. The episodic memory stores events and incidents from our lives and if these are brought back through certain signals, the highest emotional reaction is caused. It isn't said for nothing that you learn best through your own experiences and that you are most interested in facts that personally affect you.

"It is easier to decide if an image agrees with information contained in a sentence if the words contain a confirming statement. Negative and/or passive sentences make processing information more difficult. Language is a bridge when it makes easier the naming of images and their recognition."

THE ABSORBTION AND PERCEPTION OF IMAGES "I'm a really visual person - there has to be a picture and I don't care what!" This is another sentence that I heard while researching. There is certainly a flood of flyers and a large bundle of them won't fit in a trouser pocket, so you have to decide which ones to take with you.

"Optical observation is quicker and easier than the decoding of verbal concepts as it is older: the talent to be able to simply identify pictures also explains the popularity of visual media forms and the emotional effect of images of faces."

CLARITY AND THE AGREEMENT OF FORMS Which aspects make a picture aesthetic or interesting? Kant said that people find beautiful what they find to be true. According to this, false promises won't lead very far.

Furthermore, illustrations are objects that can be interpreted in all cultures as being similar to another objects. To represent another object, the picture must be able to connected with something that is known (visual similarity alone is not enough).

In his book "A picture is more than a picture", Christian Doelker gives a number of "rules" for the absorbtion of pictures. These rules can help when designing a flyer.

The use of meaningless elements should be avoided, as they can distract the reader's attention from the most important things and also cause contradictions. It is confusing if, for example, a pedestrian crossing red-man pictogram is combined with the headline "Let's party!"

At the same time you should bare in mind that differing interpretations for various items can exist in other cultures· If you want to offer a roast hog at your party and you use such a picture to advertise this on your flyer, you shouldn't expect any vegetarians to come. If you then add to this the motto "Discovering moslem culture" then some people will doubt your sensiblity as well as your sanity. So you have to consider exactly which symbols and colours you use at the same time. If the word "stop" is presented in red ink, then the word "go" shouldn't be used in the same colour on the same flyer.

In psychological experiments different people gave certain geometric figures the same qualities. The tests showed that squares and circles work in opposite ways. A square represented expressions like sad, father, hate, hard, evil, dead and darkness. Following this, squares should not be used together with words such as happy, mother, love, soft, living and light, which you could do with a circle.

The layout of the illustrations and the text is also important. If you place two pictures alongside each other, not only is a connection created as far as the content is concerned, but this could also make an impression of contradiction or of comparison. Placing one picture below another is similar, though through this you could create kind of ranking. A visual or textual emphasis is only worth doing

with details that are of particular importance, otherwise this can lead to distraction or to the 'drowning' of other points.

A particular style is reflected as soon as a particular element appears on a flyer. You should either radically break with this style immediately, as otherwise continuity is expected, or keep with the style.

Doelker also writes that the picture idea can be increased through the effect of repetition. In this way "memorised pictures" are created. Such illustrations are reproduced so often, that despite the flood of pictures in today's society, they can be brought into mind just by naming them (Albert Einstein sticking his tongue out, Marilyn Monroe with her blown-up dress). These pictures are highly memorable and recognisable.

"Systems based on visual symbols are restricted to certain fields and are not suited to constitute a comprehensive picture-based language system. All attempts to develop a pictorial writing system based on a universal visual language collapse by necessity due to the stated restriction in their scope, unless such attempts wish to free themselves from the characteristics of pure visualisation. This is how writing developed."

PRESENTATION FORMS AND "PICTURE AREAS" If a picture stimulates the viewer's senses, e.g. through the emphasising of colour and light, a "picture of perception" is created. If the world is shown exactly as it is, then this is described as an "interface". A "symbolic picture" is created by mainly using symbols and figures that represent particular phrases or terms, and when producing an "expressionistic picture" a free and creative artistic process is used. When planning a flyer you can choose the presentation form that best represents the event. To conclude: the unity of illustration and information is the be-all and end-all. I would not connect a photo of a DJ with a particular style of music if his or her name isn't printed alongside it, because I couldn't recognise who it is and decide what they play. But if, by using this photo, you want to make a different statement that just using it to represent what it actually shows, then you should avoid "visual dead wood" that could push the meaning into another direction or direct the reader's attention away from the contents that you want them to notice.

AWARENESS OF COLOUR Text as well as pictures are produced using colour. Here I want to avoid talking about the reception of light and colour through the eyes, as it isn't in fact this course of events that is decisive regarding how the flyers are percieved, but instead the processes that follow. In other words, the eyes provide the brain with the raw materials, but to become aware of what is seen means that the information can be intrepreted.

"Colour is feeling. It is in the brain where colours come into being [...], colours that we project into the outside world. They are not objective components of visual light."

COMPLIMENTARY COLOURS When designing flyers, formal aspects can be emphasised through the use of colour. The theory of "counter oppenency" as developed by Eward Hering can be made your own. If you look at a blue area for a length of time and then look at a white surface, you see a yellow image. White and black, blue and yellow, and red and green are colours which clash with each other, which lead to a

colour oppenency mechanism, meaning that one colour will lead to a positive and the other to a negative reaction.

This mechanism evolved through time so we can find our way around our environment better.

"Complimentary colours which when placed alongside each other are allies and enhance each other, become enemies and destroy each other when they are mixed, even if only optically. A red bottle and a green bottle, when placed next to each other, enliven, but red dabs with green dabs between them just give an amalgamation which is grey and colourless."

MEANING OF COLOUR It depends on the feelings they represent as to whether colours harmonise with each other or if they conflict. As a rule, yellow represents jealousy, green means hope and nature, red - warning, life and love, violet - depression, and blue - cold, loyalty and freedom.

Goethe was of the opinion that green represented the unity of contradictions such as warm and cold. Kandinsky thought that the meaning of a colour changed according to how light or dark it appeared. For him, green embodied adaptability: a light green a complacent adaptation which isn't genuine; a medium green representing the need to fulfill the expectations of others and to achieve recognition through this; and a dark green equality of attitude and feeling. The colour blue, when dark, represents peace. A medium blue draws the observer into infintity and causes longing or nostalgia. The more lighter the blue is, the more indifference is associated with it. A meaning attributed to all shades of blue is one of divinity, of heaven.

This theory also makes clear why a colour can be classified quite differently. A further example is the colour red. Kandinsky intrepreted red on the one hand as representing affection, but on the other hand greed.

A good visualisaton of the feelings associated with different colours is the Runge's hexagram, which also makes clear that green and red, as well as blue and yellow do not find themselves next to, but opposite each other.

TRICKS OF PERCEPTION The senses do not only provide a connection to the outside world, but they also work as filters. It is not necessary to consume narcotics in order to outwit human perception and to create an effect of surprise - sometimes just a minimal knowledge of psychology is necessary.

POSSIBLE WAYS OF DECEIT Titchener's method of deception is marked out by the fact that equally-large circles seem to have different sizes thanks to the way they are arranged. Lines that are parallel to each other can, thanks to horizontal lines, seem to be slanted or diagonal (Zoellner's illusion). Rubin's vase-face illusion is made up of two faces opposite to each other, which together form the image of a vase. What is extraordinary is that you cannot acknowledge both the faces and the vase at the same time. If you are interested in tis theme and wish to use optical illusions, you should find out about the Ponzo illusion, the Hering illusion as well as Kaninza's triangle. It's certainly worth it, as these tricks do not only cause higher brain activity, but also more brain flexibility.

THE PURPOSE OF ILLUSIONS Experiments with apes have shown that primarily the viewer's favourite element is noticed in a picture which can be intrepreted in two different ways. Where a preference for faces exists, faces will be discovered first when seeing Rubin's vase-face illusion. There is therefore a higher chance that individual needs can be met.

The intensivity of nerve cell activity when viewing illusions can be compared with activities requiring significant concentration, even when you know the trick already and you expect to recognise a particular image within the double-meaning. A flyer that intends to trick the reader's perception is a bit 'different' and therefore receives continual attention. The painter Dalí is one who used the entire range of presenting double-meanings.

THE EFFECT ON THE MEDIA The human senses and the media can as much as each other both be described as "cristallisations in which the ability in order to percieve as well as the relationships of perception are organised". Therefore "media culture is always bound by the culture of perception".

"In the beginning there was the picture: before writing there was the cave mural; before articulated language there was the expression through mime; before the rational decision the mythical thought. Via the introduction of writing, the word overtook the picture. After the invention of the printing press the culture of the written word left the picture far behind it, for centuries. But the picture got back into the race again thanks to the the technical possibility of image reprodcution and distribution in the second half of the century."

WAYS TO AFFECT CONSUMER OPINION Convincing exclamations, advertising slogans, and propaganda should all be subordinate to a direct aim. Apart from following this rule, the design should also be bound to the use of facts, the truth and data. In advertising photography and in flyer culture it is possible to tailor images towards a clear intention and therefore to a single meaning. The consumer should not be offered empty promises and announcements.

The flyer-producer should put him- or herself in the shoes of the person being addressed and assume they are just as informed as the reader. When arranging a message the following questions should be considered: who? to whom? the historic situation? why? which effects? The richer the level of information / the number of flyers on offer, the more relevant individual needs and interests are when it comes to selecting what to read. Hectic visuals and verbal strain are to be avoided. Again the individuality of the singular person plays a role as the reserved prefer less 'incentives', whereas the open-minded look for as many impressions as possible.

As already said, media events best remain in memory when they can be related to things that have happened in our own lives. In the head, illustrations are related to our own biographies and political events to make a short story. Spaces, such as the famous three dots "..." are good to this effect - they can be filled with our own imagination,

Flyers can be tailored to a particular event or product and therefore place it in the centre of attention. They are not as time-consuming and work-intensive as newspapers or magazines. They also have a format that fits in the trouser pocket and can serve as a kind of reminder or notice-sheet.

POINTS TO NOTE WHEN DESIGNING FLYERS Before someone designs a flyer they should remind themselves once again of the most important points: the a medium's effect is based on the reader's individual reception, the symbols, the ability to assert when selecting what goes on to it, and its pragmatism. This can be reached on one hand on

the level of terms (statements, programme), on the other hand on the formal level (scale, intensity, emphasis). The producer should pursue the following steps while on the way to their statement: idea; conception; selection; research; formulation; presentation; formal representation; and layout. These abstract general rules are naturally only relatively valid in the praxis. An effect of distancing or alienation can come about by strictly ignoring them, which can lead it to be engraved on the reader's mind through their amazement. But beware! This creative principle of deviation can also go badly wrong.

Translation from the German: Matthew Heaney

please recount! and total black dots for al gore and white dots for g.w.bush. so important!

confirm your counting/totals to [V]ote-auction::
http://62.116.31.68 http://voteauction.sammy.org
brought to you by ubermorgen.com / SILVER SERVER

Are the horizontal lines parallel or do they slope?

How many legs does this elephant have?

FLYER LIFE CYCLES

ZUR PSYCHOLOGIE DES FLYERS

von Jana Bendig

ZUR PSYCHOLOGIE DES FLYERS: WAS IST EIN ERFOLGREICHER FLYER?

"Die Leute stürzten sich wie die Geier auf diesen Flyer ..."

Dafür sollte ein Flyer wohl die Erfüllung sämtlicher Triebe in Aussicht stellen. Dazu gehören Essen, Trinken, Tanzen, Musik, ansehenswerte Subjekte des anderen oder gleichen Geschlechts, nackte Haut und viel Sex – kurz: alles, wovon jede(r) nachts "wunschträumt" – und das an einem Ort. So wäre jedenfalls die tiefenpsychologische Deutung nach Freud.

Allerdings stellt sich die Frage, ob es wirklich eine Kunst ist, einen Flyer wirkungsvoll zu gestalten. Bei näherem Hinsehen zeigt sich: Es gehört schon noch einiges mehr dazu als Triebbefriedigung.

Während meiner Recherche sagte man mir: "Ein Flyer kann nur gut sein, wenn die Party gut ist." Abstreiten läßt sich das nicht, aber gilt das Gleiche nicht auch umgekehrt? Woher kommen die interessanten Leute, mit denen man zusammen feiern kann, wenn nicht durch interessante Werbung?

Und wie kann man die Aufmerksamkeit anderer "fesseln"? Um dieses Geheimnis zu lüften, können wir Flyer auf verschiedenen Ebenen analysieren: Sprachpsychologie, Informationsverarbeitung, Bilderaufnahme, Farbwahrnehmung, Wahrnehmungstricks und Medienwirkung.

IN DER KÜRZE LIEGT DIE WÜRZE

"Vier Dimensionen der Verständlichkeit" sind nach Arnold Langenmayers Lehrbuch über die Sprachpsychologie relevant.

Die erste und Untersuchungen zufolge auch wichtigste Dimension für das Verständnis und das Behalten von Informationen betrifft den Satzbau und die Wortwahl. Beides sollte man möglichst einfach halten, unter anderem durch Verwendung kurzer und geläufiger Begriffe.

Weiterhin ist zu beachten, dass diese Begriffe nicht sinnlos "zusammengewürfelt" werden sollten.

Ein logischer Zusammenhang sollte zwischen den Wörtern erkennbar sein. Das kann, z.B. bei Aufzählungen auf einem Flyer, durch knappe Hinweise, Übersichtlichkeit und die visuelle Kennzeichnung zusammengehöriger Punkte unterstützt werden.

Da der Flyer nicht allzu viel Platz für Ausschweifungen bietet und diese Funktion gar nicht erfüllen soll, ist auch die dritte durch den Autor dargestellte Dimension bei der Gestaltung von Belangen.

Um einen schnellen und guten Überblick über Informationen zu geben, sollte nach auffälligen und eindringlichen Ausdrücken gesucht werden. Außerdem wäre es ratsam, sich auf das Nötigste zu konzentrieren und alle Fragen, die sich dem Konsumenten stellen könnten, mit möglichst wenig Antworten "aus der Welt zu schaffen".

"SAHNEHÄUBCHEN" DER SPRACHGESTALTUNG

Die Krönung für einen Flyer ist, wenn man Witz, Emotion, aus dem (Club-)Alltag herausgegriffene Beispiele oder wörtliche Rede in die Formulierungen einbringt. Anregend wirken des weiteren aufmunternde Wertungen sowie anreizende Fragen, deren Beantwortung offen gelassen wird. Auf diese Art möchte der Leser vielleicht nicht nur prüfen, ob hinter der positiven Message "was steckt", sondern ist gleichzeitig dazu ermutigt, sein eigenes Glück zu versuchen.

Am besten wirkt Werbung auf die Handlungen der Konsumenten, wenn durch den Inhalt Aufmerksamkeit und Gefühle geweckt sowie Bezüge zu bekannten Themen errichtet werden. Fünf-Wort-Sätze, Überschriften und Bilder sowie die Vermeidung von Mehrdeutigkeiten tragen zu einer erfolgreichen Beeinflussung bei. Verben bleiben in Wortlisten schlechter im Gedächtnis als Substantive. Wenn Schrift auffallen und mit etwas Konkretem verbunden werden soll, kann man Schriftzeichen mit Bildlichkeit aufladen (z. B. den Namen eines Getränks in Flaschenform schreiben). Auf diese Weise wird Merkbarkeit und Unverwechselbarkeit erlangt.

"Informationsgehalt ist das Ausmaß an Unsicherheit, das durch ein Ereignis (eine Mitteilung) beseitigt wird."

INFORMATIONSVERARBEITUNG UND AUFMERKSAMKEIT

Wir haben gesehen, wie die Sprache am schnellsten in den Kopf des Lesers gelangt und wie sie dort am längsten bleibt. Einige der aufgezeigten Punkte und Gründe für ihre Beachtung werden deutlicher, wenn ich im Folgenden darauf eingehe, wie der Kopf Informationen verarbeitet. Dabei lege ich mein Hauptaugenmerk darauf, ob eine gewisse Idee bzw. ein Schema den Verarbeitungsprozess fördert oder ob eine reine Faktenaufzählung ebenso "eingänglich" wäre.

"Der Mensch ist umso genussfähiger, je mehr er das Wahrgenommene über ein hinreichend umfassendes Informationsverarbeitungssystem einordnen kann. Dazu gehört auch, dass ihm eine ausdifferenzierte sprachliche Benennung seiner Wahrnehmungen zugute kommt."

AUSBILDUNG VON "NETZWERKEN" IM KOPF DURCH DATENZUFUHR

Zunächst werden Informationen durch Sinnesempfindungen aus der Umwelt aufgenommen. Hat der Konsument einen Flyer in der Hand, strömen wie bei einer Aufzählung verschiedene Eindrücke auf ihn ein. Er liest die Schrift, nimmt die Farben wahr und fühlt das Material, d.h. der Aufnahmevorgang ist "datenbetrieben". Die Interpretation dieser Daten erfolgt etappenweise und beginnt mit der Umwandlung von physikalischer Energie in psychologische bzw. geistige Formen - Sinneseindrücke werden in Nervenimpulse umgewandelt, die das Gehirn verstehen kann. Übertragen werden diese Impulse über Synapsenverbindungen, die als Schaltstellen

für die Nervenzellen dienen. Je nach Gebrauch/Training des Kopfes sind diese Synapsennetze in Bezug auf gewisse Themen stärker oder schlechter ausgestaltet.

AUSWAHL DER DATEN DURCH KONZEPTE UND IDEEN

Wenn man sich dessen bewusst ist, wird auch deutlich, warum Zusammenhänge des Flyerinhalts mit dem (Club-)Alltag zu empfehlen sind. Nimmt das Gehirn etwas bereits Bekanntes wahr, reagieren die Nervenzellen, indem sie die von außen aufgenommene physikalische Energie "weiterreichen", bis sie letztendlich dort im Gehirn angelangen, wo Handlungspläne vorbereitet werden. Wenn ausschließlich fremde und neue Daten in den Kopf gelangen, können diese keiner der Synapsenverknüpfungen zugeordnet werden, wodurch auch keines der Netze ausgebaut werden kann. Auf diese Art bleibt die Information nutzlos[i]

"Es ist einfacher zu bestimmen, ob eine Bildaussage mit einer Satzinformation übereinstimmt, wenn der Satz eine bekräftigende Aussage enthält. Negative und/oder passive Sätze erschweren den Informationsverarbeitungsprozess. Sprache ist Brücke, wenn sie die Benennung von Abbildungen und deren Wiedererkennen erleichtert."

Es erschließt sich aus diesen Erkenntnissen außerdem, dass das Gehirn eine Auswahl trifft und Schlussfolgerungen zieht, d.h. es ist "ideen- und konzeptgesteuert". Je mehr Einfälle und optische Reize man in einen Flyer einbringt, desto mehr Verbindungen können im Kopf hergestellt werden. Besonders vorteilhaft ist es, wenn eine Erinnerung im episodischen Gedächtnis hervorgerufen wird. Das episodische Gedächtnis speichert Ereignisse und Begebenheiten eines Lebens. Werden diese durch bestimmte Signale vergegenwärtigt, ruft das die höchste emotionale Reaktion hervor. Es heißt schließlich nicht umsonst, dass man am besten durch eigene Erfahrungen lernt und sich eher für Tatsachen interessiert, die einen persönlich betreffen.

AUFNAHME UND WAHRNEHMUNG VON BILDERN

"Ich bin ein total visueller Typ und bin da auch nicht wählerisch - Hauptsache Bild!" Das ist ein weiterer Satz, der mir während meiner Recherche zu Ohren kam. Allerdings gibt es inzwischen eine Flyerflut, und es passt kein ganzer Stapel davon in eine Hosentasche, also muss man sich schon entscheiden.

ÜBERSICHTLICHKEIT UND ÜBEREINSTIMMUNG VON FORMEN

Welche Aspekte machen ein Bild ästhetisch bzw. interessant? Kant war der Meinung, dass die Menschen das schön finden, was sie auch wahr finden. Mit falschen Versprechungen kommt man demnach nicht weit. Darüber hinaus sind Abbildungen visuell wahrnehmbare Gestalten, die in allen Kulturen einem anderen Objekt als ähnlich gedeutet werden. Um ein Objekt zu repräsentieren, muss ein Bild dafür stehen bzw. mit etwas Bekanntem verbunden werden können (Ähnlichkeit allein reicht nicht). Für die Bilderaufnahme benennt Christian Doelker in seinem Buch "Ein Bild ist mehr als ein Bild" einige "Kodierungsregeln". Sie können bei der visuellen Gestaltung eines Flyers helfen. Der Einsatz von bedeutungslosen Elementen sollte vermieden werden, da sie die Aufmerksamkeit vom Wesentlichen ablenken und Widersprüche hervorrufen können. Verknüpft man z.B. ein rotes Ampelmännchen mit dem Aufruf: "Party can go!", ist das irreführend.

Dabei ist zu beachten, dass in verschiedenen Kulturen unterschiedliche Auffassungen herrschen. Wenn Du zum Beispiel auf Deiner Party ein Spanferkel anbieten möchtest und preist es auf Deinem Flyer mit einem Bild an, kannst Du keine Vegetarier als Gäste erwarten. Stellst Du das ganze dann auch noch unter das Motto "Einleben in die muslimische Kultur", wird manch einer an Deinem Verstand und Deiner Sensibilität zweifeln.

Man muss sich also genau überlegen, welche Symbole und Farben man zusammenbringen kann. Erscheint das Wort "Stop" in roter Farbe, sollte auf demselben Flyer nicht das Wort "Gehen" in der gleichen Farbe gehalten sein.

In psychologischen Untersuchungen teilten verschiedene Personen geometrischen Figuren die gleichen Eigenschaften zu. Die Tests ergaben, dass z.B. der Kreis und das Quadrat gegensätzlich wirken. So verkörperte das Quadrat Ausdrücke wie traurig, Vater, Haß, hart, böse, tot und dunkel. Man sollte diese Form demzufolge nicht mit Worten wie fröhlich, Mutter, weich, Liebe, gut, lebend und hell in Verbindung bringen, wie man es mit dem Kreis machen kann.

"Da die optische Wahrnehmung älter ist als die Entschlüsselung von verbalen Konzepten, funktioniert sie schneller und leichter: leichte Identifizierbarkeit von Bildern erklärt auch die Beliebtheit visueller Medien und die emotionale Wirkung bei Abbildungen von Gesichtern."

Wichtig ist auch die Anordnung der Bilder und Schriften. Wenn man zwei Bilder nebeneinander stellt, wird nicht nur ein inhaltlicher Zusammenhang geschaffen, sondern es könnte gleichzeitig den Eindruck eines Gegensatzes oder eines Vergleichs machen. Ähnlich ist es, wenn man Bilder untereinander setzt, wodurch eine Rangordnung entstehen könnte. Eine visuelle oder schriftliche Hervorhebung lohnt sich nur bei Einzelheiten, die von besonderer Wichtigkeit sind, da es ansonsten zu Überbetonung oder Ablenkung führen kann. Sobald ein Element auf einem Flyer erscheint, wird ein bestimmter Stil wiedergespiegelt. Es gilt, diesen entweder sofort radikal aufzubrechen, da ansonsten Kontinuität erwartet wird, oder den Stil beizubehalten.

Außerdem schreibt Doelker, dass man die Bildidee durch Wiederholungen steigern kann. Auf diese Weise sind "memorierte Bilder"[3] entstanden, die trotz der heutigen Bilderflut so oft reproduziert wurden, dass allein ihre Titelnennung genügt, um sie in Erinnerung zu rufen (Albert Einstein streckt Zunge raus, Marilyn Monroe mit aufgeblähtem Kleid). Diese Abbildungen verfügen über eine hohe Einprägsamkeit.

"Visuelle Zeichensysteme sind bereichsmäßig begrenzt und nicht geeignet, ein umfassendes Bildsprachsystem zu konstituieren. Sämtliche Versuche, Bildschrift aufgrund einer universellen Bildsprache zu entwerfen, scheitern zwangsläufig an der erwähnten Begrenztheit des Umfangs, es sei denn, sie vermögen sich vom reinen Abbildungscharakter zu lösen. Auf diesem Weg ist Schrift entstanden."

DARSTELLUNGSFORMEN UND "BILDBEREICHE"

Lenkt ein Bild die Aufmerksamkeit auf sinnliche Eindrücke, z.B. durch die Hervorhebung von Farben und Licht, entsteht ein "Wahrnehmungsbild". Bildet man die Welt genau so ab, wie sie ist, wird das als "Interface" bezeichnet. Durch die hauptsächliche Verwendung von Zeichen und Figuren, die bestimmte Begriffe repräsentieren, entwickelt sich ein "Symbolbild". Und den freien, kreativen Schaffensprozess wendet man bei einem "Ausdrucksbild" an. Beim Flyerentwurf könnte man die Darstellungsweise wählen, die am besten das Event repräsentiert. Zusammenfassend kann man sagen, dass die Einheit von Bildbereich und Informationsvergabe ausschlaggebend ist. So würde ich z.B. das Abbild eines DJs nicht mit einer bestimmten Musikrichtung verbinden, wenn der Name nicht daneben stehen würde, weil ich ihn gar nicht erkennen und einordnen könnte. Wenn man allerdings mit dem Bild etwas anderes aussagen will, als das, was es "in natura" darstellt, sollte man "visuellen Ballast vermeiden, der die Bedeutung in eine andere Richtung lenken oder die Aufmerksamkeit von dem beabsichtigten Inhalt abziehen kann (Retouchierung, Wahrnehmungssteuerung mittels Legende)".

"Farbe ist Empfindung. Erst im Gehirn entstehen Farben [...], die wir auf die Außenwelt projizieren. Sie sind nicht objektive Bestandteile des sichtbaren Lichts."

FARBWAHRNEHMUNG

Nicht nur Bilder, sondern auch Schriften werden mit Farbe gestaltet. Ich möchte hier auf die Darstellung der Aufnahme von Licht und Farbe durch das Auge verzichten. Letztendlich ist nicht dieser Vorgang, sondern sind die sich daran anschließenden Prozesse für den Wahrnehmungsvorgang entscheidend. Anders ausgedrückt: Das Auge versorgt das Gehirn mit den Rohmaterialien, doch Wahrnehmen bedeutet ihre Interpretation.

"[...] Komplementärfarben, die, nebeneinander angebracht, Verbündete sind und sich ge-genseitig steigern, sind Feinde und zerstören sich gegenseitig, wenn sie gemischt werden, und sei es nur optisch. Eine rote und eine grüne Fläche, wenn nebeneinandergesetzt, beleben sich gegenseitig, rote Tupfen mit grünen dazwischen ergeben ein Amalgam, das grau und farblos ist."

KOMPLEMENTÄRFARBEN

Bei der Gestaltung von Flyern besteht die Möglichkeit, formale Aspekte farblich hervorzuheben. So könnte man sich die durch Ewald Hering verfasste "Gegenfarbentheorie" zu eigen machen. Betrachtet man für eine gewisse Zeit ein blaues Feld und schaut dann auf eine weiße Fläche, erscheint ein gelbes Nachbild.

Weiß/Schwarz, Blau/Gelb und Rot/Grün sind antagonistisch wirkende Farben, die einen Gegenfarbenmechanismus auslösen, was dazu führt, dass auf die eine Farbe positiv und auf die andere negativ reagiert wird.[7]

Dieser Mechanismus hat sich im Laufe der Evolution entwickelt, um sich in der Umwelt besser zurechtzufinden.

BEDEUTUNG DER FARBEN Ob Farben miteinander harmonisieren oder einander ausstechen, hängt auch davon ab, welche Gefüh-le sie repräsentieren. Im Alltagsgebrauch steht beispielsweise Gelb für Neid, Grün für Hoffnung und Natur, Rot für Warnung, Leben und Liebe, Violett für Depression, Blau für Kälte, Treue und Freiheit.

In der Forschung vertrat z.B. Goethe die Ansicht, dass Grün eine Vereinigung von Gegensätzen wie warm und kalt repräsentiert. Für Kandinsky änderte sich die Bedeutung einer Farbe, je nachdem, wie hell oder dunkel sie erscheint. Grün verkörperte für ihn Anpassungsfähigkeit. Ein helles Grün ist dabei eine selbstgefällige Anpassung, die nicht ehrlich gemeint ist. Ein "mittleres" Grün steht für das Bedürfnis, den Erwartungen anderer zu entsprechen und dadurch Ansehen zu erlangen. Das dunkle, für Kandinsky höher gestellte Grün repräsentiert eine gleiche Gesinnung und Übereinstimmung. Die Farbe Blau symbolisiert Ruhe, wenn sie dunkel gehalten ist. Das "mittlere" Blau zieht den Betrachter ins Unendliche und ruft Sehnsucht hervor. Je heller das Blau wird, desto mehr Gleichgültigkeit wird damit verbunden. Eine Bedeutung, die allen Blautönen zukommt, ist das Himmlische. Diese Theorie macht auch deutlich, warum eine Farbe ganz unterschiedliche Zuordnungen haben kann. Ein weiteres Beispiel dafür ist Rot, das Kandinsky einerseits als Zuneigung, andererseits als Gier interpretiert.

Eine gute Darstellung der Gefühle bzw. Geschlechter, die mit Farben verbunden werden, ist das Farbenhexagramm von Runge, in dem auch deutlich wird, dass Grün und Rot, sowie Blau und Gelb nicht nebeneinander liegen, sondern einander gegenüberstehen.

"Am Anfang war das Bild: Vor der Schrift das Felsbild, vor der artikulierten Sprache der mimische Ausdruck, vor der rationalen Überlegung die mythische Vorstellung. Mit der Einführung der Schrift überholte das Wort das Bild. Mit der Erfindung des Buchdrucks ließ die Kultur der Schriftlichkeit das Bild für Jahrhunderte hinter sich. Mit der technischen Möglichkeit der Bildreproduktion und verbreitung wechselte in der 2. Hälfte unseres Jahrhunderts das Bild erneut auf die Überholspur."[3]

WAHRNEHMUNGSTRICKS

Die Sinne stellen nicht nur eine Verbindung zur Außenwelt dar, sie dienen auch als Filter und sortieren Reize aus. Man muss keine Drogen konsumieren, um die menschliche Wahrnehmung zu überlisten und einen Überraschungseffekt zu erzielen. Manchmal genügt ein wenig Wissen über Psychologie.

TÄUSCHUNGSMÖGLICHKEITEN

Die Titchener-Täuschung zeichnet sich dadurch aus, dass durch verschiedene Anordnung Kreise mit der gleichen Größe unterschiedlich groß wirken. Linien, die parallel zueinander stehen, können durch Querstriche schräg wirken und somit die Zöllnersche Täuschung bilden. Wenn zwei sich gegenüberstehende Gesichter in der Mitte eine Vase formen, wird das als Rubins Kippfigur bezeichnet. Bemerkenswert ist dabei, dass man z.B. die Gesichter und die Vase nicht gleichzeitig wahrnehmen kann. Wer sich für dieses Thema interessiert und Täuschungen anwenden möchte, sollte sich auch mal nach der Ponzo-Täuschung, der

Heringschen Täuschung und dem Kanizsa-Dreieck erkundigen. Lohnen würde es sich, da durch diese Tricks nicht nur eine höhere Gehirnaktivität, sondern auch Flexibilität hervorgerufen wird.

SINN UND ZWECK DER TÄUSCHUNGEN

Experimente mit Affen haben gezeigt, dass in einer doppeldeutigen Abbildung vorrangig das Lieblingselement wahrgenommen wurde. Das bedeutet, dass z.B. bei einer Vorliebe für Gesichter diese auch zuerst in Rubins Kippfigur entdeckt werden. Es besteht also eine größere Chance, individuelle Bedürfnisse zu erfüllen.

Die Intensität der Nervenzellentätigkeit ist bei Täuschungen mit der Aktivität bei gezielter Konzentration zu vergleichen, vor allem dann, wenn man den Trick bereits kennt und schon erwartet, ein bestimmtes Bild in der Doppeldeutigkeit wiederzuerkennen. Ein Flyer, der die Wahrnehmung austricksen möchte, ist "ausgefallen" und erhält dauerhafte Aufmerksamkeit. Die Vielfalt einer doppeldeutigen Darstellung verwendete z.B. der Maler Dali.

MEDIENWIRKUNG

Die menschlichen Sinne und die Medien können gleichermaßen bezeichnet werden als "Auskristallisierungen, in denen sich das Wahrnehmungsvermögen und die Wahrnehmungsverhältnisse organisieren." Folglich gilt: "Die Kultur der Medien ist immer an die Kultur der Wahrnehmung gebunden."

Flyer kann man direkt auf ein bestimmtes Event oder Produkt ausrichten und es somit in den Mittelpunkt stellen. Sie sind nicht so zeit- undarbeitsaufwendig wie Zeitungen oder Zeitschriften. Außerdem haben sie Hosentaschenformat und können als eine Art Merkzettel dienen.

MÖGLICHKEITEN, AUF DIE MEINUNG VON KONSUMENTEN EINZUWIRKEN

Überredende Äußerungen, Werbebotschaften und Propaganda sollten einer direkten Intention untergeordnet sein. Die Gestaltung sollte nicht nur dieser Absicht folgen, sondern auch an Faktizität, Wahrheit und Daten gebunden sein.
In der Werbefotografie und der Flyerkultur ist es möglich, Bildinhalte auf eine eindeutige Absicht und damit auf eine ausschließliche Bedeutung auszurichten. Der Konsument sollte nicht mit leeren Versprechen und Ankündigungen hingehalten oder unterfordert werden.

Der Produzent wäre gut beraten, wenn er sich in die Lage des Adressaten versetzt und von dessen Informationsstand ausgeht. Bei der Gestaltung einer Botschaft sind die Fragen: Was? An wen? Historische Situation? Welche Intention? Welche Effekte? zu beachten. Je reichhaltiger der Informationsgehalt/die Flyerflut ist, desto mehr zählen individuelle Bedürfnisse und Interessen bei der Selektion. Hektische visuelle und verbale Strapazen sind zu vermeiden. Hier spielt auch wieder die Individualität des Einzelnen eine Rolle, da zurückhaltende Menschen weniger "Ansporn" bevorzugen, während aufgeschlossene Menschen nach möglichst vielen Eindrücken suchen. Am besten bleiben Medienereignisse in Erinnerung, wenn sie, wie bereits erwähnt,

mit eigenen Lebensstationen in Verbindung gebracht werden können. Abbildungen werden im Kopf mit der eigenen Biographie und politischen Ereignissen zu einer kleinen Geschichte verbunden. Gut sind dahingehend Leerstellen, die berühmten drei Punkte "...", die man mit der eigenen Phantasie und Vorstellung ausfüllen kann.

ZU BEACHTENDE SCHRITTE UND PUNKTE BEI DER FLYERGESTALTUNG

Bevor jemand einen Flyer entwirft, sollte er sich noch einmal die entscheidenden Punkte ins Gedächtnis rufen: Die Wirkung eines Mediums basiert auf der individuellen Aufnahme, den Symbolen, seiner Durchsetzungsfähigkeit bei der Selektion und seiner Pragmatik. Sie ist zum einen auf der Ebene von Begriffen (Aussagen, Programme), zum anderen auf der formalen Ebene (Dauer, Umfang, Intensität, Hervorhebung) erreichbar. Der Produzent sollte die Schritte Idee, Konzeption, Selektion, Recherche, Formulierung, Darstellung, formale Repräsentation und Platzierung auf dem Weg zu einer Aussage verfolgen. Diese abstrakt genannten allgemeinen Regeln haben in der Praxis natürlich relative Gültigkeit. Durch ihre strikte Nicht-Beachtung kann man einen Verfremdungseffekt erzielen, der durch Verwunderung zur Einprägsamkeit führt. Aber Achtung: Dieses kreative Prinzip der Abweichung kann auch total schief gehen.

LEBENSZYKLEN DER FLYER

FLYERS – A USER'S GUIDE

by Jürgen Laarmann

For an events organizer, the ideal situation is when a club is so hip that no advertising of any kind is required, with huge crowds of eager party people forming outside as soon as the doors open, regardless of what's going on inside.

The understatement of hit clubs that do without any kind of printed advertising is also appreciated by insiders on the scene. By only advertising via itself and its clientele, a club becomes more exclusive; the opposite is true of clubs that try hard to gain more visitors by means of big promotion campaigns.

Only very view venues have this exclusive status, and even they sometimes inform their choosy clientele about program highlights and special events.

Club advertising usually consists of flyers that are handed out or sent by post, sometimes by e-mail, sometimes printed in the relevant magazines. Flyers are especially important for one-off events or new locations, club nights, or events where even the local regulars have no real idea what to expect.

Flyers tell the reader a great deal about the nature of the event in question. Beyond details of when/where/who, it provides an appetizing vision of what might happen at the party. Flyers are sometimes more than just advertisements, they are calling cards for the organizer and may even be artworks, statements or documents of their time.

Among connoisseurs, the saying goes: "bad flyer, bad party": an organizer who can't even communicate their party vision in positive form on the flyer probably won't be capable of organizing an appealing party - a suspicion that is often confirmed. If the flyer is ugly and outmoded, it can be interpreted as a lack of respect for the aesthetic sensibility of the scene that it wishes to serve. Organizers who appear so inconsiderate will be subject to all kind of other doubts, especially that the party has just as little to offer. And that there is no need to be there.

Conversely, a good flyer by no means guarantees a great party. Flyers and announcements with especially elaborate designs raise great expectations, and these must be satisfied. It's a shame for all concerned when the best thing about a party was the flyer.

The timing and mode of delivery of a flyer already tell the recipient a great deal about the event in question, the aim being to assess whether it is a more or less exclusive ticket-like pass, a binding personal invitation, or a non-binding announcement.

So if you are approached by a nice young man in the pedestrian zone of Ibiza Town and given a personal party invitation featuring the young man's name and an offer of paying 5 Euro less on the door, there's no need to imagine you've found a new friend. This is how the nice young man earns his money, and he will usually be paid the same amount you save as a commission. It's a simple fact that disco advertising inhabits a gray zone between generous hospitality and daylight robbery.

When assessing a party in advance, it is advisable to check who else is invited. Were the flyers sent by post? Did you receive it in a club from a promoter? Did the promo-

tion team give everyone the same flyer, or did they make a selection? Or was there a box of flyers lying around in a nearby ice cream parlor? If the flyer suggests that it will be a particularly exclusive party, such random mass promotion hardly adds to the claim's credibility.

When you get your flyer also says a lot. If it arrives in a hectic rush on the day before the event, you can't help thinking that the organizer and his crew are afraid (maybe rightly so) that the place will be very empty. One exception is if the event is being announced at such short notice for a good reason. It is dubious if an event that clearly offers no particular highlights is announced over a month in advance. The person assessing the flyer thinks: these people are incompetent beginners who are worried that no one will come, which could well be the case, since by the time the party rolls around, everyone will have forgotten all about it.

The art of telling in advance from flyers how good a party will be and what will actually happen there depends on being able to identify scams and interpret correctly. Here are some examples of what flyers promise, and what it actually means:

NAME OF A DJ OR STAR + "SURPRISE ACT" AND/OR "SPECIAL GUEST"

Only in the very rarest of cases does this mean the organizer has dreamed up some great surprise that will bring tears of joy to the eye, especially if entrance is being charged for the event. Why would he/she not mention something that might make someone want to come? The same applies for any special guests not identified in more detail. The organizer has no idea who it is, and the partygoer will never find out either. It just sounds better than "We still don't know who else might play apart from the DJ who's already on the flyer, but we hope you'll come anyway!"

NAME OF A MAJOR STAR WHO IS GIVING A CONCERT SOMEWHERE NEARBY EARLIER THE SAME EVENING + "AFTER SHOW PARTY!"

Those who naively think this means Robbie Williams will be having a ball with his favorite fans at this club after his concert might just be wide of the mark. What the organizer wants is to give people who were at the concert and who can't get enough, and maybe those who didn't get tickets, another party option. How generous! Even when the flyer says "Official After Show Party", not much more should be expected. Maybe a few people from Robbie's record company will be there, someone from the local concert agency, and a few roadies when their work is done. If Robbie really does turn up later on, then you know your club really is the place to be.

NAME OF AN UNKNOWN DJ + FAMOUS PLACES (E.G. "DJ PEPE – BERLIN, NEW YORK CITY, CHICAGO")

One popular strategy involves enhancing the image of unknown DJs on flyers by naming them together with cities worldwide, which means nothing. You can rest assured that DJ Pepe was NOT born in New York City, did NOT train as a electrician in Chicago, did NOT flee the drug police to Berlin, where he has NOT been known to play Saturday mornings in an exclusive fashion boutique. Whenever cities are overemphasized, it raises the suspicion that the organizer is trying to cover up the provincial character of the event. For a good artist, the name is usually enough - or do tickets for Madonna shows say "(Detroit)" after her name?

NAME OF AN UNKNOWN DJ + NAME OF A WORLD FAMOUS CLUB (E.G. "DJ PEPE - PACHA IBIZA")

Even inveterate connoisseurs of the Ibiza music scene need not doubt their knowledge if they see a

flyer announcing a big DJ they've never heard of. This happens often enough, especially where definitions are deliberately vague. Maybe Pepe really did visit Ibiza once, and perhaps he really did work at Pacha. Once, for two hours, as an opener. Or as a barman? If you're tolerant enough, you find that no one ever lies.

NAME OF DJ OR STAR + "TBC" (PROBABLY IN SMALL PRINT)

TBC means "to be confirmed". In other words, when the flyer was printed, the organizer had not yet received final confirmation that the star really was coming. And there is no way of knowing whether the star will turn up. Maybe the organizer just left a message on his/her voicemail and then thought it was too cheeky to promise partygoers that he/she would come. Or the organizer is afraid of legal repercussions and angry, disappointed people asking for their money back. It is advisable to give the organizer a call on the afternoon before the party, although even this is no sure guarantee.

(Just because he/she says "DJ Spinny is booked, we're just picking him up from the airport" doesn't mean you won't be told at the club that "DJ Spinny is an asshole. He totally blanked us. We booked his flight and paid half his fee in advance. But hey, good old DJ Norbert plays good music too. Your money back? No way!")

"NO.1 CHART ACT"

If you have never heard of the act that is being promoted, it is worth remembering that there are countless charts. Various dance charts, college radio charts, the hitlist from the local radio, or the event organizer's list of personal favorites.

TOO MANY NAMES OF STARS/DJS/LIVE ACTS

Too many DJ names usually means a festival. If the event in question is only a club night, the organizer has either a) overbooked, b) committed his fantasies to paper or c) you can get the actual line-up by crossing out all the famous names. This trick is a good way of avoiding disappointments. The organizer may not have meant that the stars will be present, but simply that their records will be played ...

PARTY DESCRIBED USING ONLY THE NAME OF A HAPPENING MUSICAL STYLE WITH NO ARTISTS/DJS OR NAMING EVERY CONCEIVABLE STYLE

Although the flyer focuses on music, the music itself is of little importance. How nice that the village hall is hosting a "trance" party. Or that DJ Trippi will treat you to his mix of trip hop, oldies, rap, disco-soul, charts and glam rock.

"LABEL NIGHT"

A record label is making waves. With an outstanding act that is storming the charts or, more often, the underground scene. Reason enough for a celebration. But it is worth checking if the star/crowd-puller is actually on the bill, or if this is merely being suggested. Most events of this kind only feature the star's less successful label-mates, giving them a chance to stand in the strobe light for a change. Understandably, the star is somewhere else, giving

a concert or doing a promo tour. Partygoers can listen to the other acts that are making trouble for this small label, and which might have bankrupted it already, if the star in question - who, as we said, is not here today - had not come along.

"ANNIVERSARY"

Great! This club has been around for ten years. Partly thanks to the many nice people who have coughed up the 10 Euros entrance fee every Saturday. Now, at last, they are getting the thanks they deserve. Unfortunately, admission is 25 Euro.

Sounds bad, but it happens. The really nice thing about anniversaries is that a success story is being celebrated with all those involved. This often means a big line-up and lots of treats, surprises and extras. Depending on the organizer and the venue, this can range from a couple of balloons dangling from the ceiling through champagne, top stars and limousines.

"BIRTHDAY"

It's great to be invited to an elaborate birthday party. Not least because it's never easier to guess who you're going to meet than at a birthday party for a close friend or well-known personality. If the flyer announces the birthday party of someone unknown, this very rarely means that everyone is invited for free food and drink anyway, even if admission is more expensive than usual. It is more likely to mean that a privileged group will share the venue with the mob, enjoying reduced prices thanks to tokens or armbands while the rest are just there to make up the numbers. The host obviously couldn't afford to hire the venue for a private party. Instead, the party announces a birthday, allows the ten best friends of the birthday boy/girl to drink for free, and lets the club owner make the usual profit off the rest.

"BENEFIT"

A party for a good cause - lovely! But on the evening itself, asking for explanations of how the benefit works and how much money is going to the organization it is supposedly in aid of might make you unpopular with the organizers.

"EVENING DRESS"

On some occasions, evening dress is a matter of course. But if evening dress is demanded at a disco that previously accepted casual dress, suspicion is called for. The organizer wants nothing more than a sophisticated clientele. In other words, known criminals in brogues are welcome, and ladies in dime store miniskirts are more likely to get in than women in Prada trousers. The legendary concept of "evening dress" is almost more flexible than that of "dress to dance". People who dream up this kind of door policy believe in the rule that trainers mean less violence than slip-on shoes with white socks - which in reality has often proved untrue.

"FETISH OUTFIT"

If everyone turns up in a rubber suit and a gasmask, then no one is keen on voyeurs who come without. If you are reminded of this at the door and denied entry, it is wise to back down without protest and go in search of an alternative. Or face the interesting challenge of finding the requisite rubber suit and gasmask, at 10pm on a Friday night...

"FANCY DRESS"

In principle, the same applies to fancy dress as to fetish parties. But if the flyer states that admission is free for those in fancy dress, then you can be sure that the door policy will not be so strict and that paying guests not in fancy dress will also be welcome. And since dressing up well is expensive, this is also the best option in financial terms. To prove the seriousness of his/her fancy dress ball, the organizer can be expected to explicitly state that no one not in costume will be admitted. If an organizer has a serious long-term interest in hosting fancy dress parties, he/she will need to build up a reputation for strict implementation of door policy. If the first party is rather empty because no one is used to dressing up, he/she will have to combat the problem with hired costumes and lots of friends in fancy dress.

"FREE ADMISSION + WELCOME COCKTAIL FOR LADIES UNTIL 10PM"

This club is clearly unsatisfied with its clientele and in desperate need of women. Looks not an issue: the loners, tourists, conscripts and their friends who frequent the place are to be offered creatures with breasts, creatures who would probably rather be somewhere else. Which is why they are lured with free drinks, so that they tell their best friends too. Maybe they are good-looking. The scenario is familiar from teenage parties. The desired effect of such an invitation is to have a disco packed with excited, slightly drunk top quality ladies by the time the first guys arrive. The girls (or models!) have been waiting since 10 o'clock, some have already started taking off their underwear, the air is hot. Ever seen such a scene? Neither have we.

SEXY FANCY DANCERS

If the go-go card is played, it usually suggests the organizer thinks it's better to have a few women dancing half-naked for money than no one dancing at all. If it is claimed that there will be go-go girls AND a few naked Chippendales, the organizer obviously hopes that besides a few peepshow types, this might also attract a few women who see this kind of thing as a bit of harmless fun. One way of raising the tone of the event above that of a table dance club is to list the go-go girls as artists/dancers/performers.

DRINKS INCLUDED IN PRICE OF ADMISSION

Some discos offer a compact price that includes admission plus one or two drinks vouchers. This measure is aimed primarily at guests who usually pay to get in and then drink tap water in the toilets. Another aim is to bind people to the event and make sure guests consume these "obligatory" drinks. In the best case for the organizer, the partygoers will then be slightly drunk so they decide they can no longer drive and spend the rest of the evening at the party, paying full price for their next ten drinks. The warning to gamblers "the bank always wins" applies here too: in the game with drinks vouchers, the barman always wins. A severe version of this is when the vouchers are only valid for drinks near their expiration date that are mixed into bowls of punch in weird colors. Or when the vouchers received at the door are not enough to buy the drink you want: "Two vouchers is only enough for a beer, for a cocktail you have to pay 5 Euro extra." If you know about these practices, you may think twice about returning to the club in question.

"BUFFET"

Right, free food eh? - Maybe the organizer wants to signal limitless opulence and involve the partygoers' taste buds in the overall sensual experience. If you know for sure that at 1am on the Saturday night in question you will be starving, or if you just love eating, hot or cold, then you will probably be delighted at this prospect. For many people, buffets seem to possess a magic that is hard to comprehend: when Mum made it at home, potato salad never triggered the kind of desires it seems to trigger as part of a snack buffet. As a nightlife feature, buffets have a harder time than elsewhere, since there is often no reason to serve food so late. This means that a critical attitude is called for concerning buffets in clubs. Buffets often cause undignified and ugly scenes: pushing, spilling, fights over the last sausage, people struggling with overloaded plates and then not knowing what to do with that leftover prawn's tail. As a result, buffets often cause more trouble than pleasure, especially once they are over. You can only hope that if the organizer offers a buffet, he/she will have the sense to make sure that platters are cleared away as soon as they are empty.

"6 COLORED LASERS, 500 KW SOUND SYSTEM" + BLAH BLAH BLAH

People who splash technical details all over their flyers would be better off at a showtech trade fair for experts, unless of course they have nothing else to offer. Anyone trying to impress clubbers with watts and volts should realize that almost no one chooses parties on this basis. It should be a foregone conclusion that the event will be adequately equipped, quite apart from this, most people are neither familiar with or impressed by technical specifications per se. Good equipment should go without saying: after all, the flyer doesn't say that the glasses are clean and the ice cubes free of nasty bacteria. And if some technical feature IS named on the flyer, it should be so fascinating that everyone notices it as soon as they walk through the door of the club. Beyond this, you can only hope that the organizer hasn't spent all the money on equipment for a third-rate DJ playing his private CD collection in a barn.

"TOMBOLA", "PRIZE DRAW"

Something is on offer as a prize or at cut price – so the target audience must consist of people who are excited by the chance of prizes or cheap offers. Maybe because this doesn't happen to them often enough. The aim of prize draws is to keep people at the event for as long as possible, because they can't win the prize if they leave before the draw. But work it out for yourself: is it really worth waiting for a 200 Euro voucher for a trip to Paris until the sun comes up, by which time you will have spent half that amount of drinks. The more worthless the prizes, the more you should be wondering if you should really still be here.

PARKING, PUBLIC TRANSPORT ACCESS

There's nothing wrong with service, and if a new or one-off venue really is off the beaten track, the organizer is well advised to explain how to get to the party. But maps and such lack glamour and the lure of insider status. In the case of well-known locations, route plans on flyers are ridiculous, especially if they take up most of the space. And references to public transport suggest that guests might not be able to afford a taxi. If that is the case, then long-winded lists of bus and subway connections are perfectly acceptable.

FLYER RICHTIG VERSTEHEN

von Jürgen Laarmann

Optimal für einen Veranstalter ist es, wenn sein Club so angesagt ist, dass er überhaupt gar keine Werbung mehr machen muß und sich egal, was passiert, sobald die Party losgeht, ein großes Knäuel seines Wunschpublikums vor der Eingangstür drängt und Einlaß begehrt.

Auch bei Szene-Insidern erfreuen sich erfolgreiche Clubs, die auf jegliche Printwerbung verzichten, einer Wertschätzung dieses Understatements. Dadurch, dass der Club lediglich Werbung durch sich und sein Publikum macht, erhöht das seine Exklusivität, anders als wenn er versucht durch breite Werbemaßnahmen angestrengt weiteres Publikum anzuziehen.

Nur sehr wenige Locations haben diesen exklusiven Status und selbst die informieren ihr wählerisches Publikum zuweilen über Programmhöhepunkte und Sonderveranstaltungen.

Clubwerbung besteht in der Regel aus Flyern, die verteilt oder versandt werden, gegebenenfalls auch elektronisch als Mail verschickt oder als Anzeige in Szenemagazinen abgedruckt. Zentrale Bedeutung haben Flyer insbesondere für einmalige Veranstaltungen oder neue Locations, Partyreihen oder Events, bei denen selbst die ortsansässigen Partypeople noch keine konkrete Vorstellung haben, was sie erwartet.

Der Flyer verrät viel über den Charakter einer Veranstaltung. Über die Information des Wann und Wo und Mit Wem hinaus gibt er eine animierende Vision dessen, was bei der Party passieren könnte. Flyer sind manchmal mehr als Werbeträger, sie sind Visitenkarte des Veranstalters und können zuweilen Kunstwerk, Statement oder Zeitdokument sein.

Kennern gilt der Bewertungsmaßstab "Scheiß-Flyer - Scheiß-Party". Der Veranstalter, dem es nicht mal gelingt, seine Partyvision in der Werbung positiv darzustellen, wird wohl kaum in der Lage sein, ein ansprechendes Fest zu organisieren - eine Ahnung, die nur allzu oft zutrifft. Ist der Flyer häßlich und unmodern, kann man aus ihm einen Mangel an Respekt vor dem ästhetischen Empfinden der Szene, die bedient werden soll, ableiten. Wer als Veranstalter derart rücksichtslos ist, dem sind noch ganz andere Dinge zuzutrauen, vor allem aber, dass seine Party der Szene genauso wenig bietet. Und, dass man nicht hinkommen muß.

Ein guter Flyer bedeutet umgekehrt jedoch noch lange nicht, dass eine besonders gute Party stattfindet. Besonders aufwendig gestylte Flyer und Ankündigungen versprechen eine hohe Erwartungshaltung, der entsprochen werden soll. Schade für alle Seiten, wenn das Beste an der Party der Flyer war.

Man kann über eine Veranstaltung allein schon eine ganze Menge lernen durch die Umstände, wie und wann einen der betreffende Flyer für diese Veranstaltung erreicht hat. Bei der Bewertung hat man zu erkennen, ob es sich um eine mehr oder weniger exklusive eintrittskartenähnliche Zugangsberechtigung, eine verbindliche persönliche Einladung oder einen unverbindlichen Programmhinweis handelt.

Wenn man also von einem netten jungen Mann in der Fußgängerzone von Ibiza Stadt eine persönliche Partyeinladung in die Hand gedrückt kriegt, auf der der Name des jungen Manns steht, und es kostet dadurch auch 5 Euro weniger Eintritt, muß man nicht denken, man hat einen neuen Freund gefunden. Der nette junge Mann verdient sein Geld damit und kriegt den gleichen Betrag, den Du sparst, in der Regel als Provision. Discowerbung bewegt sich eben im Zwielicht zwischen großzügigem Gastgebertum und Nepper-Schlepper-Bauernfängerei.

Ratsam ist es im Rahmen einer Vorab-Partybeurteilung zu sehen, wer noch alles eingeladen ist. Wurden die Flyer per Post verschickt? Hat man sie von einem Promoteam des Nachts in die Hand gedrückt gekriegt? Hat dieses Promoteam den gleichen Flyer allen in die Hand gedrückt oder selektiert? Oder stand ein Karton mit Flyern in der nächsten Eisdiele herum? Wenn suggeriert wird, dass es sich um eine besonders exklusive Party handelt, wäre das der Glaubwürdigkeit nicht gerade förderlich.

Auch der Zeitpunkt, wann man seinen Flyer erhält, sagt eine Menge. Bekam man den Flyer erst hektisch einen Tag vor der Veranstaltung, drängt sich der Eindruck auf, als hätten der Veranstalter und seine Handlager wohl sehr fürchten oder zurecht fürchten müssen, dass es sehr leer bleiben wird. Ausnahme: Die Veranstaltung ist aus guten Gründen kurzfristig angesetzt worden. Obskur ist es, wenn für eine Party, die offensichtlich kein besonderes Highlight bietet, schon mehr als einen Monat zuvor geworben wird. Der Flyerbeurteiler denkt dann: Hier sind inkompetente Neuveranstalter am Start, die Panik haben, dass es nicht voll wird, was gut möglich ist, da man sich schon zum Zeitpunkt der Party nicht mehr an sie erinnert.

Die Kunst, aus Flyern bereits vorab zu lesen, wie gut eine Party sein wird und was auf ihr wirklich passiert, bedingt auch, dass man Schummeleien erkennt sowie das, was auf dem Flyer versprochen wird, richtig zu bewerten weiß. Hier einige Beispiele:

WIRD AUF EINEM FLYER WIE FOLGT GEWORBEN:

NAME EINES DJS ODER STARS + SURPRISE ACT ODER + SPECIAL GUEST

Nur im seltensten Fall hat sich hier ein Veranstalter irgendeine dufte Überraschung ausgedacht, bei der vor Freude Tränen in die Augen treten, insbesondere wenn er Eintritt für seine Veranstaltung verlangt. Denn warum sollte er mit irgendwas, weswegen irgendwer kommen könnte, nicht werben? Gleiches gilt für den nicht näher bezeichneten Special guest. Weder der Veranstalter weiß, wer damit gemeint ist, noch wird es der Gast jemals erfahren. Es hört sich einfach besser an als: Wir wissen noch nicht, wer außer dem DJ, der bereits dasteht, noch auflegt, kommt auf jeden Fall vorbei!

NAME EINES BEGEHRTEN STARS, DER ANDERSWO IN DER NÄHE AM FRÜHEN ABEND EIN KONZERT GEGEBEN HAT + AFTER-SHOWPARTY

Wer naiv denkt, Robbie Williams würde jetzt in dieser Disco nach seinem Konzert noch mal mit seinen Lieblingskonzertbesuchern so richtig feiern gehen, könnte möglicherweise falsch liegen. Der Veranstalter wollte viel mehr den Leuten, die beim Konzert waren und den Hals nicht voll kriegen können oder vielleicht sogar gar keine Karten mehr gekriegt haben, auch noch eine Partygelegenheit bieten. nett von ihm, oder? Selbst wenn "Official After Show Party" auf dem Flyer steht, hat das wenig mehr zu bedeuten. Möglicherweise sind dann wenigstens ein paar Leute von Robbies Plattenfirma, vom örtlichen Konzertveranstalter und ein paar Roadies nach getaner Arbeit da. Sollte Robbie tatsächlich später vorbeischauen, ist Dein Club doch angesagt.

NAME EINES UNBEKANNTEN DJS + ANGABE BERÜHMTER ORTE (Z.B. DJ PEPE – BERLIN, NEW YORK CITY, CHICAGO)-

Beliebt ist es, noch unbekannte DJs durch die Angabe internationaler Orte auf Flyern zu adeln, was nichts zu bedeuten hat.
Seid ihr Euch sicher, daß DJ Pepe nicht in New York City geboren wurde, in Chicago Elektroinstallateur war und in Berlin, in das er wegen der alten Drogensache fliehen mußte, auch schon mal im Vorprogramm einer kleinen Bekleidungsboutique am Samstag auflegte? Immer wenn die Städte zu sehr betont werden, liegt der Verdacht nahe, dass der Veranstalter eine gewisse Provinzialität seiner Party zu vertuschen sucht. Bei einem guten Künstler reicht erfahrungsgemäß der Name - oder steht auf den Madonna-Tickets in Klammern Detroit?

NAME EINES UNBEKANNTEN DJS + ANGABE EINES WELTWEIT BEKANNTEN CLUBS (DJ PEPE - PACHA IBIZA)

Selbst eingefleischte Kenner der Ibiza-Musikszene müssen nicht an ihrem Know-how zweifeln, wenn mitunter mit Namen von Club-DJs großer Clubs geworben wird, die sie gar nicht kennen. Gerade da, wo man's nicht so genau nimmt, kommt sowas häufiger vor. Und vielleicht war Pepe ja mal in Ibiza und im Pacha. Einmalig zwei Stunden im Vorprogramm. Oder als Kellner? Niemand lügt, wenn man nur tolerant genug ist.

EIN FLYER WIRBT MIT DEM NAMEN EINES DJS ODER STARS UND DEM WAHRSCHEINLICH KLEINGEDRUCKTEN KÜRZEL "TBC".

TBC heißt "To be confirmed!". Die definitive Zusage, dass der Star auch wirklich kommt, hatte der Veranstalter also noch nicht bei Druck des Flyers. Ob der Star auch wirklich kommt, steht in den Sternen. Vielleicht hat der Veranstalter dem Star auch nur mal auf die Mailbox gequatscht und fand es dann auch zu frech, seinen Gästen das Kommen des Stars zu versprechen. Oder er hat Angst vor Regressansprüchen und zurückverlangtem Eintrittsgeld einer wütenden Meute, die enttäuscht und wütend ist, dass der Star nicht da ist. Ein Anruf beim Veranstalter am Nachmittag der Veranstaltung erscheint ratsam, auch wenn er keine letzte Sicherheit geben kann.
(Die Antwort "DJ Spinny ist gebucht. Wir holen ihn gerade am

Flughafen ab" bedeutet nicht, dass es am Abend nicht heißt: "DJ Spinny ist der totale Arsch. Hat uns einfach sitzengelassen. Den Flug haben wir gebucht und schon die Hälfte der Gage überwiesen. Aber die Musik von unserm DJ Norbert ist doch auch geil. Ne, ne, Eintrittsgeld gibt's nicht zurück".)

NO. 1 CHART ACT

Kennt man den Act, der hier promotet wird, trotzdem nicht, muß man darüber nachdenken, dass es unzählige Charts gibt. Diverse Dancecharts, die Uniradiocharts, die Hitliste des lokalen Radiosenders oder die persönlichen Lieblingscharts des Veranstalters.

ZUVIELE DJ-STAR-NAMEN, LIVEACTNAMEN!

Zuviele DJ-Namen deuten eigentlich auf Festivals hin. Handelt es sich jedoch nur um einen Clubabend, hat sich der Veranstalter entweder a) überbucht, b) seine Wunschträume zu Papier gebracht, oder man streicht c) einfach alle prominenten Namen aus dem Line-up, und schon weiß man, wer tatsächlich zu hören ist. Dieser Trick schützt vor Enttäuschungen. Zuweilen wollte der Veranstalter auch nicht damit sagen, dass die Stars anwesend sind, sondern, dass man ihre Platten spielt.

NENNUNG EINER PARTY NUR DURCH EINEN ANGESAGTEN MUSIKSTIL OHNE NENNUNG VON KÜNSTLERN ODER DJS/NENNUNG ALLER VERFÜGBAREN MUSIKRICHTUNGEN

So sehr auch mit Musik geworben wird, so wenig spielt sie eine Rolle. Schön, dass die Discothek "Dorfkrug" jetzt also auch eine "Trance"-Party veranstaltet. Oder dass DJ Trippi euch mit seiner Fusion aus TripHop-Schlager-Rap-DiscoSoul-Charts und Glamrock verwöhnen wird.

LABEL NIGHT

Ein Platten-Label macht von sich reden. Mit einem hervorragenden Act, der durch die Charts oder öfters noch durch die Underground-Kultlandschaft geistert. Grund zum Feiern allemal. Allerdings sollte man sich vergewissern, ob der Star und das Zugpferd auch wirklich mit an Bord ist oder ob das nur suggeriert wird.
Denn bei Label Nights darf man oft nur die kleinen Kollegen des Stars sehen, die nicht von sich reden machen und diesmal ins Strobolicht treten dürfen. Der Star ist selbstverständlich woanders auf Konzert oder Promotour. Die Gäste dürfen sich jetzt mal anhören, mit welchen Acts sich das kleine Label sonst noch so plagt oder wegen wem es fast bankrott machen mußte, wenn nicht besagter Star, der heute wie gesagt woanders spielt, aufgetaucht wäre.

JUBILÄUM

Super, dass es diesen Laden jetzt 10 Jahre gibt. Das liegt auch an den vielen netten Leuten, die Samstag für Samstag ihre 10 Euro Eintritt gelatzt haben. Jetzt endlich bedankt man sich bei ihnen. Dann kostet's aber leider 25 Euro.
Hört sich nicht nett an, kann aber passieren. Das Schöne an Jubiläen ist aber eigentlich, dass man in der Regel eine Erfolgs-

story mit allen daran Beteiligten feiern will. Das bedeutet oft ein großes Programm und viele, viele Bonbons, Überraschungen und Extras. Je nach Veranstalter und Location reichen diese von zwei Luftballons an der Decke über Champagner bis hin zu Topstars und Limoservice.

BIRTHDAY

Toll, wenn man auf einen groß aufgezogenen Geburtstag eingeladen wird. Schon allein deshalb, weil man nirgends so gut abschätzen kann, wen man dort treffen wird wie auf dem Geburtstag eines engen Freundes oder einer stadtbekannten Persönlichkeit.

Steht auf einem Flyer der Geburtstag eines Unbekannten, heißt das in den seltensten Fällen, dass einfach so die ganze Stadt zu Freibier und Torte eingeladen ist, selbst wenn der Eintrittspreis höher ist als sonst. Das heißt eher, dass sich im selben Raum wie der Mob eine illustre Geburtstagsgesellschaft rumtreibt, die durch Märkchen oder Armbändchen gekennzeichnet Vergünstigungen genießt, während der Rest als Füllstoff dient. Der Persönlichkeit war es offenbar zu teuer, den Laden einfach als geschlossene Gesellschaft zu mieten. Deshalb kündigt das Geburtstagsfest einen Geburtstag an, lässt die 10 Spezies des Geburtstagskinds frei trinken und beschert dem Besitzer mit dem Rest das gewohnte Plus.

BENEFIZ

Eine Party für einen guten Zweck - wie schön! Unbeliebt macht man sich zuweilen, indem man sich am Abend vorrechnen lassen will, wie der Benefiz eigentlich ausschaut und wieviel Geld tatsächlich der begünstigten Organisation zufließt.

ABENDGARDEROBE ERWÜNSCHT!

Bei manchem Anlaß versteht sich Abendgarderobe von selbst. Findet in einer Disco, in der man auch vorher schon "casual" gekleidet war, eine Veranstaltung statt, bei der auf einmal auf Abendgarderobe Wert gelegt wird, ist Mißtrauen angesagt.

Der Veranstalter wünscht sich nichts sehnlicher als Publikum mit Niveau. D.h. Vorbestrafte in Nicht-Turnschuhen sind willkommen, Ladies im Resterampen-Mini beliebter als die in Prada-Hosen. Die legendäre "Abendgarderobe" ist als Begriff fast noch dehnbarer als die "tanzgerechte Kleidung". Die Ausdenker so findiger Publikumsselektionen glauben an die Regel, dass Turnschuhe weniger Geld und mehr Schlägereien als Slipper und weiße Socken mit sich bringen, - was sich in der Realität oft als falsch erwiesen hat.

FETISCH-OUTFIT

Wenn alle in Gummianzug und Gasmaske da sind, haben sie auf Spanner, die ohne kommen, keine Lust. Wird man am Eingang darauf hingewiesen und nicht eingelassen, sollte man auf jeden Protest verzichten und nach einer Partyalternative suchen. Oder sich der interessanten Aufgabe widmen, wie man Freitag, 22 Uhr, noch einen passenden Gummianzug mit Gasmaske für sich auftreiben kann...

KOSTÜMPARTY

Was für die Fetischparty gilt, gilt grundsätzlich auch für die Kostümparty. Wird jedoch bereits auf dem Flyer annonciert, dass Leute, die kostümiert erscheinen, freien Eintritt genießen, weiß man sicher, dass es nicht so wild sein wird mit der strengen Türpolitik für Unkostümierte und dass man auch als zahlender Unkostümierter mitfeiern kann. Da gelungene Kostümierungen aufwendig sind, ist das sogar ökonomisch die bessere Lösung. Vom Veranstalter kann man den expliziten Hinweis erwarten, dass unkostümiert niemand hereinkommt, um die Ernsthaftigkeit seiner Kostümsause zu belegen. Ist ein Veranstalter langfristig und ernsthaft am Kostümbusiness interessiert, muss er sich auch den Ruf aufbauen, dass man sich gefälligst an seine Direktiven zu halten hat. Wenn es beim ersten Mal deswegen etwas leer ist, weil niemand gewohnt ist sich zu kostümieren, muß er mit Leihkostümen und ganz vielen kostümierten Freunden dagegen ankämpfen.

FRAUEN BIS 22 UHR FREI + EIN BEGRÜSSUNGSCOCKTAIL

Dieser Laden ist offensichtlich mit seinem Publikum unzufrieden und schreit nach Frauen. Egal, wie sie aussehen, den Einsamen, Touristen, Wehrpflichtigen & Friends sollen Wesen mit Titten geboten werden, die sich freiwillig wahrscheinlich lieber woanders aufhalten würden. Deshalb werden sie mit Begrüßungscocktails geködert, damit sie auch noch ihren besten Freundinnen Bescheid sagen. Vielleicht sind die ja hübsch. Kennt man von Pubertätsfeten.

Der Wunschzweck solcher Einladungen ist eine Disco, die rammelvoll mit aufgeregten, angeschwipsten Ladies der Topliga ist, wenn die ersten Typen eintrudeln. Die Mädels bzw. Models warten schon seit zehn, mehrere Dessousteile liegen bereits verstreut in der Gegend rum, es ist kochend heiß. Schon mal gesehen? Wir auch nicht.

SEXY FANCY DANCER

Der Griff in die Gogo-Kiste deutet an, dass der Veranstalter schon vorgesorgt hat: Lieber ein paar bezahlte halbnackte Frauen, die tanzen, als gar keine. Wird darauf hingewiesen, dass es neben weiblichen Gogos auch ein paar Chippendales- Nacktänzer gibt, erhofft sich der Veranstalter, dass auch neben ein paar Typen Marke Peepshowpublikum ein paar Frauen gezogen werden, die dergleichen für frivoles Vergnügen halten.

Ein Mittel, das Table-Dance-Niveau der Veranstaltung zumindest auf dem Flyer zu heben, funktioniert üblicherweise so, dass man die Gogos gleichwertig als Künstler/Tänzer/Showperformer ankündigt.

GETRÄNKEVERZEHR

Manche Discotheken bieten am Eingang einen Kompaktpreis, der auch noch ein bis zwei Getränkebons beinhaltet, Mindestverzehr genannt.

Hier wird einer Klientel, die nur Eintritt bezahlt und sich ansonsten am Wasserhahn auf der Toilette verpflegt, ein Zwangsgeld auferlegt. Ansonsten steht hinter der Idee des Mindestverzehrs

das Kalkül, seine Gäste erstmal an die Veranstaltung zu fesseln und dafür zu sorgen, dass die Gäste ihre Zwangsdrinks verzehren. Im besten Fall für den Veranstalter sind sie daraufhin schon angetrunken, so dass sie nicht mehr fahren wollen und den Rest des Abends auf der Veranstaltung bleiben, ergo die nächsten zehn Drinks ordentlich bezahlen. "Gewinnen tut immer die Bank", werden Spielsüchtige gewarnt. Im Getränkeverzehrspiel gewinnt eben immer der Wirt.

Ganz übel wird es, wenn der Getränkeverzehr ausschließlich für Getränke gilt, die am Rande des Ablaufdatums stehen und zu Bowlen mit komischen Farben zusammengemixt werden. Oder wenn die Getränkebons vom Eingang nicht langen, sich das Getränk seiner Wahl zu besorgen. "Die zwei Getränkebons langen hier nur für ein Bier, für einen Cocktail mußt Du noch 5 Euro hinzuzahlen." Kennt man diese Gepflogenheiten, kann man sich genau überlegen, ob man hier nochmal zu Gast sein möchte.

BÜFFET

Soso, da gibt's also Essen für umsonst? - Der Veranstalter möchte möglicherweise uneingeschränkte Opulenz signalisieren und in die Sinnesvergnügen auch die Gaumen seiner werten Gäste einbeziehen.

Wenn man weiß, dass man am angekündigten Termin Samstagnacht um 1 Uhr in der Disco definitiv großen Hunger haben wird oder sich auch sonst mal über warme und kalte Mahlzeiten freut, dürfte die Freude darüber kaum mehr Grenzen kennen.

Für viele Menschen haben Büffets eine Magie, die schwer nachvollziehbar ist, zu Hause wurde Muttis Kartoffelsalat nie eine solche Begierde entgegengebracht wie als Imbisskomponente eines Büffets. Im Nightlifebetrieb haben es Büffets noch schwerer als anderswo, da es oft keinen Grund gibt, so spät am Abend noch Essen zu servieren.

So ist eine kritische Haltung Büffets im Nachtleben gegenüber angemessen. Zunächst einmal sieht in der Regel ein Büffet wirklich in den ersten 5 Minuten nach seiner Eröffnung schön und opulent aus. Wer sich jedoch schon vor Eröffnung des Büffets in Reichweite aufhält und ständig nachfragt, wann es denn nun losgeht, erweckt den peinlichen Eindruck, er hätte es nötig. Genauso wer bei einem leergefressenen Büffet die Reste zusammenschabt, besonders dann, wenn die Resteplatten bereits von unhöflichen Gästen als Aschenbecher missbraucht werden.

Büffets bedingen oft würdelose Szenen, die nicht schön anzusehen sind. Drängelei, Kleckereien, Gerangel um's letzte Würstchen, Menschen, die mit überladenen Tellern hantieren und nachher nicht wissen, wohin mit dem abgekauten Krabbenschwanz. So ist der Missmut mit Büffets oft größer als die Freude, insbesondere im Nachhinein.

Hoffentlich ist der Veranstalter umsichtig und sorgt dafür, dass, wenn er ein Büffet bietet, leere Platten sofort abgeräumt werden.

6 FARB-LASER, 500 KW SOUNDSYSTEM + BLABLABLA

Wer schon auf seinem Flyer mit technischen Details hausieren geht, hat's wohl nötig, es sei denn, er veranstaltet eine Party im Rahmen einer Showtechnik-Messe für Fachpublikum. Wer mit Watt und Voltzahlen wirbt, sollte sich darüber klar sein, dass deswegen kaum jemand auf eine Party kommt.

Der Partygast kann erwarten, dass eine Veranstaltung angemessen ausgestattet ist, mal abgesehen davon, dass der Laie technische Bezeichnungen weder beurteilen kann noch per se beeindruckend findet. Ein gutes Equipment sollte selbstverständlich sein: Schließlich schreibt man auch nicht auf den Flyer, dass die Gläser poliert und die Eiswürfel salmonellenfrei sind.

Sollte tatsächlich in eine zusätzliche technische Errungenschaft investiert worden sein, mit der geworben wird, sollte diese auch beim Betreten der Disco so faszinierend sein, dass sie jeder bemerkt. Ansonsten bleibt nur zu hoffen, dass nicht das gesamte Geld in die Technik geflossen ist, die nun einen Aushilfs-DJ und seine private CD-Sammlung in einer Scheune verstärken soll.

TOMBOLAS, VERLOSUNGEN

Es gibt was zu gewinnen oder zu sparen - und hier wird also ein Publikum angesprochen, das es faszinierend findet, etwas gewinnen oder sparen zu können. Womöglich, weil es sonst im Leben nicht so oft die Gelegenheit dazu hat.

Verlosungen haben den Zweck, das Publikum möglichst lang am Ort zu halten, weil sie den Preis nicht gewinnen können, wenn sie schon vor der Verlosung gehen. Ob es sich allerdings wirklich lohnt, für einen 200-Euro-Gutschein für eine Fahrt nach Paris bis zum Morgengrauen zu warten und in der Zwischenzeit gut fast die Hälfte des Preisgelds zu versaufen, muß man selbst einschätzen.

Je wertloser und würdeloser die Preise, desto mehr sollte man sich überlegen, ob man hier wirklich sein sollte.

PARKPLÄTZE ETC. U-BAHN-ANBINDUNG

Service in Ehren und wenn eine neue oder einmalige Location wirklich weit entlegen liegt, tut der Veranstalter gut daran, darauf hinzuweisen, wie man ihn und seine Party erreichen kann. Glamour und den Reiz des Nur-Eingeweihte-wissen-Bescheid haben dergleichen Pläne nicht.

Bei gemeinhin bekannten Locations wirkt die genaue Wegbeschreibung auf dem Flyer lächerlich, insbesondere, wenn sie einen Großteil der Fläche des Flyers verschlingt. Der Verweis auf öffentliche Verkehrsmittel unterstellt seinen Gästen auch, dass sie nicht in der Lage wären ein Taxi zu bezahlen. Wenn dem so ist, geht das Abnudeln von Bus- und U-Bahnverbindungen voll in Ordnung.

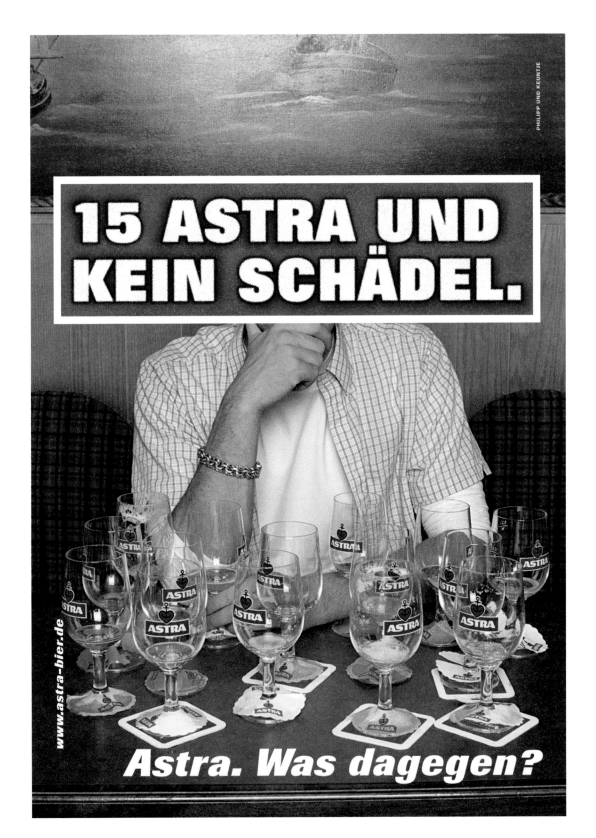

PHILIPP UND KEUNTJE

141

UNRECOGNIZED ART

by Jana Gallitschke and Jens Pacholsky

"Design is art with purpose, art is design without purpose."
Ian Anderson, The Designers Republic

"A good flyer is a carrier for an artwork. An artwork that happens to be informative."
Fubbi Karlsson, Ministry of Information

Faced with the endless abundance of images, colors and symbols, the sprawling flood of information, it is hard to focus again and again on flyers as a - truly useful - communications medium. As a result, many creative ideas and sophisticated details stay hidden, swallowed up by the great mass of visuals. But sometimes one comes to the surface, standing out from the crowd. Flyers that transcend the boundary between art and design.

"There is a clear distinction between art and design", says Ian Anderson from the British artists' collective The Designers Republic (TDR), "but it's not important where each individual sees the border." It is hard to draw a line between creativity and commerce, between art and design, on the basis of objective, generally accepted criteria; too many factors are at work in each individual case. At present, there are two different approaches. For the majority of flyers, the emphasis is on communicating information. In accordance with this philosophy, the designer must consider visual aesthetics as a luxury, of secondary importance, for which there is not enough time or money. The other position, covering far fewer flyers, is represented by intelligent, innovative designs that often take time to decipher and that manage to cleverly embed the key information in the overall composition. "It's a game of combining information and abstract ideas", explains Fubbi Karlsson of the Berlin-based Ministry of Information (MOI), which designs the flyers, among others, for the Berlin club Polar.TV. "Information can look good. Words and typography are interesting. But the associations that emerge during the typographic process are important." When a flyer is designed well, the overall look conveys information. The two elements are combined so that the idea and the concept remain legible. But some designers go one step further and insist that the best flyers can succeed with a minimum of details. Sirko Richter from the Berlin design office art-x explains: "As far as possible, information and aesthetics should be equally weighted. But it is fun to try out new design ideas or to link the content with the design. This means it's nicer to make flyers where the emphasis is on appearance. Unfortunately, many clients don't give you that chance."

CORPORATE DESIGN As Sirko Richter goes on to explain, the designer is tied to the requirements and tastes of the customer. This means constantly walking a fine line between artistic freedom and the need to consider the clients wishes. "It can turn into a struggle", says Fubbi Karlsson: "Sometimes people are desperate and think that the success of a party depends on the size and position of the date on the flyer. But it's about compromise. A good party organizer knows that a flyer doesn't have to contain masses of information, that it can act instead as an appetizer and a promise of good taste." Designers face the same conflict as any other artist who works to order. Flyers are commissioned and are primarily not art but a service. "But maybe this limitation is also the appeal, having to work creatively within more or less strictly defined constraints", adds Sirko Richter.

Another important aspect is the corporate identity for any given event. A flyer has the task not only to provide information but also to represent. The type of event a flyer announces is an essential influence on its design. "A techno audience would be looking for a different visual expression to a hip hop or drum & bass audience", explains Ian Anderson. A good designer must be able to assess the target group, know its likes and tastes. At TDR - as for many other artists who work in the electronic music scene - there is a belief that less is indeed more. The Designers Republic has been internationally successful for years, working with partners including Warp Records and !K7 Records. Their flyers are characterized by strongly reduced design consisting of a limited number of graphic elements with recurring motifs. Typographic design is reduced to a minimum, with the information integrated into the design concept. Like Ministry of Information and art-x, The Designers Republic works with a broad range of graphic styles, as the posters, record covers and flyers created to fit the music in question do not work according to the same mechanisms. In the case of the frequent sparseness of electronic music, the flyers are graphically minimalist. In an essay on record cover design, Diedrich Diederichsen, a freelance writer and professor at the Merz Akademie in Stuttgart, puts it like this: "To keep up with the pace of musical developments and the corresponding differentiation of social structures, and to offer the necessary sharpness of orientation and visual comprehensibility, the designers have to get involved and participate themselves. They must integrate themselves into the milieu whose visual language they are creating." This means that the work of a designer goes beyond assessing the target group; s/he has to identify with it, be able to anticipate impending changes. Ideally, this would mean that a designer would have to reduce his or her field of activity to a particular genre like hip-hop or electronic music in order to satisfy artistic standards. In realistic terms, this is more or less impossible unless one already has an established reputation. But as the great majority of design offices must do all they can to stay afloat, they accept any job they are offered, so that time and money also shape the design.

This means that for the collectors among us, it will continue to be hard to find specimens that excite us among the flood of flyers. And for everyone else, if not always art, flyer design at least constitutes a contribution by the designers to the cultural life of society.

WHAT'S MORE ... David Friedrich is convinced that his work is about to enter a "golden age". The Berlin-based graphic designer has been producing flyers since 1998, initially for events he organized himself (Nixclub), but soon for a wide variety of different acts and genres (e.g. the Maulhelden festival and Marusha). As he sees it, the client is of secondary importance, the key aspect being the realization of ideas. David Friedrich designs almost exclusively object flyers. The materials he uses range from dishcloths to teabags and spoons through records and circuit boards. He wants to show how much is possible. For him, the emphasis is on associative value and the sense of touch. His flyers are designed to tell stories and make people want to show them to others. Hence his fascination with the parallels to word of mouth. Friedrich's unusual, hand-made work can't help standing out from the flood of printed flyers. They also give an impression of exclusivity. He considers object flyers to be more effective, citing as an example the 120 packs of Smarties that he customized and which attracted a total of 800 people. Friedrich does not see the Internet as the future of flyers: e-mail flyers are less likely to give the recipient a feeling of being one of the chosen few, added to which they lack any appeal to the sense of touch. Flyers that are passed from hand to hand, he says, will not disappear. For Derek Michael May from Detroit, the future of flyers is indeed the web. He began designing flyers in 1994 for his own Room 213 club because he couldn't afford to commission anyone. In the meantime, he has made hundreds of flyers for clubs in Detroit and Windsor. Like David Friedrich, he is convinced that flyers have a tale to tell; but whereas with Friedrich's designs, it is the material that talks, Derek Michael May sees flyers more as an aide mémoire.

What's your name? | Derek Michael May
What's your definition of a flyer? | Something that makes people go to your show
Which projects/clubs etc. have you designed flyers for? | Hundreds of the Detroit/Windsor flyers from the mid-90s 'til now.
When did you start? | 1994
What was your motivation to design them? | I had a club called Room 213, and I needed flyers and I couldn't afford to pay somebody so I did it myself. I discovered that I was good at it.
What is important to you in terms of layout? | Color is key, everything else is just what you do with it.
Do you have any role models? | DJ Kero
What kind of feedback do you get? | Good and bad, I base my designs on emotion, and sometimes that doesn't always relate to people the same way.
How expensive are your flyers? | Whatever the promoter can afford to pay me, sometimes 1000 bucks, sometimes a bag of weed.
What's the average number of copies? | 500-10,000
What materials do you work with? | All programs for vector and bitmap design, I like to make my own brushes.
Which software do you use? | Vector I use flash, bitmap I use photoshop, but I use lots of other things to get the effect I want.
How long does it take to design them? | Usually a day or two, depends on what I get paid.
How many days/hours before the event are you usually done? | About a month.
What do you think about teamwork? | Fuck it.
Are there any problems regarding interaction between yourself, sponsors and club owners? | Some-

times, but I do what I want usually, that's what they pay me for.

How do the flyers get distributed/handed out? | Usually pretty girls in tight clothing work best.

How effective are your flyers in general – how many people are pulled to the event by how many copies of flyers? | It's a good ratio, about 5 flyers per person.

Do you collect flyers? | Yeah I got some old rave ones from back in the day.

Does something like flyer culture exist? | I think so, everybody has them laying around, they help us remember the good and bad parties and tell stories, in the end stories is all you got.

What about the future of flyers? | Web is key.

Gianni Macario is a specialist in the field of materials and production; he told us about his work:

"The paper manufacturers Schneidersöhne really like my work, which is why I was lucky enough to get all their super expensive special papers from them free of charge as a form of sponsoring. I passed on this good fortune to the HD800 Club and its organizer, Dirk Mantei, and finally it got passed on to thousands of flyer collectors. The flyers on the special papers were produced in close cooperation with Michel Mehling (now lives in Frankfurt), who supplied the illustrations. My work consisted of completing the graphics, positioning the text, and above all making the paper merge with the motif. This means that in most cases, the graphical choices were inspired by the quality of the paper! Any serial character would be totally coincidental!

As already mentioned, the product flyers were photos taken during previous nights at the club. The best photos then made it onto the flyers. With these flyers, the graphical concept was to include the key facts and to leave out all superfluous information.

Of course there are ideas that go through my head during the design process - but these ideas remain my personal secret; after all, there has to be room left for interpretation."

FLYERS AND DESIGN

VERKANNTE KUNST
von Jana Gallitschke und Jens Pacholsky

"Design is art with purpose, art is design without purpose."
Ian Anderson, the Designers Republic

"Ein guter Flyer ist Träger für ein Kunstwerk. Ein Kunstwerk mit dem Zweck auch nebenbei zu informieren."
Fubbi Karlsson, Ministry of Information

Angesichts der nicht enden wollenden Fülle an Bildern, Farben und Zeichen, dem unüberschaubar gewordenen Schwall an Informationen fällt es schwer, sich dem Flyer als - im eigentlichen Sinne nützliches - Kommunikationsmedium wieder und wieder anzunehmen. So bleiben die Kreativität der Ideen und die Raffinessen so mancher Details im Verborgenen, geschluckt von der gewaltigen Bilderflut. Doch mitunter kommen sie ans Licht, aus einem Knäuel unzähliger Artgenossen, Flyer, bei denen die Grenze zwischen Kunst und Design nicht länger existiert.

"Es existiert eine klare Trennung zwischen Kunst und Design", stellt Ian Anderson, Mitglied der britischen Künstlergemeinschaft The Designers Republic (TDR) fest, »doch es ist nebensächlich, wo der Einzelne diese Grenze definiert." Nach objektiven, allgemeingültigen Gesichtspunkten kann eine Linie zwischen Kreativität und Kommerz, Kunst und Design nur schwer gezogen werden, zu viele Faktoren bestimmen den Einzelfall. Momentan existieren zwei unterschiedliche Ansätze beziehungsweise Herangehensweisen. Bei der Mehrzahl an Flyern liegt der Focus auf der Informationsvermittlung. Der Philosophie dieser Gestaltungsweise folgend bedeutet das für den Designer, die visuelle Ästhetik als luxuriöse Nebensache zu betrachten, für die weder ausreichend Zeit noch Budget zur Verfügung stehen. Die Gegenposition wird - bei einem weitaus geringeren Anteil an Flyern - durch kluge, innovative Designs vertreten, die sich oftmals erst bei mehrmaligem Hinschauen entschlüsseln lassen und die notwendigen Informationen geschickt in die Gesamtkomposition einzubetten vermögen. "Es ist ein Kombinationsspiel zwischen Information und abstrakter Ideen", erklärt Fubbi Karlsson vom Berliner Büro Ministry of Information (MOI), die unter anderem für die Flyer des hauptstädtischen Clubs Polar.TV verantwortlich zeichnen. "Information kann auch schön sein. Wörter und Typographie sind interessant. Aber auch Assoziationen, die beim typographischen Prozess entstehen, sind wichtig." Bei gutem Flyer-Design wird das Erscheinungsbild zum Informationsträger. Beide Elemente werden miteinander kombiniert, so dass Idee und Konzept ablesbar bleiben. Einige Designer gehen noch einen Schritt weiter und bekräftigen, dass die besten Flyer mit den auf ein Minimum reduzierten Angaben auskommen. Sirko Richter vom Berliner Design-Büro art-x erläutert: "Soweit es möglich ist, sollten natürlich sowohl Informationen als auch Ästhetik gleich stark bewertet werden. Allerdings macht es Spaß, neue Design-Ideen auszuprobieren oder den Inhalt mit dem Design zu verknüpfen. Daher ist es schöner, einen Flyer zu erstellen, bei dem das Aussehen im Vordergrund steht. Viele Kunden lassen einem leider nicht die Möglichkeit."

CORPORATE DESIGN Der Designer sei an die Vorgaben und den Geschmack des Abnehmers gebunden, erklärt Sirko Richter weiter. Folglich befindet sich der Gestalter auf einer ständigen Gratwanderung zwischen künstlerischer Freiheit und der notwendigen Berücksichtigung der Wünsche seines Auftraggebers. "Es kann ein Kampf werden", berichtet Karlsson. "Manchmal sind Leute desperat und denken, dass die Party davon abhängig ist, wo und wie groß das Datum darauf steht. Aber es handelt sich um einen Kompromiss. Ein guter Veranstalter weiß, dass ein Flyer nicht unbedingt ein Telefonkatalog an Informationen sein muss, sondern eher ein Appetizer und ein Versprechen von gutem Geschmack." Der Designer sieht sich, wie jeder andere nicht freischaffende Künstler, vor denselben Konflikt gestellt. Flyer entstehen als Auftragsarbeit und sind in erster Linie nicht Kunst, sondern Dienstleistung. "Vielleicht liegt aber in der Einschränkung der Reiz, dass man innerhalb von mehr oder weniger genauen Vorgaben kreativ werden muss", ergänzt Richter.

Ein weiterer wichtiger Aspekt ist die Corporate Identity einer jeden Veranstaltung. Ein Flyer hat nicht nur die Aufgabe zu informieren, sondern auch zu repräsentieren. Die Art des Events, für das ein Flyer wirbt, ist essentiell für dessen Gestaltung. "A techno audience would be looking for a different visual expression to a hip hop or drum & bass audience", erklärt Anderson von TDR. Ein guter Designer muss die anzusprechende Zielgruppe einschätzen können, ihre Wünsche, ihren Geschmack kennen. So gilt beispielsweise bei TDR – wie auch bei vielen anderen in der elektronischen Musikszene beheimateten Künstlern – die Auffassung, dass weniger mehr ist. The Designers Republic sind seit Jahren erfolgreich international tätig; unter anderem bestehen Kooperationen mit Warp Records und !K7 Records. Ihre Flyer zeichnen sich durch stark reduziertes Design aus, bestehend aus wenigen graphischen Elementen mit immer wiederkehrenden Motiven. Die Schriftgestaltung wird auf ein Minimum reduziert, wobei die Informationen in das Gestaltungskonzept eingebunden werden. Ähnlich der beiden Büros Ministry of Information und art-x, beschäftigen sich The Designers Republic mit einem weiten Feld des Graphik-Designs, denn die von der Musik abhängig entstehenden Poster, Plattencover und Flyer funktionieren nach den gleichen Mechanismen. Bei der oft reduzierten elektronischen Musik ist es folglich der graphisch minimalistische Flyer. Diedrich Diederichsen, freier Autor und Professor an der Merz Akademie in Stuttgart, drückt es in einem Aufsatz über Plattencover-Design folgendermaßen aus: "Um im selben Tempo, in dem sich die musikalischen Entwicklungen und die daran gebundenen sozialen Zusammenhänge differenzieren, und mit der gebotenen Trennschärfe Orientierung und visuelle Verständlichkeit bieten zu können, müssen die Gestalter selber Anteil nehmen, verwickelt sein. Sie müssen sich in das Milieu integrieren, dessen Bildsprache sie kreieren." Das bedeutet, die Arbeit eines Gestalters geht über die Einschätzung einer Zielgruppe hinaus; er muss sich mit ihr identifizieren, ihre Veränderungen im Voraus diagnostizieren können. Das hätte zur Folge, dass ein Designer sein Arbeitsfeld auf ein bestimmtes Genre, wie HipHop oder Elektronik zu reduzieren hätte, um künstleri-

schen Ansprüchen zu genügen. Will man realistisch bleiben, ist das so gut wie unmöglich, es sei denn, man hat sich bereits einen Namen beziehungsweise Ruf erarbeitet. Da es jedoch für die überwiegende Mehrheit der Design-Büros gilt, sich über Wasser zu halten, wird fast jeder Auftrag bearbeitet, Zeit und Geld gestalten die Flyer mit. So wird es auch zukünftig für die Sammler unter uns nicht einfach sein, diejenigen unter der Masse kleiner Handzettel herauszufischen, die das Herz höher schlagen lassen. Und für alle anderen bedeutet Flyer-Design, wenn schon nicht immer Kunst, dann doch wenigstens einen Beitrag der Gestalter zum kulturellen Leben in der Gesellschaft.

UND AUSSERDEM ... David Friedrich ist überzeugt, für seine Arbeiten brechen "goldene Zeiten" an. Der Berliner Graphik-Designer produziert Flyer seit 1998. Zunächst für von ihm selbst organisierte Veranstaltungen (Nixclub), bald darauf für sehr unterschiedliche Künstler und Genres (z.B. Maulhelden oder Marusha). Wobei der jeweilige Auftraggeber vergleichsweise nebensächlich sei, als wichtig bezeichnet er die Umsetzung von Ideen. David Friedrich gestaltet fast ausschließlich Objekt-Flyer. Die von ihm verwendeten Materialien reichen von Waschlappen über Teebeutel bis Kaffeelöffel, Schall- und Leiterplatten. Er will zeigen, was alles möglich ist. Der assoziative Wert und das haptische Erlebnis stehen für ihn im Vordergrund. Seine Flyer sollen kleine Geschichten erzählen und das Bedürfnis wecken, sie anderen zu zeigen. Dementsprechend fasziniert ihn die Verbindung mit Mundpropaganda. Friedrichs ungewöhnliche Arbeiten, die er in Handarbeit herstellt, unterscheiden sich zwangsläufig von der Flut der gedruckten Flyer. Zudem vermitteln sie eher einen exklusiven Eindruck. Er schätzt Objekt-Flyer auch als effizienter ein und führt als Beispiel aus, 120 von ihm bearbeitete Smarties-Dosen hätten letztlich 800 Personen angezogen. Die Zukunft des Flyers sieht Friedrich nicht im Internet; Flyer per E-mail würden seltener das Gefühl der Auserwähltheit beim Empfänger erzeugen, außerdem ließen sie die, wie er sagt, "Handgreiflichkeit" - die haptische Erfahrung - vermissen. Der Flyer, der von Hand zu Hand wandert, werde nicht verschwinden. Derek Michael May aus Detroit sieht die Zukunft des Flyers sehr wohl im Netz - "web is key", bemerkt er auf die entsprechende Frage knapp. May hat 1994 begonnen, Flyer zu gestalten, damals für seinen Club Room 213, da er aus Geldmangel niemanden beauftragen konnte. Mittlerweile hat er Hunderte für Clubs in Detroit und Windsor entworfen. Beim Layout setzt er hauptsächlich auf auffallende Farben, "Colour is key, everything else is just what you do with it." Ähnlich wie David Friedrich ist aber auch May überzeugt, Flyer würden Geschichten erzählen. Wo bei Friedrich hingegen das Material spricht, sieht Derek Michael May in Flyern eher eine Gedächtnishilfe. Flyer würden an die guten und die schlechten Partys erinnern und eben Geschichten erzählen.

What is your name? "Derek Michael May".
What is your flyer-definition? "Something that makes people got to your show".
For which projects/clubs etc. did you design flyers? "Hundreds of the Detroit/Windsor flyers from the mid nineties till now."
When did you start? "1994".
What was your motivation to design them? "I had a club called room 213, and I needed flyers and I couldn't afford to pay some-

body so I did it myself. I discovered that I was good at it."
What is – referring to the layout – important to you? "Colour is key, everything else is just what you do with it."
Are there any role-models? "DJ Kero".
What kind of feedback do you get? "Good/bad, I base my designs on emotion, and sometimes that doesn't always relate to people the same way."
How expensive are your flyers? "Whatever the promoter can afford to pay me, sometimes 1000 bux, sometimes a bag of weed."
What is the average number of copies? "500-10,000".
With what materials do you work? "All programs for vector and bitmap design, I like to make my own brushes."
Which software do you use? "Vector I use flash, bitmap I use photoshop, but I use lots of other things to get the effect I want."
How long does it take to design them? "Usually a day or two, depends on what I get paid." How many days/hours before the event are you usually done? "About a month."
What do you think about teamwork? "Fuk it."
Are there any problems regarding to the interaction between you, sponsors and club-owners? "Sometimes, but I do what I want usually that's what they pay me for."
How do the flyers get distributed/handed out? "Usually pretty girls in tight clothing work best."
How efficient are your flyers in general – how many people are pulled to the event by how many copies of flyers? "It's a good ratio, about 5 flyers per person."
Do you collect flyers? "Ya I got some old rave ones from back in the day."
Does something like flyer-culture exist? "I think so, everybody has them laying, they help us rember the good and bad parties and tell stories, in the endstories is all you got."
What about the future of flyers? "Web is key."

Ein Spezialist in Sachen Material und Ausführung ist Gianni Macario, der uns zu seiner Arbeit erzählte: "Der Papiervertrieb Schneidersöhne mag meine Arbeit sehr, deshalb hatte ich das Glück von ihnen diese ganzen superteueren Spezialpapiere kostenlos, als Sponsoring, zu bekommen. Dieses Glück gab ich damals weiter an den HD800 Club, bzw. an den Macher des Clubs Dirk Mantei, und letztendlich an zigtausende Sammler. Die Flyers auf den Spezialpapieren sind in enger Zusammenarbeit mit Michel Mehling (lebt heute in Frankfurt) entstanden, der die Illustrationen lieferte. Meine Arbeit bestand darin die Illustrationen teilweise zu vervollständigen bzw. den Text zu platzieren und vor allem das Papier mit dem Motiv zu verschmelzen. Das heißt, meistens wurde das graphische Handeln von der Papierqualität inspiriert! Ein Seriencharakter ist wohl eher rein zufällig!

Bei den Produkt-Flyers handelt es sich, wie schon erwähnt, um Fotos, die während der jeweils vorhergehenden Party-Nacht geschossen wurden. Die besten Fotos schafften es dann auch letztendlich bis zum Flyer. Bei den Produkt-Flyern war die graphische Idee, die notwendigen Informationen zu platzieren und überflüssige Informationen wegzulassen.

Dass ich mir bei der Gestaltung an sich genaue Gedanken mache ist klar - doch diese Gedanken bleiben dann mein Geheimnis, schließlich will man ja auch freien Raum lassen für Interpretationen."

LEBENSZYKLEN DER FLYER

LINKE SEITE:
OBEN: Babies von Dadara
UNTEN: Flyer von Fubbi Kalsson

RECHTE SEITE:
OBEN RECHTS: Flyer von Gianni Macario
UNTEN: Flyer aus Detroit / Windsor

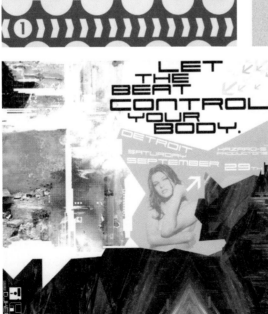

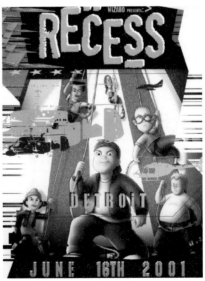

149

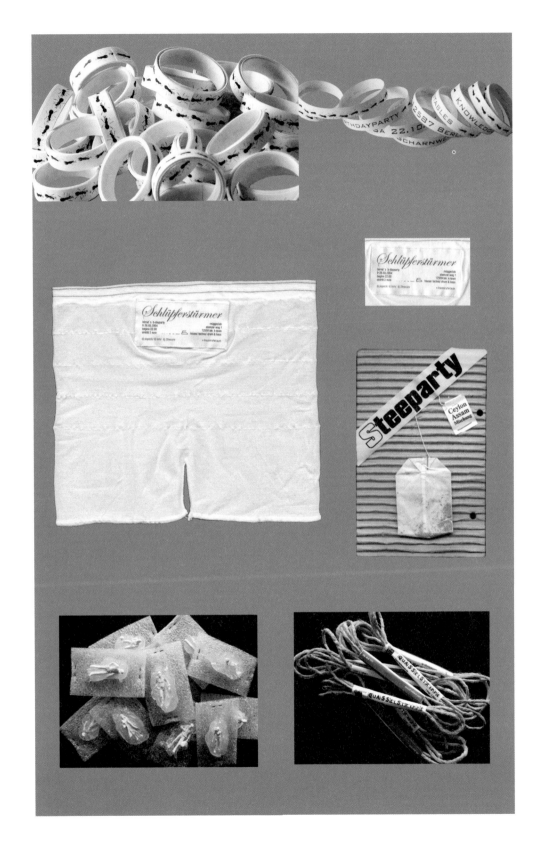

FLYER von Traumtänzer Design (David Friedrich)

COOKIE PRESENTS:
DJ **BEN E. CLOCK** AND DJ **CLÉ**
LIVE PERFORMANCE BY SUPER ZANDEE
COOKIES COCKTAILS

D E L I G H T E D
DATE/TIME
19 FEB 1999/2200

fr, 29-08-97
urban electronic experience

mit live:
gianni vitiello

STROM!
ELECTRONIC WELFARE
SOS DJ-TEAM(HH)
SPECTRO NAMIB
BURGSTR.31 HACK MARKT

...Rhizome OpenMouse™...
Rhizome.org & Cultural Alchemy/
Soundlab..Sept28 and monthly on
Thursdays at Fun 130 Madison St
NYC 7-11 pm..blue letters on a
white awning..live electronix.
.djs..projectors..big screens..
streaming media in&out..artists
sign up to show your work.go to
www.rhizome.org/events...Sept28.
Oct26.Nov16.Dec 21.Jan25.Feb22.
Mar29.Apr26.May 31.212-964-0303

mini NT
analog eats digital

du schickst uns deinen entwurf für ein bild,
das maximal 32 x 32 pixel groß ist.
der entwurf kann als datei oder einfach
nur handgezeichnet auf karopapier sein
was auch immer: hysteria arbeitet deinen
entwurf dann analog in ministeck und digi-
tal als foldericon für den computer.

dein bild wandert zu ausstellungen, dein
icon gibt es als free download mit namens-
nennung unter www.hysteria.de.

schick dein bild an:
hysteria, lassallestr. 19, 34119 kassel
hype@hysteria.de oder
pinknoise, invalidenstr. 151, 10119 berlin.
pinknoise@chickmail.com
weitere informationen unter:
http://www.hysteria.de.

OBJEKTFLYER

Wellblech
Infusionsbeutel
Metall Stanzteil
Luftpolster
Glaskugel
Zettel
Vignette
Kärtchen
Visitenkarte
Kreditkarte
Plastik
Sandpapier
Tapette
Teppich
Dose
Wellkarton
Päckchen
Glas
Röhrchen
Aufkleber
Briefmarke
Couponheft
Wertmarke
Stoff
Leporellos
Früchte
Binde
Latex
Leder
Fell
Schachtel
Plexiglas
Holz
Folie

OBJEKTFLYER

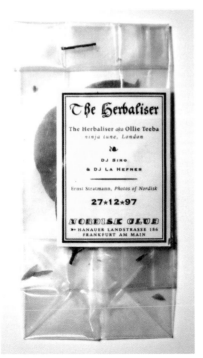

WHY COLLECT FLYERS?

Some people think it's totally stupid. Others think it's uncool or even childish. Besides the kick of researching in the living heart of the city, the main motivation is the communication involved. Just collecting is one thing. Making a collection visible through publications like this one, through websites or exhibitions, and the resulting contact with collectors, promoters and designers brings the whole thing to life. Being a mobile ambassador of a culture which in many places still works on a non-commercial and non-profit basis, is a great challenge and a great honor.

FLYER CULTURE IS FAN CULTURE! And the fans are the life blood of the culture. It is them who keep alive the designers and acts, the labels, store owners and tour organizers. Without popularity, any artist will have a hard time in the long run. The amount of interested collectors for any given club probably depends on its success and the acts on the bill. Some of the best examples of this probably come from legendary clubs of the past like Omen in Frankfurt, the first Ultraschall at the old Riem airport in Munich, Berlin's E-Werk, or Aufschung Ost / Stammheim in Kassel. The powerful myth of these seminal locations lives on through the fans and their flyer collections, in tales told at home and at parties. They are what new clubs have to measure up to.

*************WHO WILL SELL ME THEIR OMEN FLYERS??????**
Fly60311: Sat Dec 1 11:35:12 2001
Hello! Urgently looking for flyers from Omen!
Who would sell me theirs?
Please contact: SchranzerinFFM@web.de
Thanks!
http://www.techno.de/cgibin/community/click_cat?action=show&subjectID=1007202912

WHY SHOW FLYERS IN AN EXHIBITION? "Can I show you my flyer collection?"
What drives people to present these brightly colored little pieces of paper to the public for a second time? Part of the answer is easy. As we have already seen, flyers are works of art with a value in terms of music and cultural history, meaning they are worth seeing whether old or new. Bundled together, they reflect the horizons of a club, a city, or a fan. And for designers they can be used as a portfolio: "Show me your flyers and I'll tell you who you are."

Flyers act as identity-shaping representational objects. It is no exaggeration to see a collection of flyers as the collective subconscious of a generation. The act of consuming brings people together, and the same applies to the event where the consuming takes place. The snippets of paper awaken memories of days and nights gone by, and they make it easier to reassemble the dream-like fragments that usually remain after a great night out.

It is also interesting that exhibitions of this kind are like magnets. At the communicative level, a connection is established that makes it easier to explain oneself or to tell a story. Visitors rub up against their shared past, and from there new threads can be spun for the networks of the future.

Besides exhibitions organized by projects like "Flyer Research" or featuring academic disserta-

FLYER LIFE CYCLES

tions on the subject, there are also shows initiated by graphic designers or club own-ers (Red Dog/Stuttgart, Chromapark/Berlin). This is often used as a way to mark an anniversary of a venue or in times of dwindling contracts where references become an important marketing tool and a way of drawing much-needed attention. There are also shows in museums. Flyers and flyer culture are slowly arriving at this level.

Flyer Soziotope has been shown at both the German Protestant Church Congress and the Atlantis Festival in Lausanne. At the former, visitors puzzled over this culture, while the latter celebrates it. The collection certainly hands it on a plate to design acad-emies, graphic design schools, sociological and ethnological centers, as well as to the music industry and the culture management, marketing and advertising sectors.

"Even if a party costs money to get in, or if a profit is made on the drinks, the flyer is used by the organizers as a means of communication, not to draw the biggest possible audience but to draw the right audience, one that matches their general atti-tude to life and that shares their musical taste and social or intellectual background."

The "Follow the Signs" exhibition at the Zurich Design Museum (2000) was a suc-cessful and interesting show of the treasured "appeals to a special audience" produced over the years by the local scene, accompanied by lectures, presentations and – of course – parties. The overall program was heavily supported by "Partysan".

"Partysan" is a fanzine for electronic music in pocket format (A6). Founded in 1994 in Munich, it is published every month in 12 places with a total circulation of 345,000. At the moment, Partysan exists in Germany for the regions Baden-Württemberg, Bavaria, Berlin, Franken-Upper Palatinate, Central Germany, North, North-East, North Rhine-Westphalia, and Rhine-Main-Saar, as well as in Hungary, Austria and Switzerland.

Over the years, and in the different editorial offices that work independently of one another, different graphic design styles have developed for this event guide. The layout has been changed many times, moving from a brighter, patchwork techno-style concept to a more conventional layout that became less and less agitated. One reason for this development was certainly the changing tastes of the target group, but also that the early kind of techno graphics began to appear in many fields of public life: cer-tain elements were even adopted by commercial advertising, and the magazine wanted to distance itself from that.

Like the insider slang used in techno magazines, graphic design is also a means of appealing to a target group. For some, these graphical and linguistic codes are a sign that this has been made specially for them. Others who are unable to decipher the code are kept at arms length.

"Early flyers had a non-commercial background and were something fundamen-tally different to an advertising tool: they lacked the gap between advertiser and target group that is always present in advertising. Instead, they were always a sign of mutual agreement between all involved. The socio-cultural breeding ground of the party culture is the alternative youth movement. This should be remembered when posters, booklets and flyers overflowing with 'beautiful people'. As a result, collecting is all about finding the 'right' flyers."

FLYER CENTRE BARCELONA The Flyer Center Barcelona was created in 1997 as a project based around flyers, those hybrid handbills that combine art, graphics and communication. In the same year, the 1st International Flyer Contest was organized by Federica Michot and NightSunGroup. The high level of +participation, with entries from all over Spain and Europe, led to the organizers' decision to make the competition an annual one, as well as putting on other flyer-related activities. The second contest was organized from a once-only virtual venue, the Virtual Club.

Attracted by the Internet and the idea of being able to receive flyers from all over the world, Federica Michot, with the collaboration of Natàlia Herèdia, decided to give the competition a new direction, giving it a regular virtual venue. The third competition, IFC'99, was organized from the new Flyer Center Barcelona, which made its debut on the Net in March 1999. In 2000, the Flyer Center Barcelona widened its scope to become an associate group of the Centre de Cultura Contemporània de Barcelona, which is the home base for IFC'00 and other on- and off-line activities.

FLYER RESEARCH Private individuals with collections of several hundred thousand flyers; institutions like the Werkbund Archiv/Museum der Dinge in Berlin with its extensive stock of everyday graphics; and the Museum of Applied Arts in Hamburg with its comprehensive archive of posters - what do they all have in common? In my opinion, it is their belief in the value of these cultural media and their history; the desire to keep alive the memory of the periods in question in all their detail. Flyers' pleasing format makes them easy to collect in great numbers. In spite of this, one is always hearing the sad news that after four or five moves, another person finally threw out those boxes full of old flyers.

In France, Radio FG in Paris presented and organized an exhibition of flyers, and the Palais de Tokyo covered similar ground in its "Hardcore" show. The musicians Antje Greye Fuchs and Vladislav Delay reported on flyers as part of an exhibition at KIASMA Museum of Contemporary Art, Helsinki. Flyers have featured at the Berlin Beta media congress (1998 and 2001); at the Popkomm entertainment fair (1998 in Cologne); at the Contemporary Culture Convention CCC in Switzerland that has taken place four times since 1995 HTTP://WWW.R3S3T.CH/CCC/; at the Sonar "advanced media and electronics" festival (1999 and 2001); at Popup in Leipzig HTTP://WWW.POPUP-LEIPZIG.DE; at Chromapark, a major exhibition of club art (1994/1995, Berlin); and in the "Zurück zum Beton" show at Kunstverein Düsseldorf that documented the early phase of punk in Germany. MoMA/New York is said to have organized an exhibition with several hundred flyers from one typical day in the life of the city. Other examples like the Berlin club exhibition "Children of Berlin" at P.S. 1 in New York, at KIASMA in Helsinki and at Zurich Design Museum show the ongoing popularity of the subject. Bearing in mind that millions of people have already spent time in flyer exhibitions around the world, it is clear that sooner or later, shows of this kind will follow in the footsteps of poster art and culture.

Music fairs and American galleries like the Middle East Cafe in Boston or CBGB gallery in New York show poster artists like Frank Kozik. In Switzerland and Germany, too, there is a great interest in American poster art by the likes of Firehouse Kustom Rockart Co., Marco Almera, Chris 'COOP' Cooper, Kozik, Lindsey 'Swamp' Kuhn and Emek.

Faculties like that run by Diedrich Diedrichsen at Merz-akademie in Stuttgart, by the pop researcher Peter Wicke at Humboldt University in Berlin, and by the techno sociologist Ronald Hitzler at Dortmund University provide an academic context for pop culture studies. The newly founded Pop Akademie in Mannheim looks set on becoming a model project in the German educational world.

Publications like The Art of Rock I + II, DJ-Culture, Techno, Localizer and Searching for the Perfect Beat offer an overview of musical developments. Music magazines and city guides are like a diary of the scene. The websites of those involved also almost always maintain archives - because history is credibility, documenting background and integrity. Club, media and label anniversaries are also popular party occasions for those involved. Compendia like the New Trouser Press Guide try to provide historical material in encyclopedic form.

Uwe Husslein's Musikkomm Archive, that was on show for years at the Popdom in Cologne, and Klaus Farin's Archive of Youth Cultures in Berlin managed to bring together large amounts of pop culture printed matter from fanzines to books, and to make it available to an interested audience, something the German Flyer Archive in Gelnhausen was sadly unable to achieve. There are also unconfirmed rumors about a flyer museum in Hamburg.

With titles like Designagent K7, Büro Destruct, Los Logos and Flyermania, the Berlin publishing house Gestalten Verlag has for years been showing us what the future of design might look like. Due to massive demand, the designers Bringmann and Kopetzki also market their motifs on T-shirts and posters and in books.

The artifacts sold by the Hard Rock Cafe chain show that authenticity creates an atmosphere and pulls the crowds. Or at least that's the idea. The rock museum founded in Seattle by Microsoft executive Paul Allen (Experience Music Project, www.emplive. com) is an example of the possibility of creating an urban attraction that will be as appealing to Canadian tourists as the German Rock and Pop Museum in Gronau tries to be for Dutch tourists. It seems as if pop culture and tourism might be one of the possible ways out of the economic crisis for a number of regions. In Berlin, as in Seattle, Barcelona and London, this has been shown to be the case in the past and it continues to apply. At this point, it is worth referring to the work of the regional bodies whose task is to give political support to measures aimed at enhancing the conditions for business in the fields of media and culture.

Both large-scale sociological exhibitions like "Shrinking Cities" and local museums in small towns like Dingolfing show cover art. The Berlin shows "Pictoplasma" (2004), that featured modern character design, and "Backjumps" (2003), focusing on current trends in street and aerosol art, are publicly funded projects that highlight an interest in these new, dynamic cultural forms. Congresses like "Urban Drift" for architecture, "Transmediale" for media culture, "Bread and Butter" for fashion and "Ars Electronica" in Linz for media art regularly focus from their various perspectives on the latest issues in music production and presentation, political activism and media propaganda. One could describe these events as the economic/academic context for current flyer culture.

Most of the existing books on flyers have a regional or style-based focus. They usually feature particular gems and especially elaborate or striking designs. All kinds of marginalia like set lists, slipmats, projections and documents are lovingly arranged according to subjective criteria alongside opinions and statements from those involved. History is being written. The following books are much recommended. Inspiration guaranteed!

BCN CLUB FLYER

T. Barbuzza / Actar / ES / 2000

FUCKED UP AND PHOTOCOPIED

B. Turcotte, C. Miller / Gingko / US / 1999

FLY: THE ART OF THE CLUB FLYER

Thames+Hudson / UK / 1996

MASSENWARE

Seen by CAJ / Red Dog / exhibition catalog / DE / 1997

FLYER MANIA

R. Klanten, A. Peyerl / Die Gestalten / DE / 1998

DISC UND TECHNO STYLE

M. Weisbeck, M. Pesch / Edition Olms / DE / 96+99

HIGH FLYERS / NOCTURNAL

P. Beddard / Booth-Clibborn / UK / 1998, 2000

CLUB SPOTTING 1+2

P. Davoli, G. Fantuzzi / Happy Books / IT / 2000+1

FOLLOW THE SIGNS

Edition Museum für Gestaltung / CH / 2000

PROUD 2 BE A FLYER

S. Matteo / Happy Books / IT / 2003

SEARCHING FOR THE PERFECT BEAT

W. Guptill / US / 2000

Great graphics from the field of social and political work are featured in "Graphic Agitation" 1 + 2 (Phaidon'1993 and 2004) put together by Liz McQuiston, which comprehensively document the world of subverting. Many cutting-edge pieces by flyer-related designers are also to be found in specialist magazines on art, lifestyle and design like ROJO (ES), Style and the Family Tunes (D), Lodown (D), Pupumagazine (ES), Wallpaper (US) or Rugged (developed by the Carhartt fashion brand). And of course, music magazines like Groove, Spex, Visions and Intro are also permanent supply channels of the new visual terrorism.

Books like the "X-Directory" (Pi34 Publishing, ISBN 1898760004) deal with peripheral areas of the culture of exchanging handbills like the obscure English offers of sex services left in public phone booths, or the custom among amateur radio enthusiasts worldwide of designing and exchanging QSL cards, that was dealt with in depth in a 2003 book from MIT Press.

The websites funkreich.de, hyperreal.org, techno.de and flyerart.com archive thousands of relics. At times, it has even been possible to order collections of digital flyers on CD. Most of these sites allow new flyers to be contributed. The archive and portal at hyperreal.org are especially recommended as an online jumping-off point.

The events organized by the Force Inc. label – 'Five Years of Electronic Revolution' in Cologne and 'Mille Plateaux' in Berlin and Frankfurt - were milestones in the combination of music and contemporary art.

FLYER LIFE CYCLES

Artist Stefan Beck's "Multitrudi" gallery in Frankfurt offered self-collected flyers in plastic bags with certificates of authenticity. The trade in flyers is flourishing on eBay. At record stores like Optimal in Munich or Hardwax in Berlin, it is a gen-uine pleasure to study the latest offerings. There is also an incomparable selection at the largest record store on America's west coast, Amoeba in San Francisco.

State institutes of higher education like Potsdam Polytechnic College, the Univer-sities of Berlin, Weimar and Trier, and the Design Academies in Offenbach and Leipzig allow students to write seminar papers, diploma theses or even PhDs on the subject. Books from this academic field that have sadly never been published include projects close to this book: 'Flyer über Berlin' (Jule Svoboda and Steffi Lindner, 1999) and 'Rauschen als Rauschmittel', (Marco 'Microbi' Reckmann,1998). Joe Landen's study entitled 'Phänomen Flyer' was written at the Merz Akademie in Stuttgart and is pub-lished at www.Techno.de/flyer. In English, 'Visual Energy' by Simon Parkin, available online at hyperreal.org, shows how various the approaches to this subject can be. The most recent study I have heard about is being written by a linguist at Warsaw Univer-sity about the flyer and event culture related to the introduction of the Hartz IV labor market reforms in Germany.

Incidentally advertising agencies like Scholz und Friends prefer creatives with a background in flyer design, as they assume this guarantees a good instinct for youth communication.

Artists, too, work with 'our' material. One of the best known is Stefan Hoderlein, an "alert observer of social phenomena that reflect the zeitgeist". For some years, he has been focusing on techno culture, not as a neutral observer but as an active mem-ber of the scene. Hoderlein is a passionate collector and archivist of techno material of all kinds. Music, flyers, posters, stimulants, souvenirs and other relics - the material he gathers at parties is later integrated into his projects, e.g. to create whole (living) environments.

One of Hoderlein's pieces involves projecting large-format images of groups of "ravers", performing automated movements as if in a trance, onto the window of a museum foyer. He works with the principle of accumulation. He is interested not in the individual, but in the massing of persons or objects that constantly create new constel-lations, structures and rhythms. In the early 1960s, the French Nouveaux Réaliste art-ist Arman used a similar approach, accumulating everyday and mass-market objects as a way of visualizing social and socio-economic issues. HTTP://PAIK.CULTD.NET/TEXT/RENNERT.HTM

"Stefan Hoderlein is interested in the formal idiom of subcultures and their varia-tions. His backlit visuals on the walls of Tonhalle underground station show thousands of pictures from his life in pop and subculture; he understands them as a form of archae-ology of the present, reminiscent of the brightly colored temples and burial chambers of Ancient Egypt." HTTP://WWW.HELL-GRUEN.NET/PAGES/DE/KONZEPT.HTML

The young Berlin artist Jamain uses her favorite flyers to make miniature furni-ture, similar to the Parisian group "X-Fly" around Florence Picaud, but much smaller.

Some of the prototypes were on show at "Designmai 2004". Such attempts to put the visions of the night to constructive use seem to make good sense. Objects like these, private selections in the bathroom, or even clothes made out of flyers bring a link to the beloved scene into the home.

One of the most unusual pieces of art based on flyers was presented by "nino" in 1998 in the window of the Radio Berlin gallery: a model of Berlin's TV tower glued together out of the dead roach-ends of hundreds of joints, entitled "Fly, Berlin, Fly", with an index detailing the individual components.

The following excerpt from the index to another of his works entitled "F(i)L(t)Y(er) AIRlines" lists the flyers used according to motif, number and source:

Flyerlines	--	blue backgrounds
	24	computer game museum flyers
	13	Mondo Fumatore rec.rel.pty flyers
	10	Electric Ballroom flyers
	06	Big Wild & Massive flyers
	04	Kings Club flyers
	02	Selecta flyers

This use of flyers as an aid to psychedelic inspiration in connection with its positioning in the city takes the same line as the knowledge that the world's largest disco ball is in the centre of East Berlin. In other words: "Concept art based on recycling these brightly colored snippets of instant waste paper refers to their content without betraying it. This robbing of content and function sets them free, but loaded with a new meaning." (Peter Maibach/Pulp Mansion)

It was impossible to find out, whether Art Collectors like Saatchi, Flick or even Daimler Chrysler are secretly collecting Flyers as well...

All in all, collecting flyers also means capturing swarms of creative intelligence of individual generations. The visualized and implied attitudes of this culture provide inspiration for new and hopefully better trajectories for society. They strip realities to the bone and lead us towards a new, more open path.

Think for yourself! Timothy Leary
Remix is Respect

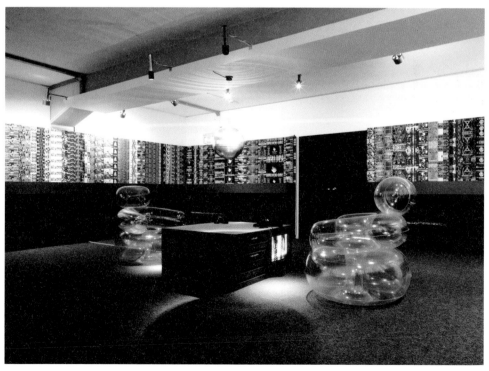

OBEN Flyer aus Zürich
UNTEN Bild aus der "Follow the Signs"-Ausstellung in Zürich

WARUM FLYER SAMMELN?

Manche denken, das ist schlichtweg Schwachsinn. Andere glauben, es ist spießig oder gar ewig-jugendlich. Die Motivation ist neben dem Kick des 'Research' am lebenden Herz der Städte die damit in Verbindung stehende Kommunikation. Nur zu sammeln ist definitiv das eine. Die Sammlung einsehbar zu machen durch Publikationen wie diese, durch Websites oder durch Ausstellungen und der Kontakt mit den Sammlern, Veranstaltern oder Gestaltern bringt das Ganze zum Leben. Mobiler Botschafter einer Kultur zu sein, die immer noch an vielen Stellen unkommerzielle und gemeinnützige Züge trägt, ist eine große Herausforderung und Ehre.

FLYERKULTUR IST FANKULTUR! Und die Fans sind die Basis der Kultur. Sie ernähren die Gestalter und Künstler, die Labels, Ladenbetreiber und Tourveranstalter. Ohne Popularität tut sich jeder Künstler auf Dauer schwer. Das Maß der Menge der Sammler ist wohl proportional mit dem Erfolg eines Clubs und den das Programm gestaltenden Künstlern verbunden. Einige der besten Beispiele hierfür dürften die geschlossenen Clubs Frankfurter 'Omen', das erste 'Ultraschall' am alten Flughafen München Riem, das Berliner 'E-Werk' oder das Kasseler 'Aufschung Ost / Stammheim' sein. Der Mythos dieser zentralen Kraftorte lebt durch die Fans und ihre Flyersammlungen in den Küchen und vielen Geschichten der Nacht weiter. An ihnen müssen sich die Neueröffnungen messen.

************* WER VERKAUFT MIR SEINE OMEN FLYER??????**
Fly60311: Sat Dec 1 11:35:12 2001
Hallo! Suche ganz dringend Flyer aus dem Omen!
Wer würde mir seine verkaufen?
Bitte melden: SchranzerinFFM@web.de
Danke!
http://www.techno.de/cgi-bin/community/click_cat?action=show&subjectID=1007202912

WARUM STELLEN LEUTE FLYER AUS? "Darf ich dir meine Flyersammlung zeigen ?"
Was treibt sie dazu diese bunten kleinen Papierschnitzel der Öffentlichkeit ein weiteres Mal zu präsentieren? Die Antwort ist zum Teil einfach. Flyer sind, wie bereits mehrfach festgestellt wurde, Kunstobjekte mit musik- und kulturhistorischem Wert, also sehenswert egal ob alt oder aktuell. Im Bündel geben sie den Horizont eines Clubs, einer Stadt oder auch eines Fans wieder. Für Gestalter sind sie gar das Portfolio ihres Potentials: "Zeig mir deine Flyer und ich sag dir, wer du bist."

Flyer fungieren als identitätsstiftende Repräsentationsobjekte. Als Sammlung kann man sie, ohne zu übertreiben, als kollektives Unterbewusstes einer Generation sehen. "Konsum verbindet" und ebenso tut dies der Anlass auf dem konsumiert wird. Erinnerungen an vergangene Tage und Nächte werden durch die kleinen Zettelchen wieder aktiviert und es fällt leichter, die traumhaften Bruchstücke, die übrig bleiben nach einer gelungenen Nacht, wieder zusammenzusetzen.

Interessant ist auch die Tatsache, dass Ausstellungen dieser Art wie kleine Magneten funktionieren. Auf kommunikativer Ebene wird ein verbindendes Element geschaffen, dass es leichter macht sich zu erklären oder eine Geschichte zum Besten zu geben. Die Besucher beginnen sich zu reiben an der gemeinsamen Vergangenheit und von da aus können neue Fäden gesponnen werden für Netzwerke der Zukunft.

Natürlich finden sich unter den Ausstellern neben den wissenschaftlichen oder akademischen Projekten wie 'Flyer Research' oder den existierenden Diplomarbeiten auch die, welche Graphiker oder Clubbetreiber (Red Dog/Stuttgart, Chromapark/Berlin) initiieren. Dies geschieht oft zum Jubiläum eines Ortes oder in Zeiten schlechter Auftragslage, wo die Referenzen zum wichtigen Marketingtool werden und Aufmerksamkeit geschaffen werden muss. Darüber hinaus gibt es die museale Ebene. Hier kommen die Flyer und ihre Kultur gerade an.

Flyer Soziotope wurde am deutschen evangelischen Kirchentag wie auf dem Atlantis Festival in Lausanne gezeigt. Hier wird über die Kultur gerätselt, dort wird sie zelebriert. In jedem Fall ein gefundenes Fressen für Designakademien, Graphikerschulen, soziologische und ethnologische Zentren sowie für die Musik- und Kulturmanagement Branchen und die Marketing und werbetreibende Industrie.

"Auch wenn die Party Eintritt kostet, oder wenn mit der Konsumation Geld umgesetzt wird, suchen die VeranstalterInnen mit dem Flyer als Kommunikationsmittel nicht ein möglichst grosses, sondern das richtige Publikum: eines, das mit ihnen in der allgemeinen Lebensauffassung übereinstimmt und das die musikalischen Vorlieben und das soziale oder intellektuelle Milieu teilt." Follow the Signs, Museum für Gestaltung Zürich, 1999

Die 'Follow the signs' Ausstellung im Züricher Museum für Gestaltung (2000) zeigt sehr erfolgreich und interessant die geschätzten "Appelle für ein spezielles Publikum", die die dortigen Szenen über die Jahre produzierten, begleitet von Vorträgen, Präsentationen und natürlich - Parties der Macher. Die gesamte Ausstellung wurde auch stark vom Szenemedium Partysan unterstützt.

Der "Partysan" ist ein Fanzine für elektronische Musik im A6-Hosentaschenformat. Gegründet 1994 in München erscheint es monatlich in 12 Orten in einer Gesamtauflage von 345.000 Stück. Derzeit existiert der "Partysan" in Deutschland für die Regionen Baden-Württemberg, Bayern, Berlin, Franken-Oberpfalz, Mitteldeutschland, Nord, Nordost, Nordrhein-Westfalen, Rhein-Main-Saar und in Ungarn, Österreich und der Schweiz.

Im Laufe der Jahre und in den verschiedenen, unabhängig arbeitenden Redaktionen haben sich unterschiedliche graphi-

sche Gestaltungsformen für diesen Event Guide herausgebildet. Es kam im Laufe der Jahre zu zahlreichen Layoutänderungen. Die Entwicklung geht von einem eher technoiden, sehr bunten, patchworkartigen Konzept hin zu einem klassischeren Layout, das immer mehr beruhigt wurde. Ein Grund für diese Entwicklung war sicherlich die Veränderung des Geschmacks der Zielgruppe, aber auch, dass jene Technographik Einzug hielt in viele Bereiche des öffentlichen Lebens. Bestimmte Elemente wurden bis in die kommerzielle Werbung übernommen, davon wollte man sich absetzen.

Wie bei der für Außenstehende zum Teil unverständlichen Sprache der Techno-Fanzines ist auch die graphische Gestaltung ein Mittel, um die Zielgruppe anzusprechen. So ist für die einen dieser graphische und sprachliche Code ein Hinweis, dass dies speziell für sie gemacht ist. Andere, die die Codes nicht decodieren können, sind ausgegrenzt. "Frühe Flyer hatten einen nichtkommerziellen Hintergrund und waren etwas grundlegend anderes als ein Reklamemittel. Das der Werbung immanente Gefälle zwischen Werbenden und Umworbenen kannten sie nicht. Vielmehr waren sie stets Zeichen gegenseitigen Einverständnisses zwischen allen Beteiligten. Der soziokulturelle Nährboden der Partykultur ist die alternative Jugendbewegung. Daran muss erinnert werden, wenn schreiendvolle Plakate, Broschüren und Flyer eher an Beautiful People denken lassen. Entsprechend geht es beim Sammeln um die richtigen Flyer." Follow the Signs, Museum für Gestaltung Zürich, 1999

FLYER CENTER BARCELONA The Flyer Center Barcelona was created in 1997 as a project based around flyers, those hybrid handbills that combine art, graphics and communication. In the same year, the 1st International Flyer Contest was organised by Federica Michot and NightSunGroup. The high level of participation, with entries from all over Spain and Europe, led to the organisers' decision to make the competition an annual one, as well as putting on other flyer-related activities. The second contest was organised from a once-only virtual venue, the Virtual Club.

Attracted by the Internet and the idea of being able to receive flyers from all over the world, Federica Michot, with the collaboration of Natàlia Herèdia, decided to give the competition a new direction, giving it a regular virtual venue. The third competition, IFC'99, was organised from the new Flyer Center Barcelona, which made its debut on the Net in March 1999. In 2000, the Flyer Center Barcelona widened its scope to become an associate group of the Centre de Cultura Contemporània de Barcelona, which is the home base for IFC'00 and other on- and off-line activities.
[Auszug aus der Website: WWW.CCCB.ORG/FLYERCENTER]

FLYER RESEARCH Was vereint Privatpersonen, die mehrere hunderttausend Stück ihr Eigen nennen, Institutionen wie das Werkbund Archiv/Museum der Dinge in Berlin, dessen Fundus an Gebrauchsgraphiken umfassend ist oder das Museum für Kunst und Gewerbe/Hamburg, dessen Plakat- und Druckgraphiksammlung einen Überblick zur Plakatkultur gibt? Ich denke,

es ist der Glaube an den Wert dieser Kulturmedien und deren Geschichten. Das Pflegen der Erinnerung an die jeweilige Epoche und ihren Detailreichtum. Das angenehme Format der Artefakte erleichtert es bei Flyern großzügig zu sammeln. Trotzdem hört man immer wieder bedauernd von "nach dem 4ten Umzug doch weggeschmissenen Kartons voller Flyer".

In Frankreich präsentierte und organisierte der Pariser Sender Radio FG eine Ausstellung wie auch das Palais de Tokyo mit der Ausstellung 'Hardcore' auf diesem Terrain arbeitete. Die Musiker Antje Greye Fuchs und Vladislav Delay berichteten von Flyern im Rahmen einer Ausstellung im Museum of Contemporary Art Kiasma, Helsinki. Leider konnte hier auch durch Telefonate nicht mehr herausgefunden werden.

Bei der Medienmesse Berlin Beta (1998 und 2001), bei der Entertainmentmesse Popkomm (1998 in Köln), der Contemporary Culture Convention CCC in der Schweiz, die zum vierten Mal seit 1995 stattfindet (HTTP://WWW.R3S3T.CH/CCC/), dem Festival 'Advanced Media and Electronics' Sonar (1999 und 2001), der Popup in Leipzig (HTTP://WWW.POPUP-LEIPZIG.DE) wurden visuelle Freudenspender ebenso präsentiert wie bei der Clubkunst-Grossausstellung Chromapark (1994, 1995/Berlin), dem 'Timewarp' Festival oder, der die deutsche Punkaufbruchsphase dokumentierenden Schau 'Zurück zum Beton' im Kunstverein Düsseldorf. So hat das MoMA/New York gerüchteweise eine Ausstellung mit den mehreren hundert Flyern eines typischen Tages der Metropole veranstaltet. Andere Beispiele wie die Berlinclubkulturausstellung 'Children of Berlin' im P.S. 1 in New York, im Museum of Contemporary Art Kiasma in Helsinki oder eben im Museum für Gestaltung Zürich zeigen die ungebrochene Popularität des Themas. Gerade wenn man annimmt, dass schon Millionen Gäste in Flyerausstellungen rund um den Globus verweilten, wird deutlich, dass Flyerausstellungen früher oder später in die Fußstapfen der Plakatkunst- und kultur treten werden.

Musikmessen und US Galerien wie das Middle East Cafe in Boston oder die CBGB Galerie in New York zeigen Posterkünstler wie Frank Kozik. Auch in der Schweiz und in Deutschland herrscht Hochkonjunktur für amerikanische Posterart von Leuten wie 'Firehouse Kustom Rockart Co.', Marco Almera, Chris 'COOP' Cooper, Kozik, Lindsey 'Swamp' Kuhn oder Emek.

Lehrstühle wie der von Diedrich Diedrichsen an der Merzakademie in Stuttgart, der des Popforschers Peter Wicke an der Humboldt Universität in Berlin oder der des Techno Soziologen Ronald Hitzler an der Uni Dortmund liefern einen akademischen Kontext der Popkulturforschung. Die noch recht neue Pop Akademie in Mannheim scheint geradezu ein Aushängeschild der deutschen Bildungslandschaft werden zu wollen.

Publikationen wie 'The Art of Rock I + II', 'DJ-Culture', 'Techno', 'Localizer' oder 'Searching for the perfect Beat' schaffen es, einen Überblick der musikalischen Entwicklungen zu geben. Musik- und Stadtzeitungen sowie A6 Hefte schreiben das Tagebuch der Szenen mit. Die Internetseiten der Protagonisten arbeiten beinahe immer auch archivarisch. Denn Historie ist Credibility und zeugt von Background und Integrität. Die Club-, Medien- und Labeljubiläen sind ja auch begehrte Feieranlässe

für die Protagonisten. Lexika wie der 'New Trouser Press Guide' versuchen auch lexikalische Geschichtsarbeit zu leisten.

Das Musikkomm Archiv von Uwe Husslein, das jahrelang im Popdom in Köln zu besuchen war, und das Archiv der Jugendkulturen von Klaus Farin in Berlin schafften es, eine große Menge popkultureller Schriften vom Fanzine bis zur Publikation zu erfassen und auch einer interessierten Öffentlichkeit anzubieten. Leider war dies dem Deutschen Flyerarchiv in Gelnhausen nicht möglich. Ebenso hört man Gerüchte über ein Flyermuseums in Hamburg, die sich aber nicht verdichten ließen.

Der Berliner Gestalten Verlag mit Publikationen wie 'Designagent K7', 'Büro Destruct', 'Los Logos' und 'Flyermania' hat seit Jahren gezeigt wie die Zukunft des Designs wohl aussehen wird. Die Gestalter Bringmann und Kopetzki vermarkten ihre Motive aufgrund der großen Nachfrage auch auf T-Shirts, Plakaten und in Büchern.

Die Artefakte der globalen Barkette Hard Rock Cafe zeigen es: Authentizität sorgt für Atmosphäre und Anziehungskraft. So hofft man zumindest. Das von einem Microsoft Manager Paul Allen gegründete 'Rockmuseum' in Seattle (Experience Music Project, www.emplive.com) ist ein Beispiel für die Möglichkeiten der Schaffung eines attraktiven urbanen Publikumsanziehungspunkt, der in Seattle ähnlich attraktiv für kanadische Touristen sein wird, wie es das Deutsche Rock und Pop Museum in Gronau versucht für holländische Reisende zu sein. Es scheint als seien Popkultur und Tourismus einer der möglichen Auswege aus der strukturellen Krise diverser Regionen. In Berlin als auch Seattle wie in Barcelona oder London war und ist dies in jedem Fall erforscht und nachgewiesen. Hier sei verwiesen auf die Arbeit der regionalen Wirtschaftsförderungsinstitutionen, die jeweils vor Ort versuchen Standortpolitik im Medien- und Kulturbereich zu fördern und zu erfassen.

Soziologische Grossausstellungsprojekte wie 'Shrinking Cities' und auch Stadtmuseen in Kleinstädten wie Dingolfing zeigen Cover Art. Die Berliner Schauen 'Pictoplasma' (2004), die modernes Charakterdesign, und 'Backjumps' (2003), die aktuelle Tendenzen der Street- und Aerosolart präsentierten, sind öffentlich geförderte Projekte, die das Interesse an diesen neuen dynamischen Kulturformen verdeutlichen. Auch 'Urban Drift' für Architektur, die 'Transmediale' für Medienkultur, die 'Bread and Butter' für Mode oder die 'Ars Electronica' für Medienkunst in Linz widmen sich regelmäßig aus ihrer Perspektive den Themen aktuellster Musikproduktion- und präsentation, politischem Aktivismus und medialer Propaganda. Wenn man so will, sind sie das wirtschaftlich-wissenschaftlich Umfeld aktueller Flyerkultur.

Die bereits erschienen Flyerbücher haben zumeist eine regionale oder stilistische Herangehensweise. Gezeigt werden meist Schmuckstücke und besonders aufwendige oder schicke Designs. Kuriose Stücke am Rande des Phänomens wie Setliste, Slipmats, Projektionen und Dokumente aller Art werden neben den Meinungen und Statements der Protagonisten subjektiv arrangiert. Geschichte wird gemacht. Sehr zu empfehlen ist der Genuss der folgenden Bücher in jedem Fall. Inspiration garantiert!

BCN FLYER Tite Barbuzza / Actar / ES / 2000
FUCKED UP AND PHOTOCOPIED Bryan Ray Turcotte, Christopher T. Miller / Gingko / USA / 1999
FLY: THE ART OF THE CLUB FLYEr Thames+Hudson / UK / 1996
MASSENWARE Seen by Caj / Red Dog / Ausstellungskatalog / DE / 1997
FLYER MANIA Robert Klanten, Andreas Peyerl / Die Gestalten / DE / 1998
DISC STYLE Techno Style / Markus Weisbeck, Martin Pesch / Edition Olms / DE / 1996+99
HIGH FLYERS Nocturnal / Phil Beddard / Booth-Clibborn / UK / 1998, 2000
CLUB SPOTTING 1+2 Paolo Davoli, Gabrielle Fantuzzi / Happy Books / IT / 2000+01
FOLLOW THE SIGNS Edition Museum für Gestaltung / CH / 2000
PROUD 2 BE A FLYER Sola Matteo / Happy Books / IT / 2003
SEARCHING FOR THE PERFECT BEAT: FLYER DESIGNS OF THE US RAVE SCENE / Watson Guptill / USA / 2000

Großartige Graphiken aus dem Bereich sozialer und politischer Arbeit findet man in den beiden bei Phaidon erschienenen Bücher 'Graphic Agitation 1 + 2', die 1993 und 2004 von Liz McQuiston zusammengestellt wurden und die Welt des Subvertisings umfassend dokumentieren. Viele 'cutting edge' Arbeiten flyernaher Gestalter finden sich auch in Kunst-, Lifestyle und Designspezialpublikationen wie ROJO (ES), Style and the Family Tunes (D), Lodown (D), Pupumagazine (ES), Wallpaper (US) oder auch in dem von der Modemarke Carhartt entwickelten Rugged. Natürlich sind die Musikmagazine wie Groove, Spex, Visions oder Intro auch permanente Versorgungskanäle des neuen visuellen Terrorismus.

Randbereiche der Tausch- und Zettelkultur wie das 'X-Directory' (Pi34 Publishing, ISBN 1898760004) zeigen spezielle Phänomene, wie die obskuren englischen Sexservice Angebote an öffentlichen Telefonzellen oder den Brauch der Funker weltweit ihre QSL Karten zu gestalten und zu tauschen. Dieser spezielle Bereich wurde in einem Buch der MIT Press 2003 umfassend dargestellt.

Die Websites Funkreich.de, Hyperreal.org, Techno.de und FlyerArt.com archivieren tausende der Relikte. Zeitweise war es sogar möglich hier digitale Flyer auf CD gebrannt zu bestellen. Die Sites erlauben zumeist auch die Kontribution neuer Flyer. Insbesondere die Archiv und Kommunikationsarbeit von Hyperreal.org sei als Sprungstelle im Netz empfohlen.

FLUSS PRODUZIEREN Die Veranstaltungen 'Five Years of Electronic Revolution' in Köln und 'Mille Plateaux' in Berlin und Frankfurt des 'Force Inc.' Labels waren richtungsweisend in Sachen Verbindung von Musik und aktueller Kunst.

Die Galerie des Künstlers Stefan Beck 'Multitrudi' in Frankfurt bot selbst gesammelte Flyer in Plastiktüten mit Echtheitszertifikat an. Auf eBay floriert ein Handel mit den Zetteln. In Plattenläden wie dem Optimal in München oder im Hardwax in Berlin ist es eine wahre Freude die aktuellsten Werke zu studieren. Unver-

gleichlich auch die Auswahl im Regalsystem des größten Plattenladenladens der Westküste in San Francisco - dem Amoeba.

Staatliche Hochschulen wie die FH Potsdam, die Universitäten in Berlin, Weimar und Trier sowie die Hochschulen für Gestaltung in Offenbach und Leipzig ermöglichen es Studenten Referate, Seminar-, Diplom- oder gar Doktorarbeiten rund um das betrachtete Sujet zu schreiben. Bücher, die aus diesem akademischen Bereich stammen und leider nie publiziert wurden sind zum Beispiel, die unserem Projekt nahe stehenden Arbeiten: 'Flyer über Berlin', 1999 von Jule Svoboda und Steffi Lindner sowie 'Rauschen als Rauschmittel', 1998 von Marco 'Microbi' Reckmann. Joe Landens Arbeit 'Phänomen Flyer' enstanden an der Merz Akademie in Stuttgart ist bei WWW.TECHNO.DE/FLYER publiziert. Auch die englische Arbeit 'Visual Energy' von Simon Parkin, die man im Internet bei Hyperreal.org findet, zeigt wie vielfältig die Sichtweisen auf diese Medien sein können. Die letzte mir bekannt gewordene Arbeit schreibt eine Linguistin an der Universität Warschau rund um die Flyer- und Veranstaltungskultur zur Einführung des Hartz IV Gesetzes.

Übrigens: Werbeagenturen wie Scholz und Friends bevorzugen Kreative mit einem Background des Flyermachens, da sie hier von der richtigen Nase für junge Kommunikation ausgehen.

KUNST MIT FLYERN Auch Künstler arbeiten mit 'unserem' Material. Einer der bekanntesten ist Stefan Hoderlein, der "ein wacher Beobachter gesellschaftlicher Phänomene, die Ausdruck aktuellen "Zeitgeists" sind", ist. Seit einigen Jahren beschäftigt er sich mit der Techno-Kultur, jedoch nicht als neutraler Beobachter, sondern als Aktiver in der Szene. Hoderlein ist ein leidenschaftlicher Sammler und Archivar von Techno-Material unterschiedlicher Provenienz. Musik, Flyer, Plakate, Aufputschmittel, Souvenirs und sonstige Relikte - das ganze Material, das er auf Parties einsammelt, arbeitet er später in seine Projekte ein, indem er damit beispeilsweise ganze (Lebens-) Räume gestaltet.

In einer seiner Arbeiten projiziert Hoderlein Gruppen großformatiger "Raver", die wie in Trance automatisierte Bewegungen ausführen, per Beamer auf die Fenster eines Museumfoyers. Es wird mit dem Prinzip der Akkumulation gearbeitet. Nicht das Individuelle interessiert ihn, sondern die Anhäufung von Personen oder Gegenständen, die ständig neue Konstellationen, Strukturen und Rhythmen ergeben. Vergleichbar arbeitete in den frühen sechziger Jahren der französische Künstler Arman aus der Gruppe der Nouveaux Réalistes, der Objekte des Alltags und der Massenkultur akkumulierte, um gesellschaftliche und sozioökonomische Zusammenhänge zu visualisieren.
HTTP://PAIK.CULTD.NET/TEXT/RENNERT.HTM

"Stefan Hoderlein interessiert sich für die Formensprache von Subkulturen und deren Variationen. Seine leuchtenden Diawände in der U-Bahnstation Tonhalle zeigen tausende Bilder aus seinem durch Pop- und Subkultur geprägten Umfeld und verstehen sich als eine Art Ausgrabung der Jetztzeit, die an die farbig gestalteten Tempel und Grabkammern im alten Ägypten erinnern." (HTTP://WWW.HELL-GRUEN.NET/PAGES/DE/KONZEPT.HTML) Susan

ne Rennert, Mixed Pixels - Siebzehn Jahre Klasse Paik, aus hellgruen, 30 Kunstprojekte im und um den Düsseldorfer Hofgarten, Oktober 2002

Die junge Berlinerin Jamain entwirft aus ihren Lieblingsflyern Miniaturmöbel, ähnlich der Pariser Gruppe 'X-Fly' rund um Florence Picaud, nur eben wesentlich kleiner. Einige der Prototypen waren auch beim 'Designmai 2004' zu sehen. Der Versuch konstruktiv mit den Visionen der Nacht umzugehen scheint sehr nachvollziehbar. Objekte wie diese, die private Selektion im Badezimmer oder gar Kleidung aus Flyern zu gestalten, bringen die Verbindung zur lieb gewonnenen Szene nach Hause.

Eines der ungewöhnlichsten Objekte von auf Flyern basierender Kunst hat 'nino' 1998 im Schaufenster der Galerie Radio Berlin präsentiert. Ein aus hunderten von benutzten Tütenfiltern geklebter Berliner Fernsehturm mit dazugehöriger Legende der Einzelteile, genannt "Fly, Berlin, Fly".

Der Auszug aus dem 'Filter-Index/ge(b)raucht', aus einer seiner weiteren Arbeiten 'F(i)L(t)Y(er) AIRlines', listet die verwendeten Schnipsel nach Motiv, Anzahl und Quelle/Herkunft tabellarisch auf:

Flyerlines	--	blaue Hintergründe
	24	Computer-Spiel-Museum Flyer
	13	Mondo Fumatore rec.rel.pty.Flyer
	10	Electric Ballroom Flyer
	6	Big Wild & Massive Flyer
	4	Kings Club Flyer
	2	Selecta Flyer

Dieser Verwendungszweck von Flyern als Hilfsmittel psychedelischer Inspiration in Verbindung mit seiner Verortung im Stadtraum schlägt in eine ähnliche Kerbe wie das Wissen um die größte Diskokugel der Welt im Zentrum Ost Berlins. Anders gesagt: "Die konzeptuelle Kunst, die auf Recycling der bunten Eintagsfliegen und Müllverursachern beruht, nimmt Bezug auf ihren Inhalt ohne ihn Preis zu geben. Der Raub des Inhalts und der Funktion macht sie frei aber mit einem neuen Sinn aufgeladen." (Peter Maibach/Pulp Mansion)

Alles in allem ist Flyer sammeln auch das Sammeln eines Schwarms kreativer Intelligenz einzelner Generationen. Die abgebildeten wie auch die impliziten Haltungen dieser Kultur inspirieren zu neuen und hoffentlich besseren Wegen unserer Gesellschaft. Sie skeletieren Realitäten und führen uns auf einen neuen, offeneren Pfad.

Ob Sammler wie Saatchi, Flick oder gar Daimler Chrysler insgeheim auch ab und an ein Paar Flyer zur Seite legen lassen, war nicht heraus zu finden... Das Museum für Gestaltung Zürich hingegen hat im Jahr 2000 dem Sammler, Musikredakteur und DJ Markus P. Kenner aus Zürich eine Sammlung von über tausend Party-Flyern für 4.000 CHF abgekauft.

DISCSTYLE
THE GRAPHIC ARTS
OF ELECTRONIC MUSIC
AND CLUB CULTURE
RELEASEPARTY
SAMSTAG 22.05.99
21 UHR
JAHRHUNDERTHALLE HOECHST

01.Oktober - 06. November 2004
Dienstags - Samstags // 16:00 - 20:00

ZENTRALBUERO
Spandauer Strasse 2
10178 Berlin - Mitte

CHARACTERS AT WAR

100 + VIOLATED COPYRIGHTS AND
THE VERY BEST OF CONTEMPORARY
CHARACTER DESIGN AND ART

ERÖFFNUNG : Freitag, 01.Oktober 2004, 19:00 // **CHARACTER CLUBNIGHT :** Samstag 02.Oktober 2004, 23:00 - 06:00
KONFERENZ : 1.INTERNATIONAL CONFERENCE ON CONTEMPORARY CHARACTER DESIGN AND ART: 28.- 30.Oktober 2004

LEBENSZYKLEN DER FLYER

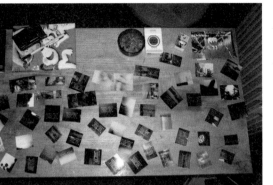

05

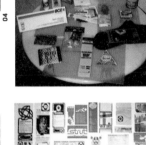

04

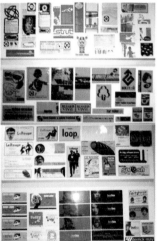

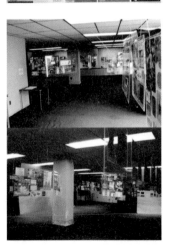

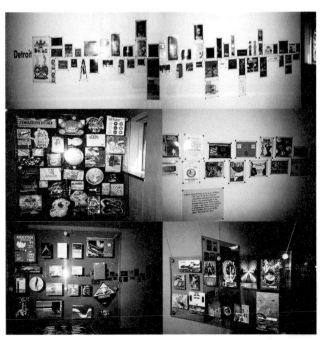

01 QSL-Karten (vgl. Text "Funker und Flyer")
02 Flyer von NINO
03 Britische Sexkontaktkarte aus "X-Directory"

04 Flyerproduktion im foto-shop-berlin.de
05 Suchanzeigen nach 9/11 in New York
ALLE ANDEREN AUF DIESER SEITE Bilder von Ausstellungen
in Detroit, Mannheim, Leipzig, Oslo

169

red dog geht gassi

neue heimat

neue heimat

RECHTS OBEN Flyer Möbelminiaturen von Jamain Dubeux, Berlin

LINKS OBEN Flyer Centre Barcelona
LINKS UNTEN Flyer von den Red Dog Stuttgart Designern

FLYER TRADING

by Marta Jecu

Translated by Peter van de Loo

"THIS FORUM IS FOR FLYERS AND FLYER RELATED STUFF" – WWW.RAVEFLYERS.CO. UK

The lifecycle of a flyer is determined by a steady reevaluation of it's worth and functionality. As a substantial transportable object it's getting new definitions and personalization by its owner by reading or using. The criteria of validation are contextual and reflect the cultural life style of the recipient. By being collected the flyer becomes an individual statement or is exhibited in public space like a museum. Archiving the complete serie of a flyer collection or the wish of getting close to this is fueling the progress of collecting. This way flyers are traded in a formal or informal way. Whole collections are being bought by museums, sold in the Internet, or exchanged between collectors. The priceless item turns into an economically valuable property.

This research is tied to the webforum Raveflyers (WWW.RAVEFLYERS.CO.UK). The fertilisation of online discussions is intended by this webforum. Delivered are interviews with the founder of the discussion group, statements of participants and a documentation of former discussions. The forum is a meeting point for connoisseurs.

Therefore it stands in contrast to sites like ebay. It's less commercial and more oriented in information exchange. A British flyer collector and rave activist named Weed founded raveflyer as an alternative to the existing hyperreal.

Most likely started the collecting of club flyers with the beginning of the early years of underground parties. With the spread of the Internet there started also the first online flyer shops (also at ebay). There was intense flyer trading that reached its peak in the year 2000. Quoted by Weed, the organisation of regular flyer fairs in Camden (GB) made this town one of the first markets for flyer trading. The history of raveforum is related to Hyperreal (WWW.HYPERREAL.ORG) that functioned as a non-commercial Webplatform for flyer swapping since the mid 90ties. Later on there have being more and more people being interested in buying flyers so that Weed started the raveforum also with the aim to link up people with common interests. It grew rapidly, became international and furthermore a platform for flyerartists. Aside of this there has been the development of a group of flyer traders that traded them way to expensive. Therefore Raveforum arranged a flyer gallery to help improving a realistic evaluation of certain flyers, by comparison with already existing ones.

Brooke and Beach two active participants of Raveforum describe there membership as being part of a wider family even by the way that most of the contacts are virtual. Flyer collectors know much about each other's interests and share common objectives. Beach said that he met several people being helpfull and a single collector stated that he collected up to 30.000 flyers.

What are the criteria for evaluation of flyerprice and quality? What factor determines the value? For defining rarities there are mostly used old flyers in low quantity advertising performances of well known Djs, parties or events. In addition to this there is design and the visualization of a certain time

related style and feeling. Also there is an emotional aspect of the collector his experience, taste and intention. The real value lies in a permanent discussion between common sense and personal interpretation.

A Flyer documents the history of subculture by presenting information and style. They are inherited documents of certain time periods and show the collectors integration into this. Weed likes flyers with psychedelic motives, mushrooms and complex texture and collects with the aim to one day donate his collection to a museum.

The demand for flyers created past 1996 is lower and therefore there are not that many on the market. Beach mentioned that there have not been any good flyers since 1994. Old school classics are related to vibrant clubs, parties or events like Sterns, Fantazia, Obsession, Peace Fest, Dance 90, Starlight, Raindance, Fusion, Pandemonium, Universe, Amnesia House, Helter Skelter, Dreamscapes, the Hard dock (Liverpool), Eclipse + The Edge, Omen, Resurection, Dance Planet, Quest, Ravescene, Life Utopia, Techno Drome, Perception, In-Ter-Dance, Desire, New Age, Orange, Spectrum, One Nation, Sunrise.

THE FOLLOWING CHART SHOWS A PRICING SYSTEM

Price guide grading system

M Mint – no creases / no marks, unblemished – as new

EX Excellent - slight creasing / faint marks / corners not perfect - almost mint

VG Very Good - creases / bluetac marks on rear / clean folds - collectable

G Good - heavy creases / taped / staple holes / faded - still intact

F Fair - some tears / defaced / very faded / scribbled on – only as a filler

P Poor - badly torn / scribbled over / incomplete - roach material

Another pricing system on Raveforum evaluates year and club. This indicates that these categories are most important.

1987-1989

| Collectable | 5.00-60.00 | Biology, Future, Genesis, Hedonism, Rage, RIP, Shoom, Spectrum, Sunrise, Wag |

1990-1995

| Collectable | 5.00-25.00 | early Amnesia House, Climax, early Dreamscape, Ektos, Entropy, early Fantazia, early Hacienda, Nemesis, early Raindance, Shelleys, Supernova, Tooty Frootie, 1st Universe |

1996-1999

| Collectable | 0.50-5.00 | Blech, Cream, Dreamscape, Frisky, Gatecrasher, Hardcore Heaven, Hacienda, Helter Skelter, MoS, Orbit, Paradise Factory, Pendragon, The Gallery, Triptonite, United Dance, Vibealite, Warp |

The value interrelates to event managers, DJs or certain bands that had their first performances. This way some flyers became pretty expensive. Furthermore there is the personal interest, the general publicity impact of a certain event or the circumstances that made it happen.

"Are any of the flyers for this legendary Manchester night that spawned the Chemical Brothers worth any money?" asked a member of Raveforum. Another possibility is the interaction that happened when a notorious club shut down. There might be some solidarity among clubbers and flyers being traded online. SUPPORT IAN JACKSON NOW. On 15/2/04 at 3am Monroes was raided and closed under a new anti social behaviour order by 200 police officers (...) then there'd probably be people interested in buying the flyers... maybe 3.50?? maybe more?"

Aside of club and year there is also creativity and design to measure flyer value. Also there is the possibility that flyers are designed by famous flyer artist like Pez (Steven Perry), Junior Tomlin, Jim Avignon. On Raveforum there is often additional information about their technique and crafting methods.

One might find often also the classification in different style. So there is the warehouse/ illegal style or the designer/ club related style.

The trading happens mostly among serious collectors and donators that trade their collection out of lacking room. Otherwise most of the collectors keep their assemblage out of nostalgia. Adjectives like: " the ultimate rarity", "impossible to find", "listed elsewhere at five hundred thousand zillion rupees", "rarer than rocking horse spunk", "some collectors unable to get hold of this flyer have committed suicide" are pretty common.

Prior of trading these collections on ebay, they tend to be traded on Raveforum to keep the spirit somehow among friends. "I could put them on ebay but I'd sooner sell them to someone on here, that way I know they would be appreciated." is a general idealistic statement of flyer collectors. Beforehand that the general deal takes place there is coming preparations like flyer description, personal history and interrelation. The platform Raveforum connects and provides room to discuss all kind of topics related to flyerculture. "I have a Spectrum Flyer that I picked up on maybe the second night Spectrum was opened, May 1988 I think, also an original membership card, have an original Future membership too. Any ideas how much these would be worth?", "March 88 saw Shoom change from the original green ticket style flyer."

Discussions on Raveforum are more than just trading talks. Experts chat about theory evaluation, the end of raves, the cultural and political attitudes of revelers, design technique, former and actual parties, club stories and DJ culture. "I think the bad press surrounding the drugs had a lot to do with the scene dying out. Plus the scene is changing and the youngsters of today maybe wanting to do something new!!"

"I think the bad press didn't do that much damage to the scene cos those that were doing it didn't care about that, or should I say I didn't know anyone who cared. I personally believe we all just grew up and when the scene changed, we left in droves."

"Rave scene still lives man, just look at all the nutters on here.", quoted and aimed to the Raveforum "Would Rave Flyer Art have existed if 60's 70's Psychedelia had not happened? And if so, why?", asked Anton.

Once I asked Brook if there is a development inside of the flyerbusiness towards commerce that is not related to the rave culture anymore. He said that there are some ravers that rely more on good memories than money. Scans are without any interest for collectors and the piping of falsifications is not the general goal. Brook mentioned that he could find out pretty fast the difference

between original and plagiarism and would ask to get his money back. In other words there seems to be some gentleman agreement among honest flyer collectors.

But sometimes this still agreement in honor is getting scratches on Raveforum mentioned a collector: "I have recently bought 2 flyers on ebay from Onelovemagazine.co.uk and I am concerned about their authenticity, unlike all the other flyers I have collected myself, the print seems very blotchy and inconsistent and in some parts have extreme colour leakage." – "I think if flyers continue to increase in value then its almost certain there will be future copies in circulation." But there are also other opinions towards that: "maybe, but they'd have to increase in value quite a bit to make it worth the cost of setting up a print run + matching the original type of paper/card + getting accurate colours (not to mention the cutting out of shaped flyers) - most of the cost of printing is the initial setup."

Finally there is the question about the value of the collection: "What is the rarest flyer in the world?" "the first Shoom flyer? (Whichever one that is), or maybe a flyer for the first of the 2 Sunrise events in Oct 1988? Anyone have any other suggestions?" This topic is very much favoured among collectors. Most of them think that the first Shoom Flyer (Whicheverone that is) from 1987 is the best, others the first energy flyer.

As be seen the raveflyer web site has much to offer for all kind of collectors and people interested in flyer culture. The end will be given to activist Anton:
"Good to have a good topic to get our teeth into. We'll think of another one hopefully."

VOM HANDEL
MIT FLYERN

by Marta Jecu

"THIS FORUM IS FOR FLYERS AND FLYER RELATED STUFF" – WWW.RAVEFLYERS.CO.UK

Der Lebenszyklus eines jeden Flyers setzt eine permanente Neuverhandlung seiner Funktion und seiner Bedeutung voraus. Als mobiler Gegenstand wird er in jedem neuen Umstand neu definiert, von jedem Besitzer personalisiert, je nach der Art und Weise, in der er gelesen oder verwendet wird. Die Kriterien, nach denen er bewertet wird, sind nicht alleine vom Kontext, in dem er sich befindet, abhängig, sondern auch impliziert von den kulturellen Anschauungen und Ansprüchen seiner jeweiligen Rezipienten. Als Sammelobjekt wird er zum individuellen oder kollektiven Statement und wird entweder im privaten Bereich oder in einem öffentlichem Museum archiviert. Der Sammeldrang, der Wunsch eine bestimmte Serie zu vervollständigen oder sich einem bestimmten absoluten Wert zu nähern, erspart sich keine Mittel. Somit werden Flyer oft formell oder informell verhandelt. Ganze Sammlungen werden für Museumsarchive erworben, auf Online-Börsen dargeboten oder von einzelnen Sammlern privat getauscht und gekauft. Das kostenlose mobile Blatt wird zum festen Bestandteil eines ökonomisch wertvollen Eigentums.

Diese kleine Recherche hat im Fokus das exklusiv der Flyerkultur gewidmete Web-Forum Raveflyers (www.raveflyers. co.uk), dessen Hauptziel es ist, Online-Diskussionen zu fördern und Flyerverhandlungen zu vermitteln. Die Informationsquellen sind Interviews mit dem Gründer des Forums, einigen Mitgliedern sowie auch die bestehenden Diskussionen, die auf der Site archiviert sind. Das Raveforum ist ein Treffpunkt für Connaisseurs.

eBay, die Online-Börse, wo man quasi alles (Gegenstände, Rechte, virtuelle Güter) tauschen oder verkaufen kann, gibt den Partnern nicht die Möglichkeit engere Beziehungen oder Fachdiskussionen zu entwickeln. Weed, ein britischer Flyer-Sammler und Rave-Kultur-Eingeweihter, hat demzufolge Raveflyers gegründet, eine Alternative nicht nur zu eBay, sondern auch zu dem zuvor bestehenden Hyperreal.

Clubflyers werden wahrscheinlich seit den ersten Jahren der illegalen Partys gesammelt, aber die ersten Online-Flyerbörsen sind am Anfang der neunziger Jahren entstanden (unter ihnen auch bei eBay); progressiv wurden mehr Flyer gehandelt, bis zu einem Boom nach dem Jahr 2000. Informell galt - laut Weed - die britische Stadt Camden als einer der ersten Märkte für Flyer, wo Mitte der 90er Jahre periodisch Treffen der Sammler stattfanden und Flyer getauscht oder verkauft wurden.

Weed erzählt, wie Raveforum zustande gekommen ist. "www. hyperreal.org hatte schon vor 5 Jahren als Online-Plattform funktioniert, für diejenigen, die Flyer tauschten, aber nicht kauften oder verkauften. Es waren viele, die nicht sammelten, aber die wissen wollten, wo sie Flyer verkaufen können und potenzielle Sammler, die wissen wollten, wo sie Flyer kaufen konnten. So habe ich das Forum gegründet, um die Leute über die Flyer, die auf eBay gehandelt werden, zu verständigen, sowie Sammlern die Möglichkeit zu geben, privat in Kontakt zu treten und zu verhandeln. Auch war das Forum als eine Diskussionplattform für relevante Themen für die Flyerkultur gedacht. Die Besucher dieser Site haben auch wichtige Sammler aus anderen Ländern eingeschlossen und Flyer-Künstler aus England oder dem Ausland bekannt gemacht. Außerdem gab es zu der Zeit eine Flyer-Gesellschaft, die einzelne Flyer verhandelte, aber Preise bekanntmachte, die tausendfach den wahren Preis darstellten." (Weed)

Auf Raveflyer gibt es auch eine Flyer-Galerie, die als Database (Archiv) funktioniert. Hier werden die Flyer datiert und somit eine objektive Grundlage für ihre Bewertung geschaffen.

Brook und Beach, aktive Mitglieder von Raveforum, erklären, dass ihnen die Diskussionplattform ein Gemeinschaftsgefühl verleiht. Die meisten Leute kennen sich persönlich, kennen die Sammlungen und jeweiligen Interessen anderer Mitglieder. "Der Web-Designer ist selbst ein Sammler. Ich habe ihn gestern gefragt, wie viele Flyer er besitzt, und er hat mir gesagt, es seien schon 30.000!" (Beach) "Ich habe viele Leute online bei Raveforum getroffen, die sehr hilfsbereit in Flyerangelegenheiten waren. Obwohl ich sie nie getroffen habe, schätze ich die Verbindung, die wir haben." (Brooke)

Nach welchen Kriterien werden Flyer bewertet, wie ist das Verhältnis von Preis und Qualität? Liegt der Preis der Flyer fest oder ist die Festlegung des Preises eher ein Prozess, der von mehreren Faktoren und Umstanden abhängig ist? - Wie in allen Sammlungen wird die Rarität gesucht. Die ältesten Flyer, diejenigen, die in einer geringen Auflage erschienen sind, diejenigen von berühmten DJs, Partys und Veranstaltern, Flyer von geschätzten Designern, Flyer, die eine bestimmte musikalische oder graphische stilistische Phase vertreten, Flyer in gutem Zustand, ungewöhnlich gestaltete Flyer - sie alle werden hoch geschätzt. Dazu gibt es auch einen emotionalen Wert, abhängig von persönlichen Kriterien, vom eigenen Geschmack und der eigenen Erfahrung. Der Wert ist also eine permanente Verhandlung zwischen einer allgemeinen Norm und einer persönlichen Interpretation. "Die Flyer erzählen die Geschichte einer Subkultur: durch die geschriebene Information, die sie vermitteln,

aber auch durch ihren graphischen Stil", meint Weed. Sie sind das kulturelle Dokument einer bestimmten Periode der Musikgeschichte, aber erzählen auch von einer persönlichen Erfahrung mit dieser Geschichte. "Die Flyer mit psychedelischen Motiven, Bilder mit Pilzen und komplizierten Muster entzücken mich persönlich, aber ich habe immer versucht meine Sammlung zu erweitern, um sie schließlich einem britischen Museum als graphisches Dokument zu stiften." (Weed)

Weed macht die folgende zeitliche Klassifizierung der Flyer: "Die 1988-89-Flyer sind nur selten zu finden, aber wenn es passiert, erhalten sie ganz gute Preise. Die 1990-91-Flyer werden von den meisten Sammlern verfolgt, und die Flyer aus dieser Zeitspanne werden heutzutage immer teurer verkauft. Die am häufigsten verhandelten Flyer auf eBay stammen aus 1992-95; sie gelten als die 'klassischen' Flyer, erscheinen jetzt auch in Form von Sammlungen von 50 bis 250 Flyern und haben noch vernünftige Preise. Flyer, die nach 1996 produziert wurden, haben eine nicht so große Nachfrage auf dem Markt und erscheinen deshalb auch seltener." Beach meint: "Anständige Flyer gibt es nach 1994 nicht mehr." Die "Old School Classics" stammen von Clubs und Parties, deren Name alleine ihren Wert bestimmt: Sterns, Fantazia, Obsession, Peace Fest, Dance 90, Starlight, Raindance, Fusion, Pandemonium, Universe, Amnesia House, Helter Skelter, Dreamscapes, the Hard dock (Liverpool), Eclipse + The Edge, Omen, Resurection, Dance Planet, Quest, Ravescene, Life Utopia, Techno Drome, Perception, In-Ter-Dance, Desire, New Age, Orange, Spectrum, One Nation, Sunrise.

MIT HILFE FOLGENDER QUALITÄTSKATEGORIEN WERDEN FLYER BEWERTET

PRICE GUIDE GRADING SYSTEM

M Mint - no creases / no marks, unblemished - as new

EX Excellent - slight creasing / faint marks / corners not perfect - almost mint

VG Very Good - creases / bluetac marks on rear / clean folds - collectable

G Good - heavy creases / taped / staple holes / faded - still intact

F Fair - some tears / defaced / very faded / scribbled on - only as a filler

P Poor - badly torn / scribbled over / incomplete - roach material

Ein Preisorientierungssystem befindet sich ebenfalls auf Raveforum. Hier werden die Flyer nach Erscheinungsjahr und Club bewertet. Die beiden Kriterien scheinen demzufolge die wichtigsten zu sein.

1987-1989

Collectable 5.00-60.00 Biology, Future, Genesis, Hedonism, Rage, RIP, Shoom, Spectrum, Sunrise, Wag

1990-1995

Collectable 5.00-25.00 early Amnesia House, Climax, early Dreamscape, Ektos, Entropy, early Fantazia, early Hacienda, Nemesis, early Raindance, Shelleys, Supernova, Tooty Frootie, 1st Universe

1996-1999

Collectable 0.50-5.00 Blech, Cream, Dreamscape, Frisky, Gatecrasher, Hardcore Heaven, Hacienda, Helter Skelter, MoS, Orbit, Paradise Factory, Pendragon, The Gallery, Triptonite, United Dance, Vibealite, Warp

Wenn Partys von einem bekannten Veranstalter organisiert wurden, wenn ein berühmter DJ aufgelegt hat oder eine Band dort ihren ersten Auftritt hatte, können die Preise in die Höhe schießen. In welchem Umfang aber bleibt eine Frage der Verhandlung. Das persönliche Interesse, der Bekanntheitsgrad des Events ("an underground scene was always there") oder die Umstände, unter denen eine Party zustande gekommen ist, sind alles Faktoren, die die Preise beeinflussen. "Are any of the flyers for this legendary Manchester night that spawned the Chemical Brothers worth any money?", fragt ein Mitglied von Raveforum. Der Wert eines Flyers von einem gegenwärtigen Club wird auch gesteigert, wenn dieser aus irgendwelchen Gründen plötzlich schließt. Unter Umständen entsteht eine Clubber-Solidarität zur Erhaltung des Clubs und die Flyer werden auf dem Online-Markt angeboten. "SUPPORT IAN JACKSON NOW. On 15/2/04 at 3am Monroes was raided and closed under a new anti social behaviour order by 200 police officers (...) then there'd probably be people interested in buying the flyers... maybe 3.50?? maybe more?"

Ausschlaggebend für die Einschätzung des Preises ist auch (unabhängig vom Club oder dem Jahr, in dem ein Flyer erschienen ist) die Kreativität und Originalität seines Designs. Wenn die Flyer von einem Künstler designed sind, steigert der Name des Flyerkünstlers den Wert des Flyers: So zum Beispiel werden Pez (Steven Perry), Junior Tomlin, Jim Avignon hoch geschätzt. Auf Raveforum werden ihre Techniken besprochen und stilistisch datiert. Ein häufig aufgegriffenes Einschätzungskriterium der Flyer ist ebenfalls stilistischer Natur: Flyer, deren Gestaltung von einen "warehouse/illegal style" geprägt ist, werden mehr geschätzt als solche des zeitgenössischen "designer/club oriented style".

Flyers werden nur an "ernste Sammler", mit guten Preisen verkauft – vielleicht, weil der Besitzer keinen Platz mehr in der Wohnung hat oder weil seine Sammlung fast vollständig ist. Ansonsten werden Flyer aus "nostalgischen Gründen" weiterhin behalten und als "the ultimate rarity", "impossible to find", "listed elsewhere at five hundred thousand zillion rupees", "rarer than rocking horse spunk", "some collectors unable to get hold of this flyer have committed suicide" gepriesen. Bevor die Sammlungen auf eBay versteigert werden, bieten die Sammler

ihre wertvollen Objekte den Freunden auf Raveforum an. Nur wenn kein Interesse auf Raveforum besteht, werden die Sammlungen Außenstehenden zur Verfügung gestellt. "I could put them on eBay but I'd sooner sell them to someone on here, that way I know they would be appreciated." Vorbereitende Diskussionen auf Raveforum (Beschreibung der Flyer, Preisvorschläge, persönliche Geschichten in Verbindung mit den jeweiligen Flyern) werden durch weitere Verhandlungen privat, direkt zwischen den beiden Partnern, fortgesetzt. Raveforum verbindet die Sammler und ermöglicht Gespräche an einem öffentlichen Ort, die eine allgemeine Relevanz für die Flyerkultur haben können. "I have a Spectrum Flyer that I picked up on maybe the second night Spectrum was opened, May 1988 I think, also an original membership card, have an original Future membership too. Any ideas how much these would be worth?", "March 88 saw Shoom change from the original green ticket style flyer."

Gespräche auf Raveforum drehen sich nicht nur um Flyer-Preise. Die Flyer-Experten greifen hier auch locker theoretische Themen auf, die die Bewertung der Flyer einschließen: Warum und ob Rave tot ist, welche sind die kulturellen und politischen Anschauungen der Party Kids, Tendenzen und Techniken im Flyer Design, vergangene und gegenwärtige Parties, Club Stories und DJ-Kultur.

"I think the bad press surrounding the drugs had a lot to do with the scene dying out. Plus the scene is changing and the youngsters of today maybe wanting to do something new!! "I think the bad press didn't do that much damage to the scene cos those that were doing it didn't care about that, or should I say I didn't know anyone who cared. I personally believe we all just grew up and when the scene changed, we left in droves."

"Rave scene still lives man, just look at all the nutters on here.", kommt die Antwort und gemeint ist Raveforum.

"Would Rave Flyer Art have existed if 60's 70's Psychedelia had not happened ? And if so, why?", fragt Anton.

Ich habe Brooke gefragt, ob die Flyergeschäfte sich nicht zu einem Business entwickelt haben, welches mit der Ravekultur nichts mehr zu tun hat. "Nein, es handelt sich nur um Partyleute, die diese Partys einmal besucht haben; viele meinen, dass es sich nicht um Geld handelt, sondern um Erinnerungen." Deshalb kommen die gescannten Kopien nicht in Frage für Sammler. Sie wären auch sehr leicht zu fälschen. Ich habe Weed auch gefragt, ob nicht falsche Flyer ausschließlich für finanzielle Gewinne produziert werden. "Wenn die Flyerpreise so schnell wie jetzt weiter steigen, könnte es sein, dass auch falsche Flyer erscheinen, besonders, weil die teuersten Flyer aus der Zeitspanne 1989-1994 stammen." Brooke meint: "Ich könnte eine Kopie gleich entdecken und würde schnell mein Geld zurückverlangen."

Aber manchmal wird die Frage der Authentizität auf Raveforum gestellt. Die Merkmale der Flyer werden beschrieben oder ein Scan wird vorgestellt, damit alle Mitglieder ihre Meinung äussern können: "I have recently bought 2 flyers on eBay from Onelovemagazine.co.uk and I am concerned about their authenticity, unlike all the other flyers I have collected myself, the print seems very blotchy and inconsistent and in some parts have extreme colour leakage." – "I think if flyers continue to increase in value then its almost certain there will be future copies in circulation." Es gibt aber auch andere Meinungen zum Thema: "maybe, but they'd have to increase in value quite a bit to make it worth the cost of setting up a print run + matching the original type of paper/card + getting accurate colours (not to mention the cutting out of shaped flyers) - most of the cost of printing is the initial setup."

Es stellt sich auch die Frage nach dem absoluten Wert in einer Sammlung: "What is the rarest flyer in the world?" "the first Shoom flyer? (whichever one that is), or maybe a flyer for the first of the 2 Sunrise events in Oct 1988? Anyone have any other suggestions?" Dieses Thema wird zu einem beliebten Gespräch. Die meisten Interviewpartner betrachten die ersten Shoom-Flyer als wertvollste Flyer, für andere sind es die Energy-Flyer. "Der höchste Preis für einen Flyer in der Ravekultur hängt von dem Geschmack des Sammlers mit dem meisten Geld ab". – "Ein 1987er Shoom-Flyer würde den Ehrenplatz in meiner Sammlung einnehmen, aber unglücklicherweise existiert er wahrscheinlich nicht." (Weed)

Und als Schlussfolgerung dieser Gespräche schreibt Raveforum-Mitglied Anton: "Good to have a good topic to get our teeth into."

Alle Zitate aus den Gesprächen des Raveforum habe ich in ihrer originalen englischen Form wiedergegeben. Die Zitate, die aus Interviews entstammen, die ich selbst mit Raveforum-Mitgliedern geführt habe, habe ich mit Erlaubnis der Interviewparter übersetzt. Hyperreal ist als Forum nicht nur Flyern gewidmet, sondern auch anderen Aspekten und Produkten der Ravekultur. Die beiden Tafeln sind dem Raveforum entnommen.

BEHIND THE SCENES

COLORFUL CHAOS
AT THE END OF AN ERA

by Martin Büsser

THE YOUTH CENTER SCENE OF THE LATE 1980S

At the end of the 1980s, punk had already come a long way. Everything began in the mid-70s in the USA, in New York, where a young British traveling salesman by the name of Malcolm McLaren came across bands like The New York Dolls and The Ramones. Using them as a model, he founded the Sex Pistols in London - and from then on, punk was considered a genuinely British phenomenon. But within just a few years, the movement was in ruins, the most important groups of the first generation had broken up. In the early 80s, when London's punks were already featuring on tourist postcards, the movement returned to the USA. Bands like the Dead Kennedys, Black Flag, Minor Threat and Hüsker Dü were a major influence on the underground in the 1980s, a decade otherwise dominated by the watered-down face of MTV.

Before grunge came out, and the hype around Nirvana in particular led to the collapse of old subculture structures, Germany too experienced another intensive post-punk phase. Bands of the first German punk generation, groups like Hans-A-Plast and Mittagspause, were long gone or, as in the case of Die Toten Hosen, had mutated into stadium rockers. But countless bands from the USA, spending most of the year touring Europe, injected a fresh dose of creative energy into a scene that took place mostly in autonomous youth clubs. At the end of the 80s, almost every medium-sized city in Germany had a center of this kind, where live concerts and political work - info shops and antifascist groups - regularly went hand in hand. During peak periods, especially in the months of fall and autumn, they hosted up to three concerts a week - some with bands that are now long forgotten, but also some that have become superstars. The acts ranged from Alice Donut, No Means No, Green Day and Gorilla Biscuits, to Fugazi, Henry Rollins and Sick Of It All, through the Spermbirds, Killdozer and Napalm Death.

What characterized this scene just before its collapse was the eclectic mix, making it hard to explain to those who weren't part of it. The musical spectrum went from melodic punk to angrily shouting hardcore right through to heavy metal and jazz influences. The audience consisted of people with long hair, skaters, shaven-headed hardcore and straight edge fans, potheads and anarchists. The only common denominator was the dominant mood of political correctness. Flyer motifs with pin-up girls were taboo and when they were used they triggered heated discussions.

The colorful mix of punk, metal and grunge elements, coupled with the political aspect of the scene, also influenced the rather heterogeneous flyer aesthetic of the period. Political motifs with bomb-throwing anarchists were just as common as the monster, splatter and fantasy repertoire borrowed from the metal scene. Deliberately bad copies of photos from live concerts, documenting their ephemeral character, stood alongside the symbol of the fist smashing a swastika. In this heady mix of political correctness and trash motifs with skeletons and bloody axes, the scene symbolically

signaled its desire to see the demise of the existing society - before experiencing it own demise. The 90s were knocking at the door, and with them the grunge sell-out, German reunification, and the Love Parade. Many of the autonomous youth centers had to close or were taken over by municipal authorities, many bands broke up or started playing bigger, commercially run venues, some of which didn't even use flyers at all, advertising concerts in magazines instead.

THE BEAUTY OF REFUSAL

"On the best punk singles", writes Greil Marcus, "there is a feeling that what needs to be said needs to be said very fast because the necessary energy and the will to say it cannot be kept up for long." In Lipstick Traces, the book from which this quotation is taken, Marcus goes so far as to compare the provocative, actionist, spontaneous, and hence ephemeral aspect of punk with the Dadaists. An element of punk culture that Marcus largely overlooks actually supports this claim - the flyers. Besides fanzines, posters and music releases, flyers were a key communicative tool within the scene. This corresponds with the Dadaists, who left behind few paintings or other artworks in the conventional sense, focusing instead on collages, manifestos and invitations to events, i.e. mostly bits of paper, small things.

AMERICAN PUNK FLYERS BETWEEN TRASH AND AVANT-GARDE ART

Fucked up + Photocopied, the lavish catalog published in San Francisco in 1999, gathers together a large number of the surviving flyers from the American punk era of the early 1980s. This book owes its existence to the collectors who didn't throw these flyers away, like most people, but who realized that they were more than purely functional concert announcements, standing instead as artistic manifestations. In the same way that Dada energetically used disposable snippets of paper to combat an art world dominated by masterpieces, punk wished to do away with a brand of rock music hooked on superstars and their chefs d'oeuvre. This resulted in a paradox that can still be seen in the surviving flyers: although the badly photocopied motifs cut out of newspapers - ranging from mushroom clouds and porn through mass murderers and the ever-present face of Ronald Reagan - resisted any claim to artistic status, they offered a complex manifestation of refusal in a very small space, a coherent interplay of anti-aesthetics and political protest. The repurposing of found elements on small pieces of paper gave the flyers a subversive appeal. Unlike the brightly colored psychedelic motifs or the techno flyers to come, the aesthetic attraction of punk flyers was based entirely on the absence of professionalism and the impression of a hurriedly cut-and-pasted disposable product. This visual trash aesthetic matched a type of music that also claimed to be trashy, at the same time as providing a liberating reflection on the dysfunctional state of society. In this way, manifestations of a visual idiom opposed to the slick appearance of advertising developed their own beauty, thriving on joyful expressions of unmasking.

The hand-drawn motifs sometimes used instead of photocopied found material were also characterized by an anti-aesthetic taken to absurd lengths, with monsters,

skulls, and splatter or porn motifs. One of the graphic artists of the period, Raymond Pettibon, is now among the most sought-after artists in the USA. It comes as no surprise that his dramatic motifs have found their way into the collections of major museums, as punk's attack on illusions matches the program of the artistic avant-garde to a large extent. Long before the advent of punk, Modernism was exemplified by museums filled with works by people who once appealed in the loudest terms for their abolition.

DAS BUNTE DURCHEINANDER AM ENDE EINER ÄRA

von Martin Büsser

DIE JUGENDZENTREN-SZENE IN DEN SPÄTEN ACHTZIGERN

Ende der achtziger Jahre hatte Punk schon eine lange Reise hinter sich. Alles begann Mitte der Siebziger in den USA, genauer gesagt in New York, wo ein junger britischer Handlungsreisender namens Malcolm McLaren auf Bands wie The New York Dolls und The Ramones gestoßen war. Nach deren Vorbild gründete er in London die Sex Pistols - Punk galt fortan als genuin britisches Phänomen. Doch schon wenige Jahre später war die Bewegung zerrüttet, die wichtigsten Bands der ersten Generation hatten sich aufgelöst. Anfang der Achtziger, als Punk in London bereits als Postkartenmotiv für Touristen herhalten musste, kehrte die Bewegung in die USA zurück. Bands wie die Dead Kennedys, Black Flag, Minor Threat und Hüsker Dü prägten den Underground der ansonsten eher von MTV verwässerten Achtziger.

Kurz bevor Grunge aufkam und nicht zuletzt der Hype um Nirvana für einen Zusammenbruch alter subkultureller Strukturen sorgte, erlebte auch Deutschland noch einmal eine intensive Post-Punk-Phase. Die Bands der ersten deutschen Punk-Generation, Gruppen wie Hans-A-Plast und Mittagspause, hatten längst abgedankt oder waren wie im Fall der Toten Hosen zu Stadionrockern mutiert. Doch unzählige Bands aus den USA, die einen Großteil des Jahres auf Tour in Europa verbrachten, sorgten noch einmal für einen kreativen Schub innerhalb einer Szene, die vorwiegend in selbstverwalteten Jugendhäusern stattfand. Ende der achtziger Jahre existierte noch in fast jeder mittelgroßen deutschen Stadt ein solches Zentrum, in dem Livekonzerte und politische Arbeit - Infoläden und Antifa-Gruppen – meist Hand in Hand gingen. In Blütezeiten, vor allem während der Herbst- und Wintermonate, fanden dort bis zu drei Konzerte in der Woche statt – zum Teil mit Bands, die heute längst vergessen, aber auch mit solchen, die inzwischen zu Superstars geworden sind. Die Namen reichen von Alice Donut, No Means

No, Green Day und Gorilla Biscuits über Fugazi, Henry Rollins und Sick Of It All bis zu den Spermbirds, Killdozer und Napalm Death.

Was die Szene kurz vor ihrem Zusammenbruch auszeichnete, war ihr eklektizistischer Mix, der es schwer macht, sie all jenen nahezubringen, die daran nicht teilgenommen haben. Das musikalische Spektrum reichte von melodischem Punk über wütend gebrüllten Hardcore bis zu Heavy-Metal- und Jazz-Einflüssen. Das Publikum bestand aus Langhaarigen, Skatern, kahlrasierten Hardcore- und Straight-Edge-Anhängern, Kiffern und Autonomen. Alleine die in der Szene vorherrschende politische Korrektheit sorgte für einen gemeinsamen Nenner. Flyer-Motive mit Pin-Up-Girls waren ein Tabu und sorgten, wenn sie denn auftauchten, für heftige Diskussionen.

Das bunte Mit- und Nebeneinander aus Punk-, Metal- und Grunge-Elementen, gepaart mit dem politischen Anspruch der Szene, prägte auch die eher heterogene Flyerästhetik dieser Zeit. Politische Motive von Bomben schwingenden Autonomen lassen sich ebenso finden wie die dem Metal-Genre entlehnte Monster-, Splatter- und Fantasy-Ästhetik; das Flüchtige festhaltende, bewusst schlecht kopierte Fotos von Livekonzerten standen neben dem Symbol der Faust, die ein Hakenkreuz zerschlug. Im Gewimmel aus political correctness und Trash-Motiven mit Skeletten oder blutigen Äxten verkündete die Szene symbolisch die Lust am Untergang der bestehenden Gesellschaft – und sollte am Ende doch selbst untergehen. Die Neunziger standen vor der Tür und mit ihnen der Grunge-Ausverkauf, die Wiedervereinigung und die Love Parade. Viele der autonomen Jugendzentren mussten schließen oder wurden fortan städtisch verwaltet, viele Bands lösten sich auf oder wanderten in größere, kommerziell geführte Clubs ab, die zum Teil gar nicht mehr mit Flyern warben, sondern in Magazinen Anzeigen schalteten.

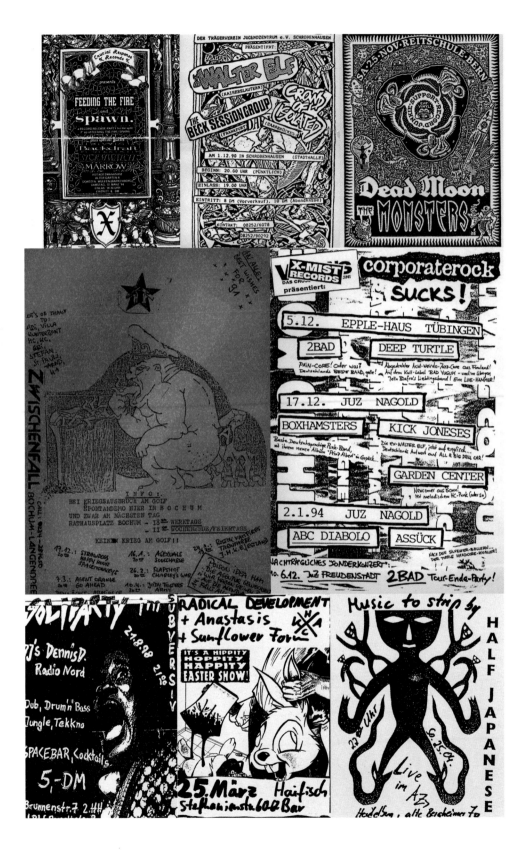

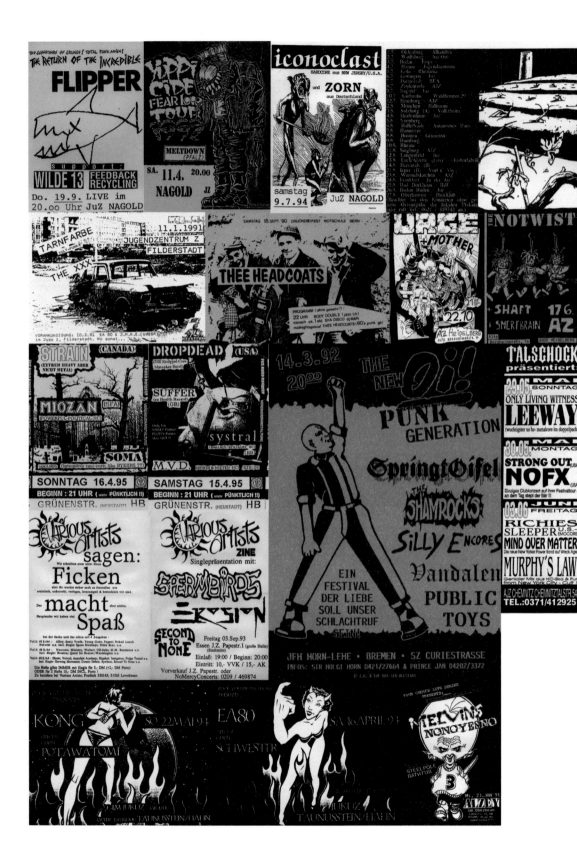

DAS BUNTE DURCHEINANDER AM ENDE EINER ÄRA

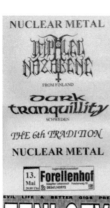

NUCLEAR METAL

IMPALED NAZARENE
FROM FINLAND

DARK TRANQUILLITY
SCHWEDEN

THE 6th TRADITION

NUCLEAR METAL

13. Mai — Forellenhof

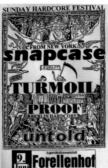

SUNDAY HARDCORE FESTIVAL

FROM NEW YORK:
snapcase

TURMOIL USA

PROOF BERLIN HARDCORE

untold...

9. Juni — Forellenhof

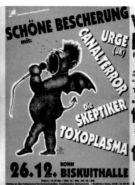

SCHÖNE BESCHERUNG
mit:
URGE (UK)
CANALTERROR
Die SKEPTIKER
TOXOPLASMA

26.12. BONN BISKUITHALLE

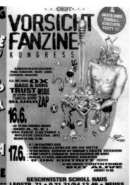

VORSICHT FANZINE KONGRESS

16.6.
17.6.

GESCHWISTER SCHOLL HAUS
LEOSTR. 71 · 0 21 31/54 13 46 · NEUSS

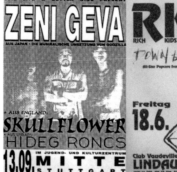

ZENI GEVA
AUS JAPAN · DIE MUSIKALISCHE UMSETZUNG VON GODZILLA

AUS ENGLAND:
SKULLFLOWER
AUS UNGARN:
HIDEG RONCS

13.09. MITTE STUTTGART
IM JUGEND- UND KULTURZENTRUM

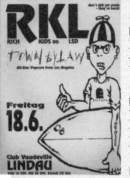

RKL
RICH KIDS on LSD

TOWN BYLAW
(All-Star Popcore from Los Angeles)

Freitag
18.6.

Club Vaudeville
LINDAU
VVK 16 DM · AK 18 DM · Einlass 20 Uhr

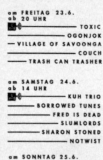

don't shit yer pants
- they're back!

am FREITAG 23.6.
ab 20 UHR
— TOXIC
— OGONJOK
— VILLAGE OF SAVOONGA
— COUCH
— TRASH CAN TRASHER

am SAMSTAG 24.6.
ab 14 UHR
— KUH TRIO
— BORROWED TUNES
— FRED IS DEAD
— SLUMLORDS
— SHARON STONED
— NOTWIST

am SONNTAG 25.6.
— JAZZFRÜHSCHOPPEN

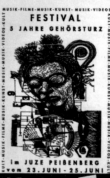

MUSIK · FILME · MUSIK · KUNST · MUSIK · VIDEOS · KUNST

FESTIVAL
5 JAHRE GEHÖRSTURZ

im JUZE PEIßENBERG
vom 23. JUNI - 25. JUNI

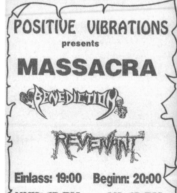

POSITIVE VIBRATIONS
presents

MASSACRA

BENEDICTION

REVENANT

Einlass: 19:00 Beginn: 20:00

VVK: 16 DM AK: 19 DM

FOR TICKETS · INFO CALL 02381-441135

28.05.91/Werl/CULT/Soesterstr.81/B1

(c) by CISUM Graphic's Team

VISIONS MAGAZINE

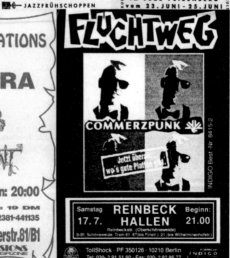

FLUCHTWEG

COMMERZPUNK

Jetzt überall
wo's gute Platten...

INDIGO Best-Nr 8415-2

Samstag **REINBECK** Beginn:
17.7. **HALLEN** 21.00

S-Bf. Schöneweide. Tram 61, 67(bis Firlatr.) 21 (bis Wilhelminenhofstr.)

TollShock · PF 350126 · 10210 Berlin
Tel: 030 - 2 91 51 60 · Fax: 030 - 2 92 95 77

INDIGO

WE BITE MAILORDER
GÖNNINGER STR. 3 72793 PFULLINGEN
TEL. 07121/991111 FAX: 07121/99150

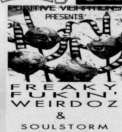

THE RICHIES
EXPLODING WHITE MICE

POSITIVE VIBRATIONS
PRESENTS

FREAKY FUKIN' WEIRDOZ
&
SOULSTORM
(Ex-INFERNO)

05. APRIL 1991

EINLASS: 20.00 Uhr BEGINN: 21.00 Uhr
VVK: 10,–DM AK: 12,–DM

CULT/4760 WERL/SOESTERSTR. 81 (B1)

M.D.C.

EUROPEAN TOUR '94

Booking: Metallysse Agency, Phone: 0032(53)/665026

LEFT FLYERCULTURE?
HURRA HURRA, THE AUTONOMOUS
ANTIFA IS HERE.

I remember still quite exactly the political flyers in my former youth center located in a small city near Hamburg: black star, Antifa-Action-drawing, cut-out layout, unclear gray-scaled black and white photocopies. As well as the slogans: "Come to ...", "Down with ...", "Up the ...". Either way, there was a high recognition value, whether in the form of hackneyed notes, undercopied placards or complicated folded pamphlets. Somehow I always knew when it was a left flyer. Certainly, in terms of demos, events and "soliparties," one did not simply expect announcement cards for a "Probeabo der Welt" or an invitation to an evening with friends. However, many people quickly glance at these cellulose products simply in order to identify a particular scene, and then benevolently stash them into their bag and in many cases, eventually throw them away at home.

That left flyer culture emerged with its own aesthetic and practice is not too difficult to trace. Since the beginning, flyers have represented the left's means of agitation and self-organization in the context of the city district - or political newspapers, pamphlets, placards and transparent demos (vulgo "Transpis"). The difference between scenes, cities, states and districts demonstrates that a

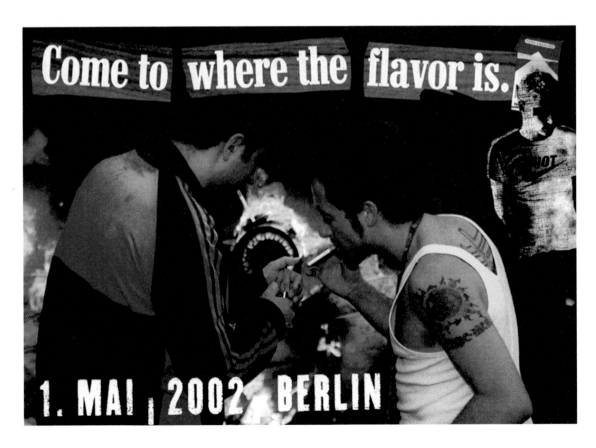

singular flyer culture doesn't absolutely have to be constructed. In fact, it is through Flyers, vulgo "Flugis," these products of the left organization, that the coherence and flux of the left aesthetic can be understood since the blissful days of 1968.

However, instead of looking that far back, we will instead focus on the trajectory of the (post)autonomous Antifa-movement since the beginning of the 1990s. Even in this overtly eclectic and splintered movement, a basic repertoire of aesthetic codes can be detected, finding its expression in notions such as "Popantifa" or "Sceneantifa," among others. By means of differentiation and marginalization (cutup layout, image montage and craftwork like drawing, copying, etc), the aesthetic codes which once defined the left are renounced. In the flyers and political pamphlets of these times and scenes. This aesthetic reorientation, which should also be of interest here in the margins, followed content and preceded technique. Luckily, the history of the new left in the BRD is still unwritten.

Coming back to our Antifa village: There, very little was transformed in the early 1990s textually or aesthetically. All that changed when the local government unexpectedly got a hold of its own computer in the middle of the 1990s. However, the occasion of this technological - if also capitalistic - advancement did not leave photocopying behind forever. Ultimately, the city was friendly enough to arrange for the hippy und shaggy-haired post-grunge kids to have a computer as well as an instructional social worker. From that point forward, they progressed while using Pagemaker - the black stars became

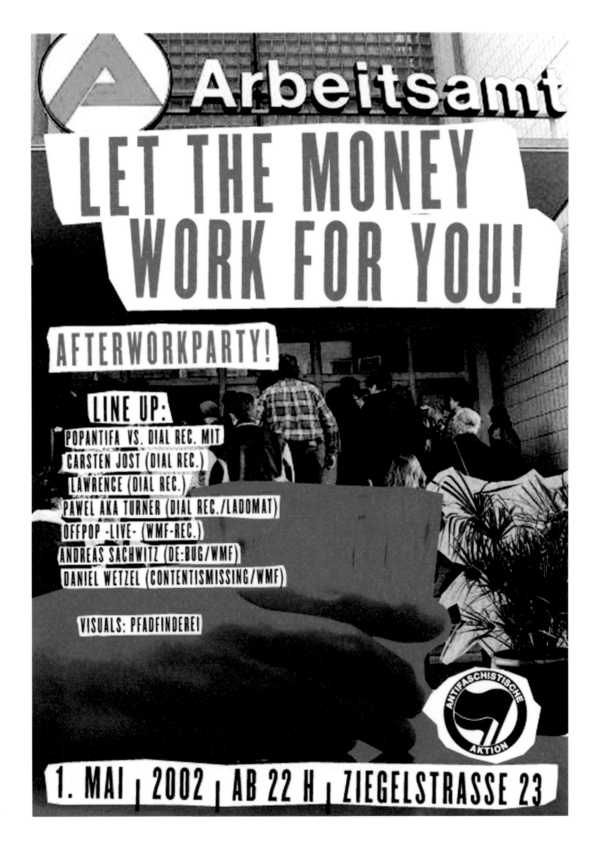

Arbeitsamt

LET THE MONEY
WORK FOR YOU!

AFTERWORKPARTY!

LINE UP:
POPANTIFA VS. DIAL REC. MIT
CARSTEN JOST (DIAL REC.)
LAWRENCE (DIAL REC.)
PAWEL AKA TURNER (DIAL REC./LADOMAT)
OFFPOP -LIVE- (WMF-REC.)
ANDREAS SACHWITZ (DE:BUG/WMF)
DANIEL WETZEL (CONTENTISMISSING/WMF)

VISUALS: PFADFINDEREI

ANTIFASCHISTISCHE
AKTION

1. MAI 2002 AB 22 H ZIEGELSTRASSE 23

sharper and sometimes also red, and the Antifa–Action symbol became more legible and eventually completely multi-colored. Nevertheless, great importance was still attached to handiwork: autonomous expressionism, naive Marxist realism, self-determined pencil drawings, lunatic chalk scenarios of struggling masses and grim policemen with clubs fighting against a silenced community. Such aesthetics were full of pathos in a kitsch kind of way, sometimes exciting and perhaps even radical, but they were certainly not original. Above all, it was collective for them: First of all, it has something to do with the content– when the flyer was merely composed of few well-thought out slogans, and secondly, where the aestheticization of political figures were to be seen, there must be a direct reference to the scene, movement, established left aesthetics and political asser-tions that is verifyable and discernable. Chic appearance and a conscious development of its own world of symbols, which would have had to initially satisfy the aesthetic norms, was not to be allowed in any way. Those who nevertheless disintegrated a beautiful appearance, who drafted chic layouts for cut-out flyers, effectively aroused suspicion of

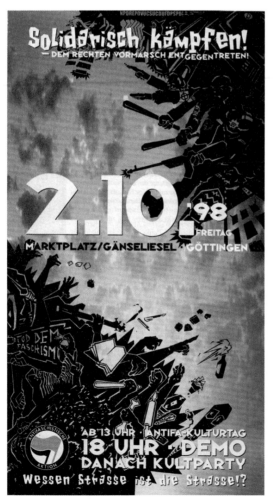

vacuousness, of the Renegatentum and of the moral fall of the culture industry. Interiority as a kind of aggravated superficiality was the normal and exclusive means of accessing the scene. Bad taste as a display of plain attitude? Many elements of the autonomous aesthetic, which built up aggravation - although in the 1980s they were already finished with their autonomous movement - managed to outlive the 1990s thanks to Antifa: Vokuhila (at that time really inappropriate), palestinean cloth, tight blue jens and Jutesack claimed a clearer visual language. Us or them, and so that is also why the flyers look the way they do.

Of course, enlisting the experience- and success-oriented teenagers into the movement was difficult, although it was even again required after the fall of the wall, GDR and socialist realism. After 1990, a real enemy, the emerging Nazi gangs, confronted the belated youth revolutionaries of the new great German unified state, a situation which called for a permanent Antifa mobilization.

Meanwhile, on the flyer front something of its own was accomplished. Mobilization, alliance meetings, plenum and "volks" cuisine wanted everything to be advertized, communicated and disseminated. The internet was not yet the appropriate means for such a purpose. It permeated first at the end of the last millenium in German federal political shared housing all over the country.

Here is a general outline of the aesthetic that was seen from the beginning to the middle of the 1990s, although this list is in no way exhaustive:

1. BRAND OF LEFT GOOD MANKIND WITH SOFT ANTI-IMPERIALIST ATTITUDE FOR THE PEOPLE IN THE THIRD WORLD AND AGAINST ENVIRONMENTAL GANSTERS, SPECULATORS AND EVIL POLITICIANS.

Aesthetic: esoteric, superficially ecological flyers out of recycled paper together with native American statements, for example, "the white man in the end cannot eat his gold," etc. Birds, forests and smoking chimneys in dense photomontage with boring font.

Contents: Fusion of environment-, anti-nuclear-, Third World- and anti-capitalist rhetoric.

2. BRAND OLD SCHOOL ANTI-FASCISM À LA AGIT-PROP OF THE 1920S: George Grosz or John Heartfield image montages in original format or as a bad plagiarism together with slogans.

Aesthetic: Deliberately Old School, no Punk-Attitude with cut-out letters, but slogans with stylised hand writing or unsexy utilitarian font: Times New Roman to Courier.

Contents: Dimitroff-Thesis: Behind fascism stands capital, the left people's front against FRG-Police state, whether green or brown, busting nazis is it, etc.

3. BRAND POSTAUTONOMOUS ANTIFA DISTRICT: Adolescent community activists in army gear, bomber jackets and Pali-Tuch, combined in the spirit of old autonomy, only younger.

Aesthetic: Black stars, Antifa-Action drawings with black banners over the red (particularly important, because the other way around, they would be the Antifa-Communists), from "krakelige" to naive battle paintings of autonomous self-defense against cops and/or Nazis. Layout is rather moderately punk on low quality self-made copies, with many cut-outs und persistent denial of computers.

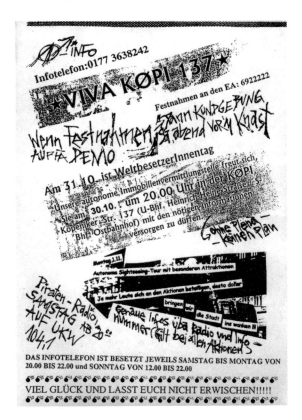

Contents: Defense of left structures, houses, cafes, shops on site against Nazis, police, etc. Less theoretically-oriented because "action speaks louder than words." Solidarity with the Prisoner XY, the nazishop Thor has to be destroyed, Germania, Hetendorf, Club88 and whatever name those places have. Organize gangs in the neighborhood!

In defiance of this triumvirate and its mixed forms, completely different and unexpected accented styles have emerged since the middle of the 1990s: popular culture, hip hop, drum 'n' bass, rave, radical chic and black [Block] with Armani sunglasses. In the case of flyers, such drives translate themselves the choice of the means of production. Computer, Quark Express, daring fonts, Helvetica und Verdana instead of Times New Roman und Arial, vivid colors, minimalism und politically-remote motives. One-to-one was now over, and so motives, like slogans, went into an altogether abstract direction. Concrete motives and direct allusions were frowned upon. Towards the end of the 1990s, a fourth current in the direction of the New School aesthetic emerges out of the three basic orientations existing in the Antifa camp and their intersections - corresponding developments could also be observed in feminist, gender and anti-rascism groups:

4. BRAND ANTI-GERMAN POPANTIFA: Popleft skilled university left with a penchant for theory and parties. PR and media competent, provocatively anti-violence and anti-german.
Aesthetic: The black block in branded-gear set on a computer, chic fonts, often very oriented towards techno or hip-hop styles. Image and Photoshop montages of the highest caliber. Either stupidy striking or Titanic-Satire moderate.
Contents: Against German "volks" community, Nazis, do-gooders and old-school lefts and for certain acquisitions of the culture industry, technological advancement and communism.

It went perfectly chic and professional into the new millenium. The left at the self-determined computer now arranges for a popular cultural major offensive. Whether the motives of the cultural-indus-

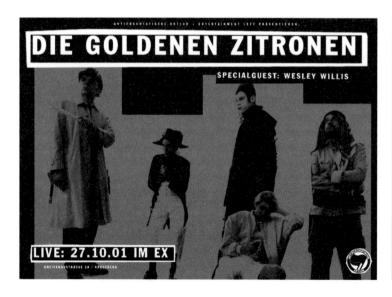

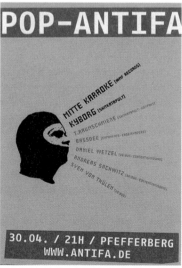

trial ambassadors from Beavis & Butthead, Sesamestreet, Southpark, Terminator, Captain America or brands from Carhartt to Nike und Adidas, in the universe of the left Signifikantendschungels (nearly) everything became quetable, affirmable and usable. An absolute left aesthetic for an insular left audience was given up in favor of a pop cultural and sub-cultural super-charged game with symbols, styles und messages. Even in the country - be it outside Hamburg - "Flugis" now definitively were called "flyers" as their print and paper quality rose. Their aesthetic transforms itself definitively from the mainstream of the minorities to the pop-cultural minority in the mainstream. And that is better that way - everyone experiences an eerie amusement to an embarrassingly discomforting melancholy for the former "Flugitage."

by Sami Khatib

SERVICEPOINT:
HTTP://PLAKAT.NADIR.ORG/BUCH.HTM
HKS 13 (HRSG.), VORWÄRTS BIS ZUM NIEDER MIT,
BERLIN, HAMBURG: ASSOZIATION A 2001
THOMAS SCHULTZE/ALMUT GROSS, DIE AUTONOMEN,
HAMBURG: KONKRET LITERATUR 1997

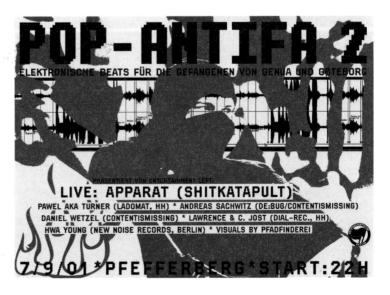

M.C.R.A.

Nuit de la Saint Jean
Samedi 19 juin

Mec, t'as envie de POMPER des queues, de boire de la PISSE, de te faire ENCU-LER, de te faire FISTER, de LECHER, d'être une LARVE, de BOUFFER des

Mec, t'as envie de te FAIRE POMPER, de PISSER, d'EN-CULER, de POINGLER des CULS, de te faire LECHER, de LARVER, de te faire BOUF-FER le CUL, ...

REJOINS NOUS A LA CAMPAGNE. TU POURRAS BAISER, BOUFFER ET BOIRE TOUTE LA NUIT.
POUR PLUS DE RENSEIGNEMENTS, ECRIS AU M.C.R.A.

RENSEIGNEMENTS - RESERVATION

Renvoyez ce bon complété au verso à :

M.C.R.A.
BP 3010
69 394 LYON Cedex 03

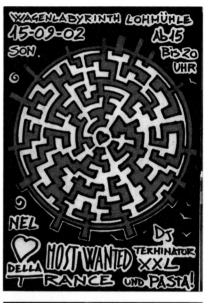

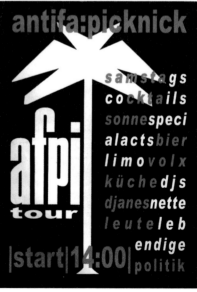

194

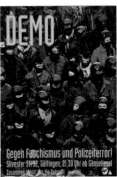

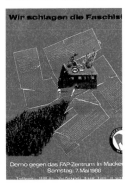

LINKE FLYER-KULTUR?
HURRA HURRA, DIE AUTONOME ANTIFA IST DA.

Sami Khatib

An die Polit-Flyer in meinem damaligen Jugendzentrum in einer Kleinstadt bei Hamburg erinnere ich mich noch genau: Schwarzer Stern, Antifa-Aktion-Zeichen, Schnippel-Layout, unscharfe Graustufen-Schwarz-Weiß-Kopien und Parolen: Kommt zur..., Nieder mit..., hoch die... So oder so ein hoher Wiedererkennungswert, ob in Form abgegriffener Zettelchen, runterkopierter Plakate oder kompliziert gefalteter Pamphlete. Irgendwie wusste ich immer, wann es sich um einen linken Flyer handelte. Sicherlich, auf Demos, Veranstaltungen und Solipartys erwartet man nicht gerade Werbepostkarten für ein Probeabo der Welt oder die Einladung zu einem Kameradschaftsabend. Dennoch genügte meist ein minimal gestreifter Blick, um das kleine eilig bis aufdringlich zugesteckte Zelluloseerzeugnis einer bestimmten Szene zuzuordnen, um es wohlwollend in eine Tasche einzustecken und daheim meist wegzuwerfen.

Ob es überhaupt so etwas wie eine linke Flyerkultur gibt, die eine eigene Ästhetik und Praxis herausgebildet hat, lässt sich nur schwer belegen. Flyer stehen als Agitationsmittel linker Selbstorganisierung seit jeher im Kontext von Stadtteil- oder Politzeitungen, Pamphleten, Plakaten, Aufklebern (vulgo "Spuckis") und Demotransparenten (vulgo "Transpis"). Unterschiede zwischen Szenen, Städten, Ländern und Stadtteilen lassen sich zwar relativ genau bestimmen, eine eigene Flyerkultur muss man dabei aber nicht unbedingt konstruieren. Vielmehr geht es bei Flyern, vulgo "Flugis", um Erzeugnisse linker Organisierung, die nur im Zusammenhang und Wandel linker Ästhetiken seit den seligen Tagen der 68er zu verstehen ist.

Doch so weit wollen hier nicht ausholen und wählen stattdessen die biographisch verengte Perspektive auf eine (post-) autonome Antifabewegung seit Anfang der 1990er Jahre. Gerade in dieser zu verschiedenen Zusammenhängen (vulgo "Szenen") zersplitterten Bewegung lässt sich ein grundlegender Wandel ästhetischer Codes feststellen, der nicht zuletzt in Begriffen wie "Popantifa" oder "Szeneantifa" ihren Ausdruck findet. An Flyern, Flugis, Spuckis und Politpamphleten dieser Zeiten und Szenen lässt sich bei aller Ausdifferenzierung und Marginalisierung eine ästhetische Abkehr von ehemals linken Codes (Schnippellayout, Schreibmaschinentexte, fünfzackige Sterne in allen Variationen, Bildmontagen und Handarbeiten wie Zeichnungen, Kopien etc.) bemerken. Dass der ästhetischen Neuorientierung auch eine

inhaltliche folgte und eine technische voranging, soll hier nur am Rande interessieren, schließlich ist die Geschichte der Neuen Linken in der BRD immer noch und zum Glück ungeschrieben.

Kommen wir zurück zu unserer Dorfantifa: Dort änderte sich in den Folgejahren der frühen 90er Jahre erstmal inhaltlich wie ästhetisch wenig, bis unverhofft die ortsansässigen Autonomen ab Mitte der 90er Jahre einen eigenen Rechner unter die Finger bekamen. Am technischen - wenn auch kapitalistischen - Fortschritt ließ sich nicht ewig vorbeikopieren, und schließlich war die Stadt so freundlich, den hippieesken und zottelbe-haarten Postgrungekindern einen Computer samt anleitendem Sozialarbeiter hinzustellen. Fortan ging es mit Pagemaker bergauf, die schwarzen Sterne wurden schärfer und manchmal auch rot, die Antifa-Aktionszeichen lesbar und später gar multicolor. Trotzdem, der Handwerkskunst wurde nach wie vor viel Bedeutung beigemessen: autonomer Expressionismus, naiv marxistischer Realismus, selbstbestimmte Bleistiftkritzeleien und größenwahnsinnige Kohlestiftszenarien kämpfender Massen und finster knüppelnder Polizisten gegen vermummte Autonome. Kitschig pathetisch und manchmal spannend, vielleicht sogar radikal, aber bestimmt nicht originell waren derartige Ästhetiken, denen vor allem eines gemeinsam war: erstens, auf den Inhalt kommt es an, auch wenn der bloß aus wenig überdachten Parolen bestand, und zweitens, wo Ästhetisierungen politischer Botschaften zu sehen waren, musste ein direkter Bezug zur Szene, Bewegung, etablierter linker Ästhetik und politischer Aussage nachweisbar und erkennbar sein. Schickes Aussehen, das bewusste Entwickeln eigener Symbolwelten, die zunächst ästhetischen Maßstäben zu genügen hätten, durfte es auf keinen Fall geben. Wer aber doch dem schönen Schein verfiel, schicke Layouts für schnittige Flyer entwarf, machte sich indes der Inhaltsleere, des Renegatentums und moralischen Verfalls an die Kulturindustrie verdächtig. Innerlichkeit als verschärfte Oberflächlichkeit war Norm und limitierender Zugang zur Szene in einem. Schlechter Geschmack als Ausweis der reinen Gesinnung?

Erschwerend kam hinzu, dass - obwohl die 80er Jahre mit ihrer Automomenbewegung gerade vorüber waren - vieles der autonomen Ästhetik dank Antifa die 90er frisch konserviert überdauern konnte: Vokuhila (damals wirklich unpassend), Palituch, Röhrenjeans und Jutesack verlangten nach klarer Bildsprache: wir oder die, und so sahen auch die Flyer aus.

So altbacken ließen sich natürlich wenig erlebnis- und erfolgsorientierte Jugendliche anwerben, obwohl es derer nach Fall von Mauer, DDR und Realsozialismus gerade wieder bedurfte. Den spätgeborenen Jungrevolutionären der neuen großdeutschen Herrlichkeit nach 1990 stand mit aufkommenden Nazibanden ein tatsächlicher Feind gegenüber, der für permanente Antifamobilmachung sorgte.

An der Flyerfront tat sich derweil einiges. Mobilisierung, Bündnistreffen, Plenum und Volxküche, alles wollte beworben, mitgeteilt und weitergetratscht werden, Internet gabs ja noch nicht so richtig. Letzteres zog erst mit Ende des letzten Jahrtausends flächendeckend in bundesdeutsche Polit-WGs ein. Zu Propagandazwecken tauglich waren ansonsten nur Plakate und Flyer.

ÄSTHETISCH GESEHEN GABS ZU BEGINN BIS MITTE DER 90ER NOCH FAST ALLES:

1. MARKE LINKES GUTMENSCHENTUM MIT SOFTER ANTI-IMP ATTITÜDE FÜR DIE MENSCHEN IN DER DRITTEN WELT UND GEGEN UMWELTGANGSTER, SPEKULANTEN UND BÖSE POLITIKER.

ÄSTHETIK: esoterisch anmutende Ökoflyer auf Recyclingpapier samt blöden Indianer-Spüchen, dass der weiße Mann am Ende nicht sein Geld essen kann etc. Vögel, Wälder und rauchende Schlote in solider Fotomontage mit langweiliger Typo.

INHALT: Fusion aus Umwelt-, Antiatom-, Dritte Welt- und Antigroßkapitalrhetorik.

2. MARKE OLD SCHOOL ANTIFASCHISMUS À LA AGIT-PROP DER 20ER JAHRE: George-Grosz- oder John-Heartfield-Bildmontagen im Original oder schlechtem Plagiat mit Parolen.

INHALT: Dimitroff-These: Hinter dem Faschismus steht das Kapital, linke Volksfront gegen BRD-Bullenstaat, ob grün ob braun, Nazis auf die Fresse haun etc.

ÄSTHETIK: Gewollt ganz Old School, keine Punk-Attitude mit ausgeschnippelten Buchstaben, sondern Parolen mit stilisierten Handschriften oder unsexy Unifachschaftsinitiativen-Typo: Times New Roman bis Courier.

3. MARKE POSTAUTONOME STADTTEILANTIFA: Jugendliche Kiezaktivisten in Armyklamotten, Bomberjacken und Palituch, im Geiste den alten Autonomen verbunden, nur jünger.

ÄSTHETIK: Schwarze Sterne, Antifa-Aktionszeichen mit schwarzer Fahne über der roten (ganz wichtig, weil andersherum es die Antifa-Kommunisten sind, s.u.), krakelige bis naive Kampfgemälde autonomer Selbstverteidigung gegen Bullen und/oder Nazis. Layout eher punkmäßig auf niedrigem Copy-Selfmadeniveau mit viel Geschnippel und hartnäckiger Computerverweigerung.

INHALT: Verteidigung linker Strukturen, Häuser, Cafés. Läden vor Ort gegen Nazis, Bullen etc. Weniger theoretisch orientiert, denn action speaks louder than words. Solidarität mit den Gefangenen XY, Weg mit dem Naziladen Thor, Germania, Hetendorf, Club88 und wie die Dinger alle hießen. Bildet Banden im Kiez!

Diesem Dreigestirn und deren Mischformen zum Trotz setzten ab Mitte der 90er Jahre völlig unverhofft andere Styles Akzente: Popkultur, Hip Hop, Drum'n'Bass, Rave, Radical Chic und Schwarzer Block mit Armani-Sonnenbrille. Auf den Flyer übersetzte sich derartiges Treiben zunächst auf die Wahl der Produktionsmittel: Computer, Quark Express, gewagtere Typos (Helvetica und Verdana statt Times New Roman und Arial) bunte Farben, Minimalismus und politferne Motive. Eins zu eins war jetzt vorbei, und so gingen Motive wie Parolen insgesamt in eine abstrakte Richtung. Konkrete Motive, direkte Anspielungen waren verpönt. Aus den drei Grundorientierungen und deren Kreuzungslinien driftete im Antifalager gegen Ende der 90er eine vierte Strömung in Richtung dieser New School Ästhetik ab (entsprechende Entwicklungen konnte man auch bei Feminismus-, Gender- und Antirassismusgruppen beobachten):

4. MARKE ANTIDEUTSCHE POPANTIFA: Poplinks geschulte Unilinke mit Hang zu Theorie und Party. PR- und Medien gewandt, provozierend anti-agitatorisch und anti-deutsch. ÄSTHETIK: Der schwarze Block in Markenklamotten setzt auf Computer, schicke Typos, oftmals sehr an Techno- oder HipHopstyles orientiert. Bilder und Photoshop-Montagen auf höherem Niveau. Mal prollig plakativ oder Titanic-satire mäßig. INHALT: Gegen deutsche Volksgemeinschaft, Nazis, Gutmenschen- und Old School-Linke und für gewisse Errungenschaften der Kulturindustrie, technischen Fortschritt und Kommunismus.

Richtig schick und professionell ging es dann ins neue Jahrtausend. Die Linke am selbstbestimmten Rechner setzte nun zum popkulturellen Großangriff an: Ob Motive kulturindustrieller Sympathieträger von Beavis&Butthead, Sesamstraße, Southpark, Terminator, Captain America oder Marken von Carhartt bis Nike und Adidas, (fast) alles wurde zitierbar, affirmierbar und benutzbar im Universum des linken Signifikantendschungels. Eine rein linke Ästhetik für ein abgeschottet linkes Publikum wurde zugunsten eines pop- und subkulturell aufgeladenen Spiels mit Symbolen, Styles und Botschaften aufgegeben. Selbst auf dem Land – und sei es in der Nähe von Hamburg –, Flugis hießen nun endgültig Flyer, Druck- und Papierqualität stiegen und ihre Ästhetik veränderte sich endgültig vom Mainstream der Minderheiten zur popkulturellen Minderheit im Mainstream. Und das ist, bei aller schaurig belustigten bis peinlich berührten Melancholie beim Gedanken an vergangene Flugtage auch besser so.

GLOSSAR:

Flugi:	Flugblatt
Transpi:	Demonstrationsplakate, meist auf Leinentuch oder Bettlaken
Spucki:	mit Spucke aufzutragende oder selbstklebende Aufkleber

SERVICEPOINT:

linke Plakate, Artwork: Zum Weiterlesen
HTTP://PLAKAT.NADIR.ORG/BUCH.HTM
HKS 13 (Hrsg.), "vorwärts bis zum nieder mit", Berlin, Hamburg: Assoziation A 2001
Zur Geschichte der Autonomen: Thomas Schultze/Almut Gross, Die Autonomen, Hamburg: Konkret Literatur 1997

ANHANG:

(auf CD) je ein Spucki/Flugi/Plakat-Beispiel für alle vier Basistypen

ASCII-FLYERS ARE RED

by Matze Schmidt

Flyers received by email, not on paper during a night out, belong in a particular category, a category all of their own. But this doesn't mean that they are merely self-reflexive, or accessories for techno geeks on account of their allegedly digital character. They are only digital because they are created using digital processing. What they are is their social context. In other words, their specific field of action is not the official catalog or the objective anthology. Their museum is their mailbox. But "what remains" is not what they are. This temporal conflict, which applies to all objects of theoretical contemplation (i.e. that looking at them creates a blind spot at the precise moment of this contemplation), distances flyers in general from that which, to vulgarly quote Freud and Marx, could be termed the anally fixated accumulation of assets. Non-paper flyers are faster, more versatile, more adaptable, more ephemeral than museum archives. Flyers can be collected, but in the case of email flyers it is about a mix of distribution and access. ASCII flyers are like open source (OS), apart from any costs incurred. This means that when they appear on an email client, they are complete, as every one of their characters is taken directly from the QWERTY (or whatever) repertoire with no diversions via complex remix filters, and they can be addressed discreetly, can be exchanged, meaning that the entire text can be rewritten, because its code is disclosed - "real" email flyers, then, are ASCII/pure text emails. This is not the case for the kind of email flyers that are sent as attachments consisting of a fixed GIF or PNG whose elements are not individually accessible; in these cases, a remix never has access to the basic components. ASCII is structural.

Their OS-like status is also their aura, their halo. This is illustrated by the ASCII graffiti typography of cracker NFOs (info files). You can just about read it, but it is supposed to be cryptic. Their fluidity, a property they share with all digital goods, and their endless, virtually cost-free copyability make them a utopian residue in the gray area between writing and speaking. Texts that are images, and vice versa, are hybrid, like the typical two-headed front-door keys in Berlin, or at least that is what the latest media theory teaches us. But it seems that email flyers are content to be classified as "mail art", "ASCII art" and the "rebellion of characters", and this contentment is the problem. The problem of their economy of coziness.

But if their classification - their division into sectors, their cut-up, their speed - were to come from within, then we would have reached and reproduced the standard of bourgeois art categorization, with all its sub-phenomena like difference, distinction, branding, etc.: art is that which refers to itself and which is devoted to nothing but its appearance, but which nevertheless includes "everything else". That is the original "l'art pour l'art", linked to society but defining the autonomy of art in the 19th century. Meanwhile, experienced ASCII masters like Markus Gebhard preach that all content can be see through ("dia") something and graphically ("gram"), and that it is a fun craft to enlarge the possibilities of text by means of a tool. Gebhart is the author of JavE (Java ASCII Versatile Editor), a freeware ASCII graphics editor based on Sun's Java Runtime Environment:

```
      _____
   ,' create Ascii art !                      `.
  /  draw sketches for e-mails !                \
  |  comment source code of programs !          |
  | diagrams for visually handicapped people ! |
  \  `... !                                      /
   `._____   _____,'
            /,,'
       O  /'
      /|-
     /|   (FROM HTTP://WWW.JAVE.DE)
```

This media craftsmanship deprives the aura of something that was so crucial to punk in the late-70s, i.e. using and abusing operating instructions for something the gentleman artists of imperial China couldn't call a hobby (because it was all they were doing) and which is precisely not the mark of true dilettantism. Characters acting at odds with their original function of forming textual syntax, being spread across the surface in such a way that they form structures, sounds like someone using something against something. This is known as resistance.

"The most beautiful flyers are the ones made by programs." The cleverest people are those who let machines do the work for them.

```
-------------------snip-------------------
```

ASCII flyer = txt-flyer. The America Standard Code for Information Interchange (ASCII) produces a fixed-pitch font where the individual text elements, the characters, do not appear in proportion to their neighbors in the line of text. Using such a font, the length of line can be accurately calculated, as each character occupies the same amount of space in absolute terms (uniform character width), which is important in order to be able to create coherent graphical figures that would fall apart immediately if converted into other fonts, which can in turn lead to surprising results, such as the famous Picasso experiment with broken-off noses, etc.

"It is a coding scheme which assigns numeric values to letters, numbers, punctuation marks, and other certain characters such as control codes. By standardizing the values for these characters, ASCII enables computers and computer programs to exchange information. ASCII is the basic coding system which computers use to communicate with one another."

ASCII texts are compact, i.e. they take up little memory space, and they are platform-independent. All operating systems provide editors to read and write ASCII texts. As such, ASCII is ubiquitous, but not universal, because these non-graphical graphics are unable to recreate all designs. Taken together, the limits of the 128 characters

of the ASCII table and the desire to make images constitute the technical/media program of ASCII flyers. What with a typewriter was only possible with complex planning of the distribution of letters on the sheet of paper, i.e. by means of imagination, can be achieved with text editors, ideally Word or maybe the email program The Bat!, in handmade mode by reversible trial and error. By contrast, the asco-o mailing list (http://www.o-o.lt/asco-o), whose community constantly produces ASCII flyers, works to a certain extent via automatic text manglers; the "unstable digest" from Florian Cramer, sent out via nettime (http://www.nettime.org), is one long flow of ASCII flyers – correct me Florian if I'm wrong – because instead of the legible data per se, the information content of the flyer consists above all of what is left out!

```
--------------------snip--------------------
```

This form of cultural production contains something known as a symbol, or signified/signifier, or allegory. A scientific approach is not sufficient to grasp the full effect of visual texts. But the "ungraspable" aspect of txt-flyers lies not in the transcendent code, but in the underground milieu as a technical/media context, in what is referred to in media theory as translation or transmission, in what is meant by *appropriation of technology*. Everything that needs to be communicated must be transmitted and deciphered, otherwise it would not be communicated. It lies in the nature of this production as an always incomplete apparatus of a memory of writing that triggers an instantaneous effect. At this point in this text this just had to happen: ASCII flyers are communications guerillas, of course. Or are they sport?

```
  o_
 /\|
 /\/
 \
```

Using the handy JavE program, symbolic repressions à la Jackson Pollock can be given form and reminiscences can be established that go against the grain of the naturalistic conservatism of the international ASCII art scene. In the case of Pollock, what is repressed is figuration, which in the case of ASCII flyers evokes the desire for abstraction that wishes to see a line in a cleverly arranged combination of , \ \ \ ` . | \. This abstraction is simple because the proximity of the meaningless characters as elements on the keyboard shapes its contours. The kick comes from a simultaneous use and misuse of characters, moving the characters out of the rigid context of a semantic framework and into a layout in 2D space. Information service is refused…

```
   ../._,.-'    .  ,8.   ___,    __,,.....ooo,''        _.--'
'-----'    |    `-]8[.--  '\  |   '  ,oOP""'\  `b  oL  ,Y-'
,!!.|.!_`-._|...__,]8[.       \ ;  (!.P'   ,. `-..  `,-'  \  `OL
`!!|.!O`-!!'oOo!!!!dPoo`..XXXX,\XXo  O`!...`MMM _,.-''      `. `'  .
,``'dOOO'-`.OOP;!,8P_XXX__.....\P' dO'  '''!....   ..'''..._ \  .:'
,!,------..OO\,,o8P',,,''_  /`-.`.oo08oo,,-' ''`!'.''  _.-'.....:'
_,'! O   :O-o8PP'_-,'..   `--.XX`||_.--'XP_.-'.''M_.-'X    ''' ._
;!!.]OO_.,..__,,.-'-...... ;  `_.|-\`.=.--: ..'_.-'MP  X    _ |
!!!:O,,''' -' ||   ;!!!-._ _.--'' |,-|'``'.`'-._...::..=..-,,.''''
`!_,'|O`..,-'-._oo`_.-''._\|_,''-..  .''_ |  `-.  ' X.'.'``..|,..`
'''-'Y,.-'`.P!  _.-'...!._.`   ,,`-..,..| `-._.'XXX`-+`'!'' '!
..| `!/!`.dO/_,-'OPdO ``i___...,;''.,-''`_-`.    '--_XX +: `!..'
`. ''\---'_---dO':O:o,'_,.-''`.-''.:---`.-|`.---XXXX`..+++\
 \ _..`-._`.OP. +-'--'    ,''`\_|  /X|XX|`.X   |  `.++-----
.---,'  `Yb _.'----.._ ,--___.['; ]__...-'.,-...._`-. ,-' +|+`._
,'!!\ ,-''.-,OOP--.`.``-_,..,---''].'X_,'`.-,,'     `-. /d|  \`-.
_| `'`J/  `YOdOO''''',,-'  `..X`-./X'/=d--'`...------._b  do80.  \ ``
Y'.o_ /O\   `Op':8L,' X`._XX|: /,/=,____.____/. `.Ob `YOo. //
``YO`P \X_,dPP `-b._ (PY8`_,,'-'/|  `````-----'''''_.o.`.ooooodYOL|
__,boo\P"'   XXXX`'---'':' `/.\_ |88888'.P""\' 'Y-`.o.`.i'""]|P
_,,'-'O':X`.     _ Y8_ ,'. :8. /  `..""' `. \ ( Y||88``. d|
.'''o,O'  `-.`-. `8o Y8o `Y88:bo.'.___|`-.____'  `.`--||88  `.O|
'OO'`.'  X `..`-.`8ooo_o8PP':''''";"""|""""`...| \.  | 8.`8'\o_
]O'  \  X _.-:| ````Yb.  : _..  `.,' _''..|.-._._ / _88|['O[`|Y
-YO----|----,'`\ |.b  `Yb_.--'  \  |.  `--.|.`.`,'oo888,' `'|
  YOL,' ----X |_ |./  ,'.'`-.._b`._`.oooooo|o`-.,'88`.8_,'  ,'
  ,'POooo_____,' '-....'/8P'  d8.'-`.`_`\.888,'.,-'`..-..' | _,,'
 _'  '`""""",'PPPOL /8'`.   ,'"""""`-.`-..-'  : `_ `._,.--.
  ,'   _,,--'   `"'/d|  `...-'   ,-'    :  `.,''---./
 '  `. `.         .--'           '   /  `'!---''
```

...or positioned somewhere between legible and illegible:

```
   ../._,.-'    .  ,8.   ___,    __,,.....ooo,''        _.--'
'-----'    |    `-]8[.--  '\  |   '  ,oOP""'\  `b  oL  ,Y-'
,!!.|.!_`-._CALL 4 E-MAIL FLYER !;  (!.P'   ,. `-..  `,-'  \  `OL
`!!|.!O`-!!'oOo!!!!dPoo`..XXXX,\XXo  O`!...`MMM _,.-''      `. `'  .
,``'dOOO'-`.OOP;!,8P_XXX__.....\P' dO'  '''!....   ..'''..._ \  .:'
,!,------..OO\,,o8P',,,''_  /`-.`.oo08oo,,-' ''`!'.''  _.-'.....:''
_,'! O   :O-o8PP'_-,'..   `--.XX`||_.--'XP_.-'.''M_.-'X    ''' ._
;!!.]OO_.,..__,,.-'-...... ;  `_.|-\`.=.--: ..'_.-'MP  X    _ |
!!!:O,,''' -' ||   ;!!!-._ _.--'' |,-|'``'.`.....::..=..-,,.''''
`!_,'|O`..,-'-._oo`_.-''._\|_,''-..  .''_ |  `-.  ' X.'.'``..|,..`
'''-'Y,.-'`.P!  _.-'...!._.`   ,,`-..,..| `-._.'XXX`-+`'!'' '!
..| `!/!`.dO/_,-'OPdO ``i___...,;''.,-''`_-`.    '--_XX +: `!..'
`. ''\---'_---dO':O:o,'_,.-''`.-''.:---`.-|`.---XXXX`..+++\
 \ _..`-._`.OP. +-'--'    ,''`\_|  /X|XX|`.X   |  `.++-----
.---,'  `Yb _.'----.._ ,--___.['; ]__...-'.,-....._`-. ,-' +|+`._
,'!!\ ,-''.-,OOP--.`.``-_,..,---''].'X_,'`.-,,'     `-. /d|  \`-.
_| `'`J/  `YOdOO''''',,-'  `..X`-./X'/=d--'`...------._b  do80.  \ ``
Y'.o_ /O\   `Op':8L,'SEND UR POLLOCK 2:e-mailflyer@n0name.de `YOo. //
``YO`P \X_,dPP `-b._ (PY8`_,,'-'/|  `````-----'''''_.o.`.ooooodYOL|
__,boo\P"'   XXXX`'---'':' `/.\_ |88888'.P""\' 'Y-`.o.`.i'""]|P
_,,'-'O':X`.     _ Y8_ ,'. :8. /  `..""' `. \ ( Y||88``. d|
.'''o,O'  `-.`-. `8o Y8o `Y88:bo.'.___|`-.____'  `.`--||88  `.O|
'OO'`.'  X `..`-.`8ooo_o8PP':''''";"""|""""`...| \.  | 8.`8'\o_
]O'  \  X _.-:| ````Yb.  : _..  `.,' _''..|.-._._ / _88|['O[`|Y
-YO----|----,'`\ |.b  `Yb_.--'  \  |.  `--.|.`.`,'oo888,' `'|
  YOL,' ----X |_ |./  ,'.'`-.._b`._`.oooooo|o`-.,'88`.8_,'  ,'
  ,'POooodeadline: 31.12.2003_ d8.'-`.`_`\.888,'.,-'`..-..' | _,,'
 _'  '`""""",'PPPOL /8'`.   ,'"""""`-.`-..-'  : `_ `._,.--.
  '    _,,--'   `"'/d|  `...-'   ,-'    :  `.,''---./
```

The conflict of not wanting to be that which is expected by the collectors and "deep storage" machines, the memory media and the rumbling archives, is a technical and a capitalist conflict: writing is cheap, memory space is cheap, but this enjoyable work usually remains unpaid because it is included in the wages. This is exactly the dilemma of the free software movement: only a financial backup safeguards after-hours production.

But their delivery via electronic transmission is also their future, their technical production determines their legibility and, besides their technical/media program, their style horizon. The historical restriction of the symbol-processing machine known as the computer to a table for the transfer of electrical signals from cryptic machine language into culturally legible script has a defining influence on style. But this specificity does not surpass the transform of *arrival* via electronic post that is transformed by reading into its *future*, i.e. meaning.

This little DJ from a design for an email flyer for a plug-in party in Berlin, rocking his laptop, with a tilde for a cable, has to be set in Courier New 10 Point otherwise it looks wrong:

```
'O'
/_\
'_'~
```

This kind of textophile details, that have their roots in control over translation and copying, is nothing other than the guarding of books by priests: text flyers have the advantage of functioning on any platform, meaning that in classical terms, they belong in the """virtual""" book, which is a meta-file as long as a truly endless reel of paper. The writing machine, the combination of an editor and a writer, then uses copy&paste to make something more out of it (value added); this is something the authors and recipients of spam texts, who still read text as text and not also as texture (like wallpaper) have sadly yet to grasp.

Rubric: Lat. rubrica red earth, refers to the titles written in red in Medieval manuscripts and early printed works that separated the individual sections.

ASCII flyers are red because instead of ignoring the conflict between text, image and doing, they show it and go beyond it, maybe someday even concerning the bourgeois fear of traffic and its costs. One group called "bad fame", for example, doesn't give a damn about what writers in the graffiti scene might regressively call "fame", i.e. 'alternative cultural production', that allows itself to be aestheticized and then actually calls in the style police. That's something that flyers in the mailbox still have to learn: to relate their hygiene (style) with their output (conditions of production).

ASCII-FLYERS SIND ROT

von Matze Schmidt

Flyer, die ohne Papier und nicht über den Kneipentisch, sondern per E-Mail zu uns kommen, gehören in eine bestimmte Rubrik, und zwar eine, die sie selbst sind. Damit sind sie aber nicht gleich bloß selbstreflexiv oder Accessoire für den Tekkie, weil angeblich digital. Digital sind sie nur, weil sie mittels digitaler Prozessierung hergestellt wurden. Was sie sind, ist ihre soziale Rahmung. Ihr genuines Aktionsgebiet ist nicht der offizielle Katalog oder objektive Sammelband. Ihr Museum ist ihre Mailbox. Aber das, "was bleibt", ist nicht das, was sie sind. Dieser temporale Konflikt, der für alle Objekte der theoretischen Anschauung gilt, nämlich im Moment ihrer Beobachtung den blinden Fleck aus eben dieser Beobachtung zu erzeugen, distanziert generell alle Flyer von dem, was vulgär mit Freud und Marx die analfixierte Akkumulation von Wert ist. Denn papierlose Flyer sind schneller, vielfältiger, wandlungsfähiger, ephemerer als die Musealisierung. Flyer können zwar gesammelt werden, aber bei E-Mail-Flyern geht es um einen Mix aus Distribution und Zugriff. ASCII-Flyer sind quasi OpenSource (OS), mal abgesehen von allen laufenden Kosten. Wenn sie im E-Mailclient erscheinen, sind sie komplett, denn jedes ihrer Zeichen aus dem QWERTY-oder-was-auch-immer-Fundus ist direkt ohne Umwege über umständliche Remixfilter und diskret adressierbar, kann also ausgetauscht werden, was bedeutet, dass der gesamte Text umgeschrieben werden kann, eben weil ihr Code offen liegt – "echte" E-Mail-Flyer sind also zuallererst ASCII- bzw. Text-E-Mails. Nicht so bei den E-Mail-Flyern, die als Attachments aus fixen GIFs oder PNGs geschickt werden und deren Elemente nicht diskret vorliegen; ein Remix kann hier nie auf die untersten Bestandteile zugreifen. ASCII ist struktural.

Ihr Status als quasi-OS ist aber auch ihre Aura, ihr Nimbus. Die ASCII-Graffiti-Typos der NFOs (den Info-Dateien) der Cracker zeigen das. Du kannst es gerade noch lesen, aber eigentlich soll es schon kryptisch sein. Ihre Fluidität, die für alle digitalen Güter gelten mag, und ihre endlose, kostenmäßig gegen Null gehende Kopierbarkeit machen sie zum utopistischen Residuum im Zwischenbereich von Schrift und Sprechen. Texte, die Bilder sind und vice versa, sind hybrid, wie angeblich der Berliner Schlüssel mit zwei Bärten, soviel kann man von der Neuen Medientheorie lernen. Doch wie es scheint, sind E-Mail-Flyer mit der Rubrizierung "Mailart", mit "ASCII-art" und mit "Rebellion der Zeichen" zufrieden, und dieses Zufrieden-Sein ist das Problem. Das Problem ihrer Gemütlichkeits-Ökonomie.

Wenn aber ihre Rubrizierung, sozusagen ihre »Abschnittisierung«, ihr Cut-up, ihre Geschwindigkeit aus ihnen selber kommen sollen, dann hätten wir damit den Standard bürgerlicher Kunst-Kategorisierung wieder erreicht und reproduziert, mit allen Subphänomen wie Unterschied, Distinktion, Branding usw.: Kunst sei das, was auf sich selbst verweist und nicht ihrem Äußerlichen verpflichtet ist, aber dennoch "Alles Andere" mit einschließt. Das ist das originäre gesellschaftsbezogene, die Autonomie der Kunst im 19. Jahrhundert formulierende "l'art pour l'art". Dabei predigen erfahrene ASCII-Meister wie Markus Gebhard, dass alle Inhalte durch "dia" (etwas), und "gramm" (grafisch) gesehen werden können, und dass es ein spaßiges Handwerk ist, die Möglichkeiten von Text mit einem Tool zu vergrößern. So auch der Erbauer des JavE (Java ASCII Versatile Editor), dem Freeware ASCII-Grafik-Editor auf der Basis des "Java Runtime Environment" von Sun:

```
           _____
        ,'  create ASCII art !               `. .
       /   draw sketches for e-mails !          \
      |    comment source code of programs !     |
      |  diagrams for visually handicapped people ! |
       \   ... !                                 /
         ._____  _____.'
             /,'
          O  /'
          /|-
          / |  (HTTP://WWW.JAVE.DE)
```

This media craftsmanship deprives the aura of something that was so crucial to punk in the late-70s, i.e. using and abusing operating instructions for something the gentleman artists of imperial China couldn't call a hobby (because it was all they were doing) and which is precisely not the mark of true dilettantism. Characters acting at odds with their original function of forming textual syntax, being spread across the surface in such a way that they form structures, sounds like someone using something against something. This is known as resistance.

"The most beautiful flyers are the ones made by programs." The cleverest people are those who let machines do the work for them.

```
--------------------schnipp--------------------
```

ASCII-Flyer = txt-Flyer. Der America Standard Code for Information Interchange (ASCII) bringt eine nonproportionale Schrifttype (fixed-pitch font) hervor, bei der die einzelnen Textelemente, die Buchstaben, sich nicht proportional zu ihren jeweiligen Nachbarn in der Zeile verhalten. Die Zeilenlänge dieser gefixten Type lässt sich also deshalb perfekt kalkulieren, weil alle Zeichen absolut den gleichen Platzbedarf haben (uniform character width), was wichtig ist, um kohärente grafische Figuren zeichnen zu können, die konvertiert in andere Schrifttypen sofort auseinanderfallen würden, was dann zu überraschenden Ergebnissen führt, wie z.B. dem berühmten Picasso-Experiment.

"It is a coding scheme which assigns numeric values to letters, numbers, punctuation marks, and other certain characters such as control codes. By standardizing the values for these characters, ASCII enables computers and computer programs to exchange information. ASCII is the basic coding system which computers use to communicate with one another."

ASCII-Texte sind kompakt, ihr Speicherplatzbedarf ist gering und sie sind plattformübergreifend: alle Betriebssysteme halten Editoren zum Lesen und Schreiben von ASCII-Texten bereit. Insofern ist ASCII universell, aber nicht universal, weil das Hervorbringen dieser nicht-grafischen Grafiken nicht alle Designs kolportieren kann. Aus dem Limit des Sets von 128 Lettern der ASCII-Tabelle und Bilderwunsch ergibt sich das technisch-mediale Programm der ASCII-Flyer. Was mit der Schreibmaschine nur durch diffizile Planung der Verteilung der Buchstaben auf dem Blatt Papier gelang, also durch Imagination, kann mit Text-Editoren, Word, am besten aber vielleicht mit dem E-Mail-Programm 'The Bat!' im handmade-Modus durch reversiblen Versuch-und-Irrtum erzielt werden. Die Mailingsliste asco-o (http://www.o-o.lt/asco-o), deren A-Community permanent ASCII-Flyer produziert, funktioniert dagegen zum Teil über automatische Text-Zerhacker; der "unstable digest" von Florian Cramer, der via nettime (http://www.nettime.org) verschickt wird, ist, Florian möge mir widersprechen, ein einziger ASCII-Flyer Flow. Denn der Informationsgehalt des Flyers liegt nicht per se in seiner lesbaren Information, sondern vor allem in seinen Auslassungen!

```
--------------------schnipp--------------------
```

Diese Form der kulturellen Produktion beinhaltet etwas, das man Symbol nennt oder Signifikat/Signifikant oder Allegorie. Die bestimmenden Wissenschaften reichen nicht hin, die Wirkmächtigkeit visueller Texte zu fassen. Das "Unfassbare" der txt-Flyer liegt aber nicht im transzendenten Code, es liegt in ihrem undergroundigen Milieu als technisch-medialer Umgebung, in dem, was medientheoretisch mit Translation oder Übertragung gemeint ist, in dem, was *Aneignung von Technik* meint. Alles was mit-geteilt werden soll, muss übertragen und entziffert werden, sonst würde es nicht mitgeteilt. Es liegt in der Leistung dieser Produktion als immer unvollständiger Apparat eines Gedächtnisses des Schreibens, das instantane Wirkung zeigt. An dieser Stelle dieses Textes mußte es ja so kommen: Natürlich sind ASCII-Flyer Kommunikationsguerilla. Oder Sport?

Mit dem bequemen JavE lassen sich à la Jackson Pollock zeichenhafte Verdrängungen gestalten und Reminiszenzen aufbauen, die den naturalistischen Konservativismus der internationalen ASCII-Art-Szene konterkariert. Verdrängt wird bei Pollock das Figurative, das für Flyer in ASCII die Abstraktionslust hervorruft, aus einer klugen räumlichen Kombination von , \ \ \ `. | \ eine Linie zu erkennen. Diese Abstraktion ist simpel, denn die Nähe der sinnentleerten Zeichen als Elemente der Tastatur bedingt ihre Konturierung. Der Kick entsteht beim Ver-Wenden und gleichsam ent-wendeten Zeichen, die Dekontextualisierung der Zeichen aus dem starren semantischen Gerüst in die Verteilung im 2D-Raum. Informationsservice wird verweigert…

```
    ../._,.-'     .  ,8.   ___,     __,,.....ooo,''         _.--'
 '-----'    |     `-]8[.-- '\ |  '  ,oOP""'\ `b  oL ,Y-'
 ,!!.|.!_`-._|...__,]8[.          \ ;  (!.P'  ,. `-.. ,-' \  `OL
  `!!|.!O`-!!'oOo!!!!dPoo`..XXXX,\XXo O`!...`MMM _,.-''    .   `.
  ,``'dOOO'-`.OOP;!,8P_XXX__.....\P' dO' '''`!.....  ..'''..._ \ .:'
  ,!,------..OO\,,o8P',,,''  _  /`-.`.ooO8oo,,-' '''!.''  _.-'.......:''
 _,'! O   :O-o8PP'_-,'..   `--.XX`||_.--'XP_.-'.''M_.-'X    '' `._
 ;!!.]OO_,,..___,,.-'-......  ;  '_.|-\`.=.--: ..'_.-'MP X    _ |
 !!!:O,,'''  -' ||   ;!!!-._.--'' |,-|'''`.'-._...::..=..-,._''''
  `!_,'|O`.._,-'-._oo`_.-''._\|_,'`-.. .''_ | `-. ' X.'.'``..|,.-'
  '''`-'Y,.-'`.P! _.-'..!._.'   ,,`-.._,..|  `-._.'XXX`-+``!''' '!
 ..| `!/!`.dO/_,-'OPdO ``i___...,;'' .,-''`_`-.  '--_XX +: `!..'
 `. ''`\---'_---dO':O:o,'__,.-'''`.-''.:---`.-|``.---XXXX`..+++\
  \ ..`-._`.OP. +-'--'    ,''`\_|  /X|XX|`.X   |`._++-----
 .---,' `Yb _.'-----.._ ,--_---.[';_]__...-'.,-.....`-._,-' +|+`.
 ,'!!\ ,-''.-,OOP--.`.``-_,.,,---'']'X_,'`.-,,'    `-. /d|  \`-.
 _| ``'J/ `YOdOO''''',,-' `.X`-./X'/=d--''`...------._b do80. \ ``
 Y'.o_ /O\   `Op':8L,' X`.XX|: / ,/=,_ _ _...../. `.Ob `YOo. //
 ``YO`P \X_,dPP `-b._ (PY8``_,,'-'/| ``!!-----''''._o.`.oooodYOL|
 __,boo\P"'   XXXX`'---'':' `/.\_ |88888'.P""\' 'Y-'.o.`.i'"']|P
 _,,'-'O':X`.     _  Y8_ ,'. :8. / `.."'' `. \ ( Y||88``. d|
 .'''o,O'  `-.`-.`8o Y8o `Y88:bo.'.___|`-.____' `.`--||88 `.O|
 'OO''.'  X `..`-.`8ooo_o8PP':'''"';"""|"""".._| \.  | 8.`8`\o_
 ]O'  \  X  _.-:| ````Yb.  : _.. `.,'  _''..|.-._._ / _88|['O[`|Y
 -YO----|----,'`\ |.b   `Yb_.--' \ |.  `--.|.`.`,'oo888,' `'| |
  YOL,' ----X |_ |./   ,'.'`-..b`._`.oooooo|o`-.,'88`.8_,' ,'
  ,'POooo_____,' '-....'/8P'  d8.'-`._`\.888,'.,-''.-..' | _,,'
   '`""""',PPPOL /8'`.  ,'"""""`-.`-..-'  :_ `._`.,,-.-.
 _'   _,,--'   `"'/d|  `...-'    ,-'    :  `.,''---./
 '  `.   _,,--' ` `'.   .--'  '  / `'!--'/
```

…oder zwischen Lesbar und Unlesbar verortet:

```
    ../._,.-'     .  ,8.   ___,     __,,.....ooo,''         _.--'
 '-----'    |     `-]8[.-- '\ |  '  ,oOP""'\ `b  oL ,Y-'
 ,!!.|.!_`-._CALL 4 E-MAIL FLYER !;   (!.P'  ,. `-.. ,-' \  `OL
  `!!|.!O`-!!'oOo!!!!dPoo`..XXXX,\XXo O`!...`MMM _,.-''    .   `.
  ,``'dOOO'-`.OOP;!,8P_XXX__.....\P' dO' '''`!.....  ..'''..._ \ .:'
  ,!,------..OO\,,o8P',,,''  _  /`-.`.ooO8oo,,-' '''!.''  _.-'.......:''
 _,'! O   :O-o8PP'_-,'..   `--.XX`||_.--'XP_.-'.''M_.-'X    '' `._
 ;!!.]OO_,,..___,,.-'-......  ;  '_.|-\`.=.--: ..'_.-'MP X    _ |
 !!!:O,,'''  -' ||   ;!!!-._.--'' |,-|'''`.'-._...::..=..-,._''''
  `!_,'|O`.._,-'-._oo`_.-''._\|_,'`-.. .''_ | `-. ' X.'.'``..|,.-'
  '''`-'Y,.-'`.P! _.-'..!._.'   ,,`-.._,..|  `-._.'XXX`-+``!''' '!
 ..| `!/!`.dO/_,-'OPdO ``i___...,;'' .,-''`_`-.  '--_XX +: `!..'
 `. ''`\---'_---dO':O:o,'__,.-'''`.-''.:---`.-|``.---XXXX`..+++\
  \ ..`-._`.OP. +-'--'    ,''`\_|  /X|XX|`.X   |`._++-----
 .---,' `Yb _.'-----.._ ,--_---.[';_]__...-'.,-.....`-._,-' +|+`.
 ,'!!\ ,-''.-,OOP--.`.``-_,.,,---'']'X_,'`.-,,'    `-. /d|  \`-.
 _| ``'J/ `YOdOO''''',,-' `.X`-./X'/=d--''`...------._b do80. \ ``
 Y'.o_ /O\   `Op':8L,'SEND UR POLLOCK 2:e-mailflyer@n0name.de `YOo. //
 ``YO`P \X_,dPP `-b._ (PY8``_,,'-'/| ``!!-----''''._o.`.oooodYOL|
 __,boo\P"'   XXXX`'---'':' `/.\_ |88888'.P""\' 'Y-'.o.`.i'"']|P
 _,,'-'O':X`.     _  Y8_ ,'. :8. / `.."'' `. \ ( Y||88``. d|
 .'''o,O'  `-.`-.`8o Y8o `Y88:bo.'.___|`-.____' `.`--||88 `.O|
 'OO''.'  X `..`-.`8ooo_o8PP':'''"';"""|"""".._| \.  | 8.`8`\o_
 ]O'  \  X  _.-:| ````Yb.  : _.. `.,'  _''..|.-._._ / _88|['O[`|Y
 -YO----|----,'`\ |.b   `Yb_.--' \ |.  `--.|.`.`,'oo888,' `'| |
  YOL,' ----X |_ |./   ,'.'`-..b`._`.oooooo|o`-.,'88`.8_,' ,'
  ,'POooodeadline: 31.12.2003_ d8.'-`._`\.888,'.,-''.-..' | _,,'
   '`""""',PPPOL /8'`.  ,'"""""`-.`-..-'  :_ `._`.,,-.-.
 _'   _,,--'   `"'/d|  `...-'    ,-'    :  `.,''---./
```

Der Konflikt, nicht das zu sein, wozu sie die Szene der Sammler und Maschinen des "Deep Storage", der Speichermedien und der rumorenden Archive bestimmen, ist ein technischer und ein kapitalistischer: Schreiben ist billig, Speichern ist billig, nur der Arbeitsspaß daran bleibt meist unbezahlt, weil er im Lohn schon inbegriffen ist. Das ist exakt das Dilemma der Free Software-Bewegung: Nur finanzieller Rückhalt sichert freizeitliche Produktion.

Ihre Ankunft per elektronischer Übertragung ist aber zugleich ihre Zukunft, ihre technische Produktion determiniert ihre Lesbarkeit und, neben ihrem technisch-medialen Programm, ihren Stilhorizont.

Die historische Beschränkung der symbolverarbeitenden Maschine Computer auf eine Tabelle zur Um-Setzung von elektrischen Signalen auf kryptische Maschinensprache auf kulturell lesbare Schrift wirkt stilbildend. Aber diese Spezifizität übertrifft nicht die Transform der *Ankunft* via elektronischer Post, die beim Lesen in ihre *Zukunft* umgewandelt wird, nämlich Bedeutung.

Dieser kleine DJ aus einem Entwurf für einen E-Mail Flyer einer Plug-in-Party in Berlin, der an seinem Laptop rockt, dessen Kabel "Tilde" heißt, muß in Courier New 10 Punkt gesetzt werden, weil er sonst nicht stimmt:

Solche textophil kennerischen Feinheiten, die der Kontrolle über die Übersetzung und die Abschrift entstammen, ist nichts anderes als die Überwachung der Bücher seitens der Priester. Denn Textflyer haben den Vorteil, dass sie plattformübergreifend funktionieren, sie gehören also, klassizistisch gedacht, ins """virtuelle""" Buch, das ein Metafile ist, so lang wie

wirklich endloses Endlospapier. Die Aufschreibemaschine, das Kombinat aus Editor + Schreiber, macht dann per Copy+Paste mehr (Wert) daraus, was die Spam-Autoren und -Rezipienten, die immer noch Text als Text und nicht auch als Textur wie eine Tapete lesen, leider noch nicht begriffen haben.

```
--------------------schnipp--------------------
```

Rubrik: spätmhd. rubrik[e] "roter Schreibstoff", bezeichnete die in rot gehaltenden Überschriften, die in mittelalterlicher Hand-

schriften und Frühdrucken die einzelnen Abschnitte trennten.

```
--------------------schnipp--------------------
```

ASCII-Flyer sind rot, weil sie den Konflikt von Text und Bild und Machen nicht ver-weigern, sondern zeigen und überschreiten, vielleicht auch mal irgendwann, was die bürgerliche Angst vor Traffic und seinen Kosten angeht. Eine Gruppe, die "bad fame" heißt, schert sich z.B. einen Dreck um das, was der regressive

"Fame" bei den Writern der Graffiti-Szene heißen mag, nämlich 'alternative Kulturproduktion', die sich verästhetisieren läßt und dann auch noch die Stilpolizei ruft. Das ist etwas, was die Flyer in der Mailbox erst noch lernen müssen, ihre Hygiene (Style) mit ihrem Auswurf (Produktionsverhältnis) in Beziehung zu setzen.

```
.,          ,; .r,                                      yZ     .                    , ...7
@fs    xev olu                                      oalrqct.  @wvfktB          ehcbmmh
hq     yd,                                          aw0 br ij  kra   ofa       gv
Bnm    qsB  WeW  ixyjhai:  itkhaWrn  Wxirho  @fspalS   ya pS    ,,   np         vavyhd8
in     ym   pxp  ow   db.  Wji.  brf  kie   un;  @sS   ersja         @iv       abmX:,fah
foq    mvm  WfW  8abbcn: tl   sg  WsZ     Zvtngf@      b@ilc   .dcs2              8hm
kt .aj      WsW  hqW:: wq, qv     fp  WuW  ibn,i 0cW   Za  gS dnr  ewe          8X    Zsb
SmiwyS      WtW ds    ie  okZ  rqt  WaW   wkB   0bZ    ck  oS xei  ZfX          hye   jr:
fsha        lch  uxfbetqyu  eoiWevmt  eel  shixymoth0  ktWppucj Xxjkljqciv7 dil tjsgrvg:
        ,    ,:;i    :      ts     ,;i .:            mq  .    i i,
                          Zcq  mnr                  Z,
                          efvcj.
```

```
]+++++++++++++++++++++++++++++++++++++++++++++++++++++++++++:
  mini-fm + radio + headphone + plug-in party + concert + filmz + stream
                                       /
(0)    (((+)))        _    _    |::::|  _  _[:-      )).((
/\                    \__/ \__/   _    `_~            |   o|
]+ friday 19.11.04 / 21.00 h / k77 / kastanienalle 77 / prenzlauer berg /
]+ u2 + tram 20 / eberswalderstr. / tram 13, 50, 53 - schwedterstr. /
]+++++++++++++++++++++++++++++++++++++++++++++++++++++++++++:
```

```
()
><
pirate cinema berlin
jeden sonntag 21 uhr
bootlab ziegelstr 20
www.piratecinema.org
```

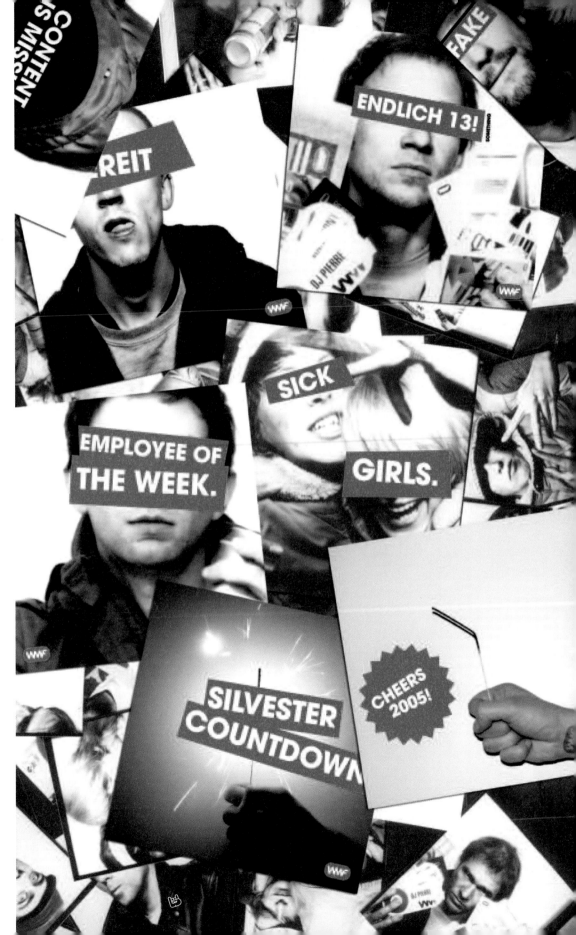

SAWING THE SEEDS OF LOVE.
BY BOTAS@OXBERLIN.DE

WMF 007
STRALAUER STRASSE 58, BERLIN

WMF

THE TIT IN CLUB CULTURE

HTTP://WWW.PLASTIKMAEDCHEN.NET/STORIES/28/

It takes only a short look at the trendy flyerland to notice that there seems to be no contradiction in sexism and a proclaimed political correctness for the people in the higher club culture.

The sad fact that half or fully nude females in erotic or idiotic poses smile at us from flyers of clubs we would never go to anyhow is not new. With the same logic as popular advertisment the naked skin of women is capitalised on as sex simply sells. No bothering thought is being spent on correctness in these mostly profit oriented spheres. To accept these loud flyers with vivid names like 'Models and More', 'Penthouse' (with playgirls to touch) or 'almost naked chicks' is just as enerving as being forced to tolerate sexist advertising but where profit rules nothing is surprising.

What's even more surprising is how clubs and organisations who are politically reflecting and known to be aware of their correctness deal with this functional form of advertising. In environments where noone would ever openly adapt rascist, fascist or anti-semitic attitudes it seems like there's no problem in using sexist imagery: there are hot naked ladies jumping out of stupid bananas, two hands in fluffy handcuffs behind a slim naked girl's bum, or cartoon male fantasies with completely unrealistic proportions show what they have got.

Even the leftist german daily newspaper TAZ was threatening in one of it's famous campaigns for subscribers with the placement of naked tits on the title in a yellow press style in case not enough subscribers would be found. Slogans like 'foreigners go home' would have been completely unthinkable in a context like this. Almost absurd seemed the antigovernmental double spread of the viennese 'Abuse Industries' in the technomagazine 'Raveline' in which porn clones with megabreasts serve men in the street willingly with oralsex to demonstrate against the black and blue government which is known for permanently having to deal with accusations of being sexist and hostile against women. Especially thougthworthy is the bad melange of exotic coloured women with stereotypes of excessive sexuality showing that sexism and racism relate to each other but are in this context tolerated as ironic exagerations.

What brings us to the next point: if one is annoyed by that kind of aesthetics and wants not to be confronted with it in the venues chosen for one's own night activities the irony shield pops up all the sudden: the imagery is fully ironic and exagerating and distorting cliches that leaves them just laughable. And above all the often used retro-softporn style is simple there to make a joke regarding the pseudo-open sexual culture of the seventies.

Irony my ass is all I can say about that as I don't see the joke. Where is the distortion of the cliche ? Copycats of pornsubjects done for male perspectives stick to the patriarchic sex role models making men voyeurs and leaders and women passive and devotional. Even if the citchy and trashy setting where the scene takes place may be ironically remixed the differences in the sexes are being cemented and the hierachies in society get affirmed. An exageration by overstyling and polishing the cliche is in no way a subversion as the same thing is being shown that is supposed to be ironicised.

As I said - may be. Because couldn't it be that the irony and the statement that these images all are so incredibly funny (who can't see that is anti-sexy) are a comfortable excuse to infiltrate consensual sexism into the leftist subculture and politically correct left ? Contrary to the right, where females have to accept their role according to the inner ideological logic, leftist men have to worry about their position of power more as they should give it up anyhow. But who likes to give up privileges. So a little image of a woman doing fellatio or luciously touching her pubic hair could be seen as decent hint for women to their (lower) seats.

Slowly, after years of women being present in nightlife as consumers and servicemaids, they really go for attacking male privileges. Because whereever female DJs, promoters, sound-engineers, grafic designers or producers appear the imagery represented will be more under the influence of females. And this should be the last laugh of the sexual irony.

DIE TITTE IN DER CLUBKULTUR

HTTP://WWW.PLASTIKMAEDCHEN.NET/STORIES/28/

Es braucht nur einen kurzen Streifzug durch trendiges Flyerland, um festzustellen, dass für viele Menschen aus der Clubhochkultur Sexismus und eine proklamiert korrekte Attitüde kein Widerspruch zu sein scheinen. (12.09.2002, 20:23)

Dass uns von Flyern für Clubs, in die wir nie gehen würden, halb- oder ganz nackte Frauen in aufreizenden oder schlicht dämlichen Posen entgegenlächeln, sind wir ja – leider – schon gewöhnt. Mit der gleichen Logik wie bei breitenwirksamer Werbung wird hier aus nackter Frauenhaut Kapital geschlagen, denn Sex verkauft sich eben, und mit einem über den Profit hinausgehenden lästigen Bewußtsein für Korrektheit quält man sich in diesen Sphären generell auch nicht lange. So ist es zwar genau wie das Hinnehmenmüssen von sexistischer Werbung nervig, marktschreierische Flyer von Veranstaltungen mit sprechenden Namen wie "Models & More", "Penthouse" (mit Playgirls zum Anfassen) und "'Fast Nackt Gschnas" ertragen zu müssen, aber wo der Mammon regiert, wundert eine nichts mehr.

Was dafür umso mehr verwundert, ist der Umgang von politisch reflektierten und durchaus um Korrektheit bemühten Clubs und Organisationen mit werbewirksamem Sexismus. In Zusammenhängen, in denen es niemand wagen würde, offen rassistische, faschistische oder antisemitische Haltungen einzunehmen, hat man offensichtlich kein Problem damit, sexistische Darstellungen von Frauen zu verwenden: da springen knackige Nackt-Damen aus idiotischen Bananen, zwei Hände werden von Plüschhandschellen vor dem dazugehörigen mageren nackten Mädchenpo zusammengeschnürt, oder vollkommen unrealistisch proportionierte Cartoon-Männerträume lassen ihre artifiziellen Reize spielen.

Sogar die deklariert linke deutsche Tageszeitung TAZ hat bei einer ihrer spektakulären Abo-Aktionen damit gedroht, falls sich nicht genug Neu-AbonnentInnen finden würden, in Bildzeitungsmanier blanke "Titten" auf das Titelblatt zu setzen – Sprüche à la "Ausländer raus" wären im gleichen Kontext undenkbar gewesen. Beinahe schon absurd war eine doppelseitige Anti-Regierungsgrafik der Wiener Abuse Industries im Technomagazin Raveline, in der Pornoklone mit Megabrüsten Männern auf der Straße willig mit Oralsex bedienen und damit gegen die blau-schwarze Regierung protestieren – eine Regierung, die ständig mit Vorwürfen des Sexismus und der Frauenfeindlichkeit konfrontiert ist. Besonders perfide ist auch die gern praktizierte Verknüpfung "exotischer" women of color mit Stereotypen primitiver, überbordender Sexualität, die wieder mal vor Augen führt, dass Sexismus und Rassismus sich gegenseitig bedingen, in dieser Form aber allzu gerne als ironische Übertreibung toleriert werden.

Womit wir auch schon beim Punkt wären, denn wenn man sich über diese Ästhetik aufregt, da man wenigstens in den selbst frequentierten Clubs von solcherlei Trash verschont werden möchte, wird das omnipotente Ironie-Schutzschild ausgefahren: diese Bilder seien doch ein rein ironischer Umgang mit Klischees, die so übersteigert und entfremdet würden, dass sie der Lächerlichkeit preisgegeben würden. Überhaupt mache man sich mit dem Retro-Softporno-Style, dem viele dieser Sexism Fiends huldigen, doch nur über die pseudoaufgeklärte Sexualkultur der 70er Jahre lustig.

Ironisierung my ass, kann ich da nur sagen, denn ich sehe den Witz einfach nicht. Wo ist die Brechung des Klischees? Wer typische Pornosujets kopiert, die traditionellerweise auf die lustvolle Betrachtung von Männern zugeschnitten sind, behält die patriarchalen Geschlechterrollen bei – der Mann als Betrachter und lenkendes Subjekt, die Frau als willfähriges, passives Objekt. Auch wenn der bewusst kitschig-trashige Rahmen, in dem solche Inszenierungen stattfinden, bei Umarbeitungen möglicherweise ironisch umgedeutet wird, wird das Gefälle zwischen den Geschlechtern zementiert und damit die gesellschaftliche Hierarchie eindeutig affirmiert. Mit einer Übertreibung des Klischees, das optisch hochstilisiert und aufpoliert wird, erreicht man nicht einen Hauch von Subversion, weil in unveränderter Form genau die Sache abgebildet wird, die – vielleicht – ironisiert werden soll.

Wie gesagt – vielleicht. Denn könnte es nicht auch sein, dass das mit der Ironie und der Behauptung, dass diese Darstellungen doch eigentlich alle irrsinnig lustig seien (und wer's anders sieht, ist sexfeindlich) einfach eine bequeme Ausrede dafür ist, einen konsensfähigen Sexismus auch in die sogenannte Subkultur oder politically correcte Linke hineinzutragen? Im Gegensatz zur Rechten, wo Frauen sich, der inneren ideologischen Logik folgend, von selbst der herrschenden Ordnung unterwerfen müssen, haben linke Männer mehr um ihre Machtposition zu fürchten, von der sie sich eigentlich freiwillig verabschieden sollten – doch wer gibt schon gerne Privilegien ab? So fungiert ein kleines Bildchen, in dem eine Frau Fellatio andeutet oder sich lüstern an die Schamhaare packt, im trendy Club vielleicht als subtiler Verweis der Frauen auf ihre (untergeordneten) Plätze.

Doch nachdem Frauen jahrelang hauptsächlich als KonsumentInnen und Dienstleisterinnen im Nachtleben präsent waren, machen sie jetzt langsam ernst mit der "Bedrohung" männlicher Privilegien. Denn wo immer mehr weibliche DJs, Veranstalterinnen, Tontechnikerinnen, Grafikerinnen und Produzentinnen auftreten, werden auch die Bild-Repräsentationen von Frauen entscheidend mitbestimmt werden. Und dann hat es sich wohl ausgelacht mit der Sexismus-Ironie... | nylon apr 01

Dies ist eine weitergeleitete Nachricht
Von : mike riemel ←border@bootlab.org→
An : lab@b.lab.net
Datum : Freitag, 25. Juli 2003, 14:42
Betreff: [lab] rueckmeldung von den herrn von der party

===8←================== Original Nachrichtentext ==================
hallo ihr PC freaks

also jetzt doch noch ein party kommentar von flyer soziotope...
nach eingehender studie des flyers (leider nicht der macher) kann ich nur
sagen der flyer ist echt drollig und nicht frauenfeindlich, sondern frauen-
verherrlichend, so wie das halt ueblich ist im hiphop, r&B, black music, disco,
classics dorf. ob das bad taste ist oder nicht...ladies, die nen sekt bekommen
und eintritte, die sich ermässigen mit flyer ? na und...ist mir manchmal am arsch
lieber wie der ganze 'underground spezi', 'friends of carlotta', szene matsch wie
er im wmf, cookies oder sonstigen 'high class total korrekt und super wichtig'
umfeldern so läuft.

ich bin mir sicher das:
a - die leute halt massiv jünger sind
b - es sich eigentlich fast um sowas wie ne typische white middleclass zehlen-
 dorfer gang handelt, die halt auch mal was machen will
c - das es nicht die party ist die wir grundsätzlich brauchen (ausser sie bringt
 geld, was ja der fall zu sein scheint)
d - cum on...a little prostitution....oh friwohl ist mir
e - der schlimmere schaden der einer absage ist. rufschaden von unglücklichen multiplikatoren.
f - die sponsoren echt regionale pussies sind die geradezu witzig rüberkommen
g - caipi und cuba libre haben korrekte preise
h - ich hoffe das ich am meer dieses wochenende auch solche babes treffe
i - global hangover auch nicht sehr viel – äh – oder weniger – alkohol verherrlichend ist
j - wir vielleicht security als thema mal behandeln sollten
k - eine absage geradezu erzreaktionär bis ultrakonservativ ist bei den argumenten
l - ich in denen ihrem alter auch gerne mal nen kraftspruch gezückt habe
m - diese gesamte diskussion um den flyer gerne auszugsweise in unser buch bringen würde
 und zwar kurz nach dem artikel 'flyer & skandale' vor 'die titte in der clubkultur'
 http://www.t0.or.at/~eismann/titte-clubkultur.html
 wer dagegen ist bitte melden
n - party ist party ist eigentlich einfach und billig und egal ob rio, ibiza, mittewahn oder
 sonstwas ne mischung aus musik, drogen und leuten in der nacht
o - wir einfach eine kulturbeauftragten brauchen der das fest entscheidet
p - wie(r) (prolls) sind auch nur leute
r - wir hier auch diskursive kulturarbeit machen - was schön ist
s - streiten im bootlab und entscheidungsfindung ein bischen unsere schwachstelle ist
t - wir vielleicht mal in richtung 'fight club' nachdenken sollten
u - u wie uuuuh
v - voll geil ey und humor ist wenn man trotzdem lacht
w - nicht alles ist http://www.camp-tipsy.de/
x,y,z - ich bin für machen lassen und dann nicht mehr

so

mike

STREET ART
AND FLYERS
MEDIA WORK
TODAY

What does graffiti have to do with flyers? What makes the different branches of modern urban propaganda comparable?

For one thing, the target groups are very similar and their statements and battle for attention often share the same space - the city. This is where those responsible want to be seen. This is where they try to get the right code and the right position for their target group. These forms of visual slang have much in common: their choice of motifs, their subjects, their background. Even the techniques of marking out a territory are similar. Since the advent of flyers disguised as stickers, it goes without saying that flyers will be present in the public domain or in the club toilets. Just like a tag, piece or throw. The stencils used by sprayers resemble the rubber stamps used by flyer makers. It's all about logos and placement, about speed, audacity and humor. The price is important too. Small clubs don't have much money to spare, and the same applies to sprayers. They can't always afford the cans of paint for a wall or a train. A cheap stencil can be cut out fast and it works with a single color. The key question remains: how do I reach people with my message?

Heroes are celebrated and some graphic designers leave their computers behind and go out to put up a few decent wallpapers "after work". The creative people know each other and express their mutual respect. When they get together, they choose places with the right flyers on the table and the right flavor outside the door. Some restaurant and club owners don't like this at all. A hip-hop crowd that DOESN'T cover the toilets in tags just isn't very "real". And that is something everyone looking to host events featuring the oh-so-popular music called hip-hop should be aware of.

The art of urban warfare, then, is a cross-media phenomenon. Pirate radios tag their frequency. Party organizers stick up their flyers, flyers appear on websites or even on TV.

Some DJs have a multiple role as street artist, photographer, promoter, events organizer and graphic designer, like Nomad from Berlin. The promotion business extends in many directions. Unusual methods on the borders of legality also contributed to the success of movies like "π" (Pi, 1997), reaching millions of people worldwide with almost no budget: during the opening weeks in New York, the producers provided street kids with stencils and Polaroid cameras and paid them for every photo giving evidence of a successfully placed tag – before long, Manhattan was full of pi signs. No question! We simply MUST see this movie!

GUERILLA MARKETING

Unconventional marketing intended to get
maximum results from minimal resources.
WWW.MARKETINGTERMS.COM/DICTIONARY/GUERILLA_MARKETING/

Flyers: Distribute them in a variety of ways,
as signs, in orders, to fusion marketing
partners to distribute as you distribute theirs.
Guerilla Marketing With Technology in,
WWW.GMARKETING.COM/TACTICS/WEEKLY_93.HTML

The guerilla entrepreneur knows
that the journey is the goal.
The Way of the Guerilla – Achieving Success
and Balance as an Entrepreneur
in the 21st Century by Jay Conrad Levinson,
WWW.GMARKETING.COM/TACTICS/WEEKLY_61.HTML

The potential for strategies for the appropriation
of public space to go far beyond what is usually per-
ceived is demonstrated by the Berlin-based street art-
ist "6", one of whose numerous homepages HTTP://STREE-
TART.INFO/ presents interesting aspects of his approach.
He quantifies the effectiveness of his work as follows:
"work fotographed 300 times/day" (a tag on the Ber-
lin Wall) or "noticed by 30,000 people/day" (massive
paintings on the former Planet club opposite the S-
Bahn train tracks). This is the kind of thing international
brands dream of – statistics that come close to mass
media coverage.

For several years, the gallery HTTP://URBAN-ART.INFO/
on Brunnenstrasse in Berlin presented and documented
these phenomena. On the website, Jürgen Grosse, one
of the organizers, has put together a good overview of

the kind of categories street art can be classified into. From a house front by Keith Haring to the most inventive objects by "6" or the fists by Cowboys Crew (aka CBS, founded in 1995), the site is also a source of inspiration for flyer designers. Besides stickers, CBS also produces extremely attractive screen-printed posters. This is not the place for a discussion on the doubtful legality of certain methods - but the damage to property is certainly far less dramatic if whitewash or chalk is tather than industrial paints.

In 2004, the Backjumps exhibition organized by the magazine of the same name showcased some of the world's most innovative active street artists in Berlin. This phenomenon is definitely an internationally networked movement at its peak. The principles of self-empowerment and occupation of empty spaces are standard subcultural practice. The heavy criminalization of "illegal flyposting" in some places to protect the interests of landlords and local billboard owners is just as predictable as the ban on flyers on Ibiza, where handing out party invitations is subject to stiff penalties.

In spite of this, the authorities often forget that these manifestations reflect positively on a city. Creativity cannot easily be channeled through concepts like "Capital of Talent". And there is certainly no shortage of reasons to be discontented in our cities today. Attempts to push forward with gentrification and to "pacify" entire districts, like Mitte in Berlin, naturally meet with resistance that also takes on visual forms. The social situation of young people is another reason for "going underground". Of over 180 squats that existed after the fall of the Berlin Wall, basically none have survived Berlin becoming the capital of Germany. The discovery of places suited to the propagation of the message says a great deal about the so-called psychogeography of a city.

A well-known website devoted to all aspects of sticker culture is STICKERNATION.NET, featuring material from Canada to Russia and from Slovenia to Brazil. Skater, biker, boarder or DJ - sticker culture is a fascinating field for flyer designers.

One of the ingenious designers who is at home in all disciplines from VJing to flyer design is the young Swiss François Chalet: WWW.FRANCOISCHALET.CH/

Out on the streets, custom designed characters and toons turn up in the weirdest places like old friends. The Pictoplasma books from Gestalten Verlag and the conference held in 2004 show the full breadth of this movement. WWW.PICTOPLASMA.COM/

Rebelart magazine also celebrates new releases and innovative works with festivals, and its website WWW.REBELART.NET is a good jump-off point in all kinds of interesting directions, with a range of articles underlining the proximity to political discourses like civil disobedience, culture jamming and hacktivism.

The book "The Art Of Rebellion" published by Publikat / Gingko also gives an excellent overview of the different variants of artistic interventions in everyday life.

Reclaim the media!
It's all a battle for Eyeballs!

STREET ART AND FLYERS MEDIA WORK TODAT

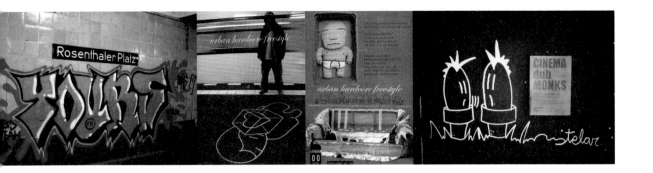

STREETART UND FLYER
MEDIENARBEIT HEUTE

Warum soll ein Graffiti ein Flyer sein? Was macht die verschiedenen Disziplinen moderner urbaner Propaganda vergleichbar?

Nun, die Zielgruppen sind sehr ähnlich und der Ort der Auseinandersetzungen und Kämpfen um Aufmerksamkeit ist oft der gleiche: Die Stadt. Hier wollen die Macher gesehen werden. Hier versuchen sie den richtigen Code für ihre Zielgruppe und den richtigen Ort zu treffen. Diese visuellen Slangs haben vieles gemein. Motivwahl, Thema und auch Anlass. Sogar die Techniken des Reviermarkierens ähneln sich. Spätestens beim Flyer, der als Aufkleber oder Spucki getarnt auftritt, wird offensichtlich, dass dieser im Stadtbild (öffentlichen Raum) oder auf der Clubtoilette zu finden sein wird. Genau wie ein Tag, ein Writing oder eine Throw. Die Schablonen der Sprayer ähneln den Stempeln der Flyermacher. Alles dreht sich um Logos und Placement, um Schnelligkeit, Dreistigkeit und Humor. Auch der Preis ist wichtig. Kleine Clubs haben kaum Geld für Werbung und auch den Sprayer geht das so. Nicht immer kann man sich die Lackdosen für eine Wall oder gar einen Train leisten. Eine billige Schablone ist schnell geschnitten und funktioniert auch einfarbig. Die zentrale Frage bleibt: Wie erreiche ich meine Leute mit meiner Message?

Heroes werden gefeiert und mancher Grafiker steht vom Rechner auf, um noch ein paar ordentliche Wallpapers 'nach der Arbeit' zu platzieren. Die Kreativen kennen sich und drücken sich gegenseitigen Respekt aus. Man trifft sich vor Ort. Dem Ort wo die richtigen Flyer ausliegen mit dem richtigen Flavor vor der Tür. Genau das schätzen manche Restaurantbesitzer und Clubma-

cher gar nicht. Eine HipHop Crowd die NICHT die Toiletten zutagt ist nun mal nicht sehr 'real'. Und damit sollte man sich vertraut machen, wenn man denkt man könnte ja mal den ach so populären HipHop mitveranstalten.

'The Art of urban warfare' ist also medienübergreifend. Piratenradios tagen ihre Frequenz. Partymacher kleben ihre Flyer, Flyer erscheinen auf Webpages oder gar im Fernsehen.

DJs haben eine Mehrfachrolle als Streetartist, Fotograf, Promoter, Veranstalter und Grafiker wie der Berliner Nomad. Das Promotionbusiness ist ein weites Feld. Ungewöhnliche Methoden am Rande der Legalität trugen auch zum Erfolg von Kinofilmen wie 'π' (Pi- der Film, 1997) bei, die beinahe komplett ohne Budget weltweit Millionen Menschen erreichten. Die Macher stellten während der Premierenphase in New York Strassenkids Schablonen zur Verfügung und Polaroidkameras. Diese wurden für jede platzierte Schablone mit Fotobeweis bezahlt und innerhalb kürzester Zeit war Manhattan voller Pi-Symbole. Alles klar! Den Film muss man sehen!

GUERILLA MARKETING

Unconventional marketing intended to get maximum results from minimal resources.
WWW.MARKETINGTERMS.COM/DICTIONARY/GUERILLA_MARKETING/

Flyers: Distribute them in a variety of ways, as signs, in orders, to fusion marketing partners to distribute as you distribute theirs. Guerilla Marketing With Technology in,
WWW.GMARKETING.COM/TACTICS/WEEKLY_93.HTML

The guerilla entrepreneur knows that the journey is the goal.
The Way of the Guerilla – Achieving Success and Balance as an Entrepreneur in the 21st Century by Jay Conrad Levinson,
WWW.GMARKETING.COM/TACTICS/WEEKLY_61.HTML

Dass Aneignungsstrategien im öffentlichen Raum auch weit über das was man wahrnimmt hinausgehen können, zeigt der Fall des Berliner Sechsenmalers, der auf einer seiner zig Homepages HTTP://STREETART.INFO/ interessante Ansätze seiner Strategie dokumentiert. Seine Werkeffektivität misst er wie folgt: "work fotographed 300 times/day" (ein tag auf der Berliner Mauer) oder "noticed by 30.000 people/day" – riesige Malereien auf dem ehemaligen 'Planet' gegenüber der S-Bahn. Davon träumen internationale Brands. Zahlen, die an die Reichweiten von Massenmeiden heranreichen.

Die Galerie HTTP://URBAN-ART.INFO/ in der Berliner Brunnenstrasse hat mehrere Jahre diese Phänomene präsentiert und dokumentiert. Auf deren Website hat Jürgen Grosse, einer der Macher, einen guten Überblick zusammengestellt nach welchen Kategorien man die Straßenkunst klassifizieren kann. Von der Hausfassade Keith Harrings bis zu den einfallsreichen Objekten des Sechsenmalers oder den Fäusten der 1995 gegründeten Cowboys Crew, auch CBS genannt, finden sich hier anregende Beispiele auch für Flyergestalter. CBS produzieren neben Aufklebern z.B. auch extrem attraktive Siebdruckplakate. Dass einige der Methoden gesetzlich nicht einwandfrei sind, soll hier nicht näher diskutiert werden. Im Zweifelsfall ist die Sachbeschädigung durch beispielsweise Kreide oder Kalkfarbe wesentlich weniger dramatisch als echter Industrielack.

Die Ausstellung 'Backjumps', der Macher des ebenso genannten Magazins hat hier 2004 einige der international innovativsten Aktiven in Berlin versammelt. Dieses Phänomen ist definitiv eine international vernetzte Bewegung in ihrer Blüte. Das Prinzip der Selbstermächtigung und der Besetzung von Leerstellen ist eine klassische subkulturelle Praxis. Dass 'Schwarz plakatieren' an einigen Orten stark kriminalisiert wird, um die Interessen von Hausbesitzern und der lokalen Plakatbranche zu schützen, ist ähnlich wenig verwunderlich wie das Flyerverbot in Ibiza, das das Verteilen von Werbezetteln unter hohe Strafe stellt.

01. - 03. 04
the rebel:art
magazine
release festival
im club der polnischen versager
redesign deutschland · kaffee
burger · baiz & zurmoebelfabrik
berlin mitte
for more information check
www.rebelart.net

rebel:art
connecting art & activism
#01

gestaltung:www.supajsy73.de

NEXT 5 MINUTES
INTERNATIONAL FESTIVAL OF TACTICAL MEDIA SEPTEMBER 11-14, 2003

I ♥ YOU

STREETART UND FLYER MEDIENARBEIT HEUTE

Trotzdem vergessen Behörden gerne, dass auch diese Äußerungen ein positiver Standortfaktor sind. Kreativität lässt sich nur schwer durch Begriffe wie 'Capital of Talent' kanalisieren. In der Tat: Es gibt auch wirklich genug Anlass zur Unzufriedenheit im Heute unserer Städte. Der Versuch die Gentrification zu pushen und ganze Stadtteile wie Berlin Mitte 'zu befrieden' stößt natürlich auf Gegenwehr, die man sehen kann. Auch die soziale Situation junger Leute ist ein Grund für 'going underground'. Von den mehr als 180 besetzten Häusern nach der Wende sind eigentlich keine mehr vorhanden seit Berlin Hauptstadt wurde. Das Entdecken von Orten, die sich für das Verteilen der Message eignen, sagt viel über die so genannte Psychogeographie einer Stadt aus.

Ein bekannter Ort im Netz zur Information rund um die Aufkleberkultur ist STICKERNATION.NET. Hier finden sich Beispiel von Canada bis Russland und von Slowenien bis Brasilien. Ob Skater, Biker, Boarder oder DJ – die Aufkleberkultur ist ein faszinierendes Feld für Flyerdesigner.

Die für die Strasse entwickelten Charakters und Toons trifft man an den ungewöhnlichsten Orten wieder wie alte Freunde. Die Pictoplasma Buchserie des Gestalten Verlags und die 2004 stattgefundene Konferenz zeigt das Spektrum dieses Movements. WWW.PICTOPLASMA.COM/

Einer der genialen Designer, die in allen Disziplinen, vom VJing bis zum Flyerdesign zu Hause sind, ist der junge Schweizer François Chalet WWW.FRANCOISCHALET.CH/

Auch das Rebelart Magazin feiert neue Releases und innvoative Arbeiten mit Festivals, deren Website ist eine gute Startrampe für Wissenswertes aller Art. HTTP://WWW.REBELART.NET/

Die Nähe zu politischen Diskursen wie 'Ziviler Ungehorsam', 'Culture Jamming' und 'Hacktivism' wird hier in diversen Artikeln aufgezeigt.

Das bei Publikat / Gingko erschienene Buch "The Art Of Rebellion" eignet sich für einen Überblick über die Varianten künstlerischer Interventionen in den Alltag ebenso hervorragend.

Reclaim the media!
It's all a battle for Eyeballs!

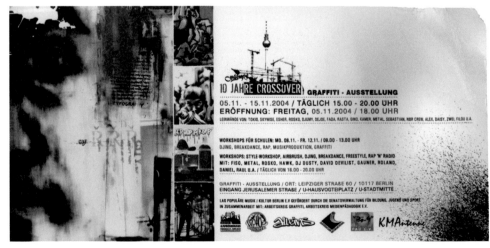

FLYERS FOR ART
FLYER FÜR DIE KUNST

The role of flyers in transporting political messages and in promoting all manner of causes and products has been sufficiently documented here. The question of whether the materials produced to announce private views at galleries and museums also count as flyers triggered heated, irresolvable disputes within the editorial team and before various exhibitions. It's a matter of opinion!

But however you see it, the following images are like flyers, they are interesting, and the events in question often include a full-on musical element. Especially in Berlin, but also in Frankfurt and elsewhere, the art scene and the club scene overlap. Club-goers and organizers alike sometimes meet in a temporary fringe space that shows art (or claims to), or at a new club before it opens for dancing. And because the flyers tend to be designed by the artists involved, they are often a treat for friends of this visual culture.

Dass Flyer politische Boten sind und natürlich Werbung für allerlei Zwecke und Produkte, ist ja hinreichend gezeigt worden. Ob diejenigen Zettel, welche Vernissagen in Galerien oder Museen bewerben, auch als solche zu bezeichnen sind, hat redaktionsintern und vor diversen Ausstellungen dogmatische Grabenkämpfe in unserem Team ausgelöst. Ansichtssache!

In jedem Fall sind die folgenden Bilder Flyer-ähnlich interessant und oft sogar in Kombination mit einem musikalischen Beitrag, der sich gewaschen hat. Gerade in Berlin, aber auch in Frankfurt überlappen sich die Szenen der Kunstmacher mit denen der Clubber. Auf Gast- wie auf Aktivistenseite trifft man sich mal in einem temporären Offspace, der Kunst zeigt (oder vorgibt zu zeigen), oder eben im neuen, noch unbetanzten Club. Da Kunstflyer oft von den Künstlern gestaltet werden, sind sie ein Leckerbissen für Freunde dieser visuellen Kultur. Also zeigen wir im Folgenden ein paar Beispiele.

soutien: Ville de Lausanne, Lausanne
OFFICE FEDERAL DE LA CULTURE,
Loterie Romande,
UBS,
La Mobilière Suisse,
Accu Holding AG.

CIRCUIT
freistilmuseum
blair thurman
exposition du 26 mai au 30 juin 2001
vernissage le 25 mai 2001 dès 18h00
14, passage Montriond, CH-1006 Lausanne
+41(0)21/601 18 49
horaire: jeudi, vendredi, samedi
de 14h00 à 18h00 ou sur rendez-vous

FOUR HOUR LOOP. SOUN
D BY KLINKUSCH. VIDE
O BY ANDREAS SCHIMAN
SKI. BERLINBIENNALEL
OUNGE AT POSTFUHRAMT
19.DEC.1998 20-24.00

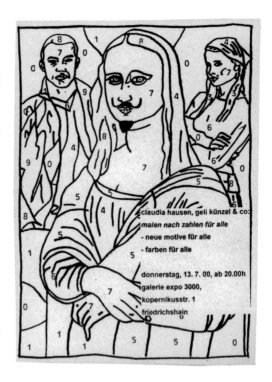

claudia hausen, geli künzel & co:

malen nach zahlen für alle
- neue motive für alle
- farben für alle

donnerstag, 13. 7. 00, ab 20.00h
galerie expo 3000,
kopernikusstr. 1
friedrichshain

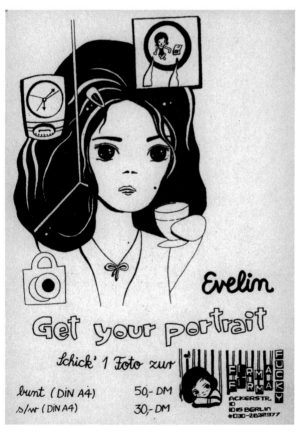

Evelin

Get your portrait

Schick' 1 Foto zur

bunt (DIN A4) 50,- DM
s/w (DIN A4) 30,- DM

FIRMA FIRMA FUCKY
ACKERSTR.
10
1015 BERLIN
#030-2832977

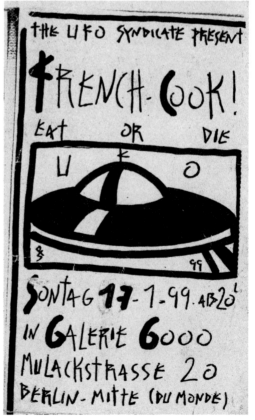

THE UFO SYNDICATE PRESENT

FRENCH-COOK!

EAT OR DIE

U K O

SONTAG 17-1-99. AB 20
IN GALERIE 6000
MULACKSTRASSE 20
BERLIN-MITTE (DU MONDE)

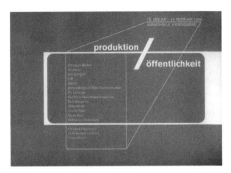

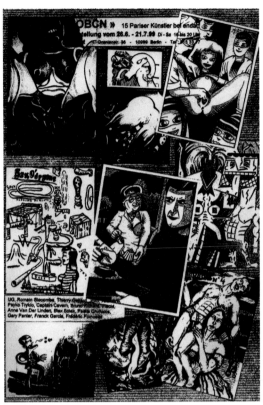

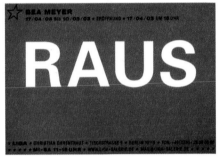

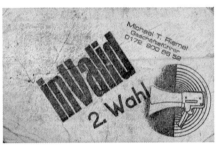

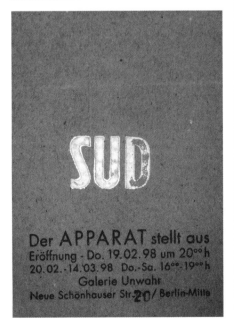

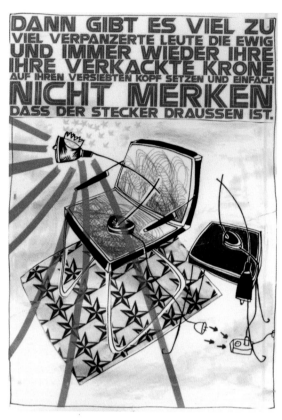

01 and travellab present a libidinous
evening: ---> uRBAN sEX aTTAC Theo
Altenberg and Djuna Lou Finidee Marie
Luise Angerer Lucio Auri Chris Chroma
Anja Czioska Hartnut Fischer with Andreas
L. Hofbauer Regina Florida Undine
Goldberg Noritoshi Hirakawa Ewa Juenemann
Elke Krystufek Ewa Latoszek Gabriele
Leidloff Rémy Markowitsch Seán Dorrick
Cooper Marquardt Shelley Masters
Gottfried Meyer-Thoss Rudi Molacek
Juergen Moritz Karen Oldenburg Cameron
Rudd Brigitte Schaller Ira Schneider
Joulia Strauss & Moritz Mattern Dita
Bella Vart Kerstin Weiberg curated and
hosted by Manuel Bonik and Mir Mikina
http://travellab.net/u s a zero.html

aüsstellung+release 09.08.02 20uhr cc:room gipsstraße 11 berlin-mitte www.masz1.de

maß.1
zeitschrift für inhalt und form

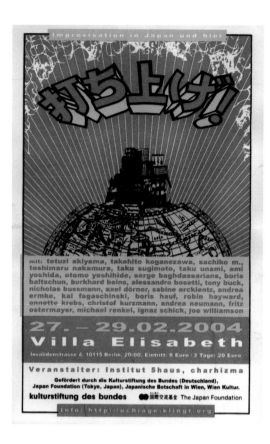

LESUNG:ClaudiusHage
meister,NickGrindell,C
hristianIsheim.Hendri
kJackson KONZERT:Ultr
aMegaMegaParkingPr
oblem VIDEO:TimCoe,M
arkusBrenner DJ:Rolle
Rolle BAR:Herb&Stark

isd photo: terry richardson für INDEX magazin

KW

ROYAL ACADEMY OF ARTS
PICCADILLY W1

APOCALYPSE
BEAUTY AND HORROR IN CONTEMPORARY ART

23 SEPTEMBER–15 DECEMBER 2000
DAILY 10am–6pm FRIDAYS UNTIL 10pm
www.royalacademy.org.uk

www.electrica.de

CLUB ART: TULIP ENTERPRISES

Hans Booy and Paulus Fugers from "Tulip Enterprises" speak with Betty Stürmer of "Everybody Magazine"
on Radio Twen FM in the summer of 2000.

Betty: Hello. Today "Everybody Magazine" is speaking with the club specialists from Tulip Enterprises. How did Tulip begin?

Hans: We fell into it because people were asking us to do things for parties. We tried it out and it became more graphic and more clear. It was definitely a switch from normal pictures to club art because the requirements were so different. I think that the Interference Festival was the first.

Betty: Interference was organized by Dimitri Hegemann, right?

Hans: No, by Uwe Reinecke. I think that Motte supported him. Space Teddy was also involved.

Paulus: In the old "Planet" on Köpenicker Straße. That was a lot of fun for us and for the promoters as well, it seemed. Then it just continued from that point.

Betty: When was the Interference Festival, and how long have you been working in Berlin?

Hans: We've been in Berlin since 1986, and I believe Interference took place in 1995, and then for many years after. But we had already designed the projections for the walls of the first house club in Berlin, the Beehive, and other things like that. Then it was always a separate thing, to do the design and to do the art production along side it. 1989 was, I believe, the very first time.

Betty: It just came to my mind that Chromapark existed at that time as well. You were involved in that too, weren't you?

Paulus: Yes, once. It was in Kunsthof on Oranienburger Straße, but it was more in conjunction with Interference, which was going on at the same time.

Betty: How did you come up with the name Tulip Enterprises?

Paulus: To begin with, the Tulip is colorful and odorless. Its also a joke referring to its cultural background, Holland and such.

Hans: In addition, because we deal exclusively with stencilling, the tulip is the flower that shows up the most in Arabic stencils. Another connection to clubs is that earlier, tulips were not cultivated as flowers, instead they were used as drugs. They were preserved, and just like with orchids, people thought they were an aphrodisiac. So it came about that they were grown first as drugs and only later were they valued as flowers.

Betty: You are officially listed in the internet as "Representatives of Club Art". You have made numerous visuals. What are visuals and what does this term mean to you?

Paulus: Mainly we make pictures. They are very visually stimulating and have a specific symmetry. But because they are shown in clubs doesn't mean that they can't be shown in other locations as well. We play with visual elements and in that respect they are visuals. Aside from that the term doesn't say much to me, its not like I sit down and make visuals. I paint pictures.

Betty: Because people write "visuals" on flyers and not "exhibition".

Paulus: To me it makes sense. To call it an "exhibition" would be too dry and nobody would come. When its presented as decoration or visuals, the expectation is a lot different.

Hans: I understand visuals to be anyways not as tangible as slides or videos. The difference is that we paint real pictures. Its supposed to be a very tangible thing. We also have different techniques, but the most important thing is that the large collection of pictures that we have made for clubs were made specifically for a large type of space. Just like other art is made to be shown in galleries or offices or homes, this installation aspect is actually present in all types of art. For us, it's about the club, which is why our images are much brighter and have technological qualities that allow us to combine them with the music.

Betty: So you make some things specifically for clubs?

Hans: Yes. It wouldn't work very well at home. It would be too colorful and too loud.

Paulus: When it comes to the technology, it's pretty much aimed at being effective in dark spaces. And for that one needs light-technique. When these things work together then the effect is amazing.

Betty: What is so fascinating about dark rooms?

Hans: That they are not as Calvinistic as these "white cubes" (sic) in galleries. It's funkier and more underground to do something in some dark dive, and has this aspect of improvisation, like we know from the last few years in Berlin-Mitte, that you have some old rooms that you have to transform into something, that themselves are already exciting, and that you also work with the rooms. That's something completely different than working within a clean gallery situation.

Paulus: You have a "Complete Surrounding". It is music, sounds, it's an environment that is new to many people. It's part of a whole concept, and that's what i find exciting about it.

Betty: That is exactly what is typical of club art. I agree completely. Visuals are only a part of it, then you have the people and the music. In that situation the label "Gesamtkunstwerk" is the only available description. Speaking of music, which Dj's have you worked with, and which musical styles?

phonossage

Paulus: Often with Prodomo and recently with Motte, e.d. 2000 and Ultratracks. It's more housy. Techno and house mainly.

Betty: Do you find that your images get into the groove?

Hans: They go well together. What's important is that in a club you reach people that were not expecting to see art. There is something educational about it. We are often the first artists these (kids) 18 year olds see, and perhaps they see the first art that they actually like when they go to a club. That is an advantage, when you grab the Kundenshaft young, you can only profit from it, "My First Painting".

Paulus: When it really works with the music, which is also a question of proper lighting choreography, you can get things out of the pictures that otherwise would not have been acknowledged. Whether the pictures go with the music or not can be controlled.

Betty: Is club art an avant gard new form of art, that brings music and pictures together in any way we have already seen before?

Paulus: I don't believe it is avantgarde because as you said, placing music and pictures together has been done often. It's nothing new, and in that respect I don't want to do anything new with it. I don't have that inclination.

Hans: The new aspect is that it occurs completely apart from Autorengedanken. It's pretty much a part of our times, that one says a work of art can so sub-consciously operate, and one must not give it any particular importance, or take it on board, or filter-out the sub-conscious thoughts of the artist. That's pretty new. But technique-wise, a lot of things are being recycled from the 60's and 70's, like the psychadelic-look or Interferenzen or all of the slide-shows. There are definitely influences or revival elements involved.

Betty: Out of Art, Beyond Art - the observer aspect doesn't exist in relation to club art because club art cannot be found in galleries, due to the fact that it did not develop in galleries and there is no art market for it. Do you think it will remain this way, or is there the possibility for change?

Paulus: The divide between Club, Museum, and Gallery is not that clear. We have already made many exhibits in galleries. The room is appropriately reconstructed and made dark, and then light fixtures etc. are installed. It works. People do go to clubs and galleries or museums.

Hans: The club scene is exotic to the art world, and when you recreate club art in a gallery or museum, people find it compelling. To sell it as an art product is a bit more difficult. Okay, we also make pictures, but other people just make projections and they can only hire themselves out to provide a service. We also make most of our money by renting out pictures, by renting out installations that we create. You can make more money in a club than in a gallery. Every time we've done an exhibit in a gallery we end up totally broke. Its this exploitation principle, when the gallerist says, "many thanks, sorry we didn't sell anything", you see where you stand. That's a good reason not to work with galleries.

Betty: Club art has developed a kind of art that doesn't really need galleries. But to really show this art, maybe more mixed spaces, like club-galleries, should be established.

Hans: We don't need that. We purposefully went into clubs because we wanted to reach a larger, unaccedemic crowd. To go back, by means of a detour, and arrive in a gallery, is not the goal. We don't need an audience that knows about art. That's what's good about what we do, that it speaks directly to you and not through some deep, meaningful thoughts.

Paulus: A club-goer looks at things much unbedarfter. They don't try to fit it somewhere in art history, they look at it and decide if they like it or not. Entsprechend sind die Reaktionen. I like this lack of filtering.

Betty: What kind of people are interested in or love club art if the art is not to be experienced intellectually? The intellectual background can be found because a club-artist basically works as any other artist does. Wahrscheinlich ist es eher die Kuntkritik, die Schwierigkeiten hat darüber zu berichten, sich damit auseinaderzusetzen, weil sie eben sagen, es ist nur visuell.

Paulus: Its not my problem if art critics have a problem with what we do. But as I said, the direct reaction from people in clubs is what keeps me going.

Hans: You don't really need these art people and their critics. You have your audience that you get along with. Club-artists are like a new type of artist that their audience really loves and enjoys. With artists who work in galleries, you don't get that impression. You often have the feeling that they are frustrated, cynical people that often try to shock the public and don't connect with the people they should be dealing with.

Betty: That is the difference between an art opening and a party. A party includes everyone, the people who come because of the music and want to dance, or just listen to it, and also the people who want to socialize or drink. That is different to an art opening where people are just there to look at the art.

Hans: A gallery setting can also be frivolous. You shouldn't think that there art should be viewed as being much more intellectual or serious. They are also parties where people get drunk, its not so different from a club setting. There the art is also just decoration for the opening party.

Betty: In that respect, club art could be considered by art critics. It would make sense. Why should the work of club-artists not be spoken about and their visuals not featured in art publications?

Paulus: I think that the difference is that visuals have a certain stylish quality. For a short time they are hip and everybody wants to see them, and a year later they are totally out and you have to start with a whole new collection. In galleries, things are a bit more constant, the clock ticks slower.

Betty: I'm not so sure about that. The half-life in galleries is also relatively short. Maybe not one year, but perhaps three.

Hans: But it is always the case that when enough people are interested in a specific art movement, it doesn't die out as fast. That definitely has its positive side und ist dann vielleicht auch schon ins museum gelangt.

Paulus: Traditional painting is the slowest medium that there is. You paint a picture and it hangs in a room and it doesn't change with time. Club art has to change constantly.

Betty: I believe that there is much to little spoken about club art by art critics, and that when things aren't spoken about and put in print, they are quickly and easily forgotten.

Hans: But on the other side, club art is also a movement that wanted to be free of this gallery business. Why would these people want this kind of structure when they have already developed their own system within clubs? Then the only thing you considered important would be that these works would be rated better or stay longer.

Paulus: You can also turn it around and say that because it is not really talked about and not really documented, that it makes the moment that much more important. Either you were there or you weren't, and when you missed it, tough luck, you had to hear about it from someone who was. It creates suspense.

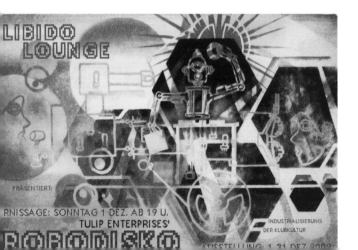

CLUBART: TULIP ENTERPRISES

Hans Booy und Paulus Fugers von Tulip enterprises im Gespräch mit Betty Stürmer bei 'everybody magazin' auf Radio Twen fm im Sommer 2000

Betty: Hallo, Everybody Magazin heute im Gespräch mit den Clubspezialisten von Tulip Enterprises. Wie ist Tulip entstanden?

Hans: Wir sind da reingerutscht, weil die Leute uns gefragt haben, für Partys was zu machen. Wir haben das dann versucht und das sollte dann immer graphischer und immer klarer werden. Es war schon eine Umstellung von normalen Bildern zu Clubart, weil die Anforderungen ganz anders waren. Ich glaube, das Interference-Festival war das erste.

Betty: Interference von Dimitri Hegemann organisiert, oder?

Hans: Nein, von Uwe Reinecke. Ich glaube auch, dass Motte ihn dabei unterstützt hat, es war auch ein Space Teddy Involvement dabei.

Paulus: Im alten Planet in der Köpenicker Straße. Das hat uns ganz viel Spaß gemacht und anscheinend den Veranstaltern auch. Dann kamen wir von dem einen zum Nächsten.

Betty: Wann war das Interference-Festival und seit wann arbeitet ihr insgesamt in Berlin?

Hans: In Berlin sind wir etwa seit 1986 und Interference war 1995, glaube ich, und dann über mehrere Jahre hinweg. Aber wir haben schon in Berlins erstem Houseclub, dem Beehive die Wände gestaltet und solche Sachen gemacht. Das war dann aber immer eine getrennte Sache, die Gestaltung machen und die Kunstproduktion, dann nebenbei. 1989 war das, glaube ich, das allererste Mal.

Betty: Da fällt mir auch noch ein, es gab auch noch Chromapark, da ward ihr auch dabei, oder?

Paulus: Ja, einmal, das war im Kunsthof in der Oranienburger Straße, aber mehr in Zusammenarbeit mit Interference, das zur gleichen Zeit stattfand.

Betty: Wie seit ihr zu eurem Namen Tulip Enterprises gekommen?

Paulus: Na, zunächst, die Tulpe ist ja bunt und geruchlos.

Betty: Tulip heißt Tulpe?

Paulus: Genau. Und das ist auch so ein Witz auf den kulturellen Hintergrund hinzuweisen, holländisch und so.

Hans: Mir fällt dazu ein, da wir ja ausschließlich Schablonenmalerei machen, dass die Tulpe die Blume ist, die in der arabischen Schablonenmalerei am meisten vorkommt. Und noch ein Bezug zum Club ist, dass Tulpen früher nicht als Blume gezüchtet wurden, sondern als Droge. Die wurden eingemacht und genau wie bei den Orchideen haben die Leute geglaubt, es ist ein Aphrodisiakum und so sind sie erst als Droge gezüchtet worden und später als Blume bewertet worden.

Betty: Ihr seit auch im Internet ganz offiziell als Vertreter der Clubart zu finden. Ihr habt zahlreiche Visuals gemacht. Was sind für euch Visuals, was bedeutet dieser Begriff für euch?

Paulus: Wir machen hauptsächlich Bilder. Die sind ganz graphisch und haben eine gewisse Symmetrie. Aber, dass die jetzt in Clubs gezeigt werden, das ist ein Ort, wo sie sich richtig einsetzen lassen, aber sie lassen sich auch an anderen Orten zeigen. Wir spielen mit visuellen Elementen und in dem Sinne sind es dann Visuals. Ansonsten sagt mir der Begriff nicht viel, es ist nicht so, dass ich mich jetzt hinsetze und Visuals mache. Ich male Bilder.

Betty: Weil man schreibt ja immer auf den Flyern Visuals und nicht Ausstellung.

Paulus: Ja, das ist mir eigentlich ganz recht, denn es Ausstellung zu nennen, das wäre zu trocken, da würde keiner hinkommen. Und wenn das als Deko oder als Visuals präsentiert wird, dann ist die Erwartungshaltung ganz anders.

Hans: Unter Visuals verstehe ich eher etwas Ungreifbares, wie Dias oder Video. Der Unterschied ist, dass wir richtige Bilder malen. Es soll eine sehr greifbare Sache sein. Wir haben zwar auch andere Techniken, aber das Wichtigste ist, die große Kollektion von Bildern, die wir für Clubs produzieren, die sind schon für diese Räume gemacht. So wie andere Kunst für die Galerie gemacht ist oder für Büros und Wohnräume und dieser Einrichtungsaspekt ist doch eigentlich bei aller bildender Kunst vorhanden. Bei uns für den Clubraum und deshalb sind die Bilder sehr viel greller und haben diese Lichttechnik, die sich mit Musik kombinieren lässt.

Betty: Ihr arbeitet hauptsächlich für den Club?

Hans: Ja, genau. Das würde zuhause wohl nicht so gut funktionieren oder würde etwas zu bunt und zu laut sein.

Paulus: Was die Technik betrifft, ist es ausgerichtet auf dunkle Räume und in dunklen Räumen soll es zur Geltung kommen. Und dazu braucht man Lichttechnik, wenn das zusammenarbeitet, dann hat man schon was zu sehen.

Betty: Was ist das Faszinierende an dunklen Räumen?

Hans: Dass sie nicht so calvinistisch sind, wie diese White Cubes in der Galerie. Es ist mehr funky und mehr undergroundig in irgendwelchen dunklen Spelunken was zu machen und hat auch diesen Aspekt des Improvisierten, wie man das aus den letzten Jahren in Berlin-Mitte kennt, dass man irgendwelche alten Räume hat, die man verwandeln muß, die an sich schon sehr spannend sind, und dass man auch mit dem Raum arbeitet. Das ist etwas ganz anderes, als wenn man eine cleane Galeriesituation hat.

Paulus: Man hat ein ganzes Umfeld. Es ist Musik, es sind Geräusche, es ist eine Umgebung, die für viele neu ist, es ist Teil von einem Gesamtkonzept eigentlich und das finde ich das Spannende daran.

Betty: Findet ihr, dass eure Bildsprache mit in den Groove einsteigt?

Hans: Das lässt sich gut kombinieren. Das Wichtige ist auch, dass man im Club Leute erreicht, die eigentlich dort gar keine Kunst erwarten. Da gibt es etwas Pädagogisches dabei. Wir sind oft die ersten Künstler, die sie jemals erleben, mit ihren 18 Jahren, wenn sie in den Club gehen, ist es vielleicht das erste Bild, das sie gut finden. Das ist ein Vorteil, wenn man sich die Kundschaft jung schnappt, dann kann man nur davon profitieren, "My first painting"

Paulus: Wenn es mit der Musik richtig stimmt, was auch eine Frage einer ordentlichen Lichtregie ist, kann man bei den Bildern noch Sachen rausholen, die sonst nicht zur Geltung kommen. Das läßt sich quasi steuern, ob die Bilder zur Musik passen oder nicht.

Betty: Ist Clubkunst eine avantgardistische neue Kunst, die Musik und Bild wieder zusammenbringt, was es ja früher auch schon einmal gab?

Paulus: Ich glaube nicht, dass es avantgardistisch ist, weil, wie du schon sagst, Musik und Bild zusammen zu führen, das gab es schon ganz oft. An sich ist das nichts Neues und ich will auch nichts Neues in dem Sinne machen. Das Anliegen habe ich gar nicht.

Hans: Das Neue ist schon, dass es völlig ohne Autorengedanken auskommt. Das ist schon von dieser Zeit, dass man sagt, ein Kunstwerk kann einfach so nebenbei wirken, man muß das jetzt nicht ganz aufmerksam betrachten oder in sich aufnehmen und die hintersinnigen Gedanken des Künstlers da irgendwie herausfiltern. Das ist schon neu. Aber technisch sind einfach ganz viele Sachen aus den 60er und 70er Jahren vorhanden, die wiederverwendet werden, wie dieser Psychedelic-Look oder Interferenzen oder die ganzen Diaproduktionen, da gibt es schon Einflüsse oder Revival-Elemente.

Betty: Out of Art, beyond Art - der museale Aspekt ist in der Clubart eigentlich gar nicht vorhanden, weil Clubart nicht in einer Galerie stattfindet, bzw. sich dort nicht entwickelt hat und auch auf dem Kunstmarkt nicht präsent ist. Glaubt ihr, dass das immer so sein wird oder dass sich da was ändern kann?

Paulus: So streng ist die Trennung nicht zwischen Club, Museum und Galerie. Wir haben schon verschiedene Ausstellungen gemacht in Galerien. Es wurde dann zwar entsprechend umgebaut und verdunkelt, Lichtanlage rein und so Sachen. Das geht doch. Menschen gehen doch auch in Clubs und Galerien oder Museen.

Hans: Für den Kunstbetrieb ist die ganze Clubszene durchaus exotisch, wenn man das dann in Galerien oder Museen "nachbaut", interessiert es die Leute sehr. Es funktioniert schon. Es als Kunst/Handelsprodukt zu verkaufen, ist aber schwieriger. Gut, wir machen auch noch Bilder, aber andere Leute machen nur Projektionen und können sich dann nur als Dienstleister verdingen. Und auch wir leben eigentlich davon, dass wir die Bilder vermieten, dass wir Installationen vermieten und aufbauen. Da wäre eigentlich auch der Club der bessere Raum dafür, sein Geld zu verdienen als die Galerie. Jedesmal wenn wir eine Galerieausstellung machen, sind wir hinterher vollkommen pleite. Da geht es wieder nach dem Ausbeutungsprinzip, wenn der Galerist hinterher sagt: "Schönen dank, leider nichts verkauft." Dann kann man sehen, wo man bleibt. Das ist eigentlich ein Grund, nicht mit einer Galerie zu arbeiten.

Betty: Mit Clubart hat sich eine Kunstrichtung entwickelt, die die Galerie nicht unbedingt braucht. Aber um diese Kunst wirklich sehen zu können, müßten sich wahrscheinlich mehr Orte, wie Club-Galerien als Mischorte etablieren.

Hans: Wir brauchen das wirklich nicht. Wir sind bewußt in die Clubs gegangen, weil wir endlich mal ein viel größeres unakademisches Publikum erreichen wollten. Da jetzt wieder unbedingt, über einen Umweg, zurück in die Galerie zu gelangen, ist nicht das Ziel. Wir brauchen kein kunstinformiertes Publikum, das ist ja gerade das gute an unseren Sachen, dass sie direkt ansprechend sind und nicht irgendwelche tiefsinnigen Gedanken vermitteln sollen.

Paulus: Ein Clubgänger guckt sich soviel unbedarfter die Sachen an. Die versuchen nicht, es irgendwie kunsthistorisch wo reinzupacken, die sagen einfach oder gucken, ob es gefällt oder nicht. Entsprechend sind die Reaktionen. Dieses Ungefilterte, das mag ich schon sehr.

Betty: Welche Menschen lieben oder interessieren sich für Clubart? Zumal sie ja nicht so intellektuell erlebt wird und auch gar nicht so gedacht ist. Den intellektuellen Background kann man finden, weil ein Clubartkünstler im Grunde auch nicht anders als ein anderer Künstler arbeitet, aber wahrscheinlich ist es eher die Kunstkritik, die Schwierigkeiten hat, darüber zu berichten, sich damit auseinanderzusetzen, weil sie eben sagen, es ist nur visuell.

Paulus: Wenn Kunstkritiker Probleme haben, mit den Sachen die wir machen, dann ist das Gott sei Dank nicht mein Problem. Aber wie gesagt, diese direkte Reaktion von den Menschen in den Clubs, dass ist das, was mich am Laufen hält.

Hans: Man braucht diese Leute und ihre Kritik eigentlich gar nicht. Man hat sein Publikum, mit dem man gut auskommt. Über das Verhältnis von Künstler und Publikum fällt mir noch ein, dass Clubkünstler so eine Art neuer Künstlertypus sind, die ihr Publikum richtig mögen und lieben. Bei den normalen Künstlern der Galerien hat man nicht so diesen Eindruck. Da hat man öfter das Gefühl, das sind frustrierte, zynische Leute, die oft versuchen, ihr Publikum

nur zu schockieren, und gar nicht klarkommen, mit dieser Kundschaft, die sie da eigentlich bedienen sollen.

Betty: Das ist ja der Unterschied zu einer Vernissage und einer Party. Auf einer Party wirken alle aktiv mit, die Leute die kommen, weil sie auf die Musik einsteigen und dazu tanzen oder sich davon beeinflussen lassen, aber auch die, die ständig reden oder etwas trinken. Anders als auf einer Vernissage, wo man nur das Kunstwerk betrachtet.

Hans: Dazu fällt mir ein, dass eine Galeriesituation auch sehr frivol sein kann, dass man auch nicht denken soll, da wird jetzt Kunst soviel intellektueller oder ernsthafter aufgenommen, da mache ich mir keine Illusionen, das sind eigentlich auch nur Partys, wo die Leute sich zusaufen, das nimmt sich nicht soviel von einer Clubsituation. Da ist die Kunst auch nur Deko für die Eröffnungsparty.

Betty: Deshalb kann Clubart dann doch auch eine Kunstkritik vertragen. Es wäre schon sinnvoll. Warum sollten die Arbeiten von Clubkünstlern nicht besprochen werden und ihre Visuals auch im Kunstmagazin zu sehen sein?

Paulus: Ich denke der Unterschied ist, dass Visuals natürlich so etwas modisches haben. Für kurze Zeit sind sie hip und alle wollen das sehen, ein Jahr später sind sie völlig out und man muß quasi mit einer neuen Kollektion antanzen. In Galerien, das hat etwas Beständigeres, da geht die Uhr etwas langsamer.

Betty: Darüber bin ich mir nicht so sicher, die Halbwertszeit ist da auch relativ gering. Vielleicht nicht ein Jahr, aber dann vielleicht drei.

Hans: Aber es ist immer so, wenn genug Leute da sind, die in eine bestimmte Kunstrichtung investiert haben, dann werden die das nicht so schnell fallen lassen. Das hat dann schon seinen Wert und ist dann vielleicht auch schon ins Museum gelangt.

Paulus: Herkömmliche Malerei ist doch eigentlich das langsamste Medium, das es gibt. Das Bild hast du gemalt und das steht dann im Raum und in der Zeit, das ändert sich nicht. Bei Clubdekos muß sich ständig etwas ändern.

Betty: Weil meiner Meinung nach Clubart viel zu wenig in der Kunstkritik besprochen wird, vergißt man sie schnell, weil Sachen, die nicht abgedruckt und besprochen werden, gehen schnell wieder verloren.

Hans: Aber andererseits ist Clubart ja auch ein Movement, das sich frei machen wollte, von diesem Galeriebetrieb. Wieso wollen diese Leute diese Struktur noch, wenn sie schon ihre eigene innerhalb der Clubs entwickelt haben? Da wäre das einzige was du sagst wichtig, dass die Arbeiten etwas besser bewertet werden könnten oder etwas länger daran festgehalten wird.

Paulus: Man kann den Spieß ja auch umdrehen und sagen, gerade weil das wenig besprochen und wenig dokumentiert wird, ist der Moment umso wichtiger. Das heißt man war dabei oder nicht, und wenn du es verpasst hast, dann hast du Pech gehabt, dann kriegst du es aus zweiter Hand und das macht auch eine Spannung aus.

Hans: Es ist mehr ein Dienstleistungsbetrieb und deshalb wird es sich im Galeriebetrieb schwierig vermarkten oder darstellen lassen. Der Künstler mag eine breite Pallette haben, aber man wird sich nur die Sachen grabschen, die man dann auch gut verkaufen kann, als handelbares, greifbares Produkt. In der Clubszene ist das mehr ein Dienstleistungsding, das hat Performanceelemente, das hat Installationselemente, das ist viel schwieriger als ein Produkt zu verkaufen oder unter Sammler zu bringen.

Betty: Clubart spricht ganz andere Leute an, eine andere Schicht als dies Galerien tun, vielleicht auch Leute, die sonst nichts mit Kunst zu tun haben und auch keine Galerien besuchen, aber eben im Club mit kreativen Arbeiten konfrontiert werden. Die Stimmung ist eher familiär, ich habe den Eindruck, es gibt so eine Clubartfamilie. Ihr seid auch manchmal ein Salon und habt in euren Räumlichkeiten auch so ein Clubambiente geschaffen.

Paulus: Die Idee war dabei, sich einmal in einem ruhigen relaxten Umfeld mit Menschen zusammenzusetzen und zu sitzen und zu essen. Ein bißchen networkmäßig, weil Begegnungen in Clubs, die sind so ziemlich oberflächlich, nicht bindend. Da spricht man über Gott und die Welt, aber am Ende des Tages war da doch nicht viel. Und diese Salons sollten das ausgleichen, dass man dort Projekte und Pläne bespricht und auch zu Ergebnissen kommt.

Hans: Was wir jetzt auch öfter machen ist, wenn wir bei Projekten mitmachen, dass wir dann diese Lounge aufbauen, dass wir nicht nur Bilder aufhängen, sondern auch Lampen und Möbel bauen, dass wir versuchen, daraus eine ganze Installation zu machen, die man dann vielleicht auch mieten könnte.

Betty: Wer sich für Euch interessiert kann im Internet nachschauen unter WWW.TULIP-ENTERPRISES.DE. Zurück zu eurer Arbeit, was sind eure enterprising plans for the future?

Hans: Wir sind eingeladen nach Hongkong, mit anderen Clubkünstlern zusammen.

Paulus: Wir werden da unsere eigene Clublounge machen. Wir sind eine Gruppe von 8 und wir kriegen jeweils unsere Räume gebaut. Angeblich in einem stillgelegten Flughafen im Stadtzentrum und ich stelle mir da was achteckiges vor. So ein Tulip Pleasure Dome wird das wohl werden.

AMATEUR RADIO AND FLYERS

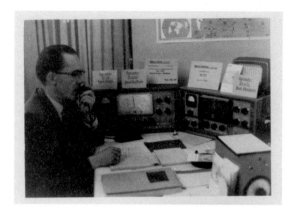
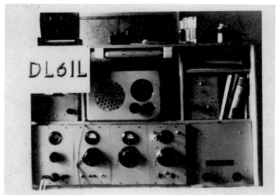

Does every community tend to develop its own flyer culture? I still have a clear image in my mind of my grandfather sitting in front of a drawer sifting through a collection of hundreds of "flyers" in postcard format. He was filing "QSL cards" - my grandparents were radio amateurs, the cards are proof of their worldwide contacts.

The QSL card tradition began with the birth of radio as a medium. In the early twentieth century, Morse code was still used. For shaky QSL contacts, radio amateurs preferred to follow up by exchanging written confirmation. Today this has become a collector's passion that fills webpages and the walls of hobby rooms. One side of a QSL card lists the details of the connection. Radio hams then submit the cards when applying for certificates like "Work All Continents". Just as event organizers add their names or logos to flyers as a signature, radio amateurs print their call signs on the image side of the QSL card. Moreover, both groups like to include references to their location when illustrating their "cards", although the party organizers may not always comply with the requirements of "decency and good manners" expected by the German Amateur Radio Club.

Radio hams may even have been pioneers in the field of sponsoring. In the 1960s and '70s, businesses were already funding the printing of QSL cards for their staff, as long as they featured the company logo. Unbelievable as it may seem today, clever radio enthusiasts even acquired state subsidies for their flyers: my grandmother rather sheepishly told me how colleagues persuaded the local tourist office to fund the printing of QSL cards bearing a picture of their home town. There are also certain similarities in the way flyers and QSL cards are distributed. Club flyers promote a loca-

tion and an event which the finder may or may not attend. Radio enthusiasts, on the other hand, attend 'club evenings' (!) where their organizations present them with the QSL cards for successful contacts. But don't party people also have to make regular visits to clubs to pick up new information for future nights out on the town?

Oliver ilan Schulz/olian: freelance journalist, events organizer and translator in Berlin. olian@web.de

Thanks to DF5RM, DL6IL and DH9JS

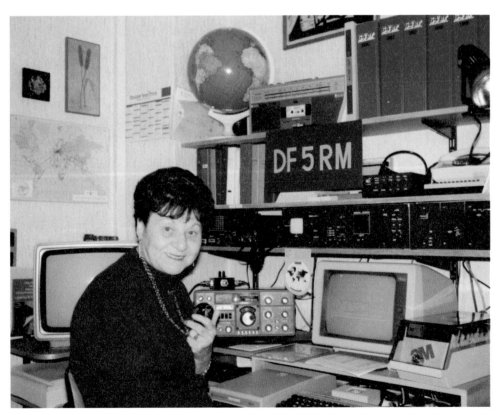

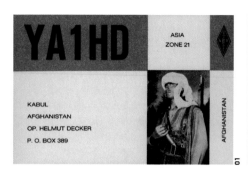

YA1HD

ASIA
ZONE 21

KABUL
AFGHANISTAN
OP. HELMUT DECKER
P. O. BOX 389

AFGHANISTAN

01

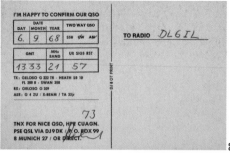

I'M HAPPY TO CONFIRM OUR QSO

DAY	DATE MONTH	YEAR	TWO WAY QSO
6.	9.	68	SSB ǴW AM

GMT	MHz BAND	UR SIGS RST
1333	21	57

TX: GELOSO G 222 TR - HEATH SB 10
FL 250 B - SWAN 350
RX: GELOSO G 209
AZE: G 4 ZU / X-BEAM / TA 33jr

73

TNX FOR NICE QSO, HPE CUAGN.
PSE QSL VIA DJ 9 DK / P. O. BOX 99
8 MUNICH 27 / OR DIRECT.

TO RADIO DL6IL

02

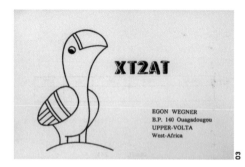

XT2AT

EGON WEGNER
B.P. 140 Ouagadougou
UPPER-VOLTA
West-Africa

03

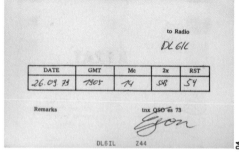

to Radio
DL6IL

DATE	GMT	Mc	2x	RST
26.09.73	1305	14	SSB	54

Remarks tnx QSO es 73

Egon

DL6IL Z44

04

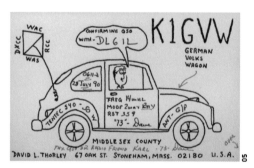

WAC
DXCC
WAS
RCC

CONFIRMING QSO
wml-DL6IL

K1GVW

GERMAN
VOLKS
WAGON

0611-z
28 July 90

FREQ 14MHz
MODE 2way RTTY
RST 359
"73"- Dave

ANT-G5P

MIDDLESEX COUNTY
Tnx QSO DR Radio Friend Karl - 73- Dave

DAVID L. THORLEY 67 OAK ST. STONEHAM, MASS. 02180 U.S.A.

05

DL6IL

CE TO MEET YOU THANKS FOR YOUR CALL!
MY NAME IS KARL KARL KARL, QTH IS PASSAU PASSAU PASSAU
A TOWN IN BAVARIA (SOUTH-GERMANY) ON THE RIVER DANUBE / AUSTRIAN BORDER
YOUR RST IS 579 579 579 KEYS BTU K1VW DE DL6IL

06

PT2TG
PT2TF

07

	PT 2 TG				ex PY1 AWO		ex PT2 ATR			PT 2 TF		DXCC
	Walter Felix Cardoso				PT2 ETY		PY1 E1			Thereainha Felix Cardoso		CBDX
	ISSB#9293				PY1 FC					ISSB#9234 CHC*1560		W P X
										DIG*1548 IOX*9806		DUF-E
SHIN QI 14 - Conj. 5 - C/23 - Brasília - DF - 71500 - Brasil								ZONE QC 11/ITU 13				W A C

TO ₀	DATE	UTC PY	BAND MHZ	MODE 2X	RST	QSL
DL6IL	30/8/90	2025	14	SSB CW RTTY	599	PSE TNX

YAESU FT 101 ZD
QUAD 2 el

Karl

Tnx Ny 85
qso Hope
again soon
83

Rosau
Germany

BST DX

08

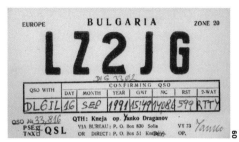

EUROPE BULGARIA ZONE 20

LZ2JG

DIG 3302

QSO WITH	CONFIRMING QSO						
	DAY	MONTH	YEAR	GMT	MC	RST	2-WAY
DL6IL	16	SEP	1991	1549	14084	599	RTTY

QSO No 33,816 QTH: Kneja op. Yanko Draganov
PSE ☒ VIA BUREAU: P. O. Box 830 Sofia VY 73 Yanko
TNX ☐ QSL OR DIRECT: P. O. Box 51 Kneja(?) OP.

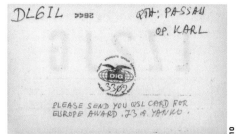

DL6IL 2866 QTH: PASSAU
OP. KARL

DIG 3302

PLEASE SEND YOU QSL CARD FOR
EUROPE AWARD. 73 op. YANKO.

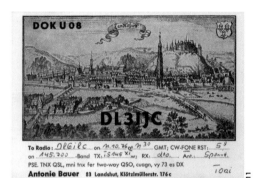

DOKU08

DL3IJC

To Radio DL6ilc on 11.10.76 at 11.30 GMT; CW-FONE RST: 5.9
on 145.700 Band TX: IS 145 X1 RX: dto. Ant. Spant.
PSE. TNX QSL, mni tnx fer two-way QSO, cuagn, vy 73 es DX
Antonie Bauer 83 Landshut, Klötzlmüllerstr. 176 c Toni

DL6ilc

hpe cnagn
dr. Maria!

dl6il 2 44

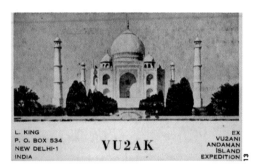

L. KING
P. O. BOX 534
NEW DELHI-1
INDIA

VU2AK

EX
VU2ANI
ANDAMAN
ISLAND
EXPEDITION

To RADIO D.L.6.I.L. POST CARD
Confirming our QSO of
Date 3 May 58
AT 0427 IST GMT
ON 14 MC/S
YOUR CW/FONE/SSB SIGS
R 5 S 7 T
XMTR 807
Remarks
 73

Jalesh O. Gangoli, VU2JG,
QSL manager, A.R.S.L,
P.O. Box 568, New Delhi-1,
India

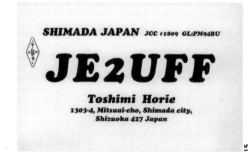

SHIMADA JAPAN JCC #1809 GL:PM94BU

JE2UFF

Toshimi Horie
1303-4, Mitsuai-cho, Shimada city,
Shizuoka 427 Japan

Post Card AdColor, Inc.
 FAX 06(763)0109
 TEL 06(763)0091

To Radio DL6IL Conf. Our QSO

DATE 1990	JST UTC	RST	MHz	2WAY	QSL
Jun. 23	2017	559	1X	RTTY	☐

Rig TS-900S + C7628 Input 250 W
Ant 3ele 22mHi
Rmks Tnx nice QSO (QSL# 8085)

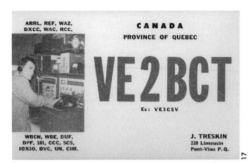

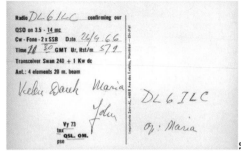

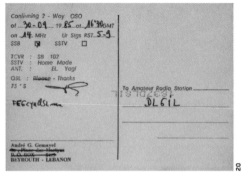

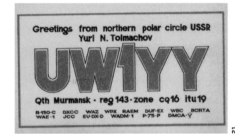

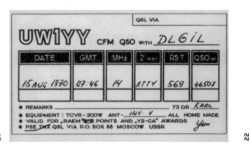

FUNKER UND FLYER

Neigt jede Gemeinschaft zur Entwicklung einer eigenen Flyerkultur? Noch wie heute sehe ich meinen Großvater vor einer Schublade sitzen, wie er eine Sammlung mit Hunderten von "Flyern" im Postkartenformat durchforstet. Er ordnet sogenannte QSL-Karten - meine Großeltern sind Funkamateure, die Karten zeugen von ihren Verbindungen in die Welt.

In meinen Kinderaugen bilden die Funkamateure eine eingeschworene, aber stets freundliche Gruppe, die mich fasziniert, auch wenn ich nie ihre Funkstationen mit den Handmikrofonen benutzen darf. Der Initiationsritus heißt "Lizenz", eine ernste Prüfung über Vorschriften, Technik und ...Morsen! Mit der Lizenz bekommt der "Funker" sein persönliches Rufzeichen, wie zum Beispiel das DL6IL meines Großvaters, das sich für immer in mein Gedächtnis eingeprägt hat. Das Rufzeichen ist der Erkennungscode, das Alter Ego, ja warum nicht der Künstlername in dieser Gemeinschaft. Seit jeher verbindet sie ihre Technikbegeisterung. Dank dem Gebrauch von Walkie-Talkies dürfen die Funker wohl als Pioniere der mobilen und drahtlosen Kommunikation gelten. Früher, in den 50ern, plünderten sie Radios für ihre selbstgebauten Stationen: Fertige Geräte kaufen war etwas für "Steckdosenamateure".

Die Tradition der QSL-Karte entsteht mit dem Beginn des Mediums. Zu Anfang des 20. Jahrhunderts wird noch gemorst. Bei den unsicheren Verbindungen, abgekürzt QSL, tauschen die Funker nachher lieber eine schriftliche Bestätigung aus. Heute ist es Sammlerleidenschaft, die Internetseiten und Wände von Hobbyräumen füllt. Auf der einen Seite einer "QSL" stehen die Angaben der Verbindung. Damit können die Funkamateure dann Diplome wie das "Work All Continents" beantragen. Beginnen wir hier Parallelen zur Clubszene zu ziehen, so ist das durchaus eine Herausforderung. Wie jeder Veranstalter sich auf seiner Werbung mit Logo oder Namen identifiziert, so druckt der Funk-amateur auf die Bildseite der Karte sein Rufzeichen. Im weiteren nehmen beide Gruppen bei der Bebilderung ihrer "Kartons" gerne auf ihren Standort Bezug, den vom Deutschen Amateur-Radio-Club geforderten "Anstand und guten Sitten" mögen die Partyveranstalter aber nicht immer genügen.

Möglicherweise sind die Funkamateure sogar Vorreiter in Sachen Sponsoring: Schon in den 60er und 70er Jahren fördern Betriebe die Herstellung von QSL-Karten ihrer Angestellten, wenn das Firmenlogo abgebildet ist. Heute kaum zu glauben, zapfen geschickte Funker sogar staatliche Stellen für ihre Flyer an. Etwas verlegen berichtet meine Großmutter, wie Kollegen für QSL-Karten mit dem Abbild der Heimatstadt einen Druckkostenzuschuss vom Fremdenverkehrsamt aushandelten. Zudem gibt es bei der Verteilung der Flyer und Karten gewisse Gemeinsamkeiten. Zwar wirbt der Club-Flyer für einen Ort und eine Veranstaltung, zu der der Betroffene hingeht oder nicht. Die Funker besuchen hingegen "Club-Abende"(!) und erhalten erst dort über ihre Verbände die Karten für vorangegangene Gespräche. Aber muss nicht auch der Party-Mensch regelmäßig abends in den Club, um Info-Material für neue Streifzüge zu ergattern?

Geographisch bildend und völkerverbindend seien die QSL-Karten, schreibt meine Großmutter. Sie erzählt von Karten aus dem Ostblock, als der Eiserne Vorhang noch Realität war, die Menschen über Amateurfunk aber dennoch kommunizieren. Ich drücke auf "Antworten" und tippe: Auf unseren Flyern stehen die Herkunftsorte der Musiker, DJs und Labels. Sie bilden eine bewegliche, internationale Community, die sich – wenn es gut läuft – beim Feiern vermischt und sich dann mit reichlich Emails beglückt. In Funkersprache schließe ich: 73 + 88, Gruß und Kuss.

Dank an DF5RM, DL6IL und DH9JS

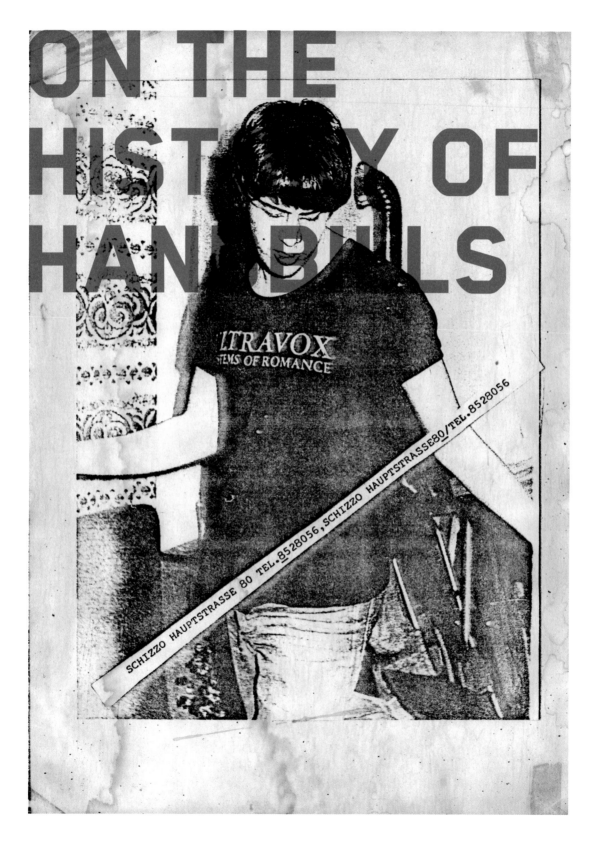

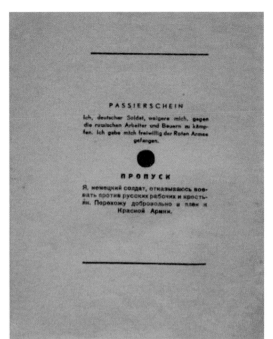

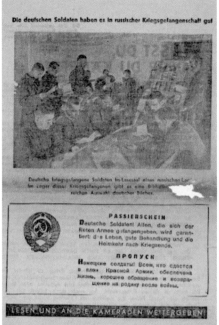

1. FOREWORD

A definition and analysis of flyers can be found in the text by Jannis Androutsopoulos in this book. This essay is intended as a brief outline of the history of handbills - from subversive pamphlets to party flyers.

It is of course impossible to mention every handbill ever printed anywhere, and this essay is not intended as a comprehensive study of handbill literature. Due to the abundance of data - both the number of handbills and the many reasons for printing them - the subject cannot be handled in anything other than a highly selective manner.

The main focus will be on Western states, due among other things to the fact that printing was invented by Gutenberg, that acid house was born in Chicago, and that the illegality of raves and the like in Britain led key developments in party flyers to occur there. It should also be noted that the means of production that enable the kind of aesthetic development seen in flyers are available and affordable above all in wealthy states.

A formal definition of handbills is offered by Ulrich Bach: one-sheet texts are hand-bills, while pamphlets consist of several pages. (CF. BACH 1997, PP. 24F.) To further distinguish between handbills, flyers and advertising handouts: handbills most commonly free, non-commercial material informing about or commenting on current events; advertising handouts are commercial by nature; and (party) flyers may fit either of these descriptions. (CF. KIRCHNER 1974, PP. 7FF., AND LANDEN 1998/99, P. 5)

Jörg Landen lists nine properties of handbills: they are to be understood here as typical rather than required features, i.e. they do not all have to apply for every handbill:

1. location-independent reception: handbills can be taken away to read later. This distinguishes them from posters. Curiously, the same printed sheet is sometimes stuck up as a "flyposter" and handed out as a "handbill".
2. short and sharp, keeping to the essentials
3. can be moved fast
4. cheap to produce
5. close links to affairs of public life and the demands of the day
6. can be refused
7. does not appear periodically
8. addresses a broad public and is publicly accessible
9. in general, only one subject is dealt with per handbill, unlike mass media such as newspapers that always have multiple features". (LANDEN 1998/99, P. 5)

As far a distribution is concerned, handbills can be left in specific places (bars, record shops, stations, universities, etc.), delivered personally (from hand to hand), dropped from airplanes, or sent by post by mass mailing or addressed to specific individuals. (CF. LANDEN AS ABOVE AND THORNTON 1996, P. 141)

2. CONDITIONS FOR MAKING MULTIPLE COPIES

The technical conditions for mass copying of handbills were fulfilled by the invention of the printing press by Gutenberg in the 15th century.

Before Gutenberg's development of moveable metal type, books copied by hand were reserved for use by a restricted circle of people. As the demand for books increased, however, the copying procedure and printing of woodcuts became too expensive, too time-consuming, and too complicated. Using moveable type, printers ink and a printing press, the duplication of news, messages and programs finally became accessible to the emancipated Third Estate.

As well as representing a more economic method of printing than woodcuts, Gutenberg's invention was thus also highly important in political and social terms (CF. KIRCHNER 1974, PP. 7F, AND LANDEN 1998/99, P. 3F). One consequence of this was the emergence of handbills and pamphlets as historical sources of great significance; they have been and continue to be produced in greater numbers in times of cultural, social and political upheaval: revolutions, wars, etc.. Today, however, the high output is unrelated to such upheaval. (CF. HAARMANN 1998, KIRCHNER 1974, PP. 7-38, AND LANDEN 1998/99, PP. 3FF)

3. SOCIAL, POLITICAL AND CULTURAL TURNING POINTS

3.1 UP TO 1945

The use of handbills in active military combat began with Napoleon, if not before. They were used to strengthen the morale of one's own troops and to weaken, demoralize, and mislead the enemy. In the Franco-Prussian war of 1870/71, they were dropped from the air for the first time, from hot air balloons. Later, grenades and airplanes were used. (CF. KIRCHNER 1974, P. 7F)

This type of warfare was systematized during World War I, with the added aspect of boosting morale on the so-called home front, i.e. among the civilian population, for example in the form of propaganda concerning enemy atrocities.

In the years between the end of World War I and the Nazis' rise to power, handbills played a minor role, serving primarily as a tool in election campaigns and in advertising. This reduction is due to the publication in the press of opinion/editorial pieces and readers' letters. (CF. HUELSENBECK 1991 AND LANDEN 1998/99, P. 3FF)

In totalitarian states, the lack of freedom of the press meant that subversive handbills were a much-used form of criticism.

During World War II, not only were billions of handbills and leaflets distributed by opponents of the war, but the handbill also proved an adequate means for forbidden parties and politically suppressed groups to communicate with the public: they could be produced in comparative privacy and were relatively easy to transport and distribute.

The best known example of underground publishing, that has even featured in a movie, took place on February 18, 1943, when leaflets produced by the anti-fascist White Rose group fluttered down into a roofed courtyard at Munich University. Shortly after, six members of the group were executed. (CF. KIRCHNER 1974, P. 7-38; LANDEN 1998/99, P. 3FF)

3.2 POLITICAL PAMPHLETS: 1945 TO THE PRESENT

Political pamphlets also played a negligible role in Germany in the early postwar years and at the start of the 'Economic Miracle'. This changed with the protest movement at schools and universities, mainly during the 1960s.

Students demonstrated on the streets of West Germany for the first time on December 18, 1964. (It was several years before the situation escalated.) On February 5, 1966, the police used truncheons against demonstrators for the time in front of the 'Amerika Haus'. On June 2, 1967, a Sergeant Kurras shot dead the student Benno Ohnesorg while policing a demonstration against a visit by the Shah of Iran.

Up to this point, political handbills dealing with university matters or the emergency laws had been addressed primarily to students. This situation now changed fundamentally, with the beginning of an extensive leafleting campaign. Students, as well as other groups outside the universities (e.g. schoolchildren), tried to inform or even educate the public. Countless handbills dealt with current social and political issues. (CF. BRUNOTTE 1973)

The marriage of handbills as a medium with music and youth culture may date from this period. Whereas initially, with the rise of the rock'n'roll DJ in the 1950s, they promoted concerts and other events, the 1960s saw the beginning of a link between handbills and pop culture. The original form of the party flyer probably emerged during those years (CF. LANDEN 1998/99, P. 6, AND POSCHARDT 1995, PP. 52-61): from 1966, for example, simple handbills were made to promote Andy Warhol's "mixed media shows" with acts including the Velvet Underground, Nico and Edie Sedgwick. (CF. BOCKRIS/MALANGA 1988, PP. 8FF) At around the same time, "events during the rock boom in San Francisco were promoted using hand-drawn posters that were often also reduced to postcard format". (LANDEN 1998/99, P. 6)

Since the turning point in the 1960s – and thanks to very cheap and simple duplication by photo-copying – political pamphlets have become an established part of life: they are found wherever their makers sense the spirit of subversive opposition and/or people they wish to convert – a legitimate goal and, in democracies, a legal one (with certain limitations). They play an important role in group communications and in the spread of information that is unable or not allowed to find its way into mass media.

It is striking that even today, political pamphlets of this kind are not especially appealing. One accusation leveled at the student movement of the late '60s is that this was due to the jargon of the various factions. In her study, Barbara Brunotte comes to the conclusion that this criticism is often based on little more than resentment against the political orientation in question and an aversion to the use of foreign words. (CF. BRUNOTTE 1973)

It is striking that even today, political pamphlets often not especially appealing. As in the past, on superficial examination, one might suspect a positive reluctance to design political pamphlets. But there may be several reasons for this reduction to the bare information.

Andrian Kreye observed that in New York, design is often looked after by the person with the best computer hard- and software, which is not necessarily accompanied by any great interest in graphic design. (CF. KREYE 2003) Also, a certain urgency and, especially, limited funds only allow for pamphlets with a simple visual design. According to Hitzler, the presence of design competence in political groups is documented, among other things, by websites, that are subject to comparatively low production costs. (CF. HITZLER ET AL. 2001, PP. 149-161)

In the following, politically motivated groups and political pamphlets will cease to be the main focus. We will be turning our attention instead to handbills as a medium in the context of youth culture and music, where an key aesthetic development emerges.

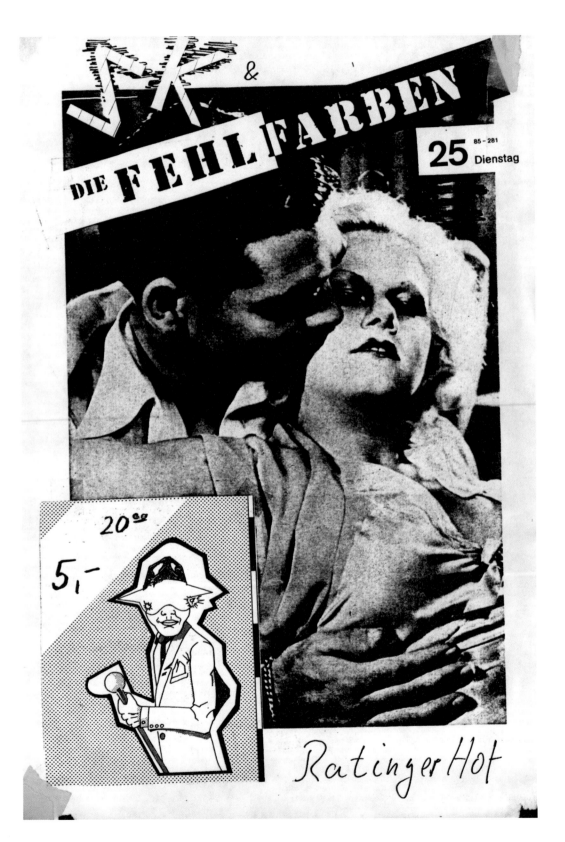

DIE FEHLFARBEN

&

25 $^{85-281}$ Dienstag

20eg

5,-

Ratinger Hof

3.3 PUNK FLYERS

The advent of the punk movement roughly coincided with the invention of the black and white photocopier (1975). The exact nature of punk, then or now, cannot be pinned down here, and maybe it never will. Significantly, other genres like industrial and new wave also emerged in the second half of the 1970s, added to which many bands of this period are hard to classify at all.

As Jello Biafra saw it, for example, bands like Television, The Avengers and Devo were punk because there had been nothing like them before. (CF. TURCOTTE/MILLER 1999, P. 8)

One motif among punk/new wave figures of the first generation was a firm rejection of anything perceived as established or traditional. Or as Frank Fenstermacher said in an interview, what interested him about the punk aesthetic was the revaluation of values.

As mentioned above, photocopying has the advantage of being cheap, simple, and fast; the new technology also had technical shortcomings that were actively accepted. (CF. LANDEN 1998/99, P. 5F, AND. POSCHARDT 1995, P. 205FF) Jello Biafra talks about this: "A good punk flyer will grab your attention, make you laugh, or piss you off - hopefully, all at the same time. Flyers had to be done quickly. Band names and the Mabuhay Gardens logo were cut out of old flyers and reused on the next. It was instant, it was cool. It was a hell of a lot of fun". (JELLO BIAFRA IN TURCOTTE/MILLER 1999, PP. 8F; CF. IBID.)

With the end of this era, caused not least by a certain trivialization, flyers became less important as an information medium: "There was no longer one single youth movement, the target groups were too fragmented, the party culture was over". (LANDEN 1998/99, P. 6; CF. IBID AND TEIPEL 2001)

But it should not be forgotten that flyers also played an important role in the formation of the hip-hop scene. In 1977, 15,000 flyers were distributed for a Kurtis Blow concert with Grandmaster Flash. Apparently, however, this subject has yet to receive any substantial study. (CF. POSCHARDT 1995, P. 196FF)

3.4 TECHNO/HOUSE

Jörg Landen has emphasized that the development of (party) flyers is closely linked to that of techno/house. At the end of the 1980s, party announcements on handbills with their own jargon were so popular that the term 'flyer' was inseparably associated with the techno/house culture. This is no longer the case: there follows an outline of the corresponding musical development.

Initially, house was not a mass phenomenon. Developed in the early 1980s in New York and Chicago, and named after a gay club - "Warehouse" - in Chicago, house has been described as a reaction to the perceived dead-end situation of disco. (CF. POSCHARDT 1995, P. 240)

In 1982, Roland designed the TB 303 - a monophonic, analog bass synthesizer combined with a sequencer. The instrument had one keyboard octave and six knobs "that could be used to modulate the bass line in real time". (LANDEN 1998/99, P. 7) The TB 303 was designed primarily for one-man shows,

but it was more expensive than an electric bass guitar (approx. 800 DM) and also sounded nothing like one. Sales were sluggish. After 18 months, Roland halted production. As legend has it, sometime in the mid-80s one was lying around in a secondhand shop in Chicago. Finally, a certain DJ Pierre bought it and begun experimenting with it at home: he, and the rest of the world, had never heard such sounds before.

With two friends, DJ Pierre made "Acid Trax": a piece of music that gave its name to a new style and had already achieved cult status even before it was finally pressed on vinyl in 1987. (CF. IBID., P. 282F, AND LANDEN 1998/99, P. 6FF)

It is in the nature of legends not to match up with all the available evidence, and here it is worth mentioning that the former Throbbing Gristle members Chris Carter and Cosey Fanni Tutti, recording as Chris & Cosey, are said to have released the first track featuring the TB 303 in 1983. Nonetheless, the circle of people who were familiar with these sounds before 1986 will not have been very large. (CF. KLEINHENZ 1995, P. 90)

In the mid-1980s, mainly British tourists turned Ibiza into a seriously happening party location. Many DJs clubbing on the island were confronted with acid house for the first time in sets by DJ Alfredo at Amnesia. They included Danny Rampling and Paul Oakenfold; as well as hearing a new sound, they also noticed a new, at least partly drug-induced atmosphere in the club. Acid house and ecstasy then found their way from Ibiza back to the UK in the DJs' luggage. (CF. LANDEN 1998/99, P. 7, AND SCHÄFER ET AL., PP. 45, 172F, 284F) In the fall of 1987, Rampling started the Shoom club in London and soon after, the Hacienda in Manchester became the second major venue for the new scene.

In 1988, there was an acid house boom across Britain, but the phenomenon also spread elsewhere. Its symbol was the "smiley" which featured on the posters and flyers of the Shoom club from 1988. When the clubs became too small, the clubbers moved on to open air locations or warehouses. Raves became established. By the end of the year, the carefree fun was over. Accompanied by massive press campaigns, the police began to clamp down. There were mass arrests and raids, raves were broken up, equipment confiscated. The scene was forced underground.

According to Lander, this step brought about the "birth of the flyer" (LANDEN 1998/99, P. 9) as an indispensable information medium for the scene. However, even before this crucial turning point, there were already flyers promoting London clubs or announcing events, so that what Lander refers to as a 'birth' was actually more of an evolutionary leap. An overview of British flyers from 1983 to 1996 is given in "Fly – The Art Of The Club Flyer". (ACKLAND-SNOW ET AL 1996)

Due to the increased police pressure on warehouse parties, raves etc. in Britain from 1988, a way of announcing such events that remained more or less invisible to the

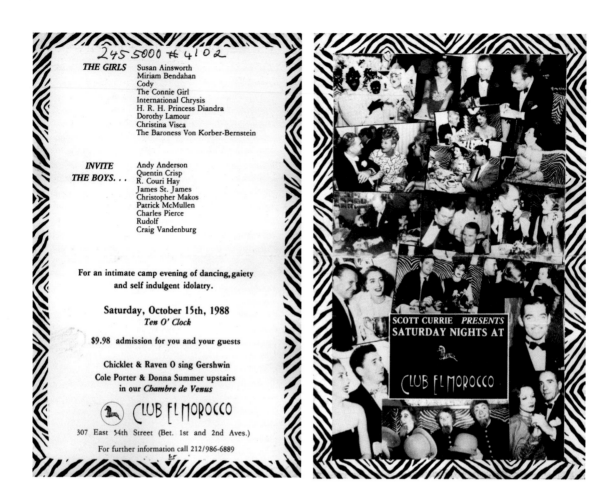

authorities and the aggressive press had to be found. This was achieved by distributing often hand-made flyers consisting of one-sided photocopies in places only known to insiders (bars etc.), or handed out by hand, often as invitations. These flyers named no sponsors and no stars, because there were none yet. "Flyers were not only the most important information medium of the scene, they practically kept it alive." (ibid, p. 9; cf. Poschardt 1995, p. 284ff). As Sarah Thornton underlines, they were the start of an information chain that continued via word of mouth, fanzines, etc. For event organizers, flyers were the cheapest and most effective way of reaching their target audience. It is doubtful if the same would apply today. (CF. THORNTON 1996, P. 141)

After the acid house boom receded in Europe around 1990, the illegal phase was also over. Of course, illegal events continued to take place (and still do), but after the end of acid house, the movement was considered finished and events that had previously been combated (on account of drug abuse, among other things) were allowed again.

In the early 1990s, the number of clubs increased, in Germany events like Mayday and the Love Parade became established. Techno and house underwent further developments. At the same time, the possibilities for flyer design increased. Computers and software became more affordable. Fly-

ers appeared as glossy four-color prints, some of them periodically where regular events were taking place. The print runs were still very small, and no sponsors were named, but around 1992, the tobacco industry, for example, began to show an interest in the movement.

One or two years later, techno and house had arrived in the mainstream. Stars like Marusha and Westbam emerged, and the music took up residence in the charts. Due to the large number of clubs and events, the flyers had to become more and more unusual to gain attention: bootlegs appeared, it became cheaper to produce unusual flyer formats (shapes), the same applied to the use of special colors. It is also worth mentioning object flyers, materials such as circuit boards, match booklets, Smarties tubes, etc. that were used to transmit the what/where/when data. (CF. GOER 2000A/B/C; LANDEN 1998/99; POSCHARDT 1995, SPP. 238-289; THORNTON 1996, PP. 137-151)

It should be noted that instead of superceding one another, the different aesthetic styles existed side by side: it is not for purely financial reasons that designers resort to older methods (like Copy Art), but because the flood of glossy flyers forces them to adopt this kind of strategy to remain distinctive.

In addition, private and/or illegal parties are obliged to use the cheapest form of flyer production, not least due to the lack of sponsors: in many cases, these are small photocopied sheets or laser prints.

Finally, it is worth remembering that in many cases, e-mails offer a cheaper, more effective option for drawing attention to a given event. This means it can no longer be claimed that classic party flyers are the cheapest and most effective means for club organizers and others to draw a specific target group to their event. But this in turn does not necessarily mean that flyers will disappear from bars, record shops and malls.

4. FINAL REMARKS

There is no avoiding it: flyers are everywhere, still, in every conceivable shape and size, in record shops, pubs, on the floor after concerts, in bars, clubs and malls. Besides those that announce a single event, program flyers (for festivals and the like) have for years been swelling the flood. Moreover, the term flyer has come to be used in common parlance for any kind of advertising handbill you might be given on the way to the bus stop or find in your mailbox. Neither collectors nor graphic designers are expecting club and party flyers to be driven out of existence by electronic communications anytime soon.

It seems almost unnecessary to mention that massive use of both the term flyer and of flyers themselves has not diminished the fascination they hold for collectors and clubbers. But these people do not control the definition of the term, which has lost much of its clarity.

Oliver Schweinoch

BIBLIOGRAPHY:

ACKLAND-SNOW, NICOLA; Brett, Nathan; Williams, Steven 1996: "Fly - The Art Of The Club Flyer". London: Thames and Hudson.

BACH, ULRICH 1997: "Englische Flugtexte im 17. Jahrhundert". Heidelberg: Universitätsverlag C. Winter.

BOCKRIS, VICTOR AND MALANGA, GERARD 1988: "Up-tight. Die Velvet Underground Story". Augsburg: Sonnentanz-Verlag.

BRUNOTTE, BARBARA 1973: "Rebellion im Wort". Frankfurt/Main: dipa-Verlag.

GOER, CHARIS 2000a: "Elektronische Musik". In: Metzler Lexikon Kultur der Gegenwart. Hrsg. von Ralf Schnell. Stuttgart; Weimar: Metzler, S. 110f.

GOER, CHARIS 2000b: "Popmusik". In: Metzler Lexikon Kultur der Gegenwart. Hrsg. von Ralf Schnell. Stuttgart; Weimar: Metzler, S. 421f.

GOER, CHARIS 2000c: "Techno". In: Metzler Lexikon Kultur der Gegenwart. Hrsg. von Ralf Schnell. Stuttgart; Weimar: Metzler, S. 502f.

HAARMANN, HARALD 1998: "Universalgeschichte der Schrift". Sonderausgabe. Frankfurt/New York: Campus.

HITZLER, RONALD; Bucher, Thomas and Niederbacher, Arne 2001: "Leben in Szenen. Formen jugendlicher Vergemeinschaftung heute". (Erlebniswelten Band 3. Hrsg. von Winfried Gebhardt, Ronald Hitzler u. Franz Liebl) Opladen: Leske + Budrich.

HUELSENBECK, RICHARD 1991: "Mit Witz, Licht und Grütze. Auf den Spuren des Dadaismus". Hrsg. von Reinhard Nenzel. Hamburg: Edition Nautilus.

KIRCHNER, KLAUS 1974: "Flugblätter. Psychologische Kriegsführung im Zweiten Weltkrieg in Europa". Munich: C. Hanser Verlag.

KLEINHENZ, JOCHEN 1995: "Industrial Music For Industrial People". In: Testcard: Pop und Destruktion. Oppenheim: Testcard-Verlag, p. 88-99.

KREYE, ANDRIAN 2003: "Die Botschaft der Ikonen". In: Süddeutsche Zeitung, 22.4.2003.

LANDEN, JÖRG 1998/99: "Phänomen Flyer: Von der Illegalität zum Kommerz." Diploma thesis / EMMA Final Project. Merz-Akademie Stuttgart. http://www.techno.de/flyer/download/Flyer.pdf

POSCHARDT, ULF 1995: "DJ-Culture". Hamburg: Rogner & Bernhardt bei Zweitausendeins.

SCHÄFER, SVEN; Schäfers, Jesper; Waltmann, Dirk 1998: "Techno Lexikon". Berlin: Schwarzkopf & Schwarzkopf.

TEIPEL, JÜRGEN 2001: "Verschwende Deine Jugend". Frankfurt/Main: Suhrkamp.

THORNTON, SARAH 1996: "Club Cultures. Music, Media and Subcultural Capital". Hanover: Wesleyan University Press.

TURCOTTE, BRYAN RAY AND MILLER, CHRISTOPHER T. 1999: "Fucked Up + Photocopied. Instant Art Of The Punk Rock Movement". Corte Madera, CA: Gingko Press.

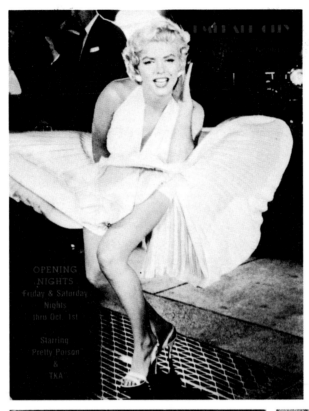

OPENING
NIGHTS
Friday & Saturday
Nights
thru Oct. 1st

Starring
Pretty Poison
&
TKA

LIGHTS, CAMERA, ACTION!
FOXY & Friends
invite you to attend
"THE MAIN EVENT"
HOT 103 • PRETTY POISON • TKA
Opening Parties of
EMERALD CITY
(617 West 57th Street; bet. 11th & 12th Ave.)

Friday & Saturday Nights
September 23rd & 24th
Performing Live "Pretty Poison" (Sept. 24th)

Friday & Saturday Nights
September 30th & October 1st
Performing Live "TKA" (Oct. 1st)
♪ with their Number 1 Hit "X-Ray Vision" ♪

ADMISSION: Fridays **$5 P.P.** before 10:30 p.m.
$10 P.P. after 10:30 p.m.
Saturdays: **$10 P.P.**
$15 without this invitation
INVITATION ADMITS 4
Proper Attire Requested (No Sneakers)
Proper I.D. Required
Plenty of Parking Information: 581-4432

D

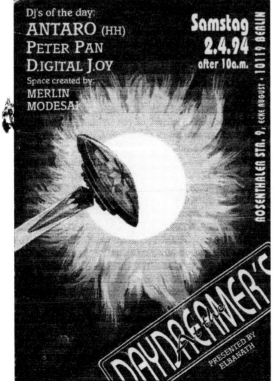

Dj's of the day:
ANTARO (HH)
PETER PAN
DIGITAL JOY
Space created by:
MERLIN
MODESAI

Samstag
2.4.94
after 10 a.m.

ROSENTHALER STR. 9, ECKE AUGUST • 10119 BERLIN

DAYDREAMER'S

PRESENTED BY ELBANATH

SONNTAG
30. MAI - 23h
DJ. Sven Väth
DR Motte

E WERK WILHELMSTR / MITTE

DUBMISSION

sundayclub

Paul van Dyk
Sonntag
24.1.-23h

next 7.2.

DUBMISSION
TURBINE-wienerstr. 46

Special

Donnerstag 05.05.94
20.00 Globus • Tresor • Bonito
SPACE BEER PARTY "How you
can make friends in space."
**feat. Dj Dole & Dixon,
live: Commander**

Freitag 06.05.94
24.00 Tresor
"mind" (Volume 1) x.d.p.
(an experiment of electronic dance music)
Dj Henry (HH), Wolle N.

Samstag 07.05.94
24.00 Tresor • **MO.TOR club opening**
(motorized house music) x.d.p.
Jeff Mills (detroit), **Dj René** (hard wax)

Sonntag 08.05.94
22.00 Globus • CLUB 21 - GLO
Dj Pheerce & Tama Sumo

Mittwoch 11.05.94
18.00 Tuna Park Reopening
22.00 Globus • Bonito House Special No. 3
"Spring!" mit Dr. Motte

Freitag 13.05.94
24.00 Tresor • MO.TOR, **Ellen Alien** (Kiss FM), **Dj Disko**

Samstag 14.05.94
24.00 Tresor • MO.TOR, **Dj Pete & Dj René** (hard wax)

Sonntag 15.05.94
22.00 Globus • CLUB 21 - GLO, **Dj Pheerce & Dj Faufi**

Freitag 20.05.94
24.00 Tresor • MO.TOR, **Dj Hell** (Disco B, Muc), **Wolle N.**

Sonntag 22.05.94
22.00 Globus • CLUB 21 - GLO, **Dj Pheerce & Dj Tama Sumo**

Sonntag 29.05.94
22.00 Globus • CLUB 21 - GLO, **Dj Pheerce & Dj Wimpy**

Dates

ZUR GESCHICHTE DES FLUG- BLATTS

1. VORBEMERKUNG

Eine Flyer-Definition und -Analyse findet sich im Beitrag von Jannis Androutsopoulos in diesem Band. Hier geht es um einen kurzen Abriss der Geschichte des Flugblatts - vom subversiven Handzettel zum Party-Flyer.

Es kann dabei selbstverständlich nicht jedes irgendwann irgendwo gedruckte Flugblatt Erwähnung finden. Folglich wird nicht der Versuch unternommen, eine umfassende Behandlung des Themas Flugliteratur zu erarbeiten, sodass Ausführungen z.B. über spätmittelalterliche Flugblätter zu Hostienschändungen oder über englische Flugtexte des 17.Jahrhunderts fehlen. Publizistischen Begleiterscheinungen der Verurteilung Philipp Jakob Siebenpfeiffers 1832 wird ebenso wenig Beachtung gezollt wie der sowjetischen Flugblattpropaganda im Zweiten Weltkrieg oder den schriftlichen Protesten der Studenten der Universität von Ica 1968 in Peru.

Anders als schlaglichtartig ist die Behandlung des Themas aufgrund der Datenfülle, bezogen auf die Anzahl der Handzettel und die Gründe sie zu drucken, also gar nicht möglich.

Das Hauptaugenmerk wird sich auf westliche Staaten richten, was nicht despektierlich gemeint ist, sondern u.a. damit zusammenhängt, dass der Buchdruck auf Gutenberg zurückgeführt, der Ursprung von Acid House in Chicago verortet wird und der Party-Flyer aus der Not der Illegalität (von Raves etc.) in England wesentlich weiterentwickelt wurde. Nicht zuletzt ist zu beachten, dass vor allem in wohlhabenden Staaten die Produktionsmittel verfügbar und erschwinglich sind, welche die ästhetische Entwicklung, wie sie bei Flyern vorzufinden ist, möglich machen.

Eine brauchbare formale Flugblatt-Definition liefert Ulrich Bach: Einblatt-Texte – einseitig bedruckte werden auch Einblattdrucke genannt – sind Flugblätter. Flugschriften sind hingegen Mehrblatt-Texte. Flugblätter und Flugschriften werden unter dem Begriff Flugliteratur subsumiert. (VGL. BACH 1997, S. 24F.)

Flugblatt, Flyer und Reklamezettel werden auch als Handzettel bezeichnet, wobei das Flugblatt als nichtkommerziell gilt, es wird zumeist unentgeltlich verteilt und dient als Information über ein aktuelles Ereignis oder diesbezügliche Stellungnahme. Reklamezettel sind, da sie für etwas werben, kommerziell. Für (Party-)Flyer kann sowohl die eine als auch die andere Umschreibung gelten. (VGL. KIRCHNER 1974, S. 7FF., UND LANDEN 1998/99, S. 5)

Jörg Landen formuliert neun Eigenschaften des Handzettels, die hier nicht als definitorische Merkmale verstanden werden sollen, sondern als typische, d.h. sie müssen nicht alle auf jeden Handzettel zutreffen:

1. ortsunabhängige Rezeption: Der Leser kann Handzettel mitnehmen und später lesen. Dies unterscheidet ihn vor allem vom Plakat. Kurioserweise kann der gleiche Zettel aufgehängt als 'Plakat' und verteilt als 'Handzettel' bezeichnet werden.
2. kurz und nüchtern, nur das Wesentliche
3. rasche Beweglichkeit
4. billige Produktion
5. engste Verbindung mit den Angelegenheiten des öffentlichen Lebens und den Forderungen des Tages
6. Möglichkeit der Ablehnung
7. kein periodisches Erscheinen
8. wendet sich an die breite Öffentlichkeit und ist öffentlich zugänglich
9. im Allgemeinen wird nur ein Thema pro Handzettel behandelt, während es bei Massenmedien, wie der Zeitung, grundsätzlich mehrere Themen sind. (LANDEN 1998/99, S. 5)

Für die Verteilung gilt, dass Handzettel an bestimmten Orten (Bars, Plattenläden, Bahnhöfe, Universitäten etc.) abgelegt, persönlich verteilt (von Hand zu Hand), aus Flugzeugen usw. abgeworfen oder als Postwurfsendung bzw. konkret adressiert im Briefkasten landen können. (VGL. EBD. U. THORNTON 1996, S. 141)

2. VORAUSSETZUNGEN FÜR DIE VERVIELFÄLTIGUNG

Die technische Voraussetzung für die Vervielfältigung von Flugblättern war - wie angedeutet - spätestens mit Johannes Gensfleisch zur Laden von Gutenbergs Erfindung des Buchdrucks im 15. Jahrhundert gegeben. In China wird diese Innovation auf einen gewissen Bi Sheng (um 1040) zurückgeführt. Die Entwicklung in China verlief jedoch vergleichsweise schleppend. Bis ins 19. Jahrhundert wurden Drucksachen immer noch als ganze Seiten in Holz geschnitten und gedruckt, wobei sich dieser Umstand mit der erheblich höheren Anzahl von Schriftzeichen erklären lässt. Streng genommen gehört auch die Entwicklung der Schrift und von Beschreibstoffen zu den Bedingungen, wobei es freilich zu weit führen würde, die Entwicklung von Buchstabenformen usw. hier auszubreiten. (VGL. HAARMANN 1998; MENNE 2000, S. 14FF).

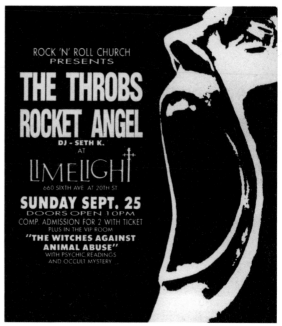

Vor Gutenbergs Entwicklung der beweglichen Metallbuchstaben (Lettern) blieb z.B. das handschriftlich vervielfältigte Buch bis ins 15. Jahrhundert nur einem eingeschränkten Personenkreis vorbehalten. Das Abschreibeverfahren sowie der Druck von Holzschnitten wurde jedoch mit dem Anstieg des Bedarfs an Büchern zu teuer, zu zeitaufwändig und zu umständlich. Durch die besagten Lettern, Druckerschwärze und Druckpresse wurde die Vervielfältigung von Nachrichten, Botschaften und Programmen schließlich dem sich emanzipierenden Dritten Stand zugänglich.

Einblattdrucke fanden zunächst unter Buchdruckern Verwendung, die damit für ihre Kunst warben, auch machten wandernde Menagerien mit diesem Medium auf ihre Veranstaltungen aufmerksam.

Tagespolitische Themen wurden 1482 in Augsburg erstmals als Einblattdrucke vertrieben. Zum Ende des 15. Jahrhunderts kommt es zu einer inhaltlichen Veränderung: An die Stelle der aktuellen und religiösen Ereignisse treten Programm, Kommentar und Analyse. Die kritischen Ein- und Mehrblattdrucke können nach Kirchner als Ursprung des Leitartikels bezeichnet werden. Formal entwickelte sich die Flugschrift aus dem Flugblatt, etymologisch verhält es sich umgekehrt. (VGL. 3.1)

Gutenbergs Erfindung stellt also im Vergleich zum Holzschnittdruck nicht nur eine ökonomischere Druckmethode dar, sie ist gleichzeitig politisch und sozial hoch bedeutsam (VGL. KIRCHNER 1974, S. 7F, U. LANDEN 1998/99, S. 3F): "Vor allem Erniedrigte sehen im Flugblatt endlich eine Chance, sich gegen die Obrigkeit durch Verbreitung oppositioneller Ansichten zu wehren". (LANDEN 1998/99, S. 4) Öffentliche Meinung konnte artikuliert, offener Ideenaustausch gewährleistet werden. Flugblätter erwiesen sich als wirkungsvolles Mittel zur politischen Meinungsbildung, was dann zum einen schon im 16. Jahrhundert und insbesondere im 19. Jahrhundert massive Zensurmaßnahmen hervorrief (Landen erwähnt z.B. ein 1543 erlassenes Dekret, dass kein Buch ohne die Erlaubnis der päpstlichen Inquisition gedruckt oder verkauft werden dürfe; bei Zuwiderhandlung habe man den Delinquenten verbrannt, was dazu führte, dass die Verfasser subversiver Schriften sich in die Anonymität flüchteten).

Zum anderen blieb das Operationsfeld Flugtexte nicht den sozial Unterprivilegierten vorbehalten, d.h. das Flugblatt blieb nicht ausschließlich ein antiherrschaftliches Instrument, vielmehr entdeckten es die Herrschenden als wirkungsvolles Mittel zur Vermittlung machtpolitischer Ansprüche.

Flugblätter und -schriften sind folglich als Geschichtsquelle von hoher Bedeutung; sie entstanden/entstehen vermehrt vor allem in Zeiten kultureller, sozialer und politischer Umbrüche: Revolutionen, Kriege etc. Dass heute wohl vor allem in westlichen Staaten unabhängig von sozialen Umbrüchen etc. vielfach eine Flut an Flugblättern zu verzeichnen ist, kann mit der Demokratisierung der Produktionsmittel erklärt werden. (VGL. KIRCHNER 1974, S. 7-38, U. LANDEN 1998/99, S. 3FF)

3. SOZIALE, POLITISCHE UND KULTURELLE ZÄSUREN
3.1 BIS 1945

Der Begriff "Flugschrift" taucht erstmals im deutschsprachigen Raum während der Französischen Revolution auf: Christian D. F. Schubart übersetzte das damals in Frankreich geläufige "feuille volante" fast wörtlich; Goethe schließlich habe von "Flugblättern" gesprochen. (VGL. KIRCHNER 1974, S. 7F)

Von Flugblättern als aktiven Kriegsmitteln kann spätestens seit Napoleon die Rede sein. Sie wurden zur Stärkung der eigenen Truppen sowie zur Schwächung, Zersetzung und Irreführung der gegnerischen verwandt. Sie seien im deutsch-französischen Krieg 1870/71 erstmals – bezeugt durch Fontane – aus der Luft, und zwar aus Ballons, abgeworfen worden. Später nutzte man zu diesem Zweck Granaten und Flugzeuge. (VGL. EBD.) Diese Form der psychologischen Kriegsführung ist bis heute beliebt – z.B. im z.Zt. letzten Golfkrieg. (VGL. SÜDDEUTSCHE ZEITUNG V. 21.03.2003)

Systematisiert wurde diese Art der Kriegsführung im Ersten Weltkrieg, wobei das Moment der Stärkung der so genannten Heimatfront, also der Zivilbevölkerung, (verstärkt) hinzukam; z.B. mittels Gräuelpropaganda: Die Herabsetzung des jeweiligen Gegners durch erfundene Nachrichten über gewalttätige Exzesse. Diese publizistische Kriegsführung wird mit als Grund angeführt, warum Berichten über die Barbarei der Nationalsozialisten zumindest zunächst nicht unbedingt Glauben geschenkt wurde.

In den Jahren zwischen dem Ende des Ersten Weltkriegs und dem Machtantritt der Nazis spielte das politische Flugblatt nur eine untergeordnete Rolle. Es diente in dieser Zeit vornehmlich als Wahlkampfmittel und Reklamezettel. Dieser Umstand wird mit der Veröffentlichung von Meinungsseiten/Leserbriefen in der Presse erklärt.

Im Bereich der Kunst wird ungefähr zu selben Zeit der Handzettel insbesondere von Dadaisten zur Verbreitung z.B. ihrer Schmähschriften genutzt. Galt für den Dadaismus zunächst wie es Hans Arp formulierte: "Wie wollten etwas machen. Etwas Neues, Nichtdagewesenes. Aber wir wussten nicht, was!" (ZIT. NACH BEST 1974, S. 289), so ist er vor allem in seiner letzten Phase als "ästhetische Negation der bürgerlichen Gesellschaft, deren Wesensmerkmale in Nationalismus, Patriotismus und Kriegsneigung gesehen wurden," (EBD., S. 290) zu verstehen; als Ablehnung der überkommenen Bildungs- und Kunstideale, Kunst als "Protest gegen Kunst". (EBD., S. 291; VGL. HUELSENBECK 1991 UND LANDEN 1998/99, S. 3FF)

Weil in totalitären Staaten nicht die Rede von einer freien Presse sein kann, da – neben dem Terror –als wichtige Elemente die Gleichschaltung sowie die Verwandlung von Wahrheit in Lüge und umgekehrt gelten (VGL. ADORNO 1994; ARENDT 2000), stellt das subversive Flugblatt eine oft genützte Form der Kritik dar.

Während des Zweiten Weltkriegs wurden nicht nur Milliarden von Flugblättern und -schriften durch die Kriegsgegner verbreitet, das Flugblatt erwies sich auch als adäquates Mittel für verbotene Parteien und politisch unterdrückte Gruppen, um sich der Öffentlichkeit mitzuteilen: Es konnte im kleinen Kreis hergestellt werden und ließ sich relativ leicht transportieren und verteilen. Das bekannteste Beispiel für die Untergrundpublizis-

tik, schon durch die filmische Bearbeitung, fand am 18.2.1943 statt, als in den Lichthof eines Gebäudes der Münchner Universität Flugblätter der Weißen Rose flatterten. Kirchner spricht von einigen hundert, Landen von ca. 3000 Exemplaren. Es handelte sich um das sechste und letzte Flugblatt der Gruppe – kurze Zeit später wurden sechs Mitglieder hingerichtet. (VGL. KIRCHNER 1974, S. 7-38; LANDEN 1998/99, S. 3FF)

Oft erwähnt, wenngleich wohl dem Bereich der Mythen zugehörig, wird ein Flugblatt der Alliierten, was in den letzten Kriegstagen aufgetaucht sei und Leichenberge mit dem Satz ´Das ist Deine Schuld´ gezeigt habe. Hannah Arendt erwähnt es in ihrem Bericht "Besuch in Deutschland", Karl Jaspers nimmt es als Ausgangspunkt seiner Überlegungen zur "Schuldfrage". Dieses Flugblatt sei jedoch in keiner Weise erhalten. (VGL. ARENDT 1993; FREI 2000; JASPERS 1946)

3.2 DAS POLITISCHE FLUGBLATT: 1945 BIS HEUTE

Auch im jungen Nachkriegsdeutschland und in den ersten Jahren des so genannten Wirtschaftswunders spielte das politische Flugblatt kaum eine Rolle. Dies änderte sich mit den so genannten Studenten- und Schülerunruhen vor allem in den 1960er Jahren.

Am 18.12.1964 gehen erstmals in der BRD Studenten demonstrierend auf die Straße. (Bis zur Eskalation vergehen einige Jahre.) Am 5. 2. 1966 schreitet die Polizei in Berlin erstmals mit Knüppeln gegen Demonstranten vor dem Amerika-Haus ein. Am 2.6.1967 erschießt der Polizeimeister Kurras den Studenten Benno Ohnesorg im Rahmen einer Polizeiaktion gegen die den Besuch des Schahs von Persien begleitenden Proteste.

Richteten sich die politischen Flugblätter mit ihren Inhalten zu universitären Belangen oder den Notstandsgesetzen bis dahin noch vornehmlich an Studenten, so änderte sich die Situation nun fundamental: Es begann eine umfangreiche Flugtextaktion. Studenten, aber eben auch Gruppen außerhalb der Universität (z.B. Schüler), versuchten, die Bevölkerung zu informieren oder gar aufzuklären. Unzählige Flugblätter setzten sich mit aktuellen gesellschaftlichen und politischen Fragen auseinander. Der überwiegende Teil (ca. 98%) der der Untersuchung von Barbara Brunotte ("Rebellion im Wort") zugrundeliegenden und ästhetisch anspruchslosen Handzettel lag in den Formaten DIN A4 und DIN A5 vor. Hergestellt wurden sie zumeist mittels eines Vervielfältigungsapparats, der das schnelle, billige und einfache Abziehen von bis zu 3000 Exemplaren ermöglichte. Andere Verfahren - Offset, Buchdruck - waren nicht nur deutlich teurer, sondern auch zeitaufwändiger; der Buchdruck nahm ca. acht Tage in Anspruch. (VGL. BRUNOTTE 1973)

In diese Zeit fällt möglicherweise die Fusion des Mediums Handzettel mit aktueller Musik und Jugendkultur.

01

02

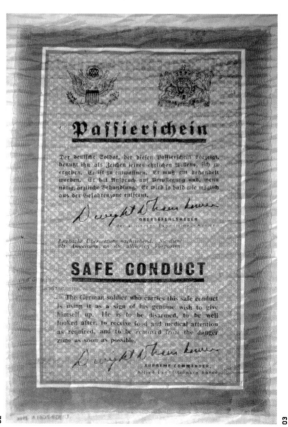

03

ZUR GESCHICHTE DES FLUGBLATTS

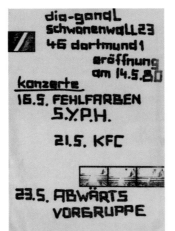

dia-gonaL
schwanenwaLL23
46 dortmund1
eröffnung
am 14.5.80
konzerte
16.5. FEHLFARBEN
S.Y.P.H.
21.5. KFC
23.5. ABWÄRTS
VORGRUPPE

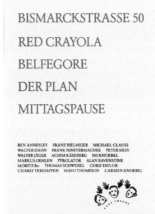

BISMARCKSTRASSE 50

RED CRAYOLA

BELFEGORE

DER PLAN

MITTAGSPAUSE

BEN ANNESLEY FRANZ BIELMEIER MICHAEL CLAUSS
WALTER DAHN FRANK FENSTERMACHER PETER HEIN
WALTER JÄGER ACHIM KÄSEBERG IMI KNOEBEL
MARKUS OEHLEN PYROLATOR ALAN RAVENSTINE
MORITZ R?? THOMAS SCHWEBEL CHRIS TAYLOR
CHARLY TERSTAPPEN MAYO THOMPSON CARMEN KNOEBEL

04

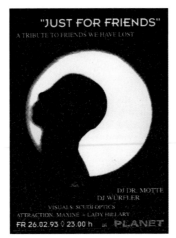

"JUST FOR FRIENDS"
A TRIBUTE TO FRIENDS WE HAVE LOST

DJ DR. MOTTE
DJ WÜRFLER
VISUALS: SCUDI OPTICS
ATTRACTION: MAXINE + LADY HILLARY
FR 26.02.93 ◊ 23.00 h at PLANET

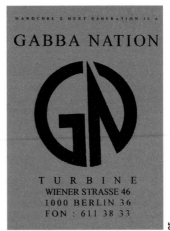

HARDCORE'S NEXT GENERATION IS A

GABBA NATION

GN

T U R B I N E
WIENER STRASSE 46
1000 BERLIN 36
FON : 611 38 33

05

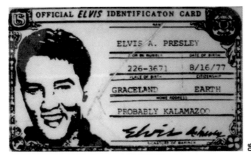

OFFICIAL ELVIS IDENTIFICATON CARD

ELVIS A. PRESLEY
226-3671 8/16/77
GRACELAND EARTH
PROBABLY KALAMAZOO

06

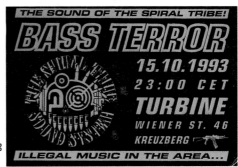

THE SOUND OF THE SPIRAL TRIBE!
BASS TERROR
15.10.1993
23:00 CET
TURBINE
WIENER ST. 46
KREUZBERG
ILLEGAL MUSIC IN THE AREA...

SEXILAND berlin

SEXILAND
Rosenthaler Platz / Mittelinsel

FUZZY LOGIC -traumzeit mo.24.6. 19.00-02.00

dj;s: Rawell ,Peter elektronic welfare ,Anne
Art: Maria Licht: Mr Nice
20.00 Film:Terence MCKenna FRISEUR

Brunotte berichtet, dass sich in ihrem Material aus den Jahren 1966 bis ´68 auch einige Handzettel fanden, die auf Theaterveranstaltungen, Filme und Tanzabende aufmerksam machten. (VGL. EBD., S. 24) Waren es zunächst ab den 1950ern mit dem Aufkommen des Rock'n'Roll – Nik Cohn bezeichnet den millionenfachen Erfolg von Bill Haleys 1954 aufgenommenen "Rock Around the Clock" als Geburt der Popmusik – DJs, die z.B. Konzerte bewarben, so findet spätestens in den 1960ern die Verbindung von Flugblättern und Pop-Kultur statt. Die Urform des Party-Flyers dürfte also spätestens in jenen Jahren aufgetaucht sein (VGL. LANDEN 1998/99, S. 6, U. POSCHARDT 1995, S. 52-61): Ab 1966 wiesen z.B. schlichte Handzettel auf Andy Warhols "Mixed Media Shows" mit z.B. Velvet Underground, Nico und Edie Sedgwick hin. (VGL. BOCKRIS/MALANGA 1988, S. 8FF) Zur ungefähr gleichen Zeit "warben Veranstaltungen des Rock-Booms in San Francisco durch handgezeichnete Poster, die oft auch auf Postkartengröße verkleinert wurden". (LANDEN 1998/99, S. 6)

Für das politische Flugblatt gilt, dass man sich heute (nicht nur in Deutschland) eher eine Demo ohne Kinder als ohne Flugblätter vorstellen kann. Politische Flugblätter sind – auch durch die sehr preiswerte und einfache Möglichkeit der Vervielfältigung (Fotokopie) – seit der Zäsur in den 60ern kaum mehr wegzudenken: Sie finden sich überall, wo ihre Macher den Geist der subversiven Opposition wähnen und/oder jenen, den sie zu bekehren wünschen – ein legitimes Ansinnen und in Demokratien überdies mit Einschränkungen legal. Sie sind bedeutungsvoll für die Gruppenkommunikation und für die Verbreitung von Informationen, die ihren Weg nicht in die Massenmedien finden dürfen oder können. Erfahrungen mit der öden Flugblattschwemme dürfte fast jeder gemacht haben, es ist daher auch nicht verwunderlich, dass sie sich in der zeitgenössischen Belletristik niederschlagen:

"Fuhr mit der U-Bahn. Beim Aussteigen geriet ich in eine Demo. (...) Unruhe kam auf, ein Gefühl von 'Widerstand', Murren, 'sprachloses Entsetzen', bald musste der erste Gegenstand fliegen. Einzelne Leute riefen 'Schweinerei', und einer sogar langatmig: 'Für die ungehinderte Ausübung der öffentlichen Meinungs- und Äußerungsfreiheit' oder so ähnlich. Der Festgenommene hatte nämlich RAF-Flugblätter mit dem Aufruf zum Attentat verteilt. Aus Zehntausenden von Kehlen donnerte es nun: 'Eins-zwei-drei / Lasst die Leute frei!!!' Es war aber nur einer. (...) Ich nahm ein Taxi, fuhr zum Hotel. Dort rauchte ich ein paar Zigaretten, wusste nicht weiter. (...) Ich las die Flugblätter, die man mir zugesteckt hatte. Der übliche Schmäh. Die Reichen beuteten die Armen aus und so weiter. Das hätten die Armen gern, dass sie noch einmal, und sei es ein letztes Mal, so schön ausgebeutet würden wie in den guten Zeiten. Damals, als es noch Straßen und Telefone gab in Afrika. Geschäfte in Somalia, Handelsvertreter in Mosambik, Ärzte am Cap Anamur, die Deutsche Welle in Algerien. Alles vorbei. Der Kapitalismus braucht die Dritte Welt nicht mehr, auch die Zweite nicht, auch die vielbeschworenen Rohstoffe nicht wirklich – aber in dem Flugblatt war man noch in den Siebzigern, als nicht nur die Idioten plötzlich an ´das Öl´ zu glauben begannen, oder an ´den Goldpreis´. Ich griff zu einem Blatt von Robin Wood, wo es wieder um den deutschen Wald ging und nicht um die Abholzung des Amazonas. Teufel auch, unser Waldbestand hat sich seit Siegfried und Kunigundes Zeiten praktisch nicht verkleinert, während in Brasilien jährlich eine Fläche von halb Europa verschwindet, einfach so, abgefackelt, ohne Sinn und Verstand. (...) Endlich ein gelungenes Flugblatt: ´Je länger Kapitalismus, desto mehr Dreck auf der Welt!´ So lautete die Überschrift. Und dann wurde in knappen, unverbrauchten, lebendigen Worten gezeigt, dass einzig unser Wirtschaftssystem, unser lieber Kapitalismus, die Welt zerstört. Kein Politiker, kein böser Unternehmer, keine falsche Pfandflaschenverordnung, kein verantwortungsloses Kind, das sein Kaugummipapierchen achtlos wegwirft, nein, keineswegs. Und so wird als einzige Forderung am Ende nur ein neues Wirtschaftssystem verlangt. Klasse. Ich las noch die wirklich schöne Zeile ´Jugend, Hand in Hand für eine saubere Welt und eine saubere Zukunft´." (LOTTMANN 2001, S. 18 - 23)

Es ist auffällig, dass sich politische Flugblätter bis heute oftmals nicht sehr ansprechend geben. Bezüglich der 68er lautete ein Vorwurf, dies sei dem Jargon der jeweiligen Gruppierung geschuldet. Brunotte kommt in ihrer Untersuchung zu dem Schluss, dass sich hinter diesem Vorwurf nicht selten wenig mehr als Ressentiment gegenüber der politischen Ausrichtung und eine Aversion gegenüber Fremdwörtern verbirgt. (VGL. BRUNOTTE 1973)

Nicht zuletzt mag der Vorwurf aber auch mit der Ablehnung der durchaus auch kruden Argumentation, mit der politische Flugblätter teilweise aufwarteten, verbunden sein. Was jedoch die oftmals mindere ästhetische Qualität der Flugblätter jener Zeit betrifft, so ist auf die im Vergleich zu heute schlechteren Vervielfältigungsmöglichkeiten zu verweisen.

Heute wie damals kann jedoch bei oberflächlicher Betrachtung geradezu ein Unwille zur Gestaltung von politischen Flugblättern (politische Plakate sind ein anderes Thema!) vermutet werden. Die Reduzierung auf den Informationsgehalt kann jedoch mehrere Gründe haben.

Andrian Kreye beobachtete in New York, dass die Gestaltung oftmals von jener Person übernommen wird, die über die beste Hard- und Software verfügt, was nicht notwendig mit einem gesteigerten Interesse an Graphik-Design einhergeht. (VGL. KREYE 2003) Gleichsam erlauben ein gewisser Zeitdruck und insbesondere eingeschränkte finanzielle Mittel nicht mehr als visuell einfach gestaltete Pamphlete. Dass in politischen Gruppierungen sehr wohl gestalterische Kompetenz vorhanden ist, belegen nach Hitzler u.a. entsprechende Internetauftritte, welche vergleichsweise geringen Produktionskosten unterliegen. (VGL. HITZLER U.A. 2001, S. 149-161)

Hinzuweisen ist abschließend noch auf den Umstand, dass politische Gruppen wie z.B. Antifa durchaus Flyerähnliches produzieren, wobei diese Medien – Spuckies, Aufkleber, kleine Handzettel – eher selten Partytermine bekannt geben, sondern Demotermine, Hotlines oder Slogans transportieren (z.B. "If I had a hammer...I'd SMASH Patriarchy", "Class War – just do it" oder "Vergewaltiger wir kriegen Euch"). Hier wird teilweise mit denselben Methoden wie beim klassischen Party-Flyer gearbeitet. (BOOTLEGGING ETC.)

Im Folgenden wird von in erster Linie politisch motivierten Gruppen und politischen Flugblättern nicht mehr die Rede sein. Unser Augenmerk richtet sich fortan hauptsächlich auf das Medium Flugblatt im Zusammenhang mit Jugendkultur und Musik; denn hier entspringt eine prägende ästhetische Entwicklung.

3.3 PUNK-FLYER

"Masterpieces of primitive graphic design or scruffy naive folk art? Whatever. You decide, but which-ever way you look at it, these flyers tell the story of the ascent of the Anybody-Just-Do-It culture of the late '70s". (BRENDAN MULLEN IN TURCOTTE/ MILLER 1999, S. 64)

Das Aufkommen der Punk-Bewegung fällt ungefähr mit der Erfindung des Schwarz-Weiß-Fotokopierers (1975) zusammen. Was genau Punk war und ist, wird an dieser Stelle, wenn überhaupt jemals, nicht zu klären sein. Bezeichnenderweise tauchen in der zweiten Hälfte der 1970er weitere Genres wie Industrial oder New Wave auf, wobei sich etliche der damaligen Bands nicht ohne weiteres in eine bestimmte Schublade stecken lassen. Für Jello Biafra waren beispielsweise Bands wie Television, The Avengers und Devo Punk, da nichts zuvor vergleichbar gewesen sei. (VGL. TURCOTTE/MILLER 1999, S. 8)

Ein Motiv der Punk/New Wave-Vertreter der ersten Stunde war die dezidierte Ablehnung von Etabliertem und als überkommen Wahrgenommenem. Oder wie Frank Fenstermacher es im Gespräch formulierte, ihn habe an der Ästhetik des Punks die Umwertung der Werte interessiert. Frank Fenstermacher und Moritz R. unterhielten zu der Zeit in Wuppertal – wegen der niedrigen Mieten – die Galerie Art Atak. Die in diesem Zusammenhang entstandenen Flugblätter, die verschickt, in Fußgängerzonen verteilt wurden und in der Galerie auslagen, machten nicht nur auf Veranstaltungen aufmerksam, sondern auch auf Bands (z.B. Der Plan) und ihre Veröffentlichungen. Oder sie wurden als künstlerische Pamphlete verstanden. Sie bieten einen interessanten Einblick in die damalige Copy-Art. Die Auflage lag ungefähr bei 100 Stück, vervielfältigt wurden sie per Fotokopie (15-30 Pfennige pro Exemplar). Die Größe war hauptsächlich DinA4, einseitig bedruckt. (VGL. HIERZU AUCH TEIPEL 2001 U. TURCOTTE/MILLER 1999)

Von Vorteil ist, wie erwähnt, bei der Fotokopie die einfache, relativ billige und zeitsparende Handhabung, hinzu kamen jedoch technische Unzulänglichkeiten der neuen Technik, welche bewusst in Kauf genommen wurden (VGL. LANDEN 1998/99, S. 5F, U. POSCHARDT 1995, S. 205FF): "Und ich habe da auch immer so halb beabsichtigte Kopierkunst gemacht. Fotos aus dem NME abkopiert und verändert", so Peter Hein: "Damals waren die Kopierer noch geil, weil die nicht so gut waren, sondern teilweise machten, was sie wollten." (ZIT. NACH TEIPEL 2001, S. 39)

Jello Biafra äußert sich ähnlich erhellend: "A good punk flyer will grab your attention, make you laugh, or piss you off - hopefully, all at the same time. Flyers had to be done quickly. Band names and the Mabuhay Gardens logo were cut out of old flyers and reused on the next. It was instant, it was cool. It was a hell of a lot of fun". (JELLO BIAFRA IN TURCOTTE/MILLER 1999, S. 8F; VGL. EBD.)

Mit dem nicht zuletzt durch eine gewisse Trivialisierung bedingten Ende dieser Ära habe der Handzettel als Informationsmedium an Bedeutung verloren: "Es gab keine große Jugendbewegung mehr, die Zielgruppen waren zu zersplittert, die Party-Kultur am Ende." (LANDEN 1998/99, S. 6; VGL. EBD. U. TEIPEL 2001)

Nicht unerwähnt sollte jedoch bleiben, dass Flyer auch für die sich formierende Hip-Hop-Szene von Belang waren. So wurden 1977 anlässlich eines Auftritts von Kurtis Blow mit Grandmaster Flash 15000 Flyer verteilt. Eine substantielle Auseinandersetzung mit diesem Thema scheint allerdings noch auszustehen. (VGL. POSCHARDT 1995, S. 196FF)

3.4 TECHNO/HOUSE

"Acid-House war die erste Dancefloor-Bewegung in Europa, die sich auf Massenbasis durchsetzen konnte. (…) Nach Punk war die Dancefloor-Szene die nächste große Teenage-Revolte in Europa." (POSCHARDT 1995, S. 282 U. 285)

Jörg Landen hat herausgestellt, dass die Entwicklung des (Party-)Flyers eng mit der von Techno/House verbunden ist. Ende der 1980er wurden die Partyankündigungen auf Handzetteln mit ihrer eigenen Sprache so populär, dass der Begriff Flyer untrennbar mit der Techno/House-Kultur verbunden war. Was mittlerweile nicht mehr der Fall ist. Die betreffende musikalische Entwicklung ist daher hier zu skizzieren.

House war zunächst kein Massenphänomen. Anfang der 1980er in New York und Chicago entwickelt und benannt nach einem Gay-Club - "Warehouse" - in Chicago, wird House als Reaktion auf die als verfahren angesehene Situation von Disco beschrieben. (VGL. POSCHARDT 1995, S.240)

1982 konzipierte die Firma Roland die TB 303. Es handelte sich um einen monophonen, analogen Bass-Synthesizer, kombiniert mit einem Sequencer. Das Gerät verfügte über eine Keyboard-Oktave und sechs Drehknöpfe, "mit denen man in Echtzeit die Basslinie modulieren konnte". (LANDEN 1998/99, S.7) Die TB 303 war in erster Linie konzipiert für Alleinunterhalter, allerdings war das Gerät teurer (ca. 800 DM) als ein E-Bass und habe zudem überhaupt nicht wie einer geklungen. Der Verkauf verlief eher schleppend. Roland stoppte nach 18 Monaten die Produktion. Der Legende nach habe irgendwann Mitte der 1980er ein Exemplar in einem Secondhandladen in Chicago herumgelegen. Ein gewisser DJ Pierre habe es schließlich erstanden und zuhause begonnen, damit zu experimentieren: Solche Töne hatte er und mit ihm die Welt noch nicht gehört.

Zusammen mit zwei Freunden erarbeitet DJ Pierre "Acid Trax": Ein Stück, das einem neuen Stil den Namen gibt und schon Kultstatus erlangt habe, bevor es 1987 überhaupt erst auf Vinyl gepresst wird. (VGL. EBD., S.282F, U. LANDEN 1998/99, S.6FF)

Es entspricht dem Wesen der Legende, dass sie nicht mit allen verfügbaren Fakten in Einklang steht, es sei daher daraufhingewiesen, dass die ehemaligen Throbbing Gristle-Mitglieder Chris Carter und Cosey Fanni Tutti als Chris & Cosey 1983 die erste bekannte Aufnahme veröffentlichten, auf der die TB 303 zu hören gewesen sei. Der Kreis, welcher schon vor 1986 mit diesen Klängen vertraut war, dürfte allerdings recht übersichtlich gewesen sein. (VGL. KLEINHENZ 1995, S. 90)

Vornehmlich englische Touristen waren es, die Mitte der 1980er Ibiza zur schwer angesagten Party-Location werden ließen. Viele DJs, die auf der Insel feierten, wurden durch die Sets von DJ Alfredo im Club "Amnesia" zum ersten Mal mit Acid-House konfrontiert. Unter ihnen befanden sich Danny Rampling und Paul Oakenfold; sie nahmen nicht nur einen neuen Sound, sondern auch eine neue, nicht zuletzt durch Drogen bedingte Atmosphäre unter den Feiernden wahr. Acid-House und Ecstasy seien dann im Gepäck der DJs von Ibiza nach England gelangt. (VGL. LANDEN 1998/99, S. 7, U. SCHÄFER U.A. S. 45, 172F, 284F) Rampling gründete im Herbst 1987 den "Shoom"-Club in London, kurz darauf eröffnete in Manchester mit der "Hacienda" der zweite wichtige Club für die neue Szene.

1988 kam es in England zum Acid-House-Boom, wobei das Phänomen nicht auf die Insel beschränkt blieb. Zum Symbol für dieses Phänomen wurde der "Smiley", er zierte ab 1988 die Poster und Flyer des "Shoom"-Clubs. Als die Clubs zu klein wurden, wich man auf Wiesen oder in Lagerhallen aus. Raves etablierten sich. Zum Ende des Jahres war der unbekümmerte Spaß vorbei. Begleitet von massiven Pressekampagnen begann die Polizei rigoros einzugreifen. Es kam zu Massenverhaftungen und Razzien, Raves wurden gesprengt, die Anlagen konfisziert. Die Szene sah sich gezwungen, in den Untergrund auszuweichen.

Dieser Schritt bedingte - so Landen - die "Geburtsstunde des Flyers" (LANDEN 1998/99, S. 9) als unverzichtbares Informationsmedium der Szene. Allerdings kursierten schon vor diesem Umbruch Flyer, die für Londoner Clubs warben oder zu Veranstaltungen einluden, so dass die von Landen sogenannte Geburtsstunde vielmehr einen Evolutionssprung markiert. Einen Überblick britischer Flyer von 1983 bis '96 bietet der Band "Fly – The Art Of The Club Flyer". (ACKLAND-SNOW U.A. 1996)

Da die Polizei in England ab 1988 verstärkt nach Warehouse-Parties, Raves etc. fahndete, musste für diese Veranstaltungen auf eine für Behörden und die Krawallpresse nicht oder nur schwerlich einsehbare Weise geworben werden. Dazu wurden häufig handgemachte, einseitige, schwarz-weiß kopierte Zettel in nur Eingeweihten bekannten Orten (Bars usw.) - oft als Einladung - an Auserwählte verteilt. Diese Flyer wiesen keine Sponsoren und, weil es sie noch nicht gab, keine Stars aus. "Der Flyer war nicht nur das wichtigste Informationsmedium der Szene, er hielt sie praktisch am Leben." (EBD., S. 9; VGL. POSCHARDT 1995, S. 284FF) Sie standen, wie Sarah Thornton unterstreicht, am Anfang der Informationskette, die dann durch Mundpropaganda, Fanzines etc. verlängert wurde. Flyer waren für Veranstalter der effektivste und preisgünstigste Weg, um die angepeilte Zielgruppe zu erreichen. Ob dies noch immer der Fall ist, darf bezweifelt werden. (VGL. THORNTON 1996, S. 141)

Nachdem um 1990 der Acid-House-Boom in Europa verebbt war, war auch die illegale Phase vorbei. Natürlich gab und gibt es nach wie vor illegale Veranstaltungen, allerdings sei nach dem Ende von Acid-House die Bewegung als erledigt betrachtet worden, und man erlaubte wieder Veranstaltungen, die man zuvor (u.a. wegen des Drogenmissbrauchs) zu unterbinden suchte.

Anfang der 1990er vergrößerte sich die Zahl der Clubs, in Deutschland etablierten sich Veranstaltungen wie die "Mayday" und die "Love Parade". Techno und House entwickelten sich weiter. Gleichzeitig wurden die Möglichkeiten der Flyergestaltung größer. Computer und Software wurden erschwinglicher. Flyer erschienen als vierfarbige Hochglanzdrucke und z.T. periodisch, da regelmäßig Veranstaltungen stattfanden. Die Auflagen waren noch immer niedrig, Sponsoren finden sich nicht auf ihnen, jedoch beginnt um 1992 z.B. die Zigarettenindustrie sich für die Bewegung zu interessieren.

Ein bis zwei Jahre später sind Techno und House definitiv im Mainstream angekommen. Stars, wie Marusha und Westbam, etablieren sich. Die Musik richtete sich in den Charts ein, "alles funktionierte mit Musik-Video und entsprechender BPM-Zahl". (LANDEN 1998/99, S. 10) Wegen der nun hohen Anzahl von Clubs und Veranstaltungen mussten Flyer immer ungewöhnlicher werden, um aufzufallen: Bootlegs tauchten auf, die Möglichkeit, ungewöhnliche Flyer-Formate (Shapes) herzustellen, wurde billiger, gleiches galt für die Verwendung von Sonderfarben. Ebenso zu erwähnen sind Objekt-Flyer, also Materialien wie z.B. Leiterplatten, Streichholzheftchen, Smarties-Dosen etc., welche die Was/Wann/Wo-Daten transportieren. (VGL.; GOER 2000A/B/C; LANDEN 1998/99; POSCHARDT 1995, S. 238-289; THORNTON 1996, S. 137-151)

Es ist festzuhalten, dass die unterschiedlichen ästhetischen Merkmale nicht einander abgelöst haben, sondern vielmehr zu einem Nebeneinander der Stile führten. So greifen Designer nicht ausschließlich aus finanziellen Gründen auf ältere Methoden der Gestaltung (z.B. Copy Art) zurück, sondern weil sich durch die Flut der Hochglanz-Zettel derartige Distinktions-Strategien aufdrängen.

Außerdem gilt natürlich für private und/oder illegale Partys, dass hierfür - schon aufgrund der fehlenden Sponsoren - auf die preisgünstigste Art Flyer hergestellt werden: oftmals kleine kopierte Zettel oder Laserdrucke.

Abschließend ist hier kurz auf den Umstand zu verweisen, dass Emails oft eine preisgünstigere und effektivere Variante darstellen, um auf eine Veranstaltung aufmerksam zu machen. Sodass die These u.E. nicht aufrechterhalten werden kann, dass der klassische Party-Flyer für z.B. Club-Betreiber das effektivste und billigste Mittel ist, um eine gewisse Zielgruppe für einen Event zu gewinnen; was wiederum nicht notwendig das Verschwinden des Flyers aus den Bars, Plattenläden und Fußgängerzonen bedeuten muss.

4. SCHLUSSBEMERKUNG

"Unten steht ein Zigarettenautomat mit Plastikmahagonifurnier. Ich ziehe eine Packung, der Automat wackelt, und stapelweise Flyer fallen herunter, denen man auch auf den zweiten Blick nicht ansehen kann, ob sie jetzt für einen illegalen Club, eine Tanja-Dückers-Lesung oder eine Fistfuckparty der Green Berets werben. So unübersichtlich ist das alles, in einer fremden Stadt."

(HERRNDORF 2002, S. 79)

Es nützt nichts, Flyer sind allgegenwärtig, alle möglichen Formen finden sich nach wie vor in Platten-läden, Kneipen, auf den Böden nach Konzerten, in Bars, Clubs und Fußgängerzonen. Neben jenen Exemplaren, die nur auf eine einzige Veranstaltung aufmerksam machen, tragen auch Programm-Flyer (für z.B. Festivals) seit Jahren ihren Teil zur Flut bei. Hinzu kommt, dass sich im allgemeinen Sprachgebrauch der Begriff Flyer für jedweden Werbezettel bewährt hat, der einem so auf dem Weg zum Bus zugesteckt wird oder den man im Briefkasten vorfindet. So bezeichnet Bernd Graff in einem Text über Armbanduhren-Werbung (VGL. GRAFF 2003) den besprochenen Prospekt unumwunden als "Falt-Flyer". Exemplarisch kann dieser Umstand auch am Phänomen Wahlwerbung betrachtet werden.

Dass aufgrund elektronischer Kommunikationsmöglichkeiten in absehbarer Zeit Club- oder andere Party-Flyer verschwinden werden, wird von Sammlern als auch von Grafikern nicht erwartet.

Es scheint fast unnötig zu betonen, dass aufgrund des inflationären Gebrauchs des Begriffs als auch des Mediums Flyer der Gegenstand seine Faszination und Bedeutung für Sammler und Clubgänger nicht eingebüßt hat. Sie verfügen jedoch nicht über die Definitionsmacht. Der Begriff hat seine Trennschärfe verloren: "An einem stillen, heißen Sonntag verließ ich Smolensk. Es war früh am Tag, die Hoteltür fiel ein letztes Mal hinter mir zu, und drüben bei Görings Hirsch standen wieder die beiden Stalinisten und verteilten ihre Stalin-Flyer."

(BÜSCHER 2003, S. 183)

Oliver Schweinoch

LITERATUR:

ACKLAND-SNOW, NICOLA; Brett, Nathan; Williams, Steven 1996: Fly - The Art Of The Club Flyer. London: Thames and Hudson.

ADORNO, THEODOR W. 1994: Minima Morali". Frankfurt/Main: Suhrkamp.

ARENDT, HANNAH 1993: Besuch in Deutschland. O.O.: Rotbuch.

DIES. 2000: Elemente und Ursprünge totalitärer Herrschaft. München: Pieper.

BACH, ULRICH 1997: Englische Flugtexte im 17. Jahrhundert. Heidelberg: Universitätsverlag C. Winter.

BEST, OTTO F. (Hg.) 1974: Expressionismus und Dadaismus. (Die deutsche Literatur. Ein Abriß in Text und Darstellung. Band 14. Hrsg. von Otto F. Best u. Hans-Jürgen Schmitt.) Stuttgart: Reclam.

BOCKRIS, VICTOR U. MALANGA, GERARD 1988: up-tight. Die Velvet Underground Story. Augsburg: Sonnentanz-Verlag.

BRUNOTTE, BARBARA 1973: Rebellion im Wort. Frankfurt/Main: dipa-Verlag.

BÜSCHER, WOLFGANG 2003: Berlin - Moskau. Eine Reise zu Fuß. Reinbek bei Hamburg: Rowohlt.

DIE GESTALTEN (Hg.) 1998: Flyermania. Berlin: Ullstein.

DIEDERICH, REINER U. GRÜBLING, Richard 1978: `Unter die Schere mit den Geiern!´ Politische Fotomontage in der Bundesrepublik und Westberlin. Dokumente und Materialien. Berlin: Elefanten Press.

DÜSEL, HANS HEINRICH 2001: Die sowjetische Flugblattpropaganda gegen Deutschland im Zweiten Weltkrieg. Leipzig: Leipziger Universitätsverlag.

FREI, NORBERT 2000: Von deutscher Erfindungskraft oder: Die Kollektivschuldthese in der Nachkriegszeit. In: Gary Smith (Hg.): Hannah Arendt Revisited. Frankfurt/Main: Suhrkamp, S. 163-176.

GOER, CHARIS 2000a: Elektronische Musik. In: Metzler Lexikon Kultur der Gegenwart. Hrsg. von Ralf Schnell. Stuttgart; Weimar: Metzler, S. 110f.

DERS. 2000b: Popmusik. In: Metzler Lexikon Kultur der Gegenwart. Hrsg. von Ralf Schnell. Stuttgart; Weimar: Metzler, S. 421f.

DERS. 2000c: Techno. In: Metzler Lexikon Kultur der Gegenwart. Hrsg. von Ralf Schnell. Stuttgart; Weimar: Metzler, S. 502f.

GRAFF, BERND 2003: Werbung. In: Süddeutsche Zeitung vom 14./15.06.2003.

HAARMANN, HARALD 1998: Universalgeschichte der Schrift. Sonderausgabe. Frankfurt/New York: Campus.

HERRNDORF, WOLFGANG 2002: In Plüschgewittern. Frankfurt/Main: Haffmans bei Zweitausendeins.

HITZLER, RONALD; BUCHER, THOMAS U. NIEDERBACHER, ARNE 2001: Leben in Szenen. Formen jugendlicher Vergemeinschaftung heute. (Erlebniswelten Band 3. Hrsg.

von Winfried Gebhardt, Ronald Hitzler u. Franz Liebl) Opladen: Leske + Budrich.

HUELSENBECK, RICHARD 1991: Mit Witz, Licht und Grütze. Auf den Spuren des Dadaismus. Hrsg. von Reinhard Nenzel. Hamburg: Edition Nautilus.

JASPERS, KARL 1946: Die Schuldfrage. Heidelberg.

KIRCHNER, KLAUS 1974: Flugblätter. Psychologische Kriegsführung im Zweiten Weltkrieg in Europa. München: C. Hanser Verlag.

KLEINHENZ, JOCHEN 1995: Industrial Music For Industrial People. In: Testcard: Pop und Destruktion. Oppenheim: Testcard-Verlag, S. 88-99.

KREYE, ANDRIAN 2003: Die Botschaft der Ikonen. In: Süddeutsche Zeitung v. 22.4.2003.

LANDEN, JÖRG 1998/99: Phänomen Flyer: Von der Illegalität zum Kommerz. Diplomarbeit/EMMA Final Project. Merz-Akademie Stuttgart. http://www.techno.de/flyer/download/Flyer.pdf

LOTTMANN, JOACHIM 2001: Deutsche Einheit. Ein historischer Roman aus dem Jahr 1995. München: Diana.

MENNE, INKA 2000: Im Land der Schriften. Diplomarbeit. Fachhochschule Potsdam.

POSCHARDT, ULF 1995: DJ-Culture. Hamburg: Rogner & Bernhardt bei Zweitausendeins.

SCHÄFER, SVEN; SCHÄFERS, JESPER; WALTMANN, DIRK 1998: "Techno Lexikon". Berlin: Schwarzkopf & Schwarzkopf.

SCHÜDDEKOPF, CHARLES (Hg.) 1990: `Wir sind das Volk!' Flugschriften, Aufrufe und Texte einer deutschen Revolution. Reinbek bei Hamburg: Rowohlt.

SÜDDEUTSCHE ZEITUNG v. 21.03.2003: Bomben im Halbstunden-Takt. München.

TEIPEL, JÜRGEN 2001: Verschwende Deine Jugend. Frankfurt/Main: Suhrkamp.

THORNTON, SARAH 1996: Club Cultures. Music, Media and Subcultural Capital. Hanover: Wesleyan University Press.

TURCOTTE, BRYAN RAY U. MILLER, CHRISTOPHER T. 1999: Fucked Up + Photocopied. Instant Art Of The Punk Rock Movement. Corte Madera, CA: Gingko Press.

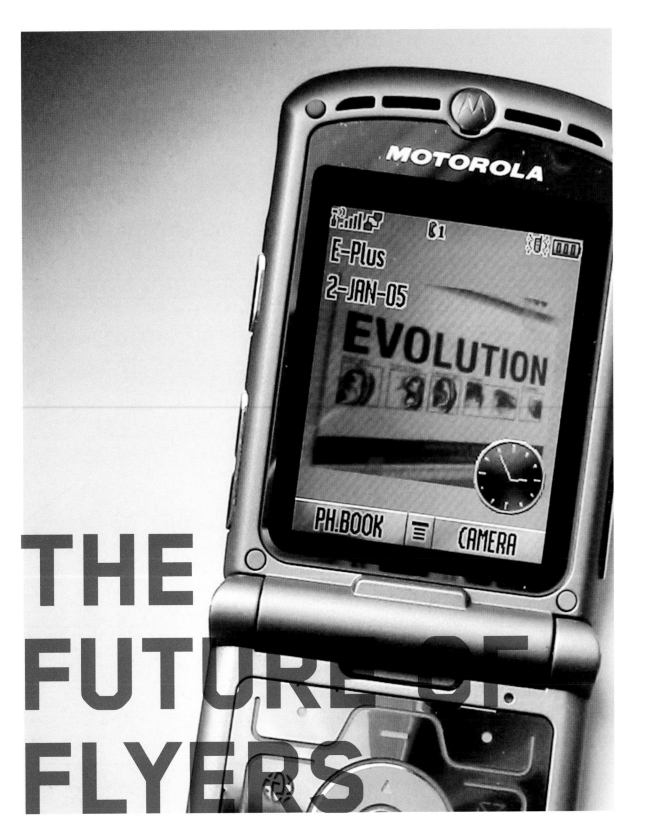

THE FUTURE OF FLYERS

WHERE ARE MY FRIENDS RIGHT NOW?

In the near future, with considerable technical support, it will be possible to get a precise answer to this question. At any time of day or night, you will be able to get the details displayed on your mobile device - be it a PDA (personal digital assistant) or a UMTS/GPRS cellphone, visualized as a card or a message like "at home", "club X", "bar Y". All you need to do then is request a rating of the club/venue by SMS, giving you access to any flyers that exist for the event and maybe even allowing you to "listen in" via direct broadcast. The context-sensitive merging of information available online, including audio and mail links, with the potential of mobile computing and mobile communications is what makes this kind of scenario conceivable. This could lead to new forms of decision-making in scene- and venue-based flyer culture. "Gate 5 AG" is a company that develops software for interactive maps, plus communication systems for applications of this kind. If you are looking for an address, websites like "stadtplandienst.de" give you a street plan of the place in question. From here, it is only a short step to a digitally enhanced flyer fed with global positioning data (GPS) and combined with services like "Keyhole.com" (recently acquired by Google) that displays original satellite images of a requested location. Type the location into your car's navigation system and off you go.

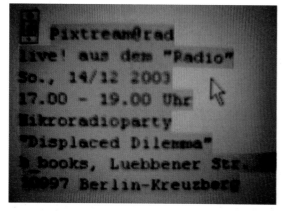

Peer groups can decide to use these new technologies to strengthen their ties and make better organized use of the time available. In the future, besides looking after their PR mailing lists and webpages, promoters will order multimedia-capable flyers from graphic designers that integrate features such as links to a sound or background information about the artist and label as 'mouse on over' into the image and that work as a kind of homepage or micro-site. Besides details of the event in question, clubs like Maria in Berlin include a "tell a friend" e-card function as a multiplier.

Another feature to be reckoned with is the "buy now" button that allows immediate purchase of existing products (be it tracks, recorded music or other merchandise). Expect to see such systems installed in urban zones like London, or in party and vacation paradises like Ibiza. Through their great popularity and affinity to sponsors, clubs like Ministry of Sound, Amnesia, Cocoonclub or Pacha could extend their already complex media activities to add extra value. Club radio, newspapers and TV will be integrated into the nightclub business. At the very least, heavily net-based service providers like online ticket shops or city guides will offer the promoters such packages. Which in turn will alter the business models of clubs, that are now mostly based on beer sales. As soon as performing at a club leads to measurable media coverage, and even increased sales, club owners are in a stronger position when negotiating with artists, who in turn will argue with certain considerations of scarcity and copyright: the booking contracts of the future will be very precise about which measures are allowed and/or expected in connection with a given performance.

For the time being, this future is hard to implement because the necessary investments are not yet likely to pay off. But it could soon become the standard scenario: when partygoers universally equipped with always-online devices and flat rates come together with a fast and easy method of payment; when promoters rethink their alliances with media and services; when the first graphic designers, artists and labels successfully demonstrate the creative and commercial potential of these new tools; and finally and all-importantly, when the critical and cost-sensitive users start to play along and acceptance for the services on offer grows. To achieve this, the new advertising "materials" must be sticky and sexy: an added, cool way to explore the output of a given artist that combines the old with the new in context-sensitive and intelligent ways. Since more and more artists are now enhancing their shows with video art and giving their performances the character of happenings, since DVD and the Internet are already established standards, and since merchandise has long since gone far beyond band t-shirts, the stars of the future will learn to use all the options available. Multimedia pioneers - bands like The Residents, clubs like WMF, or the artists associated with the UK's Warp label - may develop entirely new ideas that make more radical and durable use of the immersive environment. If this coincides with the necessary fresh breeze of psychoacoustics (which is to be expected) and if new designer drugs emerge, flyer culture and the music and club culture that surround it could become what science

Since 1998 klubradio does netcasts from famous clubs in Berlin, larger events like loveparade or mayday, and of course smaller parties.

Did you miss it?

fiction has always promised: a trip to another dimension. But it is also clear that none of this has to happen: the basics - the right place at the right time with the right people - will always remain as the key party factor.

BLUE TEETH

Just imagine: when you arrive in the club of your choice, in the scene where you feel at home, a list of invitations appears on a display and you are immediately supplied with a range of places to go next - be it the afterhours party or the next performance by the evening's acts. You too send your 'message to the people' to the local Bluetooth mobiles or WLAN portables and can rest assured that everyone (at least in theory) has been informed: no need to distribute flyers, no person-to-person handover, and no more appealing to the sense of touch with an actual object. For many people, all this is just a drag anyway. And then there is the possibility of getting in touch directly with the organizers or acts, as well as the above-mentioned extended search options. At the 'digital check-in' (realized as early as 1998 with Prontophot devised by the Monitor Automatique media group, where every guest was integrated into an automated video loaded with images from the flyer that ran in real time on the club's screens), each guest supplies a picture and all relevant data, that are then available on the local mail server for access by "all devices".

EVERYONE'S DOING IT ALL THE TIME

Intelligent clothes with integrated displays could make the event organizers and promoters of tomorrow into walking billboards. Infrared, wireless and Bluetooth make every communicator into a broadcaster. Whether or not this spam is wanted or tolerated depends heavily on the place, the subject and the context. What passes for communication-enhancing in a business-to-business context (e.g. at trade fairs), may be taboo within a hip scene. But this option is sure to be tested out nonetheless. The companies that acquired expensive UMTS licenses for 3G mobile services are now desperately searching for new ways of using these technological networks. In the socially demanding mechanisms of the scenes of tomorrow, this cultivation of new technologies is an aspect that will certainly play a role, whether positive or negative. The real underground (i.e. scenes where radically new music is joined by radical patterns of consumption, opinions and illegal locations) will of course stick to the guiding principle of punk: use no mass media, do it yourself. Because the potential for external monitoring, the cost of these services, and the threat of technical dependency can certainly be understood as a loss of autonomy.

EVERYTHING IN MOTION

TV in subway trains will tell people about the evening's concert on their way there. As they come in to land, planes will tell passengers about the hottest parties in town. MMS services will bring the night's flyers to cellphones on demand. From there, they are passed on to friends. In a word, the net is going mobile.

Apple's iTunes platform, that offers several million titles for sale, and over 100 other digital music outlets on the Internet will try to stand out from the crowd by means of unusual marketing activities. Besides live events and their official/exclusive coverage, this will include event info services and context information. Flyers communicate the image of these events, acting as the covers, portals, interfaces or homepages of the night in question; if there is enough interest, they can then be passed on to others via a whole range of media.

From the kind of instantly recognizable comic designs and illustrations supplied for events by the Dutch flyer designer Dadara, we are not far removed from animated flyers. For years, the 'Aufschwung Ost' and 'Stammheim' clubs in Kassel also worked with the amusing characters created by Bringmann and Kopetzki, who also drew the best known comic raver, Hotze in Groove magazine, who had fans laughing until they cried.

Dadara (with Fools Ark) and Jim Avignon have also moved into animation, taking the step from flyer designer to filmmaker. Fools Ark documents an installation at the Burning Man Festival, becoming increasingly animated and free. Similar processes are occurring with a whole series of VJs like the Berliners at Pfadfinderei: having started out designing for club-related print media, they ended up doing set design (for MTV, among others) and developing CI for labels like BPitch Control. The group's current DVD is also well worth a look.

Besides the interior of Sven Väth's new club in Frankfurt, the designers at "3deluxe" also developed "Scape", a youth magazine for the Expo2000 worlds fair in Hanover. This internationally active team also designed all materials for the Big Warp and Time Warp events.

It is safe to assume that after music videos and VJing, the next step will be eveninglong films. Whether live or prerecorded, this form of club TV will appeal to a particularly interesting type of audience: clubbers, musicians, VJs and media workers of all kinds. The volume of the channel (i.e. by direct contact with a website only or for all households via cable) is only a question of its popularity. The "HighFLyer" video (bbb, Absolutmedien.de) that represents an early form of club TV, did similar things as early as 1997 at Munich's "Ultraschall" club.

The DVD by Berlin's Visomat collective focusing on the culture of VJing shows the state of the art. In their function as VJs at WMF, the Visomat team also dreamed up the Automatenbar, which actually anticipated some of the above-mentioned developments: videos and music mixes from a jukebox, surveillance via CCTV, Internet on tap via wireless and LAN, live webcasts of performances, access via chip card, organized as a nonprofit, with drinks, snacks and artworks sold from vending machines - everything the clubber's heart desires.

In its role as a cultural laboratory, Berlin has a tradition of spawning innovative club, media and community projects. The Berlin Digital DVD (2003) presents some of the local players like De:Bug magazine with its great subtitle "electronic aspects of life". Even Internet television projects like America's legendary Pseudo.com or Berlin's 'Freshmilk TV' platform will continue to view clubs as production locations. Music DVDs are already an established standard, as demonstrated in the scene by recent releases like International Deejay Gigolos No. 150 and Shitkatapult No. 50.

Flyer formats, then, are changing from A6 to Quicktime, from A7 to Flash. Print run and circulation statistics will be replaced by the number of addresses on a list. Cellphone mailing lists, eyeballs and WebVisits. The handover is replaced by visiting a mailbox and opening the attachment. Spam, worms and viruses will become increasingly hard to block, also in the field of Internet telephony. Beware: your next flyer could be a text-to-speech message on your answering machine. The multimedia activities of music TV channels like MTV and VIVA also indicate where things are going: "customized user-driven programming" for "special communities". TV with a feedback channel for voting and shopping. Uninterrupted reception via DVB-T, wireless or UMTS. Mobile, fast, colorful. As a general rule, everything is interactive. Except most media. Media lead to a castration of communication. Developing a decent substitute for real communication, or at least a cheap alternative, is the task of the communications designers of the future.

NETWORKED AND TRAPPED

The "Stadtnet" terminals and the Berlin Club Network (installed in 1994 as part of Berlin's digital city) that enabled chat-based communication between nightlife locations, live streams like Klubradio.de or Boombox.ch that transmit music from clubs into the Internet, and ticket sellers like Ticketmaster have already tested important basic possibilities for the use of new media, in some cases creating successful applications.

Vodaphone's "Musicfinder", that tells a caller the title and artist after "hearing" just a few seconds of a track, and services like Shazam, whose music database can decode a DJ set by artists and track regardless of pitching or mix, will soon improve the ability to identify music heard, with the (not insignificant) advantage of also making it easier to sell.

Sony Ericsson mobile live streaming, which in Finland is successfully demonstrating that IP-based live radio on mobile phones is technically and commercially feasible, or Nokia's long-standing integration of RealPlayer as media playback software in streaming-ready devices make it clear that sooner or later, it will be possible to experience any concert from a remote location at any time, either live or later.

Although they are hard to implement, the future probably belongs to projects like "123 Deutschland", a tourist information system on 100 German cities that never got out of the development phase, that was also meant to provide variable information like the programs of different venues, including book-

ing and reservation functions, and which was to have achieved omnipresence via termi-
nals at all local banks, Aral filling stations and Burger King restaurants.

"WildWildWeb", a now defunct service for third-party information providers launched
by the Berlin program magazine "Guide", and the "Pop Alliance", a conglomerate of info
providers that arose from the online services "Planetsound", "Tamito" and "Techno.de",
offer details of events from over 3000 promoters online. In the 90s, services like "Wild-
site.de" were already collecting this kind of variable information and processing it for
online use. Unlike the A6 booklet "Flyer", the city information association "Bewegung-
smelder" survived the New Economy crash and is likely to further pursue the idea of
developing and marketing information systems of this kind. Before being taken over by
the advertising distributor "Dinamix" in 2003, the "Tec 9" flyer distribution service also
digitized flyers to make them TV-compatible for BTX and Open Channel.

ALTER EGO

Flyers are identity-forming
media that act as fingerprints
for the entry of temporary
cooperations into society.
Identity and youth are central
themes in growing up. Using
"flyer" as a pseudonym for a
virtual identity is therefore an
interesting phenomenon, and
one that can be found in any
chatroom, dating service or
other online community. This
nickname is usually used by
(young) men, often combined
with their age or year of birth.
Boys are usually the more
active music listeners, fans
and DJs, meaning they also
often organize the parties and
events promoted by flyers. As
flyers are an excellent means
of communication, they also
facilitate real-world contact
with interesting females. Girls
follow the best music, the best

flyers, and (often) the most interesting boys. In other words, flyers can be a deluxe chat-up strategy with background information.

Although not yet especially powerful, the possibilities offered by WAP, imode and GPRS (data-intensive mobile phone protocols) have led to initial contact between information providers and telecommunications providers. The telcos are noticing that they need good, interesting content to satisfy

the many and varied interests of their target groups. Artists with star status like Sven Väth have long since begun to sell their own polyphonic ringtones through T-Mobile, while others like Richie Hawtin went through phases of rejecting live streaming. The relevance of such technophobia is also shown by the example of the Beastie Boys, who make their audience hand over all cellphones on the way into concerts for fear of illegal recordings or pictures. When they come, high-quality cellphones with earphone microphones with large disc capacity for bootlegs of live concerts will inevitably lead to mobile P2P. And what will be used as the cover for these bootlegs? Correct: the flyer for the event. Or maybe the screenshot from your cellphone?

At trade fairs like MIDEM Net, Milia, Popkomm, Internetworld or CeBit, the latest products are presented, and test markets are discussed and developed. Conferences like "Transmediale", with its own club, or "Musik und Maschine" are ideal specialist platforms for new approaches in club culture. Of course, Berlin is not the only city where the future of clubs is being examined. MUTEK (Montreal), Ars Electronica (Linz), Sonar (Barcelona), Doors of Perception (Amsterdam) and EMAF (European Media Art Festival) have also furthered, focused on, promoted and presented these issues.

Things get really futuristic when people's skin starts transmitting data, as shown by Tom Zimmermann (MIT). Then, flyers will be passed on by a handshake. In such a scenario, RFID chips (miniature chips that broadcast their information content) could play an ever-increasing role. Flyers become contagious, and when you take one, your electronic ink device tells you that there are two others stored on the chip. When media start trying to activate us via every possible channel, database-assisted super-profiling will become increasingly important, as will the measures for keeping this new form of micro-marketing at bay, e.g. filter technologies, security, and identity and spam protection.

THE FUTURE OF FLYERS

FLYERS THAT SMELL

Sure, this has already been done. For the launch of a new deodorant and the associated parties, brands like Axe and FA have worked with such tools. But perfumes and the organizers of themed parties will continue to periodically try out this kind of sensual marketing simply as a way of being different. Will robotics and nanotechnology ever advance far enough for flyers to make their own way to your house and knock at the door? Hardly. Although in Japan …

THANKS TO MY INTERVIEW PARTNERS:

Andreas Steinhauser / Gate 5 AG
Peter Krell / Gameface / Suct Design
Mirko Seifert / Techno.de
Ram51 / Heavy Industries
Sascha Wolf / Tec9
Pit Schultz / Klubradio.de

NEW PRODUCTS

SMS cigarette paper printer - SMS smokes printer
One apparently excellent idea is the possibility of equipping mobile phones with printers capable of printing text messages, calling cards, images or just a greeting onto cigarette paper. The glue strip makes the printout into a Post-It note and - as we now know - the right message in the right place at the right time has an unparalleled power of persuasion. At media breaks like this, entirely new potential emerges.

PUBLIC FLYERSCAN DATABASE

Central locations where you can upload your paper flyer to the heart of the regional media 24/7 using a publicly accessible scanner (on the ATM model) should become a standard. Features will include a: archives and b: collections of current information for transmission to requesting media.

INTERNET PLATFORMS

Partyflyer.com, an existing platform created by the Düsseldorf entrepreneur Jens Haffke as "the online drop-off point for all party flyers!", represents a logical implementation of the practice (common above all in English hardcore scenes and the Goa scene) of placing flyers at a central location.

The normal procedure when looking at flyers has been faithfully copied to the online version: users can view flyers, pick them up, turn them over, take one, show them to someone else, and collect them - all free of charge. The advantage is permanent accessibility and ordering by country, region, musical style and date. The flyers never run out. Added features of this international service, that is funded by event organizers, include search and community functions as well as PDF printouts.

FLYER SOZIOTOPE ARCHIVE 2005 ca. 250.000 Flyers

ZUR ZUKUNFT
DES FLYERS

WO SIND MEINE FREUNDE GERADE?

Diese Frage wird sich, stark technisch unterstützt, schon bald genau beantworten lassen. Zu jeder gewünschten Tag- und Nacht-Zeit kommt die Antwort aufs Display deines Mobiles – sei es ein PDA (Personal Digital Assistant) oder dein UMTS- und GPRS-Handy. Die Antwort erfolgt visualisiert auf einer Karte oder verkürzt in Form von Ansagen à la 'Home', 'Club X' oder 'Bar Y'. Danach reicht eine Anfrage per SMS, die den jeweiligen Aufenthaltsort bewertet, den – falls vorhandenen – Flyer zum Ereignis weiterleitet oder gar per Direktübertragung das 'Reinhören' ermöglicht. Die kontextsensitive Verschmelzung der im Internet verfügbaren Informationen inklusive zugehöriger Listen- und Mailkommunikation mit den Möglichkeiten des 'mobile computing' und der 'mobile communication' macht diesen Fortschritt denkbar. So kann rund um die szene- und ortbasierte Flyerkultur eine neue Form der Entscheidungsfindung entstehen. Die Firma 'Gate 5 AG' entwickelt Software für interaktive Strassen- und Stadtkarten sowie Kommunikationssysteme für Anwendungen dieser Art. Sucht man heute eine Adresse, kann man sich längst bei 'Stadtplandienst.de' den entsprechenden Ort auf der Karte zeigen lassen. Der Schritt ist kurz zum digital aufgemotzten Flyer, der mit Global Positioning Daten (GPS) gefüttert ist und kombiniert mit Diensten wie dem eben von Google gekauften 'Keyhole.com' das Original-Satellitenbild des Ortes anzeigt. Eintippen ins Navigationssystem deines Wagens und los geht die Reise.

Peergroups können sich zu diesen neuen Techniken entschließen, um ihre Bande zu vertiefen und die zur Verfügung stehende Zeit besser zu organisieren. Veranstalter werden künftig neben der Pflege ihrer PR-Verteiler und Webpages multimediafähige Flyer von den Grafikern anfordern, die beispielsweise den Link zum Sound oder zu den Artist und Label Backgrounds gleich als 'Mouse-over' in die Grafik integrieren und auch als Quasihomepage oder Microsite funktionieren. Clubs wie das 'Maria' in Berlin haben selbstverständlich neben den Veranstaltungsinformationen die E-Card-Funktion 'tell a friend', um diese zu multiplizieren.

Zu befürchten ist auch die 'buy now' Taste, die den sofortigen Kauf existierender Produkte (seien es 'Tracks', Tonträger oder anderer Merchandise) ermöglicht. Zu erwarten ist, dass in urbanen Gebieten wie London oder expliziten Party- und Ferien-

paradiesen wie Ibiza solche Systeme installiert werden. Clubs wie 'Ministry of Sound', 'Amnesia', 'Cocoonclub' oder das 'Pacha' könnten durch ihre hohe Popularität und Affinität zu Sponsoren ihre bereits existierende komplexe Medienarbeit erweitern, um den Mehrwert zu steigern. Clubradio, Zeitung und TV werden ins Nachtgeschäft integriert. Zumeist werden Zulieferer wie Online-Ticket-Vertriebe oder Stadtzeitungen, die schon stark netzbasiert arbeiten, diese 'Packages' den Veranstaltern anbieten. Diese werden auch die 'Business Models' der zumeist auf Bierökonomie basierten Cluborte verändern. Sobald der Auftritt in einem Club auch zu messbarer Aufmerksamkeit in Medien führt oder gar zu Verkäufen, steigt die Verhandlungsmacht der Betreiber gegenüber den Künstlern. Diese können wiederum gewisse Knappheits- und Copyright-Überlegungen anführen, und die Bookingverträge der Zukunft werden sehr genau formulieren, welche Maßnahmen auftrittsbegleitend erlaubt oder erwartet sind.

Noch ist diese Zukunft schwer realisierbar, da die erforderlichen Investitionen sich zur Zeit kaum rechnen. Aber schon bald könnte hier ein neuer Standard entstehen, wenn die Grundversorgung der Partygäste mit 'always online devices' und Flatrate zusammenkommt mit einer schnellen und bequemen Bezahlmethode, und wenn die Veranstalter ihre Allianzen mit Medien und Dienstleistern überdenken. Wenn die ersten Grafiker, Artists und Labels die kreativen und kommerziellen Möglichkeiten dieser neuen Tools erfolgreich vorführen und – schließlich und alles entscheidend - die kritischen und kostenempfindlichen User mitmachen und die Angebote angenommen werden. Hier müssen die neuen 'Werbemittel' eben sticky und sexy sein. Eine erweiterte unpeinliche Möglichkeit sich mit dem Output eines Künstlers zu beschäftigen, die kontextsensitiv und intelligent Altes mit Neuem verbindet. Da immer mehr Artists ihre Auftritte mit Videokunst und ihre Performances mit Happening-Charakter anreichern, da DVD und Web bereits Standards sind und Merchandise längst weit über das T-Shirt zur Band hinausgeht, werden die Stars der Zukunft mit allen Möglichkeiten lernen umzugehen. Multimedia-Vorreiter wie die Gruppe 'Residents', Clubs wie das 'WMF' in Berlin oder die Künstler rund um das englische Label 'Warp' werden hier vielleicht ganz neue Ideen entwickeln, die das immersive Environment nachhaltiger und radikaler nutzen. Kommt noch die notwendige Prise Psychoakustik (mit der zu rechnen ist) hinzu und entwickeln sich neue 'Designer Drugs', könnte die Flyerkultur und die sie umgebende Musik- und Clubkultur der Zukunft das werden, was Science-Fiction versprochen hat: A trip to another Dimension. Klar ist aber auch, dass all dies nicht sein muss. Denn die Basics – der richtige Ort mit den richtigen Leuten zur rechten Zeit – werden zentrale Partyfaktoren bleiben.

BLAUE ZÄHNE

Man stelle sich vor, dass bei der Ankunft im Club deiner Wahl, in der Szene, die dir behagt, eine Liste von Einladungen auf deinem Display erscheint und du sofort die Folgeveranstaltung – sei es die 'After Hour' oder den nächsten Auftritt der aktiven Künstler – parat hast. Du selbst sendest deine 'Message to the people' ebenso auf die lokalen Bluetooth Mobiles oder WLAN Portables und kannst beruhigt sein, das jeder – zumindest theoretisch – informiert ist. Weg fallen das Auslegen der Flyer, der persönliche Akt der Übergabe und natürlich auch das Haptische des Objekts – für viele ohnehin nur Ballast. Hinzu kommen die Möglichkeiten direkt mit dem Veranstalter oder Artist in Kontakt zu treten und oben angesprochene erweiterte Rechercheoptionen. Man gibt also beim 'Digital Check-In', wie es der 'Prontophot' der Mediengruppe 'Monitor Automatique' bereits 1998 tat (jeder Gast wurde in ein automatisiertes mit Images des Flyers gestaltetes, vorbereitetes Video eingearbeitet, dass in Realtime auf den Clubscreens läuft), neben seinem Bild auch seine Daten ab, die daraufhin auf dem lokalen Mailserver für 'all-devices' abrufbar werden.

ALLE TUN ES IMMER

Intelligente Kleider mit integrierten Displays könnten die Veranstalter oder Promoter von morgen zu wandelnden Litfaßsäulen machen. Infrarot, Wireless und Bluetooth machen jeden Kommunikator zum Sender. Ob dieser 'Spam' gewünscht oder toleriert wird, ist natürlich stark abhängig vom jeweiligen Ort, Anlass und Rahmen. Was im Business-to-Business- Bereich (z.B. bei Messen) als Kommunikationsförderung verstanden werden kann, wird in der Szenekultur möglicherweise auch tabuisiert; aber sicherlich wird diese Option ausgetestet werden. Die UMTS- Lizenznehmer suchen verzweifelt nach neuen Einsatzfeldern für ihre teuer erworbenen technologischen Netze. Diese Kultivierung neuer Technologien ist möglicherweise in den sozial anspruchsvollen Regelwerken der Szenen von morgen ein Aspekt, der – ob Anti

oder Pro - in jedem Fall eine Rolle spielen wird. Wirklicher Underground (also Szenen, an denen zur radikal neuen Musik auch radikale Konsumgewohnheiten, Meinungen und illegale Orte kommen) wird natürlich einen Hauptsatz des Punk beherzigen: 'Benutze keine Massenmedien: DIY (do it yourself)'. Denn die Kontrollmöglichkeiten durch andere, die Kosten dieser Services und die drohende technische Abhängigkeit sind durchaus auch als Autonomieverlust verstehbar.

ALLES BEWEGT SICH

U-Bahn-Fernsehen wird schon im öffentlichen Verkehrsmittel auf das angestrebte Konzert verweisen. Beim Landeanflug werden die Flugzeuge ihren Passagieren die heißesten Parties der Stadt übermitteln. MMS-Services werden die Flyer der Nacht on demand auf die Phones bringen. Von da aus werden sie zum Kumpel weitergeleitet. Kurz: das Netz wird mobil.

Apples iTunes-Plattform mit mehreren Millionen verkaufbaren Titeln und die mehr als hundert anderen digitalen Musikhändler im Internet werden versuchen, sich mit ungewöhnlichen Marketingmaßnahmen von der Konkurrenz abzuheben. Dazu werden neben Live-Events und deren offiziellen und exklusiven Übertragungen auch Event-Infoservices sowie Kontextinformationen gehören. Flyer transportieren das Image dieser Events, quasi die Cover, Portale, Interfaces oder Homepages der jeweiligen Nacht, die – wenn es genug Interesse gibt – auch auf Silberlingen aller Art weitergegeben werden können.

Da, wo der niederländische Flyer Designer Dadara comichafte, wiedererkennbare Designs und Illustrationen für Veranstalter liefert, ist der Schritt zum bewegten Flyer nicht mehr weit. Auch das 'Aufschwung Ost' und spätere 'Stammheim' in Kassel arbeitete jahrelang mit den unterhaltsamen Characters der Zeichner Bringmann und Kopetzki, die auch verantwortlich sind für den wohl bekanntesten Comic-Raver 'Hotze', der im 'Groove' Magazin die Fans zum Lachen und Weinen gebracht hat.

Auch Dadara (mit 'Fools Ark') und Jim Avignon

haben den Schritt zum Trickfilm vom zeichnenden Flyer-Designer zum Filmemacher vollzogen. Fools Ark dokumentiert eine Installation auf dem 'Burning Man Festival' und wird schließlich immer animierter und freier. Ähnliches geschieht mit einer ganzen Riege von VJs wie der Berliner 'Pfadfinderei'. Gestartet im clubnahen Printdesign, landeten sie vorläufig beim Setdesign (u.a. MTV) und CI-Entwickeln für Labels wie 'BPitch Control'. Sehenswert auch die aktuelle DVD der Gruppe.

Das Gestaltungsbüro '3deluxe' hat neben dem Clubdesign für Sven Väths neuen Club in Frankfurt auch die Jugendmedienhallen 'Scape' auf der Expo 2000 in Hannover entwickelt. Die komplette Gestaltung der Materialien der Grossevents 'Big Warp' und 'Time Warp' war ebenfalls von dieser international gebuchten Truppe.

Es kann davon ausgegangen werden, dass über den Musicclip und das VJing der nächste Schritt der abendfüllende Film sein wird. Dieses Club-TV wird – egal of live oder zeitversetzt – ein besonders interessantes Fanpublikum ansprechen: Clubgänger, Musiker, VJs und Medienmacher aller Art. Das Volumen des Kanals (ob nur im Direktkontakt mit einer Website oder für alle Haushalte im Kabel) ist nur eine Frage der Popularität. Das Video 'HighFLyer' (bbb, Absolutmedien.de), welches so einem frühen Club-TV entspricht hat, bereits 1997 im 'Ultraschall' in München ähnliches getan.

Die DVD des Berliner VJ-Kollektivs 'Visomat' rund um die Kultur des VJings zeigt hier den State of the Art. 'Visomat', in ihrer Funktion als WMF-ClubVJs waren auch die Macher der 'Automatenbar', die in vielerlei Hinsicht Vorläufer einiger der oben genannten Entwicklungen war: Videos und Musikmixe aus einer Jukebox, CCTV zur Überwachung, Internet Wireless und per LAN vor Ort, Liveacts, die ins Internet übertragen wurden, Zugangscodekarte, gemeinnützig als e.V. und Getränke-, Snack- und Kunstautomaten für alles, was das Clubberherz begehrt.

Berlin und sein Laborcharakter haben traditionell immer wieder innovative Club-, Medien- und Communityarbeiten und -Projekte hervorgebracht. Die DVD 'Berlin Digital' aus dem Jahr 2003 stellt einige der lokalen Protagonisten vor wie das 'De;Bug'-Magazin mit dem schönen Untertitel 'elektronische Lebensaspekte'. Selbst Internetfernsehen wie das legendäre amerikanische 'Pseudo.com' oder die Berliner Plattform 'Freshmilk TV' werden zukünftig den Club immer auch als Produktionsort begreifen. Musik-DVDs sind quasi bereits ein Standard wie letzte Releases der Labels 'International Deejay Gigolos Nr. 150' und 'Shitkatapult Nr. 50' auch im Szenebereich zeigen.

Die Flyerformate wandeln sich also von z.B. A6 zu Quicktime, von A7 zu Flash. Aus Auflage und Stückzahl werden die Summe aus Listenadressen. Mobilnummernverteiler, Eyeballs (Zusehern) und Webvisits. Es gibt keine Übergabe mehr, sondern ein Abholen der Mailbox und ein Öffnen des Attachments. Spam, Würmer und Viren werden hier wie auch im Bereich der Internettelefonie immer schwerer zu blocken. Vorsicht: Der nächste Flyer könnte bereits ein 'Text to speech'-Hinweis auf deinem Anrufbeantworter sein. Die Multimediaaktivitäten der Musiksender der MTV und VIVA deuten ebenfalls an, wohin die Zukunft geht:

"Customized user-driven programming" rund um "special communities"; TV mit Rückkanal zum Abstimmen und Kaufen; immer empfangbar über DVB-T, Wireless oder UMTS; mobil, schnell, bunt. Allgemein gilt: Interaktiv ist alles. Außer die meisten Medien. Medien führen zu einer Kastration der Kommunikation. Wirklich guten Ersatz oder zumindest eine preiswerte Alternative für die reale Kommunikation zu entwickeln, ist die Aufgabe der Kommunikations-Designer der Zukunft.

VERNETZT UND GEFANGEN

Die Stadtnet-Terminals, das Berliner Clubnetz (bereits 1994 als Teil der digitalen Stadt Berlin installiert), die beide Chat-basierte Kommunikation zwischen Nachtlocations ermöglichten, Livestreamer wie Klubradio.de oder Boombox.ch, die die Musik der Clubs ins Internet übertragen, Ticketer wie Ticketmaster haben bereits wichtige Basismöglichkeiten der neuen Medien ausgetestet und zum Teil erfolgreich angewendet.

Der 'Musicfinder' von Vodafone, der einem Anrufer den kompletten Titel und Interpreten nach wenigen Sekunden nennt, und Dienstleiter wie Shazam, deren Musikdatenbank ein aktuelles DJ Set ungeachtet des Pitchings oder des Mixes nach Artist und Track entschlüsselt, werden es möglich machen, die gehörte Musik besser zuzuordnen, um sie – last but not least – besser verkaufen zu können.

Sony Ericsson Mobile Livestreaming führt bereits in Finnland erfolgreich vor, dass IP-basiertes Liveradio auf Mobiltelefone technisch und kommerziell machbar ist. Nokia hat den Realplayer als Medienwiedergabe-Software schon seit Jahren integriert und damit streamingfähige Geräte gebaut. So kann man früher oder später wohl jedes Livekonzert aus der Distanz und zu jedem anderen Moment mit- oder nacherleben.

Projekte wie 123 Deutschland wurden zwar nie fertig entwickelt. Geplant war aber ein touristisches Stadtinformationssystem für hundert deutsche Städte, das auch die variablen Stadtinformationen – also die Programme der diversen Spielstätten – inklusive Buchungs- und Reservierungsfunktionen bereithalten und an allen Sparkasse-, Aral- und Burgerking-Filialen Omnipräsenz gewährleisten sollte. Bei allen technischen Schwierigkeiten liegt hier wohl die Zukunft.

'WildWildWeb' - ein aus dem Berliner Stadtmagazin 'Guide' entstandener und mittlerweile wieder verschwundener Informationsdienst für Drittanbieter - oder die 'Pop Alliance' - ein Konglomerat diverser Infoanbieter - entstanden aus den Internetanbietern 'Planetsound' und 'Tamito' sowie 'Techno.de' und bieten Veranstaltungsinformationen von mehr als 3000 Veranstaltern im Internet. Dienste wie 'Wildsite.de' haben schon in den 90er Jahren eben diese variablen Stadtinformationen gesammelt und neue für das Internet aufbereitet. Der Stadtzeitungsverbund 'Bewegungsmelder' hat den Crash der New Economy rund um das Jahr 2000 überlebt (im Gegensatz zum A6 Heft 'Flyer') und wird wohl die Idee neben anderen weiterverfolgen, diese Stadtinformationssysteme weiter zu entwickeln und zu vermarkten. Der Flyervertrieb 'Tec 9' hat vor seiner Übernahme durch den Großwerbemittelvertrieb 'Dinamix' 2003 beispielsweise auch

aktuelle Flyer digitalisiert, um sie für BTX und den Offenen Kanal fernsehfähig vorzubereiten.

ALTER EGO

Communities und Chats im Internet zeigen es: Flyer eignen sich hervorragend zur Identifikation und liefern Identitäten. So nennen sich Chatter auch FlyerXY, wie diese Bilder aus der Kriegmichrum Community zeigen, die in Anfangszeiten auf dem gleichen Portal 'whow.de', wie das Flyer Magazin angeboten waren. Meist benutzen Männer oder Jungs diesen Nicknamen, oft in Ergänzung mit dem Alter oder dem Geburtsjahr. Jungs sind häufig die aktiven Musikhörer, Fans, DJs und oft auch entsprechend die Initiatoren von Parties und Events, die durch Flyer beworben werden. Da Flyer ein hervorragendes Kommunikationshilfsmittel sind, ermöglichen sie in der Realität auch am einfachsten die Kontaktaufnahme mit einer für interessant befundenen Lady. Mädels folgen der besten Musik, den besten Flyern und oft auch den interessantesten Jungs. Der Flyer ist sozusagen eine Premiumanmache mit Hintergrund.

Die noch recht schwachen Möglichkeiten von WAP, iMode und GPRS (datenintensivere Mobiltelefon-Protokolle) haben zu ersten intensiven Berührungen von Informationsanbietern und Telekommunikationsanbietern geführt. Die Telkos merken, dass sie guten und interessanten Content benötigen, um die mannigfaltigen Interessen ihrer Zielgruppen zu befriedigen. Artists mit Starstatus wie Sven Väth sind längst dabei, ihre poly-phonen Ringtones über T-Mobile zu vertreiben, während andere wie Richie Hawtin Live-Streaming zeitweise ablehnten. Diese Relevanz der Technikphobie zeigt auch das Beispiel der 'Beastie Boys', die gar am Eingang alle Handys einsammeln aus Angst vor illegalen Mitschnitten oder Fotohandys. Das hochqualitative Kunstkopf-Handy mit großem Plattenplatz für Bootlegs von Live-Konzerten wird unweigerlich zum mobile P2P führen. Das Cover dieses Mitschnitts? Richtig: der Flyer zum Abend. Oder der Screenshot auf deinem Handy?

Bei Fachmessen wie der MIDEM Net, der Milia, der Popkomm, der Internetworld, aber auch der CeBit werden neueste Produkte vorgestellt und die Testmärkte diskutiert und entwickelt. Konferenzen wie die 'Transmediale' mit angegliedertem 'Club Transmediale' oder 'Musik und Maschine' sind ideale Spezialforen für neue Herangehensweisen in der Clubkultur. Auch außerhalb Deutschlands wurde natürlich an der Zukunft des Clubs geforscht: MUTEK in Montreal, Ars Electronica in Linz, Sonar in Barcelona, Doors of Perception in Amsterdam oder das EMAF – European Media Art Festival – haben diese weiterentwickelt, thematisiert, gefördert und präsentiert.

Wirklich futuristisch wird es erst, wenn die Haut die Daten überträgt, wie das Tom Zimmermann vom MIT gezeigt hat; dann werden die Flyer durch Handshakes weitergegeben. Auch RFID-Chips (Miniatur-Chips, die ihren Infogehalt abstrahlen) könnten dann eine immer größere Rollen spielen. Die Flyer werden ansteckend und man nimmt einen, stellt aber auf seinem 'Electronic Ink' Device

NEURO ---- networking europe ---- Medienfestival ---- 27. bis 29.2.2004 ---- Muffathalle

fest, dass der Chip noch 2 weitere gespeichert hat. Wenn die Medien uns auf allen Kanälen versuchen zu aktivieren, wird datenbankbasiertes Super Profiling der Zielgruppen immer wichtiger, aber auch die Gegenmaßnahmen zu dieser neuen Art des Mikro-Marketings: Filtertechnologien, Sicherheit, Identitäts- und Spamschutz.

RIECHENDE FLYER

Dass das bereits gemacht wurde, ist klar. Für die Einführung eines neuen Deos und dazugehörige Parties haben Marken wie Axe oder FA mit Tools dieser Art gearbeitet. Parfums, aber auch Veranstalter von Mottoparties werden immer wieder so ein 'sensual Marketing' ausprobieren, um einfach anders zu sein. Ob die Robotik oder Nanotechnologie jemals soweit ist, dass der Flyer sich auf den Weg zu dir nach Hause macht, um an deiner Tür zu klopfen ? Wohl kaum. Wobei in Japan…

DANK AN MEINE INTERVIEWPARTNER:

Andreas Steinhauser/Gate 5 AG
Peter Krell/Gameface/Suct Design
Mirko Seifert/Techno.de
Ram51/Heavy Industries
Sascha Wolf/Tec9
Pit Schultz/Klubradio.de

NEW PRODUCTS

SMS Zigarettenpapier Drucker – SMS Smokesprinter
Eine sehr gute Idee scheint auch die Möglichkeit Mobiltelefone mit Druckern auszustatten die auf Zigarettenpapier SMS, Visitenkarten, Bilder oder einfach nur einen Gruß ausdrucken können. Der Klebestreifen macht den Ausdruck zum Post-It und – wie wir ja mittlerweile gelernt haben - ist die richtige Nachricht am richtigen Ort alles wenn es darum geht zu überzeugen. An diesen Stellen eines Medienbruches entstehen völlig neue Potentiale.

PUBLIC FLYERSCAN DATABASE

Zentrale Orte an denen man 24h seine Veranstaltung per öffentlich zugänglichem Papiereinzugscanner in das regionale Medienherz füttern kann ähnlich einem Bankautomaten, sollte ein Standard werden. Von dort aus wird a: archiviert und b: aktuelle Informationen gesammelt und an diese abrufende Medien verteilt.

INTERNET PLATTFORMEN

Partyflyer.com, die bereits bestehende Plattform des Düsseldorfer Webdesigners Jens Haffke eingerichtet als "die Auslagestelle im Internet für alle Partyflyer!" zeigt eine konsequente Umsetzung einer auch in englischen Hardcore Szenen, im Goabereich oder wie bei der Pariser Site www.flyersweb.com registrierten Praktik, aktuelle Flyer an zentraler Stelle zu platzieren.

Das normale Vorgehen beim Flyer-Ansehen wurde komplett auf ein Online-Format übertragen. So kann der User kostenlos die Flyer ansehen, hochheben, umdrehen, mitnehmen, zeigen und sammeln. Vorteil sind die permanente Erreichbarkeit und die Ordnung nach Land, Region, Musikrichtung und Datum. Die Flyer gehen niemals aus. Such- und Communityfunktionen sowie der Druck als PDF ergänzen die Möglichkeiten des sich durch Veranstalter finanzierten internationalen Services

Nicht zuletzt werden Flyer im stärker von anderen Einsatzfeldern eingesetzt. Seien es Medien wie Radio oder Fernsehen oder Kampagnen die politische Awareness oder Spendenbereitschaft für aktuelle Themen generieren wollen. Hier ist anzunehmen das diese Materialien ein grosses Quell der Gestaltungs- und Sammelleidenschaft bleiben werden.

ROOT 2000 international festival of live, sound and new media art
20th - 22nd October 2000
Hull - UK

root
tricks, pranks & interventions

A weekend of interventions, performance, actions, film, installation, debate and webcasting.

hausderkunst
07/18/04 >
16/01/05

utopia station

ZUR ZUKUNFT DES FLYERS

FLYER DER WELT
FLYERS OF THE WORLD

Ein Paar Anmerkungen zu unserer Bildauswahl: Wir haben lange vorgehabt, jeden einzelnen Flyer zu beschreiben, nach Land, Stadt, Party, Club, Gestalter und Jahr. Selbst Format und Skalierung waren angedacht. Wir haben es einfach gelassen, zuviel Arbeit, nicht machbar bei dieser Menge. Die Orte und Namen stehen meist darauf. Manchmal fehlen Informationen, da sie auf der nicht verwendeten Rückseite stehen oder in der Reproduktion zu klein wurden. Es gibt keine Einzelcredits für Grafiker in diesem Buch, man möge uns das nachsehen. Der beste Weg solche Fragen zu beantworten ist, den Veranstalter zu konsultieren oder ganz genau auf den Flyer zu gucken. Oft hilft das Internet. Wenn es wichtig ist: fragt uns, und wir versuchen zu helfen: redaktion@flyersoziotope.net

Den Grafikern gebühren die Lorbeeren der Arbeit. Unsere Datenbank soll auch diese Informationen beinhalten und von denen, die es wissen, gefüttert werden. Das ist doch ein Kompromiss, oder?

A few comments on our choice of pictures: for a long time, we were planning to describe every single flyer, classified according to country, city, party, club, designer and year. We even thought of naming formats and scale. But in the end we decided not to: too much work, not feasible for this volume of material. The place and names are usually visible on the flyer. Some information is missing because it appears on the reverse or became illegible in the reproduction. This books does not credit individual designers: we hope you will understand. The best way to get this kind of information is by asking the organizer or by taking a close look at the flyer. The Internet is often helpful. And if it's urgent, ask us and we'll try to help: redaktion@flyersoziotope.net

Graphic designers deserve credit for their work: our database should contain this information, supplied by those who know. Is that a satisfactory compromise?

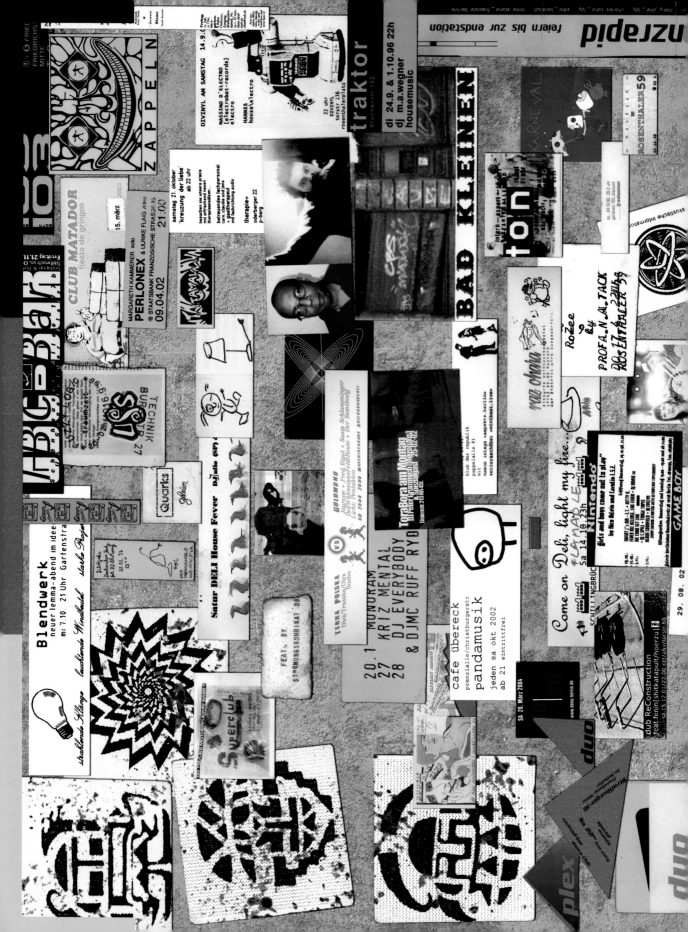

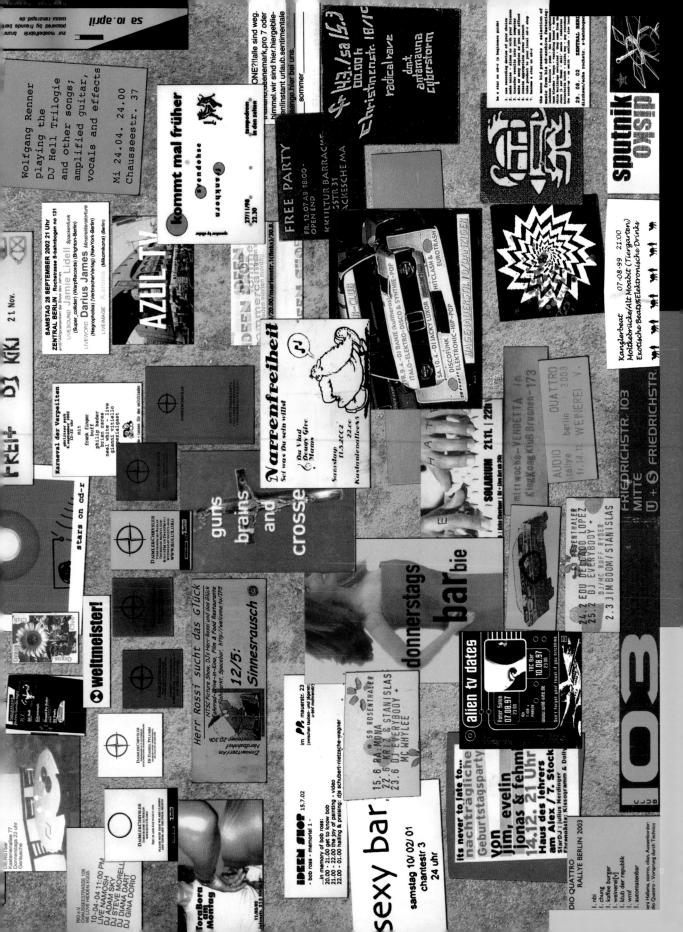

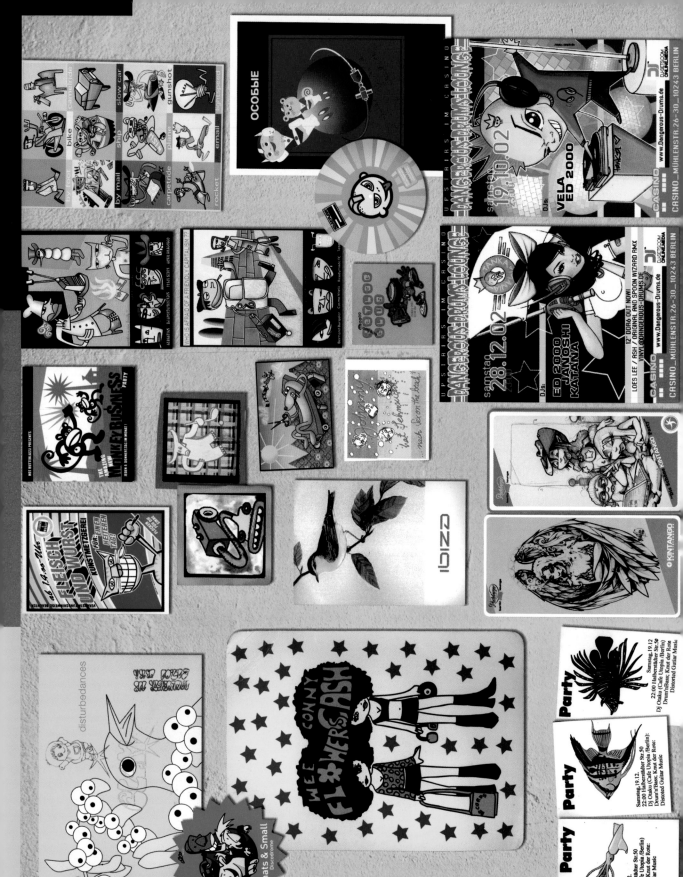

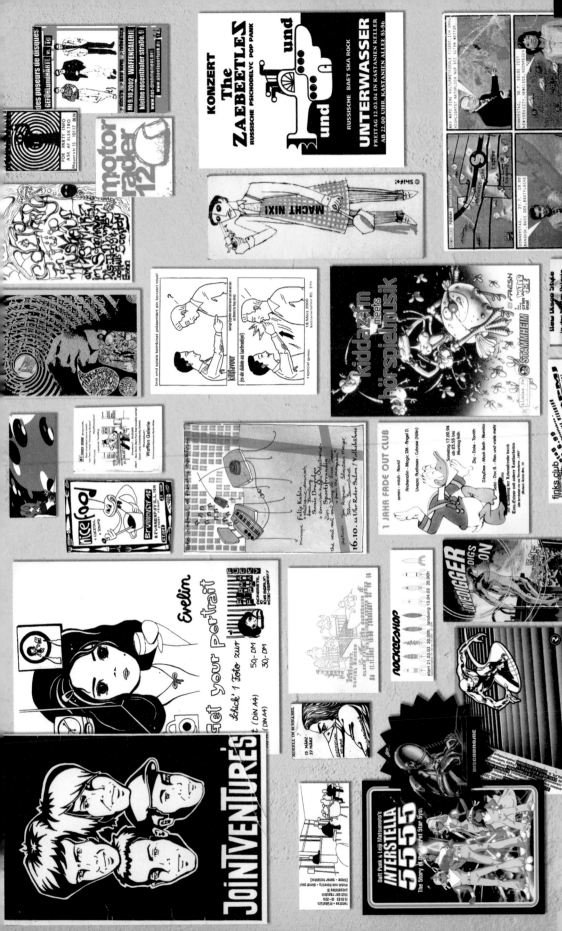

goldfish

Fr. 23-04-04 ROTER SALON • ROSA-LUXEMBURG-PLATZ • 23.00

Am 08. Maerz 2004
ab 20.00 Uhr in der
Alten Schoenhauser Str. 35
10119 Berlin

Zwischen 20-22 Uhr gibt es
Prosecco frei Haus!

DJs:
Barbara Hallama
Telecommando 0,5
Miss Yetti

Design: www.vektorfarm.de

KLEIN CLUB

JEDEN ERSTEN DONNERSTAG IM MONAT (AB 20:00 Uhr)
CAFE EIGENWAREN, SCHLESISCHE STR 18, KREUZBERG
MIT COCKTAILS UND DEN DJ's KRIZ, MENTAL & BENSONIC

SPONSORED BY

märz 03 ab 20 uhr

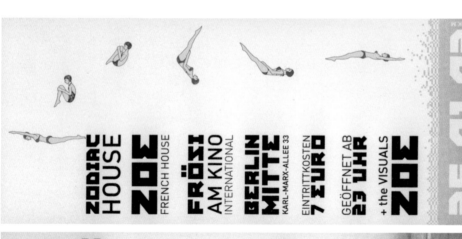

ZODIAC HOUSE
ZOE FRENCH HOUSE
FRÖSI AM KINO INTERNATIONAL
BERLIN MITTE KARL-MARX-ALLEE 33
EINTRITTSKOSTEN 7 EURO
GEÖFFNET AB 23 UHR
+ the VISUALS ZOE
25.01.02
GRAFIK M

CHICKS UNITED & ZOE
biniklub

COME TO WHERE THE FLAVOR IS

SCHRADEL BAR

ninja tune ten anniversary celebration at ntrecordings.com

DJ FOOD
NINJATUNE · UK

DJ DSL
(K7Solar Records/Wien)

TELESCOPE
(Low Club One)

28.12.2002
CLUB ONE AT XMF

KNIGHT RIDERS

It's KNIGHTRIDERS old school jungle parties

On Friday the 02 06 00
5 DM before 0:00 7 DM after

fr. Dj Disaster & Dj Shy

in Grüne Hölle
Neue Grünstr.15 - U2 Spittelmarkt - Mitte

Flyer by OZ 030 • 29 00 24 92

... try electric airliner

your ferrari has crashed...?

5. Mai
Café Bravo, Auguststraße 69,
Berlin-Mitte, 15 Uhr,
Eintritt frei,

Ich erinnere mich daran, wie
oethe aus Italien zurückkam,
ie Alpen überschritt, mit seinem
eologenhammer gegen die
ega klopfte und das
jodesepochen' zu hören glaubte,
evor er zurück nach
eutschland ging.

SAMSTAG 28.02.1998 AB 22:30 Uhr INSEL

Prototype Party

Friday, 9. August 2002, 11 pm at Casino Berlin

welcome to the Boogaloo Groove garage

serving sundays now !

7.11. A NIGHT IN GENEVA

MONTEVERDI

SONJA MOONEAR · DANDY JACK (LIVE) · TOM CLARK

raster-noton

ALVA NOTO
BYETONE
DJ KAZI LENKER

a.network

die 1 8 b a h n e n o f t h e b e w e g u n g s elite

mit Minigolfbahnen von Jim Avignon • Fehmi Baumbach + Anna Jantke • Dominik • Evelin • Roger Frank • Henrik Freiberg • Philip Grözinger • Ulrike Harbort • Jana • Andrej Lubr • Sebastian Mayer • Marek McBarek • Christian Pundschus • Angie Reed • Conny Schmidt • Julia Schnitzer • SIG + Tim • im HausDesLehrers_Alexanderplatz 4_Etage 7_Berlin

Sa_22. 04. 00 ab 20 Uhr
Eröffnungsschlag mit Uwe Ludwig, deutscher Vizemeister im Bahnengolf
Party mit Maxi und den DJs Jack Tennis, DJ Umat, Kritt
So_23. 04. 00 ab 22 Uhr
Record-Release Party: "Fucky don´t CD" mit Bands und DJs
Mo_24. 04. 16–20 Uhr
Spielbetrieb, Eiersuchen und Eisverkauf

modulor
material total

Radioeye
berlin lounge

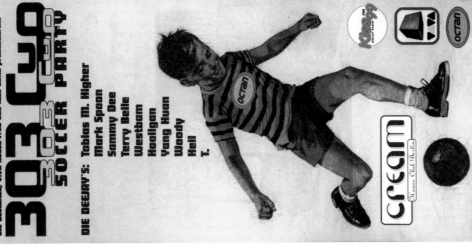

Die Gestalten, UVN House-Frau und Klas BfM präsentieren:

303 Cup
SOCCER PARTY

DIE DEEJAY'S: Tobias M. Higher
Mark Spoon
Sammy Dee
Terry Belle
Westbam
Hooligan
Yang Huan
Woody
Hell
T.

cream
House Club Berlin

Samstag : 02.09.95 ab 24.00
An der Oberbaumbrücke

sneakers etc.

sneakers music by
preview trevor jackson
friday kaos
05.04.02 dj hype
20.00h san gabriel
co-op
berlin party
23.00h cookies

Der 303 Cup ist ein Fußballturnier. Jede Mannschaft muß mindestens einen DJ in ihrer Elf haben. Gespielt wird 2x13 min. Wer nicht spielt, legt im Stadion auf! Kein Beißen, kein Kratzen, nicht an den Haaren ziehen, keine feststehenden Messer!!!

Die Teams : FC Ultraschall München
Delirium Köln
Riri United
Poison Club D'dorf
Preussen Elektra Berlin
Hundelunge Berlin
Frankfurt Allstars
Flasche Bier 7 Mark Planet Bochum
Kiss 99 Radio Team

Anstoß:
Samstag : 02.09.95 - 12.00 (Mittag)
Stadion: Alte Försterei
Erholungspark Wuhlheide
Hämmerlingstraße
Berlin-Köpenick
Eintritt frei
Speis, Sound und Trunk

juli
indie pop dates

INDIE POP DATES 09/02

Indie - Retro - Brit Pop - Neo Garage - Madchester Rave - Punk
80's Revival - Indietronic - Bastard Pop - Wave - Alternative

INDIE POP DATES 10/02

Indie - Retro - Brit Pop - Neo Garage - Madchester Rave - Punk
80's Revival - Indietronic - Bastard Pop - Wave - Alternative

NEID 6
STILL DOING IT.

POPMOBIL

FIGHT

www.kp-berlin.de

1.Mai 18h Rosa-Luxemburg-Platz

PROVO

www.kp-berlin.de

1.Mai 18h Rosa-Luxemburg-Platz

Bukaka says: ANOTHER WAR IS POSSIBLE

19.02. / 20.02.

KINZO

Live: - Saint Pauli
(ElectroHouseFilterBretter DJs)
- General Midi Orchestra
(Country Mathematics: Amateur Rec/A-Musik)
- Jack Tennis
(Professor FunkSoulBrother)
- Le Hammond Inferno (gastgeber)
SPEZIALGAST im kleinen Raum:
- KOMPOTT/Sant Petersburg
DJ Max Brittner/Sant Petropolka
DJ Electropolka

fr. 17.12.04 Uhr 23:00 Klub at Kinzo strasse Karl-Liebknecht strasse

ANTIDEUTSCHE PARTY

Samstag, 24. Januar 2004, 22:00 Uhr

push that button

FIESTA ZAPATISTA

20 y 10 años
EL FUEGO Y LA PALABRA

10. JANUAR 04
HEBBEL AM UFER HAU 2
BEGINN 22.30 UHR U-BAHN HALLESCHES TOR
Hallesches Ufer 32

DJ PANKO DONE [U-Site]
OJOS DE BRUJO [BARCELONA] LATINO+TECHNO+HOUSE+[HH]
ELECTRIC FANDANGO

PLATTENTEKTONIK
ELEKTRONISCHES+[BERLIN]

Sept. 04

WER IST DER IMPERIALIST

☐ das Ausland
☐ das HAU I, II und III
☐ der Club der Polnischen Versager
☐ die Zwischennutzerinnen im Palast der Republik
☐ das NBI
☐ das Maria am Ufer
☐ planet rock

bitte ein feld ankreuzen und einsenden an: ausland, lychener str. 60, 10437 berlin

stammheim proben

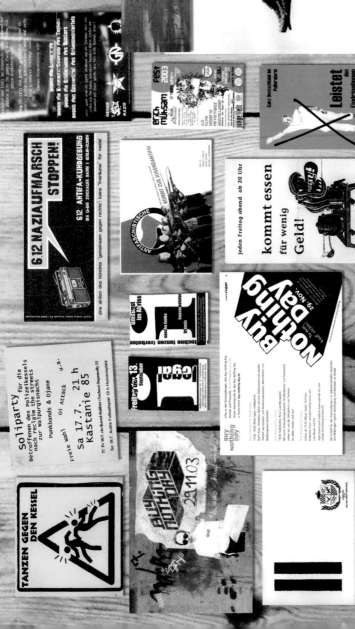

SPD
Ich habe fertig.
Wir sind bereit.

MILITARY ABEND

EINMALIGE MILITÄRDIKTATUR IM WYDOKS CLUB SCHÖNHAUSER ALLEE 5
PARAMILITÄRISCHE GESELLIGKEIT FÜR

KRIEGSVETERANEN, RESERVISTEN, FREMDENLEGIONÄRE,
MARKETENDERINNEN, FRAUEN, VON ZU HAUS, KONTERREVOLUTIONÄRE,
KANONENFUTTER, MINENSUCHER, PIONIERE UND DIVERSES ANDERES
MENSCHENMATERIAL.

EINE STRENGE DIENSTVORSCHRIFT REGLEMENTIERT DEN ABEND UND
GARANTIERT ORDNUNG UND DISZIPLINÄRE GESELLIGKEIT.

*DER TAGESBEFEHL WIRD VON DEN DIENSTHABENDEN OFFIZIEREN AM
EINLAß AUSGEGEBEN*

GÜLTIGE ODER EHEMALIGE DIENSTAUSWEISE JEGLICHER BEWAFFNETER
ORGANE VERSPRECHEN HALBEN EINTRITT

BEGINN 21.00 UHR
FILM 22.00 UHR (F
EINTRITT 2.99 DM

BORN TO KILL AM 21. 02. 95

rattical rave

6.12. NAZIAUFMARSCH STOPPEN!
6.12 ANTIFA-KUNDGEBUNG

kommt essen
für wenig
Geld!
Jeden Freitag abend ab 20 Uhr
in der Kastanie
kastanienallee 85 prenzlauerberg

BUY NOTHING DAY
29. NOV

soliparty für die
Betroffenen des polizeikessels
nach reclaim the streets
zur Walpurgisnacht

Punkbands & Djane
freie wahl · Oi Attack · u.a.
Sa 17.7. 21 h
Kastanie 85

TANZEN GEGEN DEN KESSEL

WIR BRAUCHEN KEINE FÜHRER

EDELWEISS PIRATEN
Gneisenaustr. 2a · 10961 Berlin

Nazis sind Doof-Party

Leistet den
Einfin¬linglingen
WIDERSTAND

KINGKONGKLUB PRESENTS
PUSCHEL POGO IN DEN MAI
30. APRIL · 21 UHR · FREE

fig 3

Ceci n'est pas une arme.

POSTPRODUKTION PRÄSENTIERT FÜRSPRECHER II . DIE FORTSETZUNG MIT ANDEREN MITTELN
EINE BATTLE-PERFORMANCE MIT BETTINA BRUNS UND GHADA HAMMOUDAH INSZENIERUNG JP POSSMANN DRAMATURGIE DANIEL SCHALZ
PRODUKTIONSLEITUNG INES BALTRUSZAT ORGANISATION JUTTA SCHNEIDER PRODUKTIONSASSISTENZ RAGNA KORBY DESIGN TONI HARZER (FRISCHALL)
EINE POSTPRODUKTION PRODUKTION IN ZUSAMMENARBEIT MIT THEATER AM HALLESCHEN UFER

musik in der lounge
im glaslager
hotel berlinische galerie
alte jakobstr. 124-128 .
www.hotel-b.de

*AFTER-HOURS
16.11.03

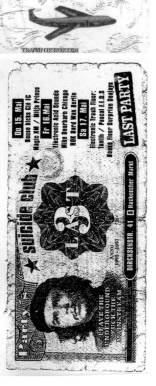

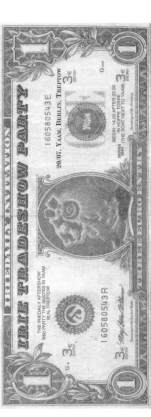

INDIE POP DATES 08/02.

Indie - Retro - Brit Pop - Neo Garage - Madchester Rave - Punk
80's Revival - Electronic - Bastard Pop - Wave - Alternative

indie pop
▶ dates

▶ mai

JET LAG

SAGE AIRLINES

Tussi Deluxe

FREITAG 12.04.2002 · FUNKY FRIDAY · SAGE TUSSI DELUXE

vacanza à gogo

the FUNKY CHICKEN CLUB

Q♣ / ♣Q

hosted by
ben e, clock
eric d, clark
disco sessur

from october 12th on
every friday 11pm
admission: DM 10,-

terra disco
friedrichstr. 95
berlin - mitte

Radeberger

6♠ / ♠6

DJ

PRIMAL

BIKINIKLUB

FR, 27.09.02

AB 23 UHR IM FRISEL

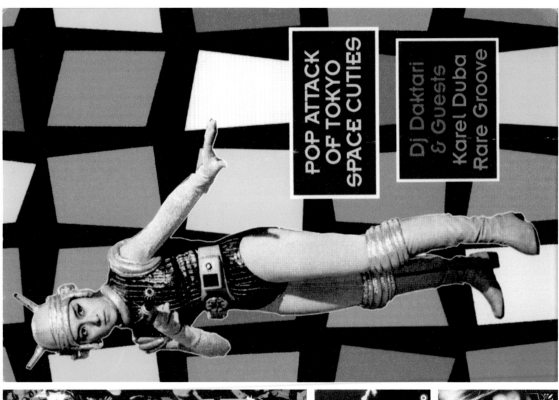

POP ATTACK
OF TOKYO
SPACE CUTIES

Dj Daktari
& Guests
Karel Duba
Rare Groove

KING
Special Night
Sa 29.5.99
23:00 Uhr
DJ's Special Guest: The Incrowd (Elvis and more)
Mr. Chung & Das Chamäleon

Paul Weller Party

GAINSBOURG
ET CETERA

INDIE POP
DATES
DEZEMBER

INDIE POP
DATES
OKTOBER

indie pop
▶ dates

▶ juni

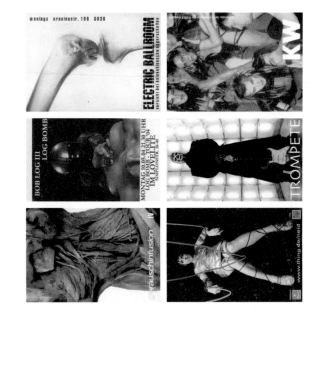

im Boudoir

open mo·sa

krossenerstr. 24 · boxhagener · 10997 berlin

STEREO 33

geräuschinfusion

V

GERÄUSCHINFUSION

VI

www.stellwerk-berlin.de

Preed.
Brooka Toira Noi 12"

kitty-yo

FANTAZY 2000

PROSTITUTE

UNDERGROUND

CHRISTUS IST VERSCHWUNDEN

WIR DUPLIZIEREN WEITER...

...IM EIMER

URBAN KARMA CLUB

URBAN KARMA CLUB

Live aus Ninas Navigation-Center@BKA-Luftschloß

NINAS Nightshift Online-TV-Show

LIFESTYLE

- part one -

BACK TO THE OLDSCHOOL!

IIII GRANDMASTER FLASH

FR 23.01.04

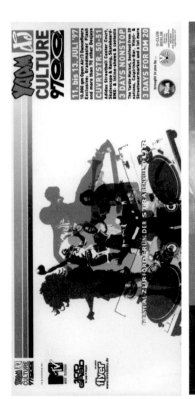

YAM CULTURE 9700

11 bis 13. JULI '97

10.000 qm Open Air/3 Dancefloors
Exclusive: Grandmaster Flash
and more than 70 other Deejays

CUVRYSTR. 50-51

3 DAYS NONSTOP

Adidas Streetball Center Court,
Skatescene & Ramp, Smallwheel-
BMX- & Inline-shows & contests

The Yardie Market, Soulfood from 20
nations, Caipirinha-Bar, Vinyl- &
Streetwearmarket and a lot more

3 DAYS FOR DM 20

brought to you by —

U-CLUB
BERLIN

FESTIVAL ZUR FÖRDERUNG DER STRAßENXKULTUR

ICON CLUB MILA-/ECKE CANTIANSTR. (B)/PRENZLAUERBERG U2:EBERSWALDERSTR.

140398 FABIO

METRO NOMAD

LONDON UK

ICON CLUB MILA-/ECKE CANTIANSTR B/PRENZLAUERBERG U2:EBERSWALDERSTR

070398 PREPHAX NOMAD
THE CHEMIST SPECIAL
GUEST B/RESIDENTS

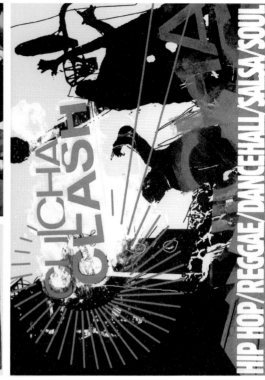

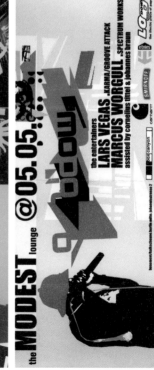

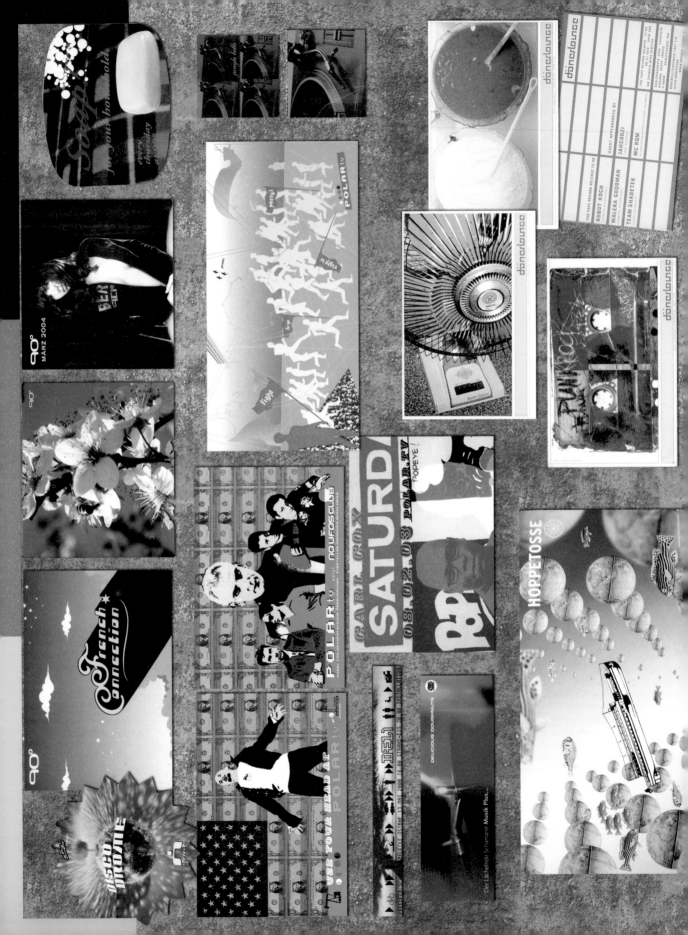

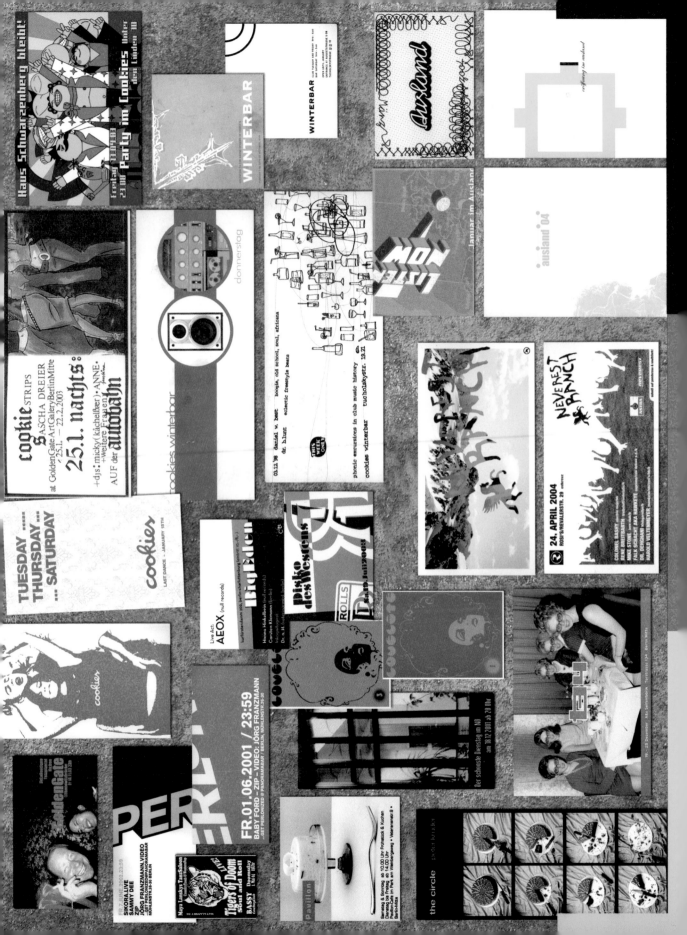

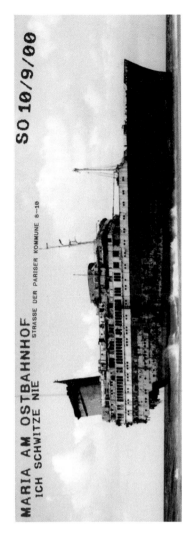

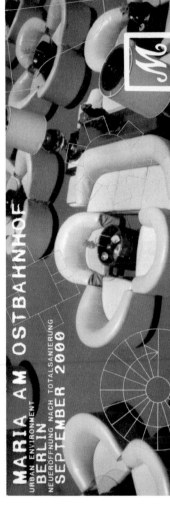

FREITAG
22.00 UHR 14.12.01

KOMM.
LAUSCH.
TANZ

AM → OSTBAHNHOF

15DM

PinqartDruck
030.44 91 57 - 0

7 18755 52302 5

rechenzentrum 16.06.2000

Doppeltonträgerveröffentlichungsaktivität
Freitag, 16.06.2000, 22 Uhr, 15 DM, Maria am Ostbahnhof, Strasse der Pariser Kommune 8–10, 10243 Berlin

Acidhouse - Revival - Party

Can you feel the bass?

maria@2004

Sa 24. April 20

Boris Tyree Cooper DJ Naughty Wolle XDP
(Ostgut Berlin) (SupaDupa Chicago) (Discount Berlin)
und vielen drehenden Blumen!

HIRSCHBAR
FAMILY ★ AFFAIRS

MARIA AM OSTBAHNHOF

06.02

delikat
RECORDS

08.11.03 MARIA

ELECTRONISCHES
VERLANGEN

03

www.delikat-records.com

interference 99

09 07 10 07 11 07

@ maria am ostbahnhof
str. der pariser kommune 8-10
berlin-friedrichshain

SUPER 24 [liveit] Starambarg DE:Bug

EUPHORIA

HARDCORE FEVER & UPBEAT PRESENT:

...CORE, BREAKBEAT & DRUM AND BASS

MARIA

03.04.04

GEGENBEWEGUNG 02

3 JAHRE MARIA

VICE
fenchurch
PARTY

RIGHT KICK LEFT KICK COBRA KILLER

KINO A
FEAR MORE

RECORD RELEASE PARTY

MITTWOCH 19.MAI 2004 23 UHR
MARIA AM OSTBAHNHOF

FREIRÄUME!

offen! 9ivffen9i Open!

LIVE
DONNACHA COSTELLO DUBLIN

JENNIFER CARDINI PARIS

DEEOP & KETLOV BERLIN

ANDRE GARDEJA & SÖNKE DOSE BERLIN

LIVE
SAMIM ZÜRICH

VISUALS GMINGO BERLIN

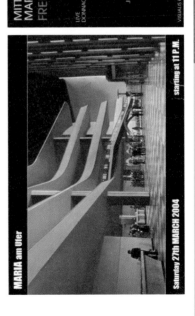

MARIA am Ufer

Saturday 27th MARCH 2004 starting at 11 P.M.

feat.october

21.12.2001 23.00
HAPPYBREAXPONENCE
KICKS LIKE A MULE: LESSONS IN THE OLDSKOOL!
ORIGINAL.AKI (PIXELKRIEG, ALICEDEE.PRODUCTIONS.COLOGNE)
ACIDO.DOMINGO, DOC.ALMOST (AMEN.IMPERATIV! UNHCRE)
MR. BLEED (COSMIC.ORGASM.COLOGNE)
KEINE LOUNGE! EINTRITT DM 12,-. WMF . ZIEGELSTRASSE 22. BERLIN MITTE.

hard:edged_07

21.12.2001 23.00
HAPPYBREAXPONENCE
ORIGINAL.AKI (PIXELKRIEG, ALICEDEE.PRODUCTIONS.COLOGNE)
ACIDO.DOMINGO, DOC.ALMOST (AMEN.IMPERATIV! UNHCRE)
MR. BLEED (COSMIC.ORGASM.COLOGNE)
KEINE LOUNGE! EINTRITT DM 12,-. WMF . ZIEGELSTRASSE 22. BERLIN MITTE.

ELEKTRONIK GALA

A-clip zeigt: gesang & elektronik

Ton und Bild
gegen die kapitalistische Stadt

Mittwoch 29. April. 21 Uhr 30. WMF. Johannisstraße 19

elektronik

Dj Bleed [de:bug], Berlin
Kazi Lenker (biegsame Elektronik) [de:bug]
Julian Goethe (April sound blAst), Berlin
Koalition gegen (House) [Produzentinnen-Koop], Berlin
Spiralen der Erinnerung [mit Justus Köhnke
von Whirlpool, Subtle Tease] Köln **taschenzaun** [de:bug]

gesang

Britta (Post-Riot), Berlin [Christiane Rösinger, früher Lassie Singers/ Britta
Neander, früher Lassie Singers und Carambolage/
Julie Miess, früher Club Venus]

Derrick (Pop), Hamburg [Christoph Leich,
Sterne (drums)/ Philipp Sollmann (guitar, piano, vocals)]
Parole Trixie (melodramatischer Punkrock) Berlin/Ham-
burg [Almut Klotz, früher Lassie Singers (vocals, guitar)/ Sandra Grether, Spex (vocals, gui-
tar)/ Sandra Ziegenhagen, 5 Freunde (bass), Erdmöbel (drums)]
Schreuf/ Wenzel/ Gaier/ Petzi Quartett (Free
Jazz), Hamburg/ München [Kristof Schreuf, Brüllen (vocals)/ Thomas
Wenzel, Goldene Zitronen, Sterne (bass)/ Ted Gaier, Goldene Zitronen/ Les
Robespierres (drums)/ Wilfried Petzi, FSK (posaune)]

Subversivstummfilm [von Nell Stump
mit lebhaftiger Tonkunst von Almut Klotz und Jan Erik Engel]
Zigarettenrauchen von gleichnamigem Tape ★

LE MARIAGE SANS FIN
Teil 1 | Verlobung

Le Mariage sans fin

1. VERLOBUNG

natasha-bar/ Groundfloor

THE HUB
LIVE
ad hawk
big bird
bill youngman
kevin blechdom
mocky
ricardo villalobos

29. 4. WMF

bill youngman - live
khan - live
dan caron
frank yonner
suzi wong

wmf@cafe moskau /10 p.m.

kaleidoskop
lounge

jeden donnerstag

kaleidoskop

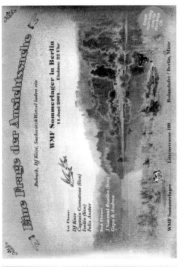

Eine Frage der Ansichtssache

WMF Sommerlager in Berlin
11. Juni 2004 Einlass 22 Uhr

Babsh, Dj Kose, Sachnicki Wetzel laden ein

1st Floor:
Dj Kose
Captain Comelone (live)
Isolée (live)
Felix Laster

2nd Floor:
Tobias Batsha (live)
Gepa & Andrew

WMF Sommerlager Littenstrasse 109 Rolandufer / Berlin, Mitte

29.05.04 **WMF Sommerlager**

Kompalte Schweden: Live: Aril Brikha (Traument, Fragil-Schins)
Djs: Tobias Thomas (Kompakt), Sven.VT (Ford De Bug)
Visuals: Pfadfinderei
www.freiluftclub.de
Powered by Smirnoff imported Vodka

Litttenstrasse 109, Berlin Mitte. 22:00.

8.1.00 mad benton rec. presents: fundamental knowlegde

WWF

1.
2.
3.
4.
5.

Cookie & CHG present:

Delighted

Wednesday
18.3. 9 PM

Cookie's Cocktails
Videoinstalation by Bauhouse

Jools Butterfield 1st floor
NuPhonic Records, Ministry of Sound and Blue Note Club, London

Bauhouse
Super Zandy, house 2nd floor

WMF, Johannistraße 19

WWF

Cookie & CHG present Delighted, wednesday 18.3. WMF

6.
7.
8.
9.

the protecé of heaven
ROMANTHONY
WWF

the legendary
Kid Batchelor London
WWF

20. + 21. 12. 96
YOUR LAST CHANCE
for WMF PART THREE
WWF

Nick Warren (brstol)
& Tom Clark
UPLIFT 96
29.03.96
WWF

die zukunft hat zeit

Klangkrieg

Ein Jahr

Die Insel Alt Treptow 6 12435Berlin

KLANGKRIEG

NOISE & LIEBE

sun. 31.03.2002
doors open 10 to 12 pm

NASS
rubber and protection outfit

FISTHALL@OSTGUT
anal deep throat, sound and light

fr. 29.03.2002
doors open 10 to 12 pm

FULL CONTACT
sneakers, sports and smelly sox

thu. 28.03.2002
doors open 10 to 12 pm

sat. **30.03.**2002
presale-tickets at LEATHERS and BLACKSTYLE

start 11 pm

pervy party men only play safe

SNAX CLUB

nd_baumecker
boris

wolle e.i.
michael stahl

www.lab-oratory.de

OST-GUT

mühlenstrasse 26/30
berlin/friedrichshain

U+S warschauer strasse
entrance rummelsburaer platz

ant to be on our ng-list? write! DevilTeufelDiable po 304312 - 10723 berlin

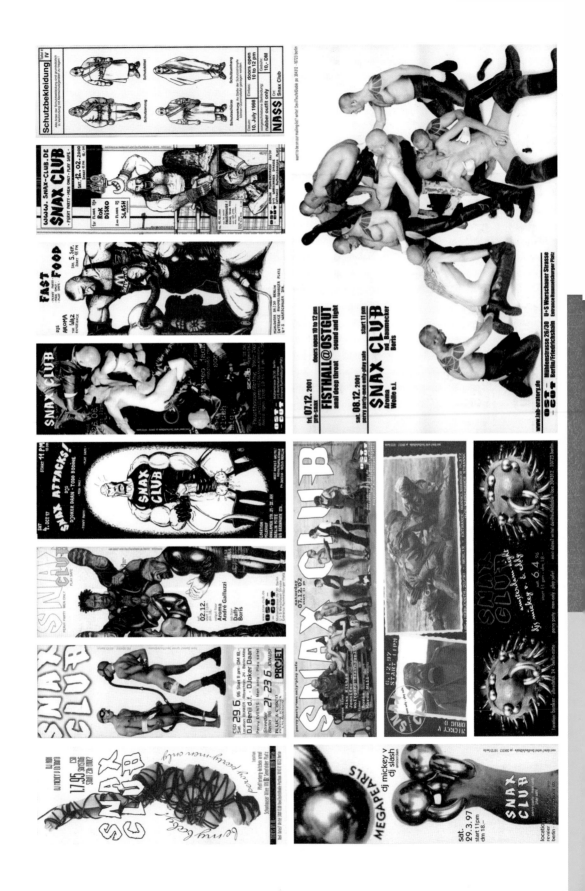

Techno hat mein Leben verändert!

DUMM FICKT GUT!

Irrtum vorbehalten

Nackt ist man glücklicher

TOXIC BASEMENT

SA., 28.März 1992

TREFF-PUNKT

BEWEGT EURE AERSCHE HIER RAUS! IHR RAUCHT MIR HIER DIE BUDE VOLL

Industrial Death Weekend

N·A·S·H

"Volldampf in die 80er"

BUM BUM

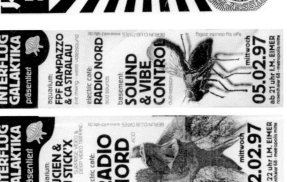
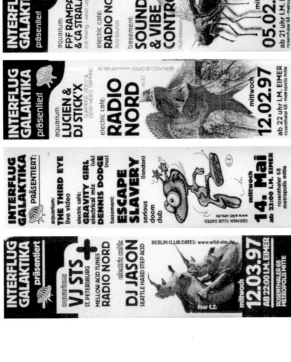

SUICIDE LOUNGE

BORED? YEAH! DESPERATE? YEAAH! ALONE? YEEEAAH! SUICIDE!

MAKE LOVE

LOVE BITE

Bored? Desperate? Alone? SUICIDE!

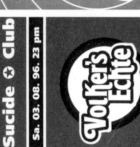

Sucide ☆ Club

Sa. 03. 08. 96. 23 pm

Volker's Echte

Only Friends Party

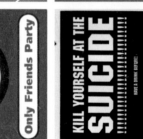

suicide ☆ circus

KILL YOURSELF AT THE SUICIDE

HAVE A DRINK BEFORE!

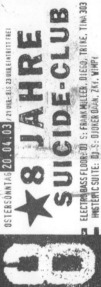

OSTERSONNTAG 20.04.03 / 21 UHR - BIS 23 UHR EINTRITT FREI

★8 JAHRE SUICIDE-CLUB

ELECTROBASS FLOOR: DJ S: FRANK MÜLLER, DIEGO, TRIKE, TINA 303
HYSTERIC SUITE: DJ-S: DJOKER DAAN, ZKY, WIMPY

[d.j.-k-r-u-s-t]

CRISPY ADVENTURES IN DRUM AND BASS. SONIC PLUG AND PLAY.

bristol-v-recordings

freitag
1605
23.00

[bassdee][bleed]

TOASTER NEUE SCHÖNHAUSERSTR. 20 BLN MITTE U8 WEINMEISTERSTR.

[LOCAL HEROES]

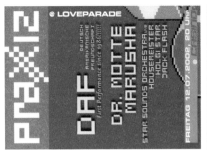

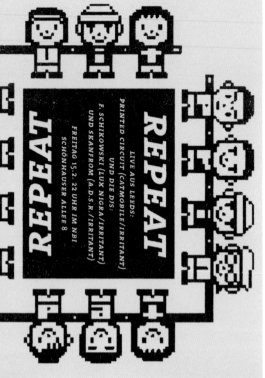

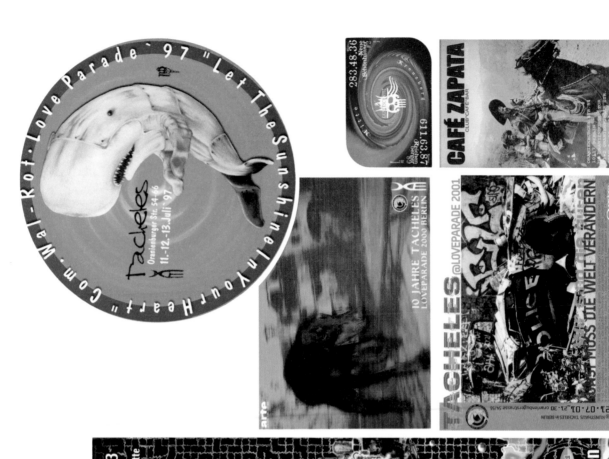

rastermusic

kyborg + die insel
präsentieren:
rastermusic labelparty

electrick

13.09.1996 insel 22.00 Uhr

dj traxx chicago

radical house

traxxx composer
fauli voxxx chemnitz
live

komet rastermusic
tol rastermusic
icon rastermusic
kyborg rastermusic

spectro namib berlin
peer berlin

die insel:
alt treptow, 12435 berlin
tel, fax: 5348851

radionord
vinyl + clothes
puschkinallee 227
10405 berlin
tel: 4414245

freak out!
vinyl + cd's
rykestrasse 23
10405 berlin
tel: 4427615

electrick

JUNI EVENTS

SENSOR 28.10

acid

Love WG
06. Okt. 1995
Neue Schönhauser Str.20

sundayclub
Paul van Dyk
Sonntag 24.1-23h

DISKUSSION

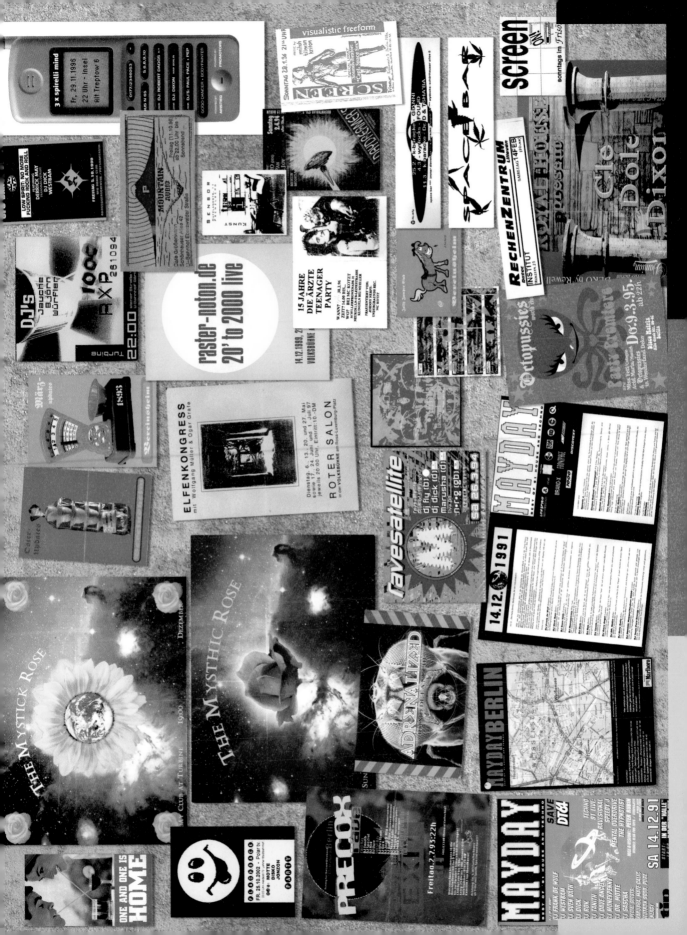

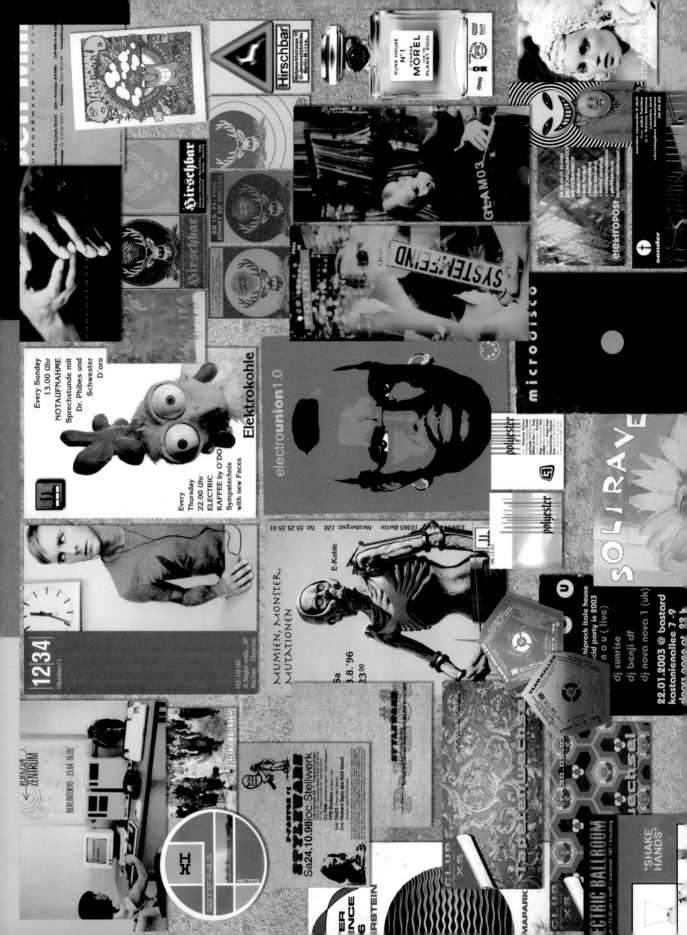

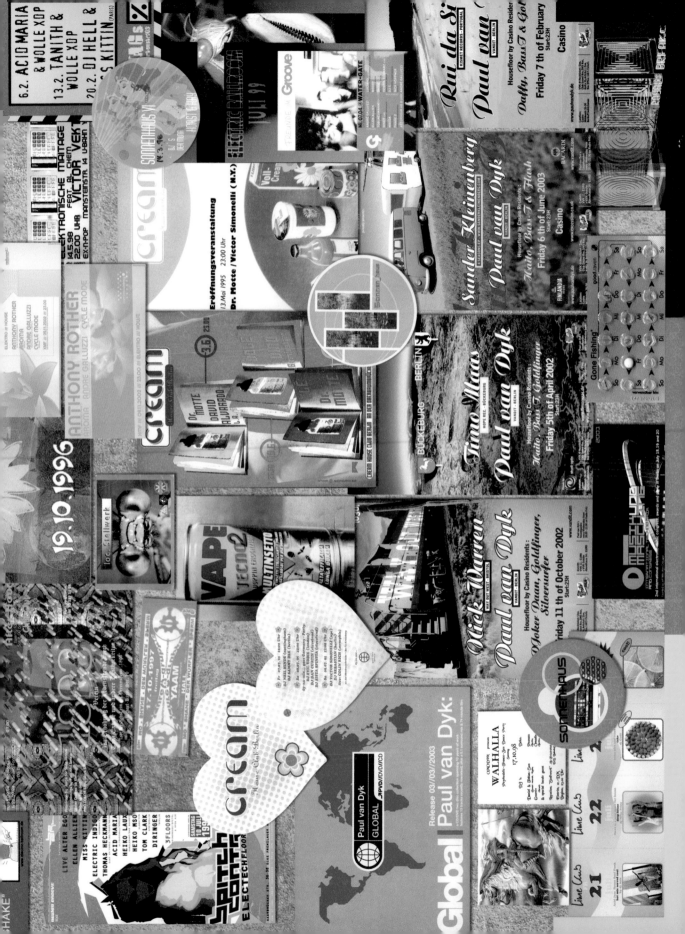

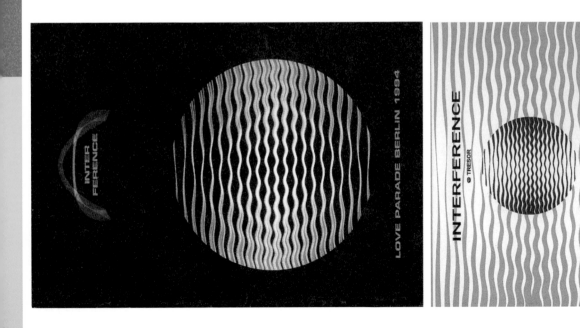

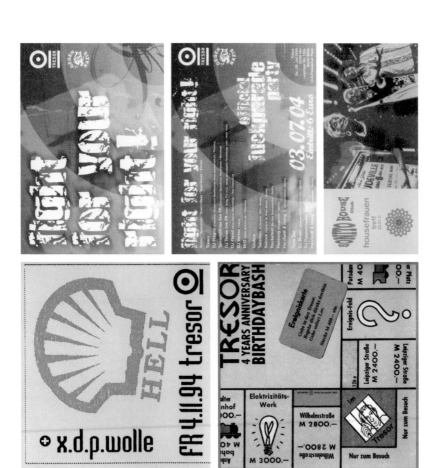

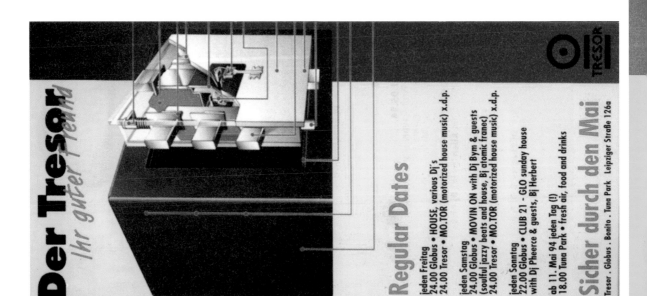

Tresor.

Lineup November 2003

Tresor loves Shinpei.

First Art Exhibition at Tresor

SPACE NOUVEAU 2003
Mi. 17. 12. – Sa. 20. 12.
Vernissage: Mi. 17. 12., 23:00–
Tresor Club · Leipziger Str. / Ecke Pi. Burn

Tresor. 03.09.2003 - 17.09.2003

Liebe Gäste!
Der September ist da und wir werden preiswerter!
Von jetzt an werden bei uns die meisten Samstage 2 Euro weniger kosten, als
bisher. Ausgenommen davon sind unsere neue monatliche True Spirit Reihe
(lasst Euch überraschen!) und natürlich Sonderveranstaltungen.
Viel Spaß im Tresor!

Mi 03.09.

Globus — **Bonito House Club**
Renato Lopes (Love Club, Jackfruit / Sao Paulo)
Dave DK (Müller Rec. / Berlin)

Tresor — **New Faces!**
Headquarters DJs feat.: **Micha Stahl** (HQ / Berlin)

Fr. 05.09.

Globus — **Rio Parade goes Berlin!**
A. J. Crypt (Rio Parade / Rio De Janeiro)
Chan Dru (Rio Parade / Rio De Janeiro)
Jazzomaniac live on Sax (Rio Parade / Zürich-Rio De Janeiro)
Ralph Bellschuh (D-Fens / Berlin)

Tresor — **Sender Berlin DJ Team** (Tresor Rec., unGleich / Berlin)

Sa. 06.09.

Globus — **Messy Household presents:**
Kidnap live PA! (Messy Household / Berlin)
Prodomo (Messy Household / Berlin)
Aurora Nova (Nectar / Berlin)

Tresor — **Ein Hundeleben**
All nite long! Recyver Dogs (Tresor Rec. / Berlin)

Tuna Bar — **Jol Bix** (Berlin)
Limette Jansen (Berlin)

Mi. 10.09.

Globus — **Bonito Superstar Club**
Spud (Superstar / Berlin)
Wimpy (Superstar / Berlin)

Tresor — **New Faces!**
Headquarters DJs feat.: **Liquid Sky**

Fr. 12.09.

Globus — **Gabba Nation – Gabba Meets Tech-House @ Tresor**
Jan Driver (Kombinat Rec.)
Oliver S (Kombinat Rec.)
Joe & Jessy (Simply Need / Kosmo)

Tresor — Sascha (Gabba Nation Rec.)
Cut-X (Gabba Nation Rec.)
Beegie (Gabba Nation Rec.)
Mike Oh Man (Midtown Rec.)

Sa 13.09.

Globus — **Clubnecht Berlin! 1 Nacht x 30 Clubs x 11 Euro**
Flavoured
Break 3000 (Mouse Muzique, Trapez / Köln)
Madrid (Maastricht)
James Flavour (Highgrade, Brique Rouge / Berlin)
Leo Kratzcyk (Intim / Berlin)
Wake Up: Micha Stahl (HQ / Berlin)

Tresor — **Angry Plastic***
Con 3 (Possible Music, mental ind. / Berlin)
Poligf (Modeselder Rec. / Tel Aviv)

Tuna Bar — *Conzuela Comatosa (Berlin)
*Angry Plastic Recordshop: Liberda Str. 10, 12047 Berlin
www.angryplastic.net

Mi 17.09.

Globus — **Bonito House Club**
Daffy (no label, no release, / Berlin)
Tama Sumo (Berlin)

Tresor — **New Faces!**
Headquarters DJs feat.: **Mike Low**

Tresor Club/Globus: Leipziger Str. 126a, 10117 Berlin. U/S Bahn: Potsdamer Platz. Doors open 23.00 h
Einlass ab 18 Jahre. Tresor Office: PO Box 360 428, 10999 Berlin. Email: club@tresor-berlin.de
Tresor Info http://www.tresorberlin.de Newsletter-Abo newsletter-abo@tresor-berlin.de
Propaganda* kykdesignstudio.de Foto: peinlich.

Dussmann ● Klubradio

Tresor.

Lineup September / 1
03.09.03 – 17.09.03

**samstag.06.09.03
messyhousehold!**

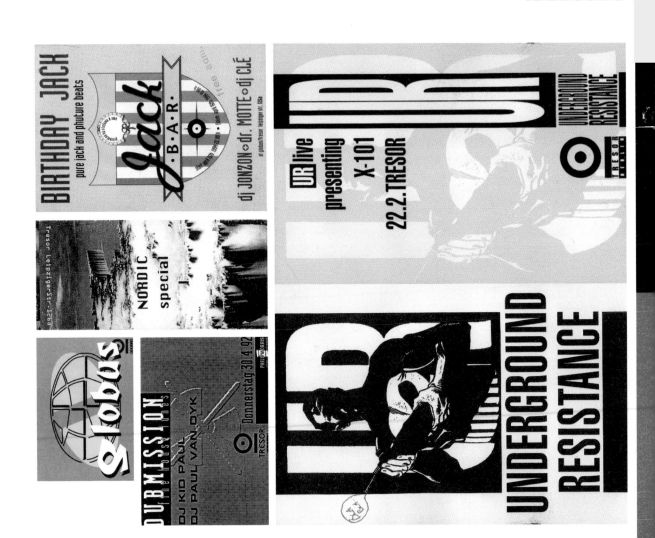

BIRTHDAY JACK
pure jack and phuture beats

jack B·A·R·

dj JONZON ○ dr. MOTTE ○ dj CLÉ

of globus/Tresor Leipziger str. 126a

NORDIC special

Tresor Leipziger Str. 126a

Globus

DUBMISSION

DJ KID PAUL
DJ PAUL VAN DYK

Donnerstag 30.4.92

TRESOR

UR live presenting X-101
22.2. TRESOR

UNDERGROUND RESISTANCE

UR UNDERGROUND RESISTANCE

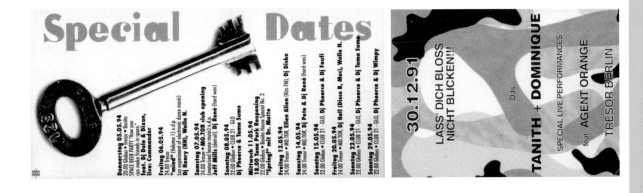

Special Dates

Donnerstag 05.05.94
20.00 Globus • Tresor • Bonito
SPACE BEER PARTY "Now you
can make friends in space."
feat. Dj Dole & Dixon,
live: Commander

Freitag 06.05.94
24.00 Tresor
"mind" (Volume 1) x.d.p.
(an experiment of electronic dance music)
Dj Henry (KMH), Wolle N.

Samstag 07.05.94
24.00 Tresor • NO.TOR club opening
(modernized house music) x.d.p.
Jeff Mills (detroit), Dj René (hard wax)

Sonntag 08.05.94
22.00 Globus • CLUB 21 - GLO
Dj Pheerce & Tanco Sumo

Mittwoch 11.05.94
18.00 Turm Park Reopening
22.00 Globus • Bonito House-Special No. 3
"Spring!" mit Dr. Motte

Freitag 13.05.94
24.00 Tresor • NO.TOR, Ellen Alien (Kiss FM), Dj Disko

Samstag 14.05.94
24.00 Tresor • NO.TOR, Dj Pete & Dj René (hard wax)

Freitag 15.05.94
22.00 Globus • CLUB 21 - GLO, Dj Pheerce & Dj Foufi

Freitag 20.05.94
24.00 Tresor • NO.TOR, Dj Hell (Disco B, Mori), Wolle N.

Sonntag 22.05.94
22.00 Globus • CLUB 21 - GLO, Dj Pheerce & Dj Tanco Sumo

Sonntag 29.05.94
22.00 Globus • CLUB 21 - GLO, Dj Pheerce & Dj Wimpy

30.12.91

LASS' DICH BLOSS
NICHT BLICKEN!!!

DJs

TANITH + DOMINIQUE

SPECIAL LIVE PERFORMANCES

feat. AGENT ORANGE

TRESOR BERLIN

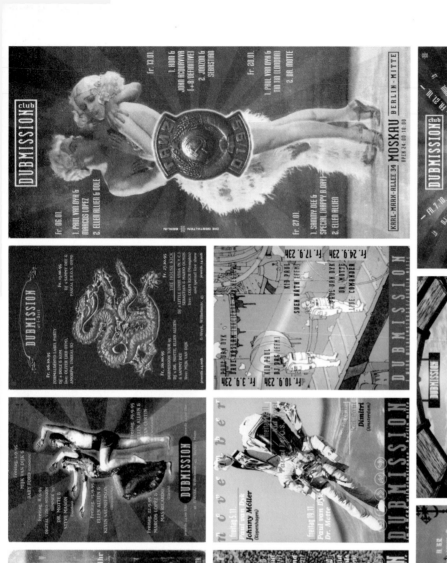

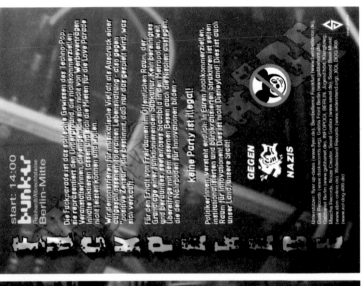
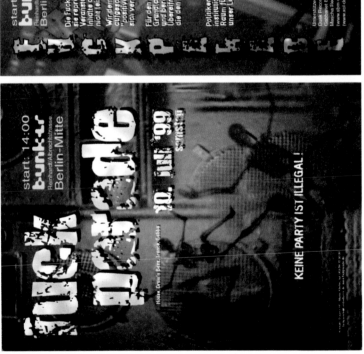

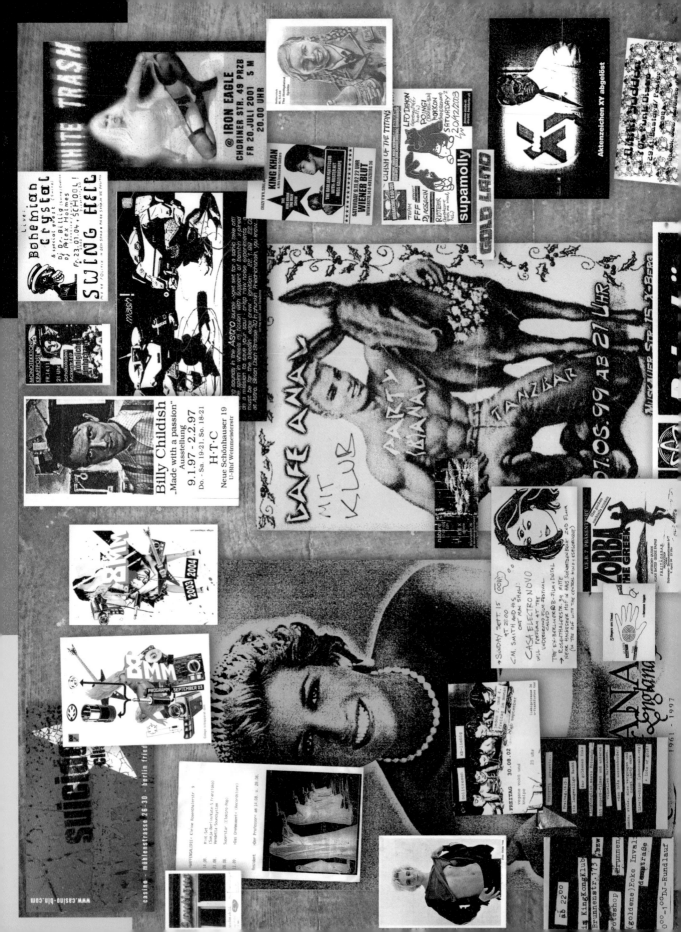

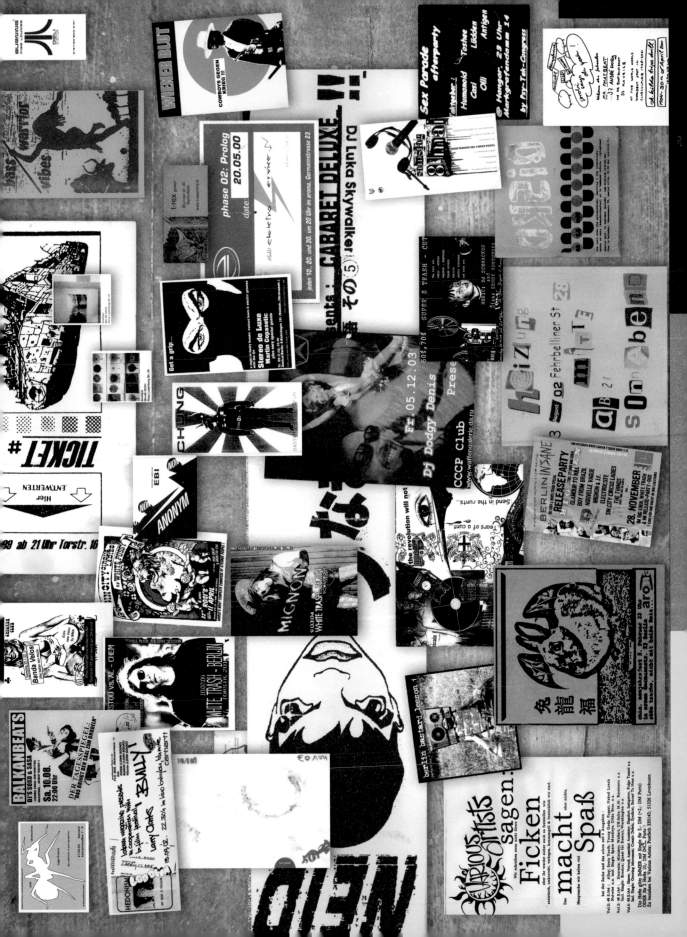

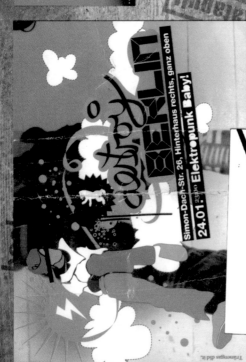

KLUB BERLIN

21.09.2002 23h
CLUB NACHT BERLIN
1 NACHT · 29 CLUBS · 11 EURO

15 SEPTEMBER 2001
CLUB NACHT BERLIN

13.9.2003 * 23H
5. CLUB NACHT BERLIN

Viele liebe Grüße aus Berlin

Simon-Dach-Str. 26, Hinterhaus rechts, ganz oben
24.01. Elektropunk Baby!

HAMBURG

AUGUST2000

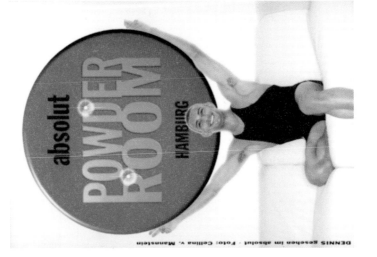

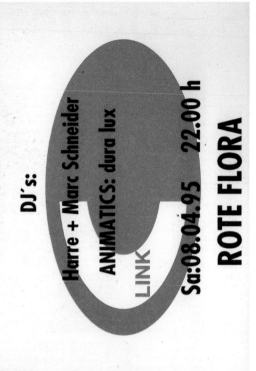

DJ's:

Harre + Marc Schneider

ANIMATICS: dura lux

LINK

Sa:08.04.95 22.00 h

ROTE FLORA

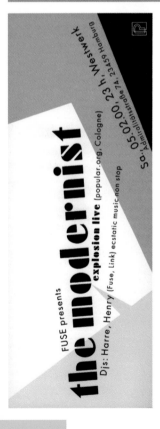

FUSE presents

the modernist

explosion live (popular.org, Cologne)

Djs: Harre, Henry (Fuse, Link) ecstatic music non stop

05.02.00. 23 h. Westwerk

Sa·Admiralitätsstraße 7A, 23459 Hamburg

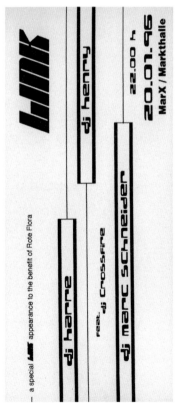

LINK

— a special LINK appearance to the benefit of Rote Flora

dj harre

feat. dj Crossfire

dj henry

dj marc schneider

22.00 h

20.01.96

MarX / Markthalle

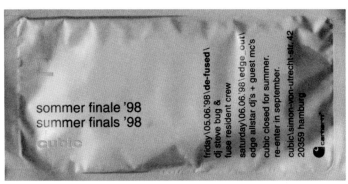

sommer finale '98
summer finals '98

cubic

friday\05.06.'98\de-fused\
dj steve bug &
fuse resident crew

saturday\06.06.'98\edge out\
edge allstar dj's + guest mc's

cubic closed for summer.
re-enter in september.

cubic\simon-von-utrecht-str. 42
20359 hamburg

carhartt°

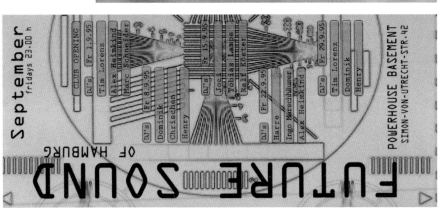

September
fridays 23.00 h

CLUB OPENING

DJ's Fr 1.9.95
Tim Lorenz
Alex Heimkind
Marc Schneider

DJ's Fr 8.9.95
Dominik
Chrischan
Henry

DJ's Fr 15.9.95
Jock
Tobias Lampe
Ralf Köster

DJ's Fr 22.9.95
Harre
Ingo Marschhäuser
Alex Heimkind

DJ's Fr 29.9.95
Tim Lorenz
Dominik
Henry

FUTURE SOUND OF HAMBURG

POWERHOUSE BASEMENT
SIMON-VON-UTRECHT-STR. 42

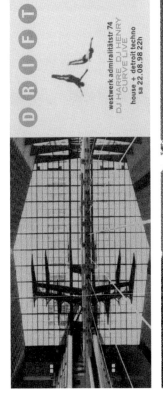

DRIFT

westwerk admiralitätstr 74
DJ HARRE DJ HENRY
CURVE LIVE
house + detroit techno
sa 22.08.98 22h

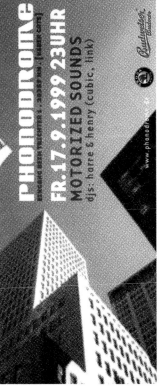

PHONODROME

FR.17.9.1999 23UHR

MOTORIZED SOUNDS
djs: harre & henry (cubic, link)

Budweiser Budvar

www.phonodrome

dj's:
harre.
henry.
marc
schneider

22.00 h

25.11.95

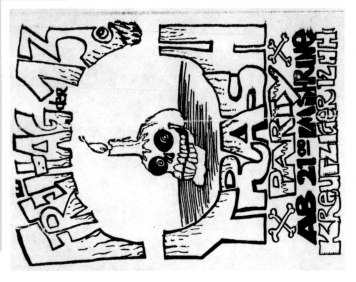

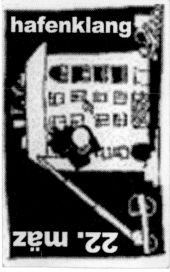

hafenklang

22. mäz '...

Dummer August

& fuse present

a night with

djs harre
& henry
(ecstatic music
non stop)

support: lawrence

fr., 02.03.01, 22 h
golden pudel club

odradek

virtuelles Zeitschriftenerbe
www.zone.hamburg.com/...

FILMMAKER FROM MEMPHIS
JOHN MICHAEL McCARTY
COMES TO HAMBURG
TO SHOW HIS MOVIES TO YOU!

SUPERSTARLET A.D.

E✱VIS
MEETS THE BEAT✱ES

LIVE PERFORMANCES BY:
— DM BOB + THE DEFICITS (#)
— THEE NARCOTICS (HEIDELBERG)

SONNTAG 6. AUGUST
SCHILLEROPER

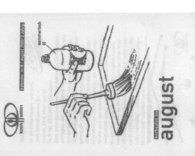

august

es ist entschieden ·wir nehmen kreativpause im august. Und zwar von di 14.8.–mi 23.8.2000, als etwas

über eine woche ·yes und daß heißt, am montag schlagen wir uns gemeinsam den wams voll und gehen entweder selbst an den herd, essen nur noch belegte brötchen oder hoffen, daß es warm genug für mutter natur´s fertigprodukte ist. Aber im september wird es dann umso schöner: regelmäßige musiksupports, die neue bildungsküche und der talentschuppen aus berlin werden vorgestellt. Dann stellen wir die gerichte die woche ins netz, so daß man so ungefähr weiß, was der teller so bringt -interessenten bitte mailadresse im ks abgeben. Bis zum 14.8. wird aber noch richtig gas gegeben und klassiker wie „themen-samstag", „japansonntag" und „kuscheliger klubabend" werden weiter zelebriert.

Um allen schönen ...

wir haben 12 sterne! (teil 1)

Fisch 19.2.–20.3.
es ist immer eine achte bereicherung, wenn sie die brittischen inseln verlassen und hh besuchen

Widder 21.3–20.4.
ihr brunftvergnügen ist durch den miesen sommer stark reduziert worden·cool bleiben und kräfte bewahren!

Stier 21.4.–20.5.
ein kleiner ausflug auf eine andere weide wird sie sicher inspirieren und ihre hörner anspitzen - yes!

Zwilling 21.5–20.6.
es kann nicht nur an den gin tonics liegen, wenn man das gefühl hat, sie wären überall.

Krebs 21.6.–22.7.
man hat den eindruck, sie würden sich in letzter zeit immer mehr zurückziehen - hey nicht überall warten töpfe!

Löwe 21.6.–22.7.
es ist immer ein großes vergnügen, sich mit ihnen zu `her herde zusammenzurücken und nur die schönsten suchen machen.

wir haben 12 sterne! (teil 2)

Jungfrau 23.8.–22.9.
ihre saison naht ! der spätsommer mit schwülen nächten und großen versprechungen - passen sie auf!

Waage 23.9–22.10.
sie sind echt sauer - da erwartet man die bikinisaison und dann das! aber jetzt bloß kein falsches timing!

Scorpion 23.10.–22.11.
stellen sie sich mal vor, sie sind ein unschuldslamm und jemand stachelt sie an - na dämmert´s?!

Schütze 23.11.–21.12
saturn steht mal wieder in ihrem mond und... sie haben hunger! wenn sie glück haben nicht zwischen dem 15. und 23.8.

Steinbock 22.12.–19.1.
auch ehrgeizige bergkraxler brauchen ruhepausen - also verschnaufen und grazieile schritte machen!

Wassermann 20.1.–18.2.
sie wollen es ja nicht anders: - viel glück in der eigenliebe?
... und sie haben recht.

kalender für august

sa. 05.08.	ab 17h „themen-samstag" hausman C plated on french
so. 06.08.	ab 17h: tapas und elvis kocht doch!
mo. 07.08.	ab 20h kuscheliger klubabend
sa. 12.08.	ab 17h „themen-samstag" freestyling con felsonia
so. 13.08.	ab 17h: los latinos fresca con jorge. andres & kuki
mo. 14.08.	ab in die ferien und vorher: gemeinsames kühlschränke leerfressen

ferien von: di 14.8.–mi. 23.8.00

mi. 23.08.	ab 13h reopening mit relaunch und trendfood ·weitere termine www.kochsalon.de

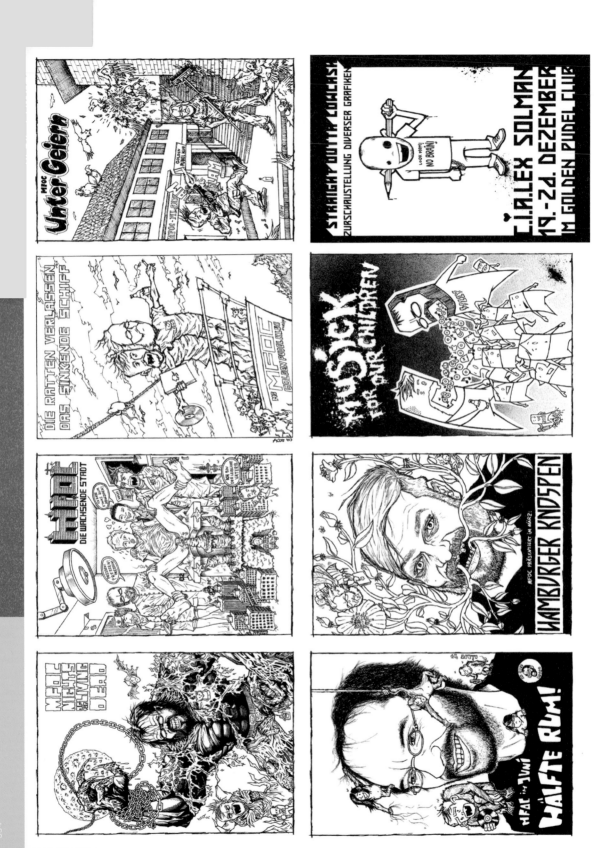

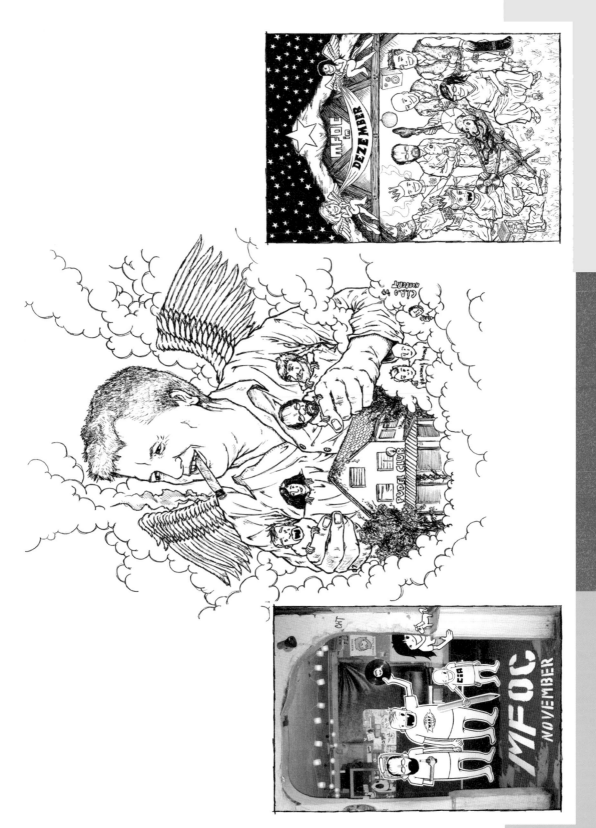

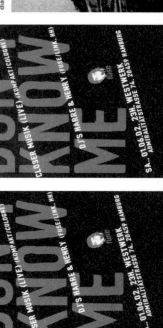

dial, playhouse und classic empfehlen: 26.08.00 23 cet luke solomon für playhouse / classic / uk lawrence und c.jost für dial.

**dial666.

Mal richtig abfeiern? Von einer Party zur nächsten? Ohne teures Taxi, ohne nervige Parkplatzsuche und ohne Führerscheinkontrolle? Dann kommt an Bord: Der HOCHBAHN Nightcruiser ist der Nachtbus mit Bar und Beats!

NIGHTCRUISER

HOCHBAHN

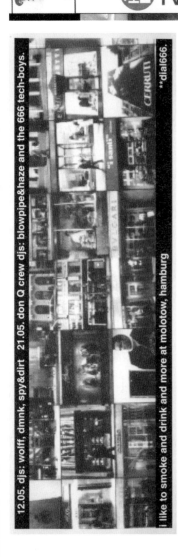

12.05. djs: wolff, dmnk, spy&dirt 21.05. don Q crew djs: blowpipe&haze and the 666 tech-boys.

i like to smoke and drink and more at molotow, hamburg

**dial666.

DEZEMBER '00

YOU DON'T KNOW ME

FUSE PRESENTS: ECSTATIC MUSIC NON STOP
CLOSER MUSIK (LIVE) (KOMPAKT/COLOGNE)
DJ'S HARRE & HENRY (FUSE/LINK, HH)
SA.. 01.06.02.. 23H. WESTWERK
ADMIRALITÄTSTRASSE 74. 20459 HAMBURG

YOU DON'T KNOW ME

FUSE PRESENTS: ECSTATIC MUSIC NON STOP
CLOSER MUSIK (LIVE) (KOMPAKT/COLOGNE)
DJ'S HARRE & HENRY (FUSE/LINK, HH)
SA.. 01.06.02.. 23H. WESTWERK
ADMIRALITÄTSTRASSE 74. 20459 HAMBURG

MANDARIN
CHINESE CHILLING THRILLS

support your local
wan tan dealer

the chinese restaurant
reaperbahn 1
cd/lp out 26. june 2000

buge wesselloft
the space brothers
thievery corporation
crazy penis
i:cube
terranova

kemistry & storm
20.05.

dj bailey & mc g.q.
dj michael sauer
dubs & effects by yell

uncompromising turntables

HAFENKLANG

8/00

Betrifft: 1. Mai, Rote Flora. Zeuginnen gesucht!

Es wird ein jetzt unbekannter Mann gesucht, der im Zusammenhang mit folgender Situation um ca 23.55 Uhr am Seiteneingang der Flora wichtige Beobachtungen gemacht haben muß, die Polizei stürmt das Schultenblatt, teilt Menschen in den Seitenbereich der Flora und prügelt auf sie ein.

Die hier betroffene Frau ist 1.63 m groß, trägt eine schwarze Stoffhose mit Tasche, eine graue Stoffjacke, schwarze Turnschuhe und ein rostbraunes Tuch. Sie erhält zunächst einen Schlag in den Magen, taumelt zurück und will sich durch den Seitenausgang der Flora in Sicherheit bringen. Sie steht schließlich hinter der Seiteneingangstreppe (zum Park hin), versucht aber diese in die Flora zu kommen. Die Frau erhält in diesem Moment aus einer Gruppe von Polizisten mindestens zwei heftige Schläge auf und die it erst, die sie sich trennt mit ihren Kopf gelöst hat. Dadurch werden ihr an beiden Händen jeweils 2 Finger gebrochen. Der drängend gesuchte Mann hat die betroffene Frau bis hinter die Treppe begleitet neben ihr gestanden und versucht, sie gegen die Knüppelschläge zu schützen und übel selbst Schläge erhalten.

Hinweise
(die selbstverständlich
vertraulich behandelt werden)
direkt an
Rechtsanwalt
Andreas Beuth
Telefon
040 - 390 05 407

VABA BUMS

DAS MOLOTOW
FESTTAGSPROGRAMM
HOT • HOT • HOT

MOLOTOW

MASTABLAST

BEATS & RIDDIMS
DONNERSTAGS
ROTE LATERNE
GERHARDTSTR.12
HAMBURG
ST.PAULI
22 UHR

R KORD

hip-hop

saturdays 23:00h powerhouse simon-von-utrecht str. 42 st. pauli

crucial.

drum&bass

saturdays 23:00h powerhouse audiomaze simon-von-utrecht str. 42 st. pauli

crucial.

WORD UP & OUT TO ALL *HARDCORE JUNGLIST*. ITS MARCH 1996 AND WE GOT RUFF CUTZ PACKIN IT. POWERHOUSE BASEMENT. SIMON-VON-UTRECHT STR. 42. ST PAULI. EVERY SATURDAY AT 11.00. 8 DM. MANY STYLES. 02.03.96 RUFF CUTZ. 09.03.96 BOOM CLAN-*DJ'S* FLEXABLE & RUFTONE/EDINBURGH. 16.03.96 MIXMASTER MORRIS/LONDON. 23.03.96 RUFF CUTZ. 30.03.96 RUFF CUTZ-INTRODUCING *DJ* S-CAPE. **RUFF CUTZ** DOING HOME GROUND. CRUCIAL. HAMBURG-HOME OF THE BRAVE. BATTLE OF THE TERRITORIES.MANY STYLES. YOU CHOOSE.

+ powerhouse basement
10.08.96 23:00h
ruff cutz

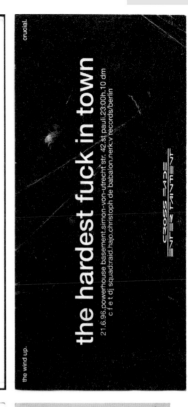

crucial.

the wind up.

the hardest fuck in town

21.6.96.powerhouse basement.simon-von-utrecht str. 42.st.pauli.23:00h.10 dm
c f e t dj squad:raid.hajo.christoph de babalon.nerk:v records/berlin

CROSS FADE
ENTERTAINMENT

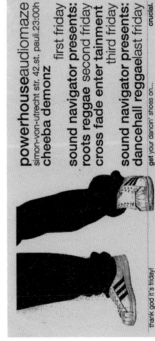

powerhouseaudiomaze
simon-von-utrecht str. 42.st. pauli.23:00h

first friday
cheeba demonz

sound navigator presents:
roots reggae second friday
cross fade entertainment
third friday

sound navigator presents:
dancehall reggae.last friday

crucial.

thank god it's friday!
get your dancin' shoes on...

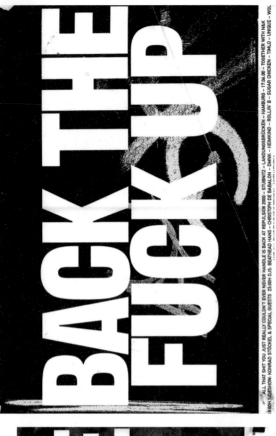

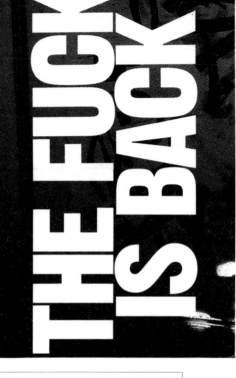

BACK THE FUCK UP

ALL THAT SHIT YOU JUST REALLY COULDN'T EVER NEVER HANDLE IS BACK AT REPULSION 2000 – STUBNITZ – LANDUNGSBRÜCKEN – HAMBURG – 17.06.00 – TOGETHER WITH N&K 18.00H SIDESHOW, KONRAD STÖCKEL & SPECIAL GUESTS 23.00H D.JS. BEATHEAD HANS – CHRISTOPH DE BABALON – DMNK – HEIMKIND – ROLLIN B – SUGAR CHICKEN – TIMLO – UNIQUE – WOL

THE FUCK IS BACK

ALL THAT SHIT YOU JUST REALLY COULDN'T EVER NEVER HANDLE IS BACK AT REPULSION 2000 – STUBNITZ – LANDUNGSBRÜCKEN – HAMBURG – 17.06.00 – TOGETHER WITH N&K 18.00H SIDESHOW, KONRAD STÖCKEL & SPECIAL GUESTS 23.00H D.JS. BEATHEAD HANS – CHRISTOPH DE BABALON – DMNK – HEIMKIND – ROLLIN B – SUGAR CHICKEN – TIMLO – UNIQUE – WOLF AND ALL THAT FLY SHIT IS CRUCIAL MUTHAFUCKA

FUCK THE BACK UP

ALL THAT SHIT YOU JUST REALLY COULDN'T EVER NEVER HANDLE IS BACK AT REPULSION 2000 – STUBNITZ – LANDUNGSBRÜCKEN – HAMBURG – 17.06.00 – TOGETHER WITH N&K 18.00H SIDESHOW, KONRAD STÖCKEL & SPECIAL GUESTS 23.00H D.JS. BEATHEAD HANS – CHRISTOPH DE BABALON – DMNK – HEIMKIND – ROLLIN B – SUGAR CHICKEN – TIMLO – UNIQUE – WOLF AND ALL THAT FLY SHIT IS CRUCIAL MUTHAFUCKA.

ORT ORANGE-CLUB/GROSSE FREIHEIT
DATUM 09.20.'85
STUNDE 23 M '10

DJ ADAMSKI
UNIQUE
CRANQUE DAVIS
VJ MOON

BE KILLER

360

RUFF CUTZ TUFF SHIT

BE KILLED

the crucial shit

if ya gonna
go out...
go out like a
murthafucker.

ALL STAR LINE-UP:
raid.christoph de babalon.zimmerit.insane child.rollin' b.paul snowden
20.12.96 23:00h powerhouse:audiomaze simon-von-utrecht str.42 st. pauli

CROSS FADE
ENTERTAINMENT

DJ CHRIS KORDA
UNIQUE
CRANIQUE DAVIS

DEUTSCHLAND OST
EASTERN GERMANY

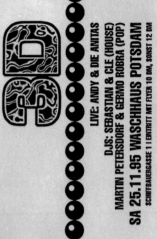

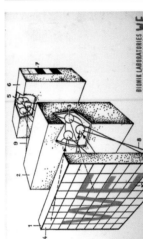

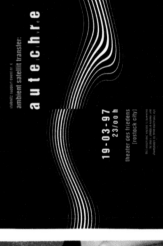

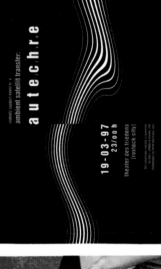

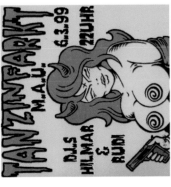

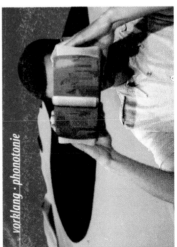

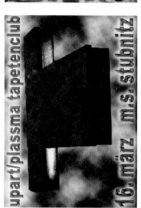

KILOS AN DER KANTE

STUBNITZ
ROSTOCK

Stubnitz geht auf die Waage:

Kilo 'ne Mark

MS Stubnitz - Kulturschiff in Rostock / Mecklenburg-Vorpommern

Ich möchte ____ symbolische Kg der Stubnitz zum
Preis von 1,- DM/Kg kaufen.
(Mindestabnahme: 10 Kg/Person ; 100Kg/Firma)
Name:
Anschrift:

Mit dem Eingang des Geldbetrages auf dem Vereinskonto
erhält jeder Bezahler eine symbolische Stubnitz-"Aktie".
Mit dem Erwerb dieser "Aktie" entstehen keinerlei Rechte
und Pflichten.

Ich bin damit einverstanden, daß mein Name/Firmenname
in eine Liste aufgenommen wird und im Betriebsgang
der Stubnitz veröffentlicht wird. JA NEIN

Überweisungen an:
MS Stubnitz, Ostseesparkasse Rostock
BLZ: 130 500 00 Ktnr: 205 029 221 Stichwort:Kilo
Weitere Informationen zum Schiff / Projekt / Programm
unter Telefon: 0381/4923143 Fax: 0381 / 4905476

230 8,4 t

An:
Motorschiff Stubnitz
Stadthafen - Liegeplatz 82
1 8 0 5 7 R O S T O C K

Foto: Mario Schmincke

3RD
EYE

upart/plassma tapetenclub
16. märz m.s. stubnitz

klub tf

STADTHAFEN HRO
03 02 01 22:00

WE
>MI 10.2.1999 MS STUBNITZ
PIONEERS OF THE
NEW YORK ILLBIENT/
CROOKLYN DUB SOUND
PSYCHEDELIC VIDEOVOYAGES
BLAUBACH
LIVE ELECTRONICS
BIONIX LABORATORIES PROUDLY PRESENTS
MEMBER 7 • VVK 10 • AK 13
ARE WE DRUM N BASS ARE WE D UB ARE WE HIP HOP?

ROSTOCK

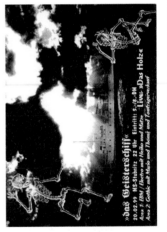

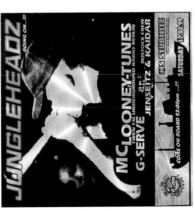

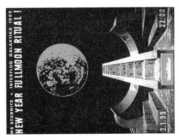

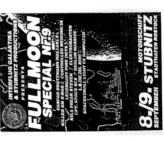

Alte Pumpstation I

31.12.99

Techno/Acid & House

2. Floors

SUCH: NOCH DJ's

Bitte meldet euch unter: 0171/7527459 (Basti)

hard

Cora S
Andrew Elliot
Ironbase
Sub-Stoic
der Schranz
Kiss the Floor
Norris Terrify

loc. scibenfabrik

kunstseidenstr. 01796 pirna
www.plasticzone.de

The Opening!

Prasha presents

samstag. 15.februar zwei:003

seidenfabrik.pirna

from past to present

disco-house-happening

yavin
money - 9
john spring

FR. 19.02.99 Start: 23.00
MELLESSE (näh. Speicher) H110

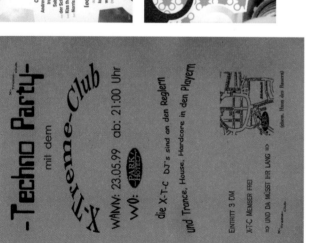

-Techno Party-

mit dem

X-treme-Club

WANN: 23.05.99 ab: 21:00 Uhr

WO: PARK HOTEL

die X-T-C DJ's sind an den Reglern
und Trance, House, Hardcore in den Playern

ENTRITT 3 DM

X-T-C MEMBER FREI

=> UND DA MÜSST IHR LANG =>

(ehem. Haus des Bauern)

zweiindustrie...

samstag 15. februar 2003

neo-pop

baby ford
/ london / uk

live northern lite

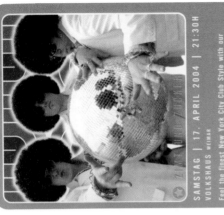

ERFURT | WEIMAR | JENA

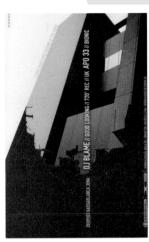

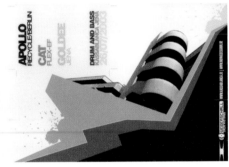

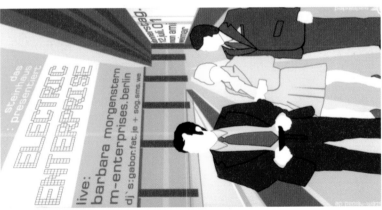

Lichtfeld.

ZEIT // 05 // 07 // 2003 // 22cet
ORT // Mensa // OberGeschoss

AKUSTIK : OUTPUT // Michael Scheibenreiter [Phoneheads] //
Party Professor [Visuelle Kommunikation] // Sog [SMS, BHC] //
Perhelio [Projekt Lichtfeld.] //
OPTIK : OUTPUT // Licht.feld Allstarz // [Projekt Lichtfeld.]

EX.tra : Chill Out Lounge | Cafeteria

Fakultät Gestaltung

PUSH IT // ALONG

LOCKSTOFF LIVE | LEIPZIG
ÜBERKINGER & MARCEL MC | LEIPZIG
DJ T-ROX | LEIPZIG
DJ MALIK | ROWDY CLUB ERFURT
VISUALS BY NEO&YAAR | BHC

REITHAUS WEIMAR 31.05.03 | 22.00

NIGHT IN MOTION

PROGRAMM | APRIL

05 future blues tour
12. klangkollektiv
19. hometory nr. 6
26. tonight's da night

CAT // STANDENT ELISE // MINUSPOL // KANEDA

MC SUPPORT / VISUALZ BY YAA & NEO

REITHAUS WEIMAR
28|06|03 22.00

XAVER FISCHER TRIO UNIQUE RECORDS

kultur cafe

REITHAUS WEIMAR
27.04.2002 22.00

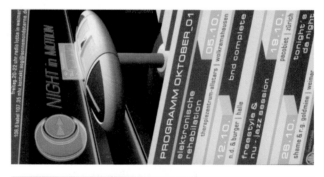

NIGHT IN MOTION

freitag 22-0 uhr | radio lotte
in weimar auf 106.6 mhz
kabel 107.35 mhz

PROGRAMM
MÄRZ_02

01.03.02
primaklimasession | gabor | monkey maffia

08.03.02
oder auf brot | greeny and his friends

15.03.02
thrillbeatconstructions | mikk & robert outter

22.03.02
impossible music | cora s. | berlin & sog | sms weimar

29.03.02
tonight's da night | shame & r.g. | goldmine weimar

three
of three

kontakt:
sog@sonnemondsterne.de

HOUSE DELUXE II
26.04.03 REITHAUS WEIMAR

WIGHNOMY BROTHERS (FREUDE AM TANZEN / KASSA JENA)
SOG SMS | BROKEN HARMONY | NIGHT-IN-MOTION.COM WEIMAR
DESMOND NIGHT-IN-MOTION.COM WEIMAR

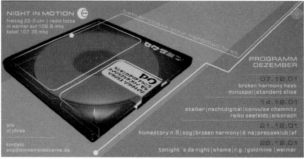

NIGHT IN MOTION

freitag 22-0 uhr | radio lotte
in weimar auf 106.6 mhz
kabel 107.35 mhz

PROGRAMM
OKTOBER_01

05.10.
therapiezentrum-allstars | wolkramshausen
elektronische rehabilation

12.10.
n.d. & burger | halle

19.10.
bnd complete

freestyle &
nu - jazz session

26.10.
tonight's da night
shame & r.g. goldmine | weimar

BERLIN SUMMIT

20.09.03 | 22.00 | REITHAUS WEIMAR

FIEBER 45
KULTURCAFE PRESENTS

BURGER & N.D.
SOG + ALESIS AIR FX SHOW

DEKO.UNRUHIGE NAECHTE
VISUALZ YAAA & NEO

kultur cafe

REITHAUS WEIMAR
14.08.2002 22.00

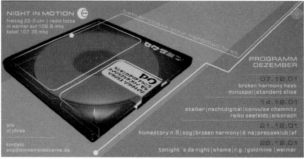

NIGHT IN MOTION

freitag 22-0 uhr | radio lotte
in weimar auf 106.6 mhz
kabel 107.35 mhz

PROGRAMM
DEZEMBER

07.12.01
broken harmony heat
minuspol | standent elise

14.12.01
stalker | nachtdigital | convulse chemnitz
reiko seefeldt | eisenach

21.12.01
homestory n. 6 | sog | broken harmony | d. na | presseklub | ef

28.12.01
tonight's da night | shame | r.g. | goldmine | weimar

one
of three

kontakt:
sog@sonnemondsterne.de

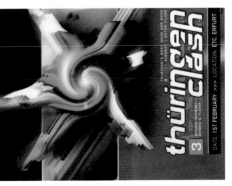

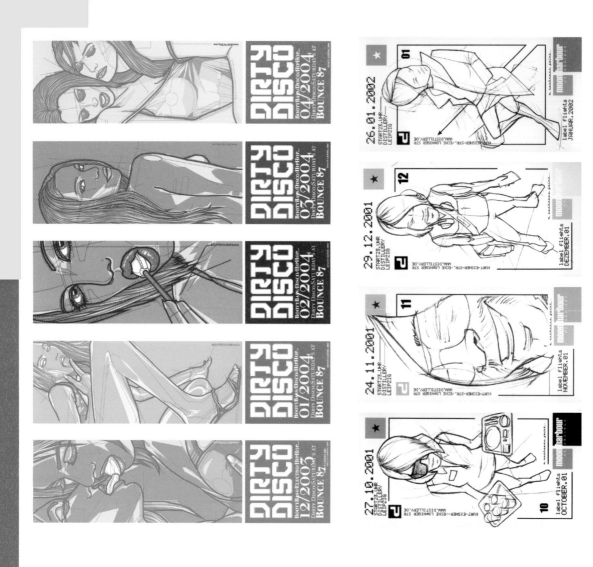

LEIPZIG

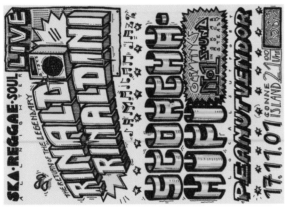

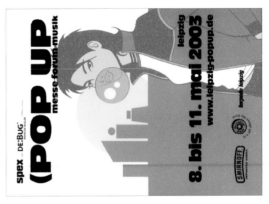

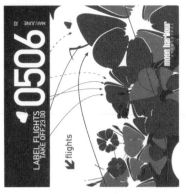

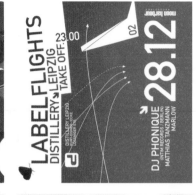

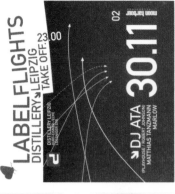

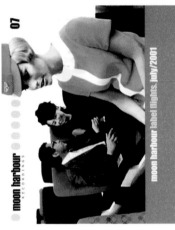

LEIPZIG

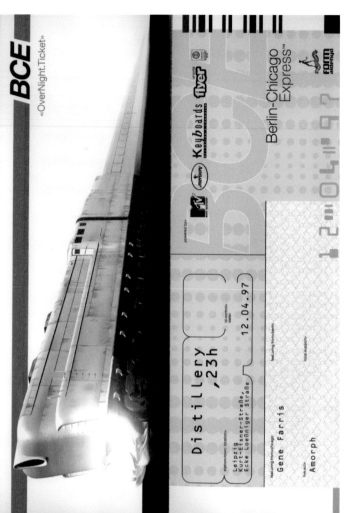

INDUSTRIALISATION

SAMSTAG, 30. JANUAR, 21 UHR
LEIPZIG, WERK II, HALLE D

INFO: 0341-3394101

VI

...der Tag danach ist am Samstag, 18. April

INDUSTRIALISATION

SAMSTAG, 18. APRIL, 21 UHR
LEIPZIG, WERK II, HALLE D, KOPFSTR.

INFO: 03 41 - 339 41 01

VII

KÖLN | COLOGNE

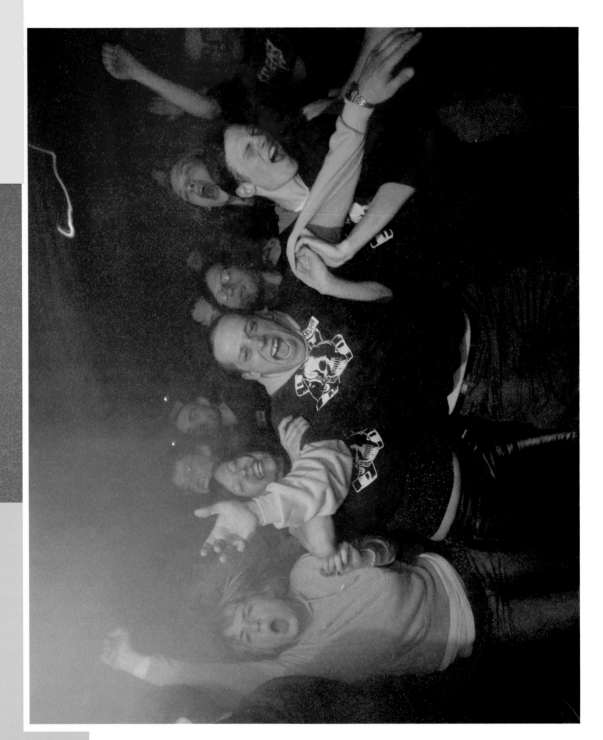

Foto: marco.microbi | Zeichnung: Oliver Pfeil

379

LIQUID SKY COLOGNE MEETS FRANKFURT CITY
SAVE ASTROGIRL!

pop hotel
techno · dub · elektro

°SAMPLE MINDS (live+acting)
irwin leschet (liquid sky cologne)
sumo (official art-cologne)
fent (six pack-cologne)

°BILDREGLER
video jammin

24°06'00
10° pm
Oman /
Mediapark
UKB 8,-

SPONSORED BY

info: www.kiddobeddo.de

KOMPRESSIONSKAMMMER

31.OKTOBER ab 14.00 h im

LIQUID SKY COLOGNE

KYFFHÄUSERSTR. 43 · 50674 KÖLN · TEL : 0221 - 216656
MIT FRANK HEISS / DR. WALKER / STROBOCOP / TALAYOT / ...

karaoke kalk

jens massel
wechsel garland
strobocop

22.8.99

liquid sky cologne kyffhäuserstr. 43 21h

audiokunststoff presents:

3 männer_3 micros_1 technics_totaler wahnsinn!

[männer]　[ohne]　[nerven]

ziel 100 (u60311, hr-xxl, frankfurt)
venus 23 (liquid sky cologne)
irwin leschet (liquid sky cologne)

17°03'01_liquid sky cologne

karaoke kalk
sonntag sechzehnter august
21 uhr
kandis+motel+thorsten lütz
liquid sky cologne kyffhäuserstr. 43

karaoke kalk
sonntag sechzehnter august
21 uhr
kandis+motel+thorsten lütz
liquid sky cologne kyffhäuserstr. 43

karaoke kalk
sonntag sechzehnter august
21 uhr
kandis+motel+thorsten lütz
liquid sky cologne kyffhäuserstr. 43

karaoke kalk
sonntag sechzehnter august
21 uhr
kandis+wunder+thorsten lütz
liquid sky cologne kyffhäuserstr. 43

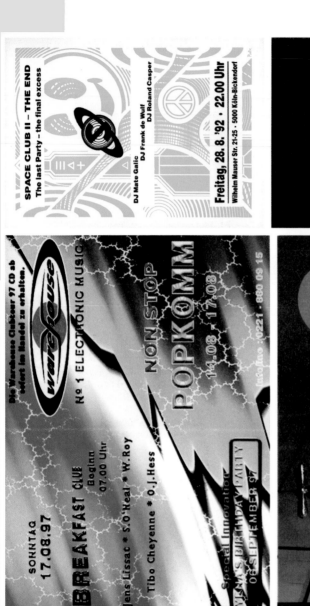

GREEN◆KOMM
the special
green komm birthday-party
16. august 1998 start 7 uhr

r&c ◆ DESIGN

GREEN◆KOMM
the special
green komm birthday-party
16. august 1998 start 7 uhr

r&c ◆ DESIGN

KITTCLUB HILDEBOLDPLATZ 5 NÄHE FRIESENPLATZ

COLOGNE

DEZEMBER

F·E·E·D · HARD·EDGED·BERLIN
X·P·L·O·R·E·R
CHILL·GATE · CASPARINDERS
M·B · GROOVE ATTACK

DEZEMBER

22.00H SHAKE UP
DRUM & BASS PRESSURE ON A2R
X·P·L·O·R·E·R · SHAKE UP·CASE·NWADO
ORIGINAL AKKI·SET·SPEED
PRESENTS
M·B · GROOVE ATTACK

KITTCLUB HILDEBOLDPLATZ 5 NÄHE FRIESENPLATZ

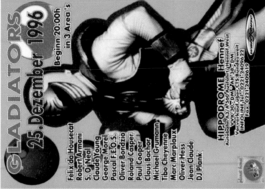

GLADIATORS
25. Dezember 1996
Beginn 20.00h
in 3 Area's

Felix da Housecat
Robert Armani
S. O'Neal
Claude Young
George Morel
Pascal F.E.O.S.
Oliver Bondzio
Roland Casper
Paul Cooper
Claus Bachor
Michael Grumann
Tibo Cheyenne
Marc Marplaux
Oliver Hess
Jean Claude
DJ Plank

HIPPODROME Hennef

DJ DAG
10.1.97

MILLE PLATEAUX

RIOT BEATS

FR. 31.03.

COLOGNE ACID NIGHT

DJs: ROOTPOWDER FORMIC REC.
MANUEL YOUNG & FRESH
RED DEEP

LIVE
FORMIC

DEEP UND HOUSEPOST PRÄSENTIEREN

HOHENSTAUFFENRING 25 / DM 15 / 23.00

HOUSE-POST

PRINZ präsentiert

stellardeluxe® Saturday September 09th 2000

Marlboro Network + Honolulu United präsentieren

josh wink (nani)
ian pooley (nz)
dope (s) (wni)
gazzarra (!)
deon (wni)
ergo aürige (verden problems)
tomin (honolulu united)
+ surprise dancefloor dc.
im avignon (b rendez dog)

ovum party popkomm '99

don | 19.8.1999 | 22 uhr
apollo | hohenzollernring 79-83 | cologne

Flyer sponsored by
HOUSE OF FETISCH & MORE
DOME
KÖLN
50674
Hundstr.27/Roddtplatz
Tel 022 1/92-34 2019

MS PANTHER KÖLN e.V. präsentiert:
Die offizielle Eröffnungsparty zu
M.v. "Leder am Rhein"
KÖLN
Fucking Fantasies
AK 10,- DM
Fr. 28.08.98 | 23.00 Uhr
Dresscode!!! Leder-Uniform-Gummi-Jeans!!!
Savoy, Hohenstaufenring 25 (Zülpicher Platz) KÖLN

Mother says:
Don't go there !!!

Sexy Funky Pumping House Directive.
by Claus Cooper & friends.

apollo • hohenzollernring 79-83 • cologne
hurven star
jeden dienstag im apollo

in association with
DISCO 2000
and
FORMIC Records

the FUNKY CHICKEN CLUB

present disegno

Thursday April 30 1998 Apollo Köln
(Tanz in den Mai)

Disco Gossner U.F.O. Walter
Claus Bachor Breakdance
Roolpowder Glitter Deco
Mick Wills & 70s lights

sender-nacht

benno blome
patrick pulsinger
t.raumschmiere live
konkord live
b.o.volt

freitag, 18.august 2000
22:00 @ kulturbunker
berliner-str.20
köln-mülheim

www.sender-records.de

POP
komm.

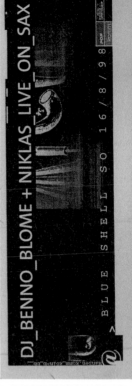

DJ_BENNO_BLOME + NIKLAS_LIVE_ON_SAX

BLUE SHELL SO 16 / 8 / 9 8

POP
komm.

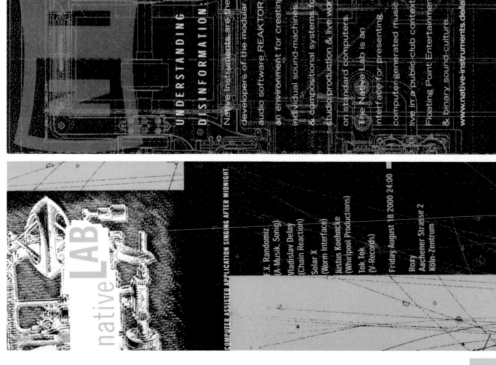

U N D E R S T A N D I N G

D I S I N F O R M A T I O N :

Native instruments are the

developers of the modular

audio software REAKTOR

an environment for creating

individual sound-machines

& compositional systems for

studio production & live work

on standard computers.

The Native Lab is an

interface for presenting

computer-generated music

live in a public-club context.

Floating Point Entertainment

& binary sound-culture.

www.native-instruments.de/lab

nativeLABit

COMPUTER ASSISTED APPLICATION SINGING AFTER MIDNIGHT

F.X. Randomiz
(A-Musik, Sonig)

Vladislav Delay
(Chain Reaction)

Solar X
(Worm Interface)

Justus Koehncke
(Whirlpool Productions)

Tok Tok
(V-Records)

Friday August 18 2000 24:00

Roxy
Aachener Straße 2
Köln-Zentrum

lab@native-instruments.de

presented by
DE:BUG

385

NOW ON AIR

ELECTRONIC MUSIC DJ RADIO

evosonic
evolution of sound

evosonic radio - das Sendeschema

evolution of sound. Der Name ist Programm: Radio-Programm. Der Musik entsprechend haben wir den Sendeaufbau evolutioniert. In grosse Zeitblöcke eingeteilt, zeigt das Schema die jeweiligen Stilrichtungen an.

Sunrise System 5:00 - 12:00

Soundrise on evosonic radio. Der sanfte morning booster bringt dich auf den rechten Fuss in die aktive Phase des ewigen Kreislaufs. Reanimierung mit Ambient, Trip Hop, etc - oder live aus den Clubs. Positive Motivation für den ganzen Tag.

Zenith 12:00 - 15:00

Die Sonne steht im Zenith. Schattenfreier Techno, House- und Trance-Sound als Energizer für das Gemüt. Täglich neu, täglich anders.

Evopool 15:00 - 20:00

evosonic radio heizt mit den besten Mix-DATs und unveröffentlichen Promos ein. Musik, die ihr einschickt. evosonic radio ist Eure Bühne. Evopool ist die Bühnenür-Danach - European electronic music - live aus dem Kölner evopool. Das Flaggschiff im wöchentlichen Programm.

Moonphase 20:00 - 2:00

evosonic geht auf die Reise. Destination: The universe of electronic music. Ein neuer Abend, eine neue Reise bis-spät in die Nacht. Jeder kommt an sein Ziel. Jedem das Seine in der elektronischen Musik.

Mind Trip 2:00 - 5:00

Tagsüber müde... nachts stundenlang wach evosonic radio ist bei Dir. Relaxter Sound für schlaflose Seelen. Einlauchen in die unendlichen Tiefen-des Unbewussten. Mit Ambient, Trip-Hop, Chill Out entschlummern wir in einen neuen Soundrise an evosonic radio.

Radio in Radiobuchse der Kabelnetz-Steckdose einstöpseln. Satelliten-Receiver direkt mit Stereoanlage verbinden.

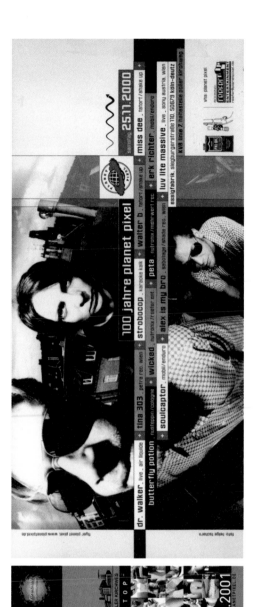

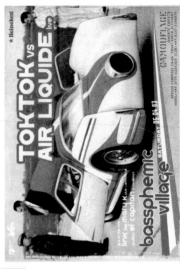

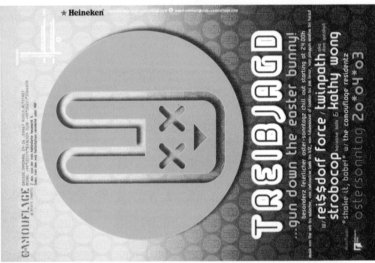

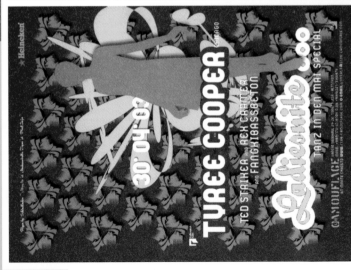

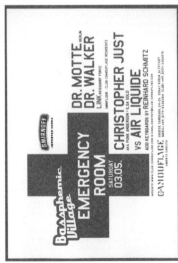

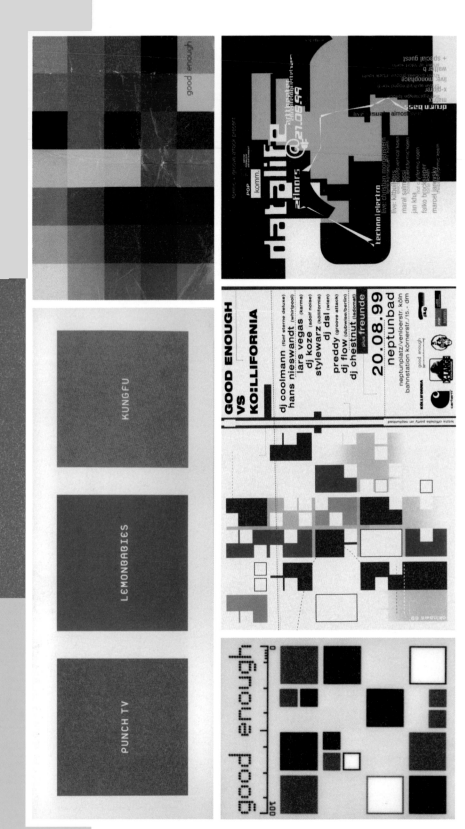

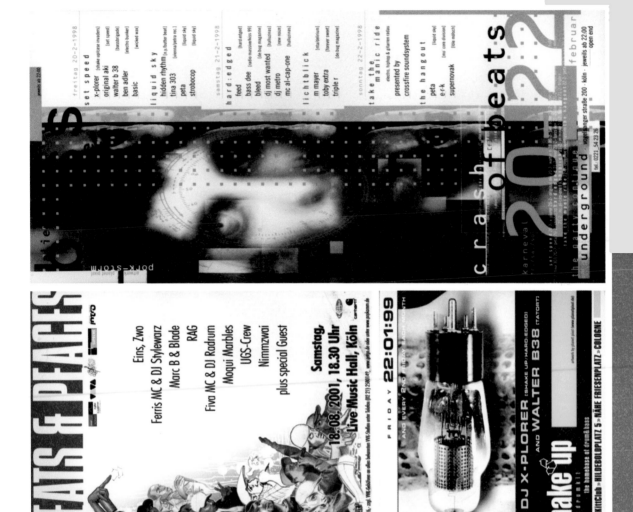

jeweils ab 22.00

freitag 20-2-1998

set speed
x-plorer (shake up/raw invaders)
original aki (set speed)
walter b 38 (bassbirgsdel)
ben adler (electro bunker)
basic (wicked wax)

liquid sky
hidden rhythm (a-jhutter beat)
tina 303 (vienna/petra rec.)
peta (liquid sky)
strobocop (liquid sky)

samstag 21-2-1998

hard:edged
feed (hard edged)
bass dee (radio massive/kris 99)
bleed (de-bug magazine)
dj most wanted (hallucinaut)
dj metro (new music)
mc al-cap-one (hallucinaut)

lichtblick
m mayer (total/kompakt)
toby extra (forever sweet)
triple i (de-bug magazine)

sonntag 22-2-1998

take the manic ride
electro, hiphop & gitarren radau
presented by
crossfire soundsystem

the hangout
peta (liquid sky)
e-r-k (nu core diversion)
supernovak (blau midschn)

crash of beats
karneval **20**-2-
februar
the nasty sunshine
underground · kopelninger straße 200 · köln · jeweils ab 22.00 · open end
tel. 0221-54 23 26

pork-storm

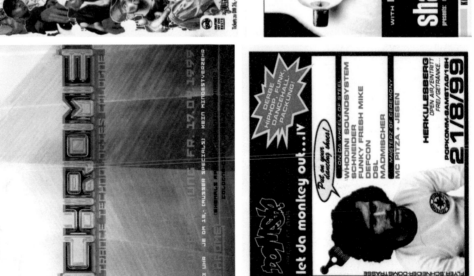

BEATS & PEACES

Eins, Zwo
Ferris MC & DJ Stylewarz
Marc B & Blade
RAG
Fiva MC & DJ Radrum
Moqui Marbles
UGS-Crew
Nimmzwoi
plus special Guest

Samstag,
18.08.2001, 18.30 Uhr
Live Music Hall, Köln

22:01:99

FRIDAY 22:01:99
AND EVERY 2ND FRIDAY OF THE MONTH

WITH DJ X-PLORER (SHAKE UP/HARD-EDGED) AND WALTER B38 (TATORT)

shake up
present: drum!!
the basebase of drum&bass

KittClub » HILDEBOLDPLATZ 5 » NÄHE FRIESENPLATZ » COLOGNE

CHROME
TRANCE TECHNO DOES COLOGNE

23 UHR · JE DM 18,- (TRUSSER SPEZIALS) KEIN MINDESTVERZEHR

UNG · FR. 17.01.1997

Paul Cooper
Oliver Bondzio
Thomas Schumacher
Marco Zaffarano Paul Cooper Mario de Bellis
Oliver Bondzio
Roland Casper

let da monkey out...lV

DERBE HIPHOP. DANCEHALL. FUNK. PACKUNG!

Put on your dancing shoes!

ON DA WHEEL Z OF STEEL
WHODINI SOUNDSYSTEM
SCHNEIDER
FUNKY FRESH MIKE
DEFCON
DBL
MADMISCHER

MASTERS OF CEREMONY
MC PITZA + JEBEN

HERKULESBERG
OPEN AIR/EINTRITT
FREI/GETRÄNKE...

POPKOMM, SAMSTAG/16H
21/8/99

FLYER SCHNEIDER·DOMSTRASSE

INNA RIDDIM
13/14.8.99

"Every girl and boy is a star"

StereøKiller®

peng, peng, baby!

KOMM TANZEN! MIT DEN STEREOKILLER DJs, CPH UND ELEKTRO TWIST
FREITAG 14.08.98 @ ACETON LUXEMBURGER STRASSE 46 KÖLN EINTRITT FREI

www.soma-festival.de

eleganz

ELEGANZ NACHT

PLASTIKPIXELPINGPONG

MIT: CUBISTIC POP MANIFESTO i ELEKTRO TWIST i STEREO KILLER DJS

FREITAG i 14.08.98 i ACETON i LUXEMBURGER STR.46 i KÖLN i EINTRITT FREI

NEW

SUN·MAID

funky / delicious

HOUSE MUSIC 22.00 h

made in Hemmer

with

precious MARC T.

15.08.98
19.09.98

Stübbelratherstraße 154 Ehrenfeld-COLOGNE

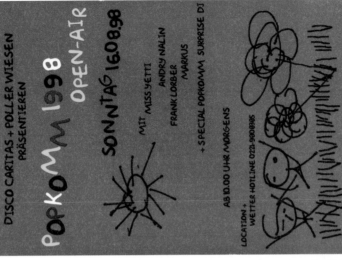

DISCO CARITAS + POLLER WIESEN
PRÄSENTIEREN

POPKOMM 1998 OPEN-AIR

SONNTAG 16.08.98

MIT MISS YETTI
ANDRU NALIN
FRANK LORBER
MARKUS

+ SPECIAL POPKOMM SURRISE DJ

AB 10.00 UHR MORGENS

LOCATION +
WETTER HOTLINE 0221-9800865

Freitags Fisch Press

Saturday Rhythm

POPKOMM.showcase
SAMSTAG 15.08.98
NACHTROCK

it's happening again...

cyber science

battle zone:
x-plorer
wiched
jens hänzhens
sven z

research area:
ill planet (live)
der dietrich
psychedelic engineering
H.B.M.

FR 21.11. 21h gebäude 9/ hhd köln-deutz

the only trisexual open air event in Europe

SR seele attractions

Sunday morning
Aug. 8th 99
Starts at 9:00 am

POLLERWIESEN & DISCO CARITAS
ata toni rios frank lorber
22.08.99 pollerwiesen 10 uhr

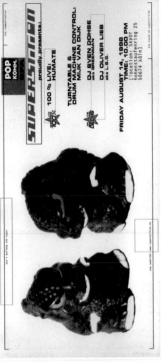

POP KOMM.

SUPERSTARR
proudly presents

100 % LIVE!
HUMATE

TURNTABLE &
DRUM MACHINE CONTROL:
MIJK VAN DIJK

DJ SVEN DOHSE
aka BREAKMAN

DJ OLIVER LIEB
aka L.S.G.

FRIDAY AUGUST 14, 1998
TIME: 10.00 PM
Location: SAVOY
Hohenstauffenring 25
50674 köln

psycho thrill
original techno & electro basics since 1992

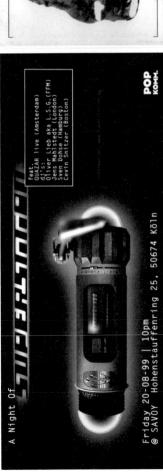

A Night Of
SUPERSTARR

feat.
QUAZAR live (Amsterdam)
dj's:
Oliver Lieb aka L.S.G.(FFM)
Jens Mahlstedt (London)
Sven Dohse (Hamburg)
Cevin Snitzer (Boston)

POP KOMM.

Friday 20-08-99 | 10pm
@ SAVOY Hohenstauffenring 25, 50674 Köln

sa. 26.08.2000
psycho thrill & d2000 magazine pres.

escape from nowhere
@arttheater, ehrenfeldgürtel 127, köln

fabrice lig
(kms/residual/f&s/music man, brüssel bel)

oliver kapp
(indulge/ray-gun/chord 44 rec., hamburg/detroit)

claus bachor
(d2000/authentic music/psycho thrill)

MCR d2000 authentic music

original techno & electro basics since 1992. there are no rules, fear is unknown and sleep is out of question.

tomorrow

two years of D.2000

electro chill zone by
mick wills & roger 23

jeff mills (axis rec. detroit-ch

(d200

friday august 14th 10:00 p.m. a psycho thrill special at kitt club hildeboldplatz 5 50672 cologne

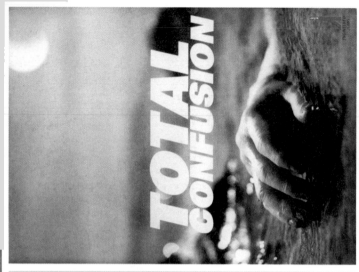

SPEICHER
CD1

ⓄKOMPAKT

MÄRZ 2003

STAMMHEIM'S
FLYING CIRCUS
@cologne

front to BLUE SHELL | gate LUXEMBURGER_STRASSE_32 | CLG | date 15.-18.AUG.01 | time 20:00/21:00

BLAUE NÄCHTE

Marlene presents:

LAXIBAR

21.08.
ab 22:00 Uhr

Line up:

MARLENE
(Green Komm)

MARKUS
(Ratinger Hof)

RAINER
(Man Dance)

Wild Life Area
Ambient Garden
Tribal Show & life percussion
Voodoo Dancers
Ethno Deco

MS Treibbut: am Webersteiger
Rheinufer Köln (am Maritim Hotel)

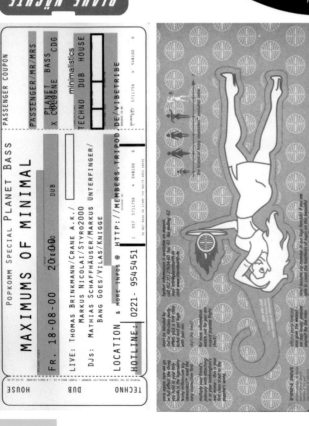

POPKOMM SPECIAL PLANET BASS

MAXIMUMS OF MINIMAL

FR. 18-08-00 20:00 DUB

LIVE: THOMAS BRINKMANN/CRANE A.K./
 MARKUS NICOLAI/STYRO2000

DJS: MATHIAS SCHAFFHÄUSER/MARKUS UNTERFINGER/
 BANG GOES/VILAS/KNIGGE

LOCATION & MORE INFOS @ HTTP://MEMBERS.TRIPOD.DE/VIBETRIBE

HOTLINE: 0221- 9545451

TECHNO DUB HOUSE

PASSENGER COUPON

PASSENGER/MR/MRS

X PLANET BASS CDG
 COLOGNE DUB HOUSE

minimalistics

TECHNO DUB HOUSE

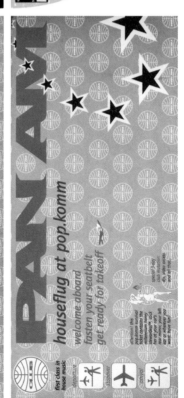

PANAM

housefug at polkomm

welcome aboard
fasten your seatbelt
get ready for takeoff

first class

SHOOP! #3 indoor

20.12.2002
22:00 - 06:00

Club Camouflage, Große Sandkaul 24 - 26, Köln Altstadt
Eintritt: 7 Euro

::: DJ's :::
::: lando | playground
::: dan cordell | sunset rec.
::: maodis | SHOOP!

::: LIVE :::
::: sample minds | elektro bunker / official art
feat. sumo, fent, irwin leschet

INFOS: info@s-h-o-o-p.de

NEUE WEBSITE:
www.s-h-o-o-p.de

SHOOP! #2

::: Parkgelegenheit :::
in der Bachemer Str. / der Beschilderung folgen
KVB: Linie 7 Richtung Frechen
bis Haltestelle Stuttgenhof

Haltet die Natur sauber!

SHOOP! #2 @popkomm

::: Sly Flynn (jacktracks, proved) - köln :::
::: Tina 3O3 (elektro bunker, müller rec.) berlin/wien/köln :::
::: Chrisma (newdrift, proved) - köln :::
::: Ziel0O (u6O311, pinku rec.) - fränkfurt a.m. :::
::: Lando (aries tunes) - köln :::
::: Irwin Leschet (liquid sky, **SHOOP!**, pinku rec.) - köln :::
::: Maodis (playground, **SHOOP!**) - köln :::
::: Tao (cybercircus) - köln :::
::: PULS -LIVE- (insolation) - köln :::
::: Hypnotoad -LIVE- - köln :::

INFOS: www.leschet.de / shoop@leschet.de

::: Open Air :::
17./18. August 2002 | Durener Str./Militärringstr.

<sa.> 12:00 bis <so.> 13:00

::: Specials :::
Multipass-Lounge
Pinku Rec. Chillout Area

audiokunststoff präsentiert zum batterypark

QUERBEAT

am 6.10.98 im sixpack köln ab 22 Uhr.
ben adler (liquid sky, live!),
irwin leschet.ext (audiokunststoff, live!),
gameboy (nintendo, live!),
catya (motorcity/stuttgart, dj),
und videoperformance.

weitere infos und probierhäppchen unter
http://www.bitlab.de/querbeat/

Abb. VII: Die Nebelmaschine Avalon 2001 – keine benebelt dichter.

audiokunststoff präsentiert zum batterypark

QUERBEAT

am 6.10.98 im sixpack köln ab 22 Uhr.
ben adler (liquid sky, live!),
irwin leschet.ext (audiokunststoff, live!),
gameboy (nintendo, live!),
catya (motorcity/stuttgart, dj),
und videoperformance.

weitere infos und probierhäppchen unter
http://www.bitlab.de/querbeat/

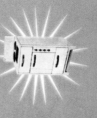

Abb. II: Ein modernes Schallplatten-abspielgerät mit zwei Plattentellern

FRANKFURT

The Technoclub History

1984 gründete Talla 2XLC mit seinem Partner Mathias Haibach den Technoclub, der Sonntag Nachmittag im Frankfurter Innenstadtclub "No Name" stattfindet. Später kamen Alex Azary und Michael Greulich dazu. Der Technoclub war weltweit der erste Club, in dem ausschließlich elektronische Musik aller Art gespielt wurde (damals von DAF bis Kraftwerk, Cabaret Voltaire bis Moskva TV).

Als Sonntagnachmittagsclub war er übrigens der erste After Hour Club für die Samstags Dorian Gray Gänger. Zu dieser Zeit ahnten nur die Macher, welchen Siegeszug Techno um die Welt antreten sollte. Aus dem Miniclub für die ersten 300 begeisterten Technofans entwickelte sich das längste, trendsetzende, erfolgreichste Clubprojekt der deutschen Technoszene. In keiner anderen Location haben soviele Leute mit "Techno" den Kick für ihr Leben gekriegt. Nach Zwischenstationen im "Roxanne" über der Frankfurter Zeit und im Omen ist der Technoclub seit nunmehr 6 Jahren freitags im Gray die Club Institution. Die Liste legendärer Parties, rauschender Raves und vieler Erinnerungen ist endlos. Von der Front 242 Backstage Party im No Name von einer der ersten Acid House Parties Deutschland im Omen, den legendären Re-Animation Parties nach der Sommerpause, der 5 Jahresparty mit Nitzer Ebb live, den aufwendigen Halloween Parties, der ersten Virtual Reality Party Frankfurts "Das Ei" bis hin zu den Holy X-Mas Raves an Weihnachten und den legendären Euphorias.

Jeder Act und DJ, der Rang und Namen hat, hat hier einmal gespielt oder aufgelegt. Von Sven Väth bis Westbam, Dag, Marusha usw. waren alle schon einmal hier. Die Liste würde Rahmen sprengen. Die Technoclub DJ´s von heute Talla 2XLC, Andy Düx, R-Damski, "T" und Jeff Johnert und die Technoclub DJ´s der frühen Tage von Thorsten Fenslau, Tom, Robby Rob, Andy Fröse, Mete Bozkurt und Uwe LZP4 prägten mit der legendären Anlage des Dorian Grays den Sound den Frankfurt weit über seine Grenzen hinaus bekannt machten.

Der Technoclub brachte 1989 Frontpage als Fanzine auf den Markt und schuf damit das trendbildene und einflußreichste Magazin der Technoszene. In den Achtziger Jahren war der Technoclub die Institution für Electronic Body Music und Agrepo, in den Neunziger Jahren war er auch Vorreiter für Techno-House mit stetig steigenden Besucherzahlen, der Konstante im Frankfurter Nightlife und einem der besten Clubs in Deutschland. Ein Ende des Technomovements ist nicht abzusehen. Der Technoclub wird noch für weitere Varianten der wichtigsten Musik und Jugendkultur unserer Zeit die Geburtsstätte werden.

Get ready for the next ten years...

Jürgen Laarmann

Keep in your mind: "Es wird immer weitergehen: Musik als Träger von Ideen" Kraftwerk; "Alles wird gut" DAF; "Never Stop" Front 242; "We are Phuture" Phuture; "Forward Ever, Backward Never" Frontpage

FR/30/12 OPEN HOMEBASE

technoclub says thank you: free entrance for all technoclubbers

featuring deejay's: ANDI DÜX, R-DAMSKI, & "T"

FR/23/12 NÄCHSTE HALTESTELLE: "FLUGHAFEN RHEIN-MAIN"

featuring deejay's: INFERNO BROTHERS, PAUL ELSTACK, CIRILLO, ROB, ANDI DÜX, R-DAMSKI, & "T"

live p.a.: PCP FRANKFURT, NEOPHYTE, ROTTERDAM TERROR CORP

FR/16/12 TRANCE STATION FRANKFURT

featuring deejay's: DAG, PASCAL F.E.O.S., TOM, SYLVIE, ANDI DÜX, R-DAMSKI, & "T"

live p.a.: EARTH NATION

FR/02/12 ELECTRO CLASS-X

opening night for one month of celebration

electropop to ebm till crossover

featuring deejay's: TALLA 2XLC, SVEN VÄTH (play's his favourite ebm classix till 1 a.m.)

ARMIN JOHNERT, ANDY FRÖSE, METE BOZKURT

radical hard disco rec. presents: D.A.F. the world of

harddiscoperator/esc voice: GABY DELGADO

freitag, 03.07.
sven väth - begg - live

"das suchtriff 3000 album gibt jeden versuch der musik-wiedergabe ung für lächerlichkeit preis, und ist natürlich suchfunk, welche der suchfunk einzelfolge zu weit seiner teenager musikzeit hat. si begg verfolgt seit seiner teenager musikzeit ist spielerfunk zuhörgerne und süss in such sehe sound a ryte hörgemeine konsequent werde."

toni rios & frank lorber

freitag, 10.07.
daniel lee & chris liebing

samstag, 11.07.
having love

freitag, 17.07.
neno rios & richard bartz - live

michael bartz kariert seit jahren tracks, die in grammmikos wie waren gefallen sitzen, er oft voll aufflickst kennlt wie mühle, oft ihm immer spielerisch treffend, raisse sucht es ar ein rascher, donnudmanig wieder-saut, ging suchfunk, höptf am strom aus väth, 12-standod.

samstag, 18.07.
chris liebing & frank lorber

freitag, 24.07.
toni rios & jim masters (devoid/london)

samstag, 25.07.
daniel lee & gayle san

freitag, 31.07.
sven väth, porter ricks (live & robi (open)

der psychoactive sound von porter ricks (andy mellwig/thomas köner) ist das ein-tauchen in massiven schallmibad in dem hypnotisch-man bogen zum körperlichen todes is weiten, erratischer minimal dub macht um club zur rauschzonen.

omen - junghofstrasse 14 - frankfurt

oktober 1998

freitag, 2.10.
good groove & josh wink (usa)

samstag, 3.10.
daniel lee, daz sound & dj pierre

freitag, 9.10.
massimo (evo sonic), chris liebing & dj t.

samstag, 10.10.
toni rios, c-smooth & chris liebing

ten years and goodbye - abschlußwochenende im omen

freitag, 16.10.
sven väth & carl lekebusch

samstag, 17.10. bis sonntag, 18.10.
frank lorber, dj dag, dj hell,
marco carola & sven väth

omen, junghofstrasse 14, frankfurt, telefon 28 22 33

404

Louder!

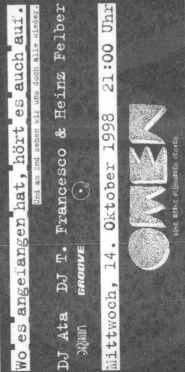

Wo es angefangen hat, hört es auch auf.

Und am End sehen wir uns doch alle wieder.

DJ Ata DJ T. Francesco & Heinz Felber

Mittwoch, 14. Oktober 1998 21:00 Uhr

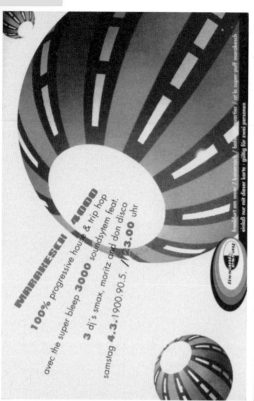

MARRAKESCH 2000

100% progressive house & trip hop

3 dj's smax, moritz and don disco

samstag **4.3.**1900.90.5. / 23.00 uhr

avec the super bleep **3000** soundsystem feat.

frankfurt am meer · kaiserack / bouti...rter / et le super puff marakesch · einlaß nur mit dieser karte · gültig für zwei personen

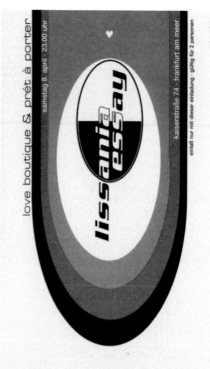

love boutique & prét à porter

samstag 8. april · 23.00 uhr

lissania essay

kaiserstraße 74 · frankfurt am meer

einlaß nur mit dieser einladung · gültig für 2 personen

markus essbeck

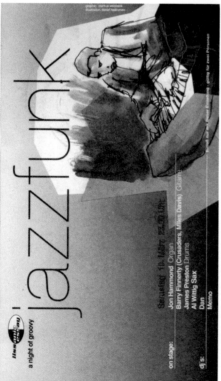

a night of groovy

jazzfunk

Samstag 18. März 23.00 Uhr

on stage:
Jon Hammond Organ
Barry Finnerty (Crusaders, Miles Davis) Gitarre
James Preston Drums
Al Wittig Sax

dj's:
Dan
Memo

Einlaß nur mit dieser Einladung · gültig für zwei Personen

graphic: markus essbeck

lissania essay

lissania e
Kaiserstraße 74
Frankfurt am Main

DJ's: Dan & Shantel · Elixier vitae · Obstsalat · Kuchen · Chadiya · Oliven · Purday's (aphrodisiakum) Samstag · 12. März · 23.00 Uhr

Einlaß nur mit dieser Einladung · gültig für zwei Personen

graphic: markus essbeck

MARAKESCH 2000

Samstag 21. 1. 1995 23.00 uhr

MARAKESCH 2000

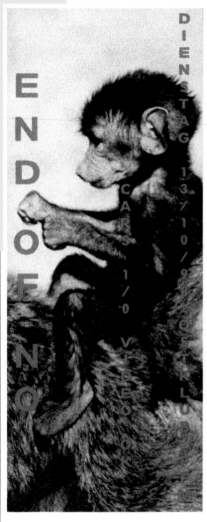

END OF NO

DIENSTAG 13/10/9...
CARS 1/0 VIDEO...KLU...

ostklubmonatsprogrammoktober98ostklub

do-o1 the everlastingleckerbeatmekka
 dj. mario (spaceplace)
fr-o2 JEANS TEAM aus berlin live
 djs: dr. Z + STUPIDDEEP
sa-o3 dj. foe (chrome/lo-kampf/sport/
 gone/also heinrich at heart...
 plus die berliner kurcikis
so-o6 andreas BAUMECKER (e-wildpitch/
 freebase
mo-o7 nix tunix
di-o6 ATA vs. HEIKO um den titel "män
 ner ohne nerven"
mi-o7 jam x-pression im down tempo
 bassfeat. james + dj. stefean X
 Kreuzer
do-o8 STATION ROSE cyberspace 1st decade
 europa-tour buchpräsentation www.well.com/www/gunafa
 multimedia supp. vno baumecker n-d
fr-o9 LIVE: sportfreunde stiller (indi)
 später djs aus münchen
sa-1o the beat goes on , the bop wont'
 stop...dj. ralf und guest
so-11 O Z plus guest (sundayhousetime
 und tea)
mo-oo oo oo oo
di-13 Bastian und heiner blum
mi-14 rhian stokes + roger kerosene (phar
 ma) "life is no wunschkonzert"
do-15 smooth operator ultramar
 ultramar
 ultramar
fr-16 elektronisch live SCHNEIDER TM
 kein vorverkauf!
sa-17 DUB X Static mit FLO & gaulboro
so-18 aus berlin die poptarts live und
 an den plattentellern zum tanzen!
mo-19 oooo oooo ooooo
di-2o F I L I Z plays elektro
mi-21 dust'n'bass mit steve morell und
 mc eno (diamanda galas lunch)
do-22 98 EMISSIONEN nachttanzdemo
fr-23 O.R.G.E.L. + Gitarre der 6oer
 und 7oerJahre
sa-24 METAsoundsystem -freestyle
so-25 house und andere sounds mit
 dj. marcel
mo-26ausruhen
di-27 KIXMINNI -strictly homemade
 effects el.nü.soundsystem
mi-28 Klub Intensiv the unforgettable
 dj. björn (abba) und oliver (gl
 atze)
do-29 f f w d (gruss von radiodreieck-
 land)
fr-3o svenghouly vs. gogogunnar 6oer
 garagensound
sa-31 mad angelique (die hefen steigt
 ihr zu kopf)

RADIO X GEBURTSTAGSPARTY
FREITAG 25. SEPTEMBER 1998, AB 21 UHR
STÄDELSCHULE, DÜRERSTR. 10, FRANKFURT
IM SEPTEMBER WIRD RADIO X EIN JAHR ALT DEN GEBURTSTAG MÖCHTEN WIR GERNE MIT UNSEREN HÖRERINNEN UND HÖRERN GEMEINSAM FEIERN.
WIR FREUEN UNS SEHR, DAß DIE PARTY IN DER STÄDEL HOCHSCHULE FÜR BILDENDE KÜNSTE STATTFINDEN KANN.
LINE-UP: CRICKS ON SPEED (GO REC./MÜNCHEN); ELEKTROPOP SHOW i FRANK (WIESBADEN); DAß, RAREGROOVES, SOUL i GOODGROOVE
(FRANKFURT); HOUSE i MICROSCIENCE DJ TEAM (FRANKFURT); ELECTRO, SENSI (BEAT/ DARMSTADT); DAß, WILDSTYLE i STEREOFREUND
(DARMSTADT); DAß, WILDSTYLE, RAREGROOVES, TOBI (FLORAT/ MÜNCHEN); HOUSE i WELLER (UNTER-SOUNDCASINO/FRANKFURT); SOUL;
SCHAMBAR VON OLIVER HUSAIN + KLAUS RICHTER (=TWENARENA/ FRANKFURT); DIA-SHOW: MAYA/X-FADE; INFOSPACE: BERND/KICH;
BARTEAM: BCR-CREW U.A. ... UND DAS GANZE RADIO X-TEAM
DAS WERNER STADTRADIO 97,1 MHZ IM KABEL 99,85 SCHÜTZENSTR. 12, 60311 FRANKFURT. TEL 069/2997/1222, FAX 069/2997/1223, E-MAIL RADIO@RADIO.DE WWW.RADIO.X.DE

FORCE INC.
MUSIC WORKS

☆ MILLE PLATEAUX

LIVE

THOMAS BRINKMANN
[ERNST.MILLE PLATEAUX]

DJ

TRIPLE R
[KOMPAKT/DE BUG]

STROBOCOB
[KARAOKE KALK]

+ MILLE PLATEAUX LOUNGE
-AUTOPOIESIS-

FR. 09.07. 23 UHR

SPACE PLACE
GUTLEUTSTR. 294

ROCK and ROLL
SEXZOMBIES ARE GO

TWIST WITH DYNAMIC
SVENGHOULY (AKA LUKY LIVVBONE)
AND
GOGO GUNNAR (THE BLACK ALLIGATOR)
IN PERSON
FR. 30.10.98
AT ANGELLounge, Hamburg!!!

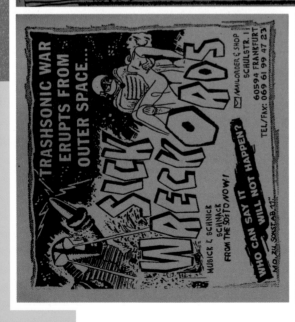

TRASHSONIC WAR
ERUPTS FROM
OUTER SPACE...

SICK
WRECKORDS

FROM THE 50'S TO NOW!

MUSICK & SCHNICK
SCHNACK

WHO CAN SAY IT
WILL NOT HAPPEN?

MO.-FR. 24, SONST AB 10³°

✉ MAILORDER & SHOP
SCHULSTR. 11
60594 FRANKFURT
TEL/FAX: 069 61 99 47 23

dienstag 26.05.- mittwoch 10.06.98

converter.....natalie gray....ngtv...
.....................sabine reitmaier.....panorama....

kleine cocktail-party sonntag 31.05 7pm

sonst öffnungszeiten
samstags und 26.05 6-8pm
mittwochs 4-6 pm

ausstellungsraum bahnhofstrasse 20 offenbach

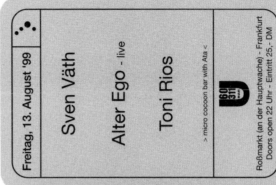

Freitag, 13. August '99

Sven Väth

Alter Ego - live

Toni Rios

> micro cocoon bar with Ata <

60 311

Roßmarkt (an der Hauptwache) - Frankfurt
Doors open 22 Uhr - Eintritt 25,- DM

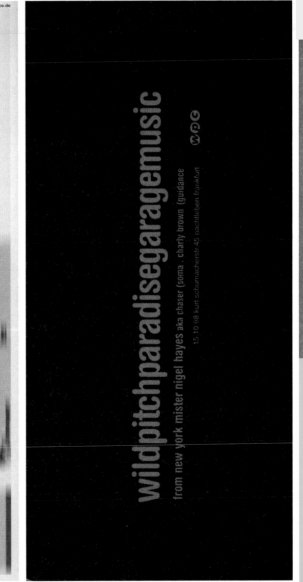

www.surface.de

http://www.sven-vaeth.de

wildpitchparadisegaragemusic

from new york mister nigel hayes aka chaser (soma . charly brown (guidance

15.10.98 kurt schumacherstr.45 nachtleben frankfurt

411

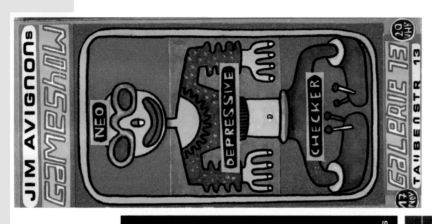

JIM AVIGNONS GAMESHOW

NEO
DEPRESSIVE
CHECKER

GALERIE 13 · TAUBENSTR 13
17 NOV 20 UHR

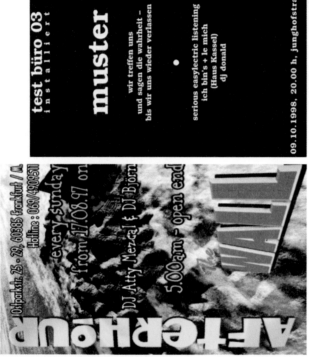

AFTERHOUR

every sunday
from 17.08.97 on
5.00am – open end

DJ Atty Mercal & DJ Björn

Ostparkstr. 25 - 29, 60385 Frankfurt / M.
Hotline: 069/490950

WALL

test büro 03
installiert

muster

wir treffen uns
und sagen die wahrheit –
bis wir uns wieder verlassen

serious easylectric listening
ich bin's + le mich
(Haus Kassel)
dj donald

09.10.1998, 20.00 h, junghofstraße 16

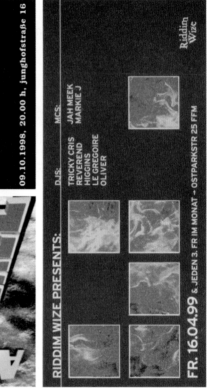

Riddim Wize

RIDDIM WIZE PRESENTS:

DJS:
TRICKY CRIS
REVEREND
HIGGINS
LE GREGOIRE
OLIVER

MCS:
JAH MEEK
MARKIE J

FR. 16.04.99 & JEDEN 3. FR IM MONAT → OSTPARKSTR 25 FFM

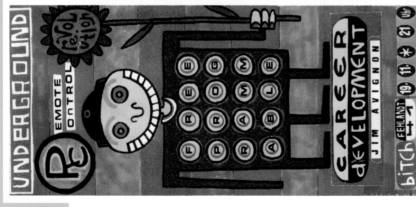

UNDERGROUND

REMOTE CONTROL

revolution

FREE
PROGRAMMABLE

CAREER DEVELOPMENT
JIM AVIGNON

bitch FEHLFARB 19. 11. 21 Uhr

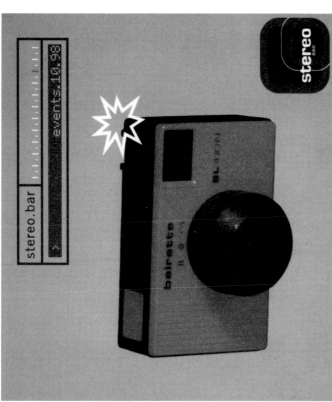

99AUGUST01/28

ACHTUNG SONDERVERANSTALTUNG:

DO29 07 DRUM'N'BASS & HIP-HOP ALLLNIGHTER FEAT. PRECISION TASKFORCE UND BINDING SQUAD/NORD MASSIVE 23.00

SO01 08 KINDERDISCO "RAPPELKISTE" MIT DJ'S, ANIMATIONEN, GEWINNSPIEL UND ELTERNBETREUUNG IM GARTEN 15.00 UHR

DO05 08
FR06 08 RITCHIE HAWTIN AKA PLASTIKMAN(NOVAMUTE/MINUS/PLUS8REC.)23.00 UHR TANZPRAXIS: HIP-HOP FLOOR: 5. TON (MASSIVE TVNE), MIKE LA ROCK, EWL, DLP (LIONS DEN PROD.) HOUSE FLOOR: DJ EDDIE KILO, TOAN VUHUU 23.30 UHR

SA07 08 06.00 UHR EARTH NATION AFTERHOUR MIT DJ T., JULIAN SMITH, TOAN-VUHUU 18.00 UHR THE NIGHTSTARTER GARTENBAR 23.00 UHR CLUB MAXIMS: DR. NO "D"ÄNY, LIVE@LE CAMINO: HOT-EL

DO12 08 LA MOVIDA: DJ FRESCO UND TAVERNA "PULSO LATINO" MIT J-D ON THEROCKS21.00-22.00 UHR SALSA SCHNUPPERKURS, OHNE ANMELDUNG, EINTRITT 5.- 21.00 UHR

FR13 08 RENEGADE HARDWARE TOUR: DJ LOXY , DJ BAILEY (LONDON) + PROVINYL MASSIVE FEAT. DOO-ZHAN, FRANKIE MASHINE, MC'S

SA14 08 CLUB MAXIMS: JAMES FAST ORCHESTRA, 23.00 UHR LIVE@LE CAMINO: COW EXPLOSION (COUNTRY PUNK'N'ROLL) 23.00 UHR 18.00 UHR THE NIGHTSTARTER GARTENBAR

FR20 08 RIDDIM WIZE PRESENTS TRICKY CRIS, REVEREND, MC'S 23.00 UHR

SA21 08 CLUB MAXIMS: CLAUDE D'AZUR, DJANE MONIQUE UND DIE KATZE 23.00 UHR THE NIGHTSTARTER GARTENBAR 18.00 UHR

SO22 08 SUMMER MADNESS: LIVE FROM BARBADOS: 4D PEOPLE SUPPORTED VON MIKE LA ROCK + VARIOUS ARTISTS 22.00 UHR

DO26 08 LA MOVIDA: DJ FRESCO UND TAVERNA "PULSO LATINO" MIT DJ J-D ON THE ROCKS, 21.00-22.00 UHR SALSA SCHNUPPERKURS, OHNE ANMELDUNG, EINTRITT 5.- 21.00 UHR

FR27 08 STRAIGHT AHEAD. MICHAEL RÜTTEN UND ARNO SCHÄFER PRESENTS BACK ON PUBLIC DEMAND JAZZANOVA 23.00 UHR

SA28 08 CLUB MAXIMS PRESENTS DIE SAUHAUFEN DJ'S FEAT. DJ SCHNUBBELHASE U. MINISTER OF BESSERES MUSIKVERSTÄNDNIS LIVE: BLACK ANGUS (DIE BESTE AC/DC-COVERBAND, OBERGEIL!!!) 18.00 UHR THE NIGHTSTARTER GARTENBAR

OSTPARKSTRASSE 25 60385 FRANKFURT/MAIN 23:00 CET

MÜNCHEN | MUNICH

X-TASY TECHNO-CLUB presents

DJ G. HELL BLUB CLUB
DJ MARKUS PARKCAFE
DJ JÖRG DELIRIUM FRANKFURT

EVERY SUNDAY **PARKCAFE**

X-TASY

PARKCAFE

DEUTSCHE BUNDESPOST 060

Herrn
Nicolas
Deinhardt
Lothringer Str. 10
8000 Muenchen 80

Fotos: marco.microbi

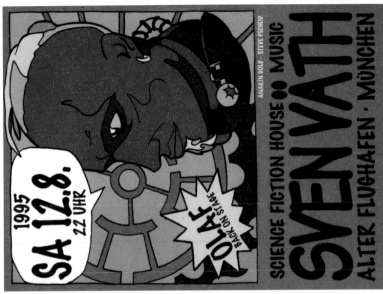

ANAKIN BOLD · STEVE PSCHEID

SCIENCE FICTION HOUSE :: MUSIC

SVEN VÄTH

ALTER FLUGHAFEN · MÜNCHEN

1995
SA 12.8.
22 UHR

OLAF
BACK ON STAGE

MÜNCHNER
präsentiert

TANITH'S
HELL FIRE CLUB

START MI. 6. OKTOBER '93

special disco

EVERY WEDNESDAY

1. Wednesday: OPENINGPARTY THUM HUVY [recordstore münchen]
 OLAF [delirium]

2. Wednesday TANITH [trash records berlin]

3. Wednesday SPEZIAL [exit walfisch berlin]

4. Wednesday MARCO ZAFFERANO [eye-0 records]

every 2° and 3° wednesday shuttle bus from berlin to munich
 start of clubbing
 21° h

LEOPOLDSTRASSE 23

SONNTAG
22.00

4.10.66 – 4.1092

HAPPY
BIRTHDAY
MICHI
mit Überraschungs DJ's

BABALU
Leopoldstr. 19, München 40

I. HARDFLOOR

DJ's:
GOOD GROOVE
Ultraworld
MASSIV
Frankfurt Beat
F.L.O.*

FREITAG – 22.1.93 – 23 UHR
KULTURSTATION OBERPFRING

+ you can't change reality +
but try to create the future

THE SEX HOUSE GANGSTER'S PRESENT

SEX
PARTY II

17 UBELLA 8.- DM

SUNDAY MARCH 26...

DJ'S G. HAL CHEFF. X-TASY

417

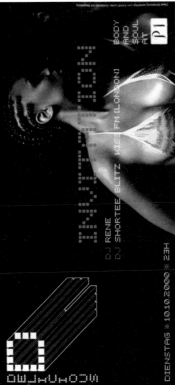

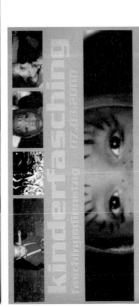

SAMSTAG 22. MAI '99
ARMAND VAN
HELDEN PROJECT
FEAT.
DUANE HARDEN
"YOU DON'T KNOW ME"

DJ MORITZ
DJ CHANEL
MC SPROCKET
13.05.1999
27.05.1999

GUEST: R D.TEAM (ALEX & FLYNN)

DONNERSTAGS 23.00 03.00 UHR
PARK-CAFE_SOPHIENSTR.7_MÜNCHEN

SAMSTAG 15.MAI '99
GERMANY'S HOUSE SUPERSTAR
MOUSSE T.
EXCLUSIVE DATE FOR 1999
WORLDLEAGUE
KW-DAS HEIZKRAFTWERK

SPARKLIN
garage_house

BLUB CLUB ®

kalender 2001

erfolg glück gesundheit geld sex liebe spaß freizeit style
blub club essen freunde schlaf trinken musik erfolg glück
gesundheit geld sex liebe spaß freizeit style blub club
essen freunde schlaf trinken musik erfolg glück gesund-
heit geld sex liebe spaß freizeit style blub club essen
freunde schlaf trinken musik erfolg glück gesundheit geld
sex liebe spaß freizeit style blub club essen freunde schlaf
trinken musik erfolg glück gesundheit geld sex liebe spaß
freizeit style blub club essen freunde schlaf trinken musik
erfolg glück gesundheit geld sex liebe spaß freizeit style
blub club essen freunde schlaf erfolg glück gesundheit

next BLUB CLUB feiern
dienstag zweiter **januar 2001**
dreiundzwanzig uhr
im park-cafe münchen
music by dj cambis

www.blubclub.com
www.parkcafe.de

graphik: prinzp-sam madl bilder: daniel zander

422

BLUB CLUB ®

churchhouse

BLUB CLUB ®
www.parkcafe.de
www.blubclub.com

dienstag
6.märz 2001
start 23 uhr
parkcafe muc

churchhouse played by
dj cambis (pool)

design: www.prinzip.tv

djspooky

RIDDIM WARFARE

MI 14.7. BERLIN ICON
DO 15.7. HAMBURG MOJO CLUB
FR 16.7. MÜNCHEN BAYERISCHER HOF

Watch out for the ABSOLUT JAM via internet 3.7.!

Riddim Warfare — out now! UNIVERSAL ABSOLUT

10 jahre hausmusik festival 2001

programm

L-o-k

MÜNCHEN
HANSASTRASSE 59

6 Min. von der U4/U5/S7 Heimeranplatz
In München auf den Mittleren Ring fahren.
VOM NORDEN: Richtung Mittlerer Ring
West / Autobahn-Ende. Über den Donnersberger-
brücke fahren und bei der Ausfahrt Laim / Heimeran-
platz den Ring verlassen. Oben an der Ampelkreuzung
links, der Hauptstraße folgen und an der nächsten
Ampel links durch das Tor zum Feuerwerk.
VOM SÜDEN: A8/A9/A94/A95. Richtung
Autobahn-Ende. In der Nähe auf der Autobahn
Laim/Heimeranplatz bleiben bis zur
nächsten Ausfahrt Laim/Heimeranplatz. An der
Ampel rechts, um die Kurve und an der über-
nächsten Ampel links durch das Tor
zum Feuerwerk. Links halten.
Großer Parkplatz!

MI-13.JUNI
(Tag vor Fronleichnam Feiertag!)
SA-25.AUGUST
(An Stelle der LOFT Party!)

TONTRÄGER,
SCHMUCK,
OUTFIT
STÄNDE

BEGINN: 22.30 UHR
ENDE: 5.30 UHR

PAGAN DJs
http://home.t-online.de/home/paganpost

Gothic DarkFolk Industrial Mittelalter AvantGarde Electro EBM GothMetal AngstPop Ritual

Dark Night

Strich & Dingolfing
http://home.t-online.de/home/paganpost

Gothic
DarkFolk
Mittelalter
Electronic
Industrial
EBM
GothMetal
Norse
AngstPop
Ritual

NEBELWERK

L-o-k MÜNCHEN HANSASTRASSE 59
http://home.t-online.de/home/paganpost

Pagan Tonträger
Outfit Stand
Verlosung!
Pagan DJs

Dark Night

Sa 1. September &
Sa 3. November
Beginn: 21.30 / Ende: 4.00

Dark Night im Strich 8 Dingolfing
Autobahn A92 (München-Deggendorf)
Ausfahrt Dingolfing; Richtung Dingolfing fahren.
Dort vor der Aral-Tankstelle links abbiegen.
Nächste Ampel links in die Bahnhofstr.62
http://home.t-online.de/home/paganpost

PAGAN ORGANIZATION

Dark Night

Gothic
Darkfolk
Electronic
Industrial
EBM
Mittelalter
GothMetal
Noise
Anger Pop
Ritual

Pagan
DJs

Alle zwei
Monate
Am ersten
Samstag

2.11.02
4.01.03
1.03.03
3.05.03

www.paganwelt.de

Strich Dingolfing

STUPOR ARTS PRESENTS

THEBLEISOUND

PERFORMERS:
SCHLOSS (USA)
LEICHE PUSTKAL (GER)
VIOLENTA PRQUESTA (CZ)
DEFFOID (GER)

FREITAG 29. NOVEMBER 2002
MÜNCHEN DONABSTR. 33 HAUS 50 RAUM 102
U6 ALTE HEDE NACHTBUS 33
EINLASS: 21.00 UHR UMKOSTENBEITRAGS: 10.-
INFO: WWW.STUPOR-ARTS.DE UND WWW.LEICHEPUSTIKAL.DE

LOFT
München - Friedensstr.22

Jeden Letzten Samstag im Monat!

DER CLUB DER ERBARMUNGSLOSEN

LOFT
München - Friedensstr.22

GOTHIC
NEO FOLK
INDUSTRIAL
ELECTRONIC
MITTELALTER
GOTH METAL
DARK WAVE
ANGST POP
NOISE
EBM
RITUAL

Beginn 22 Uhr
Ende 5 Uhr

PAGAN

Pagan Tonträger
Outfit Stand

Jeden Letzten Samstag im Monat!

6.01.	PAULI PAPA
	ALEX DUNE
13.01.	AGONY
	HOUSEPUNK DIRK
20.01.	AGONY
	NIKO H.
27.01.	AGONY
	FELIX HOUZER
4.02.	AGONY
	FLYNN
10.02.	AGONY
	NIKO H.

fr 02.06.2000 flokati vs. am dam des
stoopid am dam des, münchen
tobi neumann flokati, münchen
fr 02.06.2000 polymatrix - junge pioniere 2000 (nootek)
dj psilo, polymatrix sotrax
dj promorph, polymatrix münchen
dj a.moon, polymatrix münchen
live abismo, polymatrix freising
sa 03.06.2000 international dj gigolo night / union move
dj valium gigolo, technotika belgien
live plastique de reve, gigolo genf
dj acid maria, gigolo karlsruhe
dj sylvie marks hal, gigolo frankfurt
area II: xyramat hamburg
upstart disko b münchen
fr 09.06.2000 exquisit promotions & flokati presents
united grooves auf 2 areas!! (raum 8 + flokati) featuring djs & mcs
the hermit, 2as1 productions london
danny ward, 2as1 productions london
mc blakey, la cosa nostra london
mr buzzhard, london
the empee, luvin' lou, dj flynn sweet, münchen
sa 10.06.2000 mélodies en sous-sol
dj hacker gigolo, goodlife grenoble/france
dj to nhan le thi, dopplereffekt berlin/detroit
dj marc schneider, word and sound hamburg
area II: dj nikki detoxx, slave music münchen
dj dr. eqal kickin habit music ist.muc.ny
live three amigos, münchen
live maximilian tausend:glass, münchen
visuals toxett, münchen
plus very special guest djs
fr 15.06.2000 flokati: advanced dj-entertainment
karotte stammheim, u60 ffm
dj peabird, sellwell productions münchen
and the flokati boys, münchen
sa 17.06.2000 synthzised society
dj jay denham, disko b, black nation kalamazoo/usa
dj rok gigolo, müller berlin
dj lester jones optimal, ultraschall münchen
visuals waschmaschine, high flyer live
vj becker, bergen, heinzimann
area II: suchtrupp record release party „heile welt"
disko b münchen/regensburg
mi 21.06.2000 partyzone: disko b special
dj abe duque aka kirlian disko b, tension new york
dj n-dakar, disko b münchen
dj michelle grinser, disko b münchen
area II: la bomb de luxe, dj team münchen
fr 23.06.2000 flokati: official record release party
ian pooley v2 mainz and the flokati boys, münchen
sa 24.06.2000 convex - unruhige nächte - tour
dj jana clemen, convex fulda
dj tina lestate, convex marseille
dj melanie, convex thüringen
area II: live & dj milch gigolo, sub up berlin
fr 30.06.2000 flokati: friends on the decks
ken partysan ba/wü
lester jones, optimal münchen
sembone, flokati münchen
fr 30.06.2000 polymatrix
dj spike, polymatrix münchen
dj enrico paraxas, polymatrix münchen
dj neon genesis, polymatrix augsburg
dj dizzy devil, polymatrix augsburg

(strada featuring **middelhauve**

Ultraschall

06

remix neun

ultraschall
grafinger str. 6
81671 münchen
t.: 089.49002150
f.: 089.5438441
upstart@diskob.com
www.ultraschall.com

OPTIMAL
vinyl/cd's/books+mags

kurbel

International beatangebts

disko B

FTI no

Chicks on Speed
record s

tension

high-flyer
high season of high fidelity
mix master of
man-made media präsentieren:
neue abenteuer in pal.
die nächste generation unbekannter
lebensformen vom östlichen quadranten hat
am wochenende frei, um sich in einem netz aus
lichtpunkten zu materialisieren und uns durch den
kosmos aus farbigem sternstaub zu gleiten.

high-flyer, das videomagazin im ultraschall
diesmal mit:
maxim terentjev
angelika staudt
anni seitz
claudia schletz
frank radefeldt
molto menz
susanne matern
stefan holmeier
maria heinzlmann
nina gallwitz
gabriele gabriel
sophie friedrich
nicolette erhorn
daniel botz
melanie bielmeier
andreas bergen
peter becker

6-00

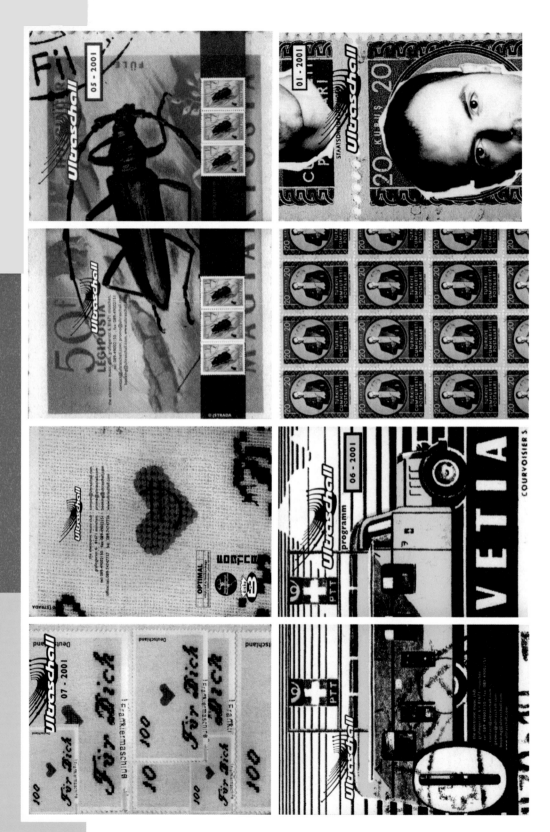

high-flyer

no budged, no boundaries.
625 bilschirmzeilen,
132m magnetband und
25 bilder pro sekunde
generieren angenehmes
flimmern für den
anspruchsvollen medientouristen
– multidimensional,
polychrom und mehrschichtig.
Die TV-Safari 7/2000 führt
uns durch sommerliche
städte mit fließenden
fassaden und
kleinen leuchtenden
einwohnern, welche
geschichten aus
tausendundeiner belichtung
zu erzählen haben.
high-flyer, das
videomagazin
im ultraschall
diesmal mit:
michael madlener
melanie bielmeier
maria heinzlmann
susanne matern
selene petersen
maxim terentjev
andreas bergen
gabriele gabriel
nicolette erhorn
angelika staudt
claudia schietz
frank radefeldt
peter becker
axel berger
daniel botz
anni seitz
ck

ultraschall
grafingerstr. 6 · 81671 münchen,
tel. 089-49002150
booking fax.089-543844
email: upstart@diskob.com
www.ultraschall.com

07 00 re 10
(strada featuring bianca strauch · berlin 2000

JEFF MILLS

SAMSTAG 4. AUGUST
ULTRASCHALL

ELECTRO BUNKER COLOGNE
26.04.
27.04.

LIVE:
AIR LIQUIDE
JIM TENOR
G.E.N.
BLACK ONE
H.E.A.D.
RAUSCHSUCHT

DJS:
MATE GALIC
MONIKA KRUSE
SILVER
DAVE HOLLANDS
BIANCA
BEN ADLER
MISTER BLEED
BIZZ O.D.
UPSTART
VERONIKA
ORIGINAL AKI
TINA 303
ELECTRIC INDIGO
at ULTRASCHALL
ALTER FLUGHAFEN RIEM

flokati
music club

World's Best

CHEESECAKE

PROGRAMM

HIGH FLYER HIGH TIME · HIGH LIFE · HIGH SEASON · HIGH FIDELITY · HIGH NOON · HIGH DEFINITION · HIGH BYTE · HIGH
RISE · HIGH DENSITY · RING · POSITION · HIGH FIVE · HIGH O · HIGH SPIRIT · HIGH LIGHT · HIGH LEVEL · HIGH RESOLUTION · HIGH SOCIETY · HIGH EXPLOITATION ·
HIGH PER SPACE · HIGH "ELLO · HIGH CLASS · HIGH DUTY · HIGH PERFORMANCE

HIGH-FLYER >> DAS VIDEOMAGAZIN IM ULTRASCHALL DIESMAL MIT:
MICHAEL MÜHLEHNER · MELANIE BREEMEIER · MARIA HELLMANN · CHRISTIANE BAETHKE · GELENE PETEPZEN · ANDREAS BERGEN · GABRIELE GABRIEL · NICOLETTE EPHORN
CLAUDIA SCHÜTZ · PETER BERKEF · AXEL BERGSEP · GABRIEL DUTZ · ANNI SEITZ

433

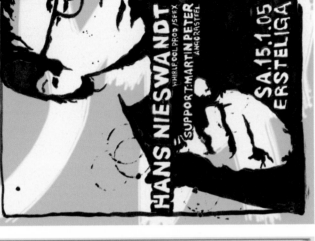

HANS NIESWANDT

WHIRLPOOL PROD./SPEX

SUPPORT: MARTIN PETER

ANG.GRSTFEL

SA.15.1.05
ERSTE LIGA

FAUNAFLASH
BENJAMIN FROEHLICH

SAMSTAG
8.5.2004
ERSTE LIGA

TSV BASSRUTSCHE
KID FLORI & MAO-TSE TOM

SA. 14.02.2004, Ab 23.00 Uhr
ERSTE LIGA, HOCHBRUCKENSTR 3

SPORTIV
by Gomma&Favorit

ERSTE LIGADonnerstags

22.4. "KILL THE DJ"-CD Release Party
feat.The OPTIMO-DJ's/UK

29.4. MODICAIMBERY

6.5. Nd_BAUMECKER
(Freundinnen/Mannheim)

13.5. GOMMAGANG

20.5. METRO AREA from NYC

TSV BASSRUTSCHE
KITTFLORRI, JRZZHILRMYV.S.
MAO-TSE TOM ,JRRF-PSGELNICHTTERS UNT.
NOE KNUCKHUT ,JRZZHILRRING PBK.
TIM YOUNG-ILL ,JRRF-PSGE NICHTTERS UNT.
TAXONWEN MIT 6YRSS VIEL WSS!!!

SA. 31.07.2004, Ab 23.00 UHR
ERSTE LIGA, HOCHBRUCKENSTR 3

Patrick Pulsinger
(Cheap rec., Tirol Wien)
supported by Stoopid

am Sa. 3.5. in der 1.Liga Start 22 Uhr

TEIL 2 VON 3

RICH AND KOOL – LIVE – PAVLEK REC.

ALEX FUNKT – STOCK5 – MUENCHEN

DARIO ZENKER – STOCK5 – MUENCHEN

FR. 19. 11. 2004

REGISTRATUR, BLUMENSTR.

WWW.STOCK5.TV

ENDLICH,
MÜNCHEN WIRD KÖLN:

●KOMPAKT

FALCO BROOKSEIFER, KÖLN
(Treibstoff/Sub Static/Dumb-Unit)
M.I.A. (APEAL/Trapez/Traum), KÖLN
NOVAME, Music of Traum), MÜNCHEN
FREITAG, 5.3.2004 ab 23.00 Uhr
HARRY KLEIN, OPTIMOL, FRIEDENSTR.37

ULTRA
VISUALS
ULTRA MEGA
VISU BASSE!
MEGA
BASSE!

12/03

FREITAGS
FRISKO!
DISKO! HARRY
BEI KLEIN

süssesgift.de

5.-13. März
bei zwölf zweitausend vier

01 2003

flokati

LUKE
SOLOMON
mff/classic - london

TOM
NOVY

437

RESTDEUTSCHLAND |
REST OF GERMANY

ACCESS ALL MOVES

UNIQUE

unique presents

ACID JAZZ NIGHTER

FEAT. EDDIE PILLER
DO 29.05.97 22:00H

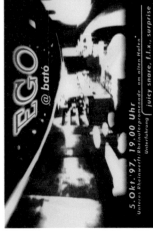

EGO

DÜSSELDORF

Terz street after hour 2.9. 22 n
DJs Sport & Felix
Red -> House Kiefernstraße

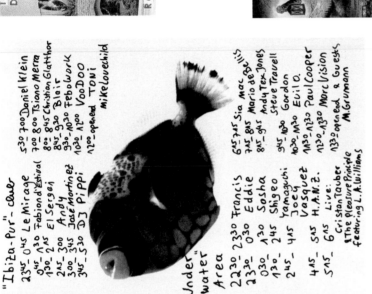

"Ibiza-Pur"-clau

23⁴⁵_0⁴⁵ Le Mirage
0⁴⁵_1³⁰ Fabiond'Estival
1³⁰_2⁴⁵ El Sergei
2⁴⁵_3⁰⁰ Andy
3⁰⁰_3⁴⁵ JoséMartinez
3⁴⁵_5³⁰ DJ Pippi

5³⁰_7⁰⁰ Daniel Klein
7⁰⁰_8⁰⁰ Tsiano Merra
8⁰⁰_8⁴⁵ Christian Glatthor
8⁴⁵_9³⁰ Blair
9³⁰_10³⁰ Febolwork
10³⁰_11⁰⁰ VooDoo
11⁰⁰_opened Toni
 Mikelovechild

"Under"
water
Area

22³⁰_23³⁰ Francis
23³⁰_0³⁰ Eddie
0³⁰_1³⁰ Sosha
1³⁰_2⁴⁵ Shigeo
2⁴⁵_4⁴⁵ Yamaguchi
 Joey
 Vasquez
4⁴⁵_5⁴⁵ H.A.M.E.
5⁴⁵_6⁴⁵ Live:
 Cristan Tauber
 1The Pleasure Principle
 featuring L.A. Williams

6⁴⁵_7⁴⁵ Sia Mac
7⁴⁵_8⁴⁵ Mario de Bellis
8⁴⁵_9⁴⁵ Andy Tex Jones
 Steve Travell
9⁴⁵_10³⁰ Gordon
10³⁰_11³⁰ Evil O.
11³⁰_11³⁰ Paul Cooper
11³⁰_11³⁰ Marc Vision
11³⁰_opened & Guests
 M. Grumann

düsseldorf stahlwerk

Elfentanz Elfentanz Elfentanz

FREITAG
29.09.1995
22.00-12.00 Uhr

harpune FEBRUAR 2001

harpune MÄRZ 2001

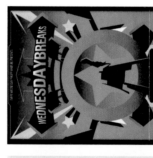

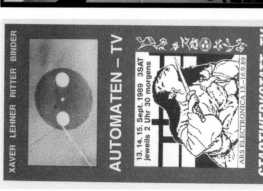

442

443

Enter the blue electric night
RauMKrümmung
06 sa **01_01**
GeIStesBLITZ.

26 02_01
rosen montag
PARALLELUNIVERSUM
RauMKrümmung AFTER HOUR
GeIStesBLITZ.

Hypnotic tricks
TECHNO HOUSE
24 sa **02_01**

LIKE LIQUID NIGHT
KORONA MILCHBAR SPEZIAL
17 sa **02_01**
GeIStesBLITZ.

ausge strahlt !
10 sa **03_01**
GeIStesBLITZ.

Raumkrümmung
TECHNO SPACE
03 sa **02_01**
GeIStesBLITZ.

Hypnotic_tricks
Techno HOUSE
24 sa **03_01**

www.hypnotic-arts.de [NJU:DRIFT]

first floor
live
PAUL BRTSCHITSCH
(freibe rec. | takal rec. | frankfurt)
EXE-CUTE (hypnotic arts)
MOLASSES

2nd floor
live
PALMER ELDRITCH
MALLET GAIN (testarossa rec.)

Hypnotic_tricks
Techno HOUSE
24 ab 22.00 H
WESTSTADTHALLEN 5-7
ESSEN

ESSEN

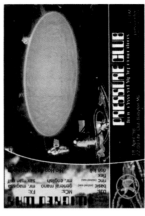

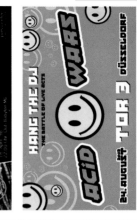

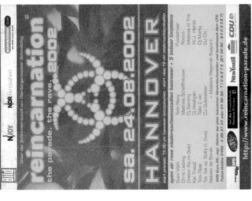

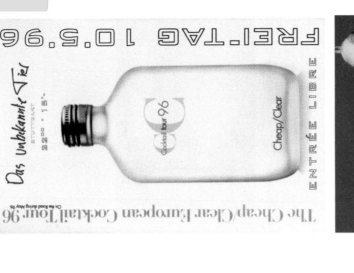

FREITAG 10.5.96

Das unbekannte Tier

STUTTGART
22.00 · 15,-

ENTRÉE LIBRE

Cocktail tour 96

Cheap/Clear

The Cheap/Clear European Cocktail Tour 96
On the road during May 96

GRAND PUBA

SADAT X

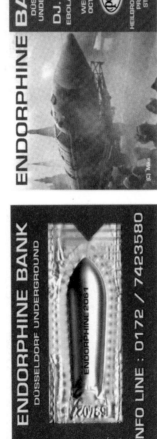

ENDORPHINE BANK
DÜSSELDORF UNDERGROUND

DJ. DOC F.
EBOLA RECORDS

WEDNESDAY
OCT 22TH 97

PRAG

HEILBRONNER STR. 261
PRAGSATTEL
STUTTGART

ENDORPHINE

[C] Makai

ENDORPHINE BANK
DÜSSELDORF UNDERGROUND

ENDORPHINE 2061

NFO LINE : 0172 / 7423580

EINLADUNG

STUTTGART

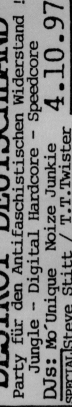

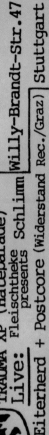

DESTROY DEUTSCHLAND

Party für den Antifaschistischen Widerstand !

Jungle -- Digital Hardcore - Speedcore

4.10.97

DJs: Mo'Unique Noize Junkie

SPECIAL Steve Stitt / T.T.Twister (Gyration/FFM)

GUEST: TRAUMA XP (Hateparade)

Live: Fleischtheke Schlimm

presents

Eiterherd + Postcore (Widerstand Rec./Graz)

22.30 Intergalactica

Willy-Brandt-Str.47

Stuttgart

BeatBoxRocker

Da brennt
der Stuhl

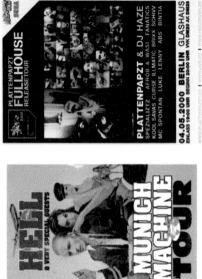

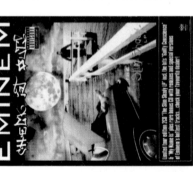

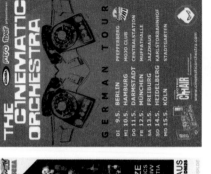

TOURFLYER

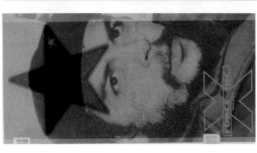

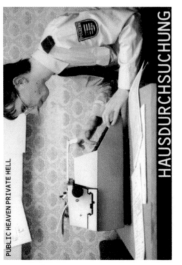

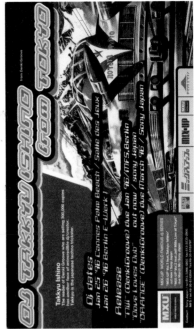

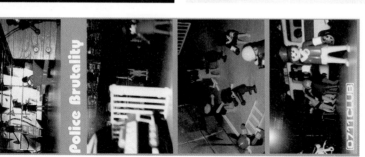

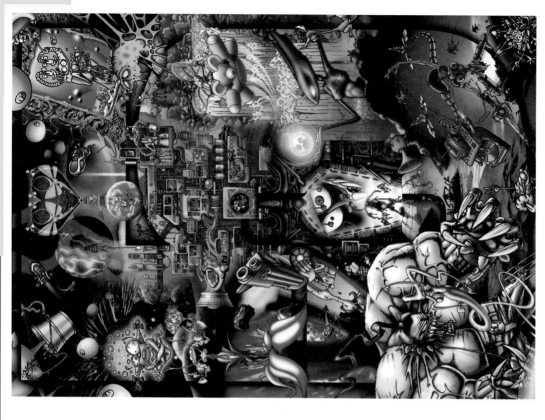

KASSEL

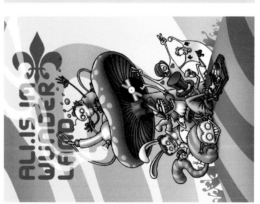

techno floor:
ellen allien [berlin]
electric indigo [berlin]
sara marius
acid maria [münchen]
horn [berlin]
voom [berlin]
pusha [poznang/polen]
shann de beers [berlin]
glenn vitello [berlin]
mercus dimitrius [berlin]
mr. bean [bremen]
radical rave djarels [berlin]
special guests

floor futur:
bok d:team [hamburg/berlin]
stereosionary[storm [berlin]
triple l [lublin]
electronic welfare [berlin]
peer [berlin]
move o.d [heidelberg]

radical rave : outdoor dance bei görlitz : hotline : [030]-612 803 11

borderline rave 24.-26.7.98

unter diesem motto findet der internationale rave statt. anschließend ist ein aktionscamp bis zum 02.08. geplant. ziel ist es die neuen unmenschlichen grenzen der festung Europa, dem menschenjagd und den abschiebewahn nach dem schengener abkommen mit vielfältigen aktivitäten, wenn nicht ins wanken, so zumindest zur sprache zu bringen.

mensch ist illegal

„ Ihr sollt wissen, daß kein mensch illegal ist. das ist ein widerspruch in sich. menschen können schön sein oder noch schöner, sie können gerecht sein oder ungerecht. aber illegal? wie kann ein mensch illegal sein?"

[elie wiesel, autor und friedensnopbelpreisträger]

hotline:[030]-612 80511
http://www.angelfire.com/ak/radicalrave

special thanks an alle dj(ane)s, visual-designers, performers und helferinnen, sowie der gruppe energie & duplikat, die alle unentgeltlich den rave unterstützen

SCHALL&RAUCH 2000
mehrschichtiges freies
open-air-festival
11.-13.8.00 Costa Mesa
alles fliessst acid area
alles fliessst soundsystem, lars[strom] u.a.
beginn samstag mittag: pumpin'stompin'house beats
ab 24h minimal chillin electric grooves

U1 Norderstedt Mitte → Bus 393 bis Theodor-Storm-Str.
mit Fiction Norderstedt → Schleswig-Holstein-Str.
→ links Industriegebiet Stonsdorf [Höhe Johnson & Johnson]

Eintritt frei!

8. Wave Gotik Treffen
Pfingsten 1999

Rencontre internationale annuelle à Leipzig [Allemagne] du 21 au 24 mai 1999

28.12.96.U.SITE

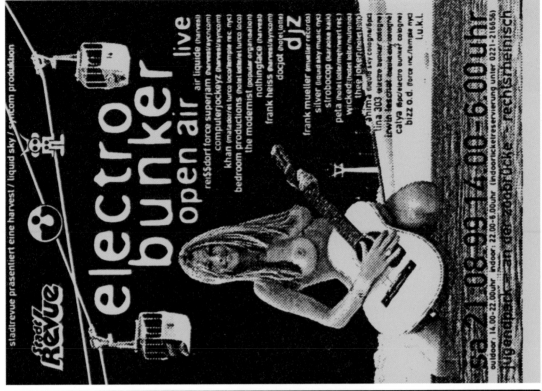

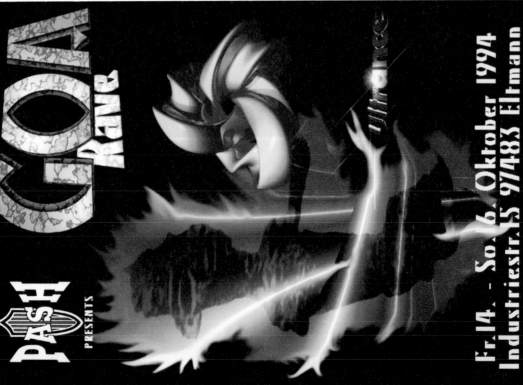

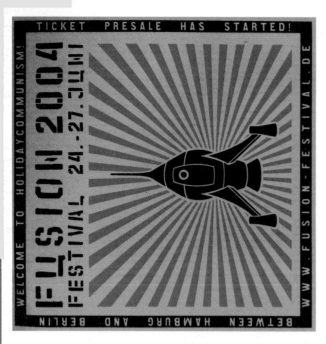

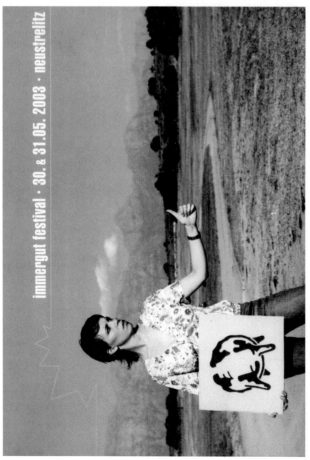

AUGEN AUF

Zivilcourage zeigen
Das Festival in Cottbus
24.8. - 26.8.2001
www.augenauf.net

17JUNI2k
HIRSCHFESTSPIELE
AUF DEM SCHLOSS
BRØLLIN

SILVER APPLE presents
a division of HIRSCHRUDEL
BRÖLLIN II 97
21 JUNI

5.|6.
Juni 1999
NEURO COMIC

2 JAHRE BEATREKONSTRUKTIONEN - OPEN AIR

LINE UP:
Alge (B)
Tscha'ba (B)
Mary Jane (B)
Sven Dohse (M)
Ryoma (DOO)
(J-Joe (B)

HOTLINE: 49 / 030 / 294 901 61

OPEN AIR BIS TRÄUMER · 30KM WESTLICH VON BERLIN · RESPECT NATURE · NO DOGS ALLOWED!
PICTURES: << SUB ROSA · COCKTAILS · SPACEBAR · FOOD · CHAI

excalibur II

...AM FREITAG, DEN
2. AUGUST 1996

SCHWEIZ
SWITZERLAND

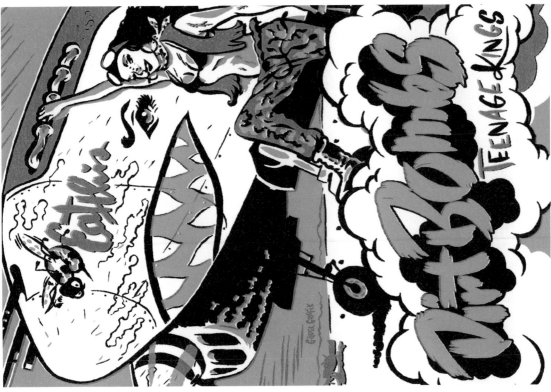

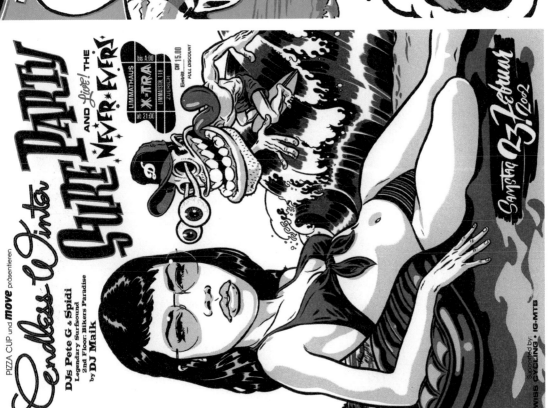

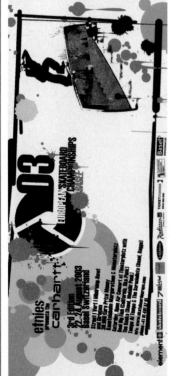

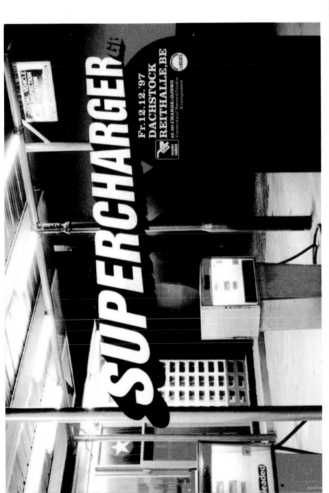

R&B
SOUL
HIP HOP
freitag, 4. september 98, 22h00

guayas

SAMSTAG
12. SEPTEMBER 98, 22h00
HOUSE

guayas

PROGRESSIVE/TRANCE
RELEASE PARTY
OF DJ MYSTERY'S FIRST RECORD "KISS THE FUTURE"
SAMSTAG, 11. SEPTEMBER 98, 22h00

guayas bar und club parkterrasse 16 3012 bern tel 031 318 70 75 fax 318 70 76

guayas

LOVEZOO'98
octobre

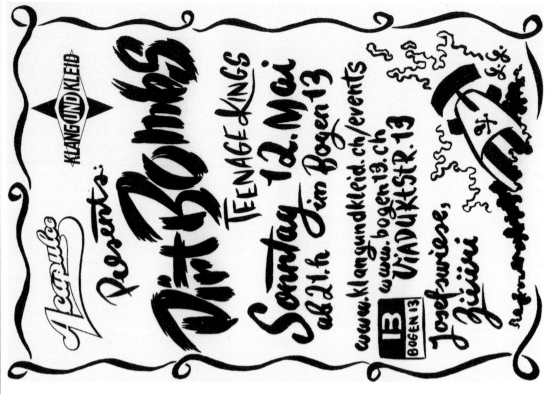

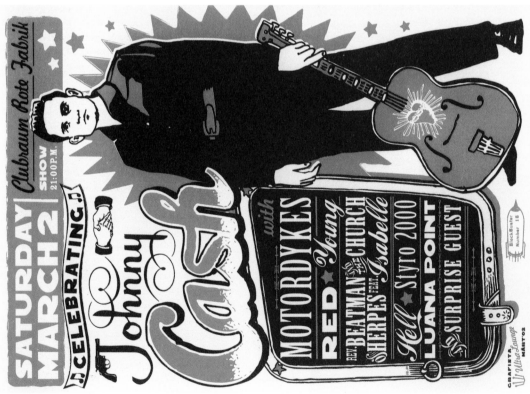

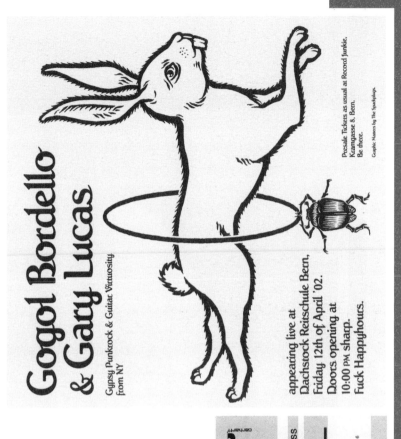

Gogol Bordello & Gary Lucas

Gypsy Punkrock & Guitar Virtuosity
from NY

appearing live at
Dachstock Reitschule Bern,
Friday 12th of April '02.
Doors opening at
10:00 PM sharp.
Fuck Happyhours.

Presale Tickets as usual at Record Junkie,
Kramgasse 8, Bern.
Be there.

Graphic: Kanes by The Spaßplugs.

carhartt

Liquid NIGHTS

LIQUID FUNK & DRUM N BASS

MOODS IM SCHIFFBAU

SAMSTAG
15.03.03

DRIFT [MUTE.CH]
MIJATOHO [MUTE.CH]
KENOBI [PROTONE.BE]
ELEJA
MC STB [MUTE.CH]

WWW.MUTE.CH

VISUALS + GRAFIK:
MODUL-GRAFIKDESIGN
ZEIT: 23:59
EINTRITT: CHF 20.00
SCHIFFBAUSTRASSE 6
8005 ZÜRICH

WWW.MODUL-GRAFIKDESIGN.CH

WWW.DRUMANDBASS.CH

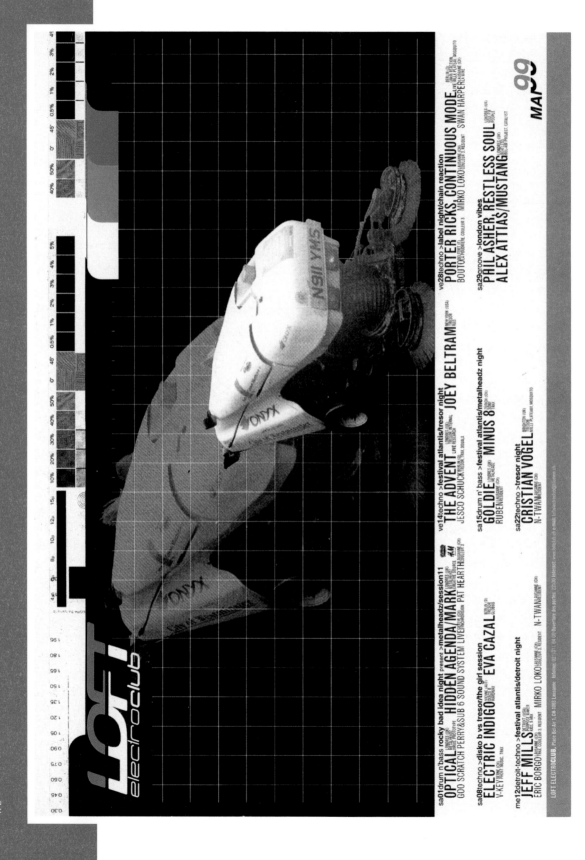

LOFT electroclub

sa01 drum n'bass rocky bad idea night present >metalheadz/session11
OPTICAL (UK) **HIDDEN AGENDA/MARK**
GOO SCRATCH PERRY&SUB 6 SOUND SYSTEM LIVE PAT HEARTH

sa08 techno >disko b vs tresor/the girl session
ELECTRIC INDIGO **EVA GAZAL**
V-KEY

me12 detroit-techno >festival atlantis/detroit night
JEFF MILLS (DETROIT USA)
ERIC BORGO MIRKO LOKO N-TWAN

ve14 techno >festival atlantis/tresor night
THE ADVENT LIVE **JOEY BELTRAM** (NEW YORK USA)
JESCO SCHUCK

sa15 drum n' bass >festival atlantis/metalheadz night
GOLDIE **MINUS 8**
RUBEN

sa22 techno >tresor night
CRISTIAN VOGEL
N-TWAN

ve28 techno >label night/chain reaction
PORTER RICKS, CONTINUOUS MODE
BOUTOU MIRKO LOKO SWAN HARPER

sa29 groove >london vibes
PHIL ASHER, RESTLESS SOUL
ALEX ATTIAS/MUSTANG

MAR 99

LOFT ELECTROCLUB, Place Bel-Air 1, CH-1003 Lausanne

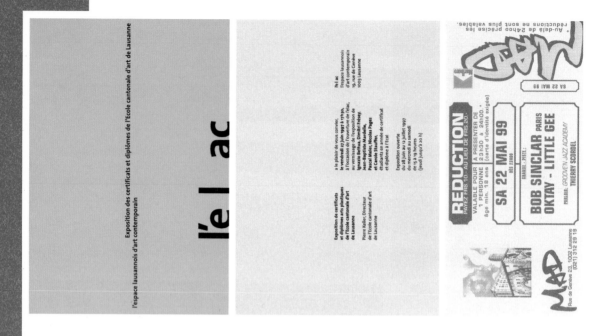

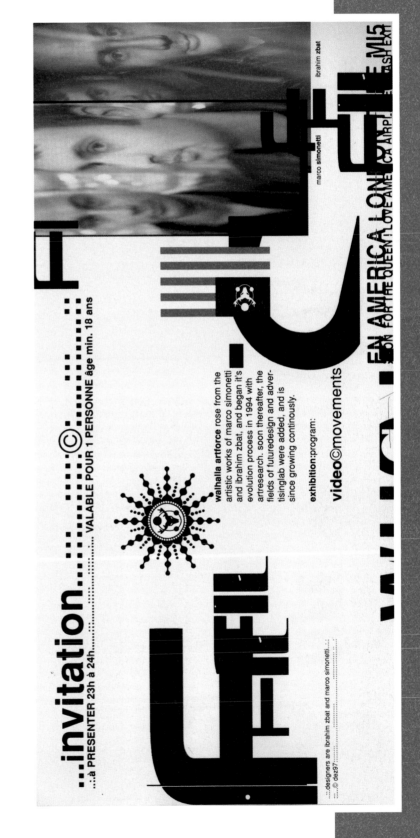

...invitation...

...à PRESENTER 23h à 24h............ VALABLE POUR 1 PERSONNE âge min. 18 ans

walhalla artforce rose from the artistic works of marco simonetti and ibrahim zbat, and began it's evolution process in 1994 with artresearch. soon thereafter, the fields of futuredesign and advertisinglab were added, and is since growing continously.

exhibition:program:

video©movements

EN AMERICA LONGE
....ON FOR THE QUEEN LOVE AMERICA AIRPL.

ibrahim zbat

marco simonetti

...designers are ibrahim zbat and marco simonetti....
...... © dez97:..............

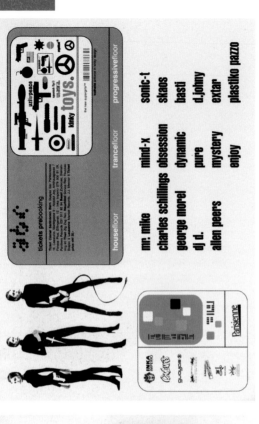

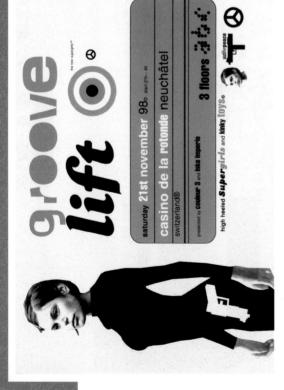

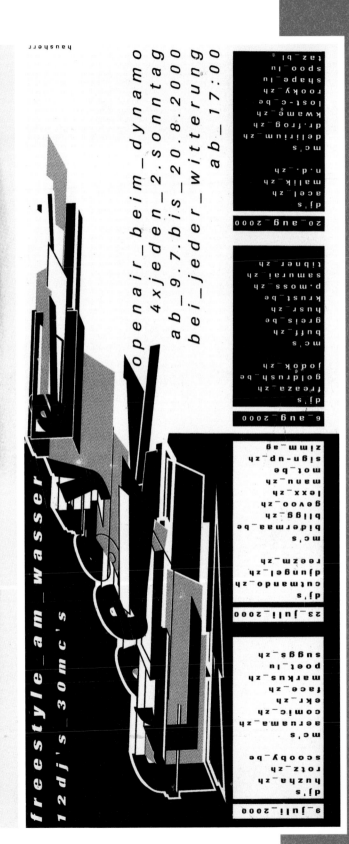

hausherr

openair_beim_dynamo
4xjeden_2.sonntag
ab_9.7.bis_20.8.2000
bei_jeder_witterung
ab_17:00

20.aug_2000
dj's
acel_zh
malik_zh
n.d._zh
mc's
delirium_zh
dr.frog_zh
kwame_zh
lost-c_be
rooky_zh
shape_lu
spoo_lu
taz_bl

6.aug_2000
dj's
freeza_zh
goldrush_be
jodok_zh
mc's
buff_zh
greis_be
husr_zh
krust_be
p.moss_zh
samurai_zh
tibner_zh

freestyle_am_wasser
12dj's_30mc's

23.juli_2000
dj's
cutmando_zh
djungel_zh
reezm_zh
mc's
bidermaa_be
bligg_zh
gevoo_zh
lexx_zh
manu_zh
mot_be
sign-up_zh
zimm_ag

9.juli_2000
dj's
huzha_zh
rotz_zh
scooby_be
mc's
aeruama_zh
comic_zh
ekr_zh
face_zh
markus_zh
poet_lu
suggs_zh

LIVE NDIRECT 97.5 () NONSTOP

>5.-9. august 1998

Loira 97,5MHz

>get system...

>midi channel 1
>synch off

478

Time	Program
24.00-6.00	**HERBALIST FOUNDATION NIGHT** FEAT. PAN, DU LAIT, CAINE, KARLA K., BLADE, MC RIDDIMFLIRT, HARDSTEP
21.00-24.00	**ADVANCED 1** LIVE: SEELENLUFT VS. PATHFINDER
19.00-21.00	**VERNISSAGE** INDEPENDENT STEREO: GALLO & MIKE LEVAN, COSMIC TUNES
18.00-19.00	
16.00-18.00	
14.00-16.00	
12.00-14.00	
9.00-12.00	
6.00-9.00	

>select sequenz...
>play pattern 23

mittwoch >5.8.98

>loading completed

>downloading data...

>loading files...

WWW.ELIXIR.CH/RTS, SUPPORT LORA! PC: 80-14.403-9

■ 3ER TAPE COMPILATION
"RETURN TO SENDER 98" LIMITIERT!
FR. 40.- & VERSANDKOSTEN
(FR. 30.- FÜR LORA-MITGLIEDER)

■ T-SHIRT
"303-ZAHLEN-MOTIV, S ■ M ■ L ■ XL ■
FR. 35.- & VERSANDKOSTEN
(FR. 25.- FÜR LORA-MITGLIEDER)

lora 97,5MHz

BITTE SCHICKT MIR UNTERLAGEN ZUR MITGLIEDSCHAFT!
BITTE SCHICKT MIR MEHR INFOS ZU MEINEM LIEBLINGSSENDER!
BITTE SCHICKT MIR DAS NEUE PROGRAMM-SCHEMA!

VORNAME, NAME:

ADRESSE:

PLZ, ORT:

EINSENDEN AN: RADIO LORA, MILITÄRSTR. 85A, POSTFACH 1036, 8026 ZÜRICH, TEL. 01 241 59 66/8, FAX. 01 241 35 80 / 97,5MHz

MO. 31.07.
doors open 23:00h free entrance till 24:00h

THE UK GARAGE AFFAIR
A NIGHT OF EXPLOSIVE TWO STEPPIN'
SOULFUL UNDERGROUND GARAGE

THE HERMIT (United Grooves/2 as one prod.) London
DJ T.C. (O-N1TE) Zürich
DJ EMPEE (Exquist Promotion) München
TAG MC (Silent Storm) Bern

MATRIX Förrlibuckstr. 151 Zürich I www.matrix-club.ch

EXTENDED
MATRIX
ab 22.00 h

FR. 11.08. (PARADE WARM UP)
Tech floor
Thomas P. Heckmann live (D)
Continuous Mode live aka Porter Ricks (D)
Electric Indigo (A), Tekjam
Starship Discotheque
Ricardo Villalobos (D), Serafin, Helga, Snur
Livingroom
Don Disco (D), Disco Dave

SA. 12.08. (AFTER THE PARADE)
Tech Floor
Sven Väth
Zombie Nation live, Franctone
Mirko Loko (Loft)
Starship Discotheque
Swayzak live (UK), Dan Bell (USA), Lo Soul (D), Serafin
Livingroom
Marco Repetto live, Gabriel Le Mar (D)

supported by: partynews

MATRIX
Ab 23:00h, Gratis Eintritt von 23:00 - 24:00h
Matrix I Förrlibuckstr. 151 I Zürich I www.matrix-club.ch

GOTHIC

BERT BEVANS MINISTRY OF SOUND, LONDON
MR. MIKE COULEUR 3
DJ DAINSKIN HIGH HOUSE

DJ GUY PRAVDA, LUZERN
DJ FLANGE VELVET, ZÜRICH
SHE JAY AJELE LOVETRAIN 98

WARM-UP
FREITAG, 7. AUGUST
AB 23 UHR
GOTHIC, GEESTRASSE 267
MARC HÜRLIMANN
HIGH HOUSE
DJ DAINSKIN
HIGH HOUSE

CAMEL

START-UP
SAMSTAG, 8. AUGUST
OPEN AIR + ZELT, WYTHENQUAI 75
BERT BEVANS
MINISTRY OF SOUND, LONDON
MR. MIKE COULEUR 3
DJ DAINSKIN HIGH HOUSE
DJ GUY PRAVDA, LUZERN
DJ FLANGE VELVET, ZÜRICH
SHE JAY AJELE LOVETRAIN 98

THE CLUB PARTY
AB 21 UHR OPEN END
GOTHIC, GEESTRASSE 267
BERT BEVANS
MINISTRY OF SOUND, LONDON
MR. MIKE COULEUR 3
DJ DAINSKIN HIGH HOUSE
DJ GUY PRAVDA, LUZERN
DJ FLANGE VELVET, ZÜRICH
SHE JAY AJELE LOVETRAIN, ZÜRICH
DANCE-ANIMATION
OPEN AREA
WATER GAMES
BODY-PAINTING
AND FUN

OF SOUND
MINISTRY

FR 7. AUGUST START, 22.00 OPEN END
WARM-UP STREETPARTY 98

RAVE FLOOR
DJ MARK SPOON LOVE PARADE 98, MAYDAY
DJ TAUCHER STREETPARADE HYMNE 98

JAIL

MIND-X (ENERGY 98, HARM REC.)
TATANA (EVOLUTION, ENERGY)
MAX B. GRANT (UNIT'Y 98, TBA REC.)
POSEIDON (GOLIATH 2, EVO REC.)
C.A KOLAR (MIXED OF FUTURESCOPE 8-CD)
(ART AND NOISE)
HOUSE FLOOR
EDX (ART AND NOISE, ENERGETIC REC.)
SIR COLIN (JAIL, GIBO FEVER)
BOOST (DX4, JAIL, TRAX RECORDS)

JAIL
KOHLSTRASSE 457, 8048 ZÜRICH
TEL. 41/1/405.70.90, FAX 41/1/405.70.91
WWW.JAIL.CH, BUS 31 BIS JAIL P LETZIPARK

481

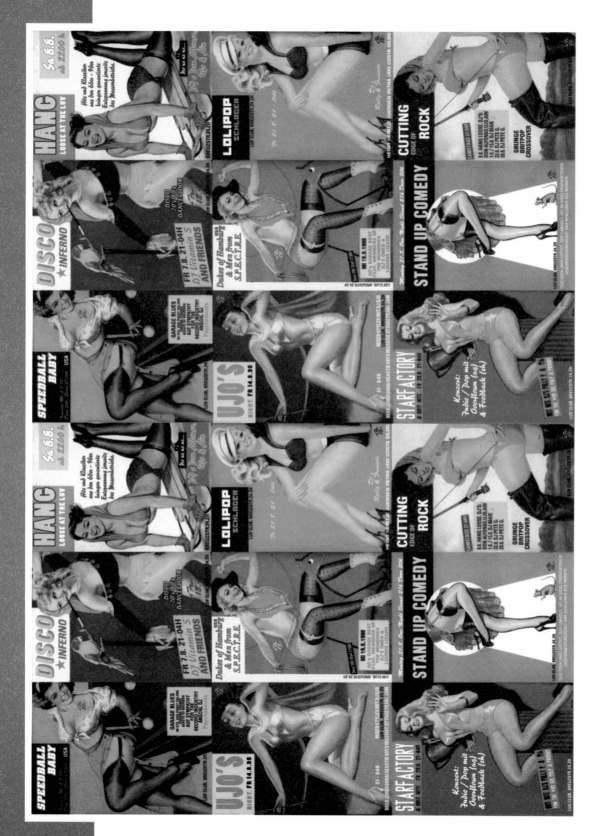

FREITAG 28. JULI 2000
MIAMI BASS & BREAKS
DJs MISK & SMASH FX
...on 4 turntables

OPEN-AIR-CHILL-OUT
PARKPLATZ-BARBEQUE
BEI JEDER WITTERUNG.
START: 23.00 UHR

MIAMI
BASS

UGclubonlounge gerolistrasse 5
8005 zürich www.ugclub.ch

MIAMI
BASS

when stereo goes surround
DOLBY SURROUND
for dreneds ears only
DOLBY SURROUND

 4

 2

1

OUT!

Flyer sind völlig

Follow the Signs

MFG™

PARTY FLYERS *from* ZRH

©2000 HINDERSCHLATTERFEUZ ZURICH

3

2

1

FR 15/08/97 SA 16/08/97

2 YEARS PARTYSAN JUBILEE
AT STREETPARADE-WEEKEND

FRIDAY 15.08.97
23.00 h - 05.00 h

DJs
MR MIKE [Couleur 3 Lausanne] (4 hours set)
HEINZ [ZH]
WIZARD [ZH]

SATURDAY 16.08.97
22.00 h - 07.00 h

LIVE
DER 3. RAUM [Göttingen D]
After their stunning 2 hours live gig at Rohstofflager in May Andreas Krüger and live-partner Rolf Dohndt are back Germany - top Show act - Atlantis - Mental Modulation (95) - Wellenbad (96)

DJs
GREEN VELVET [Chicago USA]
Curtis Jones aka Cajmere aka Green Velvet is the owner of the labels Relief and Cajual Hits - Flash - Preacher Man - Funny - The Stalker - Destination Unknown - Answer Machine. One gig alive Friday is his back in Switzerland

ERIC BORGO [Yverdon VD]
TONIO [F Communications France]
BANG GOES [ZH]

chillout-garden with ambient music
grafficgrass fotø oli zamp

ROHSTOFFLAGER Zürich
JOSEFSTRASSE 224 (STEINFELS-AREAL)
○ Escherwyssplatz, S-Bahn Hardbrücke ○ Freitag: sFr. 15.- ○ Samstag sFr. 25.- ○ Inquiries Fx 439 90 95

Parisienne

ROHSTOFFLAGER OPEN EVERY FRIDAY (NEW) & SATURDAY 22.30

ROHSTOFFLAGER Zürich
PROGRAM SEPTEMBER 98

EVERY SATURDAY: trax ○ EVERY 1ST FRIDAY: ○ EVERY 2ND FRIDAY:
EVERY 3RD FRIDAY: HOUSE ○ EVERY LAST FRIDAY: DRUM N' BASS

SA 5.9.98 **LUKE SLATER**
SA 5.9.98 **LIVE: PORTER RICKS**
FR 11.9.98 **VITAMIN S.**
FR 18.9.98 **LAURENT HERZOG**
FR 25.9.98 **KEMISTRY & STORM**
SA 26.9.98 **DER 3. RAUM**

AND MANY OTHERS

JOSEFSTRASSE 244 · STEINFELS-AREAL
TRAX @ ROHSTOFFLAGER · 8005 ZÜRICH (ESCHERWYSSPLATZ)

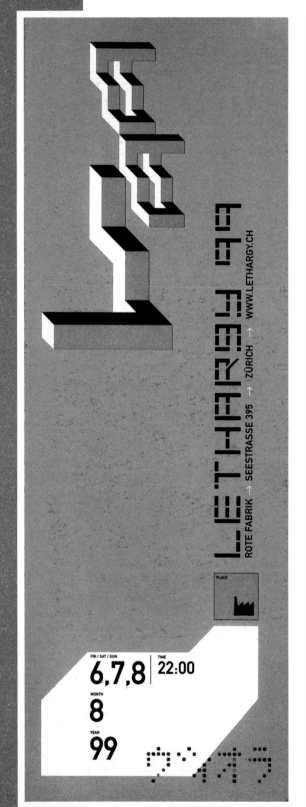

LETHARGY 99

ROTE FABRIK → SEESTRASSE 395 → ZÜRICH → WWW.LETHARGY.CH

FRI / SAT / SUN
6,7,8 **TIME** **22:00**

MONTH
8

YEAR
99

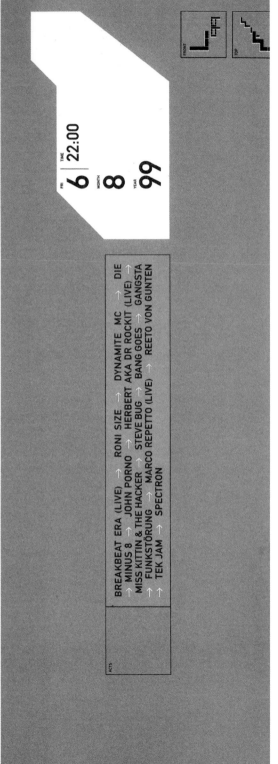

FRI **TIME**
6 **22:00**

MONTH
8

YEAR
99

ACTS:

BREAKBEAT ERA (LIVE) → RONI SIZE → DYNAMITE MC → DIE → MINUS 8 → JOHN PORNO → HERBERT AKA DR ROCKIT (LIVE) → MISS KITTIN & THE HACKER → STEVE BUG → BANG GOES → GANGSTA → FUNKSTÖRUNG → MARCO REPETTO (LIVE) → REETO VON GUNTEN → TEK JAM → SPECTRON

SAT / SUN **7,8** | TIME **22:00**
MONTH **8**
YEAR **99**

ACTS

KRUST → STORM → MC CLEVELAND WATKISS → X-PLORER → METROPOLITAN BASS SCIENTISTS → ANDREW WEATHERALL → DISKO → JESPER DAHLBÄCK → V-KEY → OLIVER MENTAL GROOVE → KLETTERMAX (LIVE) → STYRO2000 (LIVE) → NADER → I-F → TWO LONE SWORDSMEN (LIVE) → STATE OF BENGAL (LIVE) → BERRY & FIEDEL

AFTERHOUR:
SONIK → MIKKY B → SEQUENCE SIR → HALLTOWN (LIVE)

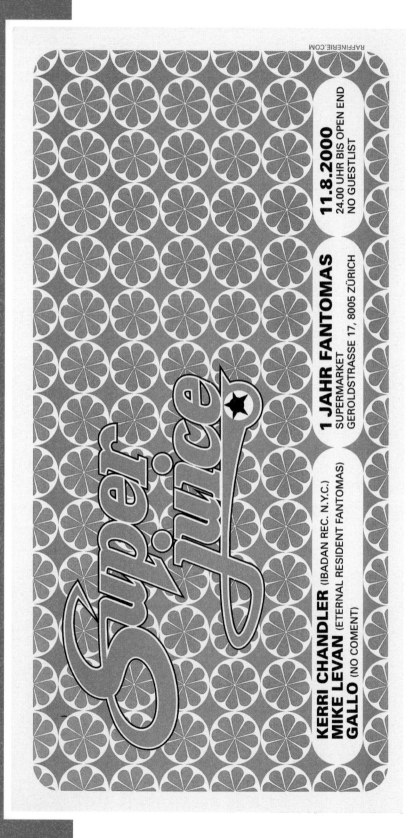

RAFFINERIE.COM

11.8.2000
24.00 UHR BIS OPEN END
NO GUESTLIST

1 JAHR FANTOMAS
SUPERMARKET
GEROLDSTRASSE 17, 8005 ZÜRICH

KERRI CHANDLER (IBADAN REC. N.Y.C.)
MIKE LEVAN (ETERNAL RESIDENT FANTOMAS)
GALLO (NO COMENT)

AUGUST 2000

SUPERMARKET

SUPERMARKET

SA 05 SUPERMARKET PRESENT: LOU LAMAR & MIKE LEVAN 24 UHR

SAMSTAG 17. OKTOBER 23 UHR OPEN END

SUPERMARKET

PRODUCTIONS PRESENT SUPERMARKET NIGHT

DJ'S DISCJOCKEY K & MARC B

www.supermarket.li GEROLDSTRASSE 17, 8005 ZÜRICH 1998

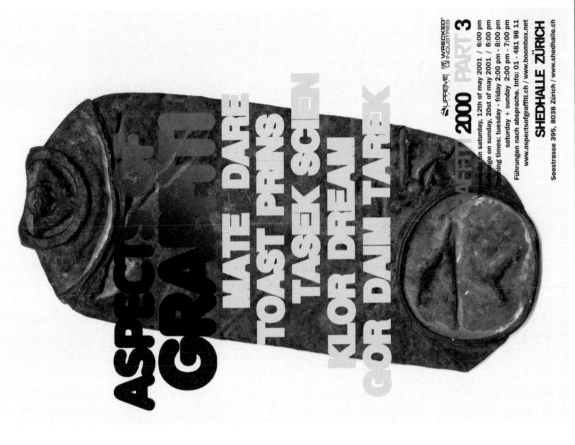

ENGLAND
GREAT BRITTAIN

5 - 29 MARCH WED-SAT 12 - 4PM PREVIEW: SAT 1 MARCH 7 - 10PM TOP FLOOR 54°N WAREHOUSE SPRING STREET HULL

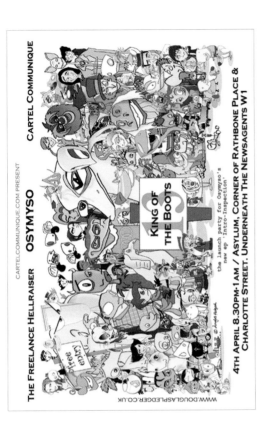

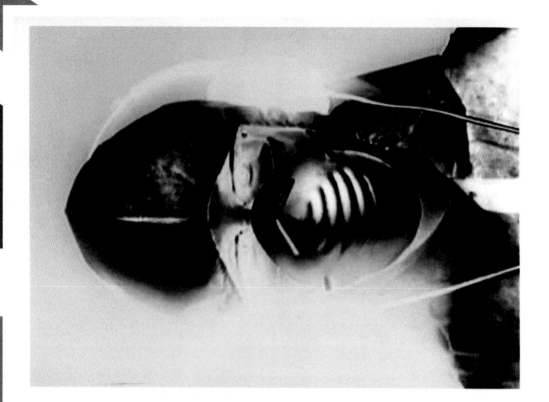

HOSPITAL PRESENTS

drum+bossa landslide

1

move

amaghetto

DAYTONA™

airsward

blowyourhead

"terrifying"

ROTATIONAL TORTURE
OPEN TO TORTURE PRESENTS ROTATION RECORDS
SATURDAY 28TH OCTOBER AT THE END

renaissance

awakening
renaissance

FRIDAY 27TH OCTOBER 2000
333 OLD STREET, LONDON. EC1

CONSPIRATOR PROJECTS PRESENT

STRUCTURE

A NIGHT OF DARK DRUM & BASS, TWO STEP GARAGE
AND LOW END EXPERIMENTAL BREAKS

x-static

SATURDAY 28th OCTOBER 2000
@THE REX MUSIC ARENA
361-373 The High Street
Stratford London E15. 10pm-6am

DREAMSCAPE
DRUM&BASS

"THE 12TH BIRTHDAY PAYBACK CELEBRATION"

A NEW DAWN ...A NEW BEGINNING ...A NEW STYLE FOR THE Y2K

YO-YO
© 2003

Successfully Independent since 1995

HULLS ORIGINAL AND BIGGEST INDIE NIGHT

yo-yo-indie.com [w]

SATURDAY 4TH MARCH 2000
SONIC MOOK EXPERIMENT
PRESENTS

THE SECOND IN A SERIES OF HEAD-TO-HEAD SOUND CLASHES

FRESH VS. FROST

BARRY ASHWORTH (DUB PISTOLS)
LONDON ELEKTRICITY / KRIS NEEDS / DJ FACE
PLUS UP TOP: BULLITT PRESENTS:
PLUS ONE (SCRATCH PERVERTS)
OLLIE TEEBA (HERBALISER) / ANDY SMITH (PORTISHEAD)
SAHIB DILLENJAH / THE USER / NICKY MILAN & NIXTON CREEPER / DUBSTRONAUT

FREDDY FRESH (USA)
EXCLUSIVE LONDON SHOW
VS JUMPING JACK FROST

PROGRESSION SESSIONS
UK MARCH TOUR 2000

glo.uk.com

Kevin (Club Skinny) presents

MILLENNIUM

EVERY FRIDAY & THURSDAY

9.30 - 3.30AM

30 YEARS OF BIG PARTY TUNES

DUB PLATES

TRANSITION STUDIOS IN FOREST HILL ARE NOW ABLE TO ADD DUB CUTTING TO THEIR LIST OF SERVICES AVAILABLE WHILE YOU WAIT. PRICES ARE VERY COMPETITIVE.

CAN'T GET TO OUR STUDIO?
WE CAN ARRANGE YOUR DUBS TO BE DELIVERED.
PLEASE PHONE FOR MORE INFO.

APPOINTMENT ALWAYS NECESSARY

TRANSITION STUDIOS
KEMBLE HOUSE, KEMBLE ROAD
LONDON SE23 2DI
TEL 020 8699 7888 FAX 020 8699 9441

DIFFERENT DRUMMER
FRIDAY MARCH 28 SOUND SYSTEM
[w]
welly club

blowyourhead [w]

funk, breaks, soul, blue note, hip hop, drum & bass, dance floor classics...

DISCOKITCHEN

EVERY FRIDAY

• Use Your Brain

CINERATOR PRESENTS

TRANSIT

DEVELOPING PROMOTERS ACROSS THE NATION

WWW.TRANSIT.UK.NET

PLAYING LIVE

THE CHINATOWNS.
THE SENSES.
THE FUZZ.

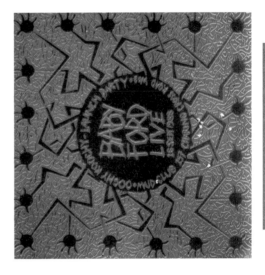

6ft.stereo

The BOUTIQUE

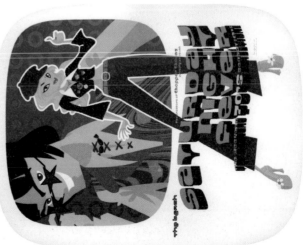

SATURDAY NIGHT FEVER

ÖSTERREICH
AUSTRIA

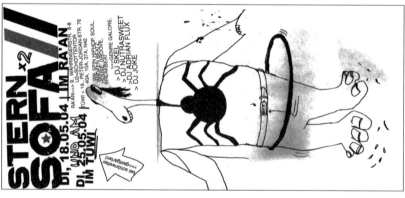

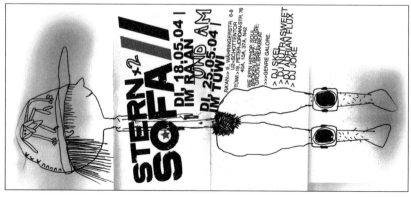

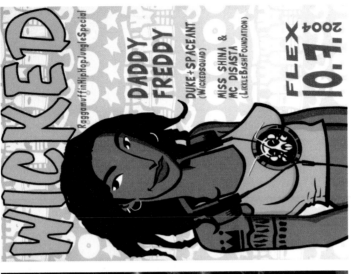

! stay tuned

5/7 OKT CEMBRANKELLER - LINZ

TWO LONE SWORDSMEN
FR. 17.11.2000
CEMBRANKELLER LINZ

FM4

klangturm
st-poelten
electronic music station

start up party

neues Musikprogramm
in allen Soundgärten
von Michael Northam (US)
Freitag, 7. September 2001, ab 20.00
Michael Northam ist anwesend

Klangturm
Landhausplatz, A-3109 St. Pölten
(02742) 9005 17 941, (02742) 90 80 50
office@klangturm.at
www.klangturm.at

northam

Freitag, 7. September 2001

SCHALLDRUCK im club cazin

15. september

mijk van dijk

club cazin - kellergasse 4 / 4020 linz

FRANKREICH
FRANCE

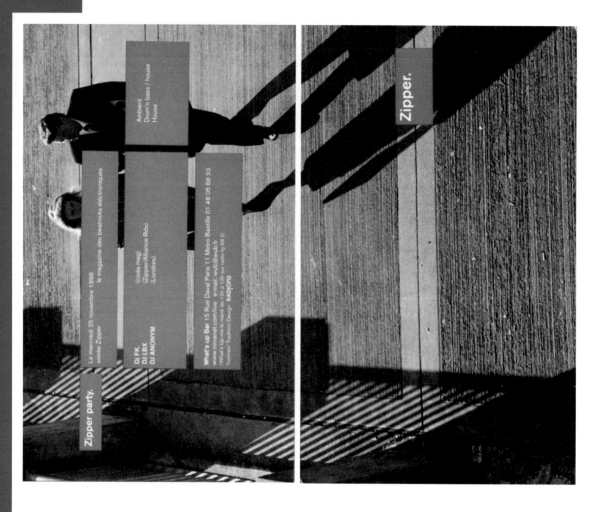

Zipper party.

Le mercredi 25 novembre 1998
le magazine des beatnicks électroniques
sortie Zipper

Dj FK,
DJ LBX
DJ ANONYM

(coda mag)
(Zipper/Alliance Rds)
(Londres)

Ambient
Drum'n bass / house
House

What's up Bar 15 Rue Daval Paris 11 Metro Bastille 01 48 05 88 33
www.nirvanet.com/live e-mail: web@web.fr
What's Up mix le vendredi de 12h à 13h sur radio fg 98.2)
Xellerat Tradition Design RADOFG

Zipper.

HEAVENLY
11_98

BASEMENT
TRACKS
03_11

SATURDAY
FREESTYLE
21_11

Saturday Freestyle.

CYR K . (E. Troneek Funk) + ADAM SCOTT(NYC)
From 22h

50 FF

+ 1Conso.

t : 01 48 05 88 33
e-mail: wub@wub.fr
sur le net: www.nirvanet.com

WHAT'S UP BAR
Hervé Dufait

SUNDAYFREESTYLE

DJ Cyr. K (E-Troneek) + guests Sam 13-02-99

RADIOFG

09/02

SYNTHETIC

515

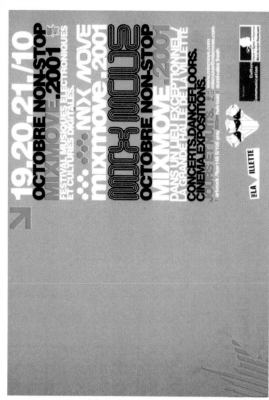

OPEN-SOUND-SYSTEM

PIXEL

AU WHAT'S UP BAR LE LUNDI 28 SEPT 1998

LA PETITE SECOUSSE

07.12.98

obsidia (part 3)
music electronik
montauban .82.
.06/07 juillet .01.

Basement Tracks boutique : 12 rue des Halles 75001 Paris - 01 45 08 02 31

...DES 22H
LE MARDI 15 DECEMBRE 1998AU WHAT'S UP BAR
SOIREE REFLEX........................JUNGLE, DRUM N' BASS & MORE
DJ VOLTA...............(MO'BREAKZ, NOVA).
DJ OTIS........
WHAT'S UP BAR.................................15 R. DAVAL 75011 PARIS 01 48 05 88 33
WWW.NIRVANET.COM/LIVE.................E-MAIL WUBSWUB.FR.
WHAT'S UP MIX LE MARDI DE 12H A 13H SUR FG 98.2.
YVELINES! TRADITION DESIGN.

517

LA PETITE SECOUSE DU LUNDI.

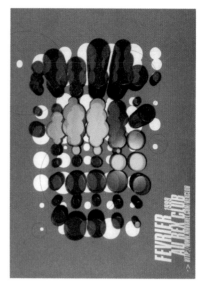

FEVRIER AU BATEX.CLUB
HTTP://WWW.BATEX.COM

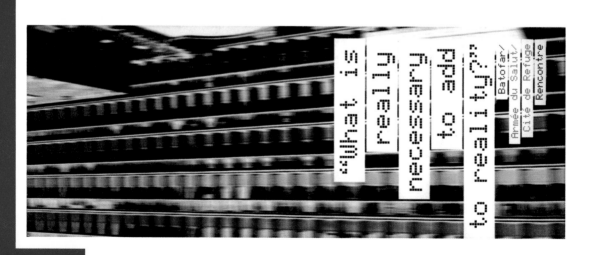

"What is really necessary to add to reality?"

Batofar/
Armée du Salut/
Cité de Refuge
Rencontre

HARVEY.

A

UCX 90

SHORT CUTS : IN PARIS

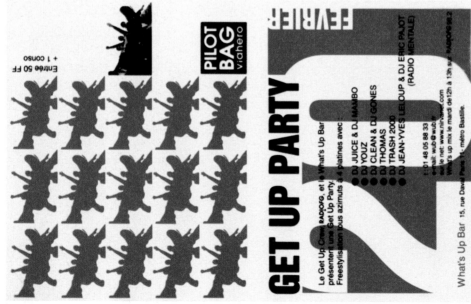

Entrée 50 FF + 1 conso

PILOT BAG viahero

FEVRIER

20

GET UP PARTY

Le Get Up Crew, RADIOFG, et le What's Up Bar
présentent une Get Up Party.
Freestylisation tous azimuts à 4 platines avec:

● DJ JUICE & DJ MAMBO
● DJ YOUZ
● DJ CLEAN & DJ GONES
● DJ THOMAS
● DJ TRASH 2000
● DJ JEAN-YVES LELOUP & DJ ERIC PAJOT
(RADIO MENTALE)

t : 01 48 05 88 33
e-mail: wub@wub.fr
site net: www.wub.fr
What's up mix le mardi de12h à 13h sur RADIOFG 98.2

What's Up Bar 15, rue Daval Paris 11e, métro Bastille.

zipper.

PICON ZINC

RADIOFG

VIP PASS

SPANIEN
SPAIN

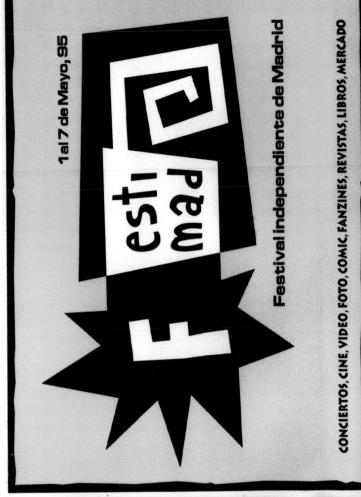

*look for the fish! '01

la terrazza
atmospherical fun club

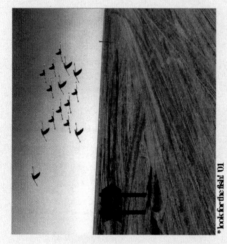

*look for the fish! '01

la terrazza
atmospherical fun club

*look for the fish! '01

la terrazza
atmospherical fun club

THE COLLECTIVE FESTIVAL
9 horas non stop / 2 sound system
domingo 16 · Junio 03
A partir de las 17H

cyberia

JUNY 2002
TECHNO TECHNO
TECHNO TECHNO
TECHNO TECHNO
TECHNO TECHNO
TECHNO TECHNO
TECHNO TECHNO
TECHNO & HARD
TECHNO TECHNO
TECHNO TECHNO
TECHNO TECHNO
TECHNO TECHNO PARTIES

REBELTECH @ MOOG
ARC DEL TEATRE 3, BCN

FREE ENTRANCE WITH THIS FLYER / ENTRADA LLIURE AMB AQUEST FLYER

JAVIER ODONYA & DJ BRUCE LEE
DIUMENGE 2 / DIUMENGE 9 – Comida D Eki (ITZELA – EUSKADI)
DIUMENGE 23 – SPECIAL ST. JOAN MESAPARTY / DIUMENGE 30
OPEN DOORS: 00.00H rebeltije@hotmail.com www.rifftechno.com

THE LOFT

JUEVES 13 EAST&WEST

FEMALE PRESSURE PARTY:
ACID MARIA
+ ELECTRIC INDIGO
+ CASSY BRITTON & DAVE THE HUSTLER live!
+ SONJA MOONEAR
+ MORTESON

VIERNES 14 EAST&WEST

COCOON BOOKING'S OFICIAL SHOWCASE:
STEWART WALKER live! (Cocoon/USA) www.cocoon.net
+ RICHARD BARTZ live! (Cocoon/Gigolo/GER)
+ FRANK LORBER (Cocoon/GER)
+ RICARDO VILLALOBOS (Cocoon/Perlon/GER)
+ Xavi Newtone

THE WRONG FESTIVAL

442 DISTRITO

mr. DIAGONAL
Passeig de Gracia
La Rambla

Wed nesday June 11
22:00 Offline visuals
22:30 E-de (ex Bordoms)
 Kubala
23:30 DJ Squich
00:30 Donna Summer
02:30 Hrvatski + sclu

Thurs day June 12
22:00 Offline visuals
22:30 Carlos Giffoni
23:30 Bloodslut
01:30 Timeblind
02:30 DJ /rupture

Fri day June 13
22:00 Offline visuals
22:30 DJ72ero
23:30 Battery Operated
01:30 Massimo
02:30 End + Atmoferik

HTTP://THEWRONGFESTIVAL.INFO

THE WRONG FESTIVAL
INVITATION
11 | 12 | 14 | 15 | JUNE 2002
FROM 20.00H TO 01.00H
CITY HALL | RAMBLA CATALUNYA 4 | BARCELONA

THE WRONG FESTIVAL
11 | 12 | 13 JUNE 2003
HTTP://THEWRONGFESTIVAL.INFO

Renaissance and Mean Fiddler present

renaissance live
privilege ibiza

Every Wednesday from 21 June to 13 September.

21.06 Opening party
Hybrid
Dave Seaman, Sister Bliss,
Danny Rampling, Mousse T

19.07
Stacker
Armand Van Helden, Sneak,
Boy George, Junkie XL

16.08
Leftfield
Carl Cox, Jim Masters, Craig
Richards, Lee Burridge

13.09 Closing Party
Live t.b.a.
Dave Seaman, Defected Records:
Full Intention

28.06
BT
Deep Dish, The End presents:
Mr C, Layo & Bushwackal

26.07
A Man Called Adam
Deep Dish, Dave Seaman,
Junior Sanchez

23.08
Moby
John Digweed, Derrick Carter,
plus special guests

Pre-parties
Every Wednesday at Café Mambo,
San Antonio. Featuring Pete
Gooding and a selection of the
above DJs. 8.30pm – midnight.

05.07
Evolution
Dave Seaman, Nick Warren,
Dope Smugglaz, Xpress 2

02.08
All Saints
Pete Tong, Dave Seaman,
Derren Emerson, Sneak

30.08
Live t.b.a.
Dave Seaman, Tall Paul, Sister
Bliss, Pete Gooding, Erick Morilo

Tickets available from
San Antonio: Café Mambo,
Mega Music, CD Music
Ibiza Town: Rock Bar/Base,
Mega Music, El Chupito, Bar
Tango, Santa Eulalia: Mega Music,
Café Guarana

12.07 Ibiza album launch party
Kylie
Deep Dish, Dave Seaman,
Danny Rampling, Richard F

09.08
Moloko
Dave Seaman, Danny Rampling,
Claudio Coccoluto

06.09
Dope Smugglaz
Nick Warren, Josh Wink,
Pete Gooding, Nu-Breed

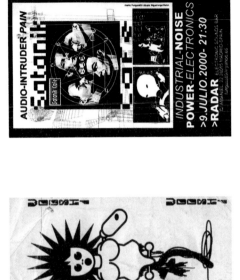

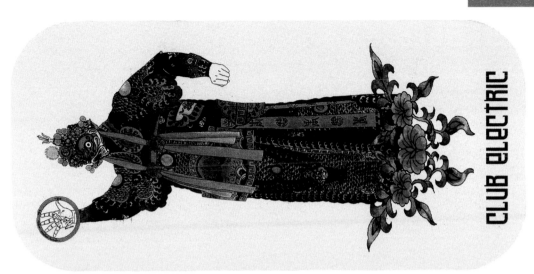

CLUB ELECTRIC

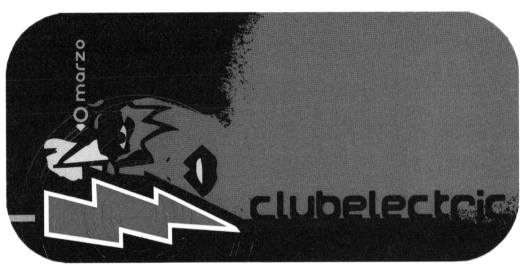

clubelectric

marzo

OSTBLOCK

erki moeshow

26.11.1999 Hell 20.00, Kalevi spordihalle

S22 Pilet eelmüügist 15, kohapeal 20.-

CLUBInterstanding

ticket / pilet 50

live acts
Monophon (Germany)
Elast (Riga)
Uni
Postrces
Ulka Mark

DJ-s
Virka Crew from Riga
(Kone, Glonijek, Smartin, Dr.Upo)
Raul Saaremarts (Rab.Cru)
Erkki Tero (Side, Heven)
Aivar Tõnso (Umnplaskid)

video-mix
by F5 Art Team (Riga) and Wireframe (Tallinn)

live internet broadcast
by net-radio OZONE /E-LAB, Riga)
http://ozone.re-lab.netlive.com

25.11.1999 >>> 22.00 04.00 >>> Mustpeade maja, Pikk 26

COMMUNICATION FRONT 2001 /project of electronic and media art and theory/ 01.14 JUNE 01 plovdiv.BG

cyber and my space – netizens and the new geography

C2 BUDAPEST

resident dj's: Tommyboy . Dän von Schulz

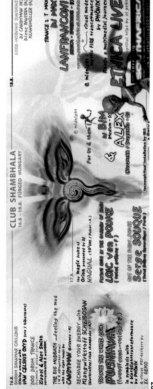

07

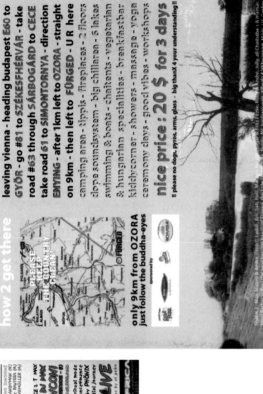

11

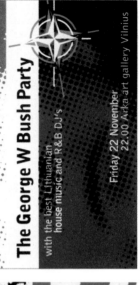

12

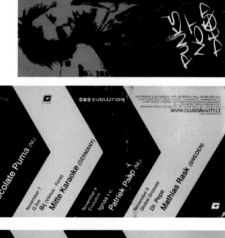

10

09

08

25

23

21

30

31

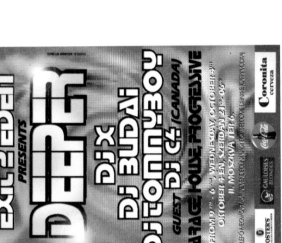

29

27

28

HOLLAND
THE NETHERLANDS

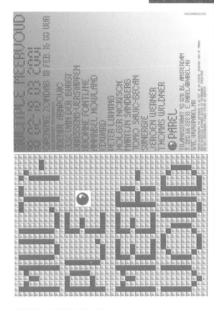

MULTIPLE MEERVOUD
8.02–18.03 2001
OPENING: ZONDAG 18 FEB. 15.00 UUR

BJERKE ARAPOVIC
LUC VAN DER BURGT
BRESSENS-VERSTAPPEN
JUVOIRE FONTIJNE
ANNABEL HOWLAND
EDWARD
PETER LUIRING
HOLGER NICKISCH
MARTIJN SANDBERG
SINERGIE
TOMO SAVIC-GECAN
JEROEN WERNER
THOMAS WALDNER

PAREL
TILANUSSTRAAT 40 1091 BL AMSTERDAM
t: 020 66 22233 e: parel@parel.nu

MULTI-
PLEER-
VOUD

Ptt Post
Port betaald

INTERACTIEVE LICHTINSTALLATIES
DOOR KUNSTENAARS UIT ZAGREB
25 MAART T/M 21 APRIL 2001
OPENING: ZONDAG 25 MAART 16.00 UUR

MAGDALENA PEDERIN
DAVOR ANTOLIĆ ANTAS
IVAN MARUŠIĆ KLIF

MET DANK AAN DARKO FRITZ

PAREL
TILANUSSTRAAT 40 1091 BL AMSTERDAM
t 06 29 51 56 14 e parel@parel.nu i www.parel.nu
OPEN: DO T/M ZA 14.00 TOT 18.00 UUR + 1e ZONDAG vd MAAND

Ptt Post
Port betaald

LIGHTS
FROM ZAGREB

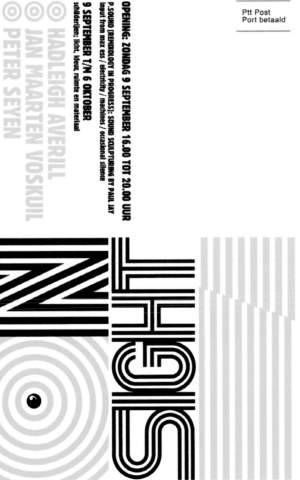

INSIGHT

OPENING: ZONDAG 9 SEPTEMBER 16.00 TOT 20.00 UUR

P.SOUND [REMIXOLOGY IN PROGRESS]: SOUND SCULPTURING BY PAUL JAY
input from max ess / electricity / machines / occasional silence

9 SEPTEMBER T/M 6 OKTOBER
schilderijen; licht, kleur, ruimte en materiaal

HADLEIGH AVERILL
JAN MAARTEN VOSKUIL
PETER SEVEN

PAREL Tilanusstraat 40 1091 BL Amsterdam t: 06 29515614 e: parel@parel.nu i: www.parel.nu

PREVIEW! zaterdag 8 september 13.00 tot 18.00 uur (food, drinks)

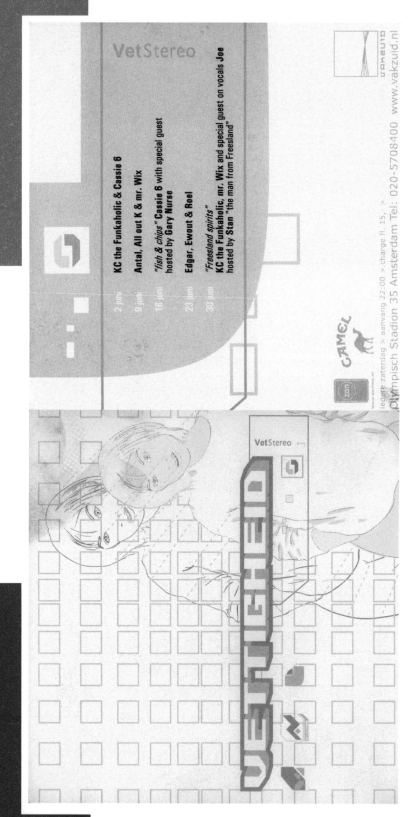

VetStereo

KC the Funkaholic & Cassie 6
2 juni

Antal, All out K & mr. Wix
9 juni

"fish & chips" Cassie 6 with special guest
hosted by Gary Nurse
16 juni

Edgar, Ewout & Roel
23 juni

"Freesland spirits"
KC the Funkaholic, mr. Wix and special guest on vocals Joe
hosted by Stan "the man from Freesland"
30 juni

iedere zaterdag > aanvang 22:00 > charge fl. 15,- >
Olympisch Stadion 35 Amsterdam Tel: 020-5708400 www.vakzuid.nl

CAMEL

vakzuid.nl

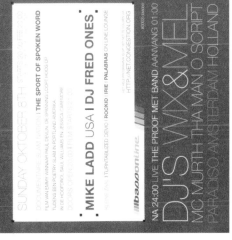

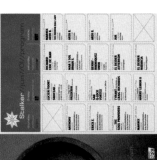

SATURDAY 02-10

BILLY NASTY
TORTURED RECORDS UK.

SUPPORTED BY ST. RESIDENTS

FERRY MICHEL DAVID V

VISUALS BY GYZ
PROVIDED BY LEFT SKATESTORE

PODIUM DE VLERK
WESTBLAAK 80 010-4116800

OPEN FROM TEN TILL FIVE DAMAGE : 17.50
(CHECK IN EARLY, ONLY 400 TICKETS)
PRESALE : VELVET MUSIC TICKETS, R'DAM

FOR INFO AND RESERVATIONS CHECK WWW.R'DAM.COM DE VLERK OR CHECK
VLERK@XS4ALL.NL WWW.XS4ALL.NL/~VLERK

STRICTLY TECHNO
[LIMITED EDITION]

danny.howells /// sander.k
...nenberg /// per /// nog harder

020 // 21th july. over het ij festival /// festival

the over het ij festival is located at the ndsm grounds neveraweg 15 on the north side of amsterdam
for more info check www.earth-link.nl // also an earthated // het write vuur speelt (trekhaak)
a special festival ferry located at pier 7 behind amsterdam cs. will take you to the festival. departure. 23.00/23.40/00.30
please note that the last ferry leaves at 00.30 hours // by bus line 74 (night bus from csl stop otaturk

earth

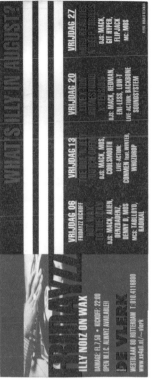

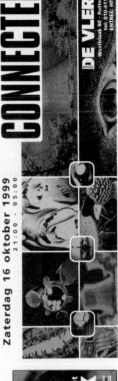

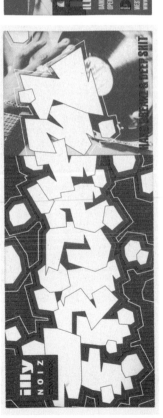

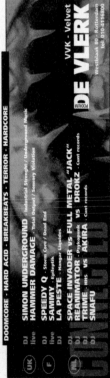

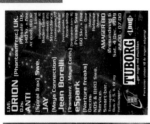

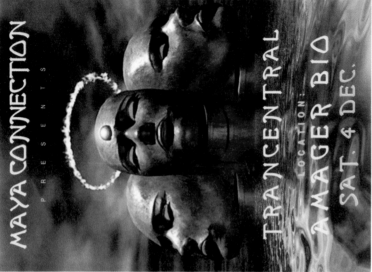

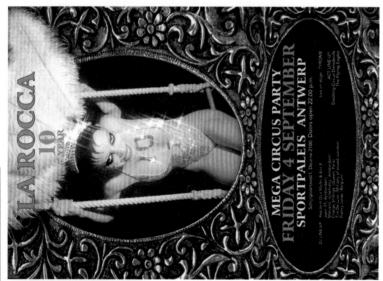

klass exclusively presents

PURE UK

July 6th 2001 11pm - 5am
New Escape Venue Amsterdam

A NEW ERA BEGINS WITH TOP UK DJS

pure uk

dj gee
isobel pearson
chriz
miss fadova

fotografie: Marjolein Huizer

JEFF KOONS
RAINALD GOETZ REGIE: THEU BOERMANS

PETER KLASHORST MAAKTE SPECIAAL VOOR DE TRUST NIEUW WERK.
VANAF 3 OKTOBER IN DE FOYER VAN HET TRUSTTHEATER, KLOVENIERSBURGWAL 50,
MA T/M ZA VANAF 12.00 UUR. OPENING 3 OKTOBER 19.00 UUR.

JEFF KOONS
RAINALD GOETZ REGIE: THEU BOERMANS

Het schrijverspodium
presenteert:

inval

→ theater
Bellevue ←
Alle talen ←
6-8 okt. ←

Festival voor
Nederlandstalig Toneelrepertoire

DesignArbeid

JAPAN

CAPTAIN TINRIB
tinrib recordings JAPAN TOUR '99

1999.11.22 mon(祝前日)

UNIVERSE

CODE

LIVE PA
CAPTAIN TINRIB

DJ's
SHINKAWA
DJ RYU
OTOME

MDMA
HIDEKI
dj DAICHI

¥ 1000LDK

ESCAPE
JAPAN TOUR
with LE HAMMOND INFERNO from BERLIN!

2000 NOV.3 FRI. AT O/D

Special Guest DJ:
LE HAMMOND INFERNO
(Bungalow from Germany)

DJ:
Masaaki Naka
Gakuji Matsuda

Support DJ:

FEE : 3,000YEN with 1DRINK/3,500YEN with 1DRINK
Ticket : Ticket Pia, Lawson Ticket, Jungle Exotica, Tom Market-R
Total Information : Access Net : 092-731-2200, O/D : 092-733-1166
web Information : http://www.jre.jp/asahi/fpg/web/
design information : fat graphics@fire@cat.email.ne.jp

FPG

COMPLETE FINESSE
presents

FLY
AT WOMB
House Ritual
DJ IZU & SAT
1 / 11 (Fri)

TOKYO SOUL BREAK
SEVEN

CAMPARI

PARTY INFORMATION

EVERY MONDAY DRUM AND BASS
HOLIDAZE

FORCE HUTCH KAJI AKI MC 電龍

22:00 START

2000yen 1/d 1500yen 1/d with flyer
1000yen 1/d before 23:00

5-10-6 B1F Minami-Aoyama Minato-Ku Tokyo 107-0062

OmniFactor

DJ
MISSIE / **KANGO** / **SAFARI**
TAK-L / **GOH** / **KON-K**
EXCLUSIVE SHOWCASE
HOOKS! / **SNAPPY** / **G'z**
VJ di MC 健也

FREE JUNKFOOD

2001.12.27

1 1 [NOV.]
1999/9/11

VUENOS
TOKYO

SUPER SPEAKER SHINKUKAN クラブ流体感覚

この迫力は真空管を愛してくださるお客様の熱烈なアンコールに答え、1999年11月5日(金)より金曜日、土曜日に限りクラブ新宿を開催致します。サウンドを体感してください。SUPER SPEAKER SHINKUKANの挑戦的

金曜=第1.3 < REGGAE > 第2.4 < R&B, HOUSE >
ADM ¥3000(2d) OPEN 22:00

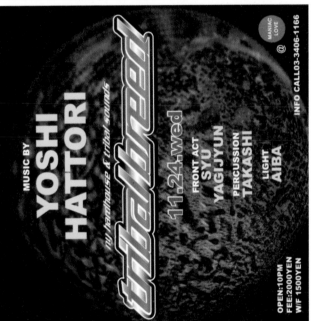

MUSIC BY
YOSHI HATTORI
ny hardhouse & tribal sounds

tribalbreed

11.24.wed

FRONT ACT
SYU
YAGIJYUN

PERCUSSION
TAKASHI

LIGHT
AIBA

@ MANIAC LOVE
INFO CALL 03-3406-1166

OPEN:10PM
FEE:2000YEN
W/F 1500YEN

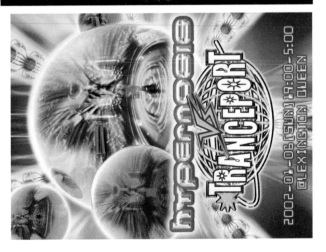

hypernesis
TRANCEPORT

2002-01-06(SUN)14:00-5:00
@LEXINGTON QUEEN

><*2

psychosexual !? [hard house]

DJ: Gunji, cocacode(Maruiwa), Kanami, AKN(Ishii)
starts: 11:00.p.m.[Fri]ﾅｲﾄ
at: Club Heavysick
(phone: 5350-7855)
fee: ¥2000 (with 1D)

written by Satoru Maruiwa

POST CARD

TANTRA
ﾀｶﾊﾞﾝﾃﾞﾝﾂﾖ
ﾁｪﾝﾉﾋﾞﾛﾗｲﾌﾞ Vol.3 [所]

1999
Nobember
Every Friday

DOOR 3,000/2drinks
FLYER 2,500/2drinks

Feel the sound at the space "54"

Lee3 Bldg.8F2-11-4,Kabukicho,Shinjuku-ku,Tokyo
PHONE 03-3205-7766

Mister Donut
馬林会館
新宿区役所
コマ劇場
交番

TRANCE RAVE PARTY

ToGeTHer
@ WOMB

2002/1/4・5・6
20:00 ~ Midnight

ENTRANCE FEE
¥2,500 [1D]
¥2,000 [1D] FLYER

SHIBUYA STATION

★ DVD release teevee graphics VIDEO VICTIM

2001年9月21日発売
¥4,700/2001年/日本/R60分/カラー/DD2ステレオ2.0/ 発売:アスミック、テレビ東京

2F HARLEM-3F BX CAFE
TRANSIT SYSTEM

3F BX CAFE
2F HARLEM

25:00以降

入口 [ID CHECK]

[2F - HARLEM]3F - BX CAFE] Information 03-3461-8806
Dr.Jeekahn's 2F 2-4 Maruyama-chou Shibuya-ku Tokyo 150-0044 JPN

to HARAJUKU
SHIBUYA STATION
BUNKAMURA TOKYU HONTEN BOOK 1st
MAC店
NOODLE SHOP
SUSHI SHOP
POLICE

POISON presents playhouse JAPAN TOUR

DATE: 2000.11.25.SATURDAY.11pm-

1st FLOOR:
GUEST LIVE:
GUEST DJ'S:
DJ/S: TAKAMARU, TATEISHI

2nd FLOOR:

PLACE: WHOOPEE'S-KYOTO-075.561.2931

playhouse

techno

toacoul

TICKET INFORMATION

JETSET KYOTO
CISCO OSAKA
YURINA KOYAMA
RA
WHOOPEES

the other side of ibiza
sunshine dance & sunset chill

[THE SHIP]

1999.11.7(Sun)@futakotamagawa
from 10:00 till 19:00

pilot : mikkie,So,Kiku,Tateyama,Kohji
and Yoda (from Mothership)
[specially Cafe del mar style]

we need your donation for sound system fee.
it will be accepted at 1,000yen a share.

Shibuya
Futakotamagawa Station
Oimachi-Line
ma-Line

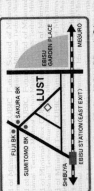

245 Aoyama-Dori
Bijouxier's
Royal Host
Omotesando
Laforet Meiji-Dori

BAR SALONE SHINKUKAN
〒150-0001
渋谷区神宮前4-4-14原宿ＦＧＣＡ Ｂ1Ｆ
Tel.03-3475-4646

VIBES

ORGANIZED BY KYOKO
INFO 098-2566-4613〈KYOKO〉
03-54 4-1483〈LUST〉
Ap03 WORK GP
1999.11.15.f.f(0m). @LUST

matsuya
buckers
sunkus
sakura bk
to MEGURO
EBISU Sta
to SHIBUYA
東京都渋谷区恵比寿4-4-6 MS EBISU4 (2F)

Sound of Minimal Trax CUBIC Future Sound of Minimal

FUJI BK SAKURA BK
SUMITOMO BK
LUST
SHIBUYA
EBISU STATION(EAST EXIT)
EBISU GARDEN PLACE
MEGURO

LUST : MS-EBIS 2F 4-4-4 Ebisu Shibuya-ku Tokyo
TEL:03-5424-1483
[CUBIK HP] http://home.att.ne.jp/red/cupid/cubik/
[flyer design] sako plexus@b.inbox.ne.jp

555

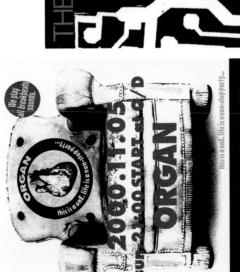
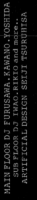

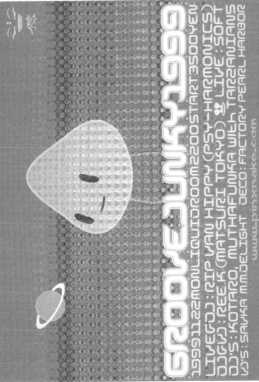

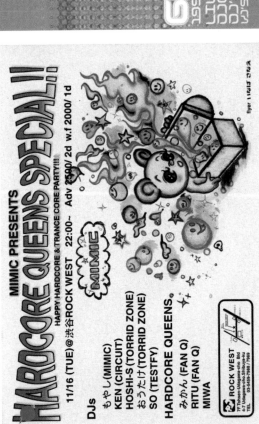

563

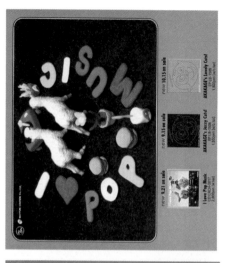

post card

カフリハ・ゴー！マイ・ヘロー！ 恋する夏のリゾートに。

Miss Maki Nomiya Sings

ミス・ビチカード・ファイヴ 野宮真貴 ソロ・アルバム

[miss maki nomiya sings] 2000.7.20 OUT / COOP-50353 ¥3,059 (incl.tax)

★ produced by 野宮真貴

★ 参加アーティスト：本田恭か (from チボ・マット)、ディーヴァ、VIP200、インスタント・カフェ・レコーズ、モリスフォオリ・ガカデラ、鈴木惣一、HEESEY (from ザ・イエロー・モンキー) ＆ 小暮旅屋

★ 野宮真貴プロデュースSHOP期間限定オープン 7.20 thu〜8.06 sun 渋谷PARCO part1 カフェ・ボン・ゴ
★ 野宮真貴デザインのオリジナル、タンクトップ、トート・バッグ、アクセサリーなどオリジナル商品を販売。
★ 先着でPARCOのお買物券をプレゼント
[SHOPでグッズ及びCDをお買い上げのお客先着全員に入場者にプレゼント]

★ EVENT 7.19 wed 17:00〜／HMV キャッチ・オン 7.60渋谷 info. 03.3837.7301
7.20 thu 15:00〜／HMV名古屋サンロードセンター名店 info. 052.585.1020
7.20 thu 19:00〜／名古屋 PARCO東館 B1 info. 052.285.1020
7.27 fri 19:00〜／名古屋 PARCO東館がアスハロー A（1F限定SHOP同時オープン）info. 052.566.1321
8.02 wed 18:00〜／渋谷本店 PARCO B1F Vngba●2F前館 info.03.5411.1191

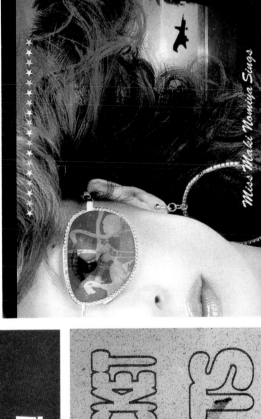

Miss Maki Nomiya Sings

NO SOCIALISM. NO COMMUNISM.
NO CAPITALISM. NO DEMOCRACY. NO POLITICS.
NO POWER. NO GOD. CRY
DO THE HOUSE !

1 DRINK TICKET

ROCKETS

Hub Club
Now
EXPLOSION

The Funky Fur
continues... Next week,
Wednesday 1/17 with
Yes, The Now Bubble
Blast?! with
Sister D's
Back. Of course.
Hub Club
533 Washington
Boston.. 451-6999

Discotheque

FREE ADMISSION
Boston's Alternative Dance Club

Authorization

13 Lansdowne St. 262-2424

THE HUB CLUB HALLOWEEN ZOO PARTY!

YOU ARE INVITED TO THE OPENING NIGHT OF:

Slam Bar

Tuesday Dec.5

Featuring Momentum D.

DOORS OPEN AT 9.

NO ADMITTANCE WITHOUT INVITATION

SLAM BAR.1270 BOYLSTON.BOSTON

BLOODSHOT

WEdNESdAYS

metromix.com

TIMEBOMB!
the Annihilation of the Millennium

Fri./Sat. December 29th/30th - 18 & over - $10.00
Sunday December 31st - New Years Eve - 21 & over $29.99 (includes libations)

DJS
PERFORMERS

POETS
VISUAL ARTISTS

Featuring:
LIVE MUSIC

Doors Open at 8:00PM

INTERACTIVE ATTRACTIONS :

Giant Slide
Swings
Projection Art
Cargo Climbing Nets

"Your Minute of Fame"
Video Booth
Percussion Structures
Pinball
Plus - a Massive HALF PIPE for Skaters!

Skee-ball
Video Games
Dome Hockey
and much, much more....

 CHARYBDIS

Multi-Arts Complex 4423 N. Milwaukee Ave. Chicago
773.427.9970 www.Charybdisarts.com

POLYFEST 2000 experimental Chicago

JIM AVIGNON
7 → 9 PM
NOV 26 DEC 27
NATIONAL ART CLUB
15 GRAMERCY PARK SOUTH, NEW YORK, NEW YORK 10003

SAT. SEPT.10 AT 11 PM
NANCY COLEMAN AND THE LATE SHOW FILM SERIES PRESENTS

THE
INFLATABLE
DOLL

BY PABLO FERRO (1969)
•
ISM ISM
BY MANUEL DELANDA (1979)
•
SAILOR'S WIFE
BY ERICH VON WAGNER (1984)
•
HENRY VIII
BY SUSAN TREMBLAY (1985)
•
GO-GO GIRL
BY M. HENRY JONES (1978)
•
SHIMMELSTEEN
BY MICHAEL WOLFE (1988)

GAS STATION
2ND ST. & AVE. B, N.Y.C.
INFO: 673-3304

■ THIS IS A SERIES OF SCREENINGS ORGANIZED BY ZONE. 23 AVE B, NYC 10009 ■

HAPPY BIRTHDAY VITO AND ROMANI WEDNESDAY, OCTOBER 12, 1988

PALLADIUM

fantazia

Tuesday 25th March 1997 at ZEP TEPI

1532 Washington Ave, Miami Beach, U.S.A

Friday April 4th, 1997

Reunite Body & Soul As We Re-Open The Doors To Your Lost Home

The Grand Re-Opening Of

SALVATION

West Avenue I South B

READY BAR

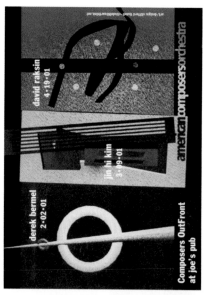

american composers orchestra

david raksin
4·19·01

jin hi kim
3·19·01

derek bermel
2·02·01

Composers OutFront
at joe's pub

MODEL
SEARCH

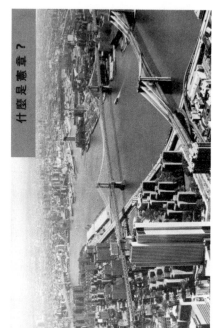

什麼是憲章?

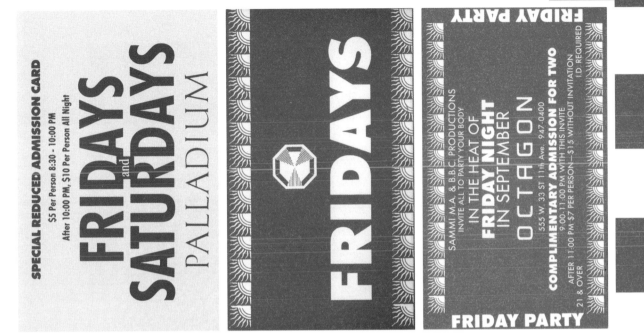

SPECIAL REDUCED ADMISSION CARD

$5 Per Person 8:30 - 10:00 PM

After 10:00 PM, $10 Per Person All Night

FRIDAYS
and
SATURDAYS

PALLADIUM

FRIDAYS

FRIDAY PARTY

SAMMI M.A. & B.B.C. PRODUCTIONS
INVITE ALL TO PARTY YOUR BODY

IN THE HEAT OF
FRIDAY NIGHT
IN SEPTEMBER

OCTAGON

555 W. 33 ST 11th Ave. 947-0400

COMPLIMENTARY ADMISSION FOR TWO

9:00-11:00 P.M. WITH THIS INVITE

AFTER 11:00 PM $7 PER PERSON—$15 WITHOUT INVITATION

21 & OVER I.D. REQUIRED

FRIDAY PARTY

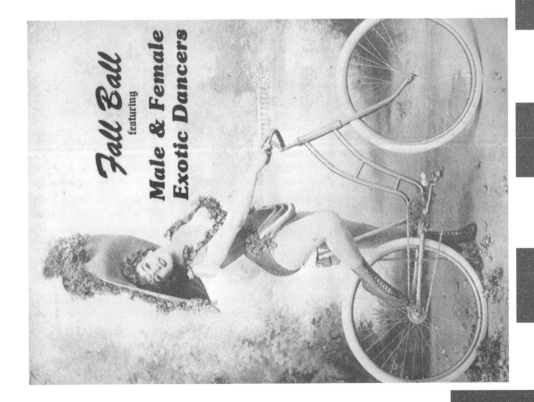

Fall Ball

featuring

Male & Female Exotic Dancers

+ **SECRET SERVICE** at **12** P.M. + **THE FLUID** at **1:00**

THURSDAY SEPTEMBER 1

...**THE MALARIANS** at 11 P.M.

sunday **4** WHISPERS presents

ross: THE PARTY.

PYRAMID - 101 AVENUE A - 420-1590

30 tuesday...**BLITZSPEER** at 11:30 and **NEVERMORE** at 12:30

31 wednesday...**THE DREAMING** at 11 P.M. and **DEM VACKRA** at 12:30

FRIDAY 2...**WARM JETS** at 11:30 + **MARIA EXCOMMUNICATA** at 12:30

+ **CHILLY DOGS** at 1:30

saturday 3 at **THE RED GARTER SALOON** **THE SINGING PEEK**

SISTERS + MASTERPIECE THEATRE featuring **LEE KIMBLE**

evening begins at 11 P.M. with hostess **SISTER DIMENSION** + D.J. John Parker

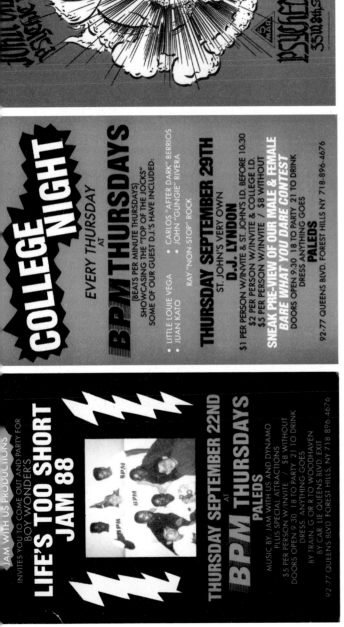

JUMP OVER THE PSYCHEDELIC SOLUTION
35 W. 8th St. 2nd Floor, New York City

COLLEGE NIGHT
EVERY THURSDAY AT
BPM THURSDAYS
(BEATS PER MINUTE THURSDAYS)
SHOWCASING THE "TOP OF THE JOCKS"
SOME OF OUR GUEST D.J.'S HAVE INCLUDED:
• LITTLE LOUIE VEGA • CARLOS "AFTER DARK" BERRIOS
• JUAN KATO • JOHN "GUNGIE" RIVERA
RAY "NON-STOP" ROCK
THURSDAY SEPTEMBER 29TH
ST. JOHN'S VERY OWN
D.J. LYNDON
$1 PER PERSON W/INVITE & ST. JOHN'S I.D. BEFORE 10.30
$2 PER PERSON W/INVITE & COLLEGE I.D.
$5 PER PERSON W/INVITE / $8 WITHOUT
SNEAK PRE-VIEW OF OUR MALE & FEMALE
BARE WHAT YOU DARE CONTEST
DOORS OPEN 9.30 18 TO PARTY 21 TO DRINK
DRESS ANYTHING GOES
PALEDS
92-77 QUEENS BLVD. FOREST HILLS NY 718-896-4676

JAM WITH US PRODUCTIONS
INVITES YOU TO COME OUT AND PARTY FOR
BOY WONDER'S
LIFE'S TOO SHORT
JAM 88
THURSDAY SEPTEMBER 22ND
AT
BPM THURSDAYS
PALEDS
MUSIC BY: JAM WITH US AND DYNAMO
PLUS SPECIAL ATTRACTIONS
$5 PER PERSON W/INVITE / $8 WITHOUT
DOORS OPEN 9.30 18 TO PARTY 21 TO DRINK
DRESS: ANYTHING GOES
BY TRAIN G OR R TO WOODHAVEN
BY CAR L.I.E QUEENS BLVD EXIT
92 77 QUEENS BLVD FOREST HILLS, NY 718 896-4676

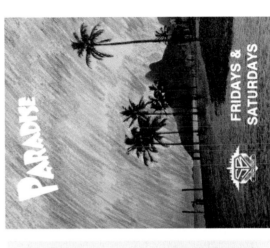

PARADISE
FRIDAYS & SATURDAYS

SUSAN & BRUCE INVITE YOU TO
PARADISE
HOTTEST TROPICAL CLUB
ON THE ISLAND!
FRIDAYS & SATURDAYS
COMPLIMENTARY ADMISSION 10:00 - 11:30
with this invitation.
$7.00 per person after 11:30 PM
$9.00 per person without this invitation.
THIS INVITATION ADMITS YOU & YOUR GUESTS
Join us for NY's top DJ's
and the best menu of
exotic tropical drinks
THIS PASS IS VALID
EVERY FRIDAY
AND SATURDAY.
Private Parties 50 to 500 - 254-5957
(Bet. 5th Ave. & B'way)
15 WAVERLY PLACE • NYC

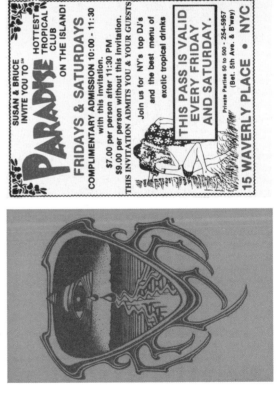

LET THE BEAT CONTROL YOUR BODY.

DETROIT SATURDAY SEPTEMBER 29th

www.DJHERO.com

FREE ADMISSION
Before 11:00pm
Void Private Parties/Special Events

Guest Of:

ZANZIBAR
One Boylston Place, Boston
(Between Tremont & Charles St.) 451-1955

Mp3.snows.com presents
ALL AGES
TVT recording artists
IGNITE
epitaph recording artists
STRAIGHT-FACED
ASIANMAN recording artists
LAWRENCE
and
WUNDER YEARS
SUN. MAR. 4TH, 6PM
1059 W. ADDISON
CUBBY BEAR CHICAGO

colette vs. angel alanis
Champion sound, L.A.CA

Be sure not to miss the first tag-team by these two in the D.
Four turntables,efx and live vocals by our favorite house djs!

twona
Hi-Jacked Records, Detroit

A full on assault to your cranium of mind blistering techno by
the techno terrorist himself. Support this local old-schooler!!

kandyman w/mc play
Hazard-s, Detroit

Special jungle set for one of his last kandyman appearences.

directions;
800-495-0376
www.hazards.com

presale tickets at:
record time [ferndale] 248-585-8463
record time [roseville] 810-775-1550
shua moon [ann arbor] 734-747-9661
threads [hamtramk] 313-874-0088
100 tickets for $6. more at the door.
+virgin venue. cheap hed, safe parking.
big sound, minimal lighting, free mix cds.

saturday sept 29th 2001

next event: Oct 22~Neil Landstrumm LIVE

printed by xavier 313. 965. 9434

DANCE
ABILITY

The Best Dancers In Boston....
Dance At The Hub Club On Wednesday.
Upstairs.

Positive Identification Required
Doors Open at 9:30

Hub Club 533 Washington St. Boston MA Ph 451.6999
$3 Validated Parking at Lafayette Parking Garage

18+

NOW EXPLOSION
DISCOTHEQUE
WANTS YOU!

$6 cover

THE ONE NIGHT A WEEK WHEN YOU CAN LOVE
AMERICA. AND IT WILL LOVE YOU BACK!!!!!
WEDNESDAY FEBRUARY 7

DJ SISTER DIMENSION SPINS
FOR TRUTH,JUSTICE, AND THE
AMERICAN WAY

HUB CLUB
533 WASHINGTON ST.
BOSTON 451-6999

578

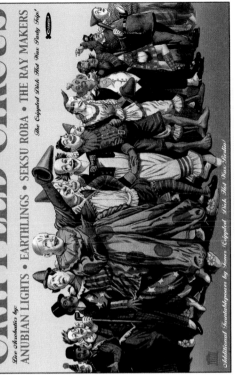

CRIPPLED CIRCUS

Live Acrobatics by:

ANUBIAN LIGHTS • EARTHLINGS • SEKSU ROBA • THE RAY MAKERS

The Crippled Dick Hot Wax Trip'

Additional Trustakepower by Tones (Crippled Dick Hot Wax Berlin)

"bridging Ancestral & Future Rhythms"

oct. 25
Kevin
Keiper
Marc
Anthony
(the Top)

jazz
funk
soul
DUB
Jazz
deep
Latin

$5

Storyville Jazz Club
1751 Fulton St.
@ Masonic
10pm – 2 am
21+ w/ ID
guestlist
415.864.5095

FATSOULS PRODUCTIONS PRESENTS:

SAT. MARCH 17th

Atmosfere

sophistifunk
wednesdays

djs
rueben (sf)
khaled (live breakbeats)
guests (weekly)

beginning Oct.18
Mauricio Aviles
Cool Chris
Travis

orangeage presents
frizar
mondays

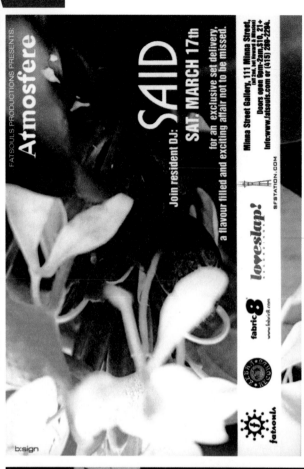

FATSOULS PRODUCTIONS PRESENTS:

Atmosfere

Join resident DJ: **SAID**

SAT. MARCH 17th

for an exclusive set delivery, a flavour filled and exciting affair not to be missed.

Minna Street Gallery, 111 Minna Street, (at 2nd, bet Howard & Mission)
Doors open 9pm-2am, $10, 21+
Info:www.fatsouls.com or (415) 289-2294.

SFSTATION.COM

loveslap!

fabric 8
www.fabric8.com

fatsouls

b:sign

BLEND

WINTER MUSIC CONFERENCE '97

THE COMPLETE CALENDAR

SATURDAY MARCH 22ND
TO
FRIDAY MARCH 27TH

Liquid Nightclub
1439 Washington Avenue Miami Beach
Tel 305.532.9154 Fax 305.532.9980
VIP Table Reservations 305.532.8899
email liquid@thenet.net

Liquid Nightclub 1439 Washington Avenue Miami Beach

Tel 305.532.9154 Fax 305.532.9980 VIP Table Reservations 305.532.8899
Email liquid@thenet.net

free...

*THURSDAYS...

2925 16th St.

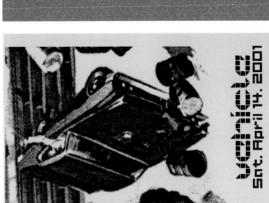

vanic
Sat. April 14. 2001

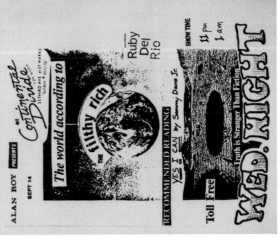

ALAN ROY PRESENTS
SEPT 14

at Continental Divide
25 THIRD AVE @1ST MARKS

The world according to
THE filthy rich

Ruby Del Rio

SHOW TIME
11 PM
1 AM

RECOMMENDED READING
YES I CAN by Sammy Davis Jr.
Truth is Stranger Than Fiction

Toll Free

WED. NIGHT

artandfilm.com

What were you born to do?

Tunnel•Vision

$$\overline{\overline{\cap}}$$

Fall '88

$$\overline{\overline{\cap}}$$

TUNNEL
SUMMERSCENE

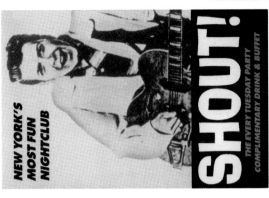

NEW YORK'S MOST FUN NIGHTCLUB

SHOUT!

THE EVERY TUESDAY PARTY
COMPLIMENTARY DRINK & BUFFET

HOTEL AMAZON

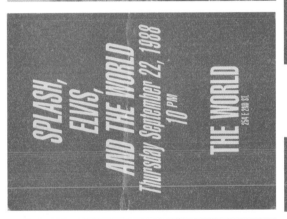

SPLASH,
ELVIS,
AND THE WORLD
Thursday September 22, 1988
10 PM

THE WORLD
254 E 2ND ST.

S P L A S H

SWING
SUIT
LIVE
KHAN

u[rge]
MAGAZINE RELEASE PARTY

MARCH 16, 1997
@PEN OF THIEVES
745 W HOUSTON
NEW YORK CITY $6

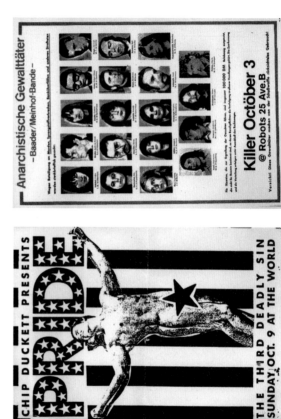

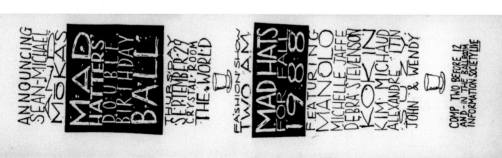

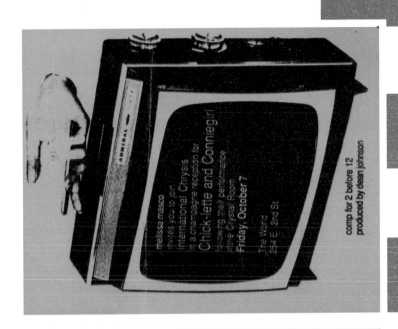

melissa masco
invites you to join
International Chrysis
in a champagne reception for
Chick-lette and Conniegirl
following their performance
at the Crystal Room
Friday, October 7

The World
254 E. 2nd St.

comp for 2 before 12
produced by dean johnson

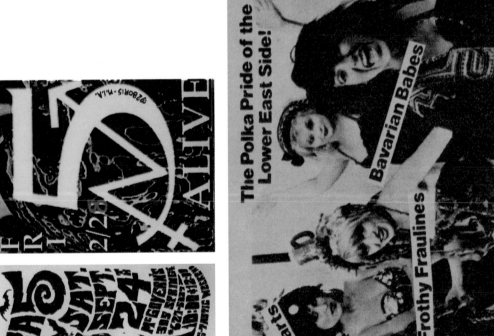

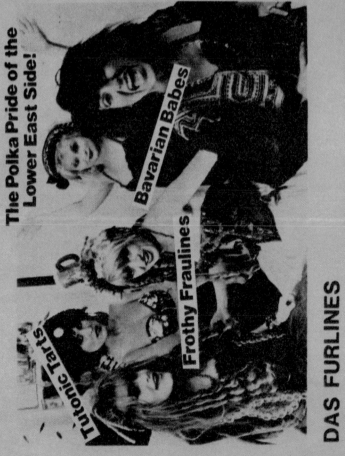

photo by Jilleen Nadolny

The Polka Pride of the
Lower East Side!

Bavarian Babes

Tutonic Tarts

Frothy Fraulines

DAS FURLINES

MEXIKO
MEXICO

ELECTRONIC DANCING SOUNDS

LO.LL.TA

JUNIO DE 2001

HIDDEN AGENDA

PARADOR ANÁLOGO SOUND SYSTEM PRESENTA
Desde Nueva York:

Tony Rohr (live PA) + Dietrich Schoenemann (dj set)
minimal deep tribal techno
Jueves 28 de septiembre, 2000

time warp méxico twm

green velvet westbam mijk van dijk blake baxter marusha frank muller
dj rok dj hell sven väth blunted gayle san ... commander tom monika kruse

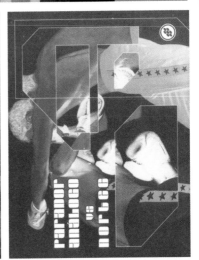

parador analogo vs norbee

PORNOGRAPHICS

Borderline > TECH HOUSE
Linga > DRUM N' BASS [DARK & TEK STEP]
Djunknown > DRUM N' BASS [JUMP TEK]
Smoke > DRUM N' BASS [JAZZ STEP]
Nihil > DRUM N' BASS [DEEP & JAZZ STEP]
Temple > TECH HOUSE MUTANTE

ENERO / FEBRERO 2001

PARADOR ANÁLOGO SOUND SYSTEM

PORNOGRAPHICS

Borderline > TECH HOUSE
Linga > DRUM N' BASS [DARK & TEK STEP]
Djunknown > DRUM N' BASS [JUMP TEK]
Smoke > DRUM N' BASS [JAZZ STEP]
Nihil > DRUM N' BASS [DEEP & JAZZ STEP]
Temple > TECH HOUSE MUTANTE

ENERO / FEBRERO 2001

PARADOR ANÁLOGO SOUND SYSTEM

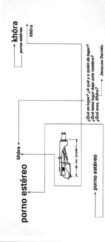

March:30

Tall Paul
Live at Club 303

www.tallpaul.co.UK

El ganador del premio *Muzik* al su del año **Tall Paul** comenzó su carrera a la edad de 16 años, animando fiestas en el club *Turnmills* de su padre. Y al mismo tiempo empezó a transmitir desde *Touchdown! FM*, su radio pirata. Pero también logró tener una presencia regular dentro de la legendaria radio pirata de Londres *Sunrise FM*. También utilizó sus poderes de persuasión para tener su propia hora, los sábados, en el *Trade All Nighter* en el *Turnmills* hasta obtener

su residencia en 1990. Más tarde obtuvo una residencia el el **Club Zap** de Brighton y ahí fue donde con **Shelley Boswell** lideró *Clubs for Life* en el **Gardening Club**. Desde entonces Paul ha mezclado por todo el Reino Unido, teniendo una residencia todos los viernes en **The Gallery** en el **Turnmills** además toca regularmente para **Godskitchen**, **Gatecrasher**, **Sundissential**, **Cream** y **Golden** por mencionar algunos. Su popularidad lo

ha llevado a mezclar también en Estados Unidos, Canada, Japón, Australia, Brasil, Hong Kong, Sudáfrica y casi toda Europa. Fue nominado el *Best Overall DJ* en los *Premios Ibiza 99* de **7 Magazine** por su residencia en el **Godskitchen**, y cada año es referido como uno de los mejores 100 DJs en la revista *Top 100 DJ*.
En 1992 Paul estableció su propio sello. Lanzando **Live Rush** una pieza del *Trade*, después colaboró con **Hooj Choons Red Jerry**, el cual lo bautizó como **Tall Paul** y sacaron el clásico dance **Rock Da House**. Posteriormente Paul ha producido numerosos *hits* incluyendo **Deeper** y **Train of Thought** de **Escrima** y la más exitosa hasta ahora **Let Me Show You** de **Camisra**. Tiene su propio sello discurro **Duty Free Recordings** el cual incorpora también un estudio de grabación, todo esto dentro del club *Turnmills*. El sello ha producido a **JS16 Robbie Rivera Radical Playaz DJ Lottie, Durango-95 Dave Aude**
Su trabajo ha aparecido también en varias compilaciones incluyendo **The Gallery Modern**

Masters Vol.#1 Club Nation 1998 and **Cream Anthems** , **House Collection** de **Fantazia** En 1999 Paul firmó con **Ministry of Sound**, para el cual ha compilado y mezclado **Dance Nation 6 The Ibiza Anual 2 Millennium Annual Dance Nation 7** y recientemente **Headliners** que es una nueva serie de **Ministry of Sound** y es el primer disco que Paul dirigió solo. No contento con encender las pistas de baile, dirigir su propio sello disquero, producir albums y éxitos en los clubs, Paul presenta su propio show de radio **The Mix Down Session** de 7 a 9 pm- en la radio de dance número uno de Londres **Kiss FM.**

segundo festival internacional de arte **sonoro**
presenta: Directo de New York City

djspooky
THAT SUBLIMINAL KID
A.K.A. PAUL D. MILLER

Sábado 29 de Julio, 2000.

GOOD MORNING AMERICA
the after party

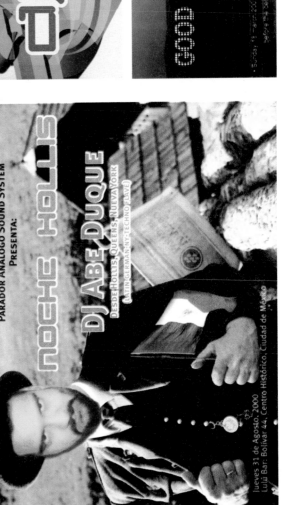

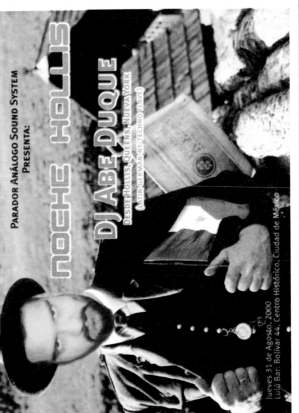

PARADOR ANÁLOGO SOUND SYSTEM
PRESENTA:

NOCHE HOLLIS

DJ ABE DUQUE
(LATIN-GERMANY-TECHNO LIVE)
DESDE HOLLIS, QUEENS, NUEVA YORK

Jueves 31 de Agosto, 2000
Lulú Bar: Bolívar 44, Centro Histórico, Ciudad de México.

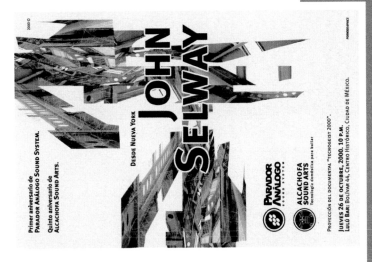

BRASILIEN
BRASIL

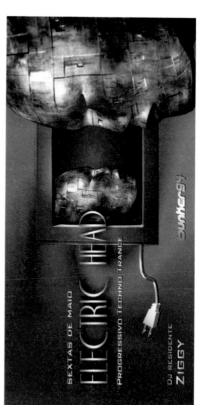

INTENSE

aj marky

drum'n bass

quartas de maio

QUARTAS DE MAIO, DRUM'N BASS

QUA 08/MAIO
DRUM'N BASS DJ MARKY

QUA 15/MAIO
DRUM'N BASS

PISTA KINKY >>
T'AI HEAD E MARKY (DRUM'N BASS)

PISTA GROOVE >>
THEDDY (ROCK)

PISTA KINKY >>
LUCIO K E T'AI HEAD (DRUM'N BASS)

PISTA GROOVE >>
THEDDY (ROCK)

LOUNGE >> VIDEOS

RedBull U2

Vem aí BUNKER NON STOP. Aguardem !!!

>> R$12,00 c/flyer até 24:00h com direito a 1 cerveja
>> R$14,00 c/flyer após 24:00h. até 01:00h >> R$ 16,00 s/flyer

Proibido p/ menores de 18 anos - Mantenha a cidade limpa

bunker94 Rua Raul Pompéia, 94
Info. 2541-0367 / www.bunker94.com.br

Bel Brito/Azul.art.br

bunker94

ALiEN NATiON

SEXTAS EM MAiO E JUNhO

SEXTA. 07/06
DEAD.FISH LiVE

SISTER MOON CLUB

BOB MARLEY
Cover

PROJETO LUAU ACÚSTICO

30/05
quinta-feira
feriado

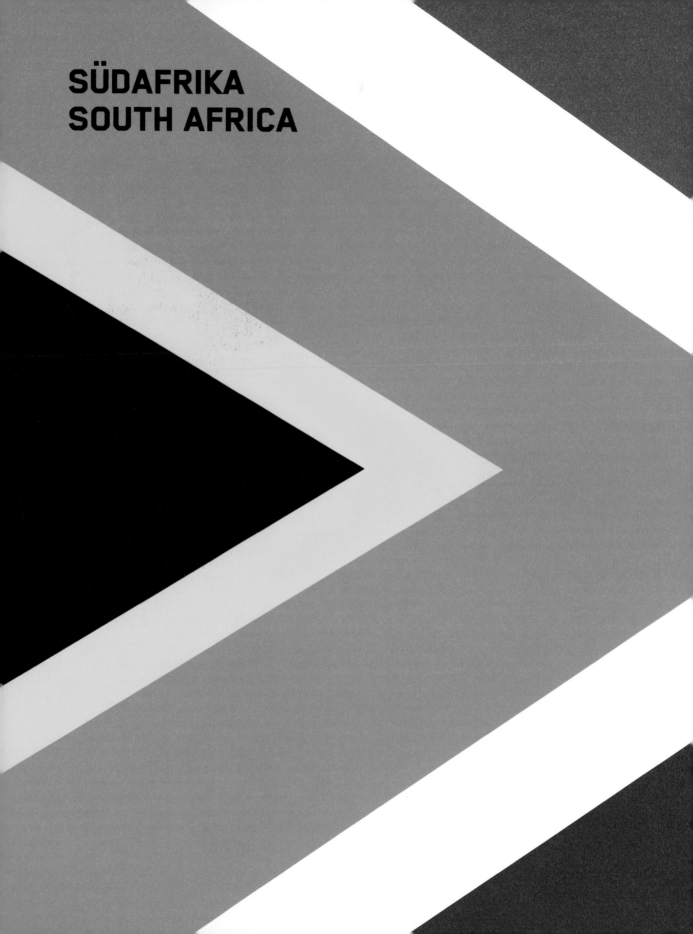

SÜDAFRIKA
SOUTH AFRICA

THE MOTHER MONTHLY'S TASTY TIM

BROUGHT TO YOU BY SKECHERS

FREEDOM... like you've never!
COMING 26 APRIL

FAITH

Creation

Saturday 1st March

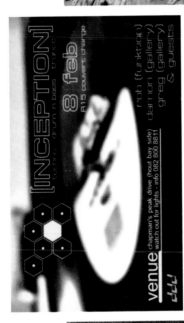

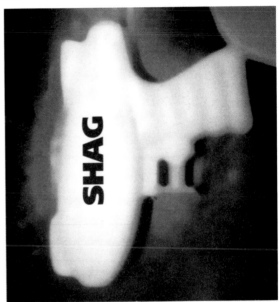

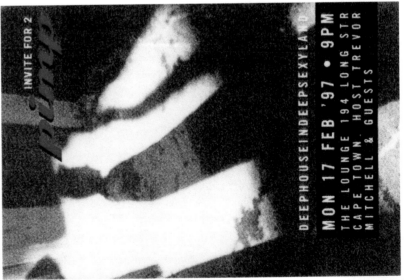

ANHANG

FLYER IM NETZ

Stammheim	http://www.hotzesworld.de/StammheimArchiv.html
Dr. Motte's Gallerie	http://www.drmotte.de/
Gabba Mafia	http://ggm.gabber.org/Flyers/Flyers.htm
Groovinkim's Seattle	http://www.pulpfiction.com/rave/groovinkim/flyers.html
Klang und Kleid	http://www.klangundkleid.ch/plakate/
FlyerArt	http://www.flyerart.com/
DJ Spooky	http://www.djspooky.com/
Jason Forrest	http://www.cockrockdisco.com/
Hyperreal Archives	http://hyperreal.org/raves/database/index.html
Electronic Music Dict.	http://www.intuitivemusic.com/technoguide.html
Climate Archives	http://www.climated.com/
Weed's Empire	http://www.raveflyers.co.uk/
DJ String	http://www.djstring.co.uk/flyer/albums.php
Dreampaint	http://dreamp.club.fr/flyere.htm
Flyer-o-magic	http://flyers-o-magic.tk/
Flyer Museum	http://www.funkreich.de/
Flyersweb	http://www.flyersweb.com/
Florida 135	http://www.florida135.com/pages/flyers/intro.htm
Goatrance	http://www.goatrance.de/goabase/flyers.php3?bPast=0
Fly Art	http://hem2.passagen.se/clan303/
Flyer Zone	http://skip.snoozland.com/
Fantazia	http://www.fantazia.org.uk/Gallery/gallery.htm
Flyermaniac	http://groups.msn.com/flyermaniac
Goatrance	http://www.goatrance.nl, http://www.goatrance.de/
Geriatric Ravers	http://www.geriatricravers.co.uk/
Nomax	http://home.tiscali.be/nomax/
Megatripolis	http://www.megatripolisarchive.co.uk/
Isratrance	http://www.isratrance.com/www/index.php
Just groove	http://www.justgroove.com/groove.php
DJ Naha	http://www.djnaha.homestead.com/FlyerIndex.html
Old Skool Homeland	http://www.oldskoolhomeland.ukf.net/Flyers.htm
DJ Hutcho	http://www.space.net.au/~hutcho/review2004.htm
Kjbi	http://www.kjbi.com/
Klangkrieg	http://www.klangkrieg-produktionen.de/flyer.htm
M 1 Club	http://www.m1-theclub.net/m_dir_fly.html
Partflyer	http://www.partyflyer.com/
Phluxproductions	http://www.phluxproductions.com/
Phatmedia	http://www.phatmedia.co.uk/Flyers1/flyers1.htm
Pirate Revival	http://retrodayz.com/prflyers/
Ravelinks	http://www.ravelinks.com/flyers/flyergallery.htm
Ravers of Alaska	http://www.raversofalaska.com
San Francisco Area	http://www.sfraves.org/flyers/
Streetnation	http://www.streetnation.com/streetraves/flyers.html
Tapes Galore	http://www.tapesgalore.co.uk/flyers.htm
The Acid House	http://www.theacidhouse.com/
The Flyer Guy	http://www.theflyerguy.com/
Tranceculture	http://tranceculture.free.fr/Pages/GalerieSomm.html
One Love Flyersale	http://www.onelovemagazine.co.uk/index2.htm
Old Skool Vibe	http://www.oldskoolvibe.com/flyers.htm
Teknoscape	http://www.teknoscape.com.au/

Joe Landen	http://www.techno.de/flyer/
UK Rave Flyers	http://ukraves.cjb.net/
GoedeWiet Database	http://goedewiet.no-ip.com/pagina_download_flyers.thc
Inyourface	http://www.house-music-inyourface.com/flyergal.htm
Zagreb Rave Fliers	http://www.geocities.com/seadd/rave/fliers.htm
Zulunation	http://www.zulunation.com/trueskoolflyers.html
Old School	http://toledohiphop.org/images/old_school_source_code/
Gigposters	http://www.gigposters.com

YAHOOGROUPS

http://groups.yahoo.com/group/cooperwr/
http://groups.yahoo.com/group/flyersland/
http://groups.yahoo.com/group/flyersland2/
http://groups.yahoo.com/group/flyersland2001/
http://groups.yahoo.com/group/flyersland2002/
http://groups.yahoo.com/group/flyersland2003/
http://launch.groups.yahoo.com/group/flyersland2004/
http://groups.yahoo.com/group/flyersland2005/
http://groups.yahoo.com/group/flyer-contest-and-club-reveiw/
http://groups.yahoo.com/group/flyerz2/
http://groups.yahoo.com/group/eastcoastraversunion/

RECOMMENDED DESIGNERS

http://www.justicedesign.com/parties/
http://www.swelt.com/
http://www.studiostrada.de/
http://www.paul-snowden.com/
http://www.djkero.com/
http://www.wabi.org/visual/cmyk/index.php
http://www.ashisandy.com/
http://www.play.drugnation.net/
http://www.bankassociates.de/
http://www.pfadfinderei.com/
http://www.poledesign.com.cn/
http://www.strukt.at/
http://www.planetpixel.de/
http://www.substratdesign.org/
http://www.fork.de/
http://www.ministryofinformation.de/
http://www.dadara.nl/
http://www.jimavignon.com/
http://www.designersrepublic.com/
http://www.walhalla.ch/
http://www.die-gestalten.de/
http://www.burodestruct.net/
http://www.surface.de/
http://www.3deluxe.de/
http://www.km7.de/
http://www.francoischalet.ch/
http://www.moniteurs.de/
http://www.xplicit.de/
http://www.nuki.org/
http://www.jjck.com/
http://www.genericpreset.com/

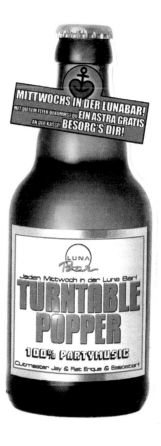

http://www.meso.net/
http://www.eikesgrafischerhort.com/
http://www.lsd-berlin.de/
http://www.bionic-systems.com/
http://www.obeygiant.com/
http://www.traumtaenzer-design.de/

EVENTS

http://www.popkomm.de/
http://www.midem.com/
http://www.mediaarthistory.org/
http://www.sonar.es/
http://www.mutek.ca/
http://www.clubtransmediale.de/
http://www.transmediale.de/
http://www.doorsofperception.com/
http://www.aec.at/
http://www.n5m.org/
http://www.ccc.de/
http://www.burningman.com/
http://www.typo-berlin.de/
http://www.designmai.de/
http://www.leipzig-popup.de/
http://www.amsterdam-dance-event.nl/
http://www.wmcon.com/
http://www.technopol.net/
http://www.streetparade.ch/
http://www.loveparade.de/
http://www.mayday.de/
http://www.sonnemondsterne.de/
http://www.festivalguide.de/
http://deaf.v2.nl/
contemporary culture convention

MEDIEN

http://www.rebelart.net/
http://www.spex.de/
http://www.goon-magazine.de/
http://www.espaipupu.com/
http://www.ladestation.net/
http://www.xlr8r.com/
http://www.de-bug.de/
http://www.techno.de/
http://www.groove.de/
http://www.novum.de/
http://www.dj-culture.com/
http://www.adbusters.org/
http://www.carhartt-europe.com/
http://www.neo2.es/
http://www.tausend.de/
http://www.sucker.de/

http://www.subculture.de/
http://www.partysan.net/
http://www.i-dmagazine.com/
http://www.metamute.com/
http://www.spin.com/
http://www.k10k.net/
http://www.intro.de/
http://www.klubradio.de/
http://www.monochrom.at/mono
http://www.strukt.at/

MUSEEN

http://www.rock-popmuseum.de/
http://www.emplive.com/
http://www.museum-gestaltung.ch/
http://www.cccb.org/
http://www.ps1.org/
http://www.palaisdetokyo.com/
http://www.documenta12.de/
http://www.museumderdinge.de/
http://www.museumsstiftung.de/
http://www.schirn-kunsthalle.de/
http://www.mkg-hamburg.de/
http://www.hamburgerbahnhof.de/
http://www.labiennale.org/
http://www.berlinbiennale.de/
http://www.kw-berlin.de/

VERLAGE

http://www.actar.es/
http://www.die-gestalten.de/
http://www.olms.de/
http://www.gingkopress.com/
http://www.schwarzkopf-verlag.de/
http://www.taschen.com/
http://www.booth-clibborn.com/
http://www.powerhousebooks.com/

INSTITUTIONEN

http://www.kulturstiftung-des-bundes.de/
http://www.zkm.de/
http://www.goethe.de/
http://www.hollandrocks.com/
http://www2.hu-berlin.de/fpm/
http://www.germansounds.de/
http://www.hitzler-soziologie.de/
http://www.merz-akademie.de/
http://www.hfg-offenbach.de/
http://www.khm.de/
http://www.v2.nl/
http://www.pop-akademie.de/

DANKE AN DIE LEUTE DIE IN LETZTER SEKUNDE NOCH TOLLE ARBEITEN GESCHICKT HABEN, NACHGEFRAGT, GEHOLFEN ODER MITGEDACHT HABEN.

Gewidmet meiner Mutter Edith Riemel und meinem Vater Tilman Uhlig
Danke an Fritz Riemel, Klaus Peter Jahn, Hans Dieter Jahn

UND DEN BERLIN PEOPLES INSBESONDERE:

Hans Reuschl, Dirk Plamböck, Jens Keiner, Ariel Authier, Stefan Siedler, Ran Huber, Massimo, Andreas Peyerl, David Friedrich, Charlotte Kreuter, Heiko Hoffmann, Horst Libera, Jochen Flad, Johannes Wilms, Karoly Toth, Katarzyna Bialousz, Kerstin Makropop, Lars Hammerschmidt, Jan Rikus Hillmann, Laura Ewertje Ewert, Mario Blum, Matthias Leh, Michael Hönnig, Nik Lisak, Peter Maibach, Pit Schultz, Kevin Zaar, Sebastian Bissinger, Bea Seggering, Guido Plonski, Thomas Junker, Wolfgang Kemptner, Heiko Pötzsch, Oliver Rednitz, Joanna Piekos, Bodo von Hodenberg, Thorsten Wiedemann, Christopher Fröhlich, Carlo von Lösch, Christoph Musiol, Danielle Glukman, Frau Nawrath, Diana McCarty, Dirk Schubert, Kirill Falkow, Jason Forrest, Manaira Assuncao, Jana, Peter Grummich, Hugo, Tania Ilinares, Usho Enzinger, Sebastian Lüttgert, Gabriele Horn, Tanja Mühlhans, Diedrich Diederichsen, Club Transmediale Crew, Ingo Bader, Dietrich Töllner und der Bootlab Crew insbesondere Jan…

OUT OF BERLIN:

Volker Steck, Martin Zülch / Karlsruhe
Jens von Bringmann und Kopetzki / Kassel
Thorsten Leucht / Freiburg
Dietmar-Stefaan Diewerge, Valentin Schommer / Trier
Richard Stichter, Claudia und Klaus / Frankfurt
Falk Klemm, Andre Quass, Mathias Müller, Jan Ziegner / Leipzig
Joe Landen / Stuttgart,
Andrea Mühlthaler, B. Röder, S. C. Steinmeyer, M. Kammerbauer, Jörg Parzl / München
Ralf Köster, Klaus Maeck, Felix Seibt / Hamburg
Oliver Pfeil, Uwe Husslein / Köln
Toci / Jena
Jens Haffke / Düsseldorf
Ute Jobmann, Uwe Clever / Somewhere
Stefan Feuz, Barbara Junod, Dr. Götz Schuck, Guido Krummenacher / Zürich
Lucas Evers, Designarbeid / Amsterdam
Paul D. Miller, Stephen Cohen, George Campbell, Kero, Derek M., Kate Specht / USA
Kevin McTavish, Malcolm Levy / Canada
Malin Götemann / Schweden
Jani Eerola / Finnland
Craig & Hayley / New Zealand
Natàlia Heredia, Tite Barbuzza, Sascha Siebenmorgen / Barcelona

DEN SPONSOREN UND PARTNERN:

Oliver Drewes & Lutz Erian, Carhartt Europe

Mehdi Bouyakhf, Nike Deutschland GmbH

Stefan Deeken, Holsten Brauerei AG

Mathias Paetzelt, Katrin Zywietz at Eastpak

Ben de Biel, Maria am Ostbahnhof

Hein C. Gindullis, Cookies

Dimitri Hegemann, Tresor

Marc Wohlrabe

Ramin Bozorgzadeh, Groove Attack

Thomas Lenz, Mode...Information

Birgit, Gerriet Schultz, Atilano González at WMF

Catia Tessarolo, Graphicom

Ramon Prat, Anna Tetas, Actar

Klaus Farin, Archiv der Jugendkulturen

Danke auch den Firmen: UMAX, Freecom, Modulor, Klubradio, MIKEA 5+

Besonderer Dank gilt der Kulturstiftung des Bundes

Andreas Heimann und Dr. Fokke Peters / Halle a.d. Saale

Den freundlichen Mitarbeitern der angefragten Unternehmen
und all unseren Gastgebern und Pressemenschen in den letzten 8 Jahren !

ALLEN AUTOREN UND DEN SAMMLERN UND BEITRÄGERN:

Marco Microbi, Alexandra Eszl, John Boerger, Holger Bangert, Mark Stolz, Honza Taffelt, Harald Westhaus, Peter Krell (Suct), Uli + Ela, Claire Koch, Svend Buhl, DJs Bass Dee, Feed (Hard: Edged), Ralf (Suicide), Bastian (Toaster), Antye Weitzel, Brains, Jim Avignon, Patrick Zollinger, Tilo Weiser, Inga Königsstadt, Dirk (No Ufos), Andreas und Dirk (Neue Berliner Initiative / Kyborg Bar), Deutsches Flyerarchiv (Gelnhausen), Jörg Sundermeier (Partysan Berlin), Wulf Gäbele (Trinidad Trier-Dortmund), Carsten Helmich (FZW Dortmund), Raik Hölzl (Kitty Yo Int.), Spiral Tribe, Uwe Reineke (Planetcom / Interference), Nature One, Die Gestalten, Pyro Design, Frank (Delicious Doughnuts), Christoph Tsha'ba, Klaus Kotai (Elektro Music Depeartment), Sensor, Marc Wohlrabe, (Archiv Flyer), Samuel Troll (Flyer Berlin), Taifun (Shedhalle), Markus Weisbeck (Surface), Dan Suter (Echo Chamber), Unique, Xplizit, Klaus Löschner (Frisbee Tracks), Liquid Sky Cologne (Elektrobunker), Uwe Husslein (PopDom), Dr. Androtsoupulos (Flyer Research), Klaus Farin (Archiv der Jugendkulturen e.V., Marc Busse (Destillery Leipzig / 1000 Grad), Antye Ludwig (Sage /Yaam), Luka Skywalker (Radio FSK / Neid), Helge Birkelbach (YOC / Flyer), Gabriele Lipp, Olian (Zora Lanson), Jana (Glam + Club Med), Christa Biedermann, Ed Marcinewski (Supersphere, Chicago), Zane und Ole (Betalounge), Kate Specht (Mint, Berlin), Claudia Z, Norbert (Ostgut), Martin Schramm (Goldmund), Schöne Welt, Gomma, Meteosound, Destillery Leipzig, Shrinking Cities, Wabi / Toronto, Ghostly, Johannes Wilms, Sebastien Springborn, Mame McCutchin und viele andere Sammler, Freunde, Grafiker, Clubs ! sorry wenn nicht namentlich erwähnt.

and my sweet team and support gang that made it possible.

UR SOZIOTOPE

SCAN + ARCHIV TEAM:

Harald Westhaus (Leitung Scan), John Boerger (Leitung Archiv), Charlotte Wiese
Helene Altenstein, Dorothea Lemme, Andreas Hillebrand, Therese Giemza
Natsuko Mizushima, Christian Mann, Bianca Bode, Aik Meier, Julian Friesel
Charlotte Wiese, Katharina Beese, Klaus Zimmermann, Roman Freytag, Helene Altenstein
Lydia Schneidewind, Susann Winkler, Undine David, Alexandra Tratzki, David Friedrich
Alexandra Eszl, Stephanie Offhaus

REDAKTION:

Oliver Schweinoch , Anett Frank, Oliver Ilian Schulz, Marta Jecu, Violetta Donhöffer

LEKTORAT:

Manuel Bonik, Violetta Donhöffer

OFFICE + ORGANISATION:

Katharina Reimer, Rudolf Kirch, Penko Stoitschev, Susann Winkler

TECHNIK:

Thomas Sarkadi (PC und Web), Michael Hempel (PC), Alexeij Schön (Video)

ÜBERSETZUNG:

Nicholas Grindell, Matthew Heaney. Athena Miller, Peter van der Loo, Alena Williams
Moritz Mattern

LAYOUT UND DESIGN:

Brigitte Speich, Markus Wohlhüter und Jacques Magiera – substratdesign (Leitung)
Benjamin Hickethier – dieDiebe.be
Fubbi Karlsson – Ministry of Information, Critzla und Honza Taffelt – Pfadfinderei
Paul Snowden, Gösta Wellmer, Reto Brunner, Natalie Körber, Doreen Sudrow – Eastend-
girl, Karoline Cerny, Karen Strempel – Underfrog, Rolf Karner, Marcus Schenck,
Amélie Mittelmann, Björn Rebner

INTERNET:

Thomax Kaulmann. Alfred Himmelweiss, Claudia Z

FOTOS:

John Boerger, Dirk Plamböck, Hans Reuschl, M. Riemel, marco.microbi/photophunk.com

Das Berliner **ARCHIV DER JUGENDKULTUREN E.V.** existiert seit 1998, und es hat sich zur Aufgabe gemacht, Zeugnisse aus und über Jugendkulturen (Bücher, Diplomarbeiten, Medienberichte, Fanzines, Flyer, Musik etc.) zu sammeln, auszuwerten und der Öffentlichkeit wieder zugänglich zu machen. Das Archiv unterhält zu diesem Zweck in Berlin-Kreuzberg eine rund 200qm umfassende Bibliothek, organisiert Fachtagungen und Diskussionsveranstaltungen in Schulen, Firmen, Jugendklubs oder Universitäten und gibt eine eigene Zeitschrift, das Journal der Jugendkulturen, sowie eine eigene Buchreihe heraus, in der sowohl sachkundige WissenschaftlerInnen, JournalistInnen u.a. als auch Szene-Angehörige zu Wort kommen.

Vereinsmitglieder erhalten sämtliche Publikationen des Archivs kostenlos zugeschickt.

|archiv|
der jugendkulturen e.v.

Fidicinstraße 3, 10965 Berlin
Tel.: 030/69 42 934
Fax: 030/69 13 016
archiv@jugendkulturen.de
www.jugendkulturen.de
Öffnungszeiten: Mo-Fr 10-18 Uhr und
nach Vereinbarung

JOURNAL DER JUGENDKULTUREN NO. 10

IDENTITÄT: SKATEBOARDER (A DISCLAIMER)

Von Martin Kowalski

CHOLOS UND GRUPEROS

Jugendkulturen an den Grenzen Mittel- und Nordamerikas

Von Manfred Liebel

"WEIL WIR MÄDCHEN UNS NACH PLATTEN, BÜCHERN UND FANZINES SEHNEN, DIE UNS ANSPRECHEN..."

(Riot) Grrrl (Fan)Zines und die Politik der Selbstermächtigung

Von Christian Schmidt

WEISSES RAUSCHEN

Eminem, die Medien und das Schreiben über HipHop

Von Jochen Flad

CALLIGRAPHICAL IDENTITY

Wie die "Styles" von den Zügen New Yorks auf die Pullover deutscher Schulkinder kamen.

Von Lutz Henke

ISSN 1439-4324, 146 Seiten, 10 Euro

|journal|
der jugendkulturen

Identität: Skateboarder | Lateinamerika | Grrrl (Fan)Zines | Eminem | Calligraphical Identity | Österreich Special von jugendkultur.at | **No. 10**

Jörg Ueberall

SWING KIDS

Die Leidenschaft der Swing Kids für die "Negermusik" Jazz und englische Kleidung, ihr Tanzstil und ihr Individualismus genügten den Nazis, um massiv gegen sie vorzugehen: Hunderte von Jugendlichen wurden wegen "Anglophilie" in "Schutzhaft" genommen, ein Teil ins KZ überstellt, zumeist ohne offizielle Anklage oder Verhandlung.

Jörg Ueberall begab sich in Hamburg auf die Spuren der ersten Jugendsubkultur, die ihr Selbstverständnis aus der Musik zog.

ISBN 3-936068-68-2, 120 Seiten, 15 Euro

Jörg Ueberall
swing kids

IN JEDER GUTEN BUCHHANDLUNG ODER UNTER WWW.JUGENDKULTUREN.DE

ARCHIV DER JUGENDKULTUREN (HRSG.):
POP UND POLITIK
HIPHOP, TECHNO, PUNK, HARDCORE, REGGAE/DANCEHALL...

Sind Jugendkulturen wie HipHop, Techno oder Punk so progres-
siv wie ihr Ruf? Was ist Interpretation und was Realität? Welche
politischen Ansätze und Diskussionen sind innerhalb dieser Ju-
gendkulturen zu nden? Ein detaillierter Blick auf diese Jugend-
kulturen soll Antworten auf diese Fragen geben und aufzeigen,
wieso sich eine Diskussion um "Popkultur und Politik" mit Ju-
gendkulturen beschäftigen muss.
Mit Beiträgen von u. a. Jannis Androutsopoulos, Martin Büsser,
Markus Hablizel, Sonja Eismann und Jörg Sundermeier
ISBN 3-86546-033-X, ca. 220 Seiten, 18 Euro

SPOKK (HRSG.):
JUGEND – MEDIEN – POPKULTUR
EIN SAMMELALBUM

In der Tradition des 1997 von SPoKK herausgegebenen "Kurs-
buch JugendKultur" stellt dieser Band Anschlüsse an eine ak-
tuelle Forschungsagenda am Schnittpunkt von Jugend-, Medi-
en- und Popkultur her. Dabei stehen Leitfragen im Mittelpunkt,
die zwischen jugendkulturellen Akteuren, Anliegen und Aus-
drucksweisen differenzieren und für alternative Sichtweisen
sensibilisieren sollen: Antworten an den Schnittstellen zwischen
Feuilleton, Wissenschaft und Literatur liefern u.a. Diedrich Die-
derichsen, Birgit Richard, Tim Staffel und selbstverständlich die
Mitglieder des Autorenkollektivs SPoKK (www.spokk.de).
ISBN 3-936068-89-5, 204 Seiten, 20 Euro

PROJEKTGRUPPE JUGEND UND RELIGION
IF GOD IS A DJ ...
"Gott ist tot! - Aber Totgesagte leben länger!" behauptet ein
Graf ti an einer Häuserwand - eine aktuelle Trendparole? Stu-
dierende der Esslinger Hochschule für Sozialwesen unter Lei-
tung von Prof. Kurt Möller recherchierten ein Jahr lang zur Reli-
giosität von Jugendlichen. Sie sprachen mit jungen Christen und
Muslimen, mit Juden und Neonazis, und sie erfuhren von Fuß-
ballfans, was ihr Kult mit Religion zu tun hat.
ISBN 3-86546-030-5, 162 Seiten, 15 Euro

IMPRESSUM

PUBLISHED BY
Archiv der Jugendkulturen Verlag KG
ACTAR

AUTHOR
Mike Riemel

GRAPHIC DESIGN
Substratdesign

PRINTED BY
Ingoprint

DISTRIBUTED BY
ACTAR D
Roca i Batlle 2
E-08023 Barcelona
Tel: +34 93 417 49 93
Fax: + 34 93 418 67 07
office@actar-d.com

ISBN: 84-96540-03-0
DL B-29923-05

© of the edition, Archiv der Jugendkulturen and ACTAR, 2005
© of the images, their authors
All rights reserved

Printed and bound in the European Union